PATTERNMAKING

for Fashion Design

Third Edition

HELEN JOSEPH-ARMSTRONG

Professor of Fashion Design
The Fashion Center
Los Angeles Trade-Technical College

Technical Illustrator:
Vincent James Maruzzi

Fashion Illustrator:
Mia Carpenter

Prentice Hall
Upper Saddle River, New Jersey 07458

Library of Congress Cataloging-in-Publication Data

Joseph-Armstrong, Helen
 Patternmaking for fashion design/Helen Joseph-Armstrong; fashion illustrator, Mia Carpenter.—3rd ed.
 p. cm.
 Includes index.
 ISBN 0-321-03423-6
 1. Dressmaking—Pattern design. I. Title.

TT520.A74 1995
646.4'072—dc20 94-39388
99-043802

Director of production and manufacturing: Bruce Johnson
Managing editor: Mary Carnis
Acquisitions editor: Neil Marquardt
Cover illustration: Mia Carpenter
Cover concept: Helen Joseph-Armstrong
Cover design: Liz Nemeth
Cover design Coordinator: Miguel Ortiz
Technical illustrations: Vincent James Maruzzi
Fashion illustrations: Mia Carpenter
Manufacturing manager: Edward O'Dougherty

Printed in the United States of America
10 9 8

ISBN: 0-321-03423-6

Prentice-Hall International (UK) Limited, *London*
Prentice-Hall of Australia Pty. Limited, *Sydney*
Prentice-Hall of Canada, Inc. *Toronto*
Prentice-Hall Hispanoamericana, S.A., *Mexico*
Prentice-Hall of India Private Limited, *New Delhi*
Prentice-Hall of Japan, Inc., *Tokyo*
Pearson Education Asia Pte. Ltd., *Singapore*
Editora Prentice Hall do Brasil Ltda., *Rio de Janeiro*

Contents in Brief

Contents

15 Kimono, Raglan, Drop Shoulder, and Exaggerated Armholes

16 Buttons, Buttonholes, and Facings

17 Plackets and Pockets

Preface

Patternmaking for Fashion Design was written with specific goals in mind:

- To provide a comprehensive patternmaking text.
- To present clear instruction, with corresponding easy-to-follow technical illustrations and up-to-date fashion sketches, that will stimulate the creative imaginations of both technical and design-oriented students.
- To make available a reference source for the professional patternmaker and designer.
- To fill the need for basic foundation patterns.
- To provide a variety of instruction so that the motivated student will continue to learn long after the classroom experience.

We believe that *Patternmaking for Fashion Design* accomplishes these goals.

The book is divided into six parts to facilitate the location of desired information. A brief description of the special features follows.

Part 1—Chapters 1 through 3—contains information that applies to all parts of the text and should be studied carefully before pattern work begins. Chapter 1, The Workroom, covers introductory information concerning tools, terms, definitions, symbols, and the completion of patterns. It is suggested that a tab be placed at Chapter 3 for quick reference. Part 1 also features measuring techniques for developing the basic pattern set of bodice, skirt, and sleeve.

Part 2—Chapters 4 through 9—is the foundation of the book. The beginning student is introduced to the flat patternmaking principles (dart manipulation, added fullness, and contouring). These principles form the basis for developing patternmaking techniques and skills relating to pattern designs. The slash-spread and pivotal-transfer methods are used to demonstrate pattern manipulation of the bodice. Once these techniques are learned they can be applied to all patterns and designs. It is suggested that the projects be taken in sequence, as each leads to more complex patternmaking.

Part 3—Chapters 10 through 14—covers collars, built-up necklines, cowls, skirts, sleeves, and sleeve combinations. The skirt section contains information about the slinky and one-dart working pattern that should be explored. The Circle/Cascade Radius Chart is included to expedite designs featuring circular skirts and cascades. The chart eliminates the need for mathematical formulas, as all measurements for the radii are included.

Part 4—Chapters 15 through 17—covers button/buttonhole placement, neckline facings, plackets, and pockets. Additional facing instructions are given in Chapter 21, Shirts, as they apply mainly to garments of that type.

Part 5—Chapters 18 through 20—covers the introduction to the torso foundation for basic dresses without waistline seams; strapless bustier designs with added information about interconstruction; and new information about pattern adjustments for bias cut garments.

Part 6—Chapters 21 through 24—covers the shirts/blouse foundation in its very basic form having a side dart for distribution at various locations. Jackets and coats include creative lapel designs. Straightline and flared capes are illustrated. Hoods are fitted and loose with and without a dart for control. Chapter 24 introduces patternmaking methods for copying ready-made garments called "knock-off."

Part 7—Chapters 25 through 29—covers pants with the four foundations and related designs remaining unchanged. An updated method is illustrated for beginning the bodysuit and leotard foundations. The swimwear sections with the four foundations remain unchanged with the exception of deleting several designs.

Part 8—Chapters 30 through 36—is related to childrenswear for sizes 3 to 6X and 7 to 14 (boys and girls).

In the back of the book the following are found:

- Metric Conversion Table
- Half-size Basic Pattern Set
- Quarter-size Basic Pattern Set
- Quarter-size Torso

(*Note:* These patterns can be cut out of the book and transferred to pattern paper of plastic for use in pattern development.)

- French Curve. If this tool cannot be purchased, cut it from the text and transfer it to pattern paper or plastic.
- Index
- Form and Personal Measurement Chart
- Children's Measurement Recording Chart
- Cost Sheet
- Patterns Chart

These charts are placed in the back of the book for use in making copies.

This book is based on the contributions of great patternmakers of the past and adds to them new innovations and concepts gained through years of experience in the industry and the classroom. It is comprehensive enough to be a valuable tool now and in the future regardless of fashion trends.

Every effort has been made to avoid errors; however, with a text of this magnitude, it is possible that errors may exist. Hopefully, errors found are minor and will not hinder the reader's understanding.

The author acknowledges that there is more than one method for developing patterns and welcomes comments and ideas from readers (see below).

For comments and questions—contact the author
Fax: 310/322-6542, or
www. hjapatternbooks.com
hjarmstrong@socal.rr.com

Acknowledgments

I wish to express my appreciation to the following persons who contributed freely of their time to help make *Patternmaking for Fashion Design* a better book. Special appreciation goes to:

- Mia Carpenter whose fashion sketches and cover have given the revised text excitement and flare.
- Loretta Sweeney for her contribution to the original text.
- Vincent James Maruzzi for his excellent technical illustrations.
- Dr. Peyton Hudson of the North Carolina State University, for giving her time, talent, and good advice when needed.
- Professors Inga Broulard, Mary Brand, Yuki Hatashita, and Sharon Tate of the Fashion Center at Los Angeles Trade Technical College for their help in so many special ways.
- All the reviewers for their helpful suggestions: Susan Joy Baker, Otis College of Art and Design; Elizabeth K. Davis, Kent State University; Ken Simmons, Houston Community College; Brygida B. Swiatowiec, Harper College; Anne Smock, Philadelphia College of Textiles; M. Jo Kallal, University of Delaware
- Jeanne Rea, for allowing me to modify the stretchy knit pattern.
- Michelle Lininger for her expertise in setting the grading rules for the measurement charts.
- Jack Fingerman, a noted designer and production patternmaker, for his insight and suggestions for the jacket foundation and interconstruction development.
- Samuel Schelter of Catalina Swimwear, who took time to answer my questions concerning swimwear and knits.
- Kay Cleverly, whose encouragement and good will helped me to forge ahead.
- The countless students over the years, who have found, as I have, the thrill and excitement of exploring the wonderful world of patterns.

I wish to say thanks to Gerber Camsco, Inc., Vilene®-Freudenberg non-wovens (formerly called Pellon), QST Industries, Inc., and Dario Grad-O-Meter, for allowing me to use them as references.

Last, but not least, my thanks to Prentice Hall for helping to make *Patternmaking for Fashion Design* a beautiful presentation.

HELEN JOSEPH-ARMSTRONG

1

The Workroom

Patternmaking Tools

To work efficiently, the patternmaker must have the proper tools and supplies. To communicate effectively in the workroom and to minimize errors due to misunderstanding, the patternmaker should know and understand terminology. This chapter introduces tools, supplies, and definitions of terms used in industry.

The professional patternmaker arrives on the job with all tools required for patternmaking. Each tool should be marked with an identity symbol and transported in a carrying case. Tools may be purchased from apparel supply houses, art stores, department stores, and yardage stores. Specialized tools, such as a rabbit punch used to punch pattern holes for hanger hooks, are generally supplied by the manufacturer.

1. *Straight pins:*

 ___ Dressmaker silk #17 for draping and fittings.

2. *Straight pin holder:*

 ___ Pincushion, or magnetic holder for wrist, or table.

3. *Scissors:*

 ___ Paper scissors

 ___ Fabric scissors

4. *Pencils and pens:*

 ___ Mechanical pencil and sharpener. (Use #4-H lead for pattern work.)

 ___ Red and blue colored pencils to identify pattern changes. Black, green, red, and blue felt tip pens for pattern information.

5. *Rulers:*

 ___ Flex general rule—1/2 × 12-inch (very accurate).

 ___ 36-inch ruler

 ___ 18 × 2-inch plastic rule (flexible for measuring curves)

 ___ Tailor's square—24 × 14-inch metal ruler with two arms forming a 90° angle that measures, rules, and squares simultaneously.

 ___ Triangle with measurements to square lines.

6. *Curve rules:*

 ___ French curve, Deitzgen #17 is one of several curves used for shaping armhole and neckline.

 ___ Hip curve rule, shapes hipline, hem, lapels.

 ___ Vary form curve, blends and shapes armhole necklines.

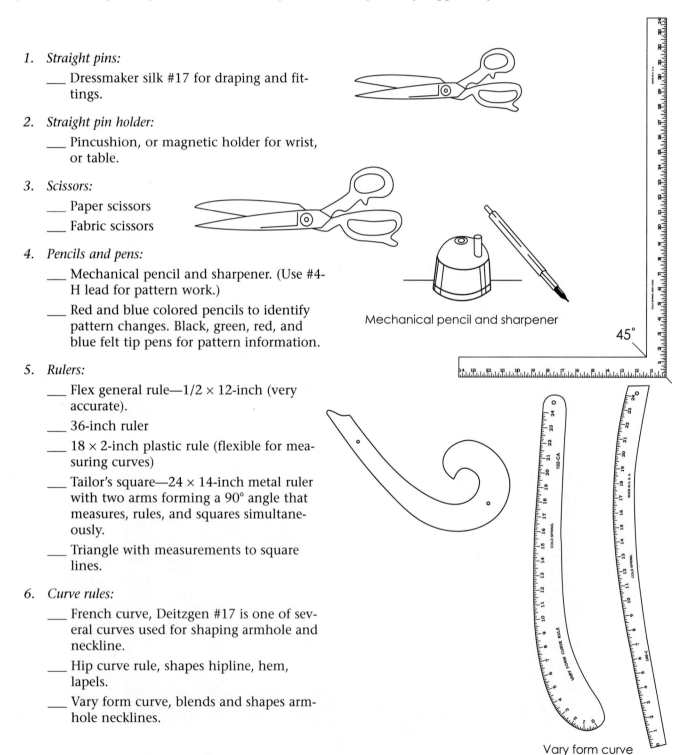

Mechanical pencil and sharpener

45°

Vary form curve

Hip curve rule

7. *Hanger hooks or ringers:*

 ___ To hold patterns together for hanging on rods.

8. *Push pins:*

 ___ For pattern manipulation.

9. *Stapler and remover:*

 ___ Prevents pattern slippage when cutting several plys of paper together.

10. *Magic mend scotch tape:*

 ___ To mend pattern work.

11. *Black twill tape:*

 ___ For placement of stylelines on form, or garment.

12. *Notcher:*

 ___ Cuts a 1/4 × 1/16-inch opening at the pattern's edge to indicate seam allowance, center lines, and ease notches and to identify front and back of patterns.

13. *Tracing wheels:*

 ___ Pointed wheel transfers pattern shapes to paper.

 ___ Blunted wheel is used with carbon paper to transfer pattern shapes to muslin.

14. *Awl:*

 ___ Pierces 1/8-inch hole in the pattern to indicate the ending of darts, pocket, trim, and buttonhole placements.

15. *Metal weights* (several):

 ___ Holds patterns in place for tracing and marking.

16. *Measuring tape:*

 ___ Metal-tipped, linen or plastic to measure the form (not very accurate).

 ___ Metal tape 1/4 inch wide inside a dispenser. It is convenient and flexible, and very accurate.

17. *Tailor's chalk:*

 ___ Clay, chalk, chalk wheel, or chalk marking pencils in black and white. Use for marking adjusted seams and style lines.

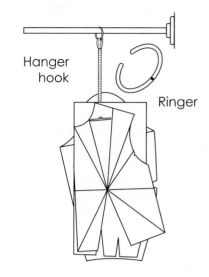

Hanger hook

Ringer

Functions of Patternmaking Tools

Tools provide the symbols used in marking fabric and patterns in the production of garments. It is the silent language that is understood among the designer or draper, seamstress, grader, marker maker, and production personnel. Without symbols, garments would not be cut or stitched with accuracy. Missing or misplaced symbols disrupt the flow of production.

Notches

The notch symbol is used for the purposes listed:

- Seam allowances
- Center lines
- Ease and gather control

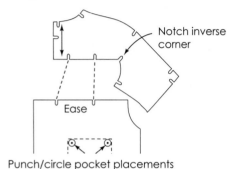

Ease

Punch/circle pocket placements

- Placement of pockets
- Dart legs
- Identifies front (1 notch) and back (2 notches) of tops, skirts, sleeve, and armhole)
- Sh/neck at collar neckline edge
- Sleeve cap
- Inward curves to release tension
- Shoulder tip of extended shoulders
- Zipper placement
- Fold-back
- Hemline lines
- Waistline or dresses without waistline
- Identifies panel parts when notched in a series
- Dart intake

Awl Punch and Circle

- Dart back-off point
- 1/8 inch in from corners
- Buttonholes and buttons
- Trimming
- Pocket placements

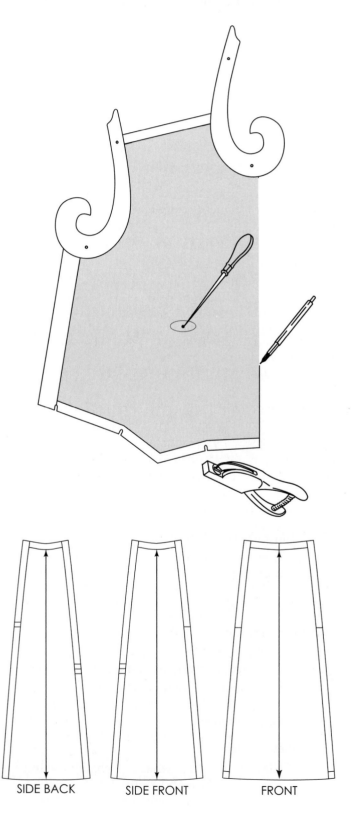

SIDE BACK SIDE FRONT FRONT

Pattern Paper

Pattern paper comes in a variety of weights and colors, each serving a special purpose. Each paper supplier uses a code system to indicate the range of paper weights available. The manufacturer's preference is based on personal choice and the use to which it is put. The heavy pattern papers are commonly referred to as *tag board, manila,* or *hard paper,* whereas the lighter weights are called *marking paper.* Their proper coding and common usage are as follows:

IX Granite Tag (.007) to

5X Granite Tag (.019)

Heavy pattern paper can be purchased in a color-coded series. A single sheet, for example, may be green on one side and white on the other, so you can see at a glance the working surface of the pattern. Companies with several divisions can color code the pattern to indicate to which division it belongs. This paper is generally used for the *first pattern,* but always used for *production pattern* (the final pattern, made after the fit of the garment has been perfected and the first pattern corrected), and for *pattern grading* (developing size ranges).

1 to 5 Double-Duty Marking Paper

Light to heavy, white marking paper is used for developing first patterns and for making *markers* (precise pattern layout, see page 6). It contains symbols as an aid for establishing true grainlines.

Patternmaking Terms

The following terms and definitions are related to the workroom.

Pattern drafting. A system of patternmaking that depends on measurements taken from a form or model to create basic, foundation, or design patterns. An example is the draft of the basic pattern set.

Flat patternmaking. A system of patternmaking that is dependent on previously developed patterns. In flat patternmaking the patterns are manipulated by using a slash or pivotal method to create design patterns.

Basic pattern set. A five-piece pattern set, consisting of front and back bodice and skirt and a long sleeve, which represents the dimensions of a specific form or figure. It is developed without design features. It is always traced for patternmaking when using the slash and spread technique described in Chapter 2. The traced copy is referred to as a *working pattern.*

Working pattern. Any pattern used as a base for manipulation when generating design patterns.

Basic Pattern Set

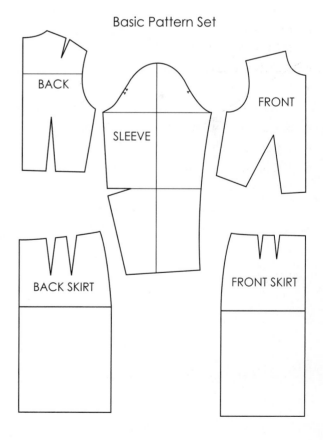

Pattern Production Terms

First patterns. The original pattern developed for each design. This pattern is generally made from marking paper and usually requires fitting and adjustments. Half a pattern is developed unless the design is asymmetrical.

Production pattern. The production pattern is a pattern set that has been corrected and perfected and contains every pattern piece required to com-

plete the garment. It is used by the grader for grading sizes, and by the marker maker for a fabric layout. See example below. A pattern chart is placed in front of the set (see page 11, and for a blank copy see back of book).

Marker maker. The marker maker's responsibility is to lay the production patterns on marking paper so that there is little waste of fabric. Pattern sizes are often mixed on the marker to prevent waste. The marker is either pencil marked, photo marked, or marked on a computer system.

Ⓞ **Pattern grader.** The grader proportionately increases and decreases the size of an original pattern within a size range (referred to as the pattern grade). The grade is in the length, width, and circumference. Grading is done using one of the following tools:

Dario Grading Machine (above). Purchase through Veccharelli Bros., PO Box 15443, Los Angeles, CA 90015.

Computer AccuMark 100 and 200 (left). Offered by Gerber Computer Company.

Grading ruler (left). The grading ruler and text can be purchased by contacting Eleanor Davis, 1128 Lafayette St., San Gabriel, CA 91776. (Convenient for classroom or the designing room.)

For those interested in learning how to use the PAD System for patternmaking, the author suggests *Pattern Drafting for Apparel with PAD System Version 2.5—A Workbook* by Sharon Underwood, Ph.D. and Cynthia Istook, Ph.D.

Ascot Publications
ISBN 1-888452-02-1
P.O. Box 330205
Ft. Worth, X 76163-0205

Pattern marker maker. A marker is a length of paper containing a copy of all pattern pieces to be cut at one time. All patterns are interlocked and aligned on the marker paper so that when cut, the grainlines will lie parallel to the selvage of the fabric. The completed marker is placed on top of layers of fabric as a guide for the cutter. There are three methods for making markers:

1. A pattern marker maker traces each pattern on marker paper.

Courtesy of Sharon Tate, Inside Fashion

2. Patterns are photographed (photo marking) on paper as a conveyor belt carries the patterns under a camera.

3. A computer system with miniaturized copies of the original pattern used in the lay-up process houses the information in its memory bank until needed (AccuMark™ 200 and 500 systems).

Accumark™ 200 and 500 Systems
Provide piece grading, marker making, and pattern design.

Pattern cutter. After the marker is made and laid on top of the layers of fabric, the garments are cut by the cutter or by a computer cutting machine.

High-Ply Cutter. Up to three inches of compressed fabric can be consistently and accurately cut using a high-efficiency vacuum hold-down system.

Pattern Development Systems

Design patterns can be generated through pattern manipulation by hand, or with the use of computer systems called PDS (pattern development system), CAD (computer-aided design), and PAD (pattern-aided design). Computer companies offer several methods for pattern generation.

AccuMark Silhouette is an innovative concept designed to enhance the skills, experience, and capabilities of the patternmaker. Designers are free to apply their instinctive talents, individual techniques, and preferred tools to patterns. Excellent for copying ready-made designs.

Pattern Design System
Micro Mark™ **PDS** The system provides the following functions: pattern drafting and design, pattern modification, style changes, and others.

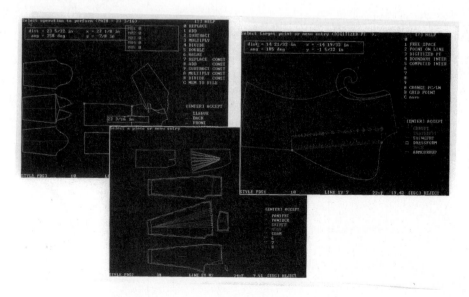

Cost Sheet

A cost sheet is a complete record of each design and is used to *cost* the garment and establish the wholesale price. The top part of the form (items 1 and 2) is completed in the design room. It should include the names and telephone numbers of salesperson, fabric and trim companies, as well as fabric swatches, a sketch, and special pattern information or instructions. A blank copy is included in the back of the book for duplicating.

The original copy is for the manufacturer or production person, who completes the lower part (items 3 and 4) and marks yardage. This provides the manufacturer with information required for production. A duplicate kept in the design room for quick reference makes for fewer interruptions in the design department.

COST SHEET

GENERAL INFORMATION			FABRIC INFORMATION			STYLE INFORMATION	
MARKER	Length	Yards	RESOURCE	*Cone Fabrics*		DIVISION	*Jr. Div.*
FABRIC			PATTERN	*6354*		STYLE	*1003*
			WIDTH	*45"*		PRICE	*62.50*
			PRICE	*2.75*		SEASON	*Spring*
LINING			CONTENT	*Poly/visca*		REFER. NO.	*16165*
			COLORS	*Blk/white Green/Bl*		DATE	*8-30-93*
INTER			SALESMAN	*Mr. Tabing*		ITEM	*Blouse comb bikini*
			TELE. NO.	*216-322-6542*		SIZES	*6 — 18*
TRIM			MISC.			COLORS	*Blk/white Green/Bl*
						MISC.	

1. MATERIAL		Estimate	Actual	Price	Amount
Poly/cotton		*2½*	*2¼*	*3.50*	*8.75*
LINING					
INTER					

TOTAL MATERIAL COST

2. TRIMMINGS	Estimate	Actual	Quantity	Amount
BUTTONS		*6*	*4.00 gr.*	*.15*
ZIPPERS		*1*		*.12*
Elastic		*23¾"*		*.25*
BELTS				
Shoulder pad		*2*		*35*
PLEATING				
TUCKING				

TOTAL TRIMMINGS COST

3. LABOR	Estimate	Actual	Dozen
CUTTING	*1.15*	*1.00*	*12.00*
LABOR	*2.75*	*3.00*	*36.00*

TOTAL LABOR COST *13.62*

4. TOTAL COST	
A. % OF MARKUP	*45%*
B. TOTAL WHOLESALE	*(round out) 62.50*

5. REMARKS:

SKETCH

Swatch here

FORM 71 ADAMS PRESS, 830 SO. BROADWAY, L.A. 14. MA 7-2151

Pattern Chart

The pattern chart is a complete record of all pattern pieces within the pattern set. It also includes swatches, special pattern information. Each pattern shape is identified by name and number of pieces to be cut. A color code is used to distinguish linings and interlinings from other pattern pieces. When completed, the chart is placed in front of the production pattern and given to the production manager. Some charts require sewing guides, as shown. A copy is found in the back of the book, page 804.

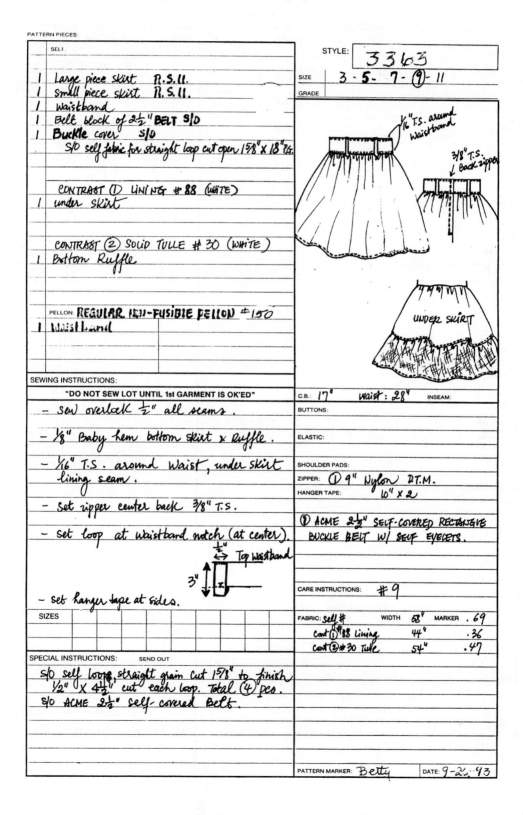

The Design Specifications Sheet

The specifications design sheet is a record of the finishing requirements for each design. It is used by those responsible for finishing to ensure that the garment meets company standards. Study the chart and compare the information to the design it represents.

Design Specifications
(Juniors) Womens

Date 8-4-87 Fit Base NEW Style SJ04507B

Name: NANI

Facing, (2pc) 1pc Width 2½" Lining ___
set
facing Bander: 2 needle___ 4 needle___
at ¼" Finish: fold back___ clean end___
 Other: edgestitch top waist

Belt Loops: ___Tunnel__Reg. Jean (6)___
 Width___Other:___
½", to finish at 2", ½" from top, OVER FOR
 BARTACK PLACEMENT

Front: Plain___ Inverted (2) Pleat Depth ½"___
 Other: length-3"-BARTACK

Front Pockets: set to front ¼", edgestitch ___
Finished Opening 8¼"___
Western___ Reese___ Welt___ Trim___
Button Hole: Vertical___ Horizontal X___
Rivets___ Other:___
Pockets · BARTACK-below elastic + at bottom

Belt: Self___ Width 3/4" Special___
 Other___ bonded

Side Seam: Felled___ Open___ Safety ½" Cord___
 Other:___

Inseam: Felled___ Open___ Safety___ Cord___
 Other___

ELASTIC: ½"×17" cut length, ¼" from top
edge, start at inverted pleat
Seatseam: Felled___ Open___ Safety ½" Cord___

Back Pocket: Button Thru___ Welt___ Double___
 Single___ Patch___ None___ Flap___
 Trim:___ Rivets___ Other___
 Buttonhole: Vert.___ Horizontal___
NONE

Fly: 2 pc. (1) 1 pc. fly extension Other + ½ turnback
 Fly Stitch: 1 needle X 2 needle___ Cord___
 Botton:___ 6" nylon

Bottoms: SPLIT-½" clean finish Hem 1" clean finish
 BARTACK Width___
 Snap___ Button___ Elastic___

Pocket Lining: Self X + Lining A SMILE logo

Buttons Type___ Ligne 24 Mfg.___ Color DTM
or Snaps: Finish___

Fabrics Model Will Be Made In:
07

BELT-

BARTACK

A. SMILE strip label

BARTACK→

The Dart

Bust point. A designated place on the bust and pattern and referred to in flat patternmaking as the pivotal point or apex.

Dart. A wedge-shape cutout in a pattern to control the fit of a garment.

Dart legs. The two lines that converge at a predetermined point on the pattern.

Dart intake. The amount of excess (or space) confined between dart legs. Its purpose is to take up excess where it is not needed, and gradually release fabric where it is needed to control the fit of the garment.

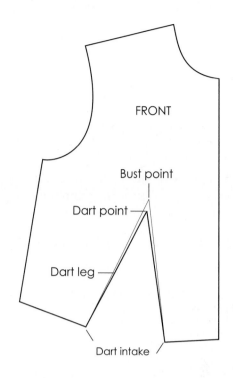

Direction of Dart Excess

Dart legs may be cut to within seam allowance (e.g., 1/2 inch with excess cut away) or folded. The center of folded darts or seams of cutout darts will lie toward the center front or center back when placed along the shoulder, waist, or neckline. The excess of darts placed at armhole, center front, center back, and side seams, is directed toward waistline (downward). Darts placed at the corners of a pattern (shoulder tip, shoulder at neck, side waist, and center front waist) can be folded in either direction.

Dart Shape at Pattern's Edge

Two methods are described for folding and shaping darts.

Method 1: *Cupping the Pattern*

Figure 1

- Crease-fold one dart leg (A) to dart point.
- Fold over to dart leg (B). See Figure 3a.

Figure 2

- Using the corner of the table, fold dart leg (A) over to meet dart leg (B). Crease and remove pattern. See Figure 3a.

Figure 3a, 3b

- With a tracing wheel, trace waistline, transferring waist to dart excess underneath (Figure 3a). Pencil in perforated lines. See Figure 3b.

Figure 3a

Figure 1

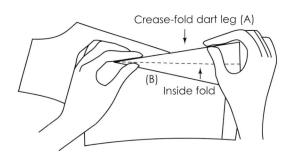

Crease-fold dart leg (A)

(B) Inside fold

Figure 2

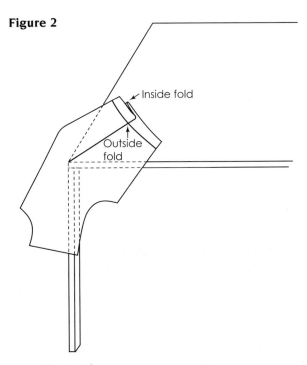

Inside fold

Outside fold

Figure 3b

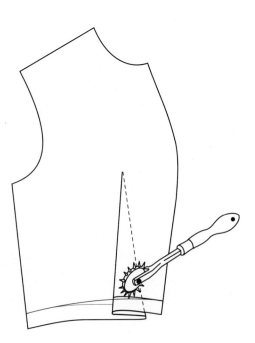

FRONT

Method 2: *Tissue copy of dart area*
Figure 1
- Trace dart and part of waist on transparent paper (shaded area).
- Remove paper and fold dart using method 1 as a guide.

Figure 2
- Unfold, place over original pattern (shaded area).
- With tracing wheel, trace shape of seam edge to pattern underneath.
- Remove paper and pencil in perforated lines.

Figure 1

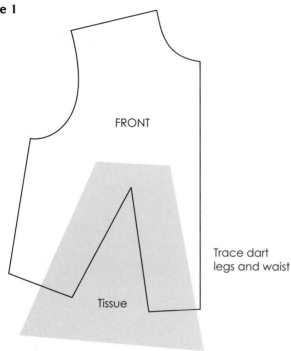

FRONT

Trace dart legs and waist

Tissue

Figure 2

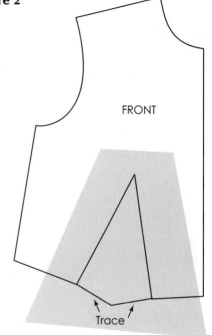

FRONT

Trace

Completing Darts

Dart Points

All darts radiate from the highest part (apex) of a mound. Mounds are rounded, not pointed. If a dart is stitched to the apex (highest point), it would cause strain in the garment (most noticeable around the bust). By ending the dart before it reaches the apex (such as the bust point), fabric is released to accommodate the rounded mound shape of the bust (or any other mound). Lighter lines indicate released fabric.

Front Bodice Darts

Figure 1 Single dart pattern:
- *Dart point:* approximately 1/2 inch from bust point (a greater distance if bust mound exceeds B-cup).

Figure 1

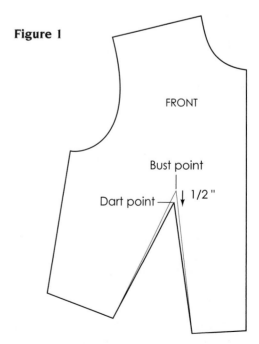

FRONT

Bust point

Dart point

↓ 1/2 "

Figures 2 and 3 Two-dart pattern:

- *Waist dart point:* marked 3/4 to 1 inch from bust point.
- *Other dart points* (side, shoulder, or any other location): marked 3/4 to 1½ inches (average to large bust) from bust point.

 Figures 2 and 3 show two versions of side dart leg placement. Both versions are acceptable.

Figure 2 *Side dart point centered.*

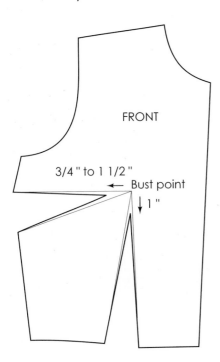

Figure 3 *Side dart leg on crossgrain.*

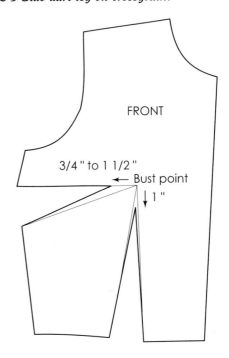

Shaping Dart Legs

Figure 1

- Follow the illustrations below as a guide for shaping dart legs to conform them to the shape of bust.

Figure 1

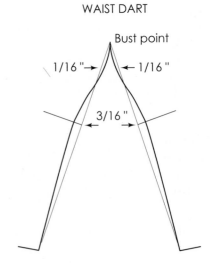

Trueing, Blending, Pin Marking, and Tape Marking

Trueing. The blending and straightening of pencil lines, crossmarks, and dot marks for the purpose of establishing correct seam lengths; for example, trueing a side seam having a side dart.

Blending. A process of smoothing, shaping, and rounding angular lines along a seam for a smooth transition from one point to the next, and for equalizing the discrepancies of joining lines and marks made on the pattern or muslin. (Blending includes trueing.)

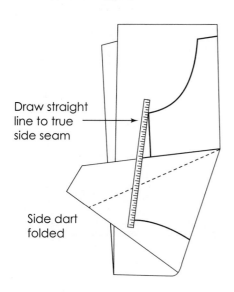

Draw straight line to true side seam

Side dart folded

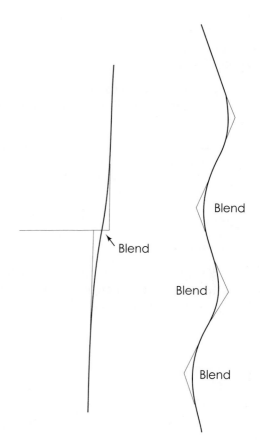

Blend

Blend

Blend

Blend

Pin marking. Placing a series of pins through the muslin or form to evaluate style line placement.

Tape marking. Style line placement by tape to evaluate design features, and to provide a guide when developing design patterns.

Fabric Terms

Muslin. A plain-woven fabric made from bleached or unbleached corded yarns in a variety of weights:

- *Coarse weave:* Used for draping and testing basic patterns.
- *Light weight:* Used for softly draped garments.
- *Heavy weight:* Firmly woven, used for testing tailored garments, coats, and suits.

Grain. The direction in which the yarn is woven or knit (lengthwise grain or *warp,* crosswise grain or *weft*).

Lengthwise grain (warp). Yarns parallel with selvage and at right angles to the crosswise grain. It is the strongest grain and drapes best when perpendicular to the floor.

Crosswise grain (weft). Yarns woven across the fabric from selvage to selvage. It is the filling yarn of woven fabrics. Crosswise grain yields to tension.

Selvage. The narrow, firmly woven, and finished strip on both lengthwise grain edges of the woven fabric. Clipping selvage releases tension.

Bias. A slanting or diagonal line cut or sewn across the weave of the cloth.

True bias. The angle line that intersects with the lengthwise and crosswise grains at a 45° angle. True bias has maximum give and stretch, easily conforming to the figure's contours. Flares, cowls, and drapes work best when cut on true bias.

Bowing and skewing. Fabric grains that are not at true right angles cause bowing (Figure 3a), skewing (Figure 3b), or a combination of both. This is the result of stresses and strain imposed during weaving or finishing.

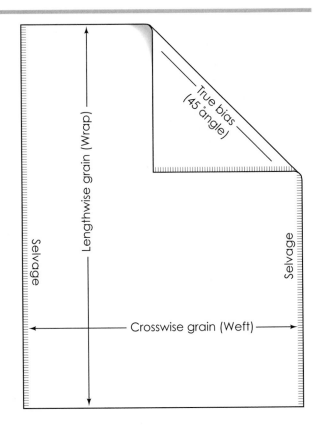

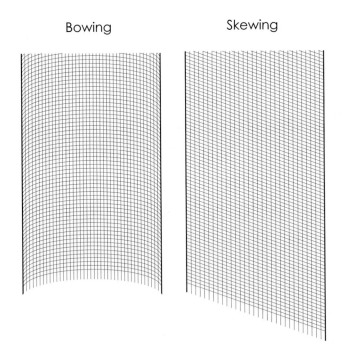

Bowing Skewing

Aligning grainline. To correct bowing or skewing of the fabric, pull diagonally at opposite ends of the fabric. Repeat at the other ends. This process will help to realign the straight and cross grains. This is done for fabrics on individual garments, but impractical for mass-produced designs. However, the manufacturer can request that the condition be corrected by the fabric company at a cost.

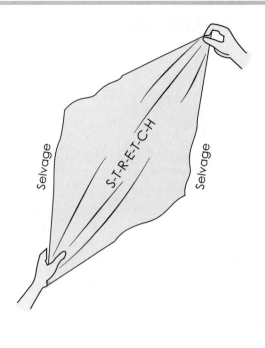

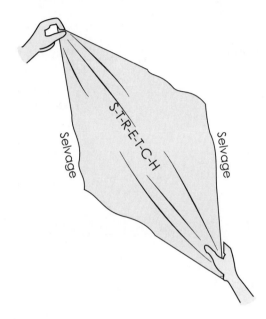

Finding the grainlines. This process can be accomplished by pulling a thread, then cutting along the pulled space, or by tearing the fabric along the grainline. The fabric then can be stretched until the grainlines are at right angles to each other.

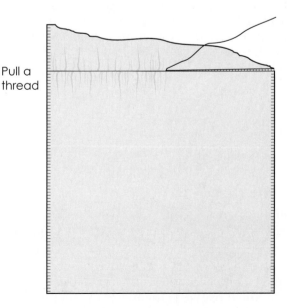

Pull a thread

Pattern Grainline

The pattern grainline is a line drawn on each pattern piece (from end to end) to indicate how the pattern should align with the lengthwise grain of the fabric. Regardless of where the grainline is drawn on the pattern, it will always be placed on the fabric so that the grainline is parallel to the selvage edge. Pattern placement is illustrated in Figure 1. The effect of grainline on garments is shown in Figures 2, 3, and 4.

Direction of Grainline

- Vertical grainlines are drawn parallel to center for garments cut on straight grain (Figure 2).
- Bias grainlines are drawn at an angle to center (45° angle for true bias) for garments cut on the bias (Figure 3).
- Horizontal grainlines are drawn at right angles to center for garments cut on crosswise grain (Figure 4).

Figure 1

Figure 2

Straight Grainline

Figure 3

Bias Grainline

Figure 4

Crossgrain

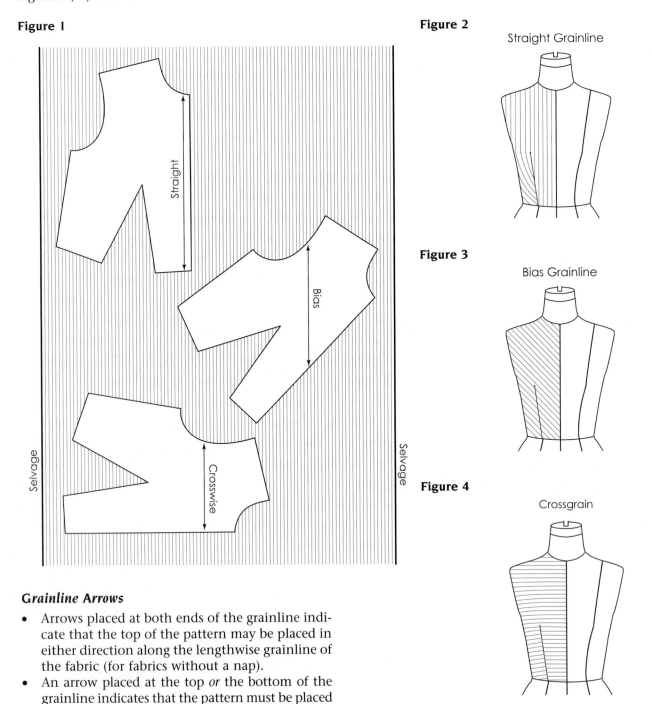

Grainline Arrows

- Arrows placed at both ends of the grainline indicate that the top of the pattern may be placed in either direction along the lengthwise grainline of the fabric (for fabrics without a nap).
- An arrow placed at the top *or* the bottom of the grainline indicates that the pattern must be placed in one direction only (for fabrics with a nap).

Balance Line Terms

Plumb line. A vertical line that is at right angles with the floor. Used to determine the balance of the figure.

Perpendicular line. A straight line at right angles to another line. (See right angle.)

Vertical line. A line that is straight up and down.

Horizontal line. A straight line parallel with the floor.

Right angle. The 90° angle formed by two intersecting lines, referred to as a *squared* line.

Asymmetric line. A center line with unequal proportions on either side of it.

Symmetrical line. A center line with equal proportions on either side of it.

Balance. The perfect relationship between parts that when combined form a unit (or whole) in which each part is in exact proportion and harmony with all others.

Balancing a pattern. Finding and adjusting the differences between joining pattern parts to improve the hang and fit of the garment.

Horizontal balance line (HBL). A reference to any line marked around the form that is parallel with the floor. Patterns are also marked with horizontal balance lines squared from the centerlines representing the crosswise grain when the garment is cut in fabric. The HBL lines help when balancing the patterns.

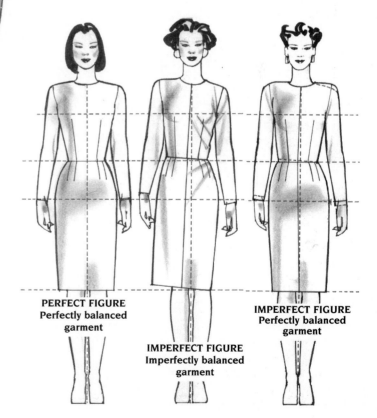

PERFECT FIGURE
Perfectly balanced garment

IMPERFECT FIGURE
Imperfectly balanced garment

IMPERFECT FIGURE
Perfectly balanced garment

Special Information

Right-side-up (when sides differ). Instruction applies to asymmetrical designs (right side differs from the left side), and for patterns cut from engineered fabrics such as border prints, randomly spaced flowers, geometric forms, and multiple colors. Such fabrics require specific pattern placement so that the fabric design can be arranged in the same location for all garments cut from that fabric. *Right-side-up* (RSUP) indicates to the marker maker that the pattern is to be placed face up on the marker.

Detail location. Mark the location in which a detail is to be placed on the pattern. This will ensure that the flower, abstract detail, or wrap will always be on the correct side and in the correct place on the garment.

Stripe or plain placement.

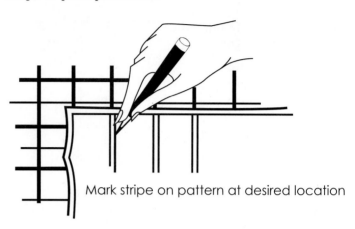

Mark stripe on pattern at desired location

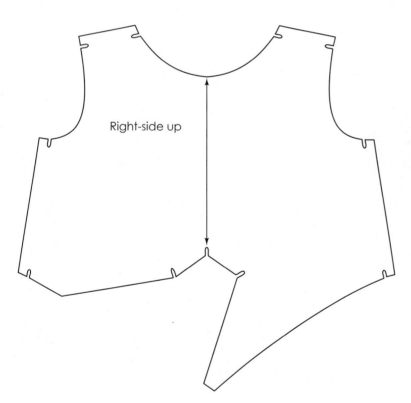

Right-side up

Color differences. Indicate specific color requirements for different pattern pieces, such as color-block designs.

Fabric type. Any other information special to the design pattern.

Facings. For facing instructions, see Chapter 16.

2

Model Form and Measurements

During the past 40 years dress forms have evolved to keep pace with changing silhouettes and fashion trends. The original forms were shapeless, willow-caned, with woven mounds that were padded to individual specifications. Today forms are made of metal and canvas and hand-molded with papier-maché, having collapsible shoulders and attachable arms and legs. Forms can be ordered to specific measurements, and also with ease added. Different types of forms and sizes are available from infants, toddlers, children's, teens', missy, and larger sizes for both male and female. Forms are available for specific garments: dresses, evening gowns, skirts, and pants.

Who Is the Standard Ideal Figure?

She is a composite figure whose measurement standards are based upon who is listening to whom. She evolved from consumer feedback to buyer, buyer to manufacturer, and manufacturer to model form company. Her standards are whatever successful manufacturers, commercial pattern companies, chain and department stores, and industrial form companies say they are. She is a form; she is a figure; she is a set of measurements; and her silhouette changes at the slightest whim of fashion. She is considered "ideal" only when her measurements satisfy a majority of consumers.

Who needs her? Technicians need her dimensions for patternmaking and fittings; designers need her silhouette for creating new designs; manufacturers need her for showings; models need to have her dimensions to be hired; and consumers need her for their representation.

Does this elusive figure have standards? Even though her dimensions vary, she does have standards. She is symmetrical, with an upright stance and aesthetically pleasing body proportions, with a ratio of 10- to $12\frac{1}{2}$-inch differences between bust, waist, and hips. These standards are based strictly on Western concepts of what is ideal. There will never be a universally acceptable standard because of the variety of anatomical figure types. Other countries set their own standards based on their own regional concept of the ideal figure.

Pattern Industry Standards

In response to national standards and consumers' needs, the pattern industry established the Measurement Standard Committee, which devised its own standard set of figure types and sizes. Figure 1 is a composite of the pattern industry figure types. Specific measurements can be found on page 31. They are periodically revised and updated.

Department Store Standards

Department stores and catalog merchants such as Sears, J.C. Penney, Montgomery Ward, and Spiegel have developed their own strict specifications to satisfy the needs of their customers. Some use National Bureau of Standards' measurements. Others conduct surveys and samplings of the population by sending survey forms to their consumers requesting their measurements. This information is compiled, and specification sheets are given to the manufacturer to use in developing patterns for that particular merchant.

Other Attempts at Standardization

Attempts to standardize sizes in America originally began in the late 1800s, when manufacturers mass-produced farm labor uniforms in small, medium, and large sizes—which proved less than ideal for those smaller or larger than this size range. The next serious effort was made by the military in their attempt to mass-produce well-fitting uniforms. In 1901, the federal government created the National Bureau of Standards (NBS), a nonregulatory agency for the purpose of standardizing measurements for science and industry. By 1970, NBS had developed complete size range standards based on frequency measurements from large segments of the population.

ASTM Standards

Recent updated measurements were developed by the American Society for Testing and Materials (ASTM). Address: 100 Barr Harbor Dr., West Conshohocken, PA 19428. Phone: (610) 832-9585; fax (610) 832-9555. The following tables of measurement are available:

- Children: Sizes 2 to 6X/7, order # (D5826)
- Adult Female Misses: Sizes 2 to 20, order # (D5585)
- Women aged 55 and older, order #(D5586)

Some manufacturers prefer not to use standardized measurements. They want the flexibility to quickly change measurements to suit customer needs. Increasing world trade has created a need for a central database that contains regional measurements for non-Western trading partners. Computer technology may ultimately provide ready access to such information.

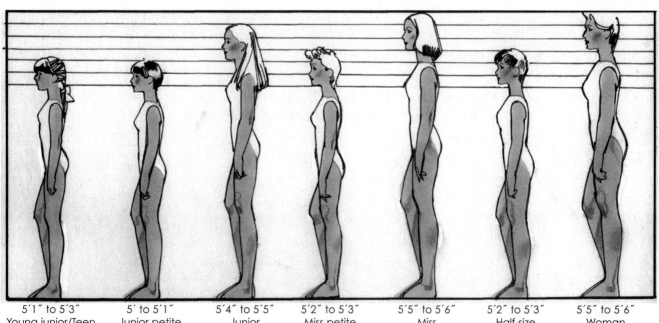

5′1″ to 5′3″	5′ to 5′1″	5′4″ to 5′5″	5′2″ to 5′3″	5′5″ to 5′6″	5′2″ to 5′3″	5′5″ to 5′6″
Young junior/Teen	Junior petite	Junior	Miss petite	Miss	Half-size	Woman
5/6–15/16	3jp–13jp	5–15	6mp–16mp	6–20	10½–24½	38–50

Landmark Terms

The following landmark terms identify the parts of the form that are referred to when measuring from one landmark to another.

Numbers refer to both the front and back wherever indicated.

1. Center front neck
 Center back neck
2. Center front waist
 Center back waist
3. Bust points
4. Center front bust level (between bust points)
5. Side front (princess)
 Side back (princess)

6. Mid-armhole front ⟩ at level with
 Mid-armhole back ⟩ plate screw
7. Shoulder tip
8. Shoulder at neck (shoulder/neck)
9. Armhole ridge or roll line
10. Plate screw
11. Armhole plate

Symbol Key

- CF = Center front
- CB = Center back
- BP = Bust point
- SS = Side seam
- SW = Side waist
- SH = Shoulder
- HBL = Horizontal balance line
- SH-TIP = Shoulder tip

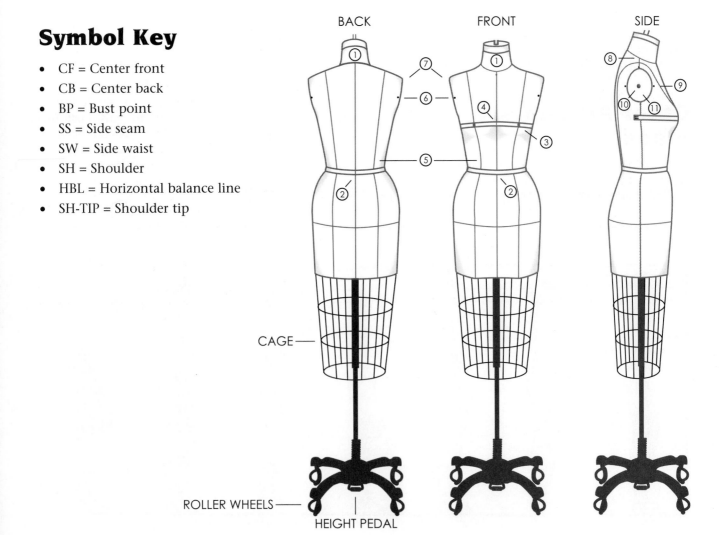

BACK FRONT SIDE

CAGE

ROLLER WHEELS

HEIGHT PEDAL

Measuring the Form

The drafting method depends on measurements taken of the form. Take them carefully to avoid fitting problems.

Record measurements on the *Model Measurement Chart* found in the back of the text. The chart can be removed for duplication.

Personal measurements: The model should wear a leotard or bodysuit. Chalk-mark the center front and back. Place elastic around the waist.

Preparing the Form for Measuring

Forms are not always perfect in shape, nor are measurements always equal on each side of center. The shoulder or side seam may be misplaced, causing a sleeve to hang out of alignment (shoulder or side seam is corrected at the time of the fitting).

Figure 1

- **Bust bridge:** Cut a strip of cloth $1^1/_2 \times 26$ inches. Fold edges to center, and fold again. Place across bust points, ending 1 inch past the side seam. Push pins through to secure. Trim unneeded length. Thrust pins through bust points. Mark centerline.

- **Waistline:** Replace waistline tape, if damaged.

Figure 2a, b

- **Pinhead guides:** Thrust pins through shoulder tip at the ridge, or roll line, mid-armhole at level with the plate screw, and 3/8 inches below the center front neck.

- **Armhole depth chart:** To locate the armhole depth of the form, choose the measurement that corresponds to the form size. Measure down from armhole plate at the side seam, and thrust a pinhead at that point (Figure 2a). Grade up or down by 1/8" for smaller or larger sizes. Record depth (Figure 2b).

Size 3/4 — 1/2"	Size 11/12 — 1"
Size 5/6 — 5/8"	Size 13/14 — 1-1/8"
Size 7/8 — 3/4"	Size 15/16 — 1-1/4"
Size 9/10 — 7/8"	Size 18 — 1-3/8"

Figure 3

- **Personal fit:** Chalk-mark 3/4 inch down from armhole seam of the leotard.

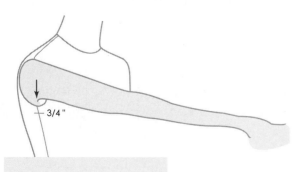

3/4 "

Figure 1

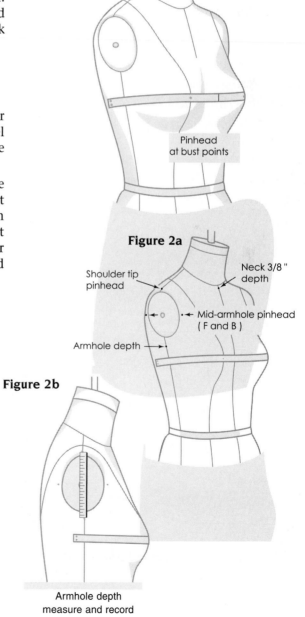

Pinhead at bust points

Figure 2a

Shoulder tip pinhead

Neck 3/8 " depth

Mid-armhole pinhead (F and B)

Armhole depth

Figure 2b

Armhole depth
measure and record

Taking Measurements

- Place the metal tip end of the tape measure at one reference point, and extend to the next reference point when taking measurements.
- Record measurements on the Model Measurement Chart (found at the back of the text).
- Numbers in parentheses correspond with those on the chart.
- Arc measurements are taken from centerlines to the side seam.
- The same half of the front and back of the form is measured.

Circumference Measurements

Figure 5

- **Bust** (1). Across bust points and back.
- **Waist** (2). Around waist.
- **Abdomen** (3). Three inches below waist.
- **Hip** (4). Measure widest area with tape parallel with floor. Pin to mark hip level at center front (referred to as X-point).

Figure 5

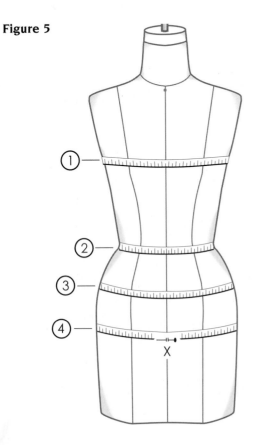

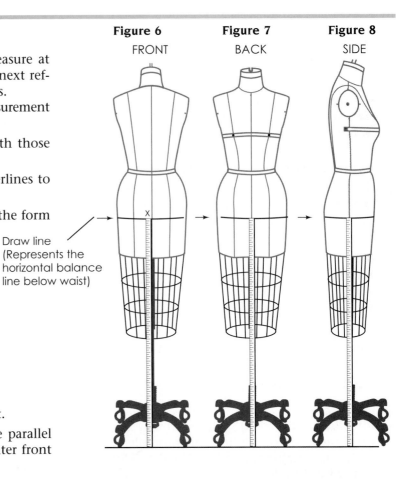

Figure 6 **Figure 7** **Figure 8**
FRONT BACK SIDE

Draw line (Represents the horizontal balance line below waist)

Horizontal Balance Line (HBL)

Figures 6, 7, and 8

- Measure from the floor to the pinmark (X) at center front (Figure 6).
- Use this measurement to measure up from the floor and pinmark center back and side seams. Recheck measurements (Figures 7, 8).
- Draw a line around the hip touching each of the pinmarks, or place elastic around the hipline. Pin elastic at each pinhead location. The standard hip depth is 6 to 7 inches down from the center front waist for juniors and petites, and 8 to 9 inches down for missy size.

Horizontal Measurements

Front
Figure 9

- **Across shoulder** (14). Shoulder tip to center front neck.
- **Across chest** (15). Center front to 1 inch above mid-armhole (pinhead mark).
- **Bust arc** (17). Center front, over bust point, ending 2 inches below armplate at side seam.
- **Bust span** (10). Place tape across bust points, divide in half for measurement.
- **Waist arc** (19). Center front waist to side waist seam.
- **Dart placement** (20). Center front to side front (princess line).
- **Abdomen arc** (22). Center front to side seam, starting 3 inches down from waist.
- **Hip arc** (23). Center front to side seam on HBL line.
- **Hip depth** (25). Center front to HBL line.

Back
Figure 10

- **Back neck** (12). Center back neck to shoulder at neck. Reference measurement.
- **Across shoulder** (14). Shoulder tip to center back neck.
- **Across back** (16). Center back to 1 inch above the mid-armhole at ridge of pinhead.
- **Back arc** (18). Center back to bottom of arm plate.
- **Waist arc** (19). Center back waist to side waist seam.
- **Dart placement** (20). Center back waist to side back (princess line).
- **Abdomen arc** (22). Center back to side seam, starting 3 inches down from waist.
- **Hip arc** (23). Center back to side seam on HBL line.
- **Hip depth** (25). Center back waist to HBL line.

Figure 9

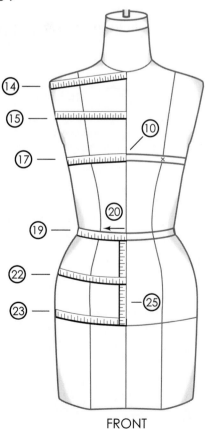

FRONT

Figure 10

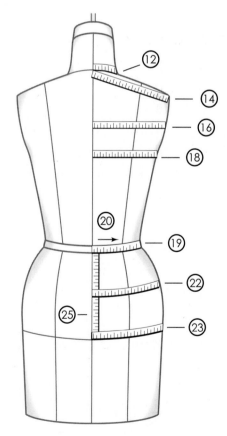

Vertical Measurements

Figures 11 and 12

- **Side length** (11). Pin mark below armplate at side seam to side waist.
- **Shoulder length** (13). Shoulder tip to neck.
- **Side hip depth** (26). Side waist to HBL, on side of form being measured.
- **Bust radius** (9). Measure from bust point ending under bust mound.

Front and Back

Figures 13 and 14

- **Center length** (5). Neck to waist (over bust bridge).
- **Full length** (6). Waist to shoulder at neck, parallel with center lines.
- **Shoulder slope** (7). Center line at waist to shoulder tip (pinhead mark).
- **Bust depth** (9). Shoulder tip to bust point and bust radius.

Figure 11 **Figure 12**

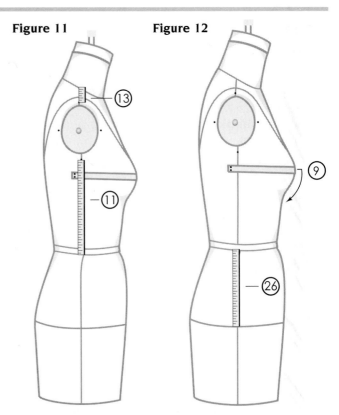

Figure 13

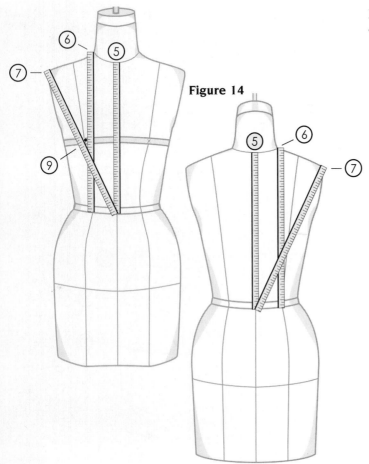

Figure 14

Strap Measurements

Figure 15

- **Strap front** (8). Place metal tip of measuring tape at shoulder/neck, and measure down to pinhead mark below armhole plate. Take the measurement on the same side of the tape from neck to armhole. The tape may pass over some part of the plate.

Figure 15

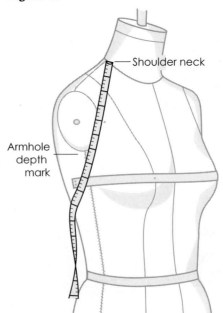

Shoulder neck

Armhole depth mark

Standard Measurement Chart
Use when form or model is unavailable.

CIRCUMFERENCE MEASUREMENTS: (Ease not included)	Grade: Sizes:	1″ 6	1″ 8	10	1½″ 12	1½″ 14	1½″ 16	2″ 18
1. Bust:		34	35	36	$37^1/_2$	39	$40^1/_2$	$42^1/_2$
2. Waist:		24	25	26	$27^1/_2$	29	$30^1/_2$	$32^1/_2$
3. Abdomen:		$32^1/_2$	$33^1/_2$	$34^1/_2$	36	$37^1/_2$	39	41
4. Hip:		$35^1/_2$	$36^1/_2$	$37^1/_2$	39	$40^1/_2$	42	44
UPPER TORSO (bodice):								
5. Center length:								
Front		$14^1/_2$	$14^3/_4$	15	$15^1/_4$	$15^1/_2$	$15^3/_4$	16
Back		$16^3/_4$	17	$17^1/_4$	$17^1/_2$	$17^3/_4$	18	$18^1/_4$
6. Full length:								
Front		17	$17^3/_8$	$17^3/_4$	$18^1/_8$	$18^1/_2$	$18^7/_8$	$19^1/_4$
Back		$17^1/_4$	$17^5/_8$	18	$18^3/_8$	$18^3/_4$	$19^1/_8$	$19^1/_2$
7. Shoulder slope:								
Front		$16^1/_2$	$16^{15}/_{16}$	$17^1/_4$	$17^{13}/_{16}$	$18^1/_4$	$18^{11}/_{16}$	$19^1/_8$
Back		$16^1/_4$	$16^{11}/_{16}$	$17^1/_8$	$17^9/_{16}$	18	$18^7/_{16}$	$18^7/_8$
8. Strap:								
Front		$9^1/_2$	$9^3/_4$	10	$10^3/_8$	$10^3/_4$	$11^1/_8$	$11^5/_8$
9. Bust depth:		9	$9^1/_8$	$9^1/_4$	$9^3/_8$	$9^1/_2$	$9^5/_8$	10
Bust radius		$2^3/_4$	$2^7/_8$	3	$3^1/_8$	$3^1/_4$	$3^3/_8$	$3^3/_4$
10. Bust span:		$3^1/_2$	$3^5/_8$	$3^3/_4$	$3^7/_8$	4	$4^1/_8$	$4^1/_4$
11. Side length:		$8^1/_4$	$8^3/_8$	$8^1/_2$	$8^5/_8$	$8^3/_4$	$8^7/_8$	9
12. Back neck:		$2^3/_4$	$2^7/_8$	3	$3^1/_8$	$3^1/_4$	$3^3/_8$	$3^1/_2$
13. Shoulder length:		$5^1/_8$	$5^3/_{16}$	$5^1/_4$	$5^3/_8$	$5^1/_2$	$5^5/_8$	$5^{13}/_{16}$
14. Across shoulder:								
Front		$7^1/_4$	$7^3/_8$	$7^1/_2$	$7^{11}/_{16}$	$7^7/_8$	$8^1/_{16}$	$8^5/_{16}$
Back		$7^3/_8$	$7^1/_2$	$7^5/_8$	$7^{13}/_{16}$	8	$8^3/_{16}$	$8^7/_{16}$
15. Across chest:		6	$6^1/_4$	$6^3/_8$	$6^9/_{16}$	$6^3/_4$	$6^{15}/_{16}$	$7^3/_{16}$
16. Across back:		$6^3/_4$	$6^7/_8$	7	$7^3/_{16}$	$7^3/_8$	$7^9/_{16}$	$7^{13}/_{16}$
17. Bust arc:		$9^1/_4$	$9^1/_2$	$9^3/_4$	$10^1/_8$	$10^1/_2$	$10^7/_8$	$11^3/_8$
18. Back arc:		$8^1/_2$	$8^3/_4$	9	$9^3/_8$	$9^3/_4$	$10^1/_8$	$10^5/_8$
19. Waist arc:								
Front		$6^1/_4$	$6^1/_2$	$6^3/_4$	$7^1/_8$	$7^1/_2$	$7^7/_8$	$8^3/_8$
Back		$5^3/_4$	6	$6^1/_4$	$6^5/_8$	7	$7^3/_8$	$7^7/_8$
20. Dart placement:		3	$3^1/_8$	$3^1/_4$	$3^3/_8$	$3^1/_2$	$3^5/_8$	$3^3/_4$
LOWER TORSO (Skirt/Pant):								
22. Abdominal arc:								
Front		$8^1/_4$	$8^1/_2$	$8^3/_4$	$9^1/_8$	$9^1/_2$	$9^7/_8$	$10^3/_8$
Back		$7^1/_2$	$7^3/_4$	8	$8^3/_8$	$8^3/_4$	$9^1/_8$	$9^5/_8$
23. Hip arc:								
Front		$8^1/_2$	$8^3/_4$	9	$9^1/_4$	$9^1/_2$	$10^1/_8$	$10^5/_8$
Back		9	$9^1/_4$	$9^1/_2$	$9^7/_8$	$10^1/_4$	$10^5/_8$	$11^1/_8$
24. Crotch depth:		$9^1/_2$	$9^3/_4$	10	$10^1/_4$	$10^1/_2$	$10^3/_4$	11
25. Hip depth:								
Center front		$8^1/_2$	$8^3/_4$	9	$9^1/_4$	$9^1/_2$	$9^3/_4$	10
Center back		$8^1/_4$	$8^1/_2$	$8^3/_4$	9	$9^1/_4$	$9^1/_2$	$9^3/_4$
26. Side hip depth:		$8^3/_4$	9	$9^1/_4$	$9^1/_2$	$9^3/_4$	10	$10^1/_4$
27. Waist to ankle:		37	$37^1/_2$	38	$38^1/_2$	39	$39^1/_2$	40
Waist to Floor:		39	$39^1/_2$	40	$40^1/_2$	41	$41^1/_2$	42
Waist to Knee:		$22^1/_4$	$22^5/_8$	23	$23^3/_8$	$23^3/_4$	$24^1/_8$	$24^1/_2$
28. Crotch length:		$24^1/_2$	$25^1/_4$	26	$26^3/_4$	$27^1/_2$	$28^1/_4$	29
Vertical trunk:		60	61	62	$63^1/_2$	65	$66^1/_2$	$68^1/_2$
29. Upper thigh:		$19^1/_2$	$20^1/_4$	21	22	23	24	$25^1/_4$
Mid-thigh:		17	$17^1/_2$	18	$18^3/_4$	$19^1/_2$	$20^1/_4$	$21^1/_4$
30. Knee:		13	$13^1/_2$	14	$14^1/_2$	15	$15^1/_2$	16
31. Calf:		11	$11^1/_2$	12	$12^1/_2$	13	$13^1/_2$	14
32. Ankle:		$9^1/_2$	$9^3/_4$	10	$10^1/_4$	$10^1/_2$	$10^3/_4$	11

3

Drafting the Basic Pattern Set

The Basic Dress Foundation

Introduction to patternmaking begins with the draft of the basic dress foundation. The dress contains all key dimensions of the form and is represented by the basic pattern set. The basic dress is the very foundation upon which patternmaking, fit, and design are based. The basic dress is made up of five distinct parts: a front and back bodice, a front and back skirt that hangs straight from the hip, and slim, full-length sleeves. The dress follows the figure's outline, covering the outermost parts without contouring the hollow areas. It has a series of seams directed toward the figure's bulges—the bust, abdomen, buttocks, shoulder blades, and elbows. The pattern pieces are shaped to fit the figure's dimensions, and the garment fits with comfort and ease in perfect harmony with the balance of the figure's stance.

Measurement

The draft can be developed from measurements taken of the form and recorded on the Model Measurement Chart, or measurements taken from the Standard Measurement Chart.

For easy reference, record (in the spaces provided) the measurements by the number in parenthesis given in the instructions. Numbers correspond with those of the charts. Letters used in the instructions give the direction in which each line is drawn. For example, B to C means that the line is draw from point B to point C, in the amount indicated by the instructions. A shaded outline of the pattern illustrates the purpose of each line drawn on the draft.

Suggestions for the correction of fitting problems follow the instructions for drafting the bodice, the skirt, and the sleeve. To complete the patterns, see page 62.

Front Bodice Draft

The symbol (L) at corners indicates that the line is squared.

Figure 1

- A to B = **Full length (6)** _____.
- A to C = **Across shoulder (14)** _____.
 Square 3 inches down from C.
- B to D = **C.F. length (5)**, less 3/8 inch _____.
 Mark and square out 4 inches.
- B to E = **Bust arc (17)**, plus 1/4 inch _____.
 Square up from E.

Figure 1

Figure 2

- B to F = **Dart placement (20)** _____.
 Square down 3/16 inch.
- B to G = **Shoulder slope (7)**, plus 1/8 inch _____.
- G to H = **Bust depth (9)** _____.
- G to I = **Shoulder length (13)** _____.
 Square down from I to intersect with D line.

Figure 2

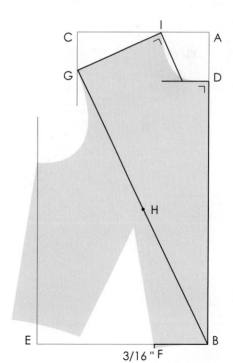

Figure 3
- **I to J = Strap (8)**, plus 3/8 inch _____.
- **J to K = Side length (11)** _____.

 Out 1¹⁄₄ inches out from E line.

 From K draw a line to F.
- **L to M = Bust span (10)**, plus 1/4 inch _____.

 (This line may pass beyond H.)

 N is one-third of D to L. Mark.
- **N to O = Across chest (15)**, plus 1/4 inch
 _____.

Figure 4
- **B to F and K to P = Waist arc**, plus 1/4 inch
 (19) _____.

 Subtract B to F from waist arc measurement.

 K to P makes up the remaining measurement.

 Mark.

 Dart legs: Draw a line from M to F, and from M to Q passing through P to equal M to F.

 Dart point: Center a point 1/2 inch from bust point and redraw dart legs to F and Q.

 Waistline: Draw slightly inward curves from K to Q, and from F blending with B.

Figure 4

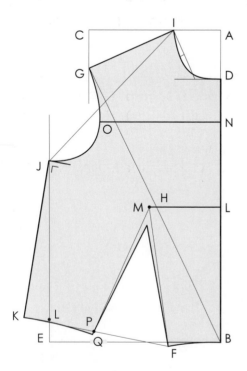

Figure 3

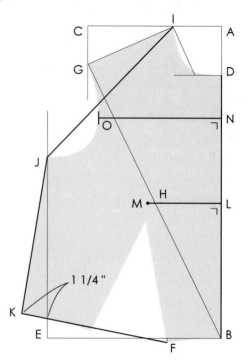

Figure 5
- *Armhole:* Square a short line from J.

 French Curve touches G, O, and the square line.

 Do not allow the rule to lay below the square line, or draw the curve upward after touching the square line.
- *Neckline:* French Curve touches I, curving inward 1/8 inch on the slant line and blending with the D line.

Figure 5

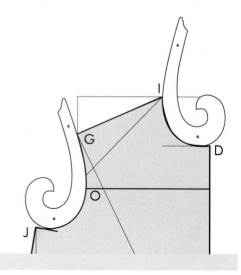

Back Bodice Draft

Figure 6

- A to B = **Full length** (6) _____.
- A to C = **Across shoulder** (14) _____.
 Square 3 inches down from C.
- B to D = **C.B. length,** (5) _____.
 Mark and square out 4 inches.
- B to E = **Back arc** (18), plus 3/4 inch _____.
 Square up from E.

Figure 6

Figure 7

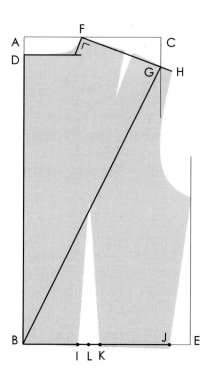

Figure 7

- A to F = **Back neck** (12), less 1/8 inch _____.
- B to G = **Shoulder slope,** (7) plus 1/8 inch _____.
- F to H = **Shoulder length,** (13), plus 1/2 inch _____.
 Line may pass G.
 Square down from F.
- B to I = **Dart placement** (20) _____.
- B to J = **Waist arc** (19), plus dart intake of $1\frac{1}{2}$ inches and 1/4 inch (ease). (Add 1 inch for junior/petite sizes.)
- I to K = **Dart intake.** Mark center and label L.

Figure 8
- **J to M** = Square down 3/16 inch.
- **M to N** = **Side length (11)** _____.
- **L to O** = Square up from L 1 inch less than M to N.

 Draw dart legs from O, 1/8 inch past I and K.

 Draw slightly curved lines from K to M and from B to I.

Figure 9

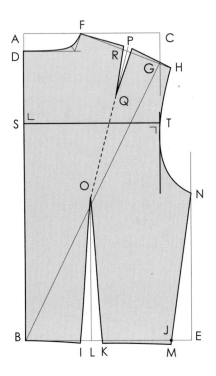

Figure 8

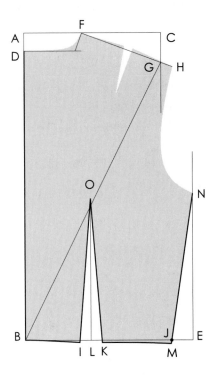

Figure 9
- **F to P** = One-half of F to H. Mark.
- **P to Q** = Draw a 3 inch line in direction of point O (indicated by broken line).
- **P to R** = 1/4 inch. Mark.

 Draw dart leg from Q 1/8 inch past R, and connect to F.

 Draw other dart leg 1/4 inch from P equal to dart leg Q to R, and connect to H.
- **D to S** = One-fourth of D to B. Mark
- **S to T** = **Across back**, plus 3/8 inch (16) _____.

 Square down 3 inches from T.

Figure 10

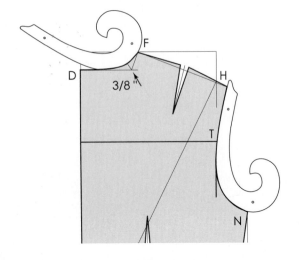

Figure 10
- *Armhole:* The ruler touches H, T, and N.

 Do not allow curve to lie inside the square line. Draw armhole.
- *Neckline:* Draw a 3/8 inch angle line from the corner, and draw neckline.

Increasing and Decreasing Bust Cup

The bodice is drafted with a B cup. The pattern can be adjusted for cup sizes A, C, D, and DD for personal fit.

Figure 1

- Draw a line from dart point to bust point and to but not through mid-armhole.

Figure 1

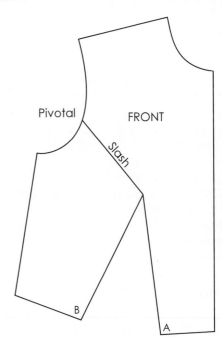

Figure 2
C, D, DD Cup size
Spread at bust point as follows:

- C Cup = 3/8 inch.
- D Cup = 3/4 inch.
- DD Cup = 1 inch.
- Center bust point.
- Lengthen dart leg A to true with B.

Figure 2

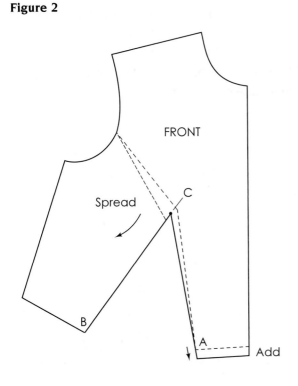

Figure 3
A Cup:

- Overlap bust point 3/8 inch. Tape.
- Center bust point.
- Shorten dart leg A to true with B.

Figure 3

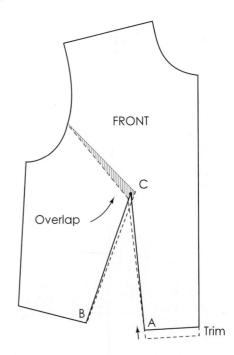

Fitting the Bodice

Sew the bodice with a long stitch. Press without steam, and place on the form. Analyze the fit, release stitches from the problem area, pin to adjust the muslin, and make corrections to the pattern.

A well-fitted bodice aligns with the center of the form after holding pins have been removed. The garment would not have stress lines (lack of ease) or gapping around the armhole. The neckline would have at least 1/8 inch ease around the front and back necklines. The garment would not be too short or too long. If the fitting problems are due to incorrect measurements, redraft the patterns for practice rather than adjusting the patterns. Suggestions are given to correct alignment, fit of the armhole, and neckline. Always make the correction to the patterns.

Perfect Alignment

Figure 1
- The bodice fits well when the center front and back align with the centers of the form after the holding pins are removed.

Imperfect Alignment

Figure 2
- Front or back bodice overlaps centerline of the form.
- Possible solutions: Raise shoulder tip, lower dart point, or check waistline measurements and adjust side waist, if required.
- If the adjustments are correct, the bodice should align with the centerline of the form.

Figure 1

Perfect alignment

Figure 3
- Front or back swings away from the centerline.
- Possible solutions: Lower shoulder tip, check waistline measurements and adjust side waist, if required.
- If the adjustments are correct the bodice should align with the centerline of the form.

Figure 2

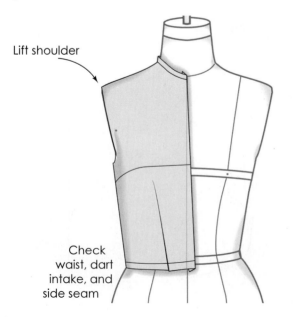

Lift shoulder

Check waist, dart intake, and side seam

Figure 3

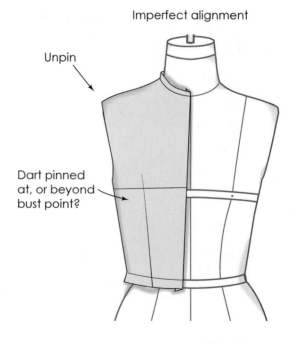

Imperfect alignment

Unpin

Dart pinned at, or beyond bust point?

Fitting the Neckline

If the front or back neckline is too loose (more than 1/8 inch), open the shoulder and smooth the fabric to fit. Mark the muslin and adjust the length of the shoulder. If stress appears at the shoulder/neck, open the shoulder. Fit the muslin to the neckline (allow 1/8 inch ease). Mark the neckline and adjust the shoulder length, if necessary.

Figure 4

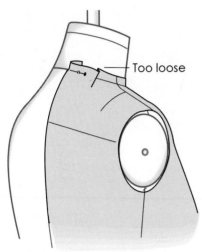

Fitting the Armhole

A well-balanced sleeve depends on the accurate shape of the armhole and the correct placement of the shoulder and side seams of the form.

A well-shaped armhole fits smoothly over the shoulder and falls away evenly from the lower part of the armhole plate, and the side seam is aligned with that of the form. There is no appearance of stress lines or gapping. See Figure 4.

If the armhole of the bodice is identified with one of the examples, follow the suggested adjustment and make corrections to the pattern.

Gap above mid-armhole:
Figures 5a, b
- Front: Release shoulder seam and smooth excess over the shoulder. Repin.

Figures 6a, b
- Back: Repeat the process.

Figure 5a, b

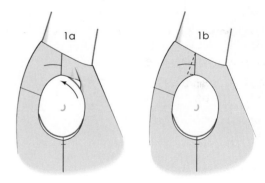

Figure 6a, b

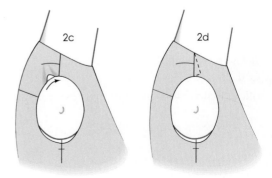

Gap below mid-armhole:
Figures 7a, b, c

- Front: Pin the excess, allowing 1/4 inch ease. Slash the pattern to bust point, and from dart point to bust point. Overlap to equal the amount pinned at the armhole. Mend.

Figure 7a, b, c

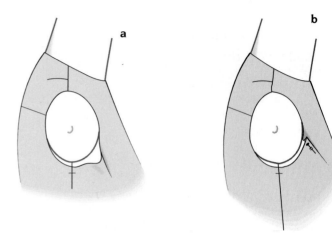

Figures 8c, d

- Back: Release side seam. Smooth excess downward past side seam. Measure the distance from the armhole depth mark. Remark side seam. Allow 1/2 inch ease. Remark side waist and waistline.

Figure 8 c. d

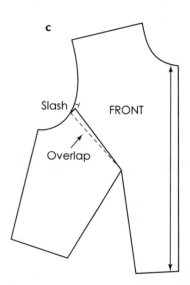

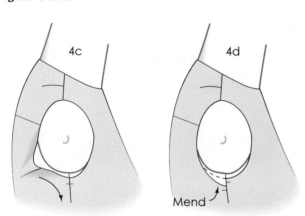

Figure 8 c. d

Gap below mid-armhole at the front and back.
Figure 9

- Follow instruction given in Figures 7a, b, and c.

Skirt Draft

The basic skirt foundation has several uses: as a base for manipulation to create design patterns, combined with the bodice as a dress, as a skirt to complete a suit, and as a separate basic skirt. Two versions of the back skirt are given. In Type 1 the back darts are of equal intake and length. Type 2 has two darts of unequal intake and length.

Record measurements from the Model Measurement Chart in the spaces provided.

Personal fit: Use the Personal Dart Intake Chart to determine the number of darts and dart intake for the skirt draft. Subtract the waist (2) from the hip measurement (4). Find the difference to the nearest whole number in column 1.

For a model having a sway back, mark one dart in front, with all remaining excess taken up by the back dart(s).

Personal Dart Intake Chart

Column 1:
4-inch Difference
Front: 1 dart—1/2″ intake. Back: 1 dart—3/4″ intake.
5-inch Difference
Front: 1 dart—1/2″ intake. Back: 1 dart—1″ intake.
6-inch Difference
Front: 1 dart—1/2″ intake. Back: 2 darts—5/8″ intake.
7-inch Difference
Front: 1 dart—1/2″ intake. Back: 2 darts—3/4″ intake.
8- or 9-inch Difference
Front: 2 darts—3/8″ intake. Back: 2 darts—7/8″ intake.
10-inch Difference
Front: 2 darts—1/2″ intake. Back: 2 darts—1″ intake.
11-inch Difference
Front: 2 darts—5/8″ intake. Back: 2 darts—$1^{1}/_{8}$″ intake.
12-inch Difference
Front: 2 darts—5/8″ intake. Back: 2 darts—$1^{1}/_{4}$″ intake.
13- or 14-inch Difference
Front: 2 darts—5/8″ intake. Back: 2 darts—$1^{3}/_{8}$″ intake.
(Allow 3/8″ ease at each quarter waist. For 3 darts at the back skirt, divide $2^{3}/_{4}$″ into thirds.)

Skirt Front

Figure 1

- A to B = **Skirt length** (as desired).
- A to C = **Center front hip depth (25)** _____.
- A to D = **Back hip arc (23)**, plus 1/2 inch (ease) _____.

 Squared out from A, C, and B.
 Draw center back line. Label E and F.
- E to G = **Center back hip depth (25)** _____.
 Crossmark location.
- A to H = **Front hip arc (23)**, plus 1/2 inch (ease) _____.

 Squared out from A, C, and B.
- Draw center front line. Label J and I.

Figure 1

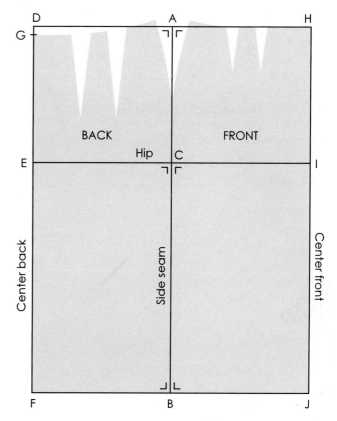

Figure 2

Back:

- **D to K = Back waist arc (19)**, plus $^1/_4$ inch (ease), and add 2 inches for dart intake _____.

 Use Personal Fit Measurements _____.

- **D to L = Dart placement (20)** _____.

 Mark first dart 1 inch from L.

 Mark dart space $1^1/_4$ inches and mark 1 inch for second dart.

 Square up and down from K.

Front:

- **H to M = Front waist arc (19)**, plus 1/4 inch (ease), and add 1 inch for dart intake _____.

 Personal fit: _____.

- **H to N = Dart placement (20)** _____.

 Mark first dart 1/2 inch from N.

 Mark dart space $1^1/_4$ inches, and mark 1/2 inch for second dart.

 Square up and down from M.

Figure 2

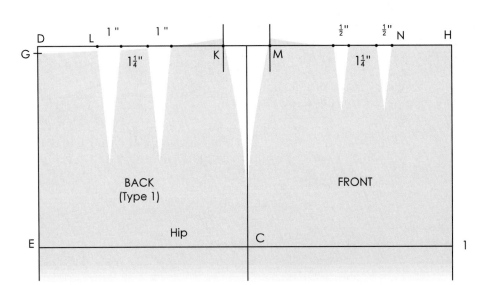

Figure 3

- **C to P = Side hip depth (26)** _____.

 Draw side seam curve using the Skirt Curve Rule. Shift the rule until the depth measurement touches the front and back guidelines. Label P, and Q.

Waistline: Draw front and back waistline using the shallow end of the curve ruler from G to P (back), and from H to Q (front).

Figure 3

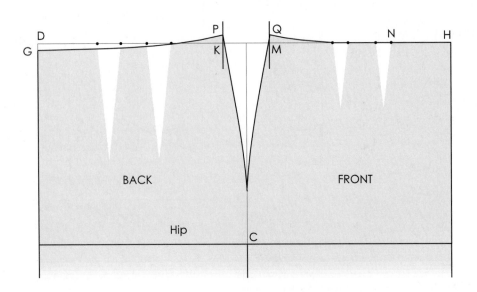

Figure 4
- Back darts: Locate centers of each dart intake, and square down 5½ inches (5 inches for junior and petites).

 Draw dart legs from dart points to curve line of the waist.

 True dart legs by adding to the shorter legs, and blend to the curve of the waistline.

- Front darts: Repeat the process with the dart legs 3½ inches long.

Figure 4

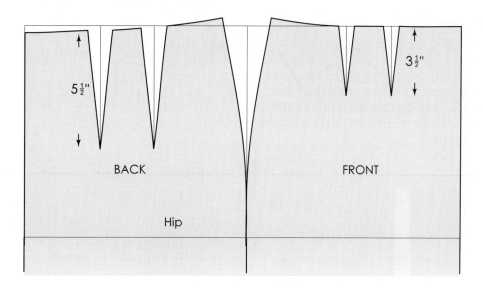

Skirt Back (for suits and separates)

Trace the skirt back. Mark the corner of the dart leg closest to center back. Do not include the dart intake.

Adjust dart intake:

- Mark first dart intake 1½ inches. Mark dart space 1¼ inches. Mark second dart intake 1/2 inch. Mark dart centers. Use this measurement from center back for dart points when drawing dart legs to length as illustrated. True dart legs by adding to the shorter leg.

- Blend to the curve of the waistline.

- Complete the pattern and cut in fabric for a test fit given on page 46.

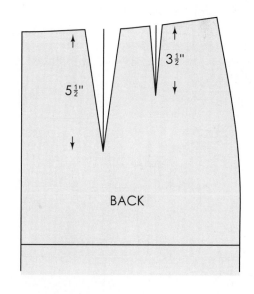

Fitting the Skirt

Sew the skirt with a long stitch. Press without steam and place on the form. The skirt may be critiqued separately as illustrated, or stitched to the bodice.

Analyze the fit of the skirt, release stitches from any problem areas, pin to adjust the muslin, and make corrections to the pattern.

A well-fitted skirt aligns with the centerlines of the form with pins at waist, side waist, and center back. There is no appearance of stress lines (for lack of ease), darts are not too short or too long, stitched incorrectly, or misplaced. If there are too many errors due to incorrect measurements, redraft the skirt.

Fitting problems of alignment are illustrated with the cause and effect of the error.

A well-balanced skirt

Figure 1a, b

- The skirt aligns with the centerlines of the form and hangs straight from the hip to the hemline, indicating that the HBL line (crossgrain) is parallel with the floor. The skirt stitched to the bodice is shown in Figure 1b.

Figure 1a, b

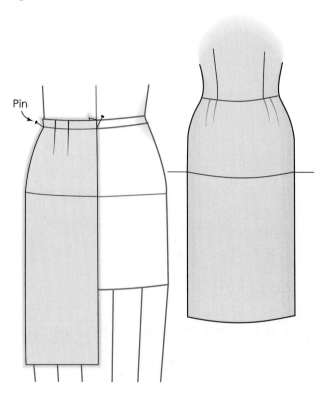

Figure 2a, b

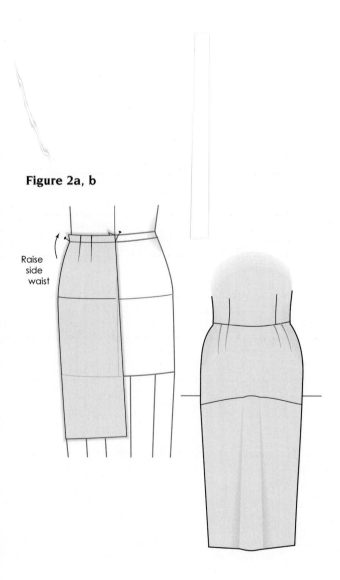

Imbalanced skirt

Figure 2a, b

- Problem: The skirt overlaps the centerline.
- Possible causes: Insufficient dart intake or side waist incorrectly marked. Check the location of the HBL on the form and the draft. A flare will appear at the center of the skirt (Figure 2b).
- Suggested solution: Raise the side waist until the skirt aligns with the centerline of the form. It may be necessary to release the side seams to correct the problem. Increase dart intake, if necessary.

Figure 3a, b

- The skirt swings away from the center.
- Problem: Excessive dart intake, or the side waist incorrectly marked. Check the location of the HBL on the form and the draft.
- If not corrected, the skirt will press against the thigh and move up the hipline when the wearer is walking (Figure 3b).
- Suggested solution: Lower the side waist until the skirt aligns with the centerline of the form. It may be necessary to release the side seams to correct the problem. Decrease the dart intake, if necessary.

Figure 3a, b

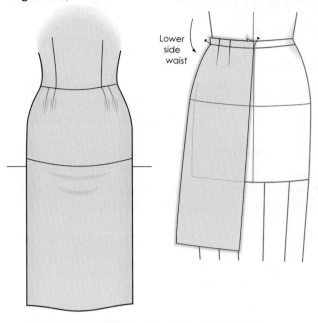

Lower side waist

Fitting Adjustments Needed

Preparing Patterns for Test Fit

Trueing Basic Patterns

To true, place patterns with darts on top of patterns without darts, if possible. Incorrect seams should be adjusted equally at each end and blended with seamline.

Trueing front and back bodice at stitch line

Figure 1

- Place back pattern on top of front pattern (shaded area), touching shoulder/neck corners and mark dart location on front shoulder.

Figure 1

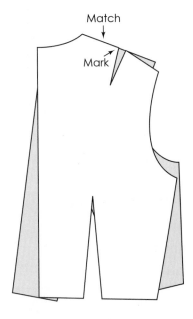

Figure 2

- Move back pattern so that other dart leg touches mark on front shoulder and pattern's edge, matching to shoulder tip. Adjust shoulder, if necessary.

Figure 2

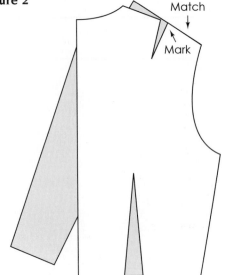

Figure 3

- Place side seams together, matching side at armhole and waist. Adjust side seam, if necessary.

Figure 3

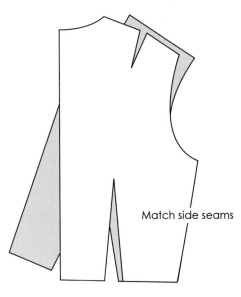

Match side seams

Trueing front and back skirt

Figure 4

- Place back and front (shaded area) skirts together at sides. Match HBL lines. Skirt should true to side waist and hem from the HBL. If it does not, recheck muslin or recheck square line on draft. If correct, adjust patterns above and below the HBL to true.

Figure 4

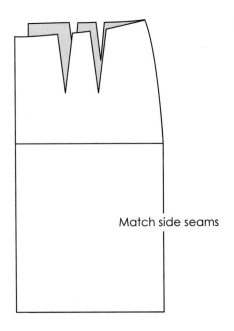

Match side seams

Trueing bodice with skirt

Figure 5

- Place center back of bodice to center back of skirt (shaded area), matching stitchline to dart leg (should match perfectly).

Figure 5

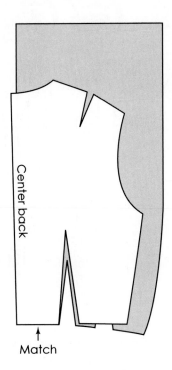

Match

Figure 6

- Shift back pattern along waistline, matching mark of bodice with other dart leg on skirt. Side seams should match. If they do not, recheck waistline measurements and adjust.

Figure 6

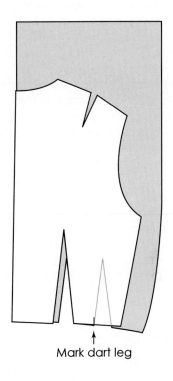

Mark dart leg

Figure 7

- Shift back pattern, matching other dart leg to dart leg of skirt. Broken line is skirt dart underneath. Mark location of dart leg on bodice.
- Repeat for front bodice and skirt (not illustrated).

Figure 7

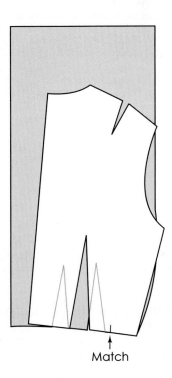

Match

The Basic Sleeve

The basic sleeve is a mounted sleeve, and is drafted to fit a basic armhole. The basic sleeve is the foundation upon which an understanding of all other sleeves is based. Other types will be discussed in appropriate chapters.

The arm is one of the most efficient and mobile parts of the human anatomy. It functions primarily in a forward motion, but is capable of moving in every direction. This flexibility places a burden on the fit of the sleeve.

It should be determined whether cap ease is sufficient and equally distributed between the front and back armhole before a sleeve is stitched to the bodice. Suggestions to correct problems of too much or not enough cap ease and rotation of the sleeve for alignment follow the sleeve draft.

A well-fitted standard basic sleeve aligns with or slightly forward of the side seam of the form. If it does not, rotate the sleeve until it does. However, when fitting a sleeve to the human figure, stance of the model must be taken into consideration. Stooped shoulders cause the arms to swing forward of the side seam. An upright stance causes the arms to swing to the back of the side seam. In either case

Sleeve Terminology

Communicating in terms familiar with those in design and production helps to avoid misunderstanding when problem solving.

Grainline—Straight grain of the sleeve, which is the center of the sleeve from top of cap to wrist level.

Biceps level—Widest part of the sleeve dividing cap from the lower sleeve.

Sleeve cap—The curved top of the sleeve above biceps line.

Cap height—The distance from biceps to the top at the grainline.

Elbow level—Placed at the articulation point of the arm, and the location of the elbow dart.

Wrist level—Entry for the hand.

Notches—A notch at the top of the sleeve cap divides cap ease between front and back sleeve and armhole of the bodice. One notch identifies the front sleeve, and two notches identify the back sleeve. Gathers begin and end at the notches.

Cap ease—Ranging from $1^1/_4$ inches to $1^1/_2$ inches depending on size.

the sleeve should align with the position of the relaxed arm, without regard to alignment with the side seam.

Terms are given to identify parts of the sleeve and to simplify drafting instructions.

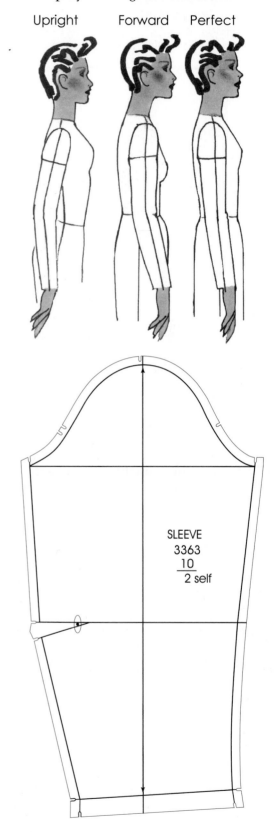

Upright Forward Perfect

SLEEVE
3363
$\frac{10}{2 \text{ self}}$

Cap Ease

Cap ease of the basic sleeve cap is approximately $1^1/_2$ inches; for sizes 10 and below $1^1/_4$ inches. The Sleeve Chart provides measurements for the sleeve draft, but does not necessarily guarantee the correct amount of cap ease. To help control cap ease follow instructions given for Armhole Measurement (Figures 1a, b, c).

Armhole Measurement
Figure 1a, b, c

- Measure the front and back bodice armholes with a plastic rule. (Do not use a measure tape). Record the measurements on the patterns for future reference.

- Add the front and back armhole measurements together.

- Divided in half, and to the measurement add 1/4 inch.

- Record under the model size of the Sleeve Measurement Chart in space provided and on the patterns.

Figure 1a

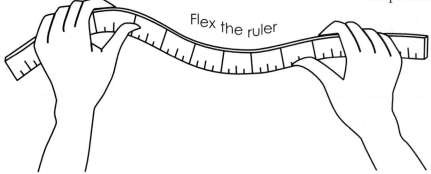

Figure 1b, c

Sleeve Measurement Chart

Grade:	1″	1″		$1^1/_2$″	$1^1/_2$″	$1^1/_2$″	2″
	6	8	10	12	14	16	18
Sleeve Length	$21^1/_2$	$21^3/_4$	22	$22^1/_4$	$22^1/_2$	$22^3/_4$	23
Cap height	$5^5/_8$	$5^3/_4$	$5^7/_8$	6	$6^1/_8$	$6^1/_4$	$6^3/_8$
Armhole Measurement	___	___	___	___	___	___	___
Biceps	$12^1/_4$	$12^5/_8$	13	$13^1/_2$	14	$14^1/_2$	$15^1/_8$

Sleeve Draft

Figure 2

Figure 2

Draw a line on paper. Mark and label:

- **A to B** = Overarm length _____
- **A to C** = Cap height. Mark _____.
- **C to D** = One-half of C to B, less 3/4 inch. Mark. Square lines from A, C, D, B.
- **Armhole Measurement** = _____. Place a ruler at A and pivot until the measurement touches biceps line. Mark.
- **C to E** = One-half of biceps measurement. Mark. Compare placement of the two marks, and mark biceps in between. Label E. Draw a line from A to E, divide into fourths. Mark and label.
- **C to F** = C to E

 Draw a line from A to F. Divide into fourths. Mark and label.
- **B to O** = 2 inches less than C–E.
- **B to P** = B to O

 Draw a line from O to E and from P to F.

Figure 3

Square lines from the following:

- G—in 3/8 inch
- H—out 3/16 inch
- K—out 5/8 inch
- L—out 3/4 inch
- M—out 3/16 inch
- N—in 1/2 inch

Figure 3

Figure 4a, b
Front Capline:

- Use the French Curve to shape the capline by touching A, L, and M. Draw curve beyond M to blend.
- Change position of the curve rule touching F, and with N blending with M line (Figure 4a).

Back Capline:

- Place curve rule so that A, K, and H touch. Draw curve past the H line to blend.
- Change position of the curve rule so that E and G touch. Draw curve to blend with H line (Figure 4b).

Figure 4a, b

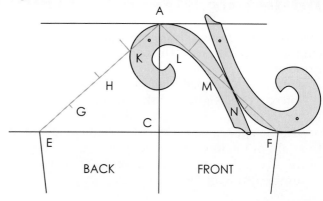

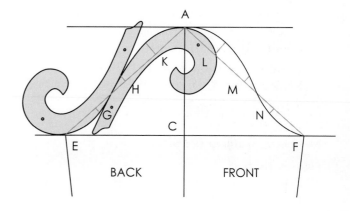

Figure 5

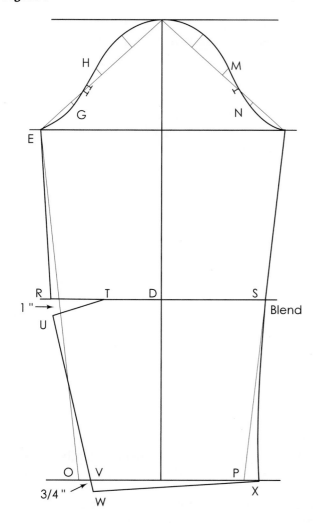

Figure 5
Completing the Sleeve:

- Label elbow Level S, and extend line R 1/4 inch. Draw a line from R to E.
- Elbow dart:

 R to T = One-half of R to D

 R to U = 1 inch

 T to U = R to T

 O to V = 3/4 inch

 Draw a line from U through V equal to R to O. Label W.

 W to X = O to P

 Draw a line ending at wrist level. Draw a slightly curved line from X to S.

Ease control notches:

- Back—Center a notch between H and G, add a second notch 1/2 inch below it.
- Front—Center a notch between M and N.

Continue with instructions to determine cap ease.

Adjusting Sleeve to Armhole of Bodice

The basic sleeve should measure approximately 2 inches more across the biceps of the pattern than the circumference of the arm. The basic sleeve cap should measure an average of $1^1/_4$ to $1^1/_2$ inches more than the front and back bodice armhole. The difference between the sleeve cap and armhole measurement is the amount of ease needed to fit over the ball of the arm. The amount of cap ease is determined by the width of the biceps, cap height, and the circumference of the front and back armhole of the bodice. If any one of the factors is out of harmony, it will affect the fit and appearance of the sleeve in the following ways: excessive or insufficient cap ease; cap ease unequally distributed between the front and back armhole; or sleeves being too tight or too loose. Incorrect placement of the shoulder or side seams of the form will affect the alignment of the sleeve. It is advisable to correct these problems before attaching the sleeve to the garment in order to minimize fitting problems later.

Determining Cap Ease

Two methods are given to determine cap ease. The sleeve can be walked around the front and back armhole, or the measurement can be taken by using the plastic rule. Both are illustrated.

Method 1: *Walking the Sleeve*

Figures 1a, b, c

- Place the corner of the front sleeve at biceps to the corner of the bodice.
- Use a pushpin to pivot and advance the sleeve cap around the curve line of the armhole.
- Mark the notch location of the sleeve to the armhole of the bodice.
- When the sleeve cap reaches the shoulder tip of the bodice, mark the location on the sleeve cap.
- Repeat the process for the back sleeve.

Figure 1a, b

Figure 1c

Mark shoulder tip

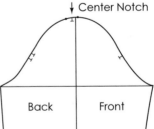

↓ Center Notch

Back | Front

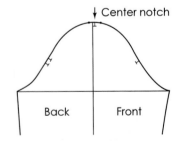

↓ Center notch

Back | Front

Cap Ease

- If the cap ease is correct, center a notch between the marks to equalize the ease. Continue on page 58.
- If cap ease is more or less than required, see pages 56–57 for suggested adjustments of the sleeve or the armhole. When adjustments have been completed, continue on page 58.

Method 2: Flex Rule Measurement

- Measure the curve of the armhole and sleeve cap using a very flexible plastic rule. Use both hands to hold the flex rule to conform to the curve of the armhole and sleeve cap.

- Measure the front armhole. Manipulate the rule around the sleeve cap, and mark this measurement on sleeve cap.

 Repeat the process for the back armhole and mark the back sleeve cap.

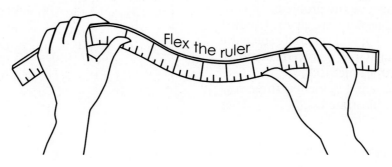

Flex the ruler

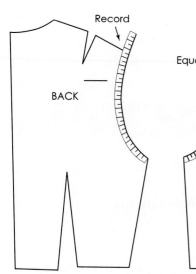

Record

BACK

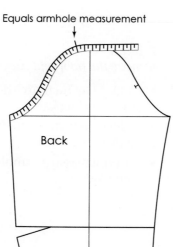

Equals armhole measurement

Back

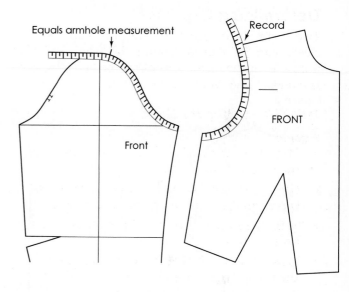

Equals armhole measurement

Front

Record

FRONT

Cap Ease

- If the amount of cap ease is co⸺
 notch between the mar⸺
 Continue to the next s⸺
 sleeve.

- If the cap ease is less or ⸺ ⸺eded, see pages 56–57 for suggested adjustments of the sleeve or the armhole. When all adjustments have been completed, return to page 58 to cut and stitch the sleeve.

Back Front

↓ Center notch

Back Front

Adjusting the Armhole to Accommodate Cap Ease

Even though the cap is the correct amount or a little more than required, the ease around the cap may show puckers (small gathers). The reason may be the fabric, or other reasons can be the problem. To control the excess, three suggestions are given. The first suggestion should be tried. It will generally solve the problem. If the problem is not resolved, combine with the second or the third method.

The example: Cap ease is $1^3/_4$ inches; three suggested modifications are illustrated.

Figure 1

Lower the front and back armhole notches.

- Lower front and back notches 1/8 inch.
- The cap ease is $1^1/_2$ inches above the armhole notches and 1/8 inch below the armhole notches.

Figure 2

Figure 3

Transfer ease to the armhole from available darts.

- Transfer 1/8 inch from the front waist dart and shoulder dart of the back bodice. Mend the pattern, or use the pivotal method.

Figure 1

Figure 2

Increase the front and back armholes.

- Add 1/16 inch to the shoulder tip to zero at shoulder/neck.
- Add 1/16 inch to the front and back armholes to zero at the waist.
- The increased armhole can absorb more of the cap ease.

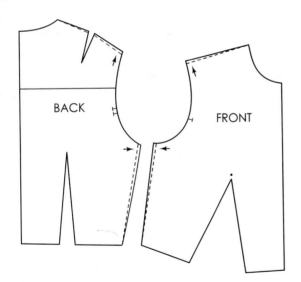

Figure 3

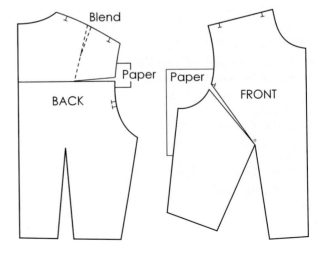

Increase or Decrease the Width of the Biceps

Changing the width of the biceps will also increase or decrease cap ease.

Figure 4

Increase biceps width:

- Trace sleeve and all markings.
- Extend biceps line equally to the amount of cap ease needed.
- Place a pushpin at the biceps line of the sleeve pattern and the extended line. Pivot the sleeve upward until sleeve curves touch. Trace and blend with the traced cap.
- Pivot the sleeve downward until the underseams touch. Trace and true the elbow dart.
- Repeat the process for the front sleeve. (Broken lines indicate the original sleeve pattern.)

Figure 4

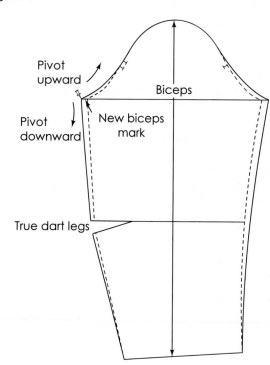

Figure 5

Decrease biceps width:

- Trace sleeve and all markings.
- Decrease biceps line equally to eliminate excess ease.
- Place a pushpin at the biceps line of the sleeve pattern and the decrease mark. Pivot the sleeve upward until sleeve curves touch. Trace and blend with the traced cap.
- Pivot the sleeve downward until the underseams touch. Trace and true the elbow dart.
- Repeat the process for the front sleeve. (Broken lines indicate the original sleeve pattern.)

Figure 5

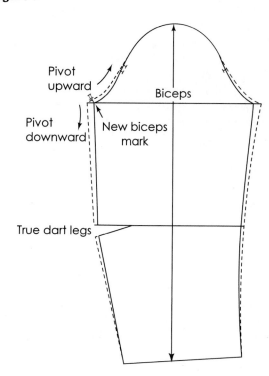

Setting the Sleeve into the Armhole

The sleeve is ready to be placed into the armhole. It is not known whether the sleeve will align with or hang slightly forward of the side seam. It is possible to precheck the fit by pinning the undersleeve to the armhole from notch to notch and pinning the cap notch to the shoulder seam. See Figures 2 and 5. If a sleeve hangs out of alignment it can be rotated to correct the problem.

Figure 1

Figure 1

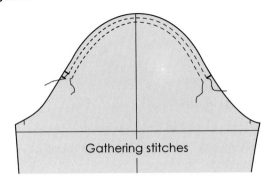

Gathering stitches

- To prepare the sleeve, trace in the fabric of choice.
- Draw the center grainline and the biceps lines and cut.
- It is suggested that two rows of gather stitches be placed front to back notch. Stitch one row at the seamline, and the other 3/8 inch above. Pull the gather stitches to equal the distance from the front to back armhole notches. Gathers should be evenly spaced to avoid puckers.
- Stitch the sleeve to the armhole of the bodice.

Evaluate the Hang and Fit of the Sleeve

Figure 1

Does the sleeve align with or hang slightly forward of the side seam (Figure 1)? Does the sleeve hang toward the back (Figure 2) or too far forward of side seam (Figure 3)? Sleeves that hang out of alignment should be rotated until aligned.

Does the sleeve show puckers or puff around the cap? If so, reduce cap height; see page 60.

Is there insufficient cap ease? If so, increase cap height; see page 60.

Sleeve with Perfect Alignment

Figure 1

- The grainline of a well-balanced sleeve is aligned with or slightly forward of the side seam.

Aligned

Imperfect Alignment

Figure 2
Sleeve hangs to the back of side seam:

Figure 2

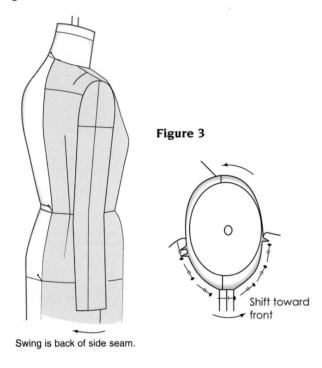

Swing is back of side seam.

Figure 5, 6a, b, c
Sleeve hangs forward of side seam:

- Repeat the process pinning to the back of side seam and forward of shoulder tip.

Figure 5

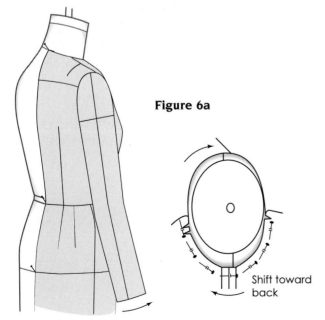

Swing is forward of side seam.

Rotating the Sleeve

Figures 3
- Remove the sleeve. Pin under sleeve 3/8 inch forward of the bodice side seam from front to back notch. Pin cap 3/8 inch toward the back of the shoulder seam.
- If alignment is not corrected, repin closer or further from the side seam.

Pattern Adjustment

Figure 4a, b
Adjust the shoulder and side seam.

Figure 4a, b

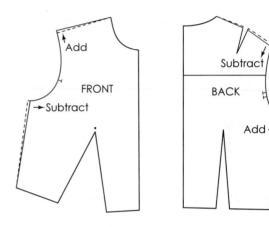

Figure 3

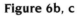
Shift toward front

Figure 6a

Shift toward back

Figure 6b, c

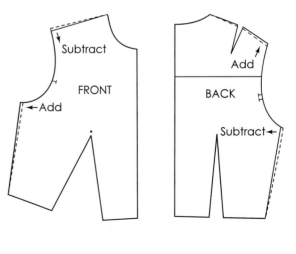

Increase or Decrease Cap Height

Problems: Puckering around the cap that appears like a puff sleeve (decrease cap height), see Figure 5 or a sleeve swinging away from the side seam (increase cap height), see Figure 4.

This method will also increase or decrease cap ease.

Figure 4
- To increase cap height, cut through the grainline to corner of the front and back sleeve, and lift to spread the cap for the extra amount of ease needed.

Figure 4

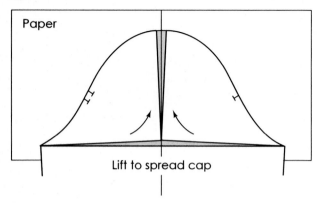

Paper

Lift to spread cap

Figure 5
- To decrease cap height, cut through the grainline to corner of the front and back sleeve, and overlap the cap to eliminate the excess ease.

Figure 5

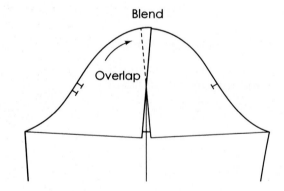

Blend

Overlap

Seamless Working Patterns

The basic pattern set should remain seamless to develop design patterns. Seams are added at the completion of the basic pattern and design patterns. The professional designer or patternmaker may prefer to develop design patterns with seamed patterns to save time. The darts are partially cut out, and a punch hole is placed at the dart ends of each dart for accuracy when tracing the pattern for manipulation.

Completing the Pattern

A completed pattern has seam allowance, pattern symbols (notches and punches or circles), grainline, and pattern information. Pattern symbols guide the seamstress in constructing the garment, and pattern information assists in the production process. If the suggested pattern information differs from that of the company's standards, defer to their standard.

Pattern Information

Write or print pattern information clearly. Patterns other than lining or interconstruction should be written in black felt-tip pen. Lining patterns are written in blue, and interconstruction in green. Pattern information can be placed in the center of the pattern or placed along the grainline, and on the right-side-up of each pattern.

Grainline. The grainline is drawn through the length of the patterns.

Pattern identification. Write the name on each pattern *(bodice front, back, skirt, sleeve, collar, pocket).*

Style number. Write the code number of the pattern set, for example: 3363 (33 may identify the type of garment and 63 may identify the fabric).

Pattern size. Record the pattern size.

Pieces cut. Write the number of pieces to cut from each pattern to complete the garment.

The above information is written in black pen.

A line separates the size (1) and number of pieces cut. The word "self" is circled, and follows the number of pieces cut.

Seam Allowance

The following are general guidelines:

1/4 Inch

- All faced areas
- Sleeveless armholes
- Narrow spacing
- Extreme curves

1/2 Inch

- Armholes with sleeves
- Waistlines
- Centerlines
- Stylelines
- Side seams (varies: 3/4 inch, 1 inch)
- Zipper seams (varies: 3/4 inch, 1 inch)

Overlock Seam

- 3/8 inch seam allowance.

4

Dart Manipulation (Principle #1)

Introduction

The flat patternmaking method is the fastest and most efficient method ever devised for developing patterns that control the consistency of size and fit of mass-produced garments. The system depends upon patterns that have been previously developed and perfected. The patterns, called working patterns, are used as a base from which a variety of other pattern shapes are generated. The original working pattern is never altered but must remain in its original form to be used as a base for developing other design patterns. In this way, the original is retained as a master copy.

Working Patterns

Working patterns, as illustrated in the text, consist mainly of the basic back and front bodice, skirt, and sleeve, and other foundation patterns derived from them. The patternmaker may, however, choose a pattern that closely relates to a specific design without having to develop a complete new pattern from the basic pattern as patternmaking skill improves. This saves time, as part of the design detail has already been worked out. These working patterns should remain seamless unless the patternmaker is experienced, as seamless patterns are easier to manipulate and develop. (All technical illustrations in this text are based on seamless patterns for clarity.)

Patternmaking Techniques

Patterns can be manipulated and changed into other shapes in two ways—through the slash-spread or pivotal-transfer techniques. The slash-spread technique is easy to understand as it clearly illustrates the changes taking place. The pivotal-transfer method is equally reliable and less time-consuming, but it is more advanced. It may be preferred once the slash-spread technique has been mastered. Both methods will be illustrated in this chapter.

All pattern manipulation is done while the pattern lies flat on the table, hence the name flat patternmaking. While it is often difficult for the beginning patternmaker to visualize the three-dimensional form of a design with a flat pattern, this skill will improve with each exercise or practice pattern that is cut in cloth, sewn, and placed on a form for evaluation. This will take time and concentration, but the effort is worthwhile in terms of the self-satisfaction and monetary rewards that come to a skilled patternmaker.

Design Analysis and the Three Major Patternmaking Principles

Along with the manipulative skills needed in the Flat Patternmaking System, the patternmaker must also develop analytical skills. To do this the patternmaker must be able to analyze the creative detailing of each design by studying the differences between the basic garment and the design (Figure 1). This involves a knowledge of the three major patternmaking principles and their corollaries:

- Principle 1—Dart Manipulation
- Principle 2—Added Fullness
- Principle 3—Contouring

Figure 1

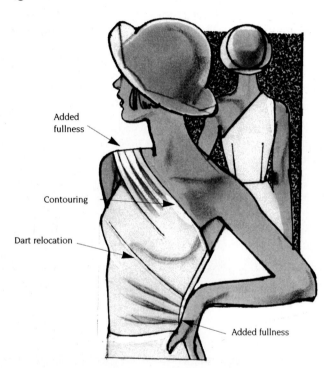

Added fullness

Contouring

Dart relocation

Added fullness

Designs are generally created without knowledge that certain principles are the basis for the creation. It is the patternmaker's responsibility to analyze designs and determine which principle(s) to apply to the developing pattern in order to ensure that the exact replica of the design will emerge from the finished pattern shapes. The beginning patternmaker should always study and compare the finished pattern shapes with the completed garment. This will help the patternmaker visualize the relationship between them. Eventually, the shape of the pattern will be visualized before the actual pattern is developed.

Design Analysis. Designs introduced in this book contain a *design analysis* to help train the patternmaker to identify the design features and patternmaking principles involved. The design features are then *plotted* on the pattern as a guide for pattern *manipulation*. Through this process, the original shape of the pattern is changed to represent the design rather than the basic garment (Figure 2).

This is the essence of the flat patternmaking system.

Patternmaking Terms

Patternmaking terms and their definitions will be introduced wherever appropriate throughout the text to help facilitate understanding.

Pattern plot. The act of placing lines on a traced copy of the working pattern relating directly to the design features. The lines are used as guidelines for pattern manipulation.

Pattern manipulation. The act of slashing and spreading or pivoting a pattern section to alter its original shape. The new pattern shape represents design features of the garment.

Design pattern. The finished pattern that contains all the features related to the design.

Pivotal point. A designated point on the pattern (for example, the bust point). The pattern is slashed to, or pivoted from, this point. This allows the pattern shape to be altered without changing its size or fit.

Basic Patterns. The original pattern set: bodice front and back, skirt front and back, and sleeve. They are the bases for all designs.

Test Fit

As each design project is completed, the design should be cut in a woven fabric (or fabric chosen for the design) and placed on a form or model for a test fit. One half of the garment is needed when fitting the form (unless it is an asymmetrical design, which requires a full garment). A full garment is required when fitting the model. Seam allowances can be added in one of two ways for a test fit:

1. The seamless pattern can be traced on cloth, adding seam allowance directly on the fabric.
2. Seam allowances can be added to the pattern before cutting in cloth.

The garment should be stitched using 6 to 10 stitches per inch. The seams are pressed (without

Figure 2

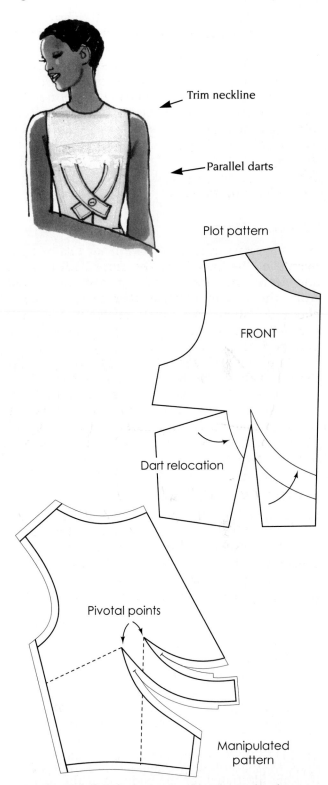

Trim neckline

Parallel darts

Plot pattern

FRONT

Dart relocation

Pivotal points

Manipulated pattern

steam), and the garment is placed on the form or model for test fitting. To complete the pattern, use the general pattern information on pages 63 and 64 as a guide.

Dart Manipulation

Principle #1 (Introduction to Design Patterns)

Principle. A dart may be transferred to any location around the pattern's outline from a designated pivotal point without affecting the size or fit of the garment.

Corollary. The dart excess can be in the form of gathers, pleats, tuck darts, stylelines, cowls, ease in armhole, or flare. The dart excess can be divided into multiple darts or style darts, or combined in other ways. Variation of the dart excess is called *dart equivalent* and will be illustrated throughout the text.

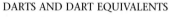

DARTS AND DART EQUIVALENTS

| Style darts | Multiple darts | Stylelines | Gathers | Flare | Tuck darts | Cowl |

Design Projects

The design projects in the dart manipulation and dart equivalent series are all based on Principle #1. They illustrate universal concepts and principles that, once understood, become the model or prototype for all similar designs. Each project should be completed in the order given, as each will prepare the patternmaker for more advanced work.

The front bodice is used to illustrate dart manipulation, added fullness, and contouring (the three major patternmaking principles), since most designing occurs on the front bodice. The same methods that are illustrated for the bodice and the darts of the five working pattern pieces can also be relocated and become dart equivalents. This will be illustrated under appropriate headings for the sleeve, skirt, pant, and so on.

Dart manipulation introduces the slash-spread and pivotal-transfer patternmaking techniques in transferring the dart excess from one location to another for design variations. It is the beginning of the pattern manipulating process for generating design patterns. Both artistic and technical skills are required to manage and control the pattern throughout the process.

Charting Dart Locations

A series of guidelines are drawn on a *traced copy* of the basic bodice front pattern. The guidelines establish common areas for dart relocation and for generating designs. They are not, however, the only locations available, as a dart may be transferred to *any* location around the pattern's outline. When the dart excess is transferred to the center from bust or to the shoulder, the space between the dart's legs varies greatly. This variance is due to the distance from the bust point to the pattern's edge, where the dart is placed. This does not change the fit of the

garment, as the number of degrees contained between the legs of the dart remains the same. (This will be proven at the end of the dart series on page 82).

The charted working pattern is used for practicing the slash-spread and pivotal-transfer patternmaking techniques of the following series, and for generating designs later in the chapter. It is suggested that after charting and labeling the pattern, the patternmaker cut a number of duplicate copies to expedite the projects.

Figure 1

Charting the Front Basic Pattern
Figure 1

- Extend lines from bust point to each location illustrated. Note that a French dart can be placed at any location below straight or side dart. (The patternmaker should learn the names given to each location for clarity in communicating with others in the workroom.)

- Label the waist dart legs A and B as shown.

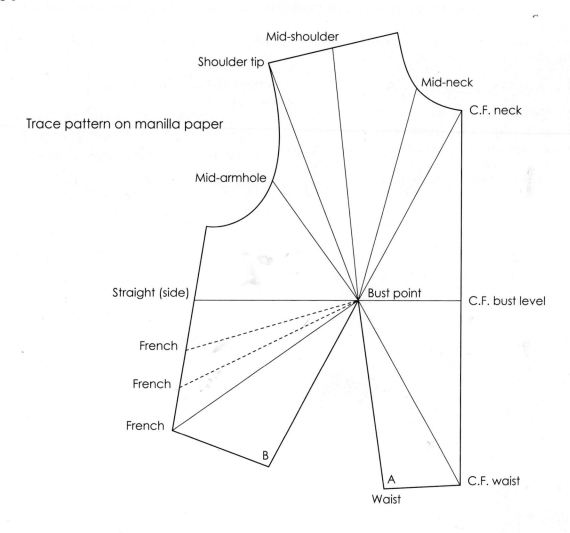

Single-Dart Series—Slash-Spread Technique

The slash-spread technique, as the name implies, requires that a pattern be slashed, cut, and manipulated to generate new pattern shapes. A *traced copy* of the original working pattern is used; the original is never altered. After the pattern is slashed and spread (manipulated), it is placed on another piece of marking paper or tag board. It is retraced along the new lines. The lines are blended. Seam allowance and grainline, and pattern information is added to complete the pattern for the test fit. For guidance refer to page 62, Completing the Pattern. The seamless patterns from the single-dart series should be saved for use later in the text.

The bust has a rounded rather than a pointed shape. To provide room for the bust mound, the dart should end approximately one-half inch from the bust point for single dart control and 3/4 to $1^1/_4$ inches for two-darted patterns.

The hinge. To manipulate a pattern, all slash lines leading to a pivotal point or stitchline must be cut to, not through, the point. The slight connecting part called the *hinge* keeps the pattern sections attached while the pattern is being spread or overlapped. If all slash lines are not cut to a pivotal point or stitchline, the pattern *cannot* be manipulated. (*Caution:* Patterns with seam allowances must also be slashed to *stitchline* from the pattern's edge to create the hinge effect.)

Center Front Waist Dart

Design Analysis: Design 1

The waist dart is relocated to the center front waist. Note the relationships that exist among the design, the plot, and the finished pattern shape. The striped fabric illustrates direction of the grainline.

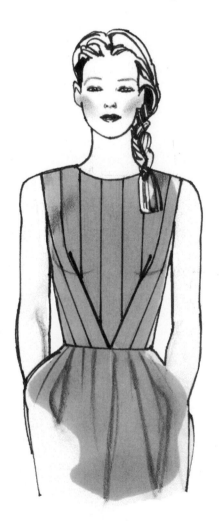

Pattern Plot and Manipulation
Figure 1
- Trace the charted pattern. Crossmark center front waist dart. Label dart legs A and B.
- Draw slash line from center front waist to bust point.

Figure 1

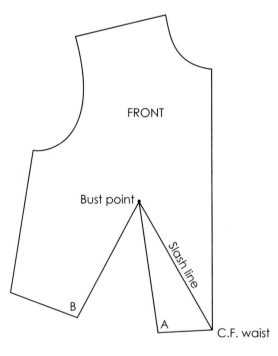

Figure 2
- Slash pattern from center front waist to, not through, bust point.

Figure 2

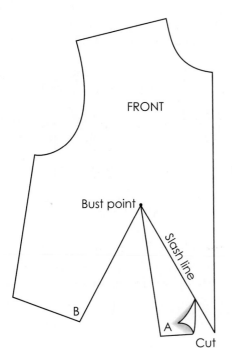

FRONT

Bust point

Slash line

B

A

Cut

Figure 3 New Pattern Shape
- Close dart legs A and B. Tape.
- Place pattern on paper and retrace.
- Center dart point 1/2 inch from bust point.
- Draw dart legs to dart point.

Figure 3

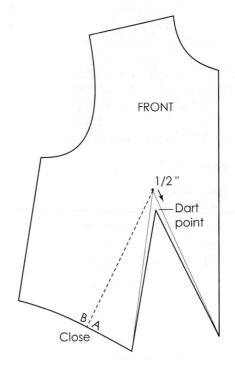

FRONT

1/2 "

Dart point

B A

Close

Figure 4

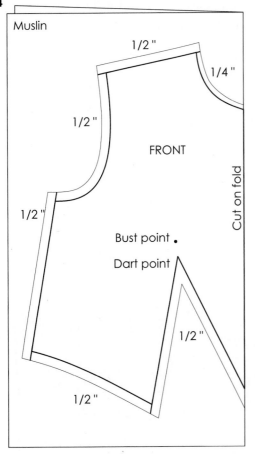

Muslin

1/2 "

1/4 "

1/2 "

FRONT

Cut on fold

1/2 "

Bust point

Dart point

1/2 "

1/2 "

Figure 4
- For test fit, cut on fold for full front; for half-muslin, add 1-inch extension at front. Cut back pattern to complete design (not illustrated).
- Add seams to pattern or muslin.
- Complete pattern using general pattern information for guidance, if necessary (see pages 62 and 63).
- Stitch, press front and back muslin (no steam). Place on form or model for a test fit.

(Punch and circle optional for cutout darts.)

Grainline can be drawn at center fold of pattern, or 1 inch in from fold (see on later patterns).

Center Front Neck Dart

Design Analysis: Design 2

Analyze the design, and plot and manipulate the patterns for designs 2, 3, and 4. Note direction of the grainline for each design.

Figure 2

• Cut slash line to, not through, bust point.

Figure 2

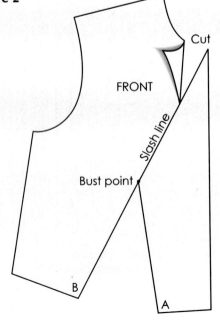

Pattern Plot and Manipulation
Figure 1

• Draw slash line to bust point.

Figure 1

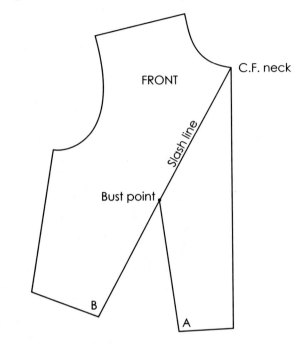

Figure 3 New Pattern Shape

• Close dart legs A and B. Tape.

• Retrace and complete dart legs.

Figure 3

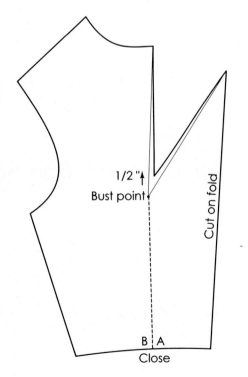

Mid-Shoulder Dart

Pattern Plot and Manipulation
Figure 1
* Draw slash line to bust point.

Figure 1

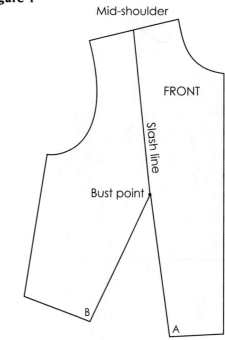

Design Analysis: **Design 3**
Figure 2
* Cut slash line to, not through, bust point.

Figure 2

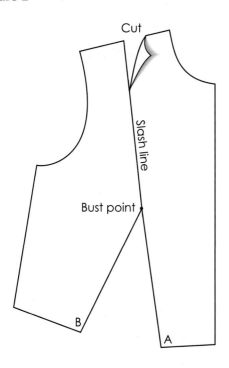

Figure 3 New Pattern Shape
* Close dart legs A and B. Tape.
* Retrace and complete dart legs.

Figure 3

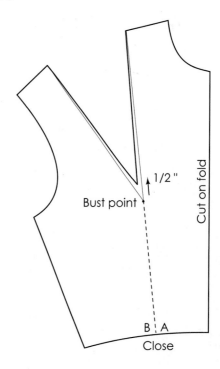

French Dart

Figure 1

- Draw slash line to bust point.

Figure 1

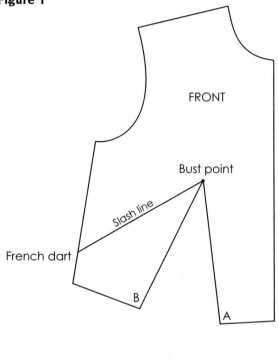

Design Analysis: Design 4

Figure 2

- Cut slash line to, not through, bust point.

Figure 2

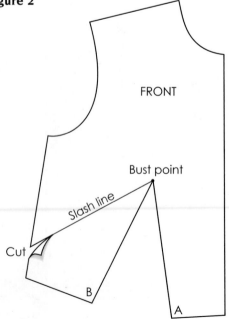

Figure 3 New Pattern Shape

- Close dart legs A and B. Tape.
- Retrace and complete dart legs.

Figure 3

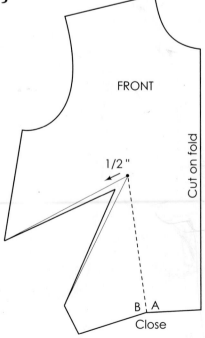

Single-Dart Series—Pivotal-Transfer Technique

The pivotal-transfer technique involves manipulating the *original* working pattern into a new shape by pivoting, shifting, and tracing, instead of cutting. The working pattern is placed on top of pattern paper with a pushpin placed through the pivotal point. To transfer a dart to a new location, the dart is marked on the paper underneath and then traced to an existing dart on the pattern. The pattern is then pivoted, closing original dart legs while opening space for the new dart. The remaining untraced pattern is traced to paper underneath. Once an area of the pattern has been traced, *it is not traced again.* This will be illustrated in the following design projects.

Pushpins are also used to transfer stylelines within the pattern's frame. When the pattern is removed from the paper, the lines are trued with straight or curved rulers, using the pin marks as a guide. The shaded area on the illustrations indicates the part of the pattern affected when traced. Complete the sequence of exercises and save the patterns for future use.

Mid-Neck Dart

Pattern Plot and Manipulation
Figure 1
- Place the working pattern on paper with a pushpin through bust point (pivotal point).
- Mark mid-neck location (point C) and dart leg A on paper.
- Trace section of pattern from dart leg A to C (bold line and shaded area).

Figure 1

Design Analysis: Design 5
The dart extends from mid-neck to bust point of Design 5. Note the relationships that exist among the design, the plot, and the finished pattern shape.

Figure 2

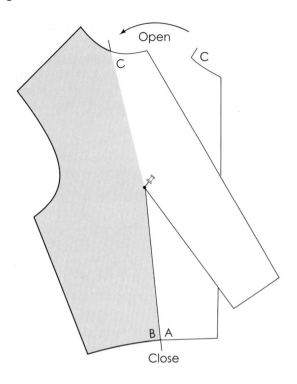

Figure 2

- Pivot pattern until dart leg B touches A on paper (closes waist dart and opens space for mid-neck dart).
- Trace remaining section of the pattern from dart leg B to point C on pattern (bold line and shaded area). Note: Whenever the pattern is pivoted, it will overlay the previously traced pattern section. This is a natural occurrence. Remember, once a section of the pattern is traced, *it is not traced again.*

Figure 3 New Pattern Shape

- Remove the working pattern from paper.
- Draw dart legs to bust point.
- Center dart point 1/2 inch from bust point.
- Redreaw dart legs to dart point.
- Cut in muslin for test fit.

Figure 3

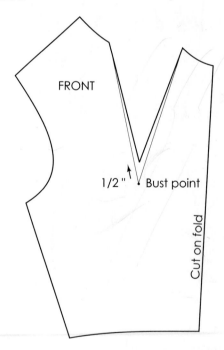

Side Dart

Analyze the design, plot and develop patterns for designs 6, 7, and 8.

Pattern Plot and Manipulation
Figure 1
- Mark new dart location and trace pattern from A to C.

Figure 1

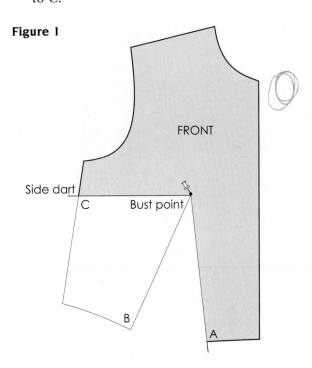

Design Analysis: Design 6
Figure 2
- Pivot pattern until dart leg B touches point A on paper (closes waist dart and opens space for side dart).
- Trace remaining pattern.

Figure 2

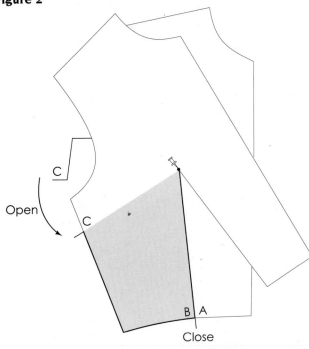

Figure 3 New Pattern Shape
- Remove pattern, draw dart legs to bust, center dart point 1/2 inch from bust point, and draw new dart legs.

Figure 3

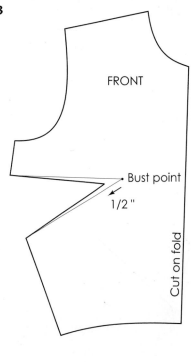

Mid-Armhole Dart

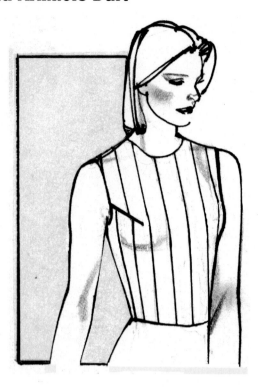

Pattern Plot and Manipulation
Figure 1
- Mark new dart location and trace pattern from A to C.

Figure 1

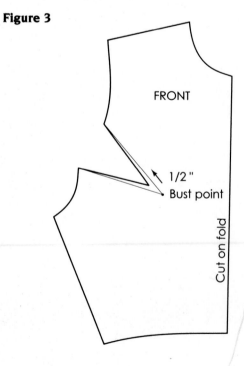

Design Analysis: Design 7
Figure 2
- Pivot pattern until dart leg B touches point A on paper (closes waist dart, and opens space for mid-armhole dart).
- Trace remaining pattern.

Figure 2

Figure 3 New Pattern Shape
- Remove pattern, draw legs to bust, center dart point 1/2 inch from bust point.
- Draw new dart legs.

Figure 3

Shoulder-Tip Dart

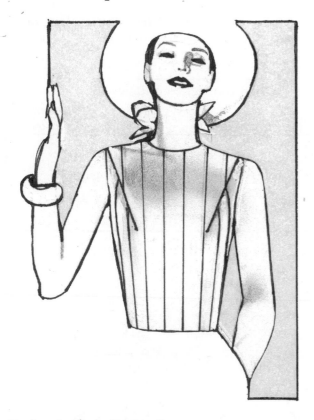

Design Analysis: Design 8

Figure 2

- Pivot pattern until dart leg B touches point A on paper (closes waist dart and opens space for shoulder tip dart).
- Trace remaining pattern.

Figure 2

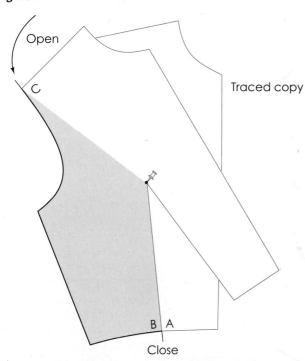

Pattern Plot and Manipulation

Figure 1

- Mark new dart location and trace pattern from A to C.

Figure 1

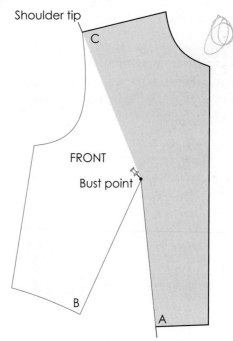

Figure 3 New Pattern Shape

- Remove pattern, draw dart legs to bust, center dart point 1/2 inch from bust point.
- Draw new dart legs.

Figure 3

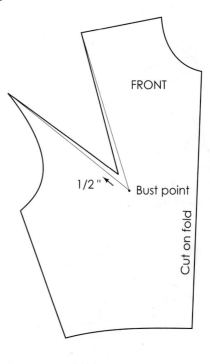

Self-Evaluation Test

1. Develop patterns by transferring the waist dart to locations listed below using the patternmaking techniques indicated. After each pattern is completed, fold darts using the methods described on pages 14 and 15.

Slash-spread technique		Pivotal-transfer technique	
Location	*Corresponding pattern shapes for comparison*	*Location*	*Corresponding pattern shapes for comparison*
Shoulder-tip	Figure 3, page 79	Center front neck	Figure 3, page 72
Side dart	Figure 3, page 77	Mid-shoulder	Figure 3, page 73
Mid-armhole	Figure 3, page 78	French dart	Figure 3, page 74

2. The pattern for Design 1 has been developed (Figure 1). Develop the pattern for Design 2. Analyze the difference between Designs 1 and 2. How do they differ? (Answer can be found at the bottom of the page.)

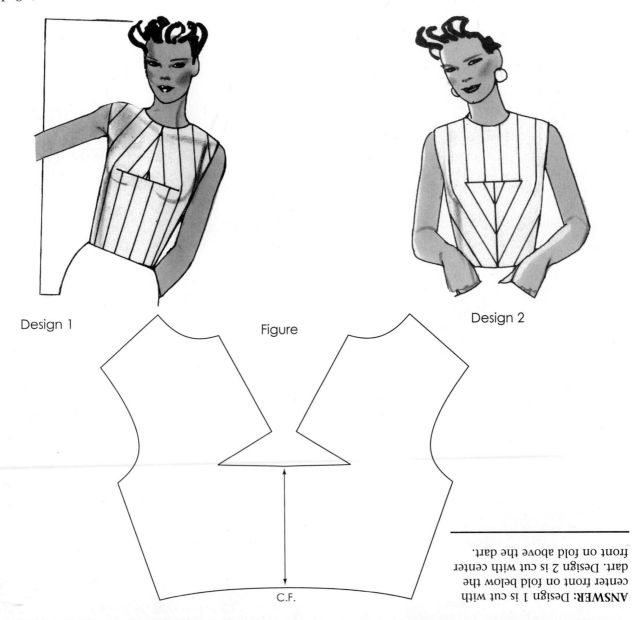

Design 1 Figure Design 2

C.F.

ANSWER: Design 1 is cut with center front on fold below the dart. Design 2 is cut with center front on fold above the dart.

3. The patterns for Designs 3 and 4 have been developed and labeled A and B. Match the design with the correct pattern shape. Write either A or B (below each sketch). Answers can be found at the bottom of the page.

DESIGN 3

DESIGN 4

PATTERN A

PATTERN B

Consistency of Dart Angle

To prove that the angle of the dart legs remains constant without regard to its location around the pattern's outline, stack the following patterns in the sequence given: the shoulder dart (longest dart—bold line), the waist dart (lined pattern), and the center front bust dart (shortest dart). Place a push-pin through the bust points of all three patterns and align the dart legs. They all match, and have the same degree of angle, from the shortest to the longest dart. The spaces between the ends of the dart legs of each pattern varies. The difference is directly related to the distance from the bust point (or any pivotal point) to the edge of the pattern where the dart is located. The closer a dart is to a pivotal point, the narrower the space between dart legs, and the farther the distance, the wider the space between dart legs (Figure 1).

Figure 1

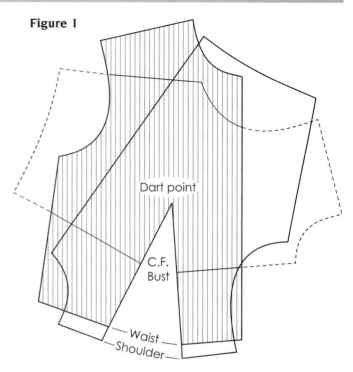

Figure 2

Proof of Principle #1

In the preceding patternmaking exercises, the dart excess was transferred to many different locations around the outline of the front bodice pattern. The shapes of these patterns vary from the original working pattern. When the dart legs are closed and taped, the patterns are the original size and shape. This can be proven by using the patterns previously developed. Bring the dart legs together, cupping the pattern, and tape securely. Stack the patterns, aligning the center fronts. Observe that the patterns coincide exactly (Figure 2).

Two-Dart Series—Slash-Spread Technique

The Two-Dart Working Pattern

A two-dart working pattern (waist and side dart) will be developed for the projects that follow.

The two-dart pattern is used in industry more often than a one-dart pattern. There are advantages to dividing the dart excess into more than one location other than the creative aspects of the design.

- The pattern pieces fit the marker more economically.

- The natural bias of the fabric at side seam is less severe.

- The fit is improved by releasing ease around the bust mound from two dart points rather than from one.

The dart points of a two-dart pattern generally end 3/4 to 1 inch from the bust point, with the side dart from 1 to 2 inches from bust point. The side dart variance depends on the size of the bust cup. For example: A cup, 1 inch; B cup, $1\frac{1}{4}$ inches (standard measurement); C cup $1\frac{3}{4}$ inches; D cup and larger, 2 inches from bust point.

The waist and side dart pattern should be completed on tagboard paper. It will be used as a base for other designs and foundations. For test-fitting, trace the front and back patterns and add seams on the muslin along with notches and punch marks (working pattern to remain seamless). For guidance, refer to page 62, "Completing the Pattern."

In the previous dart manipulation series, only one slash line to bust point was required to transfer the dart to other locations. In this series, transferring part of the dart excess requires two slash lines to bust point—one for the new dart location and the other from dart point to bust point. The slashes create a hinge that permits the manipulation of the dart.

Save patterns for using to practice gathers, tuck-darts, flare, etc.

Waist and Side Dart

Pattern Plot and Manipulation

Figure 1

- Trace front chart pattern. Crossmark side dart location and draw slash line to bust point.

- Label dart legs A and B and side waist X.

- Cut slash line to, not through, bust point (hinge).

Figure 1

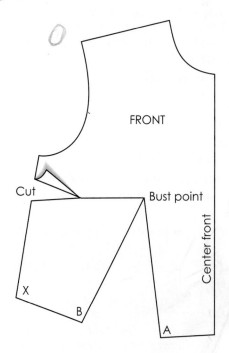

Figure 2

- Draw a square line on paper.
- Place center front on square line with center front waist touching corner as shown. Secure.
- Close waist dart until point X touches square line. (Broken line is original pattern.)
- Trace, mark bust point.

Figure 2

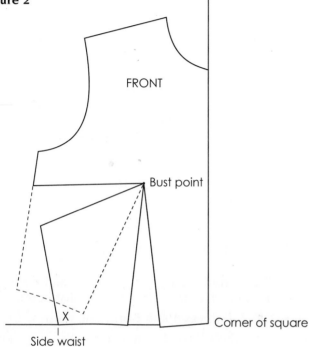

Figure 3

- Center the point of waist dart 3/4 inch from bust and side dart 1$\frac{1}{4}$ inches from bust point.
- Redraw dart legs to dart point.

Figure 3

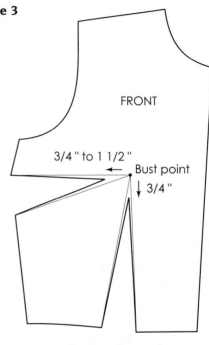

Figure 4

- Test fit: For a full front, cut pattern on fold of muslin. For half of a garment, add 1 inch extension for fold-back at center front/center back (not illustrated).
- Add seams as indicated.

 Side dart:

- Center fold lies toward waist.

 Waist dart:

- Center fold lies toward center front (toward center back for back muslin). (Fold dart legs when cutting muslin.) (To shape darts on pattern see page 14.)
- Stitch, press, and place on form or model for test fit.
- Chart dart locations on pattern for future use (see page 68).

Punch and circles can be placed from 1/4 to 1/2 inch from dart points.

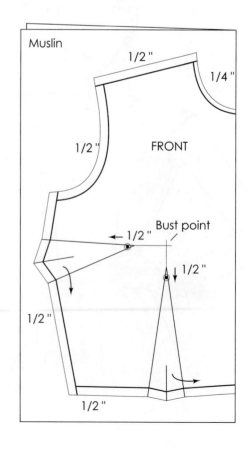

Mid-Shoulder and Waist Dart

Pattern Plot and Manipulation

Figure 1

- Trace pattern, mark bust point and mid-shoulder.
- Draw slash line to bust point from mid-shoulder and from dart point of side dart to bust point.

Figure 1

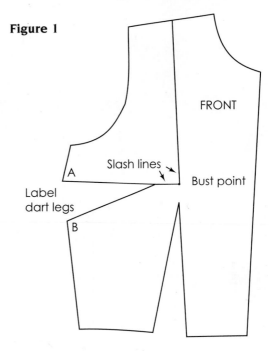

Design Analysis: Design 1

In Design 1 the shoulder dart replaces side dart. The pattern can be used as a seamless working pattern.

Figure 2

- Cut slash lines to, not through, bust point (hinge).

Figure 2

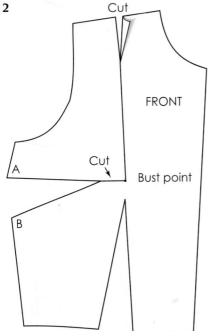

Figure 3 New Pattern Shape

- Close dart legs A and B. Tape.
- Trace pattern.
- Center dart point 1 inch from bust point.
- Draw dart legs to new dart point.

Figure 3

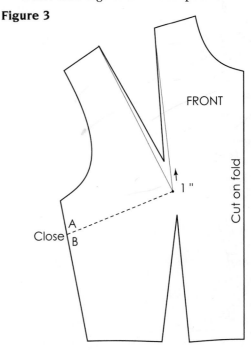

Mid-Armhole and Waist Dart

Design Analysis: Design 2

Pattern Plot and Manipulation

Figure 1

- Trace pattern. Mark bust point and mid-armhole. Cut from paper.
- Draw slash line to bust point from mid-armhole and from dart point of side dart to bust point.

Figure 1

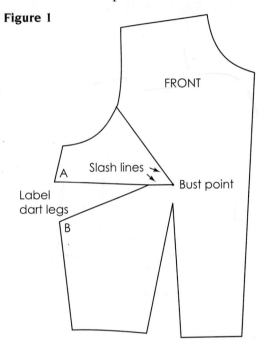

Figure 2

- Cut slash lines to, not through, bust point.
- Bring dart legs A and B together. Tape.

Figure 2

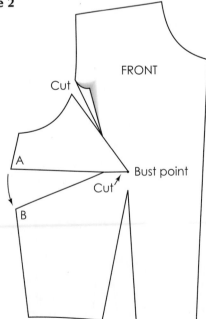

Figure 3 New Pattern Shape

- Place on paper. Trace.
- Center dart point 1 inch from bust point.
- Redraw dart legs to dart point.

Figure 3

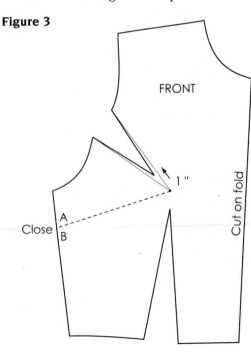

Two-Dart Series—Pivotal-Transfer Technique

Mid-Neck and Waist Dart

Design Analysis: Design 3

Figure 2

- Pivot pattern downward until dart leg A touches B on paper.
- Mark point C at mid-neck and trace to dart leg A.

Figure 2

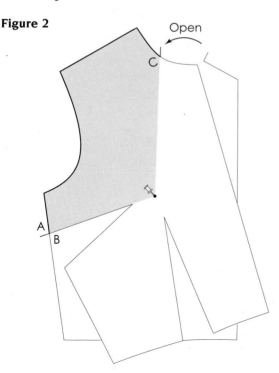

Pattern Plot and Manipulation

Figure 1

- Place pattern on paper with pushpin through bust point. Mark mid-neck. Label C.
- Mark B and trace to point C (bold line, shaded area).

Figure 1

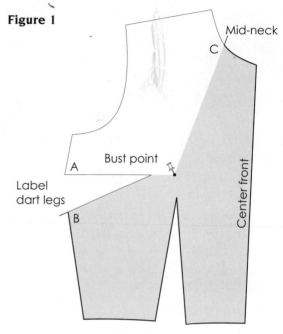

Figure 3 New Pattern Shape

- Remove pattern and draw dart to bust point.
- Center dart point 1 inch from bust point.
- Redraw dart legs to dart point.

Figure 3

Shoulder-Tip and Waist Dart

Design Analysis: Design 4

In Design 4 the side dart is transfered to shoulder tip, as a dart (a), tuck dart (b), or pleat (c).

Figure 2
- Pivot pattern downward until dart leg A touches B on paper.
- Mark point C at shoulder tip and trace to dart leg A.

Figure 2

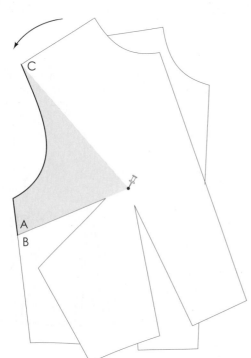

Pattern Plot and Manipulation

Figure 1
- Place pattern on paper with pushpin through bust point. Mark shoulder tip C.
- Mark at dart leg B and trace to point C.

Figure 1

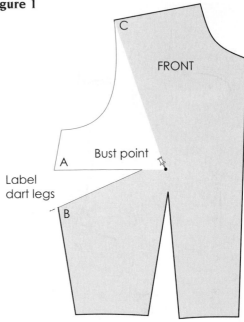

Figure 3 New Pattern Shape
- Remove pattern, draw dart legs to bust point.
- Center dart point 1 inch from bust and redraw legs to dart point.

Figure 3

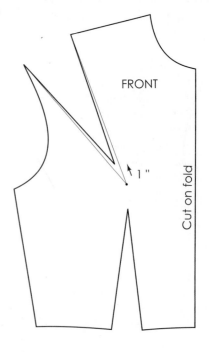

Center Front Neck and Waist Dart

Pattern Plot and Manipulation

Figure 1

- Place pattern on paper with pushpin through bust point. Mark center front neck C.
- Mark at dart leg B and trace to point C.

Figure 1

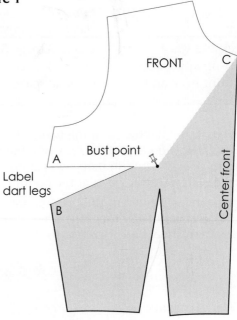

Design Analysis: Design 7

Figure 2

- Pivot pattern downward until dart leg A touches B on paper.
- Mark point C at neck and trace to dart leg A.

Figure 2

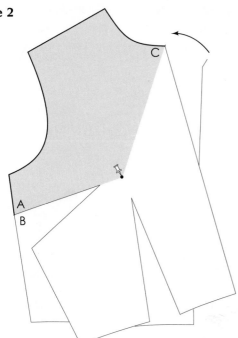

Figure 3 New Pattern Shape

- Remove pattern, draw dart legs to bust point.
- Center dart point 1 inch from bust and redraw legs to dart point.

Figure 3

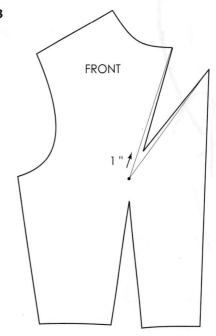

Self-Evaluation Test

1. Develop patterns for the following dart locations using the patternmaking techniques indicated below. After patterns have been developed, fold in darts using the methods described on pages 14 and 15.

Slash-spread technique		Pivotal-transfer technique	
Location	*Corresponding pattern shapes for comparison*	*Location*	*Corresponding pattern shapes for comparison*
Mid-neck and waist	Figure 3, page 87	Side dart and waist	Figure 3, page 84
Shoulder-tip and waist	Figure 3, page 88	Mid-shoulder and waist	Figure 3, page 85
Center front neck and waist	Figure 3, page 89	Mid-armhole and waist	Figure 3, page 86

2. Designs 1 and 2 differ from the two-dart series in which the waist dart remains and the side dart changes location. How do they differ? Analyze the two designs. Compare with that of the working pattern. Four pattern shapes are illustrated. Two patterns relate to the designs. Choose the correct pattern shape for each design. (Answer given at the bottom of the page).

 Using concepts given in the previous design projects, develop pattern shapes for Designs 1 and 2. Use the slash-spread technique, then repeat the exercise using the pivotal-transfer method. Practice until the pattern shapes are identical to those illustrated. Have patience and perseverance.

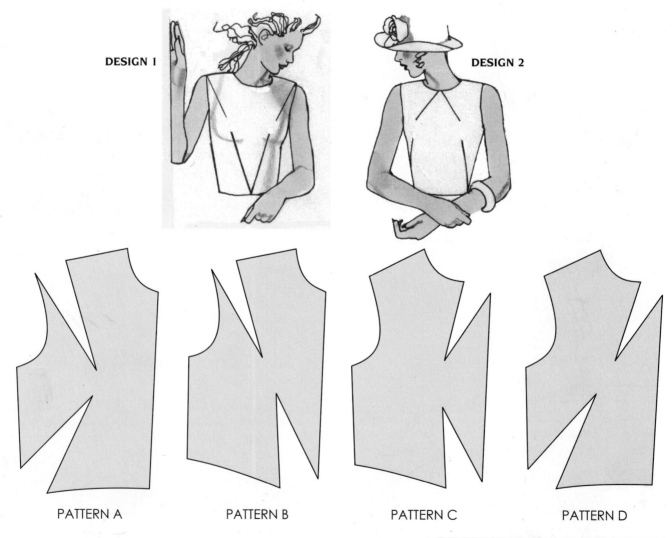

DESIGN 1

DESIGN 2

PATTERN A PATTERN B PATTERN C PATTERN D

ANSWER: Pattern B relates to Design 1.
Pattern D relates to Design 2.

The Shoulder Dart

The shoulder dart should be relocated when it interferes with a design detail. The shoulder dart, like the bust dart, can be transferred to any location around the pattern's outline. It can be used creatively by changing its shape or by transferring it to the waist dart when additional flare is desired at the waist or hemline.

 The most common dart locations are illustrated. If preferred, other locations can be used.

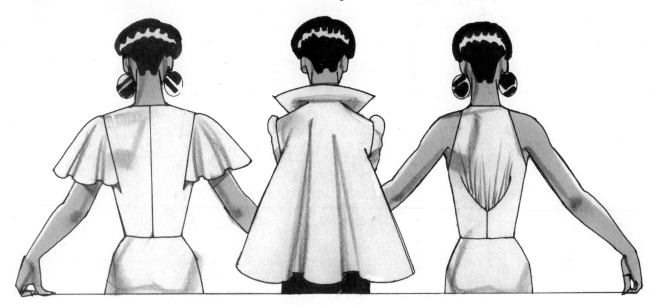

The Multidispersion Working Pattern
(For use when shoulder dart is not required)

Pattern Plot and Manipulation
Figure 1a and 1b
- Trace back pattern, including the HBL line.
- Draw slash line from dart point and mid-neck to the guideline. Draw facing.
- Trace and cut facing from paper.

Figure 2
- Cut slash lines from neck, shoulder dart, and mid-armhole to, not through, pivotal point.
- Spread sections equally.
- Place on paper. Secure.
- Trace and blend neck, shoulder, and armholes.
- Mark ease control notches as shown. (Mark notches on front shoulder.)

Figure 1

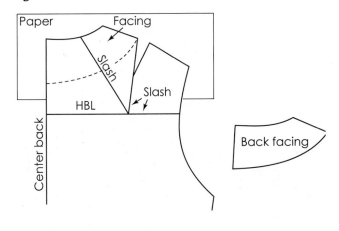

Figure 2

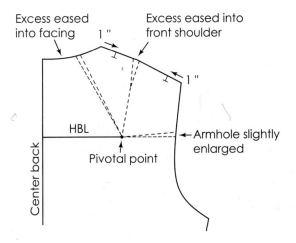

The Back Neck Dart

Pattern Plot and Manipulation
Use slash or pivotal method.

Figure 1
- Trace back pattern and all markings.
- Draw slash lines from mid-neck on a desired angle to the HBL line, and to the dart leg of the shoulder.
- Crossmark 3 inches down on line from the neck.

Figure 2
- Cut slash lines from neck and dart leg at shoulder to pivotal point.
- Pivot pattern to close shoulder dart. (The shoulder will jog at the dart closing.) Tape to secure.

Figure 3
- Trace pattern and draw a straight line from neck to shoulder tip.
- Draw dart legs to the center point of the crossmark.

Figure 1

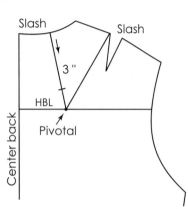

Figure 2

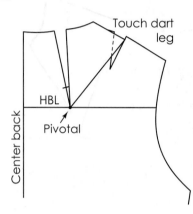

Figure 3

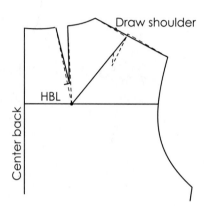

Excess Transferred to Armhole
Pattern Plot and Manipulation

Figure 1
- Trace back pattern and all markings.
- Draw line from dart point to HBL guideline.
- Slash from HBL at armhole to pivotal point and from dart point to, not through, pivotal point.

Figure 2
- Close shoulder dart. Tape. Retrace. Blend armhole.

Figure 1

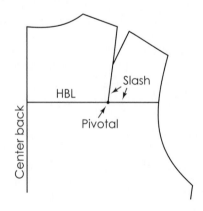

Figure 2

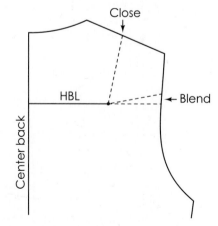

5

Designing with Darts

(Tuck-Darts, Pleats, Flares, and Gathers)

Introduction

The dart is one of the most flexible and creative parts of the pattern. The space (excess) between the dart legs can be used in a variety of creative ways, limited only by the imagination of the designer. Dart excess used as design is referred to as a *dart equivalent*. Dart equivalents are illustrated as tuck-darts, pleats, flares, and gathers. Dart equivalents replace the dart as control and will always end at the pivotal point of a pattern (such as bust point). The difference between a dart and a dart equivalent is the manner in which each is marked (and subsequently stitched). Darts are stitched end to end, tuck-darts are partially stitched, pleats are folded, and fullness is spread and gathered along the stitchline.

Gathers are illustrated separately using the slash-spread and pivotal-transfer techniques. Advanced design using darts and dart equivalents follow. A sample of each dart equivalent should be cut in fabric. It is important to view the different effects created by varying the dart.

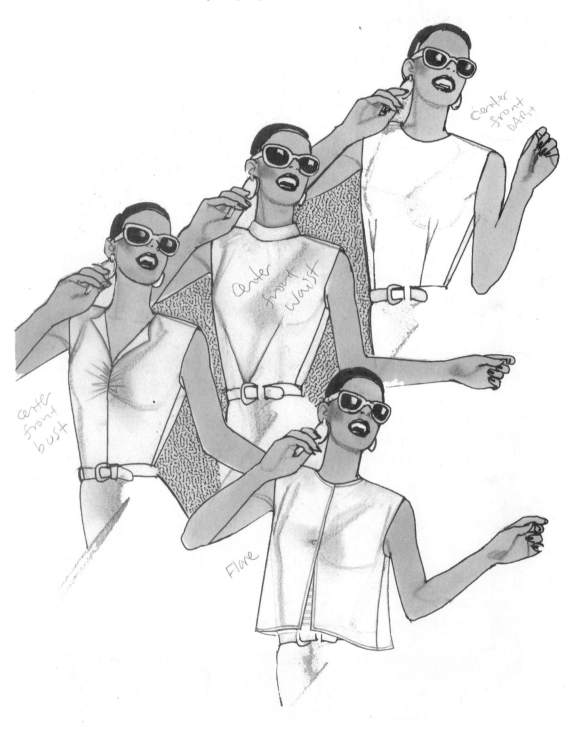

Tuck-Darts 10/8/04

Figure 1a

- A tuck-dart is a partially stitched, inverted dart that is marked by punch holes and circles along the centerfold and 1/8 inch inside the stitchline, 1/2 inch below the finished length.

Figure 1b

- The underside of the dart illustrates the stitched area. Note that stitching is 1/2 inch beyond the punch holes.

Figure 1a

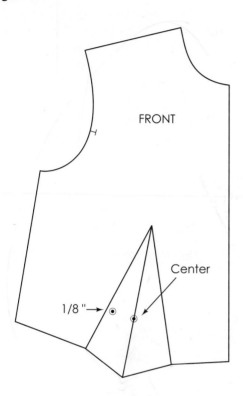

Figure 1b

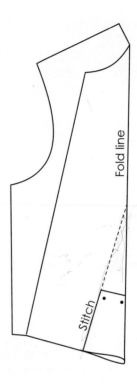

Pleats

Figure 2

- A pleat is an unstitched, folded dart held securely along joining seamline. It is developed as a dart on the pattern but does not include punch hole and circle for dart point. Dart legs are notched. (Broken lines indicate the original dart legs.)

Figure 2

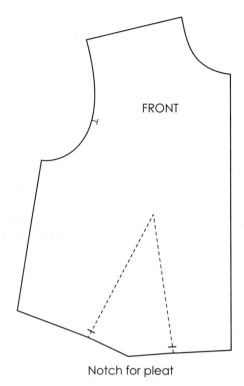

FRONT

Notch for pleat

Flare

Figure 3

- A flare is an open, unstitched dart. The open dart space is blended across the bottom. Punch holes, circles, and notches are not needed. (Broken lines indicate original dart legs.)

- Flare should be added to side seam; see page 142, Figures 3 and 4 for another version.

Figure 3

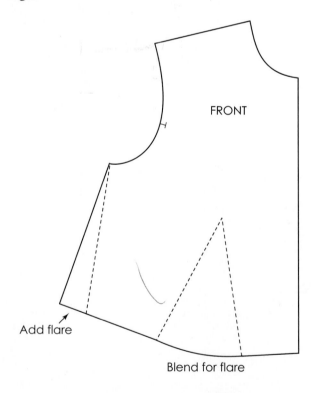

FRONT

Add flare

Blend for flare

Gathers

Gathers are illustrated using the slash-spread and pivotal-transfer techniques. Gathers change the look of the basic garment, but will not affect the fit. The slash-spread technique illustrates *half* of the dart excess used for gathers, and the pivotal-transfer technique illustrates *all* of the dart excess transferred for gathers.

Pattern Plot and Slash-Spread Technique

Figure 1 *Gathers at shoulder*:
- Trace charted front pattern. Mark mid-shoulder. Label dart legs A and B.
- Draw slash lines 1 inch out from each side of mid-shoulder, ending at bust point (pivotal point).

Figure 1

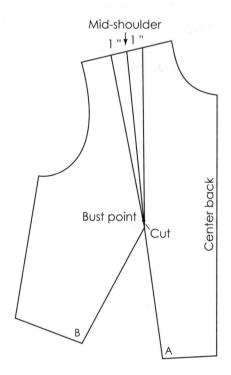

Figure 2
- Cut slash lines to, not through, bust point.
- Place on pattern paper, and bring dart leg B halfway to A. Secure.
- Spread slashed sections equally and secure.
- Trace outline of the pattern (bold line).
- Place notch marks 1/2 inch beyond first and last opening, for gather control.
- Draw blending line between openings, touching center sections.

Figure 2

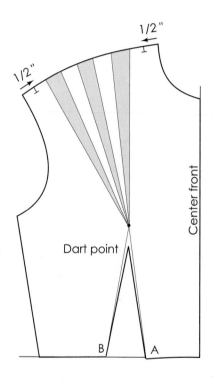

Figure 3
- Mark back shoulder notches same distance in from shoulder tip and shoulder at neck.

Figure 3

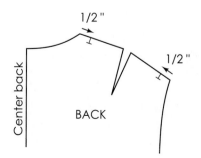

Pattern Plot and Development: Pivotal-Transfer Technique

Figure 1

- Mark mid-shoulder and 1 inch on each side of mark. Label 1, 2, and 3.
- Label dart legs A and B.
- Place pattern on paper with pushpin through bust point.
- Divide waist dart into thirds on paper underneath. Label 4, 5, and 6.
- Trace from corner of dart leg A to shoulder mark 1, and crossmark.

Figure 1

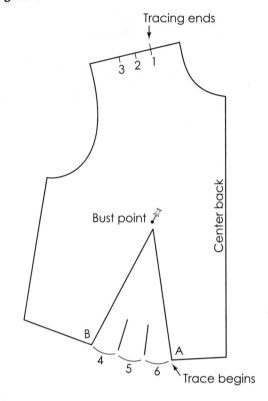

Figure 2

- Pivot dart leg B, covering space 4.
- Trace pattern from shoulder mark 1 to 2. (Heavy line indicates section traced.)

Figure 2

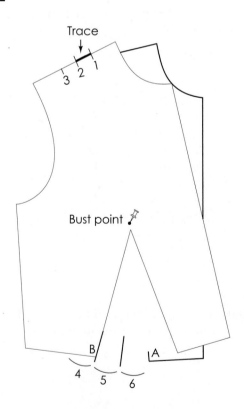

Figure 3

- Pivot dart leg B, covering space 5.
- Trace pattern from shoulder mark 2 to 3, and crossmark.

Figure 3

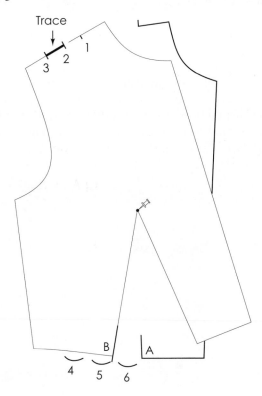

Figure 4

- Pivot dart leg B, covering space 6 (dart closes).
- Trace pattern from shoulder mark 3 to dart leg B.

Figure 5

- Blend shoulder line, touching centers of each section as shown. Crossmarks 1 and 3 should be notched for gather control.

Figure 5

Figure 4

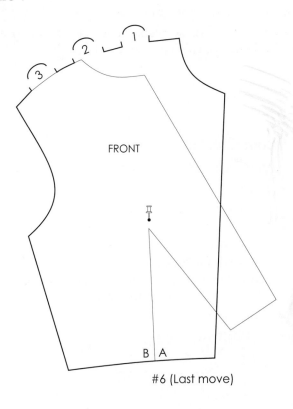

#6 (Last move)

Dart Clusters and Dart Equivalents

The dart excess may be divided among multiple openings that are spaced and treated as a single design unit. When used as a single design feature, they may be identified as a group of basic or stylized darts, tuck-darts, pleats, or a variation in any combination desired.

 The following instructions (Figures 1, 2, and 3) apply to the development of darts, tuck-darts, and pleat clusters. The slash lines for cluster arrangements can vary, being made parallel, or radiating. The examples are for practice. The method for *completing* each cluster differs and will be illustrated by Figure 4 (dart cluster), Figure 5 (tuck-dart cluster), and Figure 6 (pleat cluster). Add seams at the beginning of pattern development.

Waist Cluster

Pattern Plot and Development

Figure 1

- Trace basic bodice.
- Square a guideline out from each dart leg 1 inch below bust point.
- Draw parallel slash lines to guideline 1 inch away from dart legs. Darts may be tapered to 3/4 inch at waistline for a slimming effect.
- Connect to bust point.
- Cut pattern from paper.

Figure 1

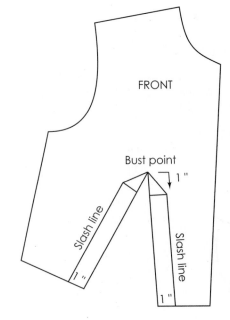

FRONT

Bust point

1"

Slash line

Slash line

1"

1"

Figure 2

- Cut slash lines to, not through, bust point.
- Place on paper and spread equally and secure.
- Draw dart legs ending 1/2 inch below guideline and trace pattern.
- Add seams, and allow excess of paper below waistline for shaping darts. Cut from paper.

Figure 2

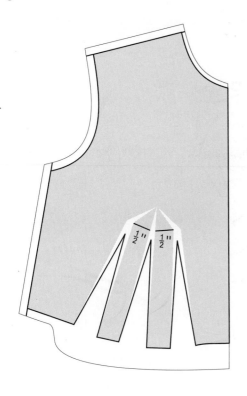

Figure 3

- Fold dart excess toward center front (allow pattern to cup). Waistline will be uneven.
- Draw blending line across waistline. Draw seam allowance, 1/2-inch line parallel with waistline.
- Cut excess while darts are folded, or trace (with tracing wheel) across seam allowance line.
- Unfold and pencil in perforated line.
- To complete the pattern, choose the dart equivalent desired (darts, tuck-darts, or pleats; see Figures 4, 5, or 6). Cut three copies for practice.

Figure 3

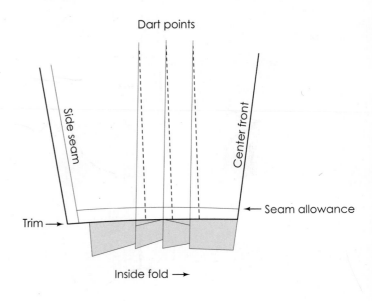

Figure 4

Dart Cluster

Figure 4

- Center punch hole 1/2 inch from dart point and circle.
- Notch pattern, including dart legs.
- Draw grainline. Cut basic back for test fit.

Tuck-Dart Cluster

Figure 5

- Mark the center fold of each dart for punch holes one-half the distance to dart point (varies).
- Mark punch holes in center and 1/8 inch from dart legs.
- Circle all punch marks as shown.
- Notch pattern and dart legs.
- Draw grainline. Cut basic back and complete for test fit.
- For stitching guide see instruction given on page 95, Figure 1b (unstitched dart indicated by broken lines).

Figure 5

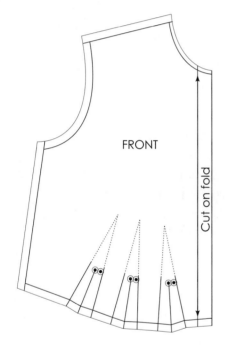

Pleat Cluster

Figure 6

- Notch each dart leg (broken lines indicate original dart legs). (Punch holes—not required for gathers.)
- Draw grainline. Cut basic back and complete for test fit.

Figure 6

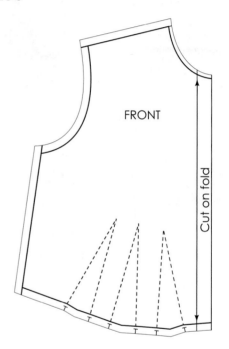

Notes:

Shoulder Cluster

Tuck-darts Darts Pleats

Pattern Plot and Manipulation

Figure 1

- Trace basic bodice.
- Mark mid-shoulder and label dart legs A and B.
- Draw a slash line from mid-shoulder to bust point.
- Square a guideline $1\frac{1}{2}$ inches above bust point.
- Draw parallel line 1 inch out from each side to guideline. Connect to bust point.

Figure 2

- Cut slash line to, not through, bust point.
- Close dart legs A and B. Tape.
- Place on paper and spread slash lines equally.
- Draw dart legs to guideline.
- To complete pattern for each design; see Figures 3, 4, 5, and 6, pages 101 and 102.

Figure 2

Figure 1

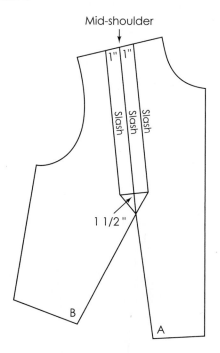

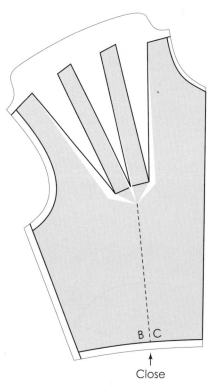

Center Front Bust Cluster

Tuck-darts

Pleats

Darts

Pattern plot and development

Figure 1

- Trace basic bodice pattern. Label dart legs A and B. Square a line from center front to bust point.
- Draw guideline 1 inch from bust point, parallel with center front.
- Draw line 3/4 inch out from each side of line to guideline. Darts may be tapered at center front, for varying effects.
- Connect to bust point as shown.
- Cut pattern from paper.

Figure 1

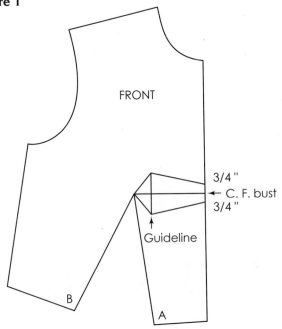

Figure 2

- Cut slash lines to, not through, bust point.
- Close dart legs A and B. Tape.
- Place on paper and spread equally. Secure.
- Draw dart legs to guideline as shown.
- To complete pattern for each design, see Figures 3, 4, 5, and 6, pages 101 and 102.

Figure 2

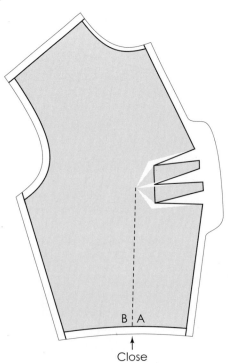

Graduated and Radiating Darts

Graduated darts are darts of varying length within a group. Radiating darts spread out (radiate) from a focal point in a balanced arrangement and may be of the same or a graduated length. To prevent bulging at the tip of the darts farthest from the bust mound, the shorter dart excess is generally 1/2 inch at seamline, with all remaining excess being absorbed by the dart closest to the bust mound. Use back pattern to complete the design.

Graduated Darts

Design Analysis

Design features graduating darts along the shoulderline. The longest dart ends at bust level.

Pattern Plot and Manipulation

Figure 1

- Trace bodice front and label darts legs A and B.
- Square a line from center front to side seam, passing through dart point.
- Draw a slash line from center front to 1 inch past dart point. Label C.
- Draw 4 slash lines equally spaced from shoulder to guideline.
- Cut from paper.

Figure 1

Figure 2 New Pattern Shape

- Cut from neck to C and from C to dart point.
- Close dart legs A and B. Tape.
- Cut slash lines to, not through, guideline.
- Place on paper, spread, and tape. (Corner at neck will not meet, and part of guideline overlaps.)
- Trace the pattern and blend neckline.
- Center dart legs about 1 inch up from slash lines.
- Fold dart legs and blend shoulder.
- Trim fullest dart legs to within 1/2 inch of seamline.

Figure 2

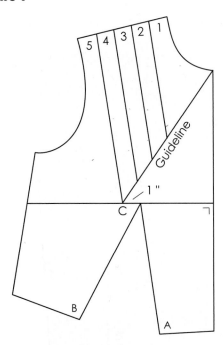

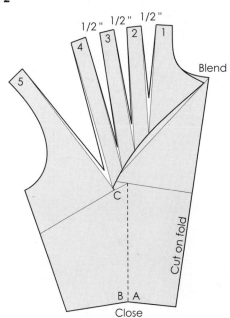

Radiating Darts

Design Analysis

Design features radiating darts from neck, with the longest dart placed at mid-neckline and directed to bust point.

Pattern Plot and Manipulation

Figure 1

- Trace basic pattern. Label dart legs A and B.
- Draw a slash line from mid-neck to bust point. Label C.
- Locate midpoint on line C. Square out 1 inch on each side. Label D and E.
- Measure out 1/2 inch on each side of C. Mark and draw slash lines to D and E, and to bust point.

Figure 2 New Pattern Shape

- Cut slash lines to, not through, bust point.
- Place on paper. Close dart legs A and B. Tape.
- Spread lines D and E 1/2 inch at neck. Remaining excess is taken up by middle dart.
- Locate dart points between guidelines as shown, with middle dart point 1 inch from bust point.
- Draw dart legs to dart point. Fold darts and blend neckline.
- Trace basic back and complete pattern for test fit.

Figure 1

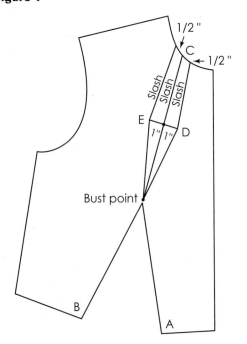

Figure 2

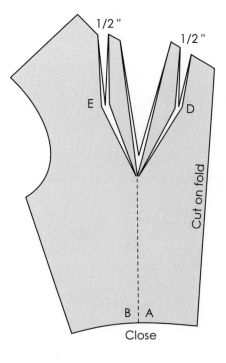

Parallel Darts

Parallel darts can be created by using the dart points, or the bust point and dart point of a two-darted pattern. Space between the parallel darts can be increased by moving the dart point of the side dart farther from bust point.

Parallel French Darts

Design Analysis: Design 1

Design 1 features curved and parallel French darts that are developed by transferring the waist and side dart excess to the curved dart lines, using the dart points as the guide.

Figure 2 New Pattern Shape

- Cut slash lines to, not through, dart points.
- Close side and waist darts. Tape.
- Trace pattern on fold.
- Add seams and grainline.

Method for Finishing Darts

- Add 1/2-inch seam allowance to darts.
- Where dart seams come together, slash a line 1/16 inch wide to within 1/2-inch of dart point, following curve of dart. Slash concave curve.
- Use the basic back pattern to complete pattern for test fit.

Pattern Plot and Manipulation

Figure 1

- Trace two-dart front bodice pattern.
- Draw curved parallel slash lines from dart points to side as shown.
- Cut pattern from paper.

Figure 1

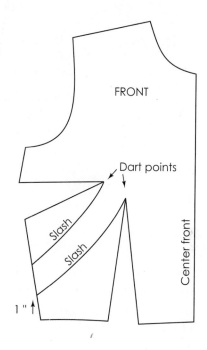

Figure 2

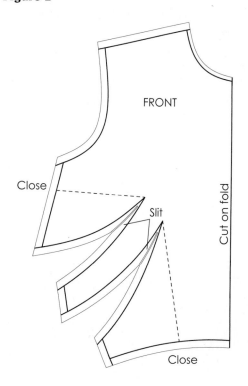

Parallel Darts at Neck

Figure 2

- Cut to dart points and close darts.
- Place on paper and trace.
- Draw new dart points 1 inch from original dart points, and from mark.
- Add seams and grain lines.
- A jog seam at dart and neckline intersection requires 1/4-inch seam allowance for facing.

Figure 2

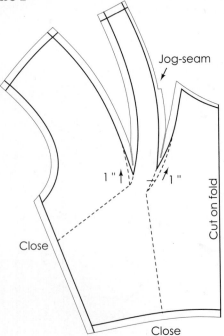

Design Analysis: Design 2

Parallel curved dart legs end at corner of neck and shoulder. The neckline depth is placed 3 inches below the basic neck, where it curves and intersects the dart legs.

Pattern Plot and Manipulation

Figure 1a, b

- Trace two-dart front bodice.
- Draw curved slash line from dart point of waist dart to corner of neck. Crossmark at bust.
- Draw a parallel slash line from dart point of side dart to shoulderline.
- Draw curved neckline and cut neckline from paper.

Figure 1a

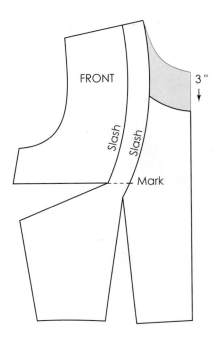

Figure 1b
Facing: Trace on folded paper.

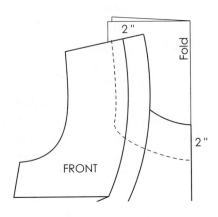

Parallel Darts—Cape Effect

Design Analysis: Design 3

Stylized darts extend beyond the shoulder tip, creating a cape effect. The neckline parallels the curved lines. Develop the back pattern to complete the design.

Figure 2 New Pattern Shape
- Cut slash lines to dart points and bust point.
- Close darts and tape.
- Place on paper and trace.
- Draw dart legs and mark punch holes.
- Add seams and grainline.

Figure 2

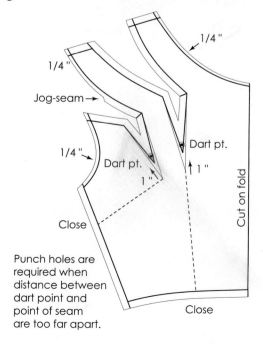

Pattern Plot and Manipulation

Figure 1a, b
- Trace two-dart bodice pattern.
- Extend shoulder $1^1/_4''$.
- Draw vertical slash lines up from dart points, parallel with the center front. Mark bust point.
- Draw a curved line from extended shoulder until it intersects with vertical line from the side dart.
- Draw a parallel curve line to next vertical line.
- Draw a parallel curve line for the neckline.
- Cut from paper and trim neckline.

Figure 1a

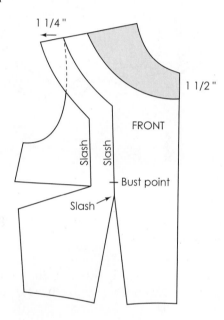

Facing: Trace on folded paper.

Figure 1b

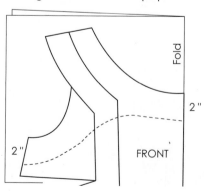

Parallel Dart Design Variations

The parallel dart designs are practice problems. The generated patterns are correct if they result in exact replicas of the designs.

Asymmetric Darts

Asymmetric darts cross center front of the garment. Pattern shapes will change radically from that of the working pattern. Asymmetric darts require special pattern handling and identification, as do all designs that differ from side to side. Compare pattern shapes with each design. Cut basic back to complete the design for test fit.

- A full pattern is required.
- Right-side-up instructions are necessary.
- The existing dart of the working pattern may interfere with the placement of a stylized dart. If so, the dart should be transferred temporarily to another location (such as mid-armhole) before the pattern is plotted. Seam allowance is illustrated for each pattern because of the dart's unique shape and location. (1/4 inch at neck, 1/2 inch at shoulder, armhole, and waist, and 1/2 to 3/4 inch at side seams).

Asymmetric Radiating Darts

Design Analysis: Design 1

Both darts end at the waist on the same side, forming tuck-darts. Scoop neckline completes the design. Transfer waist darts to mid-armhole location where they will not interfere with plotting of the stylized darts. Beginners may want to use a basic neckline. (Bow not illustrated.)

Pattern Plot and Manipulation

Figure 1

- Trace pattern on fold, transferring waist dart to mid-armhole dart location. Draw neckline.
- Cut from paper. Unfold.
- Draw slash lines from bust points to side waist.
- Crossmark 3 inches up from the corners of each slash line to indicate the length of the tuck-dart.

Figure 1

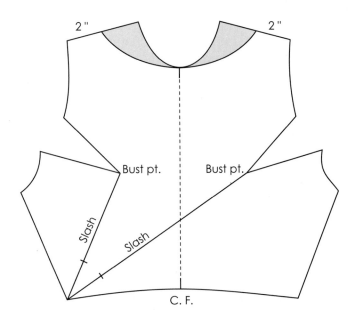

Figure 2 New Pattern Shape

- Cut slash lines to, not through, bust point.
- Close dart legs. Tape and trace.
- Label right-side-up. Draw grainline and add seams.

Tuck-darts:

- Draw seams across open dart 1/2 inch below each crossmark.
- Cut from paper. (Broken lines show the discarded part of dart legs.)

Figure 2

Figure 3

- To complete pattern, trace back, marking 2 inches in from shoulder tip, ending at center back.
- Remaining dart excess is trimmed at shoulder.
- Complete pattern for test fit.

Figure 3

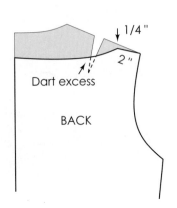

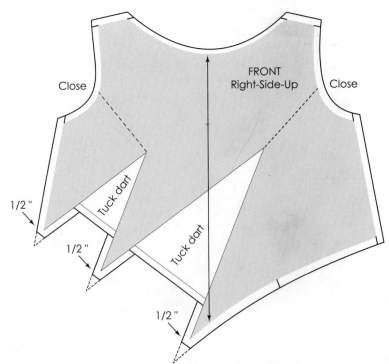

Asymmetric Curved Darts

Pattern Plot and Manipulation

Figure 1

- Trace front pattern on fold, transferring waist dart to mid-armhole location.
- Cut from paper. Unfold.
- Draw a curved slash line from bust point to 1 inch above waist.
- Draw a parallel line from bust point to armhole.

Figure 1

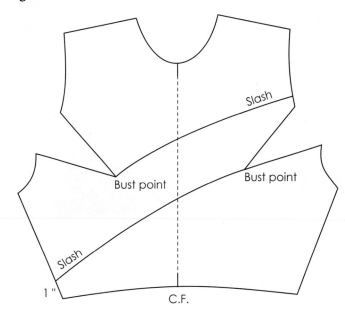

Design Analysis: Design 2

Design 2 features stylized curved darts starting at bust points and crossing over center front. One dart ends at the armhole and the other at side waist. The waist dart interferes with the styleline location and should be transferred to mid-armhole location before plotting the pattern.

Figure 2

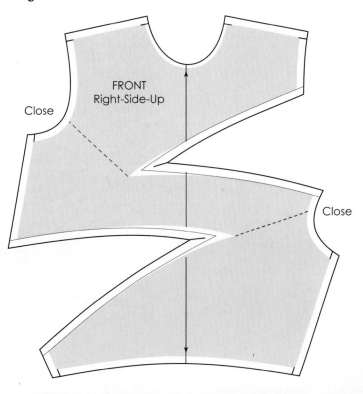

Figure 2 New Pattern Shape

- Cut slash lines to, not through, bust points.
- Close dart legs. Tape and trace pattern.
- Center dart points 1 inch from bust point. Draw dart legs.
- Label right-side-up. Add seams and grainline.
- Complete pattern for test fit.

Asymmetric Dart Variations

Designs are practice problems. Designs 2 and 4 are given for the advanced student. The generated patterns are correct if they result in exact representations of the designs.

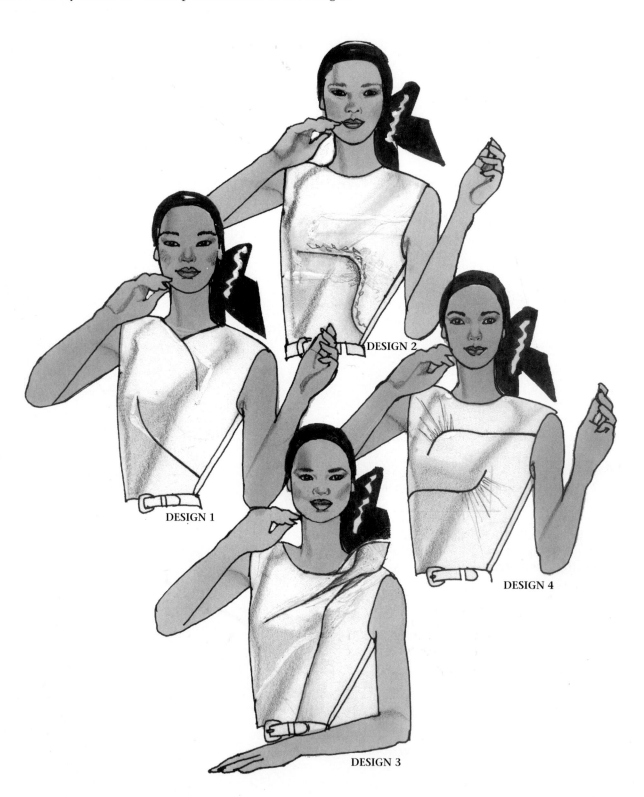

DESIGN 2

DESIGN 1

DESIGN 4

DESIGN 3

Intersecting Darts

Intersecting darts resemble asymmetric darts and dart equivalents. The darts cross center front and intersect with each other. To complete the design, use basic back patern. See Chapter 16 for guidance in developing facings.

Intersecting Dart to Waist

Design Analysis: Design 1

Darts are treated as pleats in the "V" section. The neckline is cut away.

Figure 2

- Cut slash lines to, not through, bust points.
- Close dart legs. Tape.
- *Pleats:* Form dart using fold, or tissue method, pages 14 and 15.
- Add seams, and notches for pleats.
- Trim to seam allowance from pointed section of dart leg (broken lines).
- Draw grain and label right-side-up.
- Cut from paper.

Figure 3

- To complete the design, trace back, marking 1 inch from shoulder at neck. Blend to center back neck.
- Complete the pattern for test fit.

Figure 3

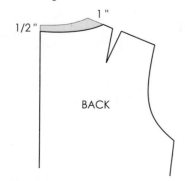

Pattern Plot and Development
Figure 1

- Trace pattern on fold, transferring waist dart to mid-armhole.
- Draw neckline 1 inch out from neck at shoulder. Blend to center front neck.
- Cut from paper. Unfold.
- Draw slash lines as they appear on the design.

Figure 1

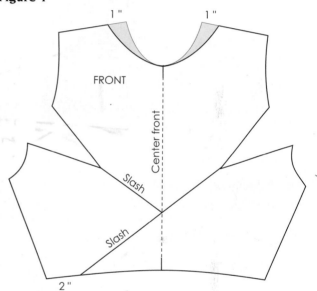

Figure 2

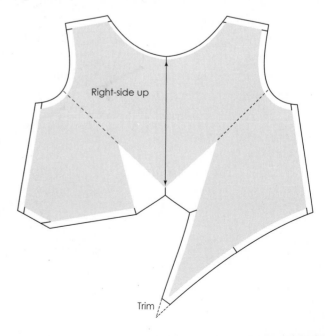

Intersecting Dart with Gathers

Pattern Plot and Manipulation

Figure 1

- Trace pattern on fold, transferring waist darts to mid-armhole.
- Cut and unfold.
- Draw slash lines for dart passing 3 inches below bust and for gathers.
- Mark notches ¹/₂ inch out from first and last slash line for gather control.

Figure 1

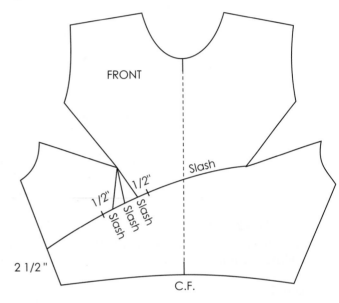

Design Analysis: Design 2

Design 2 features one stylized dart crossing the center front to the opposite side, ending above the side waist. Gathers (dart equivalents) form under the bust.

Figure 2

- Cut slash lines to, not through, dart points.
- Close darts. Tape.
- Place on paper and spread section equally for gathers and trace.
- Center dart point 1/2 inch from bust point.
- Add seams, blend gathered area.
- Draw grainline, mark notches, label right-side-up.
- Cut from paper.
- Trace basic back and complete pattern for test fit.

Figure 2

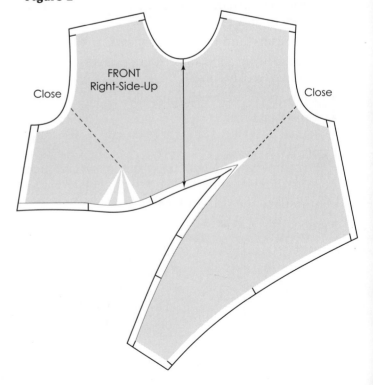

Intersecting Dart Design Variations

The intersecting dart designs are practice problems. The generated patterns are correct if they result in exact representations of the designs.

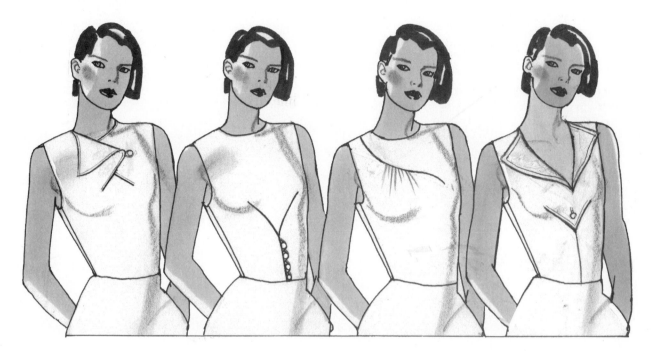

6

Stylelines

Introduction

Stylelines fall into two classifications: those that cross over the bust, and those that do not. Stylelines discussed in this chapter are those crossing over the bust, replacing dart legs with style seams extending from one side of the pattern to the other. Stylelines that absorb dart excess within stichlines control the fit of the garment and are called *dart equivalents*, as discussed in the corollary for Principle #1, Dart Manipulation. The original size and fit of the garment remain the same even though the shapes of the pattern pieces have been changed through manipulation.

Stylelines *not* crossing bust point are not dart equivalents. The panel design included in the chapter represents this type and clarifies the difference between the two styleline types (see page 127). For facing instructions see Chapter 16. Other design variations are illustrated throughout the text.

The Classic Princess Styleline

The classic princess should be developed and perfected as a seamless working pattern. It is a popular base for other design variations. Seams are added as a guide for all stylelines:

- Neckline 1/4 inch
- Armhole 1/2 inch (with sleeve), 1/4 inch (sleeveless)
- Side seam 1/2 to 3/4 inch (varies)
- All other seams 1/2 inch, unless otherwise stated.

Pattern Plot and Manipulation

Figure 1 *Front bodice*:

- Trace front of two-dart pattern.
- Draw styleline from mid-shoulder (in line with back shoulder dart) to bust point and from bust point to dart leg at waist.
- Crossmark for ease control notches, $1\frac{1}{2}$ to 2 inches above and below bust point (2 inches for bust cup sizes C and up).
- Draw slash line from bust point to dart point of side dart.

Figure 1

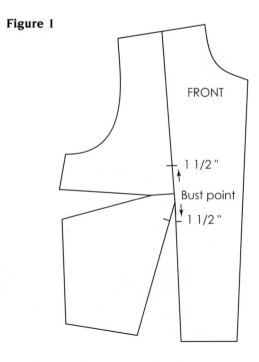

FRONT

1 1/2"

Bust point

1 1/2"

Design Analysis

The classic princess is distinguished by a styleline that starts at the front and back waist darts, and continuing over bust points and shoulder blades and ending at mid-shoulder dart of the back (position of dart point can vary to improve styleline). Stylelines replace darts. The design can be based on the one- or two-dart pattern. (The two-dart pattern is illustrated.) The puff sleeve is illustrated in Chapter 14.

Figure 2 S*eparate pattern*:
- Crossmark 3/4 inch from bust point (new pivot point). Label X.
- Cut and separate pattern along styleline.

Figure 2

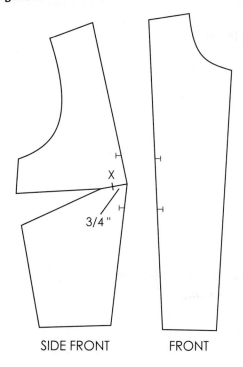

SIDE FRONT FRONT

3/4 " X

Side Bust Ease

Figure 3
- Cut slash line from bust point and dart point to, not through, point X.
- Close side dart legs. Tape. (This provides ease for side of the bust.)

Figure 3

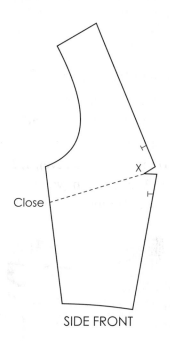

Close X

SIDE FRONT

Figure 4 S*haping styleline*:
- Retrace side front panel.
- Shape bust curve as shown. (Broken lines represent original shape of panel.)

Figure 4

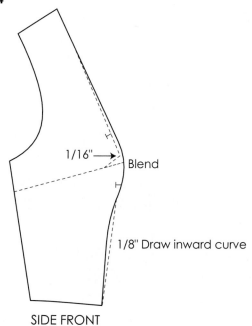

1/16"→ Blend

1/8" Draw inward curve

SIDE FRONT

Figure 5 A*dding more ease*:
- When developing designs from a one-dart pattern or when more ease is needed, slash from bust point to side seam and spread 1/4 inch or more. Retrace, blend, and shape. See Figure 4.

Figure 5

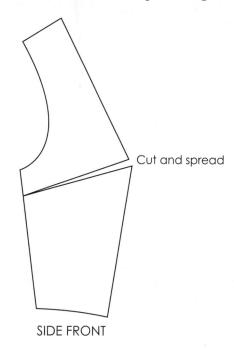

Cut and spread

SIDE FRONT

Figure 6 *Optional front panel shaping*:

- To shape front panel, place side panel pattern on top of front panel, matching waist and bust points.
- Trace shape of curve to front panel from waist to bust. Blend. (Broken line represents original shape of front panel and pattern underneath.)
- Adjust ease control notches on side front panel when trueing patterns.

Figure 6

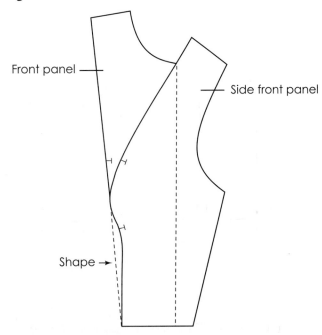

Figure 7 *Back bodice*:

- Trace back pattern.
- Place skirt curve on shoulder dart leg and waist dart point. Draw curve.
- Shift shoulder dart point to styleline and redraw dart leg. (Broken line indicates original dart.)
- Crossmark dart points on styleline.

Figure 7

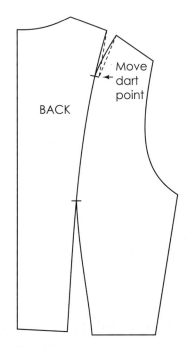

Figure 8

Figure 8

- Cut and separate pattern pieces.
- Front and back classic princess patterns are complete as seamless for use as a working pattern.

Figure 9 *Completed pattern*:

* Complete the pattern for a test fit as shown.

Note: Grainlines for side panels are squared from waistline.

Figure 9

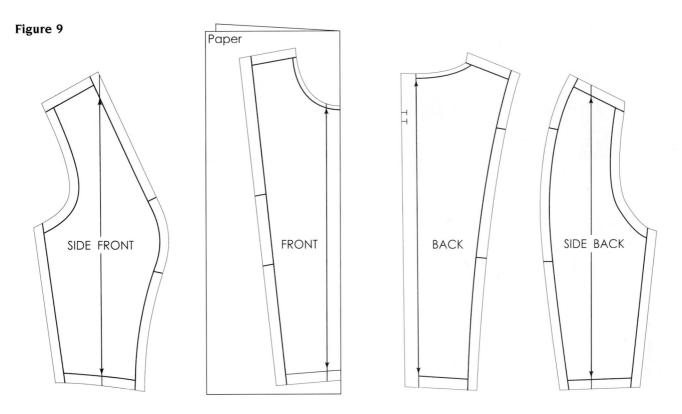

Classic Princess Styleline Variations

The following designs are based on the classic princess. Generate patterns for these designs or create other variations for practice. Use the classic princess if you are an advanced student, or develop the design from the basic pattern. Remember, draw stylelines on the pattern exactly as they appear on the design. The finished pattern shapes should result in perfect representations of each design. If they do not, locate the problem and try again.

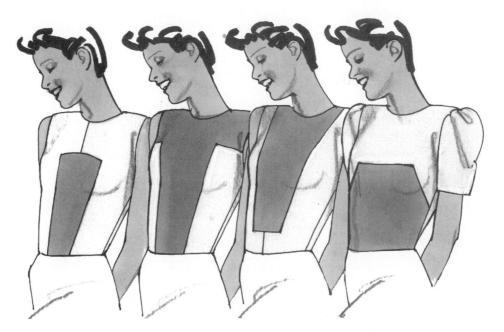

Armhole Princess Styleline

Design Analysis

The armhole princess design is a variation of the classic princess and features a styleline that curves from the bust point in front and the shoulder blades in back to about mid-armhole. The design is developed from a two-dart pattern with side dart transferred to mid-armhole as a curved dart (styleline). Add seams, grainline, and notches for test fit. This pattern may be left seamless for use as a working pattern.

Pattern Plot and Manipulation

Figure 1 *Front*:

- Trace and cut front pattern.
- Draw line from waist and side dart points to bust point. Crossmark 3/4 inch from bust point. Label X.
- Draw a straight guideline from bust point to mid-armhole. (Position can vary along armhole.)
- Mark 3/8 inch up at midpoint of guideline.
- Draw curved stylelines from mid-armhole to bust point. Extend dart legs from waist to bust point as shown.
- Crossmark $1\frac{1}{2}$ inches above and below bust point (2 inches for bust cup C and larger) for ease control notches.

Figure 1

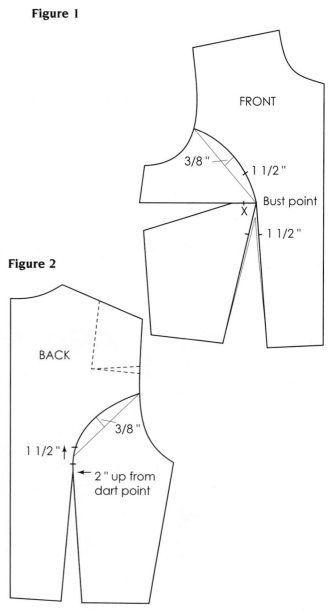

Figure 2

Figure 2 *Back*:

- Trace and cut back pattern.

 Note: Transfer the shoulder dart excess into mid-armhole where it will be absorbed into the styleline.

- *Draw a line 2 inches up from dart point of waist dart and crossmark $1\frac{1}{2}''$ up for notch.*

- *Repeat styleline instructions, placing guideline from between crossmarks to mid-armhole.*

Figure 3 *Front*:
- Cut and separate pattern along styleline.

Figure 3

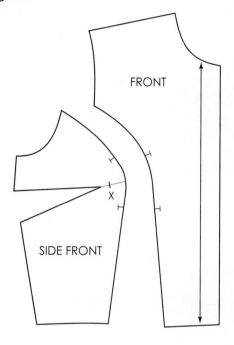

Figure 4 *Side panel*:
- Complete side panel using princess instruction for shaping styleline (see page 121, Figure 4).

Figure 4

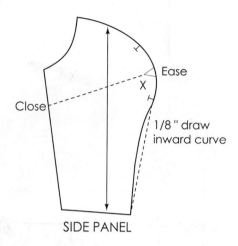

Figure 5 *Back*:
- Cut and separate pattern along styleline.
- To remove dart excess from mid-armhole, draw the dart's length and width along styleline of back panel (shaded area), and trim excess from the pattern.

Figure 5

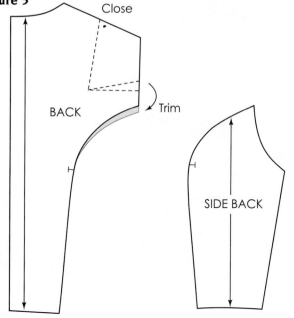

Figure 6 *Trueing and blending*:
- True pattern panels, starting from styleline at waist and ending at armhole. If panels do not true at armhole, add paper to the shortened panel at armhole. Tape both sides securely.
- Blend armhole, adding to shorter side and trimming the longer side equally as shown.

Figure 6

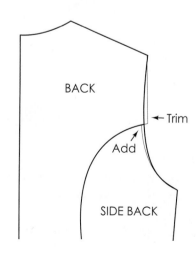

Armhole Princess Styleline Variations

The practice designs are based on the armhole princess. Design or create other variations. The finished pattern shapes should result in perfect representations of each design. If they do not, locate the problem and try again. When plotting the pattern, remember that lines are drawn on the working pattern exactly as they appear on the design. Develop the designs using the single dart pattern. (Advanced students may use the armhole princess pattern.)

The Panel Styleline

The panel styleline is *not* a dart equivalent, as it does not pass through the bust point. The existing darts control fit of the garment.

Design Analysis

The panel styleline does not cross over the bust or shoulder blades. It extends from the armhole curve to waist (front and back), forming a panel separating front and back garment. The panel can be designed either with or without a side seam. It has a short, visible dart in front and waist and shoulder darts in back.

Note: The back waist dart can be absorbed in the styleline if the panel styleline is placed close to it. In that case, the back panel styleline replaces the dart.

Pattern Plot and Manipulation

Figures 1 and 2

- Trace front and back two-dart patterns and all markings.

 Side panels:

- Square up from waist to within 1/2 inch of the curve of front and back of armholes as shown.
- Blend a slightly curved line to armhole.
- Draw slash lines from dart points to bust point.
- Cut patterns from paper.

Figure 1

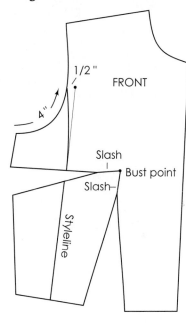

Figure 2

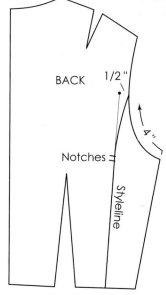

Figure 3
- Separate back pattern pieces along styleline.
- Draw 1-inch extension at center back.

Figure 3

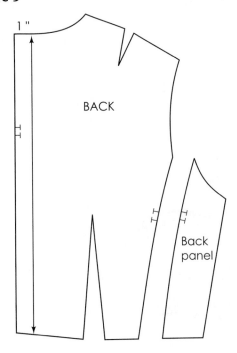

Figure 4
- Separate front pattern along styleline.
- Close dart legs on front side panel and notch at the location.
- Close dart legs on front side panel. Complete dart leg as shown.

Figure 4

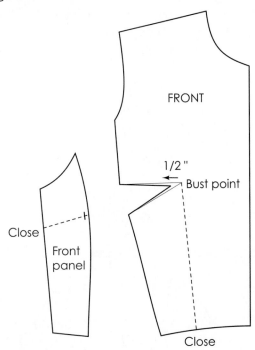

Figure 5
- To eliminate side seam, place front and back panels together and tape.
- Extend grainline through center of panels as shown.
- Mark notches on panel at waist and armhole.
- Complete pattern for test fit.

Figure 5

Panel Styleline Variations

The practice designs are based on the panel pattern. Generate patterns for the designs or create other variations using the basic pattern. Advanced patternmakers may use the panel pattern to develop the design. When plotting, draw stylelines exactly as they appear on the design. The finished pattern shapes should result in perfect representations of each design. If they do not, locate the problem and try again.

7

Added Fullness (Principle #2)

Added Fullness: Principle #2

Principle. To increase fabric in a garment to an amount greater than that provided by the dart excess of the working pattern, the length or width within the pattern's outline must be increased.

Corollary. Adding to the outside of the pattern's outline increases the amount of fabric in a garment and can change the silhouette.

Three Types of Added Fullness

To add fullness, the working pattern is increased in one of three ways:

Equal fullness:

Opposite sides of a pattern are spread equally, increasing fullness to top and bottom.

One-sided fullness:

One side of a pattern is spread to increase fullness, forming an arc shape at the top and bottom.

Unequal fullness:

One side of the pattern is spread *more* than the other, forming an arc shape at the top and bottom.

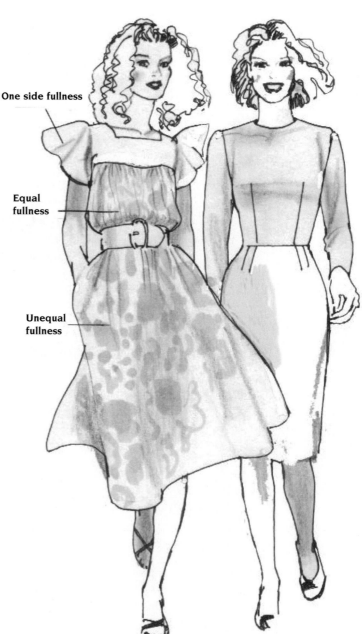

One side fullness

Equal fullness

Unequal fullness

Compare the silhouette differences between the design and the basic garment when adding fullness.

Identifying Added Fullness

Fullness from the basic dart always ends at bust level. Therefore, designs can be identified as having added fullness if fullness passes through the length, or width of the garment (Figure 1) when fullness is directed away form the bust (Figure 2), and when the garment extends beyond the outline of the figure (Figure 3). Fullness may appear in the form of gathers, pleats, drape, cowls, or flares. Fullness can be on the horizontal or vertical, or at an angle, and can be developed as equal, unequal, or one-sided fullness. The dart may become part of added fullness when needed.

Added fullness may be combined with Dart Manipulation (Principle #1) and Contouring (Principle #3). (Examples of this will be illustrated throughout the text.)

The patternmaker determines the type of fullness required by the way the sketch is rendered. When the patternmaker is unsure of the designer's intent, it is best to ask before developing the pattern.

| Figure 1 | Figure 2 | Figure 3 |

Method for Plotting the Pattern for Added Fullness

Added fullness is plotted as a series of straight slash lines drawn across the pattern in the direction the fullness appears on the design (horizontally, vertically, or on an angle). When preparing the pattern, the slash lines must end at the bust point, dart point, or the pattern's outline. The beginning and end of each slash line depend on where the fullness begins and ends on the design.

Formula for Adding Fullness

To determine the amount of added fullness desired, give consideration to the fabric type. Lightweight and loosely woven fabrics (cottons and chiffons, for example) may require more fullness than bulky, closely woven fabrics. Using a 26-inch waist as an example, added fullness may equal:

- One and one-half times the measurement (26˝ + 13˝ = 39˝)
- Two times the measurement (26″ + 26″ = 52″)
- Two and one-half times the measurement (26″ + 26″ + 13″ = 65″).

To help train the eye in visualizing different amounts of fullness, it is suggested that examples of each be stitched, using 10 inches as the measure to be increased. Follow the formula above for each example (finished length of each sample should be 10 inches). Save the examples for use when determining fullness.

Fullness Along Princess Line

DESIGN 2 DESIGN 1

Design Analysis: Design 1

The princess styleline is gathered on each side of styleline from waist to just under bust and at the front side seam, indicating parallel fullness. A guideline controls the pattern when cut through and spread for fullness. Design 2 is for practice.

Pattern Plot and Manipulation

Figure 1

- Trace front and side front princess panels. Include grainline. Back is not illustrated. (See page 120.)
- Draw slash lines in direction the gathers indicate. Number each section and cut from paper.

Figure 1

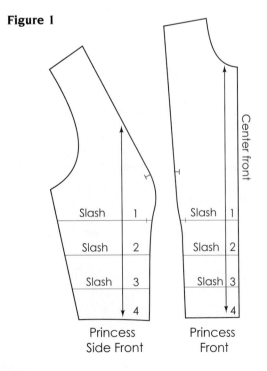

Princess Princess
Side Front Front

Figures 2 and 3

- Cut through slash lines separating patterns.
- Draw grain guidelines on paper.
- Place cut pattern parts on paper with center front on fold. Match grainline of pattern with guideline. Spread equally using from 1/2 to 1 inch for fullness (shaded area). Secure pattern parts.
- Trace outline of pattern and blend styleline (bold line). Draw grainline and complete for test fit.

Figure 2

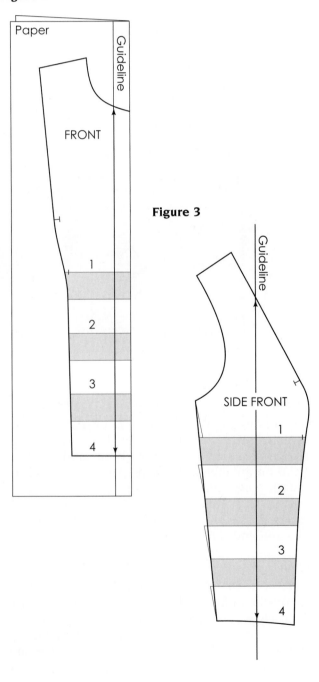

Figure 3

Fullness at a Semi-Yoke Above Bust

DESIGN 1 DESIGN 2

Pattern Plot and Manipulation

Figure 1

- Trace front bodice.
- Square from center front to mid-armhole.
- Square a slash line to dart point. Label X.
- Draw slash lines in the direction fullness falls, and cut pattern from paper.

Figure 1

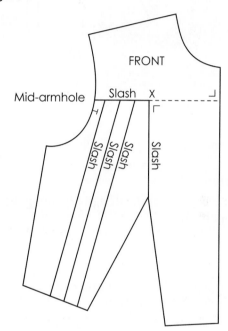

Design Analysis

A short styleline above the bust of Design 1 controls gathers that end a mid-armhole. One-sided fullness is indicated. Design 2 is given for practice.

Figure 2

- Cut from mid-armhole to point X and from bust point to point X, separating pattern.
- Close waist dart, overlapping dart point 1 inch (less excess over bust). Fullness created by the spread areas next to bust compensates for any loss of measurement due to overlap.
- Cut remaining slash lines to, not through, waist.
- Place on paper and spread each slash 3/4 inch.
- Trace pattern's outline and blend.
- Draw grainline and complete for test fit using basic back pattern.

Figure 2

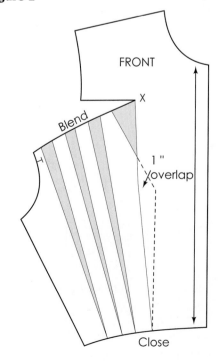

Added Fullness to a Dart Leg

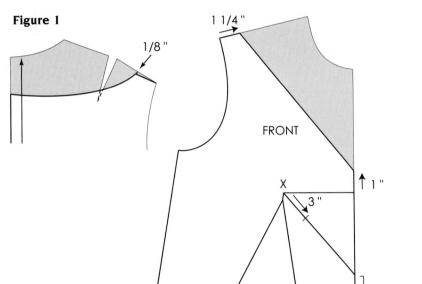

Design Analysis

Analyze the elements of the design and apply to the plot of the patterns.

Pattern Plot and Manipulation

Figure 1
- Plot the design as indicated.

Figure 1

Figure 2
- Slash dart legs to bust point and close waist dart. Continue to plot the pattern.
- Dart leg is shaped to contour the bust.
- Trim shaded areas and draw slash lines.

Figure 2

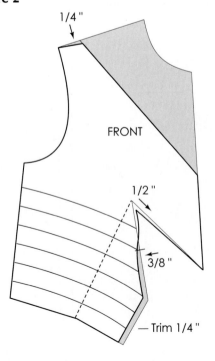

Figure 3
- Cut slash lines to, not through, side seam.
- Spread a 2:1 ratio (2 times gathered area).
- Trace pattern and blend spread area.

Figure 3

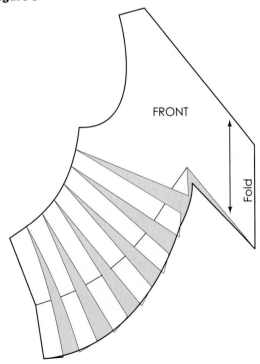

Gathers on a Style Dart

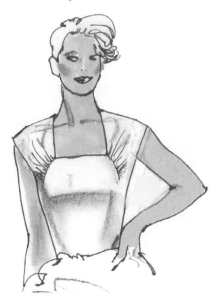

Design Analysis

The bust point is moved 1 inch from the original location. This is acceptable because dart points are regularly marked away from bust point. The gathers are directed away from the bust, indicating one-sided added fullness.

Figure 2
- Trim shaded area of the neckline.
- Cut style dart to bust point and close waist dart. (One dart leg will not meet the waistline.) Blend waist at the finish of the pattern.
- Cut slash lines to, not through, shoulder.
- Spread slash lines to a ratio of 2:1.

Figure 2

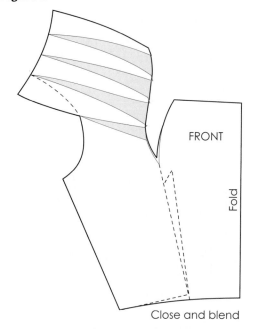

Close and blend

Pattern Plot and Manipulation

Figure 1
- Trace back and front patterns and redraw dart legs 1 inch from bust point.
- Square a line from center front $3\frac{1}{2}$ inches up from bust level that equals bust span.
- From this point draw a curved dart leg to dart point, and to the shoulder $1\frac{1}{4}$ inch from neck.
- Extend shoulder $1\frac{1}{4}$ inches and draw a curve line to the mid-armhole.
- Draw slash lines.

Figure 1

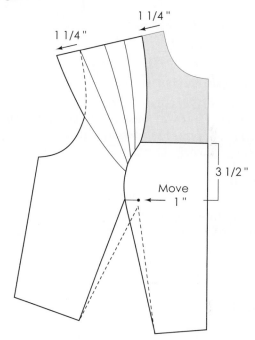

Figure 3
- Trace the back pattern. Draw and trim the neckline. Extend shoulder $1\frac{1}{4}$ inches.
- Complete the patterns for a test fit.

Figure 3

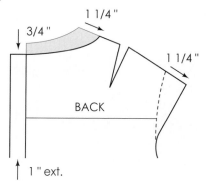

Fullness Around Neck Band

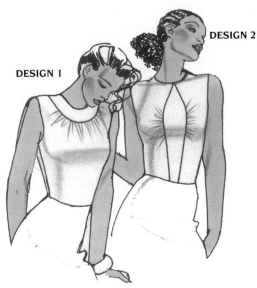

DESIGN 1

DESIGN 2

Design Analysis: Design 1

Gathers follow the edge of the inset band. Dart excess (gathers) ends at bust level. The remaining gathers indicate one-side added fullness.

Figure 2a, b

- Cut inset band from pattern.
- Cut slash lines to, not through, pattern's outline or bust point. Close dart legs.
- Spread added fullness as desired.
- Trace and blend the spread area.

Figure 2a, b

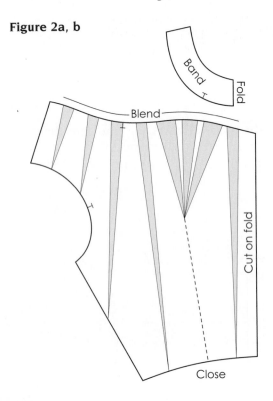

Pattern plot and manipulation

Figure 1

- Trace front and back patterns.
- Draw inset band $1\frac{1}{2}$ inches wide.
 Front Pattern:
- Draw 3 slash lines from bust to band 2 inches up from center front. Notch.
- Draw other slash lines as indicated.
- Cut pattern from paper.

Figure 1

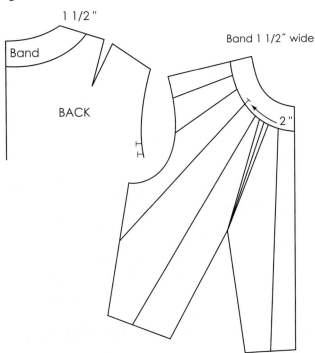

Figure 3a, b

Back:

- Extend 1 inch at center back.
- Separate patterns, draw grainline and notches, and complete the patterns for a test fit.

Figure 3a, b

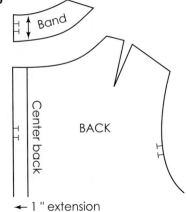

Added Fullness Design Variations

The practice designs are based on added fullness. Develop patterns for each design, or design other variations for practice. Which design requires an add-on for fullness? The finished garment should look like the design. If it does not, locate the problem and try again.

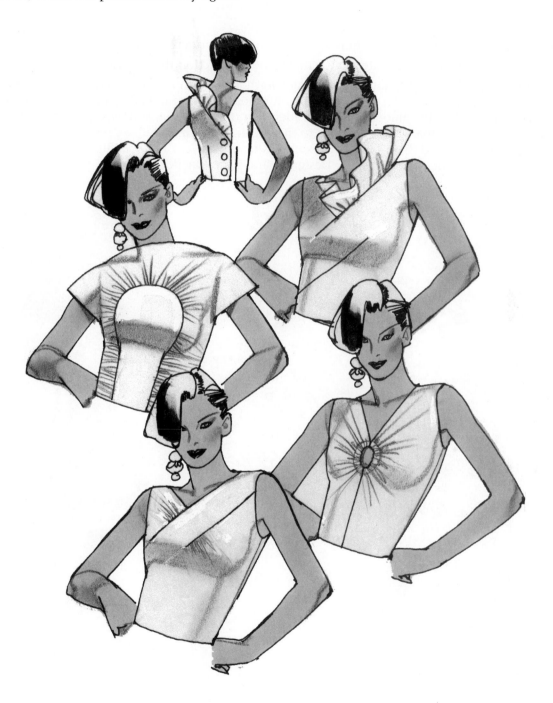

The Blouson Foundation

A blouson is a billowy-topped garment with an overhang anywhere from below the bust to the ankle. The blousing is controlled (held in place) by one of the following methods:

- Lining cut shorter than the finished length of the outer part.

- Elastic or drawstring inserted in the hemline of the top.

- Casing that accommodates elastic or drawstring (within the garment's frame).

- A yoke, band, or belt (either separate or attached below the section that blouses).

The blouson foundation is developed by adding length and width to the pattern within its frame and at its outline. This is an application of Principle #2, combined with manipulation of the existing dart excess (Principle #1). To determine the amount of length added for the overhang, add twice the amount desired. For example, for a $1\frac{1}{2}$-inch overhang, add 3 inches to the existing length.

Blouson Designs 1, 2, and 3 are but a few examples of this style. Design 1 illustrates modified fullness. Included is a method for increasing fullness. Designs 2 and 3 are practice designs.

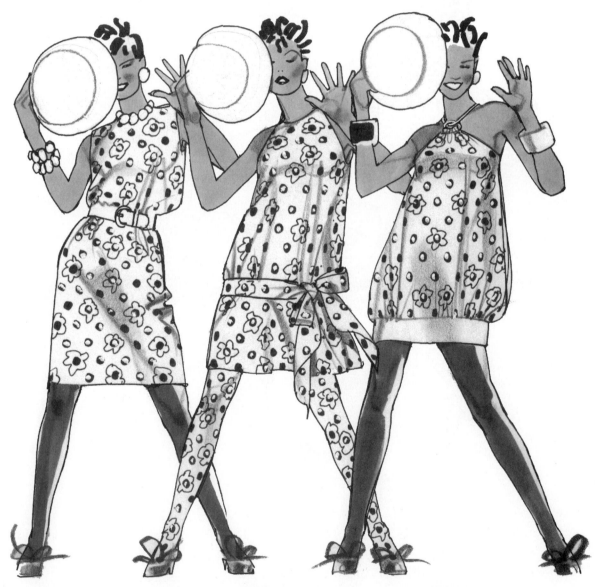

DESIGN 1 DESIGN 2 DESIGN 3

Modified Blouson

Pattern Plot and Development

Figures 1 and 2

- Trace front two-dart pattern and back.
- Measure down $1\frac{1}{2}$ inches or more from front and back waistline. Draw a parallel line across hem for overhang, creating blouson effect.
- Square up from hem to armhole.

- Measure out $1\frac{1}{2}$ inches or more at front and back side seams. Draw line from hem to armhole. To true side dart of front, fold dart and draw line from hem to armhole (see page 17).
- Complete pattern for test fit.

Figure 1 **Figure 2**

BACK BLOUSON

1 " extension

1 1/2 " for 3/4 " blouson

FRONT BLOUSON

Blouson with Increased Fullness

Pattern Plot and Manipulation

Figures 1 and 2

- Trace front and back patterns. Include the back horizontal balance line (HBL).
- Draw slash lines from front and back waist to approximately 3 inches up from armhole curve. (Figure 1).
- Draw slash line from dart points of waist and shoulder darts to a joining point at the back HBL (Figure 2).

Figures 3 and 4

- Cut slash lines to, not through, armhole (front) and pivotal point (back).
- Close back shoulder dart.
- Place patterns on paper and spread slash sections 1½ inches (varies). Secure pattern and trace.
- Add 1 inch at side seam of back pattern to balance the fullness between back and front. Blend armholes.
- Add desired length. (Example: 2 inches below waist for 1-inch overlay.)
- Complete pattern for test fit.

Figure 1

Figure 3

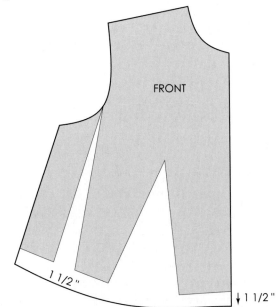

Figure 2

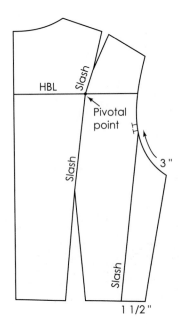

Figure 4

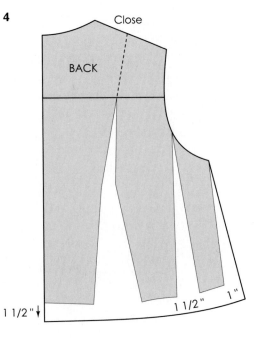

8

Yokes, Flanges, Pin Tucks, and Pleat Tucks

Yokes for Bodice

A yoke is the upper part of a garment that fits the shoulder or hip area. It is attached to the lower section by a seam that may appear as a horizontal or stylized line. A yoke styleline can be placed anywhere above the bust level or on the back garment above, at, or below the shoulder blades. The yoke controls gathers, pleats, or a plain area to which it is attached. Yokes, as a design feature, are found on all types of garments. Refer to the yoke instruction when designing shirts.

Basic Front Yoke—Slash and Spread

Pattern Plot and Manipulation

Figure 1

- Trace front two-dart pattern.
- Square a line $2\frac{1}{2}$ inches down from center front neck to armhole (varies).
- Draw slash lines from bust point to yoke line parallel with center front, and from side dart to bust point. Mark notches as shown.
- Extend center front 1 inch for buttons and buttonholes (See Chapter 16).
- Mark notches $1\frac{1}{2}$ inches out from each side of slash line at yoke and dart legs at waist for gathers control.

Figure 1

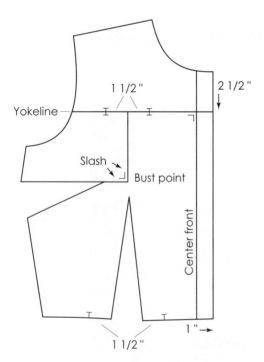

Design Analysis: Designs 1 and 2

The yoke series include a front yoke without a collar (Design 1) or with a collar (Design 2). The back bodice illustrates a yoke attached to an inverted box pleat, and with gathers (page 146).

DESIGN 1 **DESIGN 2**

Figure 2

- Cut and separate pattern sections.
- Cut slash lines to, not through, bust point.
- Close side dart and tape. Retrace patterns.
- Blend areas for gathers (broken line sections).
- Draw grainlines. Complete pattern for test fit.

Figure 2

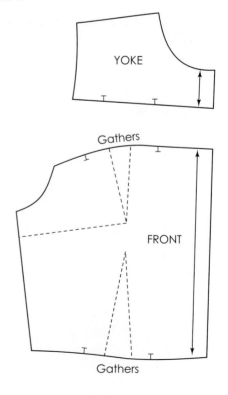

Basic Back Yoke—Pivotal and Transfer

Back yokes are developed without a shoulder dart. Excess from the back dart is transferred to mid-armhole where it may remain (will gap slightly) or may be eliminated at the yokeline of the armhole. Use this yoke to develop patterns for Designs 2, 3, and 4.

Pattern Plot and Manipulation

Figure 1

- Square a line from the center back to mid-armhole, or at a point that is one-fourth of the center back length. If the HBL is on the working pattern, use this line.
- Draw a line from dart point to yokeline for use as the pivotal point. Label A, B, C, D.

Figure 1

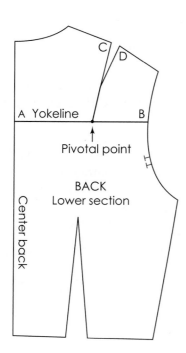

Figure 2

- Place the pattern on paper with a pushpin through pivotal point.
- Mark yokeline on the paper at points A and B.
- Trace the pattern from A to dart leg C and mark dart leg (shaded area).

Figure 2

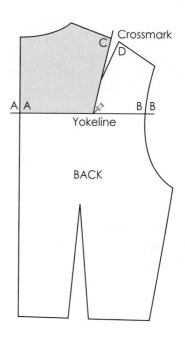

Figure 3

- Pivot pattern so that dart leg D touches crossmark on paper.
- Trace remaining pattern from dart leg D to B on pattern. Mark yoke line B and label armhole E. Remove pattern.

Figure 3

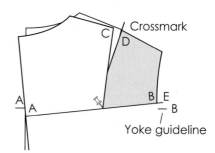

Figure 4

- Draw line connecting A to B. (The distance between E and B represents dart excess.) To remove excess, see Figure 5.

Figure 4

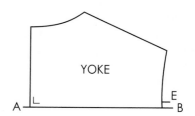

Back Yoke with Inverted Box Pleat

Figure 5

- Trace back pattern from yoke line (A–B) to waist. Mark pivotal point and remove pattern.
- Draw yoke line from A to B.
- Measure down from B to equal E – B, and trim.

Inverted pleat:

- Add 3 inches to width of the back pattern.
- Mark notches to indicate fold of the pleat at center back and at $1^1/_2$ inches. Cut on fold, or add a seam at center back.

Figure 5

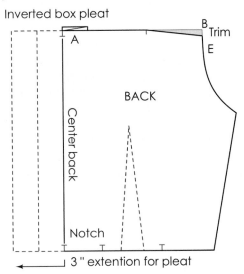

Back Yoke with Added Fullness/Gathers

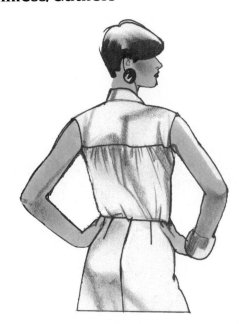

Design Analysis: Design 3

Fullness is gathered across the back yoke of Design 3. To develop yoke line, refer to instructions given on page 145.

Pattern Plot and Manipulation

Figure 1

Yoke gathers:

- Trace lower back section, extending center back 3 or more inches for gathers. The excess from the waist dart (broken line) is absorbed into gathers. For this example A to B is a straight line.
- Mark notches for gathers and for center back.

 Note: For yokes that are stylized, pointed, or curved, draw slash lines and spread lower section for gathers (not illustrated).

Figure 1

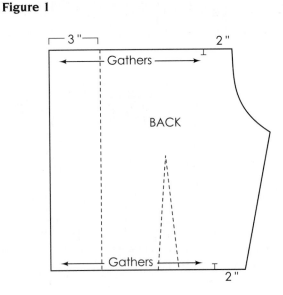

Back Yoke with Action Pleat

Pattern Plot and Manipulation

Figure 1

- Crossmark B, $2\frac{1}{2}$ inches from A (varies).
- Mark D, 3 inches from C (can vary).
- Draw line from B to D.
- Cut slash line from B to, not through, D. Spread 3 inches for pleat intake (shaded area).
- Mark gather control notches 1 inch out from each side of dart leg. (Dart is indicated by broken lines.)

Figure 1

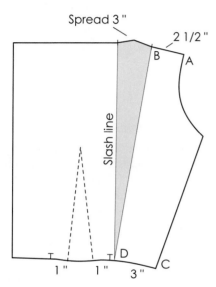

Design Analysis: Design 4

Design 4 features action pleats that are placed $2\frac{1}{2}$ inches in from armhole at yokeline. To develop yokeline, refer to instructions given on page 145.

Yoke Design Variations

The yoke design variations are practice problems. The generated patterns are correct if they result in exact representations of each design.

The Flange

A flange is an extension or part of a pattern that forms a continuation of the garment. It may be part of the same garment or a separate, set-in piece shaped as desired, and stiched within a styleline. A flange may be developed anywhere along the shoulderline or at any location of any garment. The fold of a flange placed at the shoulderline should not fall within the curve of the armhole. This could distort the fit of the armhole and the look of the garment.

Dart Flange

Pattern Plot and Manipulation

Figure 1
Flange pleat:

- Trace front bodice pattern, transferring dart to shoulder tip.
- Fold flange with inside fold toward center front.
- Mark notches at each dart leg, or half the width of the dart beyond the notch, where the fold ends (see dot placement).

Figure 1

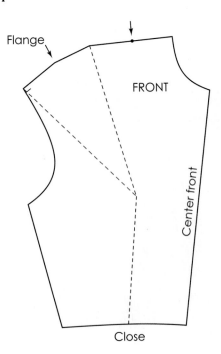

Design Analysis: Design 1

The flange is placed at shoulder tip, using the dart excess to create the effect of Design 1. The flange can be folded as a pleat (Figure 1) or stitched partway (Figure 2) as a tuck dart when controlling fullness (as indicated by the sketch).

Figure 2
Flange tuck-dart pleat:
- Trim excess within $1\frac{1}{2}$ inches of dart leg (shaded area).
- Mark dart legs and seam allowance notches.

Stitching Guide:
Stitch inside seams together. Fold dart legs. Top stitch 1 inch in from fold, 4 inches down on dart legs on right side of garment.

Figure 2

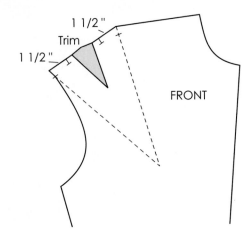

Flange to Waist

The flange is developed by adding fullness (Principle #2) without the use of the dart excess.

DESIGN 2

Design Analysis: Design 2

The front and back flanges of Design 2 are connected to each other and not to the shoulder seam. The flange extends slightly beyond shoulder tip.

Pattern Plot and Development

Figures 1 and 2

- Trace front and back patterns, transferring shoulder dart to mid-armhole.
- Mark A, 1 inch from front and back shoulder tip.
- Mark B, 3 inches in from side waist.
- Draw slash line from A to B for flange placement.
- Cut patterns from paper.

Figure 1

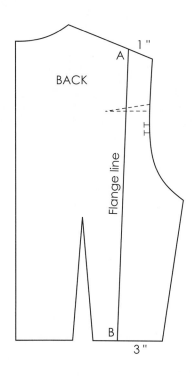

BACK

1"

A

Flange line

B

3"

Figure 2

1"

A

FRONT

Flange line

Center front

B

3"

Figures 3 and 4

- Cut slash lines from A to, not through, B.
- Place on paper and spread A, 3 inches for 1½-inch wide flange. (Shaded area.)
- Trace pattern.
- Draw a straight line across open space A.
- Mark punch and circles 3 inches down from center and 1/8 inch in from stichline for stitching guide.*
- Extend 1 inch at center front for button and buttonholes. See Chapter 16.
- Draw grainlines and complete for test fit.

Figure 3

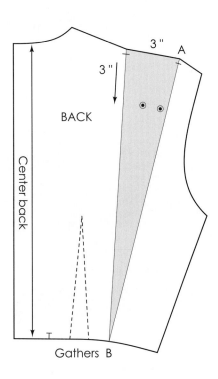

Figure 4

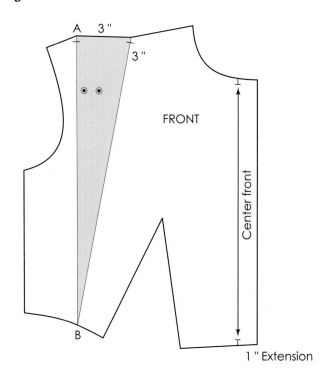

*Note: Punch holes cause damage in the fabric. Punch hole placement required for the right side of the garment should be marked with chalk dust.

Flange Inset

Design Analysis: Design 3

A flange effect is created by inserting a shaped section of fabric into the bodice.

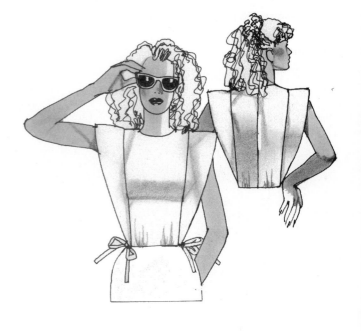

Pattern Plot and Manipulation

Figures 1 and 2

- Trace front and back patterns.
- Mark A, 1 inch from front and back dart legs at waist.
- Mark B, 1/2 inch in from front and back shoulder tips.
- Draw slash line to connect A and B.
- Measure A to B length for front and back flange. Record _____.
- Reshape armholes by blending to slash lines B.
- Mark gather control notches at front and back waist 2 inches from center lines.
- Extend center back 1 inch for closure.
- Trim shaded area of armhole.

Figure 1

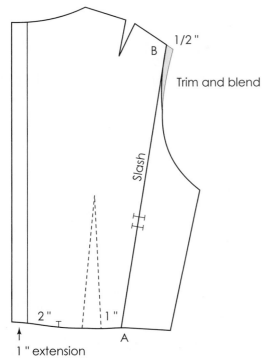

1 " extension

Figure 2

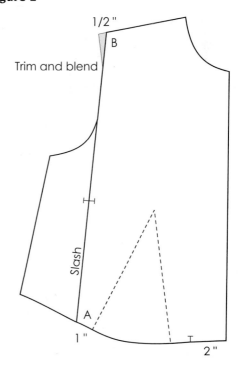

Figures 3 and 4

- Cut and separate pattern parts.
- Draw grainlines as shown.

Figure 3

Figure 4

Figure 5 *Flange*:

- Draw vertical line on paper equal to front and back flange length.
- Using A-B measurement of front bodice, cross-mark shoulder tip location (label B). Fold paper.
- Square out from fold at B equal to desired flange width (Example: 3 inches), and connect to flange points A using front and back A-B measurements as shown. Mark notches for front and back.
- Complete pattern for test fit.

Figure 5

Flange Design Variations

Flange design variations are practice problems. The generated patterns are correct if they result in exact representations of the designs. If they do not, locate the problems and try again.

Pleat Tucks and Pin Tucks

A tuck is a stitched fold on the right side of the fabric resembling a pleat. Tucks used as a design detail may be placed on any garment (top, skirt, dress, sleeves, pants, and so on). Tucks can be placed in any direction (vertical, horizontal, and diagonal). Tucks may be of any width (finished to a width of 1/16 inch to 1 inch, or more) and spaced close or far apart for varying effects. It is less expensive for a manufacturer to have tucking done by a trim house than to have it stitched in the factory. Tucks can be created by two methods: the running yard of fabric can be tucked and then cut into individual pattern pieces, or cut pattern pieces can be sent to a trim house for individual tucking. However, to test tuck placement and the "look" of the design before production, or to develop individual garments, use the general instructions that follow. For instructions on button/buttonholes and facings see Chapter 16.

Pleat Tucks

Design Analysis: Design 1
Design 1 features pleat tucks from neck to waist with stitchline of one tuck meeting fold line of preceding tuck. Extensions provide for buttons and buttonhole closure.

Pattern Plot and Manipulation
The method shown for developing tucks does not involve slashing and spreading the pattern. The pattern is plotted for tuck locations, and pattern paper, or fabric is marked for the required tucks and tuck intake.

Figure 1
Pleat-tuck guidelines

- Trace front pattern.
- Draw a line for the extension 3/4 inch from center front.
- Draw tuck guideline 3/4 inch from center front.
- Draw second guideline 1 inch from first line.

Figure 1

Figure 2

Plotting tucks at 1/2-inch width.

Industry: Tuck placement and intake is developed on a paper pattern.

- Draw a line 3 inches from paper's edge.
- Mark the width of the first tuck at 1 inch.
- Mark space 1/2 inch.
- Mark second tuck at 1 inch.
- Repeat the process for each additional tuck.

Figure 3

- Fold tucks on paper right side up.
- Place the pattern on paper, aligning tucks with the guidelines.
- Trace the pattern.

Figure 3

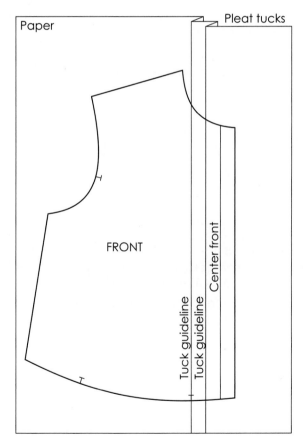

Figure 5

Individual designs: Mark tucks on the fabric rather than on paper.

- Mark tucks with pins or by slip stitching each line.
- Fold the fabric, trace the pattern, and stitch the tucks.

Figure 2

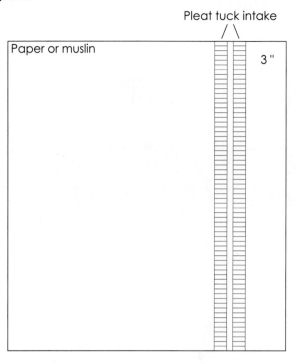

Figure 4

- Cut the pattern and unfold.
- Mark and notch each tuck and center front.

Figure 4

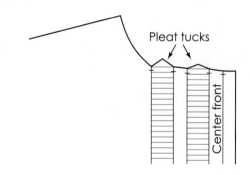

Figure 5

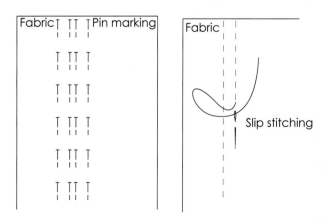

Pin Tucks

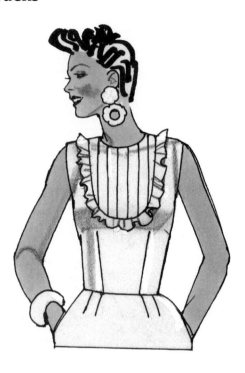

Design Analysis: Design 2

Design 2 features pin tucks in a bib inset. Pin tucks are placed with space between them.

Figure 2

- Draw four sets of parallel lines, 1/8 inch wide, for tuck intake, and spaced 1/4 inch apart. Draw first tuck line approximately 6 inches in from paper's edge. This will allow room to cut on fold (actual allowance will depend on the number of tucks and the intake of a particular design).

Figure 2

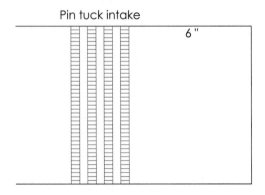

Pin tuck intake

6"

Pattern Plot and Manipulation

Figure 1

Plotting tuck placement and intake:

- Trace pattern and draw bib styleline.
- Cut from paper and separate patterns.
- Draw first line 1/16 inch in from center front (1/8″ space on fold). Draw additional parallel lines spaced 1/4 inch apart.

Figure 1

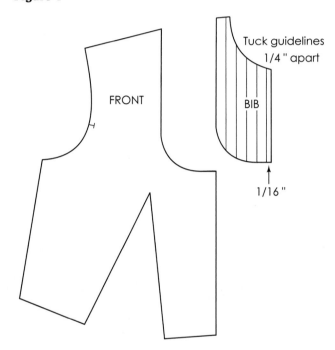

FRONT

BIB

Tuck guidelines
1/4 " apart

1/16 "

Figures 3 and 4

- Fold paper for each tuck and place bib guidelines on tuck folds and trace (Figure 3).
- Cut and unfold. Fold paper and trace for other side (not illustrated). Figure 4 shows completed bib.

Figures 3 and 4

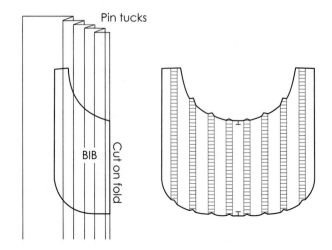

Pin tucks

BIB

Cut on fold

9

Contouring (Principle #3)

Contouring: Principle #3

Principle. To fit the contours of the upper torso closer than does the basic garment, the pattern must be reduced *within* its frame to fit the dimensions of the body above, below, and in between the bust mounds and shoulder blades.

Corollary. To fit the upper torso closer than does the basic garment, the *outline* of the pattern is trimmed to fit the slope of the shoulder and the side seam ease is eliminated.

Contour Designs

Contour designs follow the contour of the body rather than hanging loosely over the hollow areas around the bust and shoulder blades. Contour designs include the empire styleline (contouring under the bust), strapless, bra top (contouring over, under, and at times between the bust), surplice (contouring over and under the bust), and cutout armholes and necklines (contouring above the bust). To avoid fitting problems, patterns developed for contour designs must be based on Principle #3, Contouring and its corollary. Fitting problems occur if adjustments are not made to compensate for the differences between the pattern and the body's dimensions. The following information deals with the methods used to circumvent fitting problems through the use of the remarkable Contour Guide Pattern.

Figure versus Basic Garment

The contour of the figure is shown enclosed in a basic garment. (Visualize the garment as transparent.) The garment has straight lines touching only the outer limits of the figure and fits the figure loosely. Study the relationship between the contour of the figure (dotted pattern) and the garment. The hollow areas above, below, and in between the bust mounds do not come in contact with the garment. The figure's dimensions measure less in those areas than does the garment or pattern. The differences are measurable, and compensation can be made for them by using the Contour Guide Pattern.

View looking down

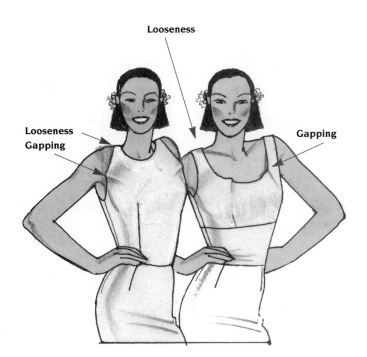

Looseness

Looseness
Gapping

Gapping

Fitting Problems

The following fitting problems will occur if the pattern is not adjusted for contour designs:

- Looseness will appear along the shoulder and neckline where a portion of the neckline or armhole is cut out. The garment loses support of all or part of the shoulderline and neck and will fall to the hollow area over the bust.

- Empire, strapless, or bra designs have little or no bust definition. (That is, the designs will not fit closely under the bust to contour but hang loosely over the hollows of the figure.)

In each case, the look is changed and a good design is ruined.

The Contour Guide Patterns

The Contour Guide Patterns are tools that assist the patternmaker to circumvent fitting problems before they are incorporated into the design. The patterns are charted with guidelines that indicate the amount of excess to be removed from stylelines or darts for a closer fit. The guidelines are labeled by design types and represent the measurement between the garment and the hollow areas of the figure (above, below, and in between the bust mounds), decreasing in both directions to the bust point and to the pattern's outline. The back bodice is charted for designs having low-cut necklines and for strapless garments. Illustrated below are the front and back Contour Guide Patterns after the guidelines have been charted. The development and use of these patterns are illustrated in the pages that follow.

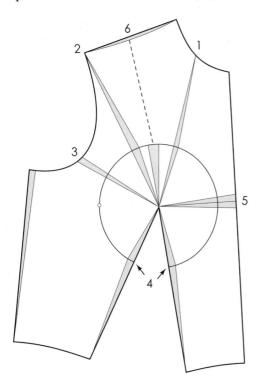

Preparing the Contour Guide Patterns

Measurement needed
- (9) Bust radius _____
(See Chapter 2 for measurement if needed.)

Figures 1 and 2
- Trace front and back patterns including all markings.
- Place compass at bust point and draw a circle using the bust radius measurement.
- The circle represents the depth of the hollow area between the figure and the basic garment.
- Punch a hole (with the awl) for pencil insertion when transferring the circle to the traced pattern.

Figure 1

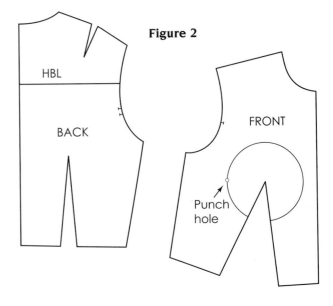

Figure 2

Measure Depth of the Hollow Areas and Chart the Patterns

Patternmakers should use the standard measurements given *if* the form has an 11-inch difference between the bust and waist. Otherwise, measure the form as illustrated.

- Use bust radius measurement to pin mark above and below bust as a guide when measuring the depth of the hollow areas.
- Two rulers are required for measurement. One ruler is used to bridge the hollow at each desig-

nated area. The other ruler is used to measure the depth. The measurement indicates the amount of excess (gapping or looseness) that can be removed from the area for a closer fit.

Caution: When measuring a model, do not press ruler into the flesh.

Suggestion: Color-code the spaces contained within the guidelines for emphasis.

Note: Single markings are illustrated for each guideline for clarity; however, all markings are to be placed on one pattern as indicated on example given on page 160. Measure, label, and chart each location that follows.

Guideline 1—Cut Out Necklines

Eliminates excess (gapping) from the neckline.

Form

- Place the end of the ruler at mid-neck and in the direction of the bust point.
- The other ruler measures depth at the pinmark.

Pattern

- Draw guideline 1 from bust point to mid-neck.
- Mark measurement out from the circumference line and connect to neck and bust point.

Standard Measurement = 1/4″

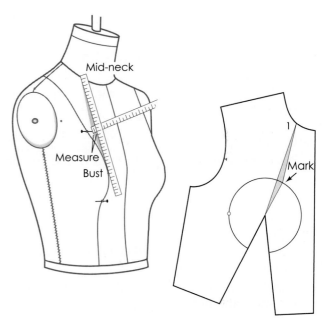

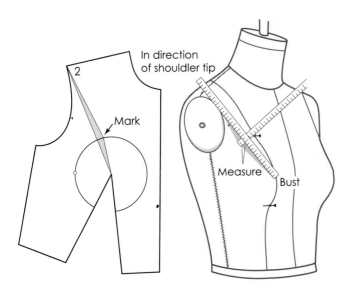

Guideline 2—Cut Out Armholes

Eliminates excess (gapping) from the armhole.

Form

- Place the end of the ruler at bust point and in the direction of the shoulder tip.
- The other ruler measures depth at the level of the pinmark. Add 1/4 inch to the measurement to offset bias stretch.

Pattern

- Draw guideline 2 from bust point to shoulder tip.
- Mark measurement out from the circumference line and connect to shoulder tip and bust point.

Standard Measurement = 1/2″

Guideline 3—Armhole Ease

Eliminates ease that had been added to the pattern draft. The ease is not needed for strapless garments and cutout armholes. The ease can be eliminated for sleeveless designs.

Pattern

- Draw guideline 3 from the curve of the armhole to bust point.
- Mark 1/4 inch (standard) and draw line to the bust point. (Do not include with cutout armhole designs.)

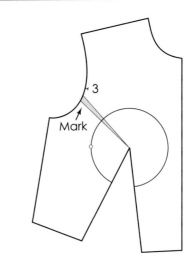

Guideline 4—Empire Styleline

An empire is any styleline that crosses under the bust mound. Eliminates fabric to reveal the contour of the underbust.

Form

- Place the end of the ruler at waist and in the direction of the bust point.
- The other ruler measures depth at the pinmark.

Pattern

- The measurement is divided between the two dart legs at the circumference line of the circle.
- Mark the measurements and draw guideline 4 to the waist and bust point.

Standard Measurement = 3/4″ (3/8″ at each dart)

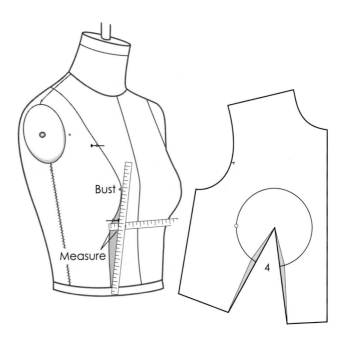

Designs with a Semi-Fit

The measurement under the bust is marked at half the amount (3/16″) given above. This applies to contour darts and to princess stylelines. To contour dart, follow illustration.

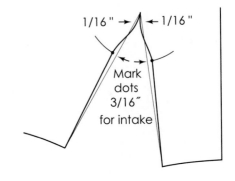

Guideline 5—Contour between the Busts

Reveals cleavage between the busts

Eliminates excess at the centerline between the busts.

Form

- Place the ruler across bust points.
- The other ruler measures depth at the center front between the busts.

Pattern

- Square guideline 5 from center front to the bust point.
- Mark half the measurement on each side of the square line to bust point.

Standard Measurement = 3/4″ (3/8″ each dart leg)

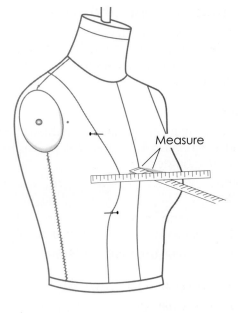

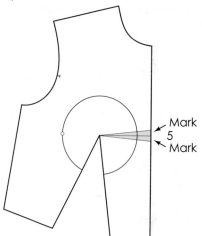

Guideline 6—Strapless Designs

Eliminates excess above the bust for strapless designs and those held up with narrow straps.

Pattern

To simplify the process, guideline 6 is a combination of guidelines 1, 2, and 3.

- Draw guideline 6 from bust point in the direction of mid-shoulder.

- Add the depth measurements of guidelines 1 and 2 and include guideline 3.

- Subtract 1/8 inch to offset the thickness of the interconstruction.

- Connect lines to bust point.

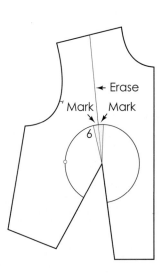

Shoulder Slope and Side Ease

To eliminate unneeded fabric at the shoulderline when the neck or armhole is cut-out, and at side seam for strapless and bra tops. Optional: sleeveless garments.

Form

- Place ruler on end from shoulder/neck to shoulder tip. With the other ruler measure depth at mid-shoulder.

Pattern

- Mark depth measurement at mid-shoulder, and connect to shoulder/neck and shoulder tip.

Standard Measurement = 1/8 inch.

- Mark side ease and draw guideline from mark to zero at waist.

Standard measurement = 1/2 inch

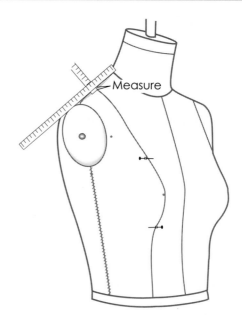

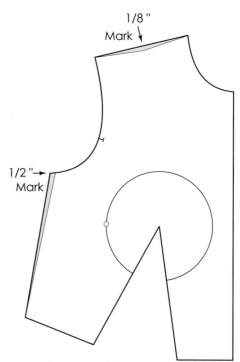

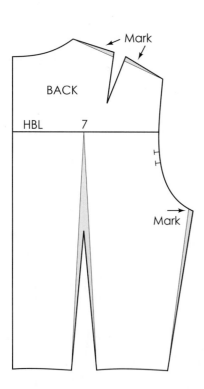

Guideline 7—Back

Eliminates unneeded fabric for strapless and cutout necklines.

Pattern

- Mark a point on the HBL line that is in line with the dart point of the waist dart.
- Draw guideline 7 from the dart legs at waist to the mark.
- Shoulder and side ease are the same as for the front bodice.

How to Use the Contour Guide Pattern

The Contour Guide Pattern should be used for all designs that fit closer to the figure than does the basic garment. Designs may require more than one modification. This will be illustrated later.

A styleline must cross a guideline before modification is required.

The amount of excess to be transferred, or absorbed for a closer fit, is indicated at a *point where the styleline crosses the guideline*. The closer a styleline is to the circumference line on the pattern, the greater the intake.

The excess indicated between the guidelines (shaded areas on the pattern) can be transferred to an existing dart or absorbed into design detailing (pleats, ease, or styleline). The excess can be trimmed from a styleline (example: princess stylelines) above or below the bust. The method chosen depends on the design.

Designs 1, 2, and 3 feature cut-out necklines placed at, or at varying distances from, the bust circumference line of the Contour Guide Pattern. Through design analysis, determine which guidelines are required before plotting the pattern. For example, Designs 1, 2 and 3 require Guideline 1 (cut-out necklines), and front and back Shoulder Slope Guideline (always combined with cut-out necklines and armholes). Design 3 with a low back requires the use of Guideline 7.

DESIGN 1 DESIGN 2 DESIGN 3

Procedure for Pattern Plot Using the Contour Guide Pattern

Figures 1 and 2

- Trace front and back Contour Guide Patterns. With a pushpin, transfer required guidelines to paper underneath (in the example, Guidelines 1 (front) and 7 (back), include front and back shoulder slope guidelines.

 Note: With a pencil in hole of the circle, draw bust circumference (all or part), when needed for controlling placement of stylelines.

- Remove pattern and connect guidelines. The straight guideline is always the cut line.

Figure 1

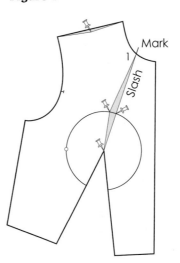

Figure 2

Transferring Excess at the Styleline

- The cut-out necklines of Designs 1, 2, and 3 are drawn to show the relationship of each neckline to the bust circumference and shoulderline. Remember, the amount of excess to be removed is indicated at the point where the styleline crosses a guideline. For clarity, label the guideline A and B at the styleline, as shown in each illustration.
- Cut pattern, discarding unneeded areas of neckline and shoulder.
- Cut slash line A to, not through, bust point.
- Bring slash line A to meet B when transferring excess. Tape, retrace, and blend neckline.

Figure 3

- When stylelines cross a guideline indicating less than 1/8 inch of excess, such as Design 1, modification is not required.

Figures 4 and 5

- The neckline of Design 2 is above the circumference line. Therefore, looseness will re-main in the garment over the hollow area above bust point (indicated by the broken lines), but the neckline will fit closely.

Figures 6 and 7 *Front*:

- The cut-out neck touches the circumference line of the bust. The neckline will fit the hollow area above the bust after the excess is transferred.

Figure 6

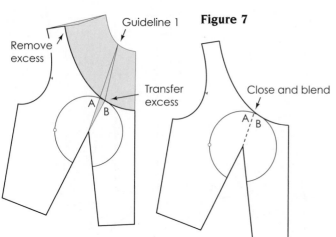

Figure 3

Pattern for Design 1

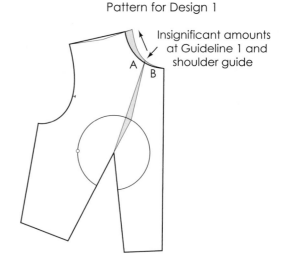

Insignificant amounts at Guideline 1 and shoulder guide

Figure 4 **Figure 5**

Patterns for Design 2

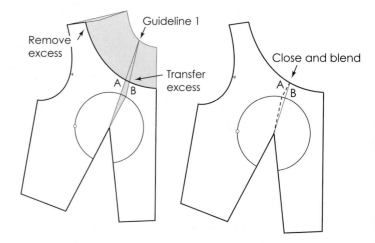

Figures 8 and 9 *Back*:

- The low cut neckline crosses Guideline 7. After the neckline and shoulder are trimmed, slash the leg of one guideline and overlap to other guideline. Tape, trace, and blend.

Figure 8 **Figure 9**

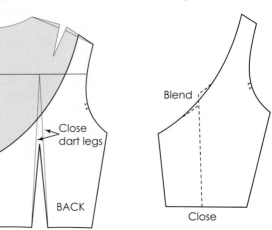

Figures 10 and 11 *Modifying the neckline facing:*

- Facings for cut-out necklines (scooped, square, V-neck) and armholes may be modified instead of the bodice. This is done by tracing the guidelines to the facing pattern which is overlapped. The bodice and facings are notched to control the ease at the neckline. Modifying the facing may be preferred when excess from several guideline areas is transferred to a dart. The increase of excess to the dart legs can cause too much fullness at the bust point.

Figure 10

Figure 11

Figure 12 *Stretch-gapping adjustment:*

- When a garment with a cut-out neckline and/or armhole is gapping or loose after pattern adjustment, pin in the excess on the garment and measure. Correct the pattern as follows.

- Slash across neckline and through mid-shoulder. Overlap the needed amount. Blend armhole and neckline. This will not decrease the armhole because the fabric will stretch to the original armhole after garment is cut. Write on the pattern that armhole was modified due to stretch.

Figure 12

Designs With Cut-out Armholes

The following designs are practice problems. Use previous instructions and illustrations as a guide. Garments having cut-out armholes should include side seam guide markings for a tighter fit. More advanced designs requiring the Contour Guide Pattern follow.

The Classic Empire

The Classic Empire is a popular styleline that is found on many types of garments. It is distinguished as the styleline that crosses under the bust, separating the pattern into two parts. The lower section is called the midriff. To emphasize the contour under the bust, the midriff fits close to the body and controls the fit of the upper garment. The empire styleline may or may not continue to the bodice back.

For design variations, the styleline can be drawn in many different directions after having crossed under the bust.

Design Analysis

The midriff styleline of the Classic Empire crosses, and contours under the bust. The styleline slopes gently downward to the center back. The garment fits closer to the figure than does the basic garment. Darts (or gathers) control the fit above the midriff under the bust.

Pattern Plot and Manipulation

Use the Contour Guide Pattern, or follow the plot and measurements given.

Figure 1

- Trace patterns side by side, and mark guidelines 7 (back) and 4 (front).
- Draw bust circumference. Remove patterns and connect guidelines.
- Square a line from center front touching dart leg under bust (A to B).
- Side seam measures 3/4″ less than A-B. Mark.
- Center back measures $1\frac{1}{4}$″ less than A-B. Mark and square a short line.
- Draw a curved styleline from dart leg to center back, blending with the square line.
- Contour the bust dart and trim shaded area.
- Trim shaded area of the back dart only to styleline.
- Separate patterns and cut through styleline.

Figure 1

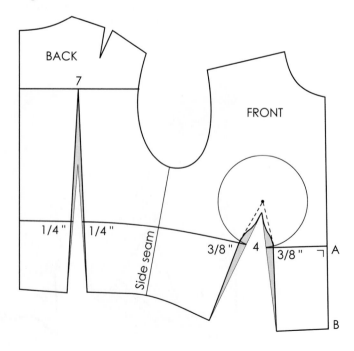

Figure 2 *Front*:
- Retrace bodice. Include all contour guidelines for future reference (shaded areas). See pages 160–164.
- Extend dart legs 3/16 to 1/4 inch and center front 1/8 inch. (Additional length is needed when fitting under the bust.)
- Draw blending line across bottom. (Broken line indicates original shape.)
- Draw grainline.

Figure 2

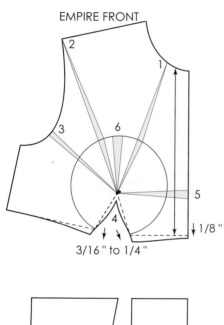

Midriff front sections

Figure 3 *Back*:
- Trace back. Include the HBL line and Guideline 7.
- Extend center back 1 inch.
- Original dart intake is used; excess from Guideline 7 is removed from side seam when midriff is trued to bodice (broken line).
- Draw grainline.

Figure 3

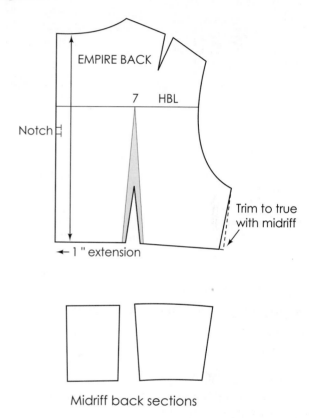

Midriff back sections

Figure 4 *Midriff front*:
- Close dart legs. Tape.
- Trace on fold and blend.
- Draw grainline.
- Cut from paper.

Figure 4

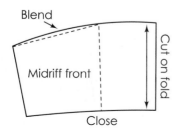

Figure 5 *Midriff back*:
- Close dart legs. Tape.
- Retrace and blend.
- Extend center back 1 inch.
- True patterns and draw grainline.

Figure 5

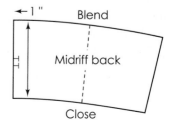

Empire with Shirred Midriff

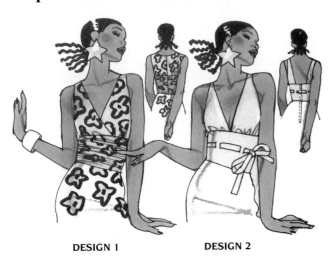

DESIGN I DESIGN 2

Design Analysis: Designs 1 and 2

Design 1 features a shirred midriff. Centers overlap, giving a V-neck effect, and are gathered under the bust. The gathered cummerbund is held in place by a midriff shell. Pattern is based on the classic empire pattern. Design 2 is given as a practice problem. Design other variations for additional practice.

Pattern Plot and Manipulation

Use the Contour Guide Pattern, or follow plot and measurements given.

Figures 1 and 2
- Trace front and back empire patterns. (If not available, see page 168.)
- Transfer Guidelines 1 and 5 (increase to 1 inch). Mark shoulder slope guide.
- Remove patterns and connect guidelines.

Front:
- Extend empire line out from center front $2\frac{1}{2}$ inches. Label A.
- Mark B, $1\frac{1}{2}$ inches from shoulder tip.
- Connect A to B.
- Extend Guideline 5 to styleline.

Figure 1

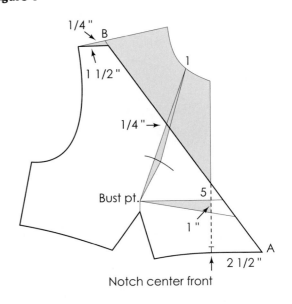

Notch center front

Back:
- Mark B, $1\frac{1}{2}$ inches from shoulder tip.
- Mark C, 3 inches below center back neck. Square a short line.
- Draw curved neckline from C to B.

Figure 2

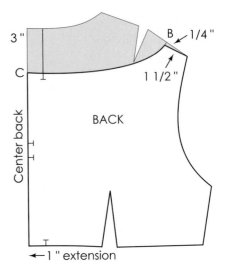

Figures 3 and 4

Front:

- Cut guidelines and dart point to, not through, bust point. Overlap Guideline 1 and Guideline 5.
- Retrace patterns (broken line represents original pattern.
- Draw blending line from A to B and under bust.
- Mark 1$\frac{1}{2}$ inches out from each dart leg for gather control notches.
- Draw center front grainline, and notch.

Back:

- Blend dart, notch for gathers, draw grainline.

Figures 5 and 6

- Use original midriff pattern as a base for supporting the gathered midriff.

Figure 5

Figure 6

Figures 7 and 8

Cummerbund:

- Place center front of midriff on fold of the paper and trace. Label A and B. (Broken line indicates waist of midriff.)

Figure 7

Figure 3

Figure 4

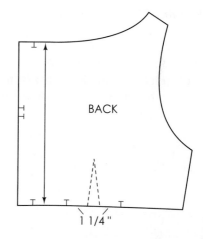

- Shift midriff downward until top of midriff touches B. Trace bottom and side of cummerbund.
- Using skirt curve, draw side seam.
- Repeat for back (but do not place on fold).
- True side seams. (They must be of equal length.)
- Draw parallel or bias grainline. If bias, remove 1/2 inch from side seams to compensate for stretch (not illustrated).
- True patterns and complete for test fit.

Figure 8

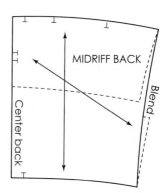

Surplice (or Wrap) Designs

Surplice designs are those whose right and left sides cross over each other. The underneath section of a lapped side can be the same pattern shape, or the underneath side can be controlled by a dart. The overlap section may be designed as gathers, tucks, or pleats. The style requires a full pattern and special instructions (right-side-up). Design 1 has a controlled lapped section. Design 2 is for practice. See Chapter 11 for built-up neckline.

DESIGN 1 **DESIGN 2**

Pattern Plot and Manipulation

Use the Contour Guide Patterns, or follow plot and measurements given.

Figure 1

- Trace the front pattern on fold.
- Transfer Guideline 1 (intake increased to offset bias stretch) and the shoulder and side seam guides.
- Remove the pattern and connect guidelines.
- Cut pattern from paper and unfold.
- Mark A, $1\frac{1}{2}$ inch from shoulder tip and down 1/4 inch.
- Mark B, 2 inches up from side waist.
- Draw a curved line from A to B, touching dart point.
- Draw a slash to mid-armhole.
- Cut from paper and trim shaded area.

Figure 2 Back:

- Trace back pattern and transfer shoulder and side seam guides.
- Mark C, $1\frac{1}{2}$ inches from shoulder tip and down 1/4 inch to eliminate shoulder dart excess.
- Mark D, $1\frac{1}{2}$ inches down from center back neck. Square a line and draw a curved line to C.
- Draw 1 inch center back extension.
- Cut pattern from paper and trim shaded area.

Figure 1

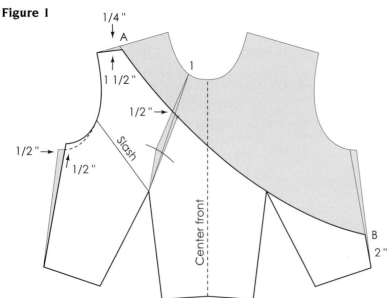

Figure 2

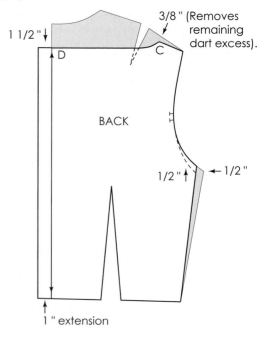

Preparing Pattern *For Left Side of Garment*
Figure 3

- Slash guideline 1 to, not through, bust point and overlap 1/2 inch. Tape.
- Close waist dart. Tape.
- *Turn pattern over.* Trace and remove pattern.
- Mark 1/2 inch in from B and draw a line to waist. Trim.
- Draw a straight line from B to A.
- Shape dart legs to contour the bust.
- Label traced pattern *Right-side-up.*

Figure 3

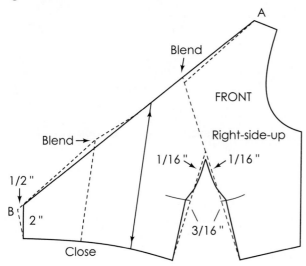

Preparing Pattern *For Right Side of Garment*
Figure 4

- Cut slash line from mid-armhole to, not through, bust point.
- Close waist dart. Tape.
- Draw slash line from bust to 1 inch below point B.
- Draw a blending line from A to B, and trim pattern (shaded area).

Figure 4

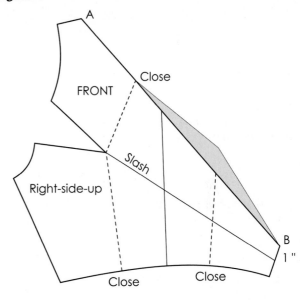

Figure 5

- Cut slash line to, not through, bust point for gathers.
- Close mid-armhole plus 1/4˝ dart and trace.
- Blend open space between dart legs at side.
- Label *Right-side-up.*

Figure 5

Figure 6

- After the test fit, if it is necessary to eliminate part of the fullness or to reduce the length of the A-B line, reshape styleline using the measurement suggested.

Figure 6

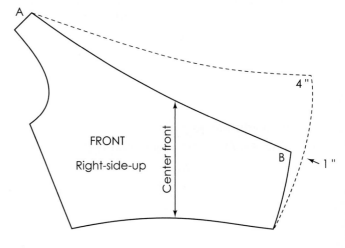

Off-Shoulder Designs

Gathered Shoulder

Design Analysis: Designs 1 and 2

Design 1 has a gathered shoulder, with the other side of the design fitted under the armhole. Part of the dart excess is for gathers; the remaining excess is for waist dart control. Design 2 is for practice. Design other variations for an additional challenge.

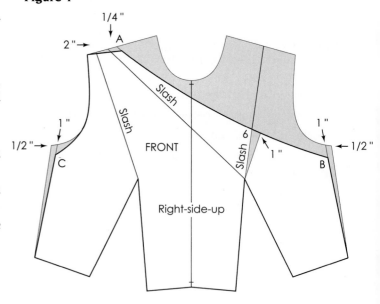

DESIGN 1 DESIGN 2

Pattern Plot and Manipulation

Use the Contour Guide Pattern, or follow plot and measurements given.

Figure 1

- Trace front pattern on fold. With a pushpin, transfer Guideline 6. Include side seam and shoulder guides. Remove pattern.
- Cut pattern from paper. Unfold.
- Connect guidelines, marking Guideline 6 on shoulderless side of the pattern only.
- Mark A, 2 inches from shoulder tip and down 1/4".
- Mark B and C, 1 inch below armholes on side seam guideline.
- Draw line from A to B.
- Blend armhole to point C.
- Draw slash lines from bust points to shoulder.
- Cut pattern from paper.

Figure 1

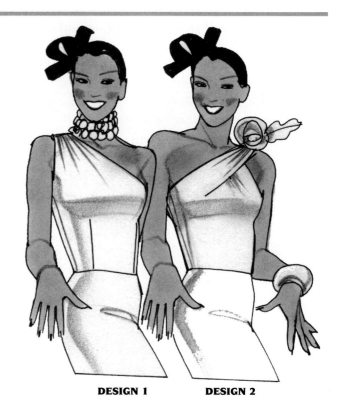

Figure 2

- Cut slash lines to, not through, bust points.
- Place on paper.
- Close dart legs at $1^1/_2$ inches A–B (broken lines indicate position of original darts).
- C – D = A – B space.
- Close Guideline 6 (broken line). Tape.
- Trace pattern.
- Blend styleline and shoulder for gathers.
- Draw grainlines. Label *Right-side-up*. **Figure 2**

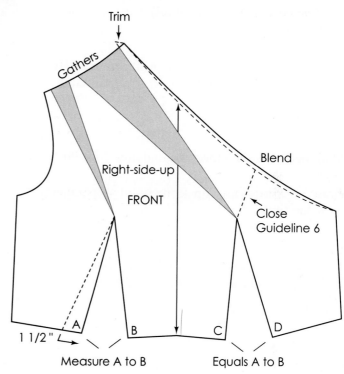

Figure 3 Back: **Figure 3**

- Repeat styleline and armhole shape instruction given for the front pattern. Label pattern *Right-side-up*.
- Cut shaded area from pattern.
- Complete patterns for test fit.

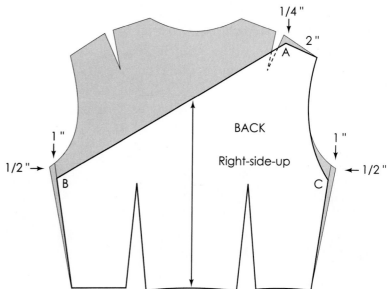

Halters

Halters are designed with bare shoulders created by cutting the armhole deeply into the shoulder line. In Design 1, the halter cut is extended for tie around the neck. The back may be low-cut. Design 1 is illustrated and Design 2 is a practice problem.

DESIGN 1 **DESIGN 2**

V-Neck Halter

Pattern Plot and Manipulation

Use the Contour Guide Pattern, or follow plot and measurements given.

Figure 1

• Trace front pattern. With a pushpin, transfer Guidelines 2, 4 (for modified fit), and 5. Include side seam guide. Remove pattern. Connect guidelines.

Neck:

• Mark neck A and connect to Guideline 5 (at Bust Level).

• Draw an 8-inch line up from point A parallel with the center front line.

• Mark B $1\frac{1}{2}$ inches from point A.

• Draw an inward-curved line from point B ending 1/2 inch below armhole on side seam guide.

• Continue line from point B to tie point.

• Cut pattern from paper.

Figure 1

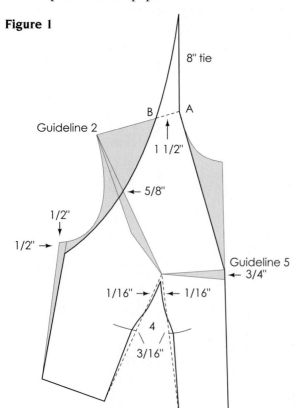

Figure 2

• Slash Guidelines 2 and 5 to, not through, bust point, overlap, tape, trace, and blend.

• Draw grainlines.

• To develop low back, use instructions in Chapter 19, pages 441–442.

Figure 2

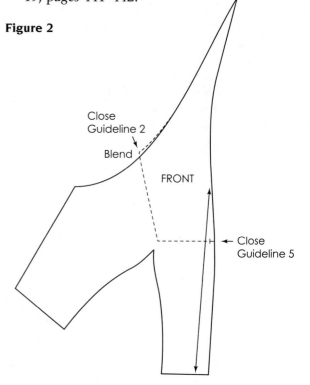

10
Collars

Introduction

A collar encircles the neck and frames the face, offering great opportunities for design variations. Collars may be developed close to or away from the neckline. They may be wide, narrow, flat, or high, and with or without an attached stand. The collar edge may be stylized or may follow a basic shape—it may be round, curved, scalloped, square, or pointed (long or short) in any direction.

The choice of a collar design should complement and enhance the style and purpose of the garment. Other collar shapes such as the shawl or lapel collars will be discussed in Chapter 22 with jackets and coats.

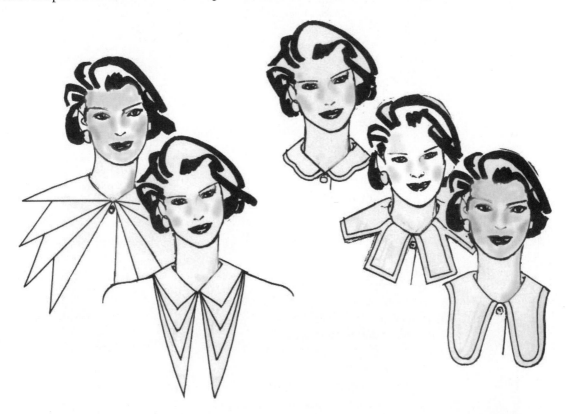

Collar Terms

Neckline edge. The side of the collar that is stitched to the neckline of the garment.

Collar edge. The outer edge or design of the collar.

Collar stand. The height at which the collar rolls over itself.

Roll line. The foldover at the collar stand.

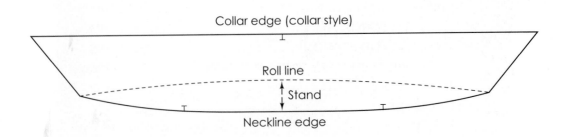

Collar Stand and Roll Types

The roll line of the three collars illustrated indicates where the height of the stand stops and the roll line begins.

Figure 1
1-inch stand (full roll)

Figure 2
1/2-inch stand (partial roll)

Figure 3
1/8-inch stand (flat roll)

Collar Classifications

Regardless of the design of the collar, the neckline edge generally has one of two basic shapes:

a. Contrary to the neckline curve of the form or garment. This type of collar will spring open when unbuttoned—convertible. Figures 4 and 5. Prototype—The Basic Shirt Collar.

b. Follows closely to the curve of the neckline of the form or garment. This type of collar will stay in place when unbuttoned—nonconvertible. Figure 6. Prototype—The Peter Pan Collar.

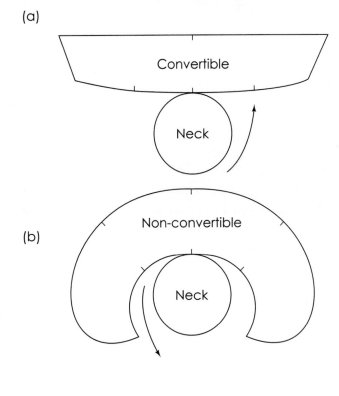

(a)

(b)

Figure 4 **Figure 5** **Figure 6**

Basic Shirt Collar Foundation

The basic convertible collar may be worn open or closed. The collar has a 1-inch stand at the center back, and its width may vary from $2\frac{1}{2}$ to 3 inches. It can be developed with a seam along the collar edge, or folded and cut as either a one-piece or two-piece (center back seam) collar. The grainline may be either straight, crosswise, or bias, depending upon the design effect desired when cut in stripes, checks, or plaids. The basic collar can be a base for other designs.

Measurements needed:
Center back neck to shoulder: _____
Center front neck to shoulder: _____
Total: _____

Figure 1
- Square a line in the center of the paper. Mark and label the following locations:

 A to B = $2\frac{1}{2}$ inches (collar width).

 B to C = Total neck measurement. Label C.

 B to D = Center back to shoulder. Mark for notch.

Figure 1

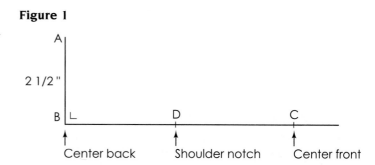

Figure 2
- Square a line up from C.
- Mark E, 1/2 inch from C.
- Draw a curved line from E blending with D.
- Square a line from A passing 1 inch or more from guideline C. Label F.
- Draw a line from E to F.
- Draw grainline and cut collar from paper.

Figure 2

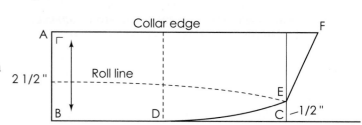

Straight Collar

Figure 3
- Develop straight collar using instruction given in Figures 1 and 2 except that the neckline edge is straight. The collar's width may be increased to 3 or 4 inches.

Figure 3

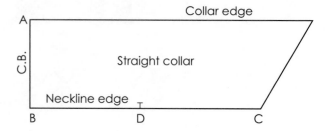

Undercollar

The undercollar pattern is made shorter in width than the uppercollar. Two types are given to prevent the undercollar from rolling out beyond the stitchline. The undercollar is drafted from the uppercollar. (The broken line in the illustrations indicates the original collar.) The undercollar should be notched 1/4 inch out from each side of center back at neckline edge. The following instructions apply to the development of all undercollars.

Figure 4

- Trace the upper collar.
- Trim 1/8 inch and more for bulky fabrics. Square a short line at the center back and gradually draw the line to zero at the collar point.

Figure 4

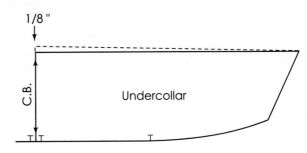

Figure 5

- On collars with an uneven styleline, trim the excess from the neckline edge of the collar.
- Following the same instructions given in Figure 4.

Figure 5

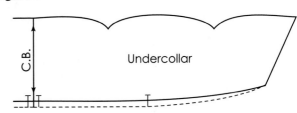

Figure 6

Figure 6

- The collar is illustrated with a center back seam.
- The grainline can be drawn straightgrain, crossgrain, or bias.

Figure 7

- Collar cut on fold.

Figure 7

Folded Basic Collar

Figure 1

- Fold paper lengthwise.
- Square a guideline down from fold in center of paper.

- Place collar on paper with center back on guideline and collar edge along fold line.
- Trace collar. Cut out the collar, ending at center guideline.

Figure 1

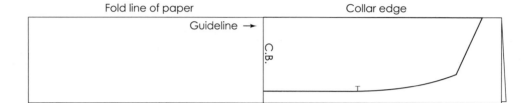

Figure 2

- Unfold paper. Refold collar and paper on guideline.

- Trace the collar. (Completed collar shown.)
- Cut from paper, notch, draw grainline.

Figure 2

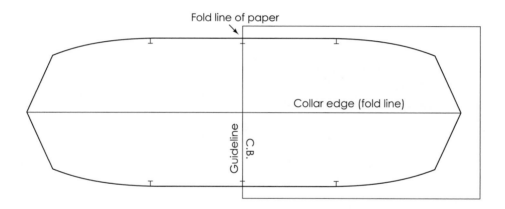

Increasing Collar Width

Figure 3

- Trace basic collar from center back neck to shoulder.
- With pushpin at notch (point X), swing pattern upward 1/2 inch from original center back neck (broken line).
- Retrace neckline edge of collar from point X to center front to establish new neckline edge. Remove pattern.
- Extend center back 1 inch.
- Draw new collar's edge parallel to neckline. (Any collar shape may be designed.)

Figure 3

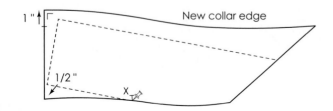

Collar Variations

Figure 4

- Examples of collar designs that vary from the basic collar. Collar variations begin and blend approximately in line with shoulder notch.

Figure 4

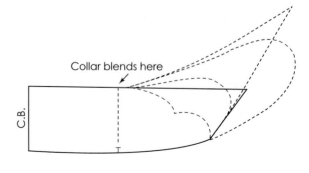

Fit Problems of the Collar

Figure 1

- *Problem:* Collar's edge lies above the stitchline at the back neck.
- *Solution:* Increase the collar's edge. Cut three slash lines between the shoulder and the center back to the neckline.

Figure 2

- Pin collar to fall 1/4 inch below stitchline of center back.
- Use tape to secure the slashed areas, and measure the opened spaces.

Pattern Correction

Figure 3

- Cut 3 slash lines from shoulder to center back neck.
- Spread to equal measured spaces. Trace pattern.

Figure 1

Figure 2

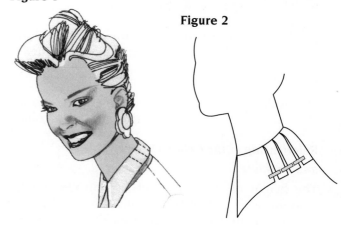

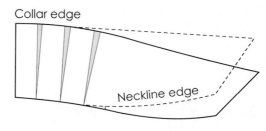

Figure 3

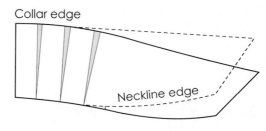

Collar edge

Neckline edge

Figure 4

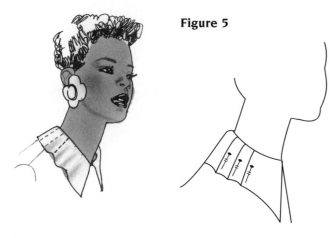

Figure 5

Figure 6

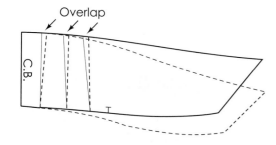

Overlap

C.B.

Figure 4

- *Problem:* Collar falls loosely around the garment.
- *Solution:* Decrease the collar's edge.
- Cut three slash lines to the neckline between the shoulder and the center.

Figure 5

- Overlap the slashed parts to take up the excess and pin.
- Remove collar from the garment.

Pattern Correction

Figure 6

- Slash pattern, overlap equal amounts, and tape.
- Trace the pattern.

Peter Pan Collars

The Peter Pan series introduces the principle of the full-roll, partial-roll, and flat-roll collars. Apply this principle to all collar designs that stay in place when unbuttoned.

Principle

The neckline edges of nonconvertible collars are similar in shape to the curve of the form's neckline. The closer in similarity, the lower is the stand of the collar; the less similarity, the higher is the stand.

Relationship of the Collar's Stand, Width and Neckline

The height of a collar stand is controlled by the amount of overlap at the shoulder tips of the front and back patterns. This patternmaking technique is called the 4 to 1 rule, and is illustrated in the development of the Peter Pan collars.

Compare the neckline edge of each collar to that of the basic neckline. Compare the width of each collar to the height of the collar stand.

A – Full-roll: 1-inch stand—$2^3/_4$ inches wide.

B – Partial roll: 1/2-inch stand—$3^1/_2$ inches wide.

C – Flat-roll: 1/8-inch stand—any width.

(closest to the shape of the basic neckline.)

The width of the collar is limited by the height of the collar stand.

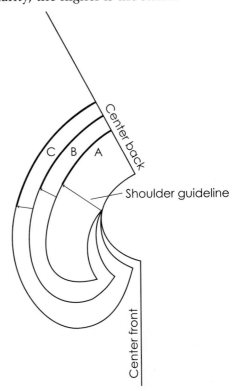

Three Basic Peter Pan Collars

By design, the collar of the Peter Pan is rounded. Designs 1, 2, and 3, illustrate the height of the collar stand and the collar width. The front part of a collar can be designed to any length or width but must blend with the back collar at the shoulder line.

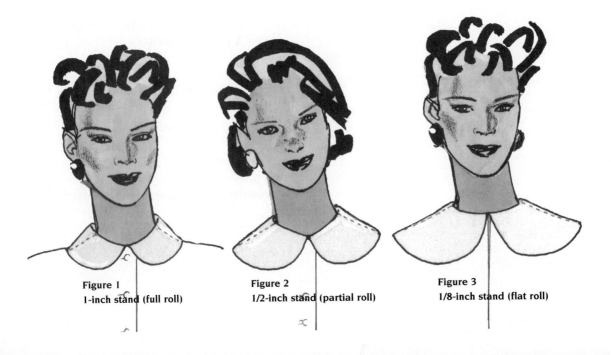

Figure 1
1-inch stand (full roll)

Figure 2
1/2-inch stand (partial roll)

Figure 3
1/8-inch stand (flat roll)

Peter Pan with 1-Inch Stand (Full Roll)

Pattern Plot and Manipulation

Figure 1

- Trace back pattern. Place front pattern on traced copy, touching the neckline and overlapping the shoulder tips 4 inches.
- Trace the neckline and part of the centerlines.
- Note point at shoulder/neck.

Figure 1

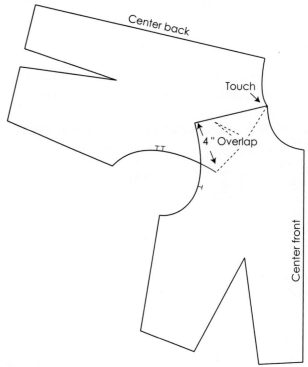

Figure 2

- Extend center back neck 1/8 inch. Draw the neckline through the point ending 1/4 inch below center front.
- Draw style collar parallel with the neckline.
- Cut the collar from the paper.
- Mark notch at shoulder/neck and where noted.
- Cut from paper and true to the neckline of the garment to which it will be attached. Allow an extra 1/16 inch beyond the collar point.

Figure 2

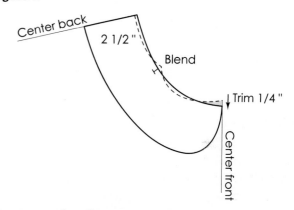

Figure 3

- Trace collar on fold of the paper.
- Mark center back notches.
- Cut from paper.

Figure 3

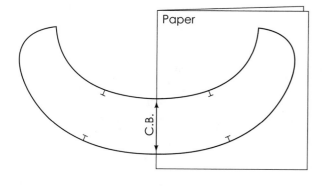

Figure 4 *Undercollar*:

- Trace collar on the fold. Remove the pattern.
- Trim 1/8 inch (shaded area) as illustrated.
- Mark two notches 1/4 inch apart at center back on the neckline edge, and one notch on collar's edge.

Figure 4

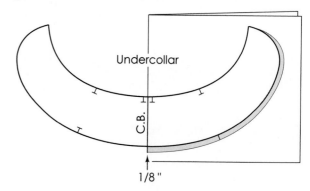

Peter Pan with 1/2-Inch Stand (Partial Roll)

Pattern Plot and Manipulation

Figure 1

- Trace back pattern. Place front pattern on traced copy, touching the neckline and overlapping the shoulder tips 2 inches.
- Trace the neckline and part of the centerlines.
- Note a slight point at shoulder/neck.

Figure 1

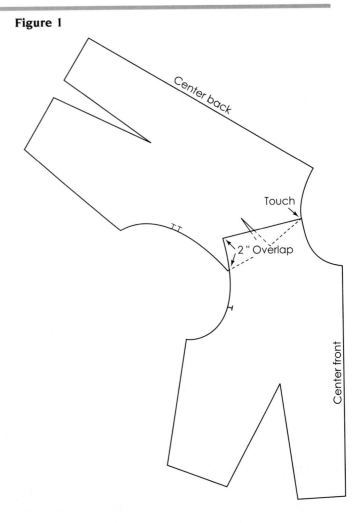

Figure 2

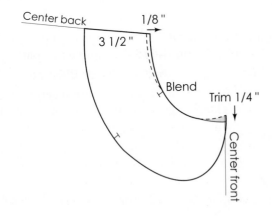

Figure 2

- Extend center back neck 1/8 inch. Draw the neckline through the point ending 1/4 inch below center front point.
- Draw style collar parallel with the neckline.
- Cut the collar from the paper.
- Mark notch at shoulder/neck and where noted.
- Cut from paper and true to the neckline of the garment to which it will be attached. Allow an extra 1/16 inch beyond the collar point.
- To develop the undercollar, see page 185, Figure 4.

Peter Pan with Flat Roll

Pattern Plot and Manipulation

Figure 1

- Trace back pattern. Place front pattern on traced copy, touching the neckline and overlapping the shoulder tips 1/2 inch.
- Trace the neckline and part of the centerlines.

Figure 1

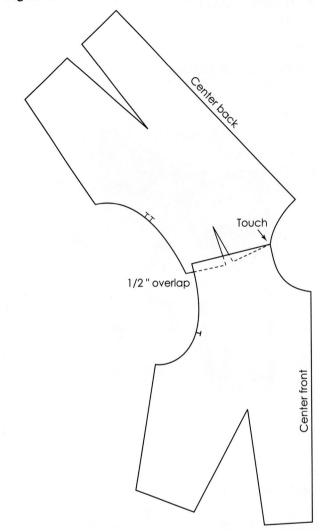

Figure 2

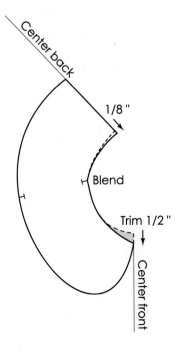

Figure 2

- Extend center back neck 1/8 inch. Draw the neckline through the point ending 1/2 inch below center front point.
- Draw collar to width desired and parallel with the neckline.
- Cut the collar from the paper.
- Mark notch at shoulder/neck and where noted.
- Cut from paper and true to the neckline of the garment to which it will be attached. Allow an extra 1/16 inch beyond the collar point.
- To develop the undercollar, see page 185, Figure 4.

Sailor Collar

The sailor collar was inspired by the sailor's uniform and is based on instructions for a nonconvertible collar.

Basic Sailor Collar

DESIGN 1

Figure 1

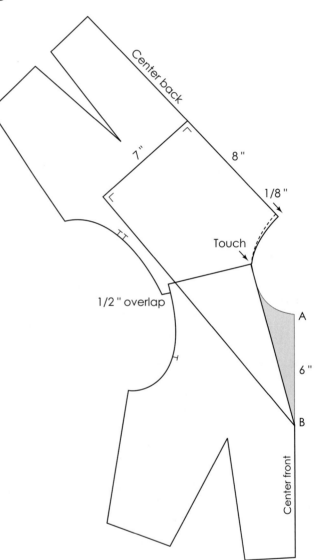

Design Analysis: Design 1

Design 1 features a sailor collar that is long and squared in back, ending at a V-neck line of the bodice cut in front. The tie is detachable. For designs with an extension for button and buttonholes, see page 189, Figure 1 for the pattern development.

Pattern Plot and Manipulation
Figure 1
- With front and back necks touching, overlap shoulder tips 1/2 inch.
- Trace center front, center back, and neckline. Remove patterns.
- A to B is the depth of the V-Neck and applies to the collar and neckline of the bodice.
- Develop collar as illustrated.
- Square a line to shoulder, and from shoulder connect with B. Blend shoulder.
- Cut collar from paper.

Figure 2 *Completed collar:*

- Trace collar on fold. Cut from paper and unfold.
- Draw grainline. (Broken line indicates shape of undercollar.) If the center front is cut on fold, the collar at center back should be split and seams added.

Figure 2

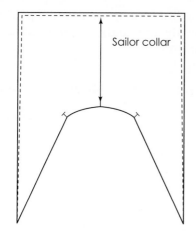

Sailor collar

Sailor with Extension

Figure 1 Collar:

Repeat instructions for Design 1 with the following exceptions:

- Draw a parallel line 1 inch from center front. Draw a line from shoulder neck past B to the extension point C and complete collar.

Figure 1

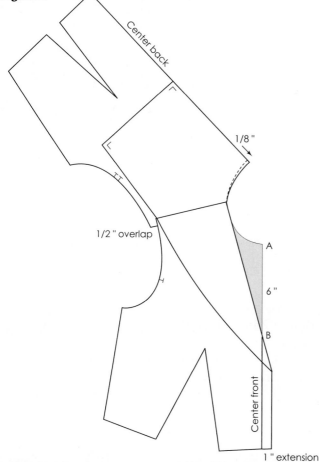

Center back

1/8 "

1/2 " overlap

A

6 "

B

Center front

1 " extension

Figure 3

- Establish sailor neckline on bodice.
- Cut from paper. (Tie not illustrated.)

Figure 3

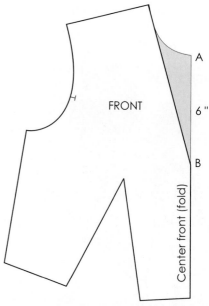

FRONT

A

6 "

B

Center front (fold)

Figure 2 Bodice:

- Establish sailor neckline on bodice.
- Mark buttonhole placement. (See button and buttonholes, Chapter 16.)

Figure 2

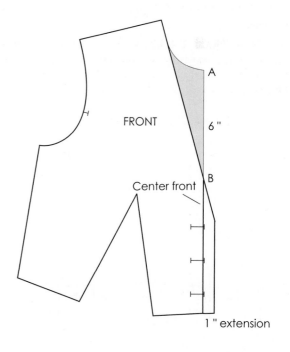

FRONT

A

6 "

B

Center front

1 " extension

Sailor with Inset

Design Analysis: Design 2

Design 3 is a stylized version of the sailor collar. The inset section in front controls the deep neckline. The sailor tie is part of the collar.

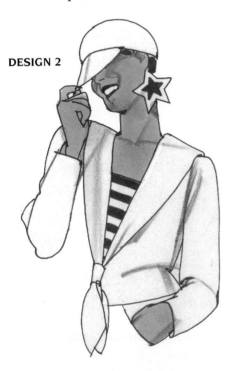

DESIGN 2

Figure 2 Inset:

- Trace wedge-shaped inset sections on fold (lined area).

 Note: Draw 1 inch extension on one-side for opening and for button or snaps.

Figure 2

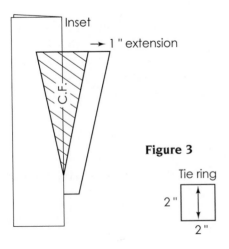

Inset
→ 1 " extension

C.F.

Pattern Plot and Manipulation

Figure 1 Collar:

- Develop the neckline from A, B, C, to D. Inset noted as angle lines.

- Extend C-line 6 inches past B (tie).

- Square a line out from E and up to shoulder. Continue the line to the length of the tie that is 2 inches from B.

- Shape the tie ends.

- Cut from paper. Save wedge section from inset.

Figure 1

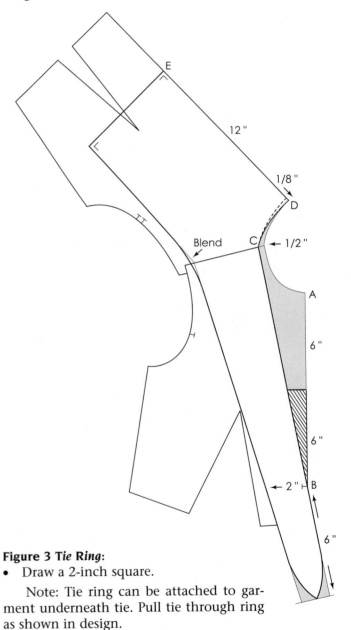

E

12 "

1/8 "

D

Blend C ← 1/2 "

A

6 "

6 "

← 2 " H B

6 "

Figure 3

Tie ring

2 "

2 "

Figure 3 Tie Ring:

- Draw a 2-inch square.

 Note: Tie ring can be attached to garment underneath tie. Pull tie through ring as shown in design.

Collars with Deep Open Necklines

Design Analysis: Designs 1 and 2

Designs 1 and 2 both illustrate collars on an open neckline. In Design 1, the collar with a flat roll passes shoulder at neck of the garment. In Design 2, the collar with a 1/2-inch stand crosses shoulder.

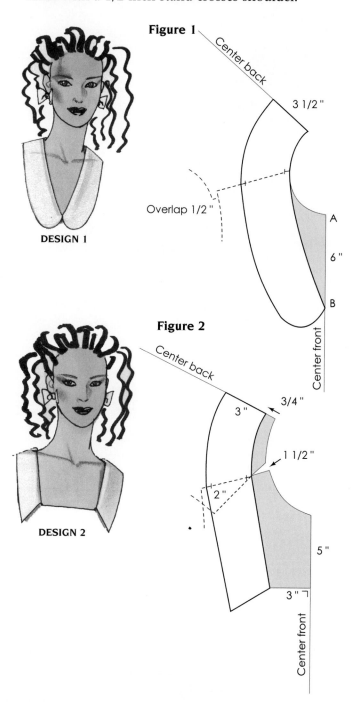

Figure 1

Center back

3 1/2 "

Overlap 1/2 "

A

6 "

B

Center front

DESIGN 1

Figure 2

Center back

3/4 "

3 "

1 1/2 "

2 "

5 "

3 "

Center front

DESIGN 2

Collar for V-Neck
Figure 1

- Place front and back patterns together on paper, matching shoulder at neck.
- Overlap shoulder tips 1/2 inch.
- Develop collar as illustrated.
- Cut collar from bodice.
- To complete bodice pattern, trace using A-B instruction given for collar.
- Trace collar and modify for undercollar. See page 185, Figure 4.

Collar for Square Neck
Figure 2

- Before overlapping shoulder, plan neckline on front and back bodice. Trim neckline (shaded area).
- Place front and back on paper, matching shoulder at new neckline. Overlap shoulder tips 2 inches and trace neckline, center back, and center front. Remove pattern.
- Develop collar as illustrated.
- Cut collar from paper.
- To complete pattern, use front and back pattern with trimmed neckline.
- Trace collar and modify for undercollar. See page 185, Figure 4.

Mandarin Collar

A Mandarin collar (also called military, Nehru, and Chinese collar) is a close-fitting, stand-up collar. It parts in front and varies in width from $1\frac{1}{4}$ to $1\frac{1}{2}$ inches on the average. This foundation is the base for the development of other collars, stands, and combination collar-and-stand variations. The collar may meet at center front, be overlapped and buttoned, or be extended to any point along the neckline. The stand can be developed either close to or away from the neck. It can be curved, blunted, pointed, or extended for a partial folded-over collar effect. The neckline edge of the draft is the basis for all such collars.

DESIGN 1 DESIGN 2 DESIGN 3

Basic Mandarin

Measurements needed:
Center back neck to shoulder: _____
Center front neck to shoulder:_____
Total: _____

Pattern Plot and Manipulation

Figure 1

- Square a line in the center of the paper equal to the following measurements:

A–B = $1\frac{1}{2}$ inches (collar stand).

B–C = Total back and front neck. Label C.

B–D = Center back to shoulder measurement.

- Mark for shoulder notch.

Figure 1

A

11/2"

B L D C

↑ ↑ ↑
Center back Shoulder notch Center front

Figure 2
- Square up 1/2 inch from C. Mark and label E.
- Draw a curved line from E to D, completing the neckline edge of collar.
- Square a $1\frac{1}{2}$-inch line at right angles to E-D. Label F.
- Draw a line from A to F, parallel with B-D-E line.

Figure 3
- Cut collar from paper.
- To complete pattern, trace on fold. Draw grainline and notch center back.
- Complete the pattern and trace to make a duplicate copy for the collar facing.

Figure 2

Figure 3

Mandarin Collar Variations

The following examples are variations of the Mandarin foundation. Trace pattern and modify as illustrated:

Curved neckline (Design 2)
- Draw curves as shown.

DESIGN 2

Wing collar (Design 3)
- Extend line 1 1/4 inches at center front.
- Blend to collar band as shown.

DESIGN 3

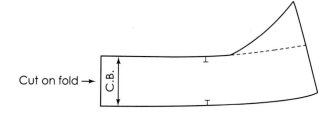

Collar with Stand

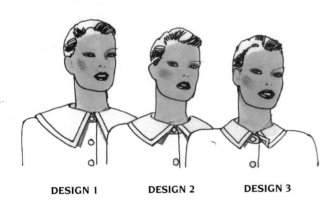

DESIGN 1　　**DESIGN 2**　　**DESIGN 3**

Design Analysis

A collar is attached to the top edge of a Mandarin, having an extension for button and buttonhole. (Also referred to as a shirt collar.) To develop the Mandarin foundation, see page 192. Pattern for design 3 is illustrated.

Pattern Plot and Manipulation

Figure 1

- Trace Mandarin stand.
- Square out 1-inch extension from A and B. Connect.
- Draw curved line.
- Mark buttonhole placement as shown.

Figure 1

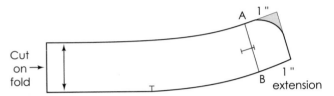

Figure 2

- Trace Mandarin stand. (Broken line indicates part of collar not needed.
- Draw collar, using measurements given.
- Notch midpoint of upper edge of collar.

Figure 2

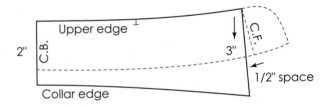

Figure 3

- Draw slash lines.
- Cut from paper.

Figure 4

- Cut slash lines to, not through, collar's upper edge.
- Place center back on fold. Spread sections 1/8 inch. Trace (Spreading allows collar to lie on garment without riding upward at center back.)
- Cut from paper.

Figure 3

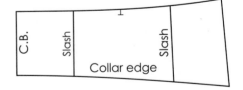

Figure 4

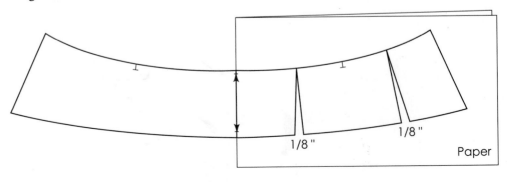

Wide Collar and Stand

Designs featuring wide collars with stand either follow the basic neckline, as illustrated, or stand away from the basic neckline; see page 196. Both collar and stand are based on the nonconvertable collar principle.

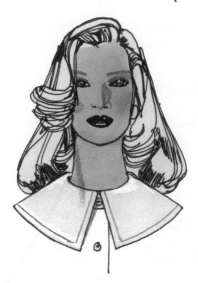

Pattern Plot and Manipulation

Figure 1

- With the front and back necks touching, overlap shoulder tips 2 inches.
- Trace center back, center front, and neckline.
- Draw the neckline, ending 1/2 inch below center front.
- Draw the collar parallel with the neckline, ending 1½ inches from the center front line. (The collar may be as wide as desired, and the front collar may be of any shape.)

Figure 1

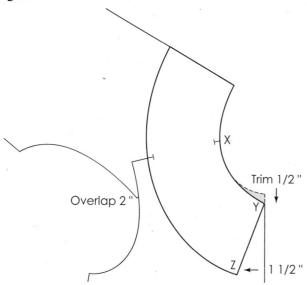

Figure 2

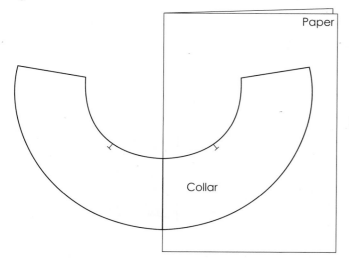

Figure 2

- Trace collar and fold.
- True collar to stand (allow 1/8″ for ease.
- Cut from paper, and retrace for undercollar. (See page 185, Figure 4 for guidance.)

Figure 3

- To draft stand, use measurement of the neckline edge of the new collar. See pages 192 and 194 for guidance.

Figure 3

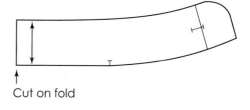

Collar and Stand away from the Basic Neckline

Design Analysis

The distance from the basic neckline and the style of the collar may be varied to create different versions of this design.

Pattern Plot and Manipulation

Figure 1

- Draw the neckline on front and back pattern.
- Trace back pattern. Transfer new neckline as illustrated.
- Place front pattern on back pattern with new necklines touching (mark X).
- Overlap shoulder tips 2 inches.
- Trace front pattern and transfer new neckline.
- Remove pattern and pencil in the new neckline.

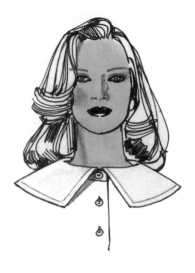

Figure 2

- Lower neckline 1 inch at center front.
- Draw collar parallel with the new neckline, ending approximately 2 inches from center front. (Collar can be as wide as desired.)

Figure 1

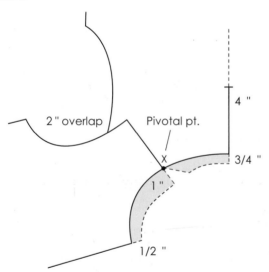

Figure 2

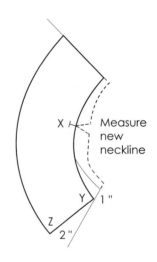

Figure 3

- Trace collar on fold.
- Cut collar from paper and retrace for undercollar. (See page 185, Figure 4 for guidance.)

Figure 4

- For guidance in developing the collar stand, see pages 192 and 194.

Figure 3

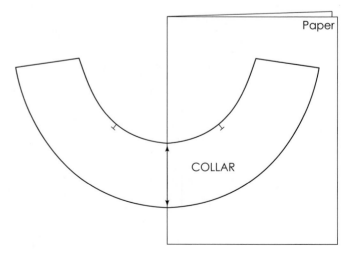

Figure 4

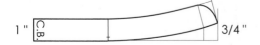

All-in-One Collar and Stand

Figure 1

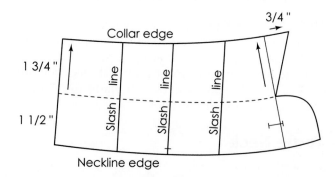

Figure 1

Figure 1

- Trace Mandarin collar with extension. (See page 194, Figure 1.)
- Extend a line up from center front and center back equal to collar width plus 1/4 inch.
- Draw a line parallel with bottom edge of Mandarin. Extend 3/4 inch beyond center front line to form point of collar. Connect with center front of stand.
- Draw slash lines.

Figure 2

- Cut slash lines to, not through, neckline edge.
- Place center back on fold. Spread to increase collar's edge (prevents collar from riding upward at center back).
- Trace. Blend collar edge.

Figure 2

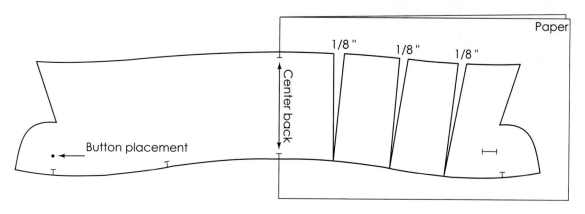

Roll Collars

Bias-fold collar bands can be developed for any neckline (basic or cut-out). The finished length, however, should be slightly shorter than the area covered to compensate for the stretch of the bias fabric. The collar width may be planned for either a folded bias band or a band folded back on itself. Both will be illustrated. Cut the band equal to front and back neck measurement. Stretch collarband slightly when stitching to the neck of the garment. Trim the overhang and reduce the pattern by the same amount, or use the formula given in the instructions that follow.

Turtle Neck

DESIGN 1

Pattern Plot and Development

Figures 1 and 2 N*eckline modification:*

- Trace pattern and adjust neck as illustrated.
- Blend new neckline.

Neckband: (shortened to offset stretch)

- Measure A-B, less 1/4 inch (front neck). Record _____.

- Measure B-C, less 1/4 inch (back neck). Record _____.

Figure 1

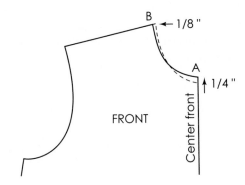

Design Analysis: Design 1

In Design 1 a folded bias band encircles the neck with an opening at the center back. The turtle neck can also be developed to fold back on itself.

Figure 2

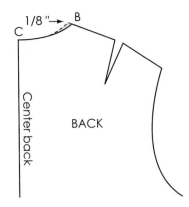

Figure 3 *Turtle band*:

- Fold paper.
- Square a line from fold to equal front and back measurement (A, B, C). Mark B for notch placement at shoulder.
- Draw parallel lines, spaced 3 inches apart for single fold ($1\frac{1}{2}$ inches finished width), or $6\frac{1}{2}$ inches apart for double fold ($3\frac{1}{4}$ inches finished width indicated by broken line).
- Connect ends.
- Draw bias grainline and complete pattern for test fit.

Figure 3

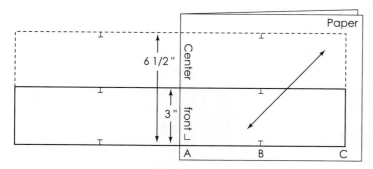

Roll Collar with Cutaway Neck

Design Analysis: Design 2

In Design 2 a bias band encircles a cutaway shoulderline.

Figure 1

- Plan new neckline by placing shoulderlines together, matching at neck. Use measurements given.
- Cut out new front and back necklines and measure.

Figure 1

Figure 4

- The center back can be closed with loops and buttons.

Figure 4

Figure 5

- The center back can also be left open when folded back onto itself.

Figure 5

DESIGN 2

Figure 2 Band:

- Use instructions for the turtleneck as a guide for developing band, using front and back neckline measurements.

Figure 2

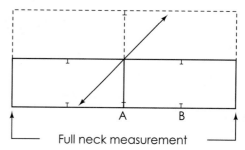

Collar Design Variations

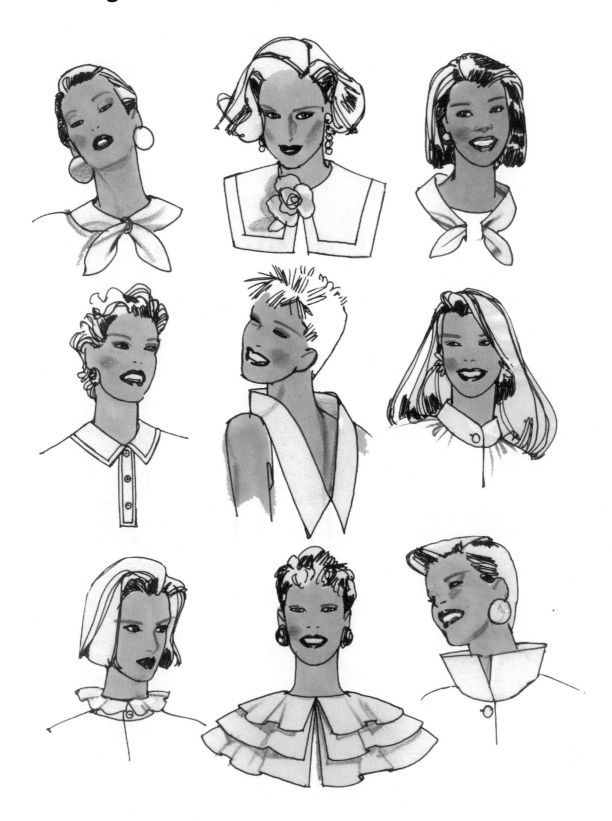

11

Built-Up Necklines

Built-Up Necklines

Built-up necklines extend above the base of the neck and must accommodate the position of the neck as it juts forward (Figure 1). There are two basic types of built-up necklines: all-in-one with the bodice (Figure 2) and set-in bands (Figure 3). Either type can be developed from any point along the shoulder and to any height. Added room is provided along the outer edge of built-up neckline. This allows the neckline to rise up and away from the neck and shoulder of the garment to prevent strain from the neck's forward position. The development of this type of neckline is an application of Principle #1, Dart Manipulation (when transferring dart excess to the neckline) or Principle #2, Added Fullness (when adding to the pattern's outline). Because of the special features of this type of neckline, facings are included in the instructions. (More about facings can be found in Chapter 16.)

Figure 2

Figure 3

Figure 1

Stovepipe Neckline

Design Analysis: Designs 1 and 2

The neckline of Design 1 extends above the natural neckline in front and back, with seams at center front and center back. Design 2 is a practice problem.

DESIGN 1 **DESIGN 2**

Pattern Plot and Manipulation

Figure 1 *Front*:

- Trace and cut front bodice pattern.
- Mark A, 2 inches down from center front.
- Mark B, 1/2 inch in from neck at shoulder.
- Draw curved slash line from A to B.

Figure 1

Figure 2

- Cut slash line from A to, not through, point B.
- Place on paper and spread 2 inches. Secure.
- Trace and label center front neck C.

Figure 2

Figure 3a, b

- Continue line $1^1/_2$ inches up from point B and square a short line.
- Complete curved neckline to point C. Connect C with point A. Blend at A and B. Notch (Figure 3b).
- Cut from paper.

Figure 4 *Facings*:

- Place center front of pattern on fold of the paper.
- Trace neckline from center front to 1 inch past B on shoulder.
- Remove pattern. Draw bottom edge parallel with neckline. Notch center front neck.

Figure 3a **Figure 3b**

Figure 4

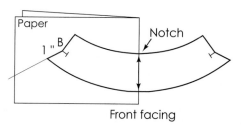

Front facing

Figure 5 B*ack*:

- Trace back. Mark A at neck/shoulder and draw a guideline parallel with center back.

- Extend center back 1 inch. Label B and square a short line.

- Mark C, 1/2 inch from A.

- From C draw 1$^1/_2$ inch line to guide. Label D.

- Draw a curved line parallel with neckline from D to B, and D to shoulderline.

- Add 1-inch extension at center back for closure and mark notches.

Figure 6 F*acing*:

- Trace back pattern 1 inch past point C, starting at original *center back*. Remove pattern. Draw facing's edge parallel with neckline edge. Notch at point C and center back.

- Draw grainline and complete pattern for test fit.

Figure 5

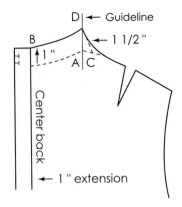

Figure 6

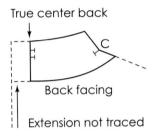

Built-Up Bateau Neckline

D*esign* Analysis: D*esigns* 1 *and* 2

The neckline of Design 1 extends upward from mid-shoulder and center front of neck. Excess from dart is transferred to neckline to allow room for the neck, which juts forward. Design 2 is included for practice. Design other variations for additional practice.

DESIGN 1 **DESIGN 2**

Pattern Plot and Manipulation

Figure 1 Front:

- Trace pattern, transferring 1/2 inch of the dart excess to mid-neck.

- Extend center front neck 3/4 inch and square a short line. Label A and mid-shoulder B.

- Square a line $1\frac{1}{2}$ inches long from B, ending 3/4 inch up from shoulder. Label C.

Figure 1

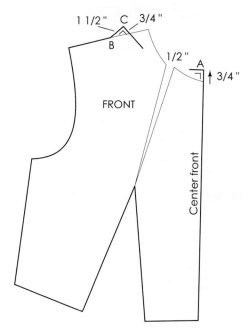

Figure 2

- Draw neckline, blending curved line with square lines A and C. Mark notch at point B. (Broken line indicates original pattern.)

- Cut pattern from paper.

Figure 2

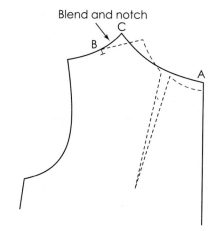

Figure 3 Facing:

- Trace neck area on fold ending 1 inch past B. Remove pattern. Draw bottom edge parallel with neckline.

Figure 3

Figure 4 Back:

- Trace back pattern, transferring all, or half of shoulder dart to neck. Ease in remaining excess along shoulderline (or use multidispersion back pattern—see page 91).

- Draw a 1-inch extension. Mark notches.

Figure 4

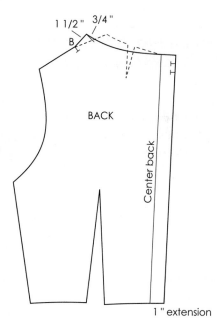

Figure 5

- Draw facing (width same as front), ending at center back.

- Draw grainlines and complete patterns for test fit.

Figure 5

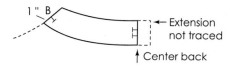

Inset Bands

An inset band is developed from part of the front and back bodice and located anywhere along the shoulder or neckline. The band is modified so that it will not lie flat on the model's neck. The following instructions apply to any type of inset neckline. The shoulder dart can be shifted to another location along the shoulderline or transferred to the neckline to become part of the band; or use multidispersion back pattern; see page 91.

Rounded Inset Band

Design Analysis: Design 1

The inset band is formed around the garment, with the upper edge away from neck and mid-shoulder.

Pattern Plot and Manipulation

Figure 1

- Trace back, transferring shoulder dart to neck (Dart is eventually closed).
- Place front on back shoulderline. Draw neckline and band, using illustration as a guide. (Broken lines indicate original pattern.)
- Cut neck band from front and back patterns, discarding unneeded section (shaded area). The lower part of the front and back bodice completes the design.

DESIGN 1

Figure 2a, b

- Close neck dart.
- Draw three slash lines on each inset section starting $1\frac{1}{2}$ to 2 inches from center front and center back.

Figure 2a, b

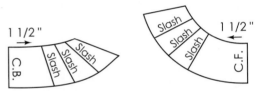

Figures 3 and 4

- Cut slash lines to, not through, neckline edge.
- Place patterns on paper with center front on fold.
- Spread each section 1/4 inch and add 1/2 inch at shoulder to zero at neckline edge.
- Add a 1-inch extension at center back for closure.
- Draw grainlines, add seams, and complete for test fit.

Figure 1

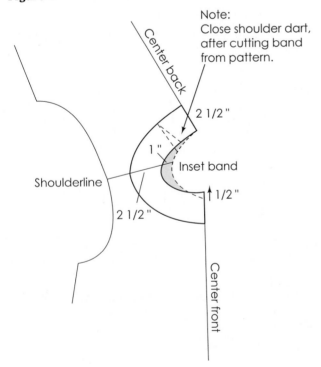

Figure 3
BACK BAND INSET

Figure 4

FRONT BAND INSET

Inset Band Variations

Design Analysis: Designs 2 and 3

Design 2 has an inset band that comes to a point at center front and curves around to center back. Design 3 is given as a practice problem.

DESIGN 2 **DESIGN 3**

Pattern Plot and Manipulation

- Use instructions for Design 1 and the illustrations that follow as guides for developing the patterns.

Figure 1 Plotted patterns

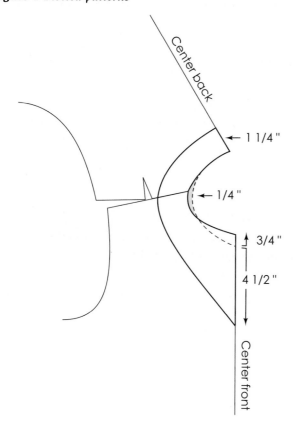

Figures 2 and 3 Inset bands

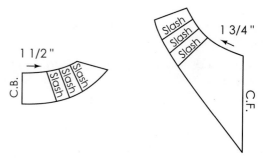

Figures 4 and 5

- Back and front bands, slashed and spread.
- Trace front on fold.
- Draw grainlines, add seams and notches. Complete pattern for test fit.

Figures 4 and 5

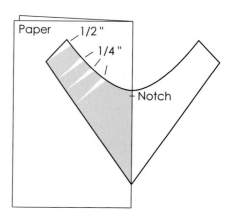

12

Cowls

Cowls

Cowls are folds created by allowing fabric to fall to desired depths from secured ends of a bias triangle. Cowls drape best on true bias, and when cut in soft, loosely woven fabrics—crepe, silk, gauze, rayon, satin, chiffon, and certain knits. The *bodice* cowl depends on excess taken from the basic dart—lower the depth of the cowl, greater the amount of excess needed—an application of Dart Manipulation.

Types of Cowls

Cowls can be designed with, or without pleats/gathers, with few, or many folds, and fall at varying depths creating a soft look to any garment. Cowls fall from the shoulder at necklines, armholes, or from the waist of dresses, gowns, blouses, pants, jackets, and coats. Cowls can also be designed to fall from the cap area of the sleeve. Cowls can be in-one with the garment, or be set-in to save fabric. With the help of a broach or clip, the cowl can be pulled in any direction to create interesting effects.

Nature of the Bias Cut

Figure 1

The straight and crossgrains run in opposite directions as the cowl hangs from the shoulder (or from any part of a garment). The fold of the cowl follows more closely to the straight grain on one side, and on the other side the fold follows more closely to the crossgrain. The straight grain, which is twisted more firmly than the crossgrain, may cause the fold of the cowls to roll differently, and often is the reason for twisting. For additional information about the nature of bias, see Chapter 20 Bias Dresses.

Figure 1

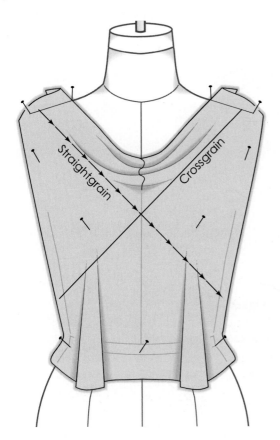

Twisting

Figure 2

Place a finger at the center of each fold of the cowl. Press downward gently. If the fold of the cowl(s) twists, redrape the cowl on the side of the twist until the fold falls smoothly. Correct the pattern (the sides may differ).

Figure 2

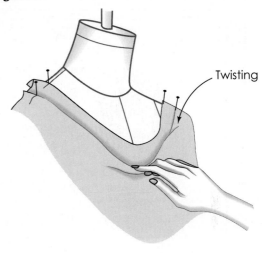

Making Patterns for Bias-Cut Cowls

Patterns are generally developed for garments cut on woven fabrics, and not for those cut on the bias. The cowl patterns will require adjustments if the garment is to fit. The cowl is cut on perfect bias, and draped on the form for a first fitting to determine the stretch of the bias. The amount that the cowl bodice stretches when fit on the form is marked and trimmed or added to the original pattern. The adjustments cause the pattern to be reduced in size to the amount that it will stretch and when re-cut it should fit in the final test.

Figure 3

The original pattern is cut on perfect bias. To find perfect bias, the crossgrain of the fabric is folded to the straight grain—or parallel with it. The fold is marked with chalk or a thread line. This line remains at the center of the form at all times throughout the drape. To prevent the fabric from slipping as the pattern is traced and cut, it is pinned to tissue paper. The center of the seamless cowl pattern is placed on the fold, secured, and traced. One inch is added around the pattern to allow for adjustments.

Figure 3

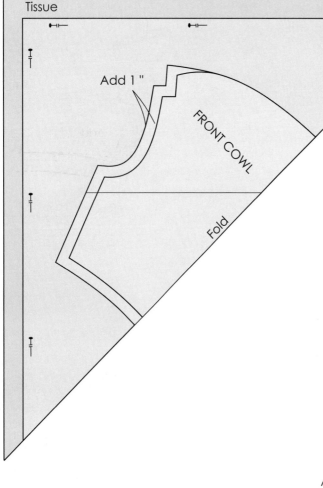

Fitting the Cut Garment

Figure 4

Cut the pattern in fabric (darts are pinned or basted). Pin cowl to the form at center waist, bust level, and shoulderline. As the fabric is smooth around the form, allow the bias to stretch (which it will do automatically). Mark, pin, and outline the following locations: shoulder tip, armhole, armhole depth (may fall below armhole depth, add equal amount to the pattern), side seam, and waistline.

Figure 4

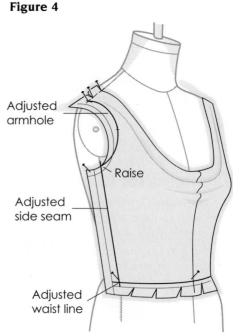

Correcting the Pattern

The amount of stretch varies with the choice of fabric.

Figure 5

- Remove the cowl bodice from the form.
- One side of the draped cowl is measured to correct the paper pattern.
- Measure the distance between the original pattern and the new markings. Mark this amount on the pattern.
- Blend to smooth the connected lines on the pattern.
- Trim the pattern and re-cut for a final fitting. The cowl bodice should stretch to a perfect fit; if it does not, make further adjustments.

Figure 5

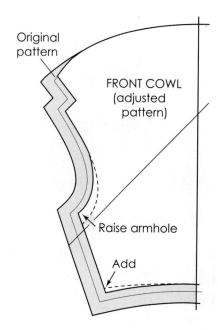

Original pattern

FRONT COWL (adjusted pattern)

Raise armhole

Add

High Relaxed Cowl

Design Analysis: Design 1

The relaxed cowl of Design 1 indicates that some part of the dart excess was transferred to the neck cowl.

Figure 2

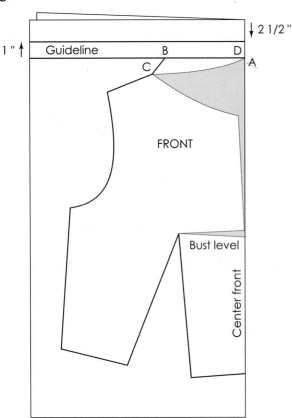

Pattern Plot and Manipulation

Figure 1

- Trace front bodice pattern. Label center front neck A.
- Mark B, 3/4 inch from shoulder neck.
- Mark C, 3/4 inch from B.
- Draw slash lines from A to B and from A to C.
- Square a slash line from center front to bust point.
- Cut pattern from paper along A–B line, discarding unneeded section (shaded area). Broken line is original neckline.
- Cut slash lines to, not through, bust point and point C.

Figure 1

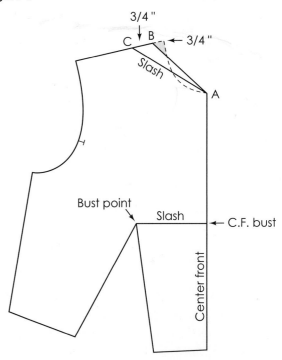

Figure 2

- Fold paper. Square a guideline $2\frac{1}{2}$ inches down from paper's edge and label D.
- Draw a parallel line 1 inch up from point D (fold-back facing).
- Place pattern on paper so that point B touches guideline and point A touches point D.
- Align center front with the fold of paper below bust level. (Transfer some dart excess to the center front.)
- Trace pattern starting from B and ending at center front waist. Remove pattern.

Figure 3

- Fold across A–B line.
- Trace shoulder and blend. (Broken line is original shoulder.)

Figure 3

Figure 4

- Cut pattern from paper and unfold.
- Draw bias grain.
- Follow the instructions given for the first fitting on page 212, Figures 3, 4, and 5.

Figure 4

Figure 5

- Trace the basic back pattern.
- Mark B 3/4 inch from shoulder/neck.
- Draw the neckline from back neck curving to B.
- Extend center back 1 inch.
- Draw grainline and stitch to cowl front after the first fitting.

Figure 5

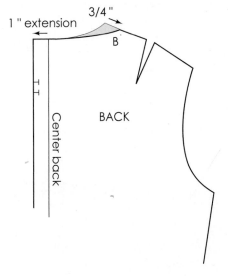

Mid-Depth Cowl

Design Analysis: Design 2

The cowl falls from mid-shoulder to a depth between neck and bust level. The depth of the cowl takes up one-half of the waist dart excess. The fold-back facing is rounded.

Figure 2

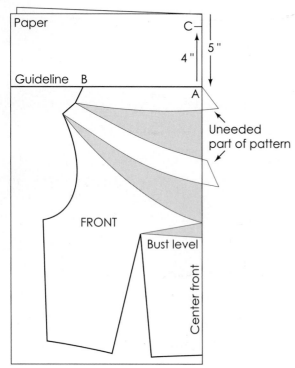

Pattern Plot and Manipulation
Figure 1 *Front*:

- Trace front bodice and square a slash line from center front to bust point (bust level).
- Mark A between the center front neck and bust level.
- Mark B at mid-shoulder and draw a line to A.
- Draw slash line from shoulder tip to bust level and another in between.
- Cut pattern from paper.
- Cut slash lines to, not through, shoulder and bust point.

Figure 1

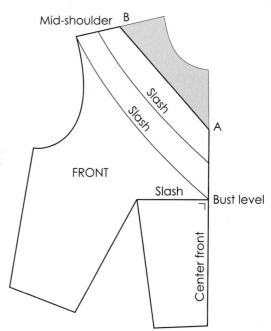

Figure 2

- Fold paper and square a guideline 5 inches down from paper's edge.
- Place pattern on paper so that A–B line touches the guideline and point A touches fold of paper.
- The center front pattern is placed on the fold below bust level.
- Trace the pattern starting from B and ending at center front waist.
- Mark C, 4 inches up from A for foldback facing.

Figure 3

- Fold on the A–B line and trace the shoulder.
- Blend the shoulder (broken line is the original shoulder).
- Draw and trace the facing ($1^1/_4$ inches wide at shoulder).

Figure 4

- Unfold and draw the traced facing.
- Draw the bias grainline and cut from paper. *Follow the instruction given for the first fitting on page 212, Figures 3, 4, and 5.*

Figure 3

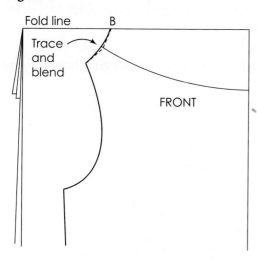

Figure 4

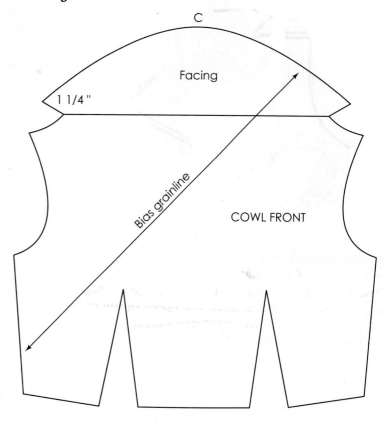

Figure 5

- Trace the basic back pattern.
- Mark A, $1^1/_2$ inches below center back.
- Mark B, 1/4 inch down from mid-shoulder.
- Draw the neckline from A curving the line to B.
- Extend a parallel line from center back.
- Draw a straight grainline.
- For instructions for facing, see Chapter 16.
- Cut and stitch to the front cowl after the first fitting.

Figure 5

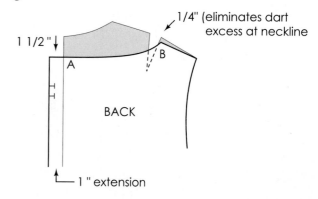

Low Cowl

Design Analysis: Design 3

The low cowl as featured in Design 4 drapes at or slightly below bust level. All of the waist dart excess is transferred to the neckline for a cowl of this depth.

Figure 2

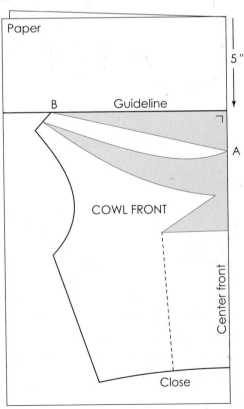

Pattern Plot and Manipulation

Figure 1

- Trace front bodice.
- Square a line from center front to bust point. Label A (bust level).
- Mark B, $1\frac{1}{2}$ inches from shoulder tip. Draw line from A to B.
- Draw slash line between shoulder tip and point B, ending at point A.
- Cut from paper.
- Cut slash lines to, not through, shoulder and bust point.
- Close dart leg. Tape.

Figure 1

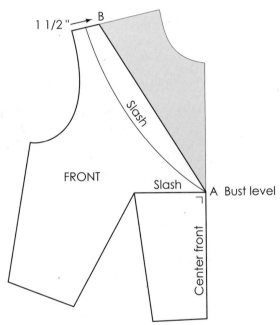

Figure 2

- Fold paper and square a guideline 5 inches down from paper's edge at fold.
- Place pattern with center front on fold and point B on guideline. Spread sections until point A touches, or extends center front fold.
- Secure and trace from B to center front waist.
- Complete pattern for test fit.
- Develop back pattern using instructions on page 220, Figure 6 as a guide.

Deep Cowl

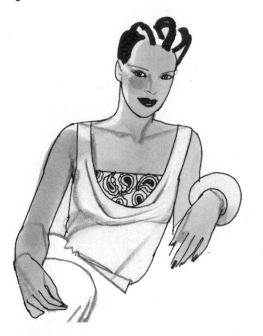

Design Analysis: Design 4

Deep cowls are usually designed with a strapless top. They can be stitched into the side seam of the cowl bodice (as illustrated) or continued around to the back. Cowls that fall below bust level indicate that fullness has been added to the center front.

Figure 2

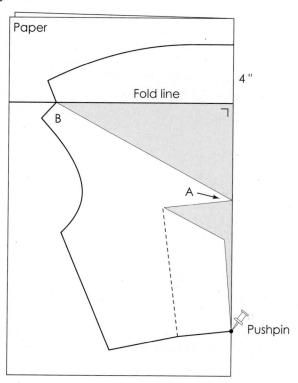

Pattern Plot and Manipulation

For those not using the Contour Guide Pattern, use measurements given.

Figure 1
Cowl pattern

- Mark cowl depth 2 inches down from bust level. Label A.
- Mark B $1\frac{1}{2}$ inches from shoulder tip. Draw a line from B to A, and from A to bust point.
- Trim neckline (shaded area).
- Cut slash lines A and the dart point to, not through, bust point.
- Close the dart legs.

Figure 1

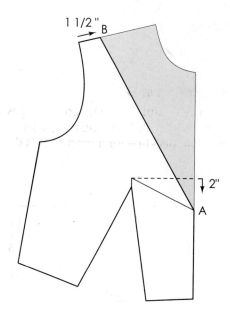

Figure 2
- Fold paper.
- Place waist at fold and with a pushpin, pivot the pattern until point A touches the fold.
- Trace the pattern from B to center front waist.
- Square a line from the fold, touching B.
- Draw facing as illustrated.
- Follow instructions given for the first fitting on page 212, Figures 3, 4 and 5.

Figure 3

Strapless plot:

- Trace the pattern and transfer contour guidelines 6 and 4 (semi-fit). Include side seam ease. Connect the guidelines (shaded area).
- Square a line from center front, passing $3\frac{1}{4}$ inches above bust point, and ending 2 inches below side seam.
- Cut the strapless bodice from paper. (Do not separate the princess panels.)

Figure 3

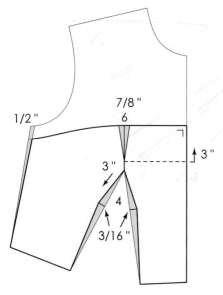

Figure 5

- If boning is attached, add 1/4 inch at bust point and blend the curved line above and below bust point.

Figure 5

Figure 4

- Blend the curve seams over and under the bust of each princess panel.
- Mark notches 2 inches above and below bust point.
- Separate the princess panels.

Figure 4

SIDE FRONT PANEL FRONT PANEL

Cut on fold

Figure 6

- Trace the back pattern.
- Mark A, $1\frac{1}{2}$ inches down from center back, and square a short line.
- Mark B, $1\frac{1}{2}$ inches from shoulder tip, and down 1/4 inch.
- Draw the neckline.
- Extend the center back 1 inch.
- Draw a straight grainline.
- For facing instruction, see Chapter 16.

Figure 6

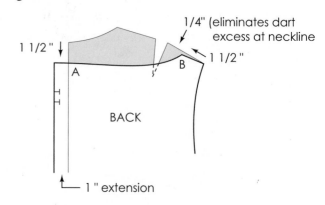

Back Cowls

Back cowls are developed with the use of a square ruler. Designs 1, 2, and 3 illustrate a high, medium (mid-center), and low cowls.

DESIGN 1 **DESIGN 2** **DESIGN 3**

High-Back Cowl

Pattern Plot and Manipulation

Figure 1

Paper needed:

- Cut a 36-inch square of paper, and fold.

Back:

- Mark A 4 inches down from back neck.
- Mark B at the dart legs at mid-shoulder.
- Measure from A to B. Record.
- Mark C from center back waist equal to the width between the dart legs.

Figure 1

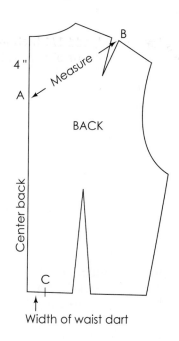

Figure 2
- Square a line from the fold that equals the A–B measurement and label.
- Place the pattern on the paper so that points B of the pattern and paper touch and point C touches the fold.
- Secure and trace the pattern indicated by the bold line, omitting the part indicated by broken lines.
- Remove the pattern.
- Square a short line at C and draw a curved waistline.
- Draw a slightly curved line from B to shoulder tip.
- Mark D 3 inches up from A.

Figure 2

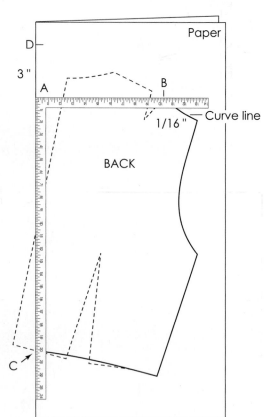

Figure 3
- Crease-fold paper on A–B line. Trace shoulder.

Figure 3

Figure 4

Figure 4
- Unfold. Draw $1\frac{1}{4}$ inches of shoulder and shape to point D for fold-back facing.
- Cut pattern from paper. Unfold.
- Draw bias grainline.
- Develop front pattern, adjusting shoulder for test fit.
- See page 212 to correct the drape.

Mid-Back Cowl

Back:

- Mark A midway between neck and waist.
- Mark B 2 inches from shoulder tip.
- Measure from A to B. Record.
- Mark C to equal dart intake.

Follow instructions given for the first fitting on page 212, Figures 3, 4, and 5 to complete the cowl draft.

Low-Back Cowl

Back:

- Mark A 4 inches up from center back waist.
- Mark B 1 inch from shoulder tip.
- Measure from A to B. Record.
- Mark C to equal dart intake.

Follow instructions given for the first fitting on page 212, Figures 3, 4, and 5 to complete the cowl draft.

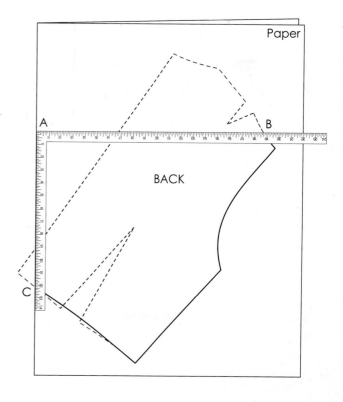

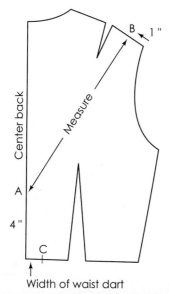

Armhole Cowls

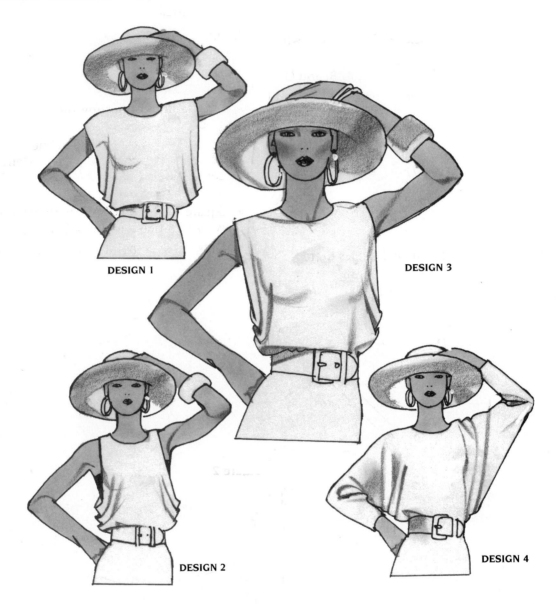

DESIGN 1

DESIGN 3

DESIGN 2

DESIGN 4

Design Analysis: Designs 1, 2, 3, and 4

Cowl drapes under armhole, replacing side seams.

Four variations for underarm cowls:

Design 1—Over shoulder cowl, Figure 1

Design 2—Halter cowl, Figure 1

Design 3—Armhole cowl, Figure 2

Design 4—Sleeved cowl, Figure 2

One-Piece Armhole Cowl

Pattern Plot and Manipulation

Figure 1

- Use front and back basic 2 dart bodice with shoulder dart transferred to armhole.

- Draw a square line on paper. Label A, B, and C.

- Place front bodice on A–B line. Place back bodice 1 inch in from B–C line (for extension) with 1-inch space between front and back side waists for ease.

- Secure and trace front and back pattern, omitting sections indicated by broken lines. Remove patterns.

- Blend a curved line between front and back waist.

Design 1 Over-shoulder cowl

- Stitch shoulder and continue 3 inches more.

Design 2 Halter

- Draw a line from front mid-shoulder to back mid-shoulder.

Design 3 Sleeveless cowl

- Draw a line connecting front and back shoulder tips. Label D–E.

Design 4 Long-sleeve cowl

- Draw a line connecting the shoulder tips. Label D–E.

- Mark the center of the D–E line and draw a line to side waist. From this point, extend the line to equal the desired sleeve length. (Add length if gathers are desired.)

- Square a line out from both sides that equals wrist measurement plus $1\frac{1}{2}$ inches.

- Draw a line to points D and E (over arm seam).

Figure 1

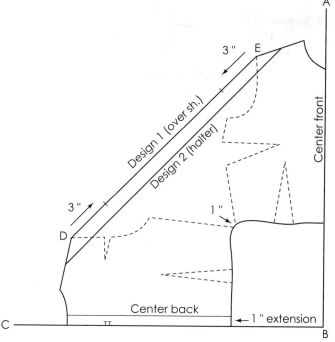

Figure 2

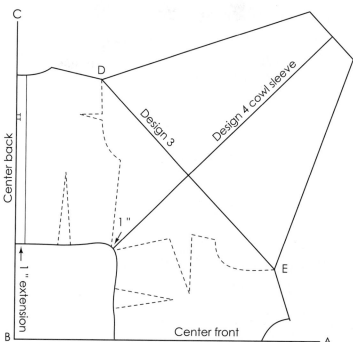

Pleated Cowls

Pleats control the fold of cowls and add fullness. The instructions that follow show the development of cowls with pleats along the shoulderline. The same procedure can be used for cowls with pleats along the armhole and side seams. Cowl designs show some of the possible cowl variations created with pleats. Development of Design 1 is illustrated. For practice, develop patterns for Designs 2 and 3.

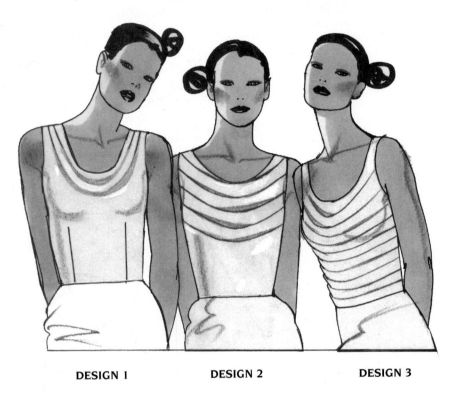

DESIGN 1 **DESIGN 2** **DESIGN 3**

Pleated Shoulder Cowl

Design Analysis

The cowl has two pleats at shoulderline with cowl depth above bust level.

Pattern Plot and Manipulation

Figure 1 Front:

- Trace front pattern and square a slash line from center front to bust point (bust level).
- Mark A between neck and bust level.
- Mark B at mid-shoulder.
- Connect A with B.
- Draw two slash lines, each starting between point B and shoulder tip and ending between point A and bust level.
- Cut pattern from paper.

Figure 1

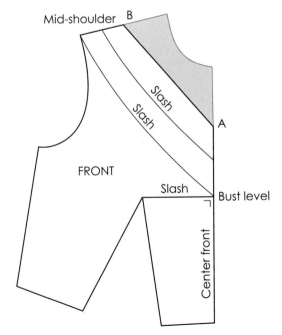

Figure 2

- Fold paper. Square a guideline 4 inches down from fold.
- Cut slash lines to, not through, shoulder.
- Place section A–B on guideline with point A and center front of pattern, touching fold line. (Part of waist dart will close and the slashed sections will spread.)
- Secure pattern sections.
- Draw a parallel line 2 inches in from center front, passing through pattern sections.

Figure 2

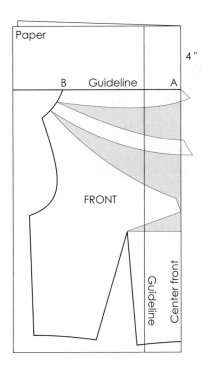

Figure 4

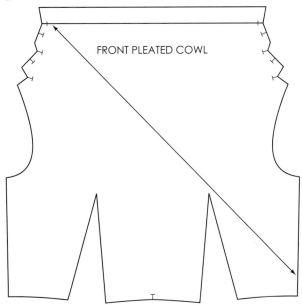

Figure 3

- Release shoulderline.
- Spread each section $1\frac{1}{4}$ inches or more at shoulder (pleat depth), keeping each section on guideline. Secure.
- Trace outline of pattern and corner of each spread section along shoulder for pleats.
- Mark centers of each pleat and connect lines following the angle of the arrows, and end at center mark. Mark notches at each pleat.
- Draw a parallel line 1 inch above A–B line for fold-back (facing).

Figure 3

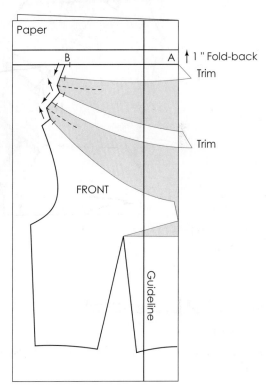

Figure 4

- Cut pattern from paper. Unfold.
- Draw bias grainline.
- Complete pattern for test fit.
- *Follow instructions given for the first fitting on page 212, Figures 3, 4, and 5.*
- To complete back pattern, follow instructions given on page 217, Figure 5.

Exaggerated Cowls

Fuller cowls can be achieved without pleats by spreading the pattern beyond the 90° square line at center front. This type of design requires a seam at the centerline. The empire pattern was used to develop the design illustrated; however, any pattern may be used.

High Exaggerated Cowl

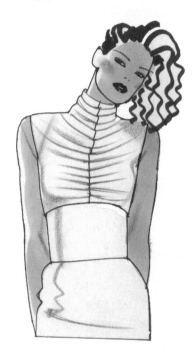

Design Analysis: Design 1

Design 1 features deep cowl folds having a center front seam.

Pattern Plot and Manipulation

Measurement needed

(12) _____ (one-fourth of neck measurement).

Figure 1 *Front*:

- Trace basic front Empire bodice and midriff (pages 168–171).
- Extend a line up from center front neck and square a line 1 inch above shoulder/neck equal to one-fourth of neck measurement plus 1/4 inch.
- Square down to shoulder. Blend a curved line with shoulder line. Label A and B.
- Draw slash lines, with one slash line squared to bust point.
- Cut pattern from paper.

Figure 1

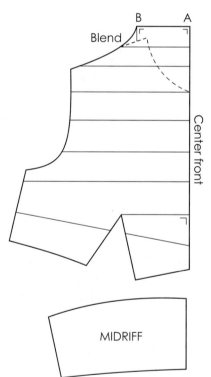

Figure 2

- Cut slash lines from center front to, not through, sides and bust point.
- Close dart legs. Tape.
- Place on paper and spread equally, or vary to control fullness as shown.
- Trace outline of pattern.

Figure 2

Figure 3

- Exaggerated pattern shapes should be labeled for identification.
- Draw grainline.

Figure 3

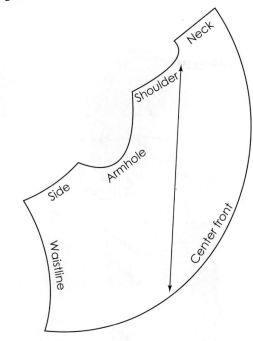

Figure 4

Figure 4 B*ack*:

- Trace basic back empire bodice and midriff.
- Mark 1 inch up from shoulder/neck.
- Square a line from center back touching mark, equal to one-fourth of neck measurement plus 1/4 inch.
- True front and back shoulderlines.
- Draw grainline and complete pattern for test fit.

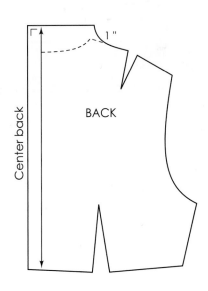

Inset Cowls

Inset cowls can be developed on any bodice, torso, or similar garment. Any styleline cowl inset can be designed. For purposes of instruction, the cowl inset is developed and does not represent a complete pattern. Back patterns are not illustrated. Designs 2 and 3 are included as practice problems.

V-Inset Cowl

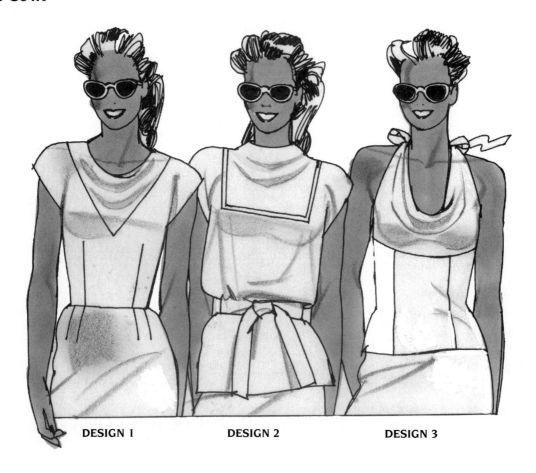

DESIGN 1 DESIGN 2 DESIGN 3

Design Analysis

The V-inset cowl of Design 1 is placed away from neck at shoulder. The point of the V-styleline falls below bust level.

Pattern Plot and Manipulation

Figure 1

- Trace front two-dart pattern. Square a guideline from center front to bust point (bust level). Plot pattern as illustrated.
- Measure down 1/16 inch from shoulder between B and C and draw curved line (controls folds of the cowl when stitched to back shoulder).
- Crossmark for notch between C and D.
- Cut pattern from paper.
- Cut inset from pattern (A, B, C, and D areas). (Lower section of pattern is used to complete the design.)

Figure 1

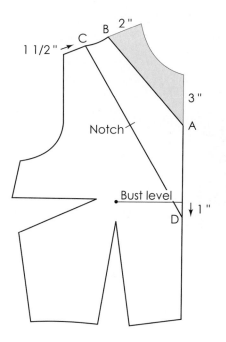

Figure 2

- Trace inset cowl section on center of paper.
- Locate A–B measurement on one leg of square ruler and place at B and the other leg of ruler touching D.
- Draw a line along the ruler from B to A to D as shown.

Figure 2

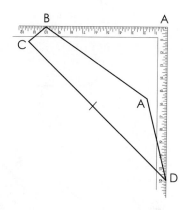

Figure 3

- Fold paper on A–B line. Trace pattern.
- Draw 1-inch line parallel with A–B line. Fold A–B line. Trace shoulder.
- Unfold and complete pattern.

Figure 3

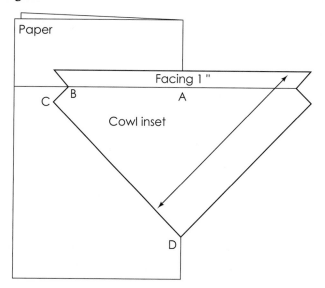

Skirts/Circles and Cascades

Introduction

Changing the silhouette of a skirt (its outer shape, without regard to creative detailing) is one of the focal points for designers who wish to change the look and direction of fashion. A skirt whose basic shape hangs straight from the hipline to the hem is radically changed by increasing or decreasing the sweep of the hemline, moving the skirt away from or closer to the figure, or raising and lowering the waistline.

Skirt Lengths

| Micro Mini | Mini (mid-thigh) | Knee-length | Midi (mid-calf) | Ballerina | Ankle length | Floor length |

Four Skirt Foundations

Each of the four skirt foundations has a specific name that identifies its silhouette. It is the amount of deviation from the basic skirt that determines the new silhouette.

Straight or Rectangular Shape (Basic Skirt)

The skirt hangs straight from hipline to hemline.

A-Shape or Triangular

The skirt falls away from the hip, flaring out at the hemline, increasing the hemline sweep (Circular and flared shapes are included in this category.)

Pegged or Inverted Triangle

The skirt falls inward from hip level to hemline. The pegged silhouette may be achieved by increasing waist and hip fullness or by tapering from the hip to the hem.

Bell-Shape

The skirt clings to the figure's curves at, above, or below the hip and breaks into fluid movement along the hemline.

Skirts are described in terms of the following three areas:

- *The sweep:* The width of the skirt at hemline.
- *Movement:* The fullness of the skirt silhouette.
- *The break point:* The point at which the skirt breaks away from the body into fluid movement.

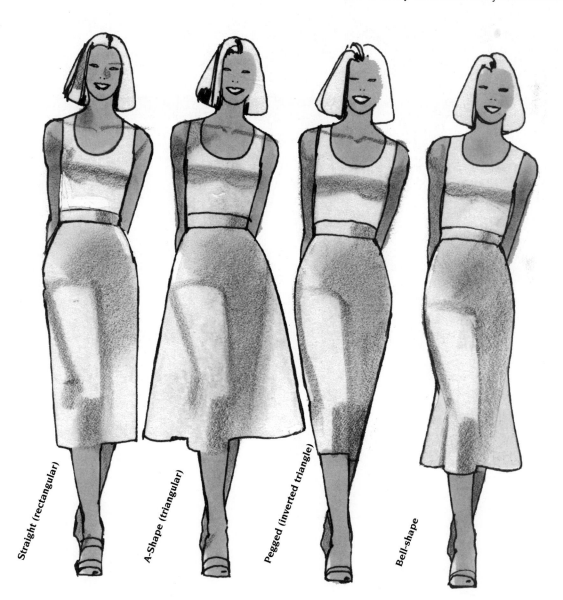

Straight (rectangular)

A-Shape (triangular)

Pegged (inverted triangle)

Bell-shape

Flexibility of Skirt Darts

The three groups of designs illustrate the flexibility of the waist dart when the major patternmaking principles are applied. (The second and third groups show completed pattern shapes.) The design variations are provided to encourage further exploration.

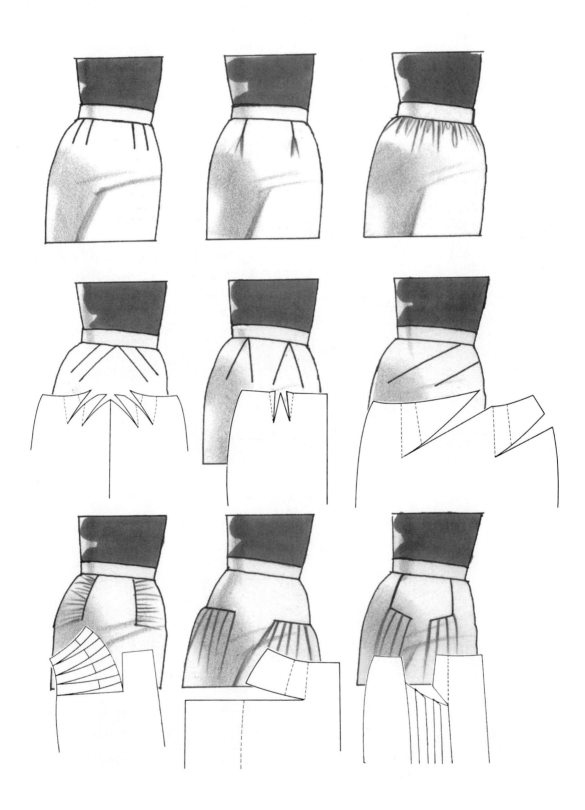

Low-Waisted and High-Waisted Skirts

The waistline of any skirt can be raised above or below the natural waistline.

DESIGN 1 **DESIGN 2**

Low-Waisted Skirt

Design Analysis: Designs 1 and 2

The low-waisted skirt hugs the hip below the waist-line. The waistline can be lowered to any depth desired. The low-waisted and high-waisted skirts are developed from the basic skirt foundation. Design 1 is illustrated. Design 2 is provided for practice. For Bra Tops, see page 663.

Pattern Plot and Manipulation
Figure 1

- Trace front and back skirt patterns.
- Measure down from waist to the desired amount (example: 3 inches), and draw a line parallel to waist.
- *Front:* Remove 1/4 inch at side seam for closer fit.
- *Back:* Remove leftover dart excess at side waist (shaded area).
- Cut patterns from paper.

Figure 1

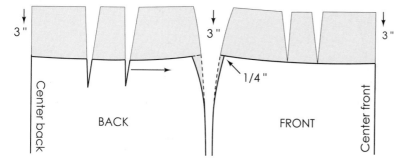

Figures 2 and 3 Facing:
- Trace $2\frac{1}{2}$ inches below new waist of front and back skirt. (Center front should be cut on the fold.)
- Draw grainline, notch, and complete for test fit.

Figures 2 and 3

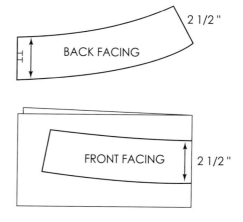

High-Waisted Skirt

Pattern Plot and Manipulation

Figure 1 *Extending waist:*

- Trace front and back skirt. Crossmark center lines, dart points, and side waist.
- Extend center lines upward $2^1/_2$ inches. Label A.
- Flip patterns over, aligning center lines and touching side seams. Draw 2 inches of pattern's side seams. Label B. (Broken lines indicate untraced pattern.)
- Draw new waistline connecting points A and B. Blend side seams.
- Draw line in between dart legs at level with dart points, keeping lines parallel with centerlines.

Figure 1

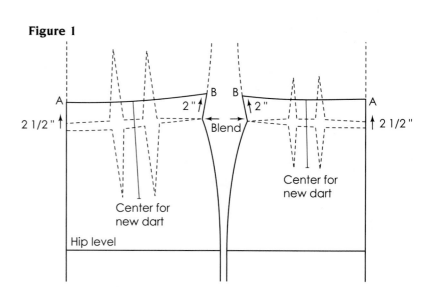

Design Analysis

The waistline extends above the natural waist. Darts on both the front and back are combined into single darts, which are then extended to the new waistline. The waistline can be extended to any height.

Figure 2 **D***art development*:

- Measure out from each side of the line at high waist and at waistline.
- Back—3/4 inch. Mark. Front—3/8 inch. Mark.
- Connect lines to form waist darts.

Figure 2

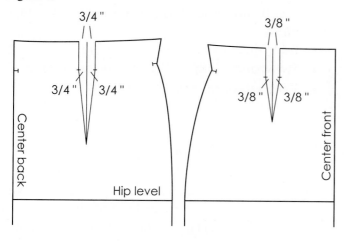

Figures 4 and 5 *Facings*:

- Trace top of skirt to 1 inch below waist, close darts, blend, notch, and add 1-inch extension in back. Cut front on fold.

Figures 4 and 5

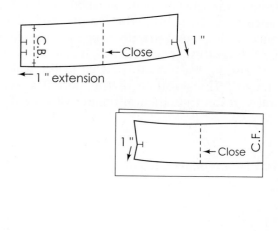

Figure 3

- To complete pattern for test fit, punch and circle darts.

Figure 3

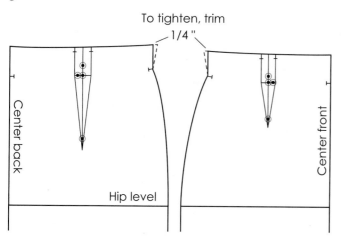

Basic Waistband

The waistline of a skirt (or pant) may be finished with an attached waistband or faced without a band. An attached waistband should be larger than the true waistline measurement (without ease), to compensate for thickness of the darts and seam allowances stitched into the band. The ease allowance varies, but generally, one-half the ease allowed for waistline (example: 1-inch ease at waist, 1/2-inch ease for waistband) is added to the waistband length. The waistline of the skirt has ease allowance greater than the waistband (with the dif-

ference eased in). Ease helps to eliminate possible abdominal stress and a rolling of the skirt just below the band. The extension of the waistband is for a button and buttonhole. The extension can be blunted, pointed, or curved, and can extend more or less than 1 inch.

Example: 24-inch waist (without ease).

- Waistband length = 24 plus 1/2 inch = $24\frac{1}{2}$ inches.
- Add 1-inch extension = $25\frac{1}{2}$ inches.
- Waistband width = $2\frac{1}{2}$ inches before folding.
- Finished width = $1\frac{1}{4}$ inches.

Pattern Plot and Manipulation

Measurements needed:

- (2) Waist _____ (without ease)
- (19) Front waist arc _____

Figure 1

- Fold paper lengthwise and use measurement given.

A–B = Finished width, squared from fold.

B–C = Waistband length, squared from B.

C–D = 1-inch extension (for button and button-hole), squared to fold line.

B–E = One-half of B–C (location for center front).

- If required, locate side seam notches out from each side of E, using front waist arc measurement plus 1/8 inch. Mark.

Figure 1

Figure 2

- Add 1/2-inch seam allowance. Locate buttonhole and button placement (see Chapter 16). Cut from paper.

Figure 3

- Completed waistband.
- Draw grainline straight or crosswise.

Figure 2

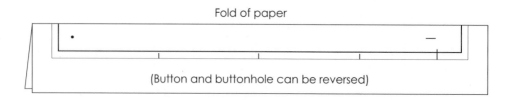

Figure 3

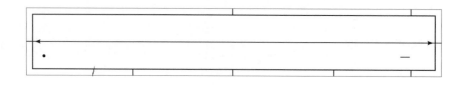

Flared Skirts

The flared skirt series applies Principle #1, Dart Manipulation (dart excess transferred to the hemline) and Principle #2, Added Fullness, to increase the sweep of the hemline. These types of skirts have a triangular silhouette.

A-Line Flare Skirt

Design Analysis

The A-line silhouette is one in which the hemline measures greater than the hipline circumference. It is achieved by transferring the excess of one dart to the hemline and by adding width to the hem of the side seam. The result is a more rounded effect along the hemline that provides additional stride room.

Pattern Plot and Manipulation

Figures 1 and 2

- Trace front and back basic skirt.
- Draw slash lines from the dart points nearest side seams to hemline, parallel with center lines, and label.
- Cut from paper.
- Cut to, not through, dart points.
- Place on paper.

Figures 1 and 2

FRONT

Slash line

Center front

Center back

Slash line

BACK

A | B

C | D

Figure 3 *Front*:

- Close dart and trace pattern.
- Label flare at hem A and B.

A-line silhouette:

- Label side seam at hem X.
- X–Y = one-half of A–B space. Mark.
- Draw a line from Y to the outermost part of hipline. Where lines intersect, label Z.
- Z–Y = Z–X length. Square in from Y just past X.
- Draw blending line along hem. (Use the instruction for other garments having an A-shape silhouette.)

Figure 3

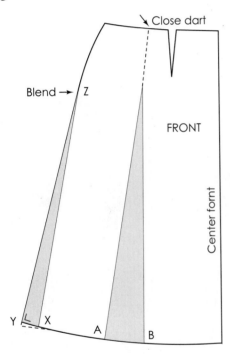

Figure 4 *Back*:

- Transfer just enough excess from waist dart to hemline so that space C–D equals A–B space of front skirt. The remaining dart excess is taken up by the other dart.
- Move dart point half the amount and draw dart leg (broken lines = original dart leg).
- Trace, adding to side seam using X, Y, Z instructions (Figure 3).
- Draw grainlines, cut from paper, and complete for test fit.

Figure 4

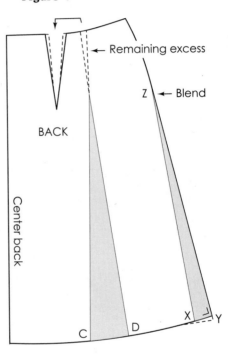

Figure 5

- Completed pattern with seam allowance.

 Note: Cut front on fold, or add 1/2 inch seam for a 4-gore skirt. Use seamless pattern as a foundation pattern and seams when used as a skirt design.

See page 306 for instruction of the effects that grainline has on flare placement.

Figure 5

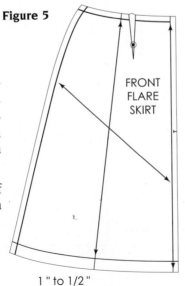

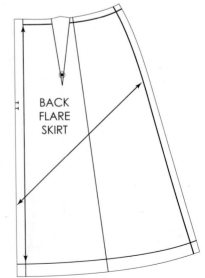

1 " to 1/2 "

Basic Flared Skirt

Design Analysis

A flared skirt has more sweep along its hemline than does the basic A-line skirt. All of the dart's excess is transferred to the hemline to increase flare. The dart intake of the back skirt is greater than the front, causing the hemline sweep from front to back to differ. If this difference is not equalized, the side seams will hang unequally. (The longer length will be eased in by the operator, causing the seamline to twist and curl. To correct the problem, two methods are given for balancing the sides of the skirt: slash-spread, and pivotal-transfer using the one-dart skirt foundation.

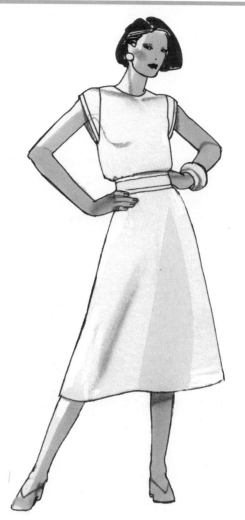

Pattern Plot and Manipulation

Figures 1 and 2

- Trace front and back skirts.
- Draw lines from dart points to hemlines parallel with center lines.

Figures 1 and 2

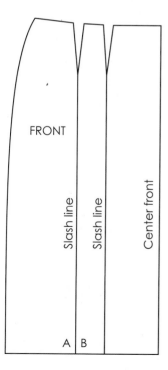

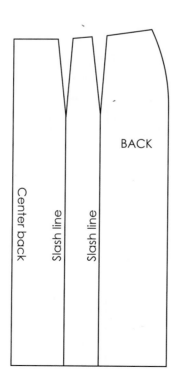

Figures 3 and 4
- Cut slash lines to, not through, dart points.
- Close darts. Tape.
- Trace patterns.

- Establish front and back A-shape at side, using one-half of A–B space and instructions given for basic A-line skirt for blending hemline (see page 242, Figure 3).
- Blend across hemline as shown.
- Cut out front only.

Figure 3

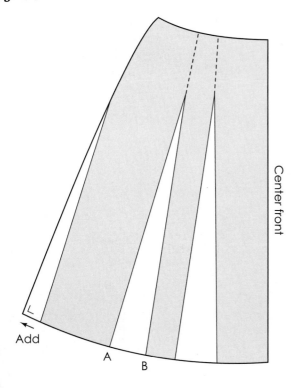

Figure 4

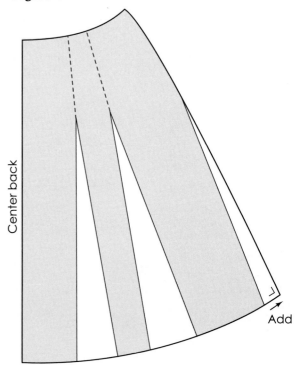

Figure 5

Figure 5 B*alancing the side seam*:
- Place front on top of back pattern, matching center lines.
- Measure and divide the difference between front and back skirt at the side hems.
- Add one-half of this amount to the front and remove one-half from the back (shaded section).
- Blend side seams to hipline.
- Cut front skirt from paper. Draw grainline and complete for test fit.

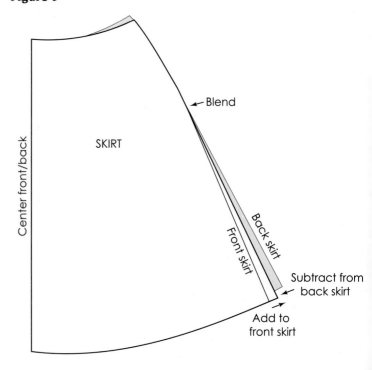

One-Dart Skirt Foundation

The one-dart skirt foundation has several functions: to develop flare skirts with a near equal hemline sweep and to create skirts that cling to the hipline by transferring the dart excess below the dart points. To develop the pattern, the basic skirt is modified.

The example is a guide. Use your own measurements:

- Add dart intake of the front and back together. Front darts = 1″, back darts = 2″, total 3″.
- Divide in half = 1½″ (intake for each dart).

Figures 1 and 2

- Trace front and back patterns, disregarding dart legs (broken lines). Mark in between darts at waist. Draw guidelines from marks to hemline, parallel with center lines.

- Measure down 4½ inches from front and back waist on guideline and crossmark for dart point.

- Measure out 3/4 inch (personal measurement may vary) from each side of guideline at waist. Mark and connect with dart point.

- Measure down on guideline from dart point, making a series of four marks spaced 1½ inches apart. (Marks represent future pivotal points for developing slinky skirt styles that cling.)

Figure 1

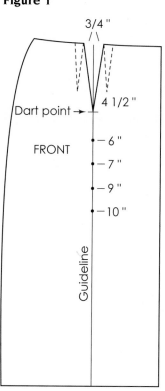

Figure 2

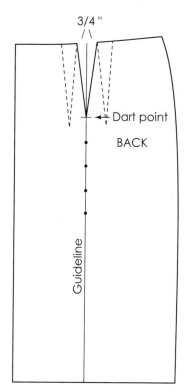

Flared Skirt Based on One-Dart Pattern

Pattern Plot and Manipulation

Figure 1

- Trace front one-dart skirt pattern from A to C (shaded area).
- Crossmark at A on paper.

Figure 1

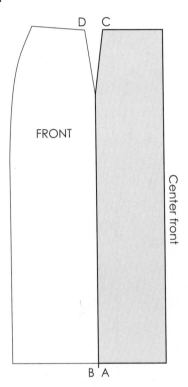

Figure 2

- With pushpin at dart point, bring dart leg D to C.
- Trace from D to B. Crossmark (shaded area). Remove pattern.

Figure 2

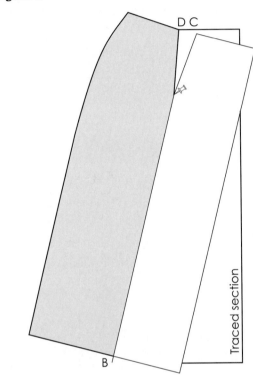

Figure 3

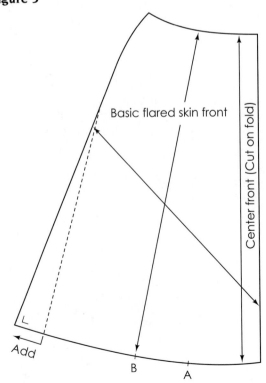

Figure 3

- Add to side seam using one-half of A–B space and follow A-line instructions for blending hemline (page 242, Figure 3). Mark choice of grainlines as shown. (Choice of grainline affects the hang of flared skirt. See page 306, Figure 1.)
- Repeat instructions to develop skirt back.

Added Flare Skirt

Design Analysis

The hemline sweep may be increased by adding additional flare within the pattern's frame and to the side seams (for balance). The skirt will have more sweep than the basic flared skirt. Long skirts with great sweeping hemlines are often wider than the fabric. A separate pattern should be made for the section that extends beyond the fabric (Figure 3). Skirts with added flare may be developed from either the basic one-dart or two-dart skirt or from the circle chart (page 302). One-dart pattern is illustrated.

Pattern Plot and Manipulation

Figure 1

* Trace skirt pattern.
* Draw slash lines. Label A and B.

Figure 1

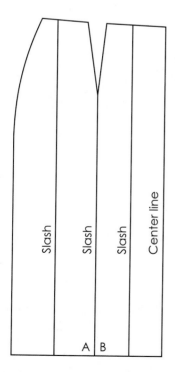

Figure 2

- Cut slash lines to, not through, waistline.
- Place on paper and spread each section 5 inches or more.
- Trace outline.
- Add to side seams and blend hemline; draw a straight line from hemline to waistline. (Broken line indicates the hipline curve no longer needed when sufficient fullness is added to skirt.)
- Draw grainline.
- Repeat instructions for skirt back.
- Complete pattern for test fit. Before marking hemline, hang skirt overnight (allows grain to fall) and mark new hemline. Adjust pattern.

Figures 3 and 4

Modification for wide hemline sweep:

- Broken line indicates section of skirt that overhangs the width of fabric.
- Mark pattern at selvage. Crossmark for notches.
- Make separate pattern for section that hangs over selvage as shown (Figure 4).

Note: Center line can be placed on crosswise grain to avoid adding this section in some instances.

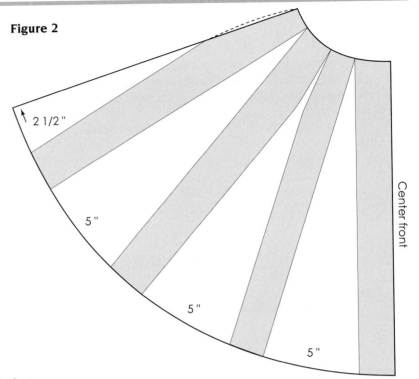

Figure 2

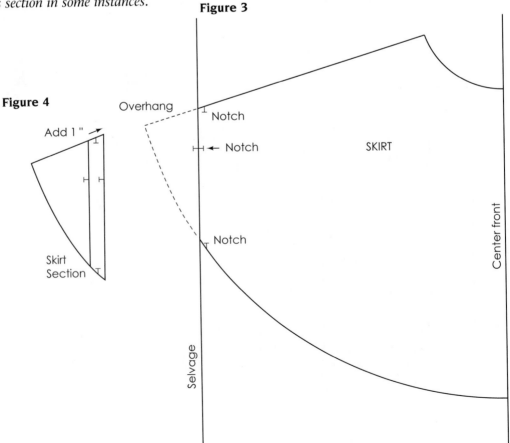

Figure 3

Figure 4

Skirts with Gathered Waistlines

Several factors should be considered before computing the amount of fullness required for gathers.
a. Fabric weight: Firmly woven fabric limits the amount of gathers that can be stitched into a seam; lightweight fabrics can tolerate greater fullness.
b. Cost of the garment: Gathering increases the amount of fabric in the garment and adds to the labor cost.

Computing for Gathers

Example: Gathers for a 26-inch waistline. See Figure 1.

$26 \times 1^1/_2$ = 39 inches (13 inch for gathers), $1^1/_2$ to 1 ratio—inexpensive garments

26×2 = 52 inches (26 inches for gathers). 2 to 1 ratio—average fullness

$26 \times 2^1/_2$ = 65 inches (39 inches for gathers) $2^1/_2$ to 1 ratio—average fullness

26×3 = 72 inches (52 inches for gathers) 3 to 1 ratio—chiffon and lightweight fabrics

26×4 = 104 inches (78 inches for gathers) 4 to 1 ratio—chiffon and lightweight fabrics

There are two popular skirt foundations having a gathered waist: the flare skirt and the dirndl, or rectangular skirt. The skirts are developed differently and have different silhouettes. Long skirts may exceed the width of the fabric; see page 248 for guidance. The flared skirt is illustrated first, followed by the dirndl.

Figure 1

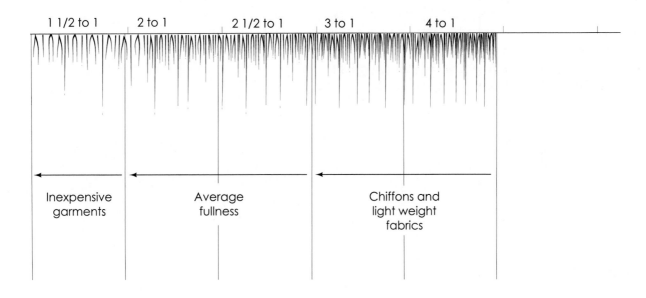

Flared Skirt with Gathered Waistline

The flared skirt can be based on the basic or the one-dart skirt pattern. (The basic skirt is illustrated.) The method is called the "rocking horse." The skirt is plotted in sections for spreading. Open the waist sections first and then the hemline sections. The slash and spread and pivotal-transfer methods are used together.

Pattern Plot and Manipulation

Figure 1

* Plot the front pattern and number the sections.

Figure 1

Design Analysis

This design has a gathered A-line silhouette and is achieved by adding uneven fullness within the pattern's frame and adding "A" line at the side seams. See page 242, Figures 3 and 4.

Figure 2

- Slash sections 1, 2, 3, 4, and 5 from waist to, but not through, the hemline.
- Trace waist and hem of section 1. Place pushpin at hem and spread waistline desired amount. (Labels A and B.)

Figure 2

Figure 4

- Place pushpin at hem of section 2 and spread waistline equal to A–B. Trace waist and hem of section 3.

Figure 4

Figure 3

- Place pushpin at corner of section 2 at waist, separate, and spread hemline desired amount. (Labels C and D.)
- Trace section 2.

Figure 3

Figure 5

- Place pushpin at corner of section 3 at waist and spread hem equal to C–D. Repeat this process until the five sections have been manipulated.

Figure 5

Figure 6

- Add one-half of space C–D to the side seam of the skirt.

- Draw a straight line to waist, trimming the hipline curve.

 Options: Repeat the process for the back skirt; or trace a copy of the front skirt, adjusting back waistline by trimming 3/16 to 1/4 inch from the center back, blending to zero at the side seam.

Figure 2

Trim

One-half of space C - D

5

4

3

2

1

D C

Gathered Dirndl Skirt

Dirndl skirts are rectangular in shape (waist and hemline are of equal measurements). To compute the amount of fullness for gathers, the width of the fabric is considered. Generally, if the fabric is 36 inches wide, 2 widths are cut; if it is 45 inches, 1$\frac{1}{2}$ widths are cut. If greater fullness is required, review instructions given on page 249.

Pattern Plot and Manipulation

Figure 1

- Draw a vertical line on paper equal to desired length plus 3 inches (hem and waist seam allowance). *Example:* Finished length 26 inches plus 3 inches (1/2 inch at waist and 2$\frac{1}{2}$ inches at hem); total 29 inches.
- Square a line out from the top and bottom of the vertical line at each end equal to width of the fabric. Connect lines to complete the panel.
- Cut panel twice for 36-inch fabric, and 1$\frac{1}{2}$ times for 45-inch fabric (not illustrated). Add more panels if desired.
- Lower center back panel 1/4 inch. Blend to sides.
- Notch center of panel's width for center front and center back. Notch hem and seams.
- Skirt may have either a side opening for entry or a split panel at center back for seam and zipper (broken line).

Figure 1

Full width

1/4" FRONT

Trim back waistline

BACK

Center back

Option:
Cut apart for center back seam

Clinging Hipline with Flare—The Slinky

The slinky skirt is based on the one-dart skirt foundation pattern; see page 245. The pivotal point is lowered when developing skirts that cling to the hipline. The lowered pivotal point causes a loss of measurement around the hip circumference area, tightening the skirt slightly. The skirt clings to the hips and flares out from a point above, at, or below the hipline (depending on the location of the pivotal point). Fabrics used for clinging skirts should be loosely woven, cut on the bias, or knit to allow the skirt to mold over the hipline. The skirt may be cut on a fold or seamed. If seamed, flare can be added to the center lines.

DESIGN 1 DESIGN 2 DESIGN 3

Design Analysis

Designs 1, 2, and 3 are flared skirts using different pivotal points. Each skirt clings to the hipline at a different location.

Figure 1

- As the pivotal point is lowered (A, B, and C), the hemline sweep is less flared. The lower the pivotal point, the lower the cling around hipline.

 A—Design 3

 B—Design 2

 C—Design 1

Figure 1

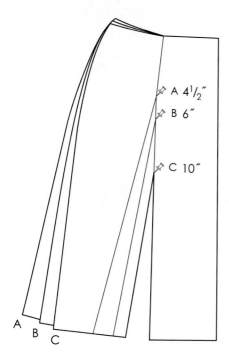

A 4$\frac{1}{2}$″

B 6″

C 10″

A B C

Figure 3

FRONT

Figure 2

- The example indicates dart closed at point C.
- Flare may be increased by adding approximately 1 inch to the side waistline and blending to hipline. The waist dart intake is increased by an equal amount (the waistline measurement remains the same). The increased dart provides more flare at hemline.
- Add flare to side seam and at center front using A–B measurement. Allow 1$\frac{1}{2}$ to 2 inches at side seam of hemline, blending to hipline. Stitch skirt from waist to hipline, and place on form or hanger (pinning along waist) overnight. Flare will fall into the hemline sweep. Repin and mark side seams along adjusted line. Correct the pattern.

Figure 2

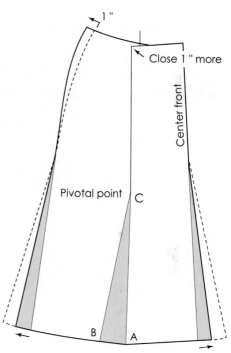

1″

Close 1″ more

Center front

Pivotal point C

B A

Figure 3

- Completed pattern for Design 2. Draw bias grainline. Repeat for back.

Gored Skirts

A gore is a skirt panel that tapers toward the waist-line. A gored skirt contains any number of gores—from 4 to 12 or more—equally spaced or in clusters, depending on the look desired. The gore may hang straight from hip level, may be flared or pleated, and may break away at any point along the seam-line of the gore. This results in a wide variety of sil-houettes. It is important to remember that each joining section (gore) must be notched to assure the correct panels are matched when stitched. Designs 1 through 12 are examples of gore variations.

4-Gore Flared Skirt

Design Analysis

The basic 4-gore skirt is developed from the basic A-line skirt and has an attached basic waistband. (The belt is separate and not part of the waistband.)

Pattern Plot and Manipulation

Figures 1 and 2

- Trace front and back basic A-line skirt (see pages 241–242).

- Add seam allowance to center front and back of a 4-gore skirt.

- Cut patterns from paper and draw straight, bias, and center grainlines (options for future designs).

- Complete pattern for test fit.

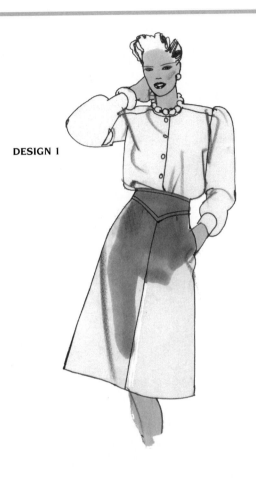

DESIGN 1

Figure 1

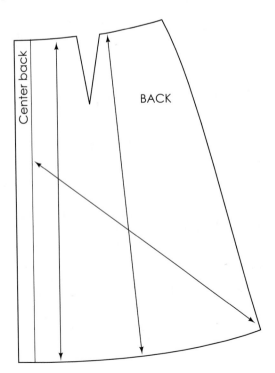

Center back

BACK

Figure 2

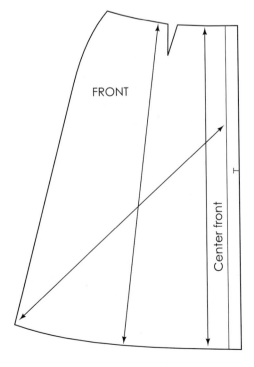

FRONT

Center front

6-Gore Flared Skirt

Two versions of the 6-gore skirt are described—a moderate hemline sweep with a side back dart, and a fuller hemline with the second dart's excess transferred to the hemline for greater fullness.

Design Analysis

The 6-gore skirt has a full panel across the front and back with two panels joining each side for a total of six gores. The zipper is placed at side seam. The 6-gore skirt is based on the basic front and back skirt.

Pattern Plot and Manipulation

Figure 1 *Front gore*:

- Trace front basic skirt.
- Draw gore line from dart points to hem, parallel with center front. Labels A–B.

Figure 2 *Back gore*:

- Trace back basic skirt.
- Draw line from dart points to hem, parallel with center back. Labels C and D.

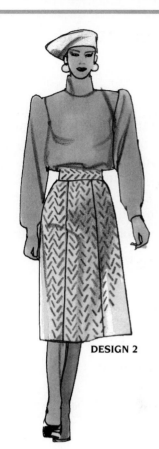

DESIGN 2

Figure 1

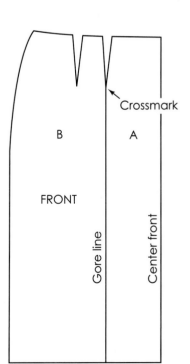

Crossmark

B A

FRONT

Gore line

Center front

Figure 2

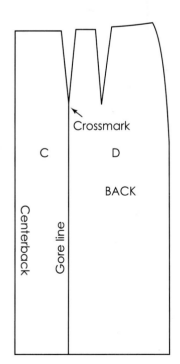

Crossmark

C D

BACK

Centerback

Gore line

6-Gore Skirt—Moderate Hemline Sweep

Figures 3 and 4

Front darts: Increase dart intake equal to the amount of the second dart. (Figure 3).

Back darts: Reduce second dart intake by 1/2 inch, and shorten to $4^1/_2$ inches. Increase longer dart by 1/2 (Figure 4).

- Add gore flare out from each side of guideline. Connect lines to dart points.

- Add flare at side seams, connecting line to hip.

Figure 3

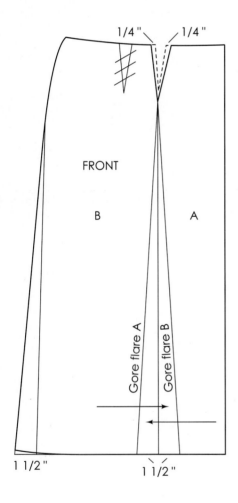

Figure 4

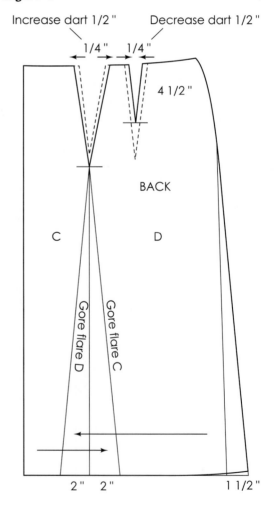

Figures 5, 6, 7, and 8 *Separate gore panels*:

To separate gore panels from the plotted pattern, slip pattern paper underneath the draft and trace for each section. The paper is removed and the perforated marks are penciled in. The side gore panels (Figures 5 and 7) have grainlines drawn through the centers of each panel. The front and back panels (Figures 6 and 8) are cut on the fold, with grainlines drawn at, or parallel to, the center lines.

Notch as indicated.

Figure 5 **Figure 6** **Figure 7** **Figure 8**

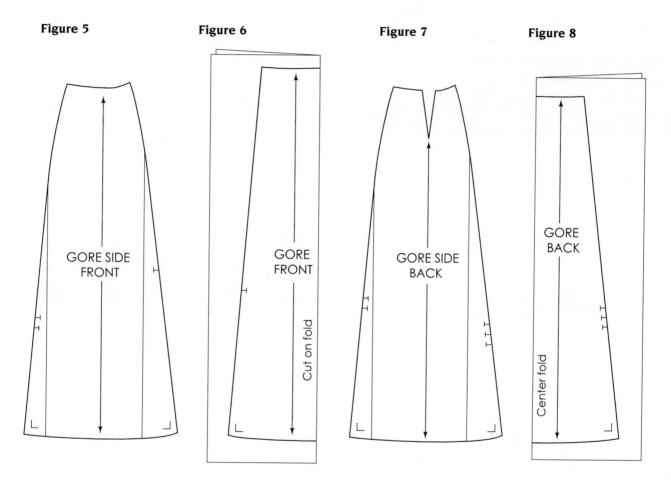

GORE SIDE FRONT

GORE FRONT

Cut on fold

GORE SIDE BACK

GORE BACK

Center fold

6-Gore Skirt—Greater Hemline Sweep

Design Analysis
The second dart of the front and back skirt are transferred to the hemline, increasing the sweep of the skirt.

Pattern Plot and Manipulation
Figures 1 and 2 *Front and back*:
- Plot the front and back skirt, using the illustrations as a guide. Follow the angle of the open dart legs when establishing gore flare lines.
- Add $1\frac{1}{2}$ to 2 inches at the side seam for A-line flare; see Figure 3 and 4 of page 242.

Figure 1

BACK

A

B

Core flare B

Core flare A

Guideline

Figure 2

FRONT

C

D

Core flare D

Core flare C

Guideline

Figures 3, 4, 5, and 6

- Transfer panels A, B, C, and D to paper with the center front and center back panels placed on fold.

- Complete the pattern for a test fit.

Figure 3

A
BACK
6 gore

Center fold

Figure 4

B
SIDE
BACK

6 gore

Figure 5

C
SIDE
FRONT

6 gore

Figure 6

D
FRONT
PANEL

6 gore

Cut on fold

8-Gore Flared Skirt

Design Analysis

The 8-gore skirt has 4 flared gores in front and back.

Pattern Plot and Manipulation

Use the instructions for the 6-gore skirt (moderate, page 257 or greater flare, page 260) to develop the 8-gore version, with the following variation: The center front and center back are seamed and notched.

Figure 1 *Back gore*:

* Add 3/4 inch to center back seam.
* Notch for zipper $7^1/_2$ inches from seamline.
* Place two notches at center back for identification.

Figure 2 *Front gore*:

* Add 1/2 inch to center front seam.
* Place a single notch at center front for identification.

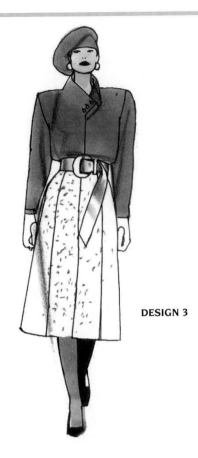

DESIGN 3

Figure 1

See the remaining pattern shapes on pages 259 and 261.

BACK

8 gore

Figure 2

FRONT

8 gore

10-Gore Skirt with Pleats

Design Analysis

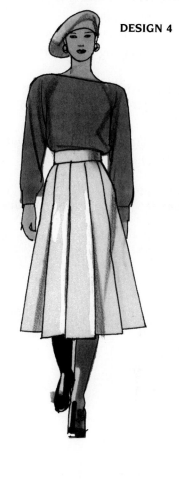

DESIGN 4

The 10 panels are arranged so that the front panel is wider than the joining panels. All panels have pleats, except at side seams. This example illustrates the flexibility of gores when used for design variations.

Pattern Plot and Manipulation

Figure 1 Front:

- Trace basic skirt front.
- Measure the distance from dart point to center front.
- Mark hem from center front to equal this measurement, *plus* 1 inch. Label A.
- Draw goreline from mark to dart point. Shift second dart 3/4 inch toward side. (Broken line is original dart location.)
- Draw second goreline from new dart point to hem, parallel with first goreline. Label B.
- Add 2 inches to side seam at hem.
- Connect line to outermost part of hip. Blend hemline using A-line instructions (see page 242, Figure 3).

Figure 2 Back:

- Repeat process to develop back skirt.

 Note: Mark gore width (C–D) at hem equal to front gore width (A–B), and shift dart to goreline.

Figure 1	Figure 2

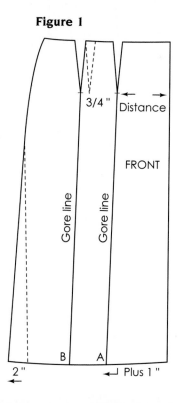

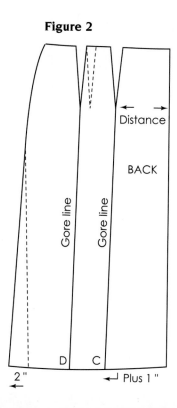

Figures 3, 4, and 5 Front:

- Cut and separate gore sections.

- Trace gores, placing center front of gore on fold (Figure 5).

- Measure down from waist of gore panels to a location where pleats are to begin (example: 6 inches).

- Square out 1/8 inch from each mark. Label X.

- With square rule held at this location, draw a line $1\frac{1}{2}$ inches out from point X for pleat depth. Mark.

- Square out $2\frac{1}{2}$ inches or more at hem. Mark and blend hemline. Connect to complete pleats.

- Draw a blend line from X to gore panel.

- Mark for notches and grainline.

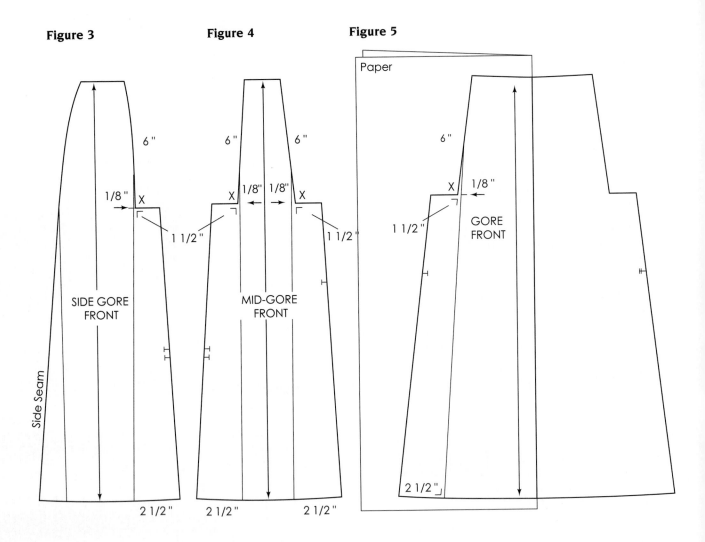

Figure 3 **Figure 4** **Figure 5**

Figures 6, 7, and 8 B*ack***:**

- Repeat instructions given for front gores.
- Mark identification notches.

Figure 6

SIDE
GORE
BACK

Figure 7

MID-GORE
BACK

Figure 8

Paper

GORE
BACK

CENTER BACK

Figure 9 P*leat support***:**

- To add seams (for gore panels with pleat), draw
 seam allowance from waist parallel to goreline,
 curving out to tip of pleat as shown.
- Place punch and circle 1/8 inch in and up from
 point X.

 Note: Allow skirt to hang several hours (for bias
 to relax.) Re-mark hemline if necessary.

Figure 9

X X

12-Gore Skirt

Introduction

Gores having 12 or more panels can be generated through the draft of a gore panel which is cut as many times as it represents. Flares can be added to the shape of the gore panel in creating the Trumpet, Flip, and Tulip silhouettes.

The gore panel is drafted by dividing the waist, and hip into the number of gores desired. The example is for a 12 gore skirt. The dart excess of the waist is absorbed into each of the cut panels.

Measurements needed:

* (2) Waist _____ plus 1-inch ease _____ .
* (4) Hip _____ plus 2-inch ease.
* Center front hip depth _____ .

 Designs using the 12 gore panel follow:

Formula for 12 Gore panel
Figure 1

* Draw a line to length desired (A–B)
* Mark C.F. Hip depth (C)
* Mark one-third between A and C. (D)
* Divide waist and hip measurement by 12. Divide in half and record.
 Waist = _____ Hip = _____

Figure 2

* Using the above measurement, square a line out from A—Waist, and B hem, C—Hip, D—Abdominal, 1/8 inch less than Hip.

Figure 3

* Draw lines connecting the outline, and blend to waist a slightly outward curve.

Figure 1

Figure 2

Figure 3

12-Gore Design Variations

Designs 1, 2, and 3 are examples of creative use of the 12-gore panels. To develop these designs, follow the instruction given for each of the gore flare designs.

Figure 1—Design 1

Flare added equally on each side of the 12-panel skirt.

Figure 2—Design 2

Angle styleline cut through each panel with flare added.

Figure 3—Design 3

Uneven flared hemline, pointed or rounded.

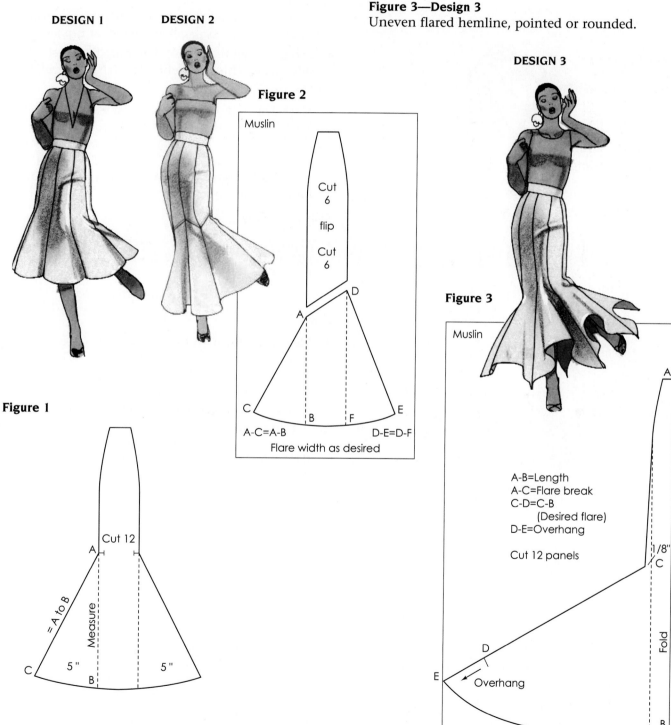

DESIGN 1

DESIGN 2

Figure 2

Muslin

Cut 6

flip

Cut 6

A-C=A-B D-E=D-F

Flare width as desired

Figure 1

Cut 12

=A to B

Measure

5" 5"

DESIGN 3

Figure 3

Muslin

A-B=Length
A-C=Flare break
C-D=C-B
 (Desired flare)
D-E=Overhang

Cut 12 panels

1/8"

Fold

Overhang

12-Gore Graduated Flare

Design Analysis

The graduated flare skirt can be developed from the 12-gore (or any gore) foundation panel by varying the hemline and the breakpoint for flare on each gore panel.

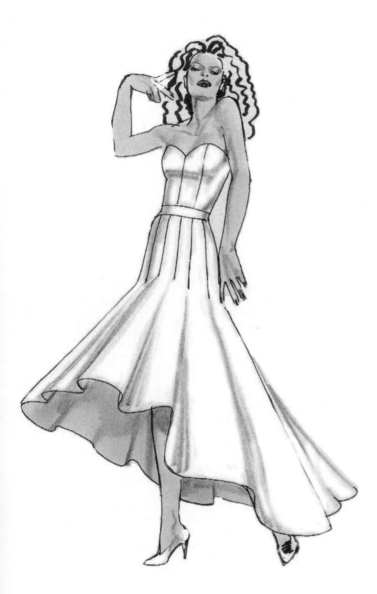

Pattern Plot and Manipulation

Figure 1

- Trace gore panel on paper. Label center front. Square line across panel and paper at hip level.
- Retrace panel five times, matching hip level and side seam. (This represents one-half of the skirt.)
- Number the panel.
- Mark 1/4 inch down from waist at center back and draw waistline to third panel (side seam). Trim.
- Extend center front (Panel 1) and back (Panel 6) to desired length. Label A and B and draw line for new hemline.

Flare development:

- Measure up from A at center front to a point where flare will begin (example: 12 inches). Label C.
- B–D = A–C. Mark. Draw line from C to D.

Panel 1:

- Measure out from A to width of flare (example: 4 inches). Mark and connect with C. This line should equal A–C length. Blend gore panel to hem. Label Flare 1.
- Repeat for other side of panel and continue marking flare on each side of each panel equal to length and width of Flare 1. (Bold lines indicate flare panels for gores 1, 3, and 5. Broken lines indicate flare panels for gores 2, 4, and 6.)

Separate panels:

- Place paper underneath pattern and transfer gores as follows: For gore 1, trace bold line. For gore 2, trace flare indicated by broken lines. Continue the process until all gores are transferred.

Figure 1

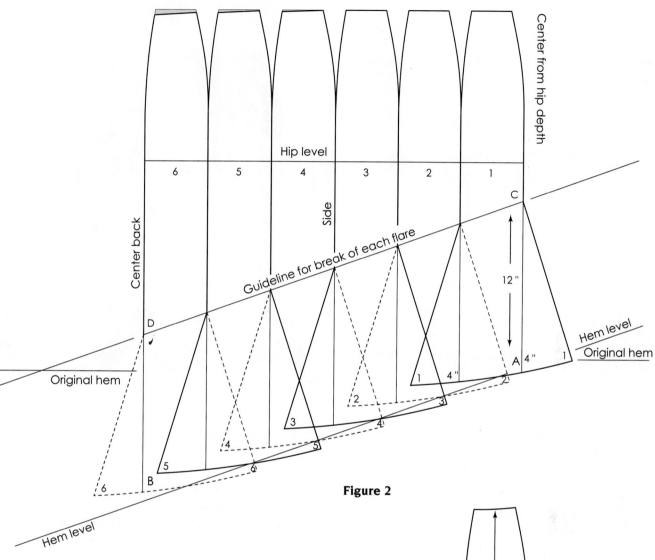

Figure 2

Figure 2

• Example of a panel shape for flare 1.

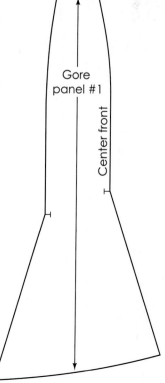

Zig-Zag 12-Gore Skirt

Design Analysis

The gore skirt is designed with a zig-zag pattern. The waist is raised above the waistline and cut to a V-shape at center. Flare breaks low on the hipline. An additional design is given for practice.

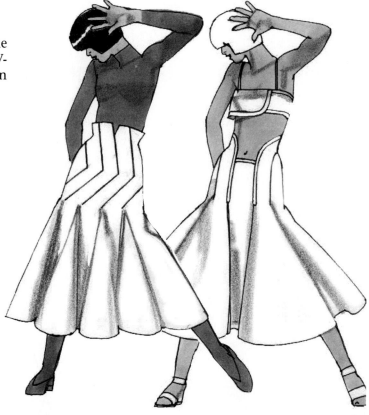

Figure 1

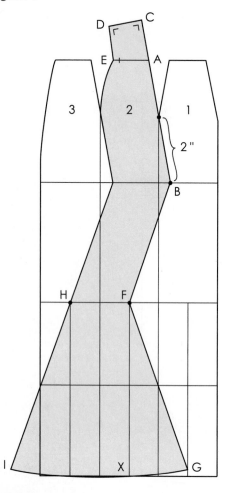

Pattern Plot and Manipulation

Figure 1 Base panel:

- Trace three copies of the gore panel side by side. Extend to desired length.

- Square short lines up from the centers of each panel. Label X at center of panel 2 at hem. Panel 2 is plotted for the zig-zag panel design.

A–B = 2 inches past dart point (line enters panel 1). Line follows angle of dart leg.

A–C = 2 inches (for high waist), as shown.

C–D = A–E, squared from C. Draw line to E.

B–F = A–B, connected to center guide of panel 2 (X guideline).

F–G = F–X (for flare) ending at center guideline of panel 1. Draw a curved hemline to X. Panel 2 establishes panel width. To complete the gore panel, draw parallel line with B, and F. Continue line from H.

H–I = F–X (for flare). Draw curved hemline.

Figures 2a, b

- Trace two copies of the pattern for center front panels.
- Label patterns: *Cut 1-right side up*
- Modify front panel by trimming 1/4 inch from high waist of skirt for "V" design.

Figure 3

- *Cut 10* panels. Label pattern.

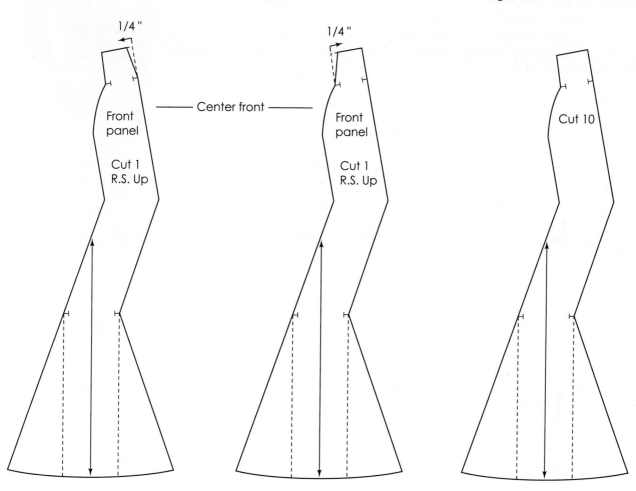

Figure 2a **Figure 2b** **Figure 3**

Figure 4 *Facing*:

- Trace tops of 6 panels side by side, ending 1/2 inch below waist. Start with panel shown in Figure 2a, and ending with panel in Figure 3. Add 3/4 inch for extension.

Figure 4

Facing - Cut two copies for facing patterns

Gore-Cowl Skirt

The skirt is based on the 12-gore pattern (page 266). The design demonstrates the versatility of the gore panels.

Design Analysis

Cowls fall from each of the joining 12 gores. The cowl depth can vary as can the length of the skirt.

Pattern Plot and Manipulation

Example: Adjust and mark the 12-gore panel as follows:

Extend to skirt length (26"). Mark the place where the fall of the cowl starts (4" below waist). Decide cowl depth (6"—12" full width) and height of the raised waistline (3").

Figure 1

- Fold the paper.
- Trace the gore panels by following the illustration.
- As each panel is traced, it is flipped upward from waist to trace the raised waistline.
- Add seams and complete the pattern. Cut in fabric for a test fit.
- The cowl can be stitched closed, or left open if a slip is worn.

Figure 1

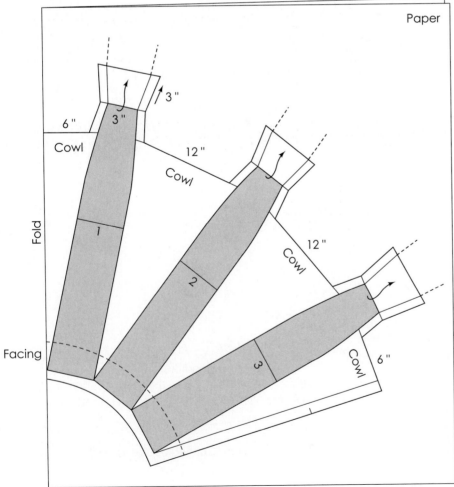

Pegged Skirt Silhouette

The pegged silhouette is achieved by adding fullness at waistline or tapering the side seams. The skirt may be gathered, pleated, or cowled into the waistband. For modified fullness at the waist, the basic back pattern may be used as is, or darts may be developed for gathers. For exaggerated fullness at the waist, the back pattern should be spread the same as the front waistline.

Pegged Skirt with Gathers

Design Analysis

The skirt has a pegged silhouette, created by gathers along the front and back waistline. Design 1 is a practice problem. (See cowl drape pant, page 589, for guidance.)

Pattern Plot and Manipulation

Figure 1

- Plot pattern, directing slash line from waist to hem and to side seams.
- Repeat for back (not illustrated).

Figure 2

- Cut to, not through, hem and side seam.
- Place on paper and spread each section (more or less as desired). Secure pattern pieces and trace outline.
- Draw blending line across the open spaces.
- Draw grain and complete pattern for test fit.
- Repeat for back (not illustrated). Back is seamed for zipper.

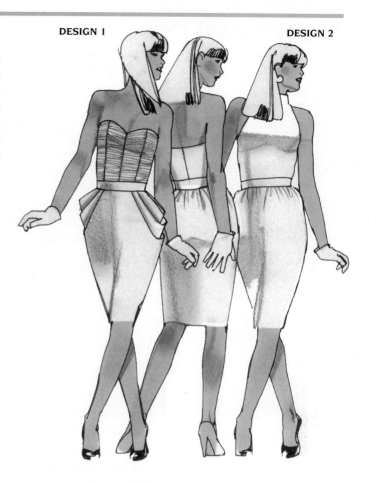

DESIGN 1 DESIGN 2

Figure 2

Figure 1

Pegged Skirt with Pleats

Design Analysis

The side seams are tapered. Pleats along waistline radiate toward side seam. The stylized waistband points at center front. The basic back skirt is tapered with slit at back seam.

Figure 1

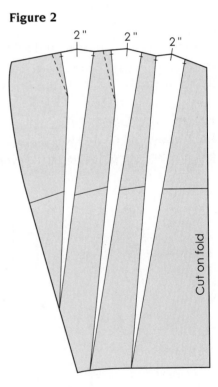

Pattern Plot and Manipulation

Figure 1

- Trace front skirt.
- Draw a line from 1 inch below center front to within 1/2 inch of dart leg at waist (shaded area).
- Mark 1 inch in at side hem and draw line to hip for pegged effect (shaded area).
- Draw slash lines for pleats.
- Cut pattern from paper. Trim shaded areas and save wedge for belt development.

Figure 2

- Cut slash lines from waist to, not through, side seam and hem.
- Close waist darts (broken line).
- Spread each section 2 inches or more. Secure.
- Trace around pattern, marking pleat opening.

Skirt pleats:

- Fold the paper between openings (pleats).
- With tracing wheel, cross over folded pleats at waistline. Open pattern and pencil in perforated marks at waist.
- Notch for pleats.

- Trace back, taper side seam, and notch for slit (example: 7 inches up from hem; not illustrated).

Figure 3 Belt construction:

- Trace basic belt on fold of paper. (See page 240, for belt development, if needed.)
- Place wedge section to bottom of belt at center front and trace.
- Draw grainline and complete pattern for test fit.

Figure 3

Draped Skirt with a Cascade Wrap

Pattern Plot and Manipulation

Figure 1 Skirt:

- Trace full front skirt. Extend dart point A 2 inches.
- Draw slash lines.
- B–C = 8 inches for cascade (varies). Draw curved line blending with hem.

Figure 1

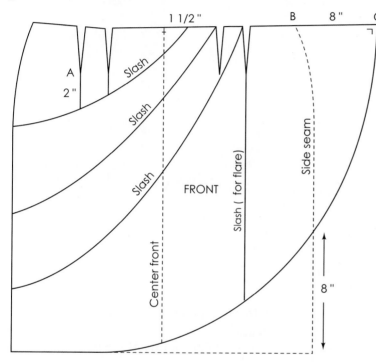

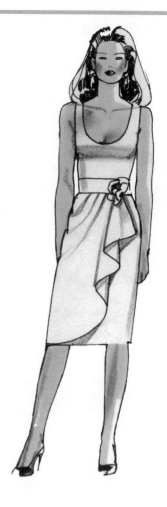

Figure 2

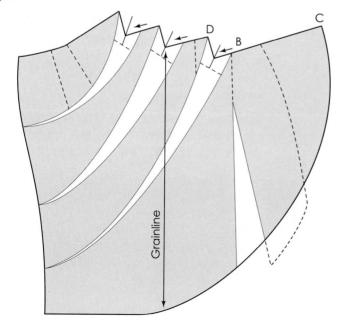

Design Analysis

The asymmetric wrap drape has a flowing cascade and is attached to the side seam. The drape wraps a straight-line basic skirt.

Figure 2

- Cut slash lines and close waist darts.
- Place on paper and spread 4 inches (or more).
- Draw curved cascade and blend to hem.

Pleat underlay:

- Draw lines across each pleat, and square guidelines through center of each opening.
- Extend lines along waist to touch center guidelines. From center, draw lines to waistline.
- Mark notches for pleat and draw grainline.

Underneath skirt:

- Trace basic skirt front on fold. Trace back with center back seam for zipper (not illustrated).

Asymmetric Radiating Gathers

Design Analysis

Gathers radiate from a curved styleline that ends at the top of the waistband into which it is stitched. It is a tunnel loop. The waist darts are arranged to accommodate the styleline. The styleline is $1\frac{3}{4}$ inches wide and half of its width crosses over center by 7/8 inch.

A facing supports the styleline area. The design should be cut in a soft fabric. The second design is a practice problem.

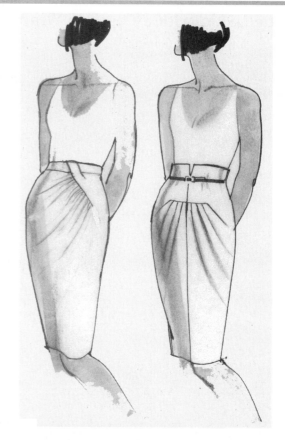

Figure 1

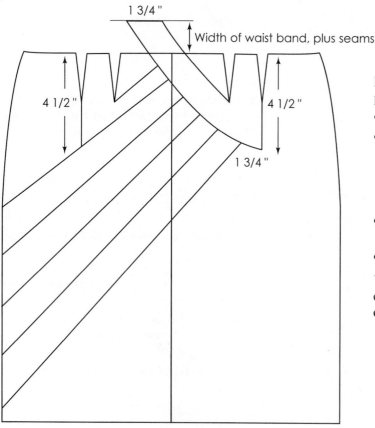

Pattern Plot and Manipulation

Figure 1

- Extend dart points $4\frac{1}{2}$ inches.
- Draw the curved styleline from the dart, crossing 7/8 inch to the other side of the center line and continuing past the waistline $1\frac{3}{4}$ inches. The width of the tunnel loop is $1\frac{3}{4}$ inches.
- Draw a line parallel with the tunnel loop, and end at the dart point.
- Draw the slash lines.

Waistband: See page 240. The waistband is cut in two sections so that the tunnel loop can be stitched into the top of the band.

Figure 2

- Slash and close darts.
- Slash gather lines. Spread at a 2 to 1 ratio.
- Trim 1/4 inch from gathered side ending to zero at dart point to offset the bias stretch.
- Cut the basic back pattern to complete the design.

Figure 2

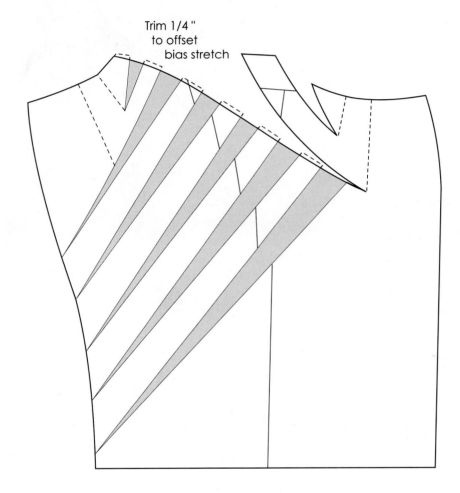

Trim 1/4 "
to offset
bias stretch

Figure 3

Facing:

- Trace the shaded outline for the facing pattern.
- Complete the pattern, and cut in fabric for a test fit.

Figure 3

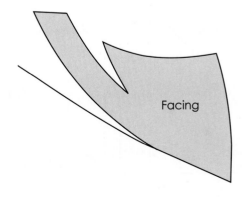

Facing

Skirts with Yokes

Yoke with Gathered Skirt

Design Analysis

The yoke begins $3\frac{1}{2}$ inches down from the waistline and is attached to a gathered dirndl skirt. The skirt is developed from a basic straightline skirt and is spread for fullness.

Pattern Plot and Manipulation

Figures 1 and 2

- Trace front and back patterns.
- Plot yoke (example: $3\frac{1}{2}$ inches below waist). Draw yoke line parallel with waistline.
- Draw slash lines below yoke and label.
- Cut and separate patterns.

Figure 1

Figure 2

— 3 1/2 " —
Yokeline

FRONT

Center front

5 | 4 | 3 | 2 | 1

BACK

Center back

1 | 2 | 3 | 4 | 5

Figures 3 and 4 *Yoke*:

- Close darts and trace front yoke on fold. (Broken lines indicate closed darts.)
- Close back darts and trace. Add 1-inch extension to center back.
- Mark notches and grainline.

Figure 3

Figure 4

Figure 5 *Dirndl*:

- Fold paper. Square a horizontal guideline 3 inches up from bottom of paper at fold.
- Cut through slash lines, place sections in sequence, and spread equally across paper (example: 5 or more inches). Secure.
- Trace, blending across yoke line and hem.
- Repeat for back (not illustrated).
- Draw grainline. Complete pattern for test fit.

Figure 5

Diagonal Yoke with Flared Skirt

Design Analysis

The yoke for Design 1 is parallel with the waist to the point where it ends at a diagonal to the center front waist. Back yoke is parallel with waistline. The lower skirt sections are flared (one-sided fullness). (Flare based on Principle #1—Dart Manipulation, and Principle #2—Added Fullness.) Design 2 is a practice problem.

Pattern Plot and Manipulation

Figures 1 and 2

- Trace basic front and back skirt.
- Plot stylelines on yoke (example: $3\frac{1}{2}$ inches below waist from side to dart point to center front waist on front). Continue yoke across back, parallel with waist.
- Draw slash lines. Label A and B.
- Cut and separate patterns.

Figure 1

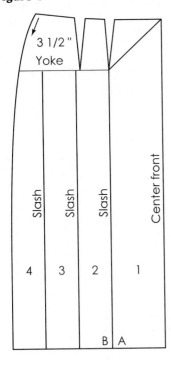

Figure 2

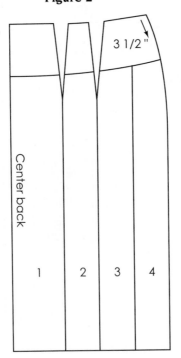

Figures 3 and 4
- Cut slash lines to, not through, waist.
- Place on paper. Spread front and back skirts. (Back skirt: If closed darts do not provide equal fullness with front skirt, open dart point to yoke line and spread for greater sweep, 6 inches more or less. Trace patterns. Add to side seam as shown. Blend hemline.)

Note: Slash and close dart legs of back pattern and trace.

Figure 5

YOKE FRONT

Close

Figure 3

Center front

3 "

6 "

6 "

6 "

B A

Figure 6

C.B.

YOKE BACK

Close Close

Figure 4

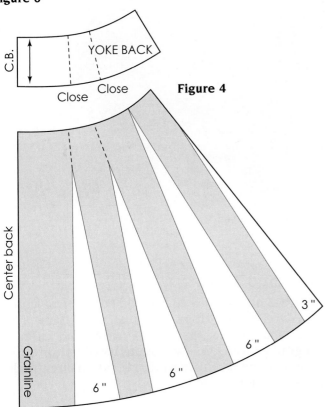

Center back

Grainline

6 "

6 "

6 "

3 "

Figures 5 and 6 Yokes:
- Close darts and trace. (Add 1 inch at center back for zipper if side opening is not desired.)

Tiers

Tiered designs are those featuring rows or layers of fabric attached to each other (as in Designs 1, 2, and 3) or separated and attached to a frame underneath (Designs 4, 5, and 6 on page 284). Tiers may be of graduated or at even lengths. The width of each tier may vary. When planning a tiered design, the first tier, which is attached to the waistline (or yoke), may be from 1 to $1\frac{1}{2}$ times the fabric width. Each subsequent tier may increase in width from $1\frac{1}{2}$ to 2 times the width of the previous tier, depending on the amount of fullness desired.

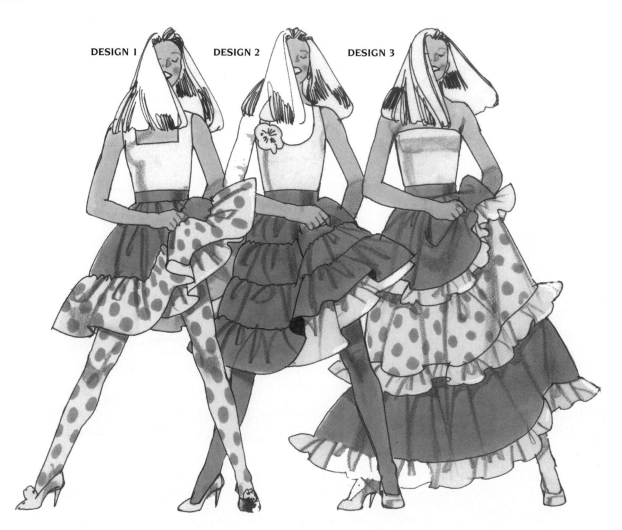

DESIGN 1 DESIGN 2 DESIGN 3

Terms

Fabric width. The distance from selvage to selvage.

One-half of fabric's width. The distance from selvage to center of fabric's width.

Three-fourths of fabric's width. The distance from selvage to a point three-quarters of the way across the fabric's width.

Attached Tiers

Design 2 is illustrated and should be a general guide for developing patterns with attached tiers. For additional practice, develop Designs 1 and 3 (floor length) or create other variations based on this concept. Use the skirt pattern to proportionalize panels when developing tiers.

Pattern Plot and Manipulation for Design 2

Figure 1 Tiers:

Plot skirt as illustrated.

Length = 29 inches.

Tier A = $6\frac{1}{4}$ inches.

Tier B = $6\frac{3}{4}$ inches.

Tier C = $7\frac{1}{4}$ inches.

Tier D = $8\frac{3}{4}$ inches.

Figure 2 Skirt panels:

- Develop patterns for each tier (A, B, C, and D), using the tier length and fabric width as a guide.

 Tier A = Cut 1 width. Adjust back skirt by measuring down $\frac{3}{8}$ inch at center back, blending to side seam.

 Tier B = Cut 2 widths.

 Tier C = Cut 4 widths.

 Tier D = Cut 8 widths.

- If more fullness is desired, add an additional one-half width or more to each panel.

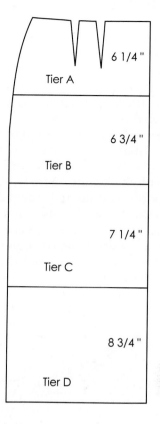

Figure 2

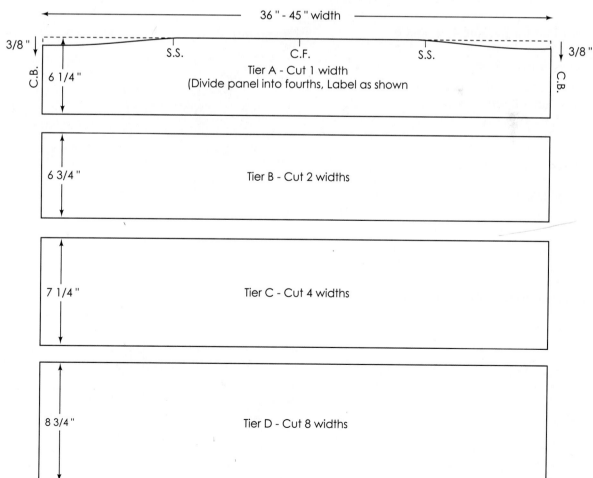

Separated Tiers

Separated tiers may be attached to a basic skirt (guided by punch marks) or stitched in between seamlines of a divided basic skirt. The last section of the skirt is usually discarded. Tiers may also be attached to a basic flared skirt. Tiers overlay each other to conceal stitchline. Design 5 is a guide for developing gathered tiers and Design 6 for developing flared tiers. Design 4 is a practice problem.

The tiers are arranged on a traced copy of the front and back basic skirt. Use measurements given for tier placement (based on 26-inch length), or arrange tier proportions as desired. The plotted tiers are not cut from the pattern but used as a guide for developing tier patterns. However, the traced skirt is separated for use as a skirt frame when tiers are supported by seamlines rather than guided by punch marks. Plotting (Figures 1 and 2) applies to all three designs.

DESIGN 4 **DESIGN 5** **DESIGN 6**

Pattern Plot for Designs 4, 5, and 6

Figure 1
- Trace front basic skirt.
- Plot pattern for visual placement of tiers based on a 26-inch skirt length.

 Tier A = 5 inches.

 Tier B = 8 inches.

 Tier C = 13 inches.

Figure 2 Underlay:
- Draw a parallel line $1\frac{1}{2}$ inches up from Tier A and Tier B (indicated by broken lines).
- The length of Tiers B and C should include $1\frac{1}{2}$ inches for underlay when developing tier panels. (Use punch marks *only* if tier is to be attached to the basic skirt frame.)

Figure 1 **Figure 2**

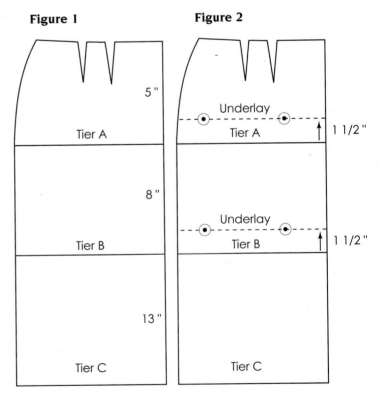

Gathered Tiers for Design 5

Figure 3 *Tier panels*:

- Draw vertical lines equal to tier length plus 1 inch for hem for Panels A, B, and C. Remember, Tiers B and C are to include $1\frac{1}{2}$ inch underlay.
- Square a line out from each end equal to fabric width, and connect to complete each panel.

- Draw grainline and complete pattern for test fit.
- Cut panels (increase or decrease for fullness as desired).

(See page 283, Figure 2, for adjusting back waist.)

Figure 3

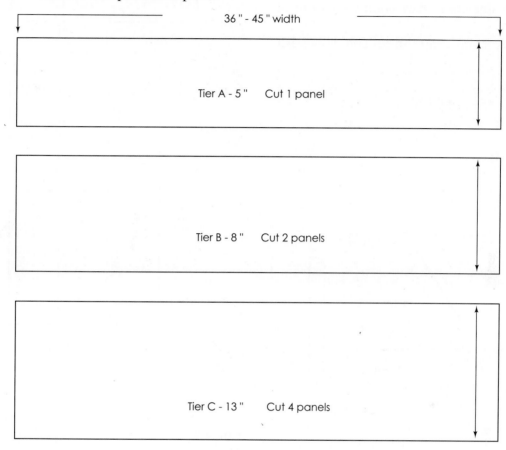

36 " - 45 " width

Tier A - 5 " Cut 1 panel

Tier B - 8 " Cut 2 panels

Tier C - 13 " Cut 4 panels

Figure 4

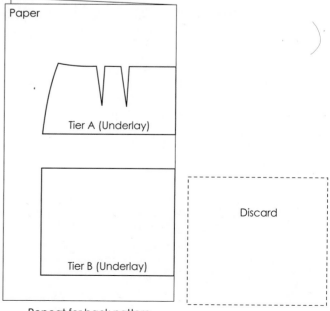

Paper

Tier A (Underlay)

Tier B (Underlay)

Discard

Repeat for back pattern

Figure 4 *Skirt frame*:

- Tiers may be attached to skirt frame by using punch marks as a guide for stitching (see Figure 2), or tiers can be gathered and inserted into seams by separating panels at underlay lines and discarding lower section (broken lines). Tiers will overlay each other $1\frac{1}{2}$ inches, hiding attaching seams.

Underlays A and B:

- Trace center front skirt on fold. Repeat instruction for back skirt (not illustrated).
- Draw grainline and complete patterns for test fit.

Flare Tiers for Design 6

(Trace basic skirt and plot as instructed for design 5, Figures 1 and 2.)

Figure 1

- Trace and cut Tiers A, B, and C from tier under-lay to individual length lines.
- Draw slash lines from dart point to bottom of tier.
- Divide Tiers B and C into thirds and draw slash lines.
- Label A–B.
- Cut tier sections from paper.

Figure 2

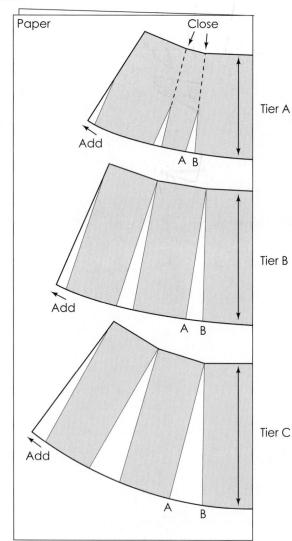

Figure 1

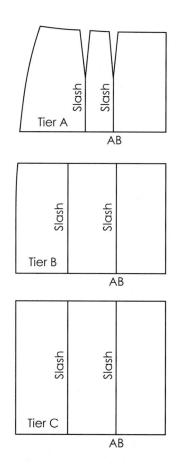

Figure 2

Tier A:

- Close darts on Tier A. Retrace on fold. (If more flare is desired, raise pivotal point of dart 1 or more inches.)

Tier B:

- Spread slash sections twice as much as spaces in Tier A. Retrace on fold.

Tier C:

- Spread slash section twice as much as spaces in Tier B. Retrace on fold.

Side seams:

- Add one-half of A–B space to side seams.
- Draw line. Blend hemline.
- Repeat for back. Spread panels and add to side seam.

Peplums

A peplum is a flounce or short, flared tier that may be added to the waistline of any garment. Peplums extend from the waist and around the hips. A peplum is developed as a tier. To develop patterns for peplums, follow instructions given for tier designs.

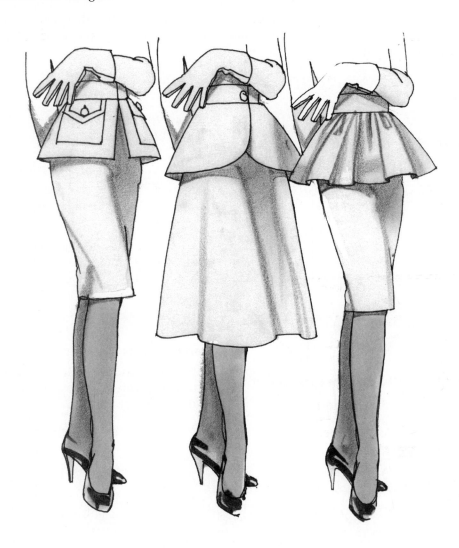

Pleats

A pleat is a fold in the fabric that releases fullness. Pleats are used to increase stride room (such as a single pleat on a straight skirt) or as a design, as with groups of pleats, or allover pleats. Pleats are found on skirts, bodices, sleeves, dresses, jackets, and so on. Pleats are formed in a variety of ways. They may be folded and left unpressed or pressed, stitched or left unstitched. They may be grouped together with even or uneven spacing. The pleat depth may be single, doubled, or tripled. For variation, they may be developed parallel with the fold line or at an angle to it.

Types of Pleats

Knife or Side Pleats

Pleats are grouped and face in one direction.

Inverted Pleats

Pleats are folded to meet each other on right side of garment.

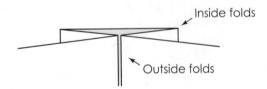

Sunburst Pleats

Pleats fan out and graduate from the waist. They are used on circle skirts. To sustain pleating, the fabric should be synthetic or a blend with over 50% synthetic fibers.

Box Pleats

Pleats are folded away from each other on right side of garment.

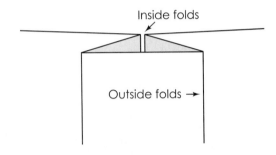

Accordion Pleats

Pleats have folds resembling the bellows of an accordion. The pleats are close together and depth is equal from waist to hem.

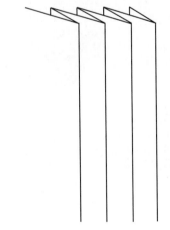

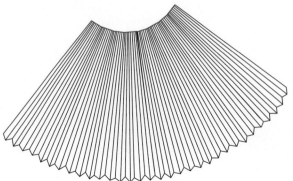

Pleat Terminology

Figure 1
Pleat Depth

Pleat depth is the distance from the outside fold of pleat (labeled X) to the inside fold (labeled Y). (See shaded area of first pleat.)

Pleat Underlay (Forms the Pleat)

Pleat underlay is always twice the pleat depth (X to Y to Z). Example: 2-inch pleat depth = 4-inch underlay (lined area illustrated at second pleat).

Pleat Spacing

Distance between pleats. Pleat markings on the pattern. (X–Y = Pleat depth; X–Z = pleat underlay; Z–X = space between pleats.)

Figure 1

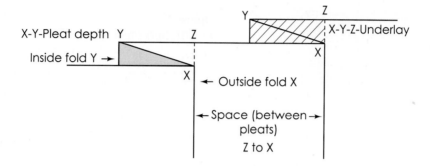

Kick Pleats

Kick pleats are short pleats (side, inverted, or box pleats) placed at center front, center back, sides, or in a gore line. A variety of different types of kick pleats are described.

Knife Pleat at Side
Figure 1

- Mark A for placement of pleat. (Example: 8 inches up from hem at center front.)

- Square out 2 inches from A for pleat depth. Label B.

- Repeat at hem and connect.

- When adding seams to skirt, add 1/2 inch along center line and curve outward to B for pleat control. Punch and circle 1/8 inch in and up from A.

Figure 2

- Stitched pleat.

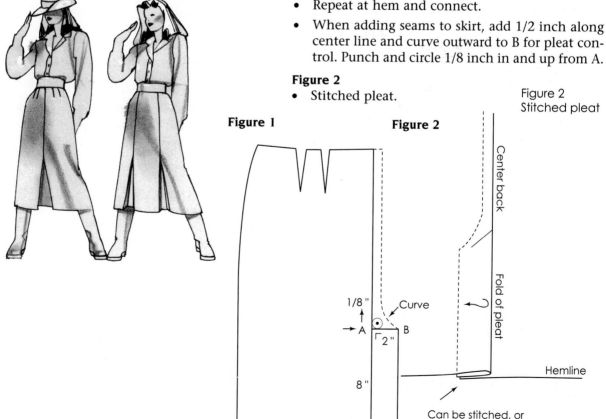

Inverted Box Pleat with Backing

Figure 1

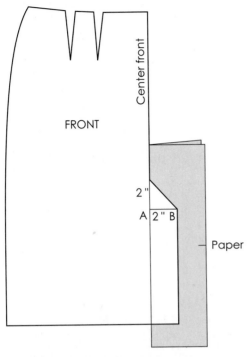

Inverted Box Pleat without Backing

Figure 1

- Mark A for pleat depth. (Example: 8 inches up from hem at center front.)
- Extend a line out 3 inches from A (pleat depth $1\frac{1}{2}$ inches).
- Notch $1\frac{1}{2}$ inches from A.
- Repeat at hem.

Figure 1

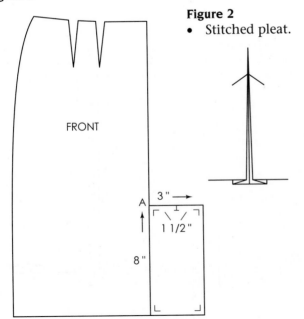

Figure 2
- Stitched pleat.

Figure 1
- Mark A for pleat placement. (Example: 8 inches up from hem at center front.)
- Square out 2 inches from A. Label B. Repeat at hem and connect.
- Mark 2 inches up from A and connect with B.
- Cut pattern from paper.
- Place center line of pattern on fold of paper (shaded section) and trace pleat.

Figure 2
- Remove and cut pleat backing.

Figure 3
- Stitched pleat.

Figure 2

Pleat backing

Figure 3

Stitched pleat

Double Inverted Box Pleat

Figure 1
- Mark A for pleat depth. (Example: 8 inches up from hem at center front.)
- Using 3 inches (pleat underlay) as a guide for each pleat, square a line out from A equal to the number of pleats desired. (Example: 6 inches for two pleats.)
- Notch every $1\frac{1}{2}$ inches for pleat fold.
- Repeat at hem (notches optional).

Figure 1

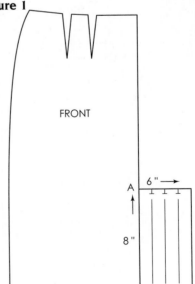

Figure 2
- Stitched pleat.

All-Around Pleated Skirt

The all-around pleated skirt can be developed by using the pleat formula, or it may be pleated by professional pleaters. Generally, it is less expensive for a manufacturer to send a skirt out for pleating than to have it done in the manufacturer's factory. Professional pleaters will conform any pleating arrangement to fit waist and hip measurements for all graded sizes and to any length desired. Some small firms will pleat fabric for those desiring a personal fit. (*Suggestion:* Contact yardage or notion departments for information about services available locally.)

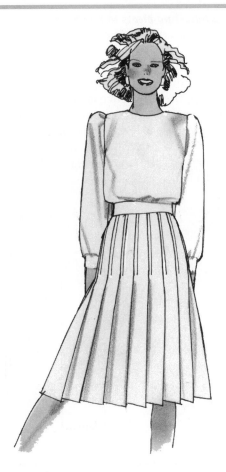

Design Analysis

The skirt features 20 pleats that encircle the figure. Each pleat is stitched approximately 7 inches below the waist, using the pleat formula as a guide.

Pattern Plot and Manipulation

Measurements needed:

- (2) Waist _____
- (4) Hip _____
- Length _____

Example: 30 inch waist; 40 inch hip; length 26 inches plus 3 inches for hem and waist seams = 29 inches.

Pleat formula:

- Number of pleats (20 pleats).
- Depth of pleat ($1^1/_2$ inches × 2 = 3 inch pleat underlay).
- Pleat spacing [Divide the number of pleats (20) into the hip circumference (40) = 2-inch spacing.

Figure 1 *Planning pleats*:

Always start the pleat series with seam allowance (A), followed by pleat depth (A to B)—forms one-half of the pleat. Continue with pleat space (B to C) and pleat underlay (C to D). Repeat the process until the next to the last pleat is formed (E to F). Mark for space (F to G) and end with pleat depth (G to H)—this completes the other half of the first pleat. Add to this seam allowance. (The seam is hidden in the center fold of the pleat.) If the pleat series is interrupted by a seam before completion, end with pleat depth and begin with seam allowance and pleat depth on the joining piece.

Figure 1

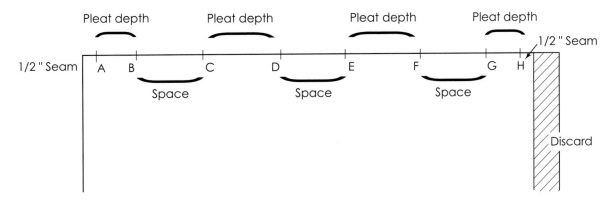

Figure 2 Adjusting pleats to waistline:
Pleats are formed to fit the circumference of the hip, making the skirt too wide for the waist. To adjust the pattern, find the difference between waist and hip measurements. (Example: 30-inch waist, and 40-inch hip, the difference is 10 inches). Divide the difference by two times the number of pleats (each pleat has two sides). (Example: 10-inch difference by 40 pleat sides = 10/40 = 1/4 inch.) This measurement represents the amount each pleat will absorb in order to fit the waist.

Use measurement as follows:

- Measure out 1/4 inch from each side of pleat (X and Z) at waist. Mark.
- Blend a curved line (new stitch line) from each mark to approximately $4\frac{1}{2}$ inches below waist. (Broken line indicates original fold line of pleat. Shaded area indicates the amount taken up by the pleats. Pleat may be topstitched at varying lengths below the waist.)

Figure 2

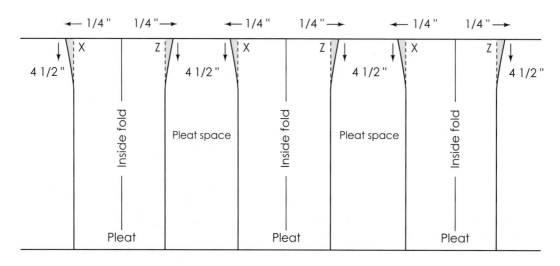

Inverted Box-Pleated Skirt

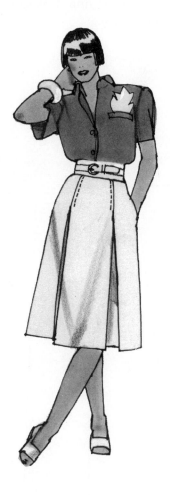

Design Analysis

The skirt features box pleats in front with slight A-line flare at side seams. Back is basic with A-line flare. Pleats can be either stitched (as shown) or unstitched.)

Pattern Plot and Manipulation

Figure 1

- Trace basic front and back skirt. (Back not illustrated.)

Front:

- Draw tentative line from dart point to hem, parallel to center front (broken line).

Front:

- Measure $1\frac{1}{2}$ inches and draw line to dart point. Label A–B (pleat guide).

Front and Back:

- Measure out $1\frac{1}{2}$ inches at side seam for A-line. Draw line to outermost part of hip. Blend hemline. (See page 242 Figures 3 and 4 as a guide.)
- Cut from paper.

Figure 1

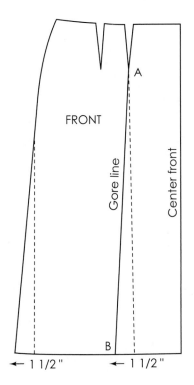

Figure 2

- Place pattern on paper and trace dart leg (A) ending at point B (shaded area).
- Remove pattern.
- Measure 3 inches from dart leg (A) and 6 inches from point B. Connect. Label C–D.
- Repeat measurements for E and F. Connect.
- Extend line up from point A.

Figure 3

- Fold A–B line to C–D line. Crease (broken line shows pleat underlay).

Figure 2

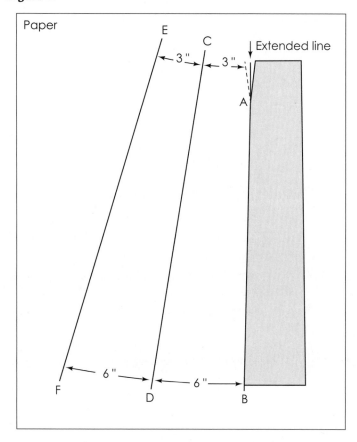

Figure 3

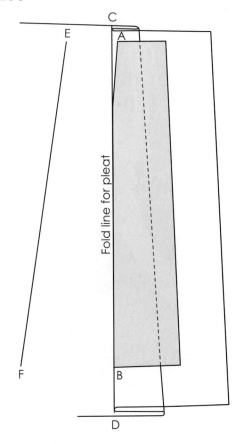

Figure 4

- Fold E–F line to B–C line. Crease.
- *Working pattern modification:*
- Before replacing pattern for tracing, cut slash line from hemline to, not through, dart point. Close dart. Tape.
- Place pattern on draft, matching center front line. Trace remaining pattern (shaded area). Remove pattern.
- With tracing wheel, trace across pleats at waist and hemline to transfer shape to pattern underneath. Seams can be added at this time (not illustrated). Open pattern, pencil in perforated marks, and blend hem.

Figure 4

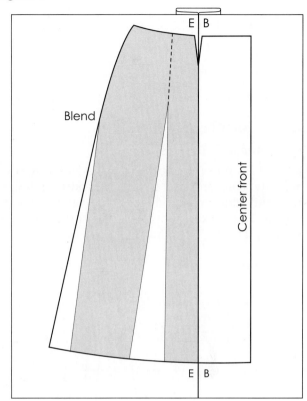

Methods for Stitching Darts

Method 1:

- Draw dart legs slightly curved and connect dart points.
- Notch dart legs and center in between dart legs.
- Place punch and circles in and up 1/8 inch from corner up 1/8 inch at center.

Method 2:

- Trim excess to within 1/2 inch of dart legs (seam allowance).
- Notch corners and center fold (lines indicate pleat).
- Cut from paper and retrace with center front on fold. Add grainlines and complete for test fit.

Godets

Godets are generally triangular-shaped wedges of fabric placed between seams, into slits, or as a replacement or cutout sections (of varying shapes). Godets provide additional stride room or may be added as a design feature. They are used singularly or in a series around the skirt. They may extend evenly to the hemline or be graduated in length. Godets may be placed on a bodice, jacket, blouse, sleeve, and so on.

Basic Godet

Design Analysis: Designs 1 and 2

Design 1 is an example of a single godet inserted in the center back or center front of the skirt for design effect and additional stride room. The godet may be attached to the skirt or be in-one with the skirt (see Figure 1). Design 2 is a practice problem.

DESIGN 1 **DESIGN 2**

Figure 2

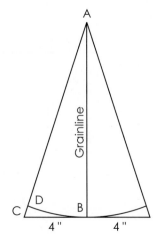

Pattern Plot and Manipulation

Figure 1 In-one with skirt:

- Mark godet placement. Measure this length (example: 10 inches) and label A–B.
- Extend hemline to desired width of godet (example: 4 inches). Label C. Connect A to C, marking a point on the line equal to A–B length.
- Blend with hemline.

Figure 1

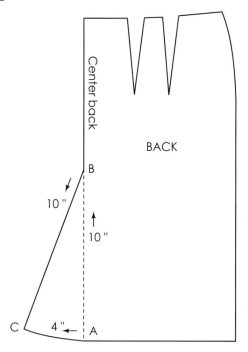

Figure 2 Attached godet:

- A–B = Godet length (also grainline).
- B–C = Godet width (example: 4 inches). Squared from B.
- Draw line from C to A.
- A–D = A–B length. Mark.
- Blend hemline.
- Repeat for other side.

Godet Variations

Godets may be curved, squared, or pointed; as a half circle, a three-quarter circle, or a full circle. Use general instructions and illustrations as a guide for developing godet variations.

Pattern Plot and Manipulation

- Plot pattern for cutout design.
- Cut from paper.
- Use cutout section for spreading.
- Draw slash lines.
- Cut slash lines to, not through, top of section.
- Spread for flare. Retrace.

Design 1

- See Figures 1, 2, and 3

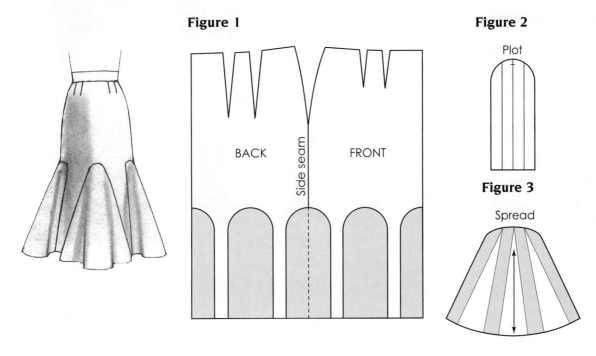

Figure 1

BACK · Side seam · FRONT

Figure 2

Plot

Figure 3

Spread

Design 2

- See Figures 1, 2, and 3

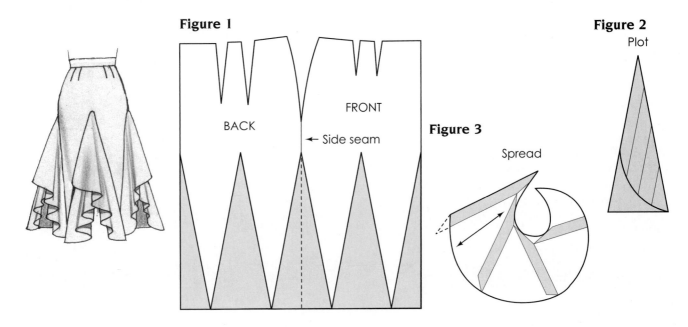

Figure 1

BACK · FRONT · ← Side seam

Figure 3

Spread

Figure 2

Plot

Wrap Skirt

A basic, A-line, flared, or gathered skirt can be developed into a wrap skirt by extending the center front. The hemline may be squared (Design 1), curved (Design 2), or of any other variation desired. Wrap skirts may have side seams or may be developed all-in-one. Belts may be buttoned (Design 1) or tied (Design 2). Designs are based on A-line flare skirt.

Wrap Skirt with Side Seam

Pattern Plot and Manipulation

Figure 1

- Trace front skirt. Extend a 6-inch line out from center front at waist and hem (extension and fold-back for facing).
- Notch center front waist and 3 inches out from waist (indicates the fold line for facing).

Figure 1

Figure 3 B*elt construction*:

- Belt extends to full length of waist less 1/2". Mark button and buttonhole. Underneath belt is buttoned and not seen.

Figure 3

Figure 2
- Trace back skirt on fold.

Figure 2

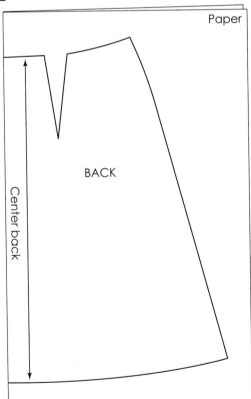

All-in-One Wrap Skirt

Figure 1

- Align side seams of the front and back skirt (straight or A-line). Note that a dart is formed at the side waist.

- Add desired extension for wrap (example: equal to distance from center front to dart). Trace

- Draw a curved hemline as illustrated.

Figure 1

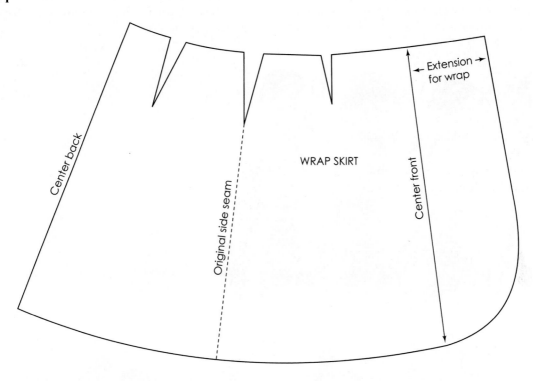

Figure 2 *Facing*:

- Trace skirt from waist to curve of hemline.
- Width = $1^{1}/_{2}$ inches to 3 inches.

Figure 2

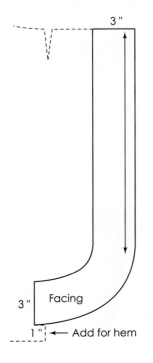

Figure 3 *Belt construction*:

- Belt extends 25 inches beyond length of waist at each end for tie.
- Place buttonhole in waistband at right side of skirt for tie to pull through.

Figure 3

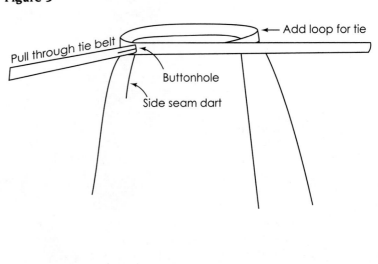

Circles, Peplums, and Cascades

Circles as creative elements have always intrigued designers. Circles can be designed as circular skirts, dresses, sleeves, collars, peplums, or capes, and as cascades falling from cutout necklines or inserted into sleeves and other types of garments. Designs are based on a full circle or part of a circle, having a rounded, pointed, or uneven hemline. Circles used in design have an inner circle (the part that is stitched to a joining seam) and an outer circle (the hemline). The radius is based on the length of the seam to which it is stitched. Skirts provide the sample of how the Radius Chart is to be used. A tool for drawing the circles is included. A discussion about grainline placement and its effect on the fall of the flare are also included.

Terminology

Circle center. The point that is equidistant to all points out from itself.

Radius. The distance from circle center (point A) to the circle's edge (point B).

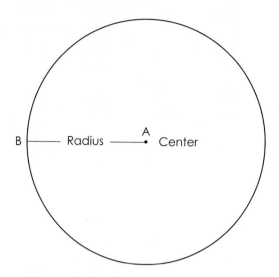

Diameter. The distance across the center of the circle. The diameter of a circle is always twice the radius (B to C).

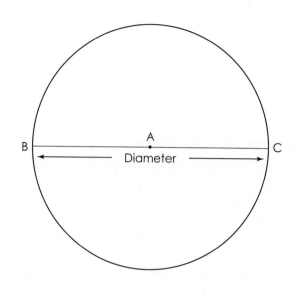

Circle within a Circle

A circle will have a circle within a circle for the purpose of designing. The inner circle is stitched to the joining seam of the garment, and the outer circle is the hemline. The radius measurement establishes the circumference (distance) around the inner and outer circles. The length of the seam to which the inner circle is attached determines the radius measurement. The Radius Chart provides the measurements; see page 302. Other methods are included.

Parts of a Circle Skirt

Think of the circle as having four quarter-sections. Sections of the circle are removed from the full circle to decrease hemline sweep.

A circle skirt is titled by the number of its quarter-sections—a full circle, 3/4 circle, 1/2 circle, or 1/4 circle. Each circle skirt is illustrated.

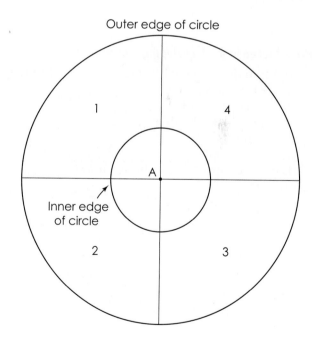

Radius Chart for Circle Skirts and Cascades

Purpose of the Radius Measurement

The chart provides a quick method for finding the radius of the inner circle for skirt or cascade.

The total measurement created by the selected radius will equal the *length* of the seam to which it is stitched.

How to Use the Circle/Cascade Chart

Column 1—Length Measurements

Measure the length of the seam to which the inner circle is stitched. For measurements in between, select the closest whole number.

Columns 2, 3, 4, 5—The radius measurements for the circle skirt of choice.

Using the length measurement from column 1, go across the chart to the column of the chosen skirt for the radius measurement. Subtract 1/2 or 1/4 inch for seam allowance.

The minus (−) and plus (+) symbols represent 1/16 inch added to or subtracted from the measurement.

Length, as desired.

Other Methods for Developing Circularity

- To find radius, divide the length from Column 1 by the fractions given.
 1/6—full circle skirt
 1/5—three-quarter circle
 3/4—half circle
 2/3—quarter circle
- Slash and spread the basic skirt; see pages 247–248.

The use of the Radius Chart and the circle tool is illustrated in the development of the following circle skirts.

Column 1 Length	Column 2 1/4 Circle	Column 3 1/2 Circle	Column 4 3/4 Circle	Column 5 Full Circle
1	$0^5/_8$	$0^1/_4+$	$0^1/_4-$	$0^1/_8+$
2	$1^1/_4+$	$0^5/_8$	$0^1/_2-$	$0^3/_8-$
3	$1^7/_8+$	$0^7/_8+$	$0^5/_8$	$0^1/_2-$
4	$2^1/_2+$	$1^1/_4+$	$0^7/_8-$	$0^5/_8$
5	$3^1/_8+$	$1^5/_8-$	$1^1/_8-$	$0^3/_4+$
6	$3^3/_4+$	$1^7/_8+$	$1^1/_4+$	$0^7/_8+$
7	$4^1/_2-$	$2^1/_4-$	$1^1/_2$	$1^1/_8$
8	$5^1/_8-$	$2^1/_2+$	$1^5/_8+$	$1^1/_4+$
9	$5^3/_4-$	$2^7/_8$	$1^7/_8+$	$1^3/_8+$
10	$6^3/_8$	$3^1/_8+$	$2^1/_8$	$1^5/_8-$
11	7	$3^1/_2$	$2^3/_8-$	$1^3/_4$
12	$7^5/_8$	$3^3/_4+$	$2^1/_2+$	$1^7/_8+$
13	$8^1/_4+$	$4^1/_8$	$2^3/_4$	$2^1/_8-$
14	$8^7/_8+$	$4^1/_2-$	$2^7/_8+$	$2^1/_4-$
15	$9^1/_2+$	$4^3/_4+$	$3^1/_8+$	$2^3/_8$
16	$10^1/_8+$	$5^1/_8-$	$3^3/_8+$	$2^1/_2+$
17	$10^3/_4+$	$5^3/_4+$	$3^5/_8-$	$2^3/_4-$
18	$11^1/_2-$	$5^3/_4+$	$3^3/_4+$	$2^7/_8$
19	$12^1/_8-$	$6^1/_8$	$4^1/_8-$	3
20	$12^3/_4-$	$6^3/_8$	$4^1/_4$	$3^1/_8+$
21	$13^3/_8$	$6^5/_8+$	$4^1/_2-$	$3^3/_8-$
22	14	7	$4^5/_8+$	$3^1/_2$
23	$14^5/_8+$	$7^1/_4+$	$4^7/_8$	$3^5/_8+$
24	$15^1/_4+$	$7^5/_8$	$5^1/_8-$	$3^3/_4+$
25	$15^7/_8+$	$7^7/_8+$	$5^1/_4+$	$3^7/_8+$
26	$16^1/_2+$	$8^1/_4+$	$5^1/_2+$	$4^1/_8$
27	$17^1/_8+$	$8^5/_8-$	$5^3/_4-$	$4^3/_8-$
28	$17^3/_4+$	$8^7/_8+$	$5^7/_8+$	$4^1/_2-$
29	$18^1/_2-$	$9^1/_4-$	$6^1/_8+$	$4^5/_8$
30	$19^1/_8-$	$9^1/_2+$	$6^3/_8$	$4^3/_4+$
31	$19^3/_4$	$9^7/_8$	$6^5/_8-$	$4^7/_8+$
32	$20^3/_8$	$10^7/_8+$	$6^3/_4+$	$5^1/_8-$
33	21	$10^1/_2$	7	$5^1/_4$
34	$21^5/_8+$	$10^3/_4+$	$7^1/_4-$	$5^3/_8+$
35	$22^1/_4+$	$11^1/_8$	$7^1/_2-$	$5^1/_2+$
36	$22^7/_8+$	$11^1/_2-$	$7^5/_8$	$5^3/_4-$
37	$23^1/_2+$	$11^3/_4+$	$7^7/_8-$	$5^7/_8$
38	$24^1/_8+$	$12^1/_8-$	$8^1/_8-$	$6^1/_8-$
39	$24^7/_8-$	$12^3/_8$	$8^1/_4+$	$6^1/_4-$
40	$25^1/_2-$	$12^3/_4-$	$8^1/_2$	$6^3/_8$
41	$26^1/_8-$	$13^1/_8-$	$8^5/_8+$	$6^1/_2+$
42	$26^3/_4$	$13^3/_8$	$8^7/_8+$	$6^5/_8+$
43	$27^3/_8$	$13^5/_8+$	$9^1/_8$	$6^7/_8-$
44	28	14	$9^3/_8+$	7
45	$28^5/_8+$	$14^1/_4+$	$9^1/_2+$	$7^1/_8+$
46	$29^1/_4+$	$14^5/_8+$	$9^3/_4$	$7^3/_8-$
47	$29^7/_8+$	$14^7/_8+$	$9^7/_8+$	$7^1/_2-$
48	$30^1/_2+$	$15^1/_4+$	$10^1/_8+$	$7^5/_8$
49	$31^1/_8+$	$15^5/_8-$	$10^3/_8+$	$7^3/_4+$
50	$31^7/_8-$	$15^7/_8+$	$10^5/_8$	$7^7/_8$

Full Circle Skirt

The formula for developing circles applies to all types of circles and includes seam allowances. The full circle skirt is the example. Grainline placement is discussed and choices are offered controlling the location of flares at the quarter-sections of skirts having circularity. A tool for drawing circles is illustrated.

Formula

1. Waist measurement = 26 inches

2. Number of seams = 2 inches (for 2 seams) or 4 inches (for 4 seams)

 Total = 28 inches

3. Subtract 1 inch for stretch = 27 inches*

 Locate this measurement (27) in column 1 and go across to column 5, full circle. The radius measurement is $4^3/_8$ inches, less 1/2 inch for seam allowance.

4. Radius measurement is $3^7/_8$ inches.

5. Length = 25 inches plus 1 inch for hem.

*(Test the stretch of chiffon and crepe by cutting the radius from a quarter section of the skirt with a length of 5 inches. Stretch across the ruler. Subtract the amount of stretch from the measurement.)

Figure 1

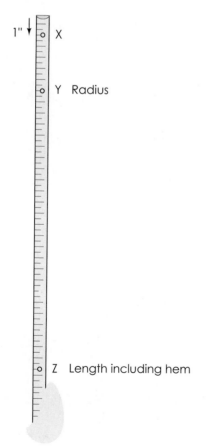

Figure 1

Circle Tool

Figure 1

Use an old tape measure and punch holes through it (with an awl) at the locations of the radius and hemline, starting 1 inch down from tape top.

X is starting point

X to Y = radius

Y to Z = skirt length, plus hem

Pattern Plot and Development

Half a circle skirt is drafted. The pattern is cut twice to complete the circle skirt.

Measurements Needed

Waist and skirt length. Use personal measurements, or follow the example given in the formula.

Paper Needed

Cut paper 30 × 60 and fold in half.

Figure 1

Figure 1

Corner fold of paper is X

X to Y = Radius measurement. Mark.

Y to Z = Skirt length (include the hem).

Circle tool—With a pushpin, secure tape measure at (X) at the 1-inch mark. Align tape measure at fold and punch holes through at level with (Y) and (Z) marks. Place a pencil through the holes and draw the radius and hemline.

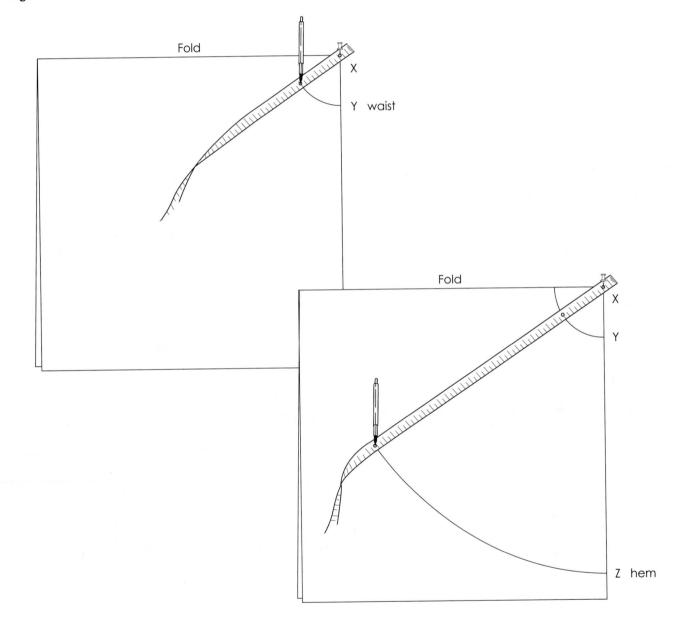

Figure 2

Optional: To flatten the flare at center front, raise 1/4 inch. The back can be lowered 1/4 inch.

- Cut the skirt from paper, and make a duplicate copy to complete the circle.

Figure 2

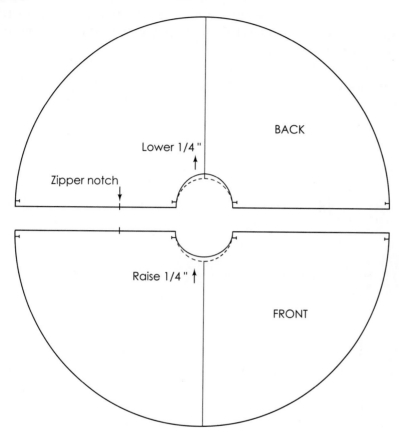

Figure 3

Figure 3 Example skirt with 4 seams

The location of the straight grainline can be changed to control the fall of flares of skirt having circularity. See page 306.

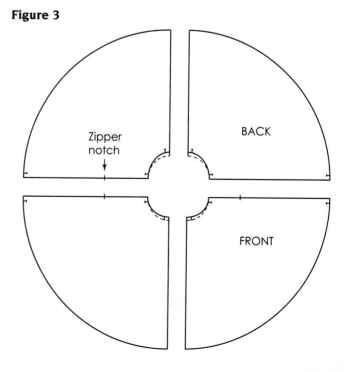

Grainline Placement Relative to the Fall of the Flare

Flares tend to fall gracefully wherever the grain is on the bias. Changing the grainline can control where the bias and flare will fall.

Grainline 1—Flares fall toward the side and side front—straight grainline.

Grainline 2—Flares fall to the center front and to the side seam—placed between front and side seams.

Grainline 3—Flares fall at center, side seam, and in between placed 3/4 inch from center.

Hemline Adjustments

Skirts with circularity should be hung overnight to allow the bias to stretch before the hemline is marked and finished. The skirt can be pinned to a hanger along the waistline or placed on the form. The corrections should be transferred to the pattern. The hemline of the pattern will appear uneven after the adjustments are made, but when cut in fabric the bias will hang parallel with the floor.

Grainline 1 **Grainline 2** **Grainline 3**

Figure 1

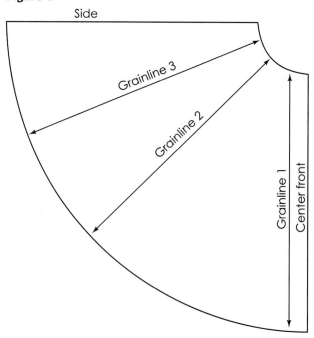

Three-Quarter Circle Skirt

A quarter-section of the full circle is removed. This results in less hemline sweep, but an increase in the radius measurement to compensate for the loss of the section. The skirt can have one seam in back, or be cut in two or more panels. See grainline placements on page 306.

Pattern Plot and Manipulation

Formula:

Waist measurement	_____
Add seam allowances	_____
Subtract 1 inch for stretch	_____
Total	_____

- Locate this measurement in Column 1 of the Radius Chart, and go across to Column 4, 3/4 circle.

- If using the sample measurement of 27 inches, the radius is $5\frac{3}{4}$ inches, less 1/2 inch; the radius measurement will be $5\frac{1}{4}$ inches. Length plus hem, as desired _____.

Figure 1

Corner fold of paper is X.

X to Y = Radius measurement. Mark.

Y to Z = Skirt length (include the hem).

- *Circle tool*—With a pushpin, secure tape measure at (X) at the 1-inch mark. Align tape measure at fold and punch holes through at level with (Y) and (Z) marks. Place a pencil through the holes and draw the radius and hemline. See page 304 for guide.

Figure 2

- Cut the skirt from paper.
- Cut away one quarter-section from the skirt.
- If two seams were calculated, cut in half.
- If four seams were calculated, cut skirt into four equal parts. Notch to identify matching seams.

Paper Needed

64-inch square (tape paper to extend length).

Figure 1

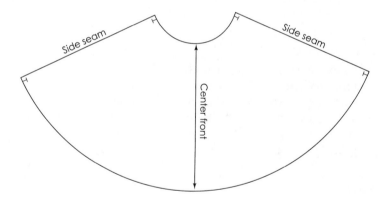

Figure 2

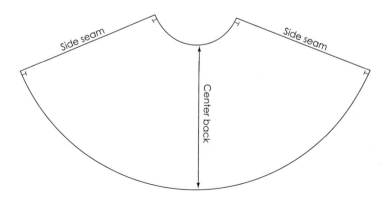

Half-Circle Skirt

Fold paper in half. Two quarter-sections result in less hemline sweep, but an increase in the radius measurement to compensate for the loss of the two sections. The skirt can have one seam in back, or be cut in two or more panels. See grainline placements on page 306.

Pattern Plot and Manipulation

Formula:

Waist measurement _____

Add seam allowances _____

Subtract 1 inch for stretch _____

 Total _____

- Locate this measurement in Column 1 of the Radius Chart, and go across to Column 3, 1/2 circle.

- If using the sample measurement of 27 inches, the radius is 8 5/8 inches, less 1/2 inch; the radius measurement will be 8 1/8 inches.

- Length plus hem, as desired _____.

Figure 1

Corner fold of paper is X. Mark the following:

X to Y = Radius measurement. Mark.

Y to Z = Skirt length (include the hem).

- *Circle tool*—With a pushpin, secure tape measure at (X) at the 1-inch mark. Align tape measure at fold and punch holes through at level with (Y) and (Z) marks. Place a pencil through the holes and draw the radius and hemline. See page 304 for guide.

Figure 2

- Cut the skirt from paper.
- If two seams were calculated, cut in half.
- If four seams were calculated, cut skirt into four equal parts (not shown).
- Notch to identify matching seams.

Paper Needed

Cut paper 32 × 64. Fold in half.

Figure 1

Figure 2

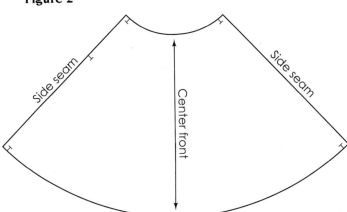

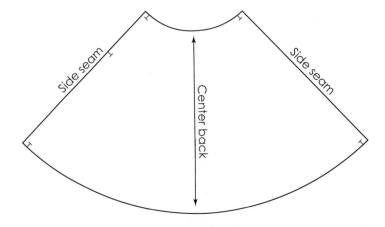

Quarter-Circle Skirt

Three of the quarter-sections are removed from the full circle. This results in less hemline sweep, but an increase in the radius measurement to compensate for the loss of the sections. The hipline may require additional width to fit the figure. The skirt may have one seam in back, or be cut in two or more panels (not shown.)

Pattern Plot and Manipulation

Formula

Waist measurement _____

Add seam allowances _____

Subtract 1 inch for stretch _____

Total _____

- Locate this measurement in Column 1 of the Radius Chart, and go across to Column 2, 1/4 circle.

- If using the sample measurement of 27 inches, the radius is $17\frac{1}{8}+$ inches, less 1/2 inch; the radius will total $16\frac{5}{8}+$ inches.

- Length, plus hem _____.

Figure 1

- Square a line on the paper.
- Mark corner X.

Figure 2

X to Y = Radius measurement.

Y to Z = Skirt length (include hem).

- *Circle tool*—With a pushpin, secure tape measure at (X) at the 1-inch mark. Align tape measure at fold. Punch holes through at level with (Y) and (Z). Place a pencil through the holes and draw radius and hemline. See page 304 for guide.

Skirt with one seam:

- Before cutting from paper, measure hipline (broken lines). If necessary, add for ease.

- Cut from paper. See options for the placement of the grainline, page 306.

Paper Needed

45-inch square sheet of paper.

Figure 1

Figure 2

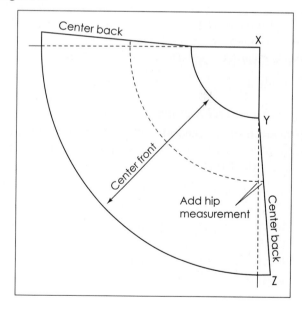

Figure 3

Skirt with two seams:

- If two seams were calculated, cut skirt in half, and add equally to the hipline at the side seams for additional ease, if necessary. Grainline options are drawn on the pattern.

- Complete either pattern for a test fit.

Figure 3

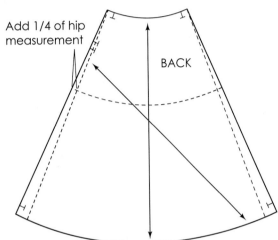
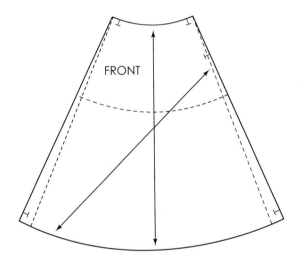

Two Circles at Waist

(Not illustrated)

Pattern Plot and Manipulation

Measurements needed: Waist measurement plus seam allowance (two seams, add 2 inches; four seams, add 4 inches).

- To develop circular skirt with two circles, divide the adjusted waistline measurement in half.
- Locate the measurement in Column 1 of the chart.
- Locate radius for full circle in Column 5, less 1/2 inch.
- Cut two circles.

 Note: If more circles, or part of a circle, are desired at waist, divide the number of circles into the waist measurement. Add for seams and subtract for stretch.

Gathered Circular Skirt

(Not illustrated)

Pattern Plot and Manipulation

- To add gathers to the waistline of a circular skirt, increase the waist measurement. (Example: waist measurement = 24 inches; add 8 inches for gathers = 32 inches at waistline.)
- Locate 32 inches on chart, and find radius needed in Column 2, 3, 4, or 5 for fullness desired.

Skirts with Uneven Hemlines

A number of hemline variations can be achieved by curving or pointing the outer circle and by placing the inner circle off-center. The following examples may be used as a guide for uneven hemlines—skirts, peplums, sleeves, tiers, hoods, capes, and so on.

Circular Skirt with Handkerchief Hem

Design Analysis

The skirt is a circular skirt with a handkerchief hemline (squared or pointed hemline). Waistline may be with or without gathers.

Figure 2
• Unfold patterns. Draw grainline and complete for test fit.

Pattern Plot and Manipulation

Paper needed:
Length, plus radius × 2 (2 pieces).

Figure 1

• For a gathered waist, increase waistline measurement.

Suggestion: 8 inches more or less. Example: 24 inches + 8 inches = 32 inches.

• Locate radius for a full circle in Column 5 of chart.

• Fold paper in half. Label corner of fold X.

X–Y = Radius measurement, minus 1/2 inch for waistline seam. Mark Y on fold.

Circle tool:
Draw circle at waist only. (See page 304 for guidance.)

• Repeat for back skirt.

• To adjust front and back waist, see page 305, Figure 2.

• Cut waistline from pattern.

Figure 1

Figure 2

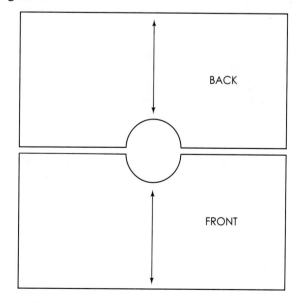

Circular Skirt with Graduated-Length Hemline

Design Analysis

The design has double circular skirts with one circle shorter than the other. A cascade effect is formed by the inner circles being cut off-center. Waistband ties skirt together.

Formula for lengths:

- To find radius, follow instructions for Circle and Cascade Radius Chart, page 302, Columns 1 and 5).
- Determine shortest and longest lengths desired. Add both measurements together, plus 2 × radius, and record total measurement: _____.
- Divide the measurement in half and record: _____.

Example:

- 27-inch adjusted waistline = 4 3/8-inch radius (full circle).
- Shortest length = 20 inches
- Longest length = 36 inches
- 2 × radius = $8^3/_4$ inches

 Total = $64^3/_4$ inches square

 (One-half of total = $32^3/_8$ inches)

Pattern Plot and Manipulation

Paper needed: $64^3/_4$ inches square

Figure 1

- Fold paper into four equal parts (evenly). Mark corner A.

 A–Z = One-half of total length (example: $32^3/_8$ inches). Draw hemline using measuring device. (See page 304, if necessary.)

 Z–Y = Short length of skirt. Mark.

 Y–X = Radius measurement minus 1/2 inch for waistline seam. Mark.

- Cut outer circle from paper.

Figure 1

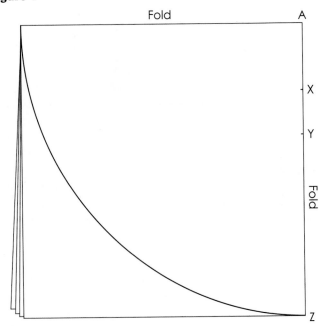

Figure 2

- Refold paper, using X-point for foldline.
- Draw waist curve using radius measurement.
- Adjust waistline. See page 305, Figure 2. Cut waistline from paper.

Figure 2

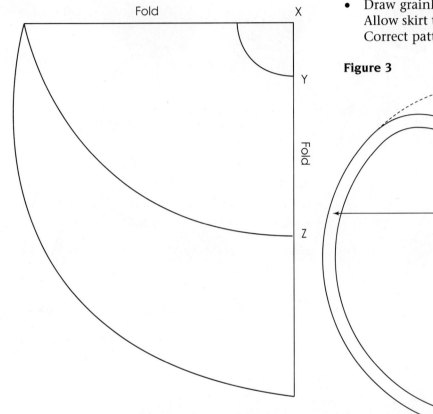

Figure 3

- Open pattern.
- Draw curved styleline for cascade and trim excess (short broken lines). Separate front and back skirts.
- Retrace for top skirt. Trim $1^1/_2$ inches (more or less) from length of skirt, shown by broken lines.
- Draw grainline and complete pattern for test fit. Allow skirt to hang. Re-mark and blend hemline. Correct pattern.

Figure 3

Skirt Design Variations

The following designs are based on circular and straightline skirts. Develop the designs for practice, using concepts illustrated in this chapter as well as the three major patternmaking principles.

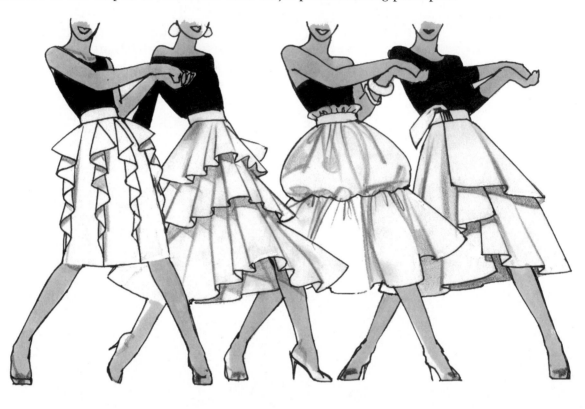

14

Sleeves

Introduction

Sleeves have been used as a device for changing the silhouette of garments throughout the history of fashion. In the 1880s, the dominant silhouette was a leg-of-mutton sleeve—a sleeve that puffs out from the shoulder with the lower section tapered toward the wrist. For the next ten years, the sleeve puff varied from slim to voluminous and billowy. In the 1920s, a sleeve with a darted or extended cap became popular. In the 1940s the sleeve was smooth and included padded shoulders ranging from square and tailored to oversized exaggeration. There was a return to a natural shoulder with minimal padding in the 1950s. This gave tailored garments an even look along the shoulder seam. Since then, these important sleeve silhouettes have appeared and disappeared, and will probably reappear again.

There are two major classifications of sleeves: the set-in sleeve cut separately and stitched into the armhole of the bodice, and the sleeve combined with part or all of the bodice. Set in sleeves are introduced in this chapter; sleeve-bodice combinations are discussed in Chapter 15.

Set-in Sleeve

Set-in sleeves can be designed to fit the armhole smoothly or with gathers. They can be designed fitted or with exaggerated fullness, and can be cut to any length.

The hemline of the sleeve can be finished in a number of ways. A straight or full sleeve can be confined by an attached cuff, band, elastic, or casing (for elastic or tie). If not confined, the sleeve may have a self-hem (either folded back or rolled up), or may be faced or edged with trim. The opening for hand entry can also be treated in a variety of ways, from slits with plackets, facings, or foldbacks to zipper-type closures.

Terminology

Sleeve cap. Curved top of the sleeve from front to back.

Cap height. Distance from biceps to cap at center.

Biceps level. Widest part of the sleeve dividing cap from lower sleeve.

Sleeve ease. Additional allowance at biceps, elbow, and wrist levels accommodating the circumference of the arm and allowing ease for freedom of movement. Ease ranges from $1^1/_2$ to 2 or more inches.

Cap ease. Difference between cap and armhole measurement (ranging from 1 to $1^7/_8$ inches).

Elbow level. The location of the dart, level with elbow of arm.

Wrist level. The bottom (hemline) of the long sleeve, level with wrist.

Grainline. Center of sleeve from top of cap to wrist level—straight grain of sleeve.

Quartering sleeve. Sleeve divided into four equal parts from cap to wrist. Used as guidelines for spreading the sleeve. Quarter sections are labelled X (see illustration).

Notches. One notch indicates front sleeve, two notches indicate back sleeve. Cap notch indicates where sleeve and shoulder meet (location can vary from center grainline.)

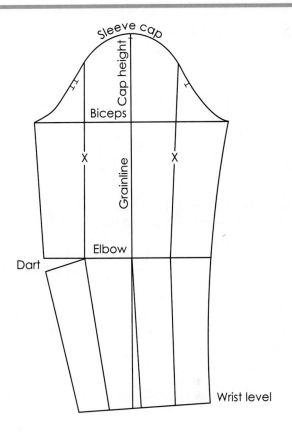

Elbow Darts

The elbow dart excess may be converted into multiple darts or pleats, treated as ease, or transferred to other locations around the pattern's outline for design variations.

Darts or pleats
- Draw slash lines 1/2 inch above and below dart legs and from dart point to elbow level (Figure 1).

- Cut slash lines and spread sections equally to absorb dart excess. Draw new darts. For pleats, omit dart points and punch and circles (Figure 2).

Ease
- Mark notches $1^1/_2$ inches up and down from dart legs.
- Draw blending line over dart area (Figure 3).

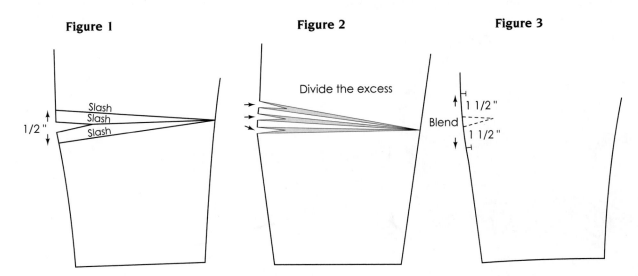

Figure 1 **Figure 2** **Figure 3**

Shoulder Pads

The shoulderline and sleeve cap are modified to accommodate shoulder pads. Add thickness of the shoulder pad to the shoulder tips of the bodice and to the sleeve cap (see two versions for adding height). It is not necessary to add to the shoulder tips of garments with a kimono design or a casual armhole (ease in the armhole of these designs allows room for the shoulder pad).

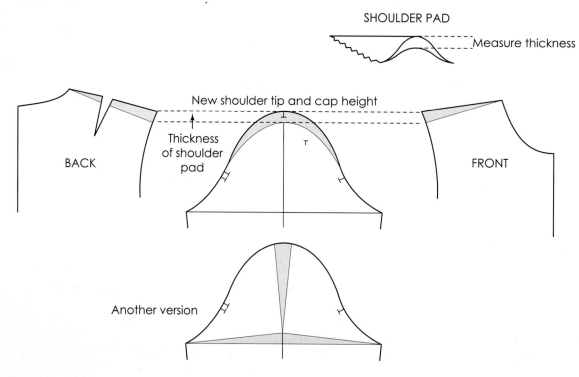

SHOULDER PAD

Measure thickness

New shoulder tip and cap height

Thickness of shoulder pad

BACK

FRONT

Another version

Sleeve Cuffs

Sleeve cuffs are developed in a variety of widths and styled in a number of ways (curved, pointed, and so on). The most common are the basic shirt cuff, the French cuff, the closed cuff, the roll-up cuff, and the wide, contoured cuff. Other design variations are easily developed using the general instructions as a guide. The grainline can be altered to accommodate straight, bias, or crossgrain as appropriate for the marker or fabric design (plaids and stripes).

Measurements needed:
Around hand _____, plus 1/2 to 1 inch ease. Cuff width as desired.
Example: 9-inch (including ease) for a basic cuff 2 inches wide.

(37) Measure around the hand —

Basic Shirt Cuff

Figure 1
- Fold paper lengthwise.
- Square a 2-inch line from fold. Draw parallel line 8 inches long. Mark.
- Add 1 inch for extension.

Figure 1

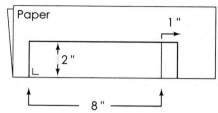

Figure 2
- Add 1/2 inch seams.
- Mark button placement in center of extension.
- Center buttonhole 3/4 inches from edge (see Chapter 16 on button placement).
- Cut from paper.

Figure 2

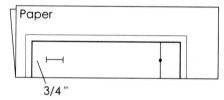

Figure 3
- Unfold cuff pattern. Add grainline, straight or crosswise.

Figure 3

Self-Faced Cuff

Figure 4
- Develop cuff using general instructions above.
- Cuff can be designed with square corners or curves (broken lines).
- Cut four pieces to complete the set.

Figure 4

French Cuffs (Used with Cufflinks)

One-Piece Cuff

Figure 5
- Fold paper lengthwise.
- Square a 4-inch line from fold equal to twice the cuff's width.
- Draw parallel line 8 inches long. Mark for notch and add 1-inch extension to both ends of cuff. Connect ends.
- Mark for buttonholes (see Chapter 16).
- Add seams and grainline.
- Cut from paper.

Figure 5

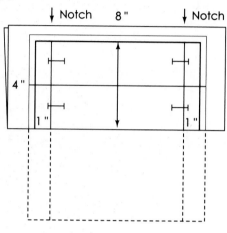

Two-Piece Cuff

Figure 6
(Straight or pointed ends. See broken lines.)
- Develop cuff on open paper, using instructions for one-piece French cuff.
- Add seams to all sides of pattern.
- Draw grainline.
- Cut from paper.

Figure 6

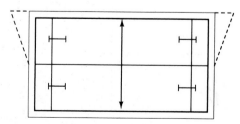

Contoured Cuffs

Design Analysis

Contoured sleeve cuffs follow the shape of the arm and can be as wide as desired, ranging from the wrist to the elbow. Cuffs may be straight, pointed, or curved.

Cuff Based on Basic Sleeve

Figure 1

- Trace sleeve from wrist to desired cuff width (example: 6 inches parallel with wrist).
- (The line may be curved or pointed for variation.)
- Transfer part of the back sleeve (shaded area) to front, as illustrated.

Figure 1

Figure 2

- Notch 1 inch from underseam on right side for extension (to tighten cuff).
- Mark for buttons and buttonholes (see Chapter 16).
- Cut cuff from pattern.

Figure 2

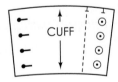

Figure 3

- Add 1 inch to the upper sleeve.
- Mark notches on sleeve for cuff placement.

Figure 3

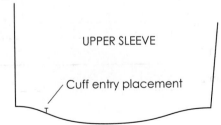

UPPER SLEEVE

Cuff entry placement

Cuff Based on Dartless Pattern

Figure 1

Develop cuff as follows:

- Draw line equal to around hand measurement (example: 9 inches).
- Square up from both ends equal to cuff width (example: 6 inches). Draw line across or curved.
- Divide into four equal parts.

Figure 1

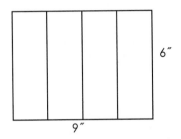

Figure 2

- Slash and spread each section 1/4 inch.
- Add 1-inch extension.
- Mark for buttons and buttonholes

Note: Remember to subtract cuff length (less 1 inch) from pattern before developing sleeve pattern (not illustrated). Notch for entry.

Figure 2

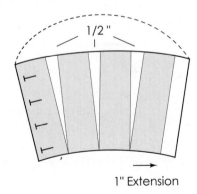

1" Extension

Roll-Up Cuffs

Design Analysis

Roll-up cuffs are developed all in one with the sleeve or as separate cuffs stitched to the sleeve and turned up. To develop this type of cuff, determine the finished length of sleeve (between biceps level to hem) and add cuff width. Example: Sleeve length below biceps = 4 inches; cuff $1^{1}/_{2}$ inches (for roll-up). Use these measurements or personal measurements. *Note:* Use this process for pants with cuffs.

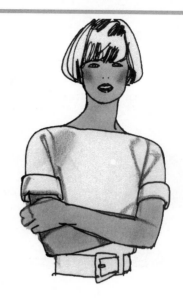

All-in-One Cuff with Sleeve

Figure 1

- Trace sleeve to finished length desired. Label A–B.
- Draw three parallel lines spaced $1^{1}/_{2}$ inches apart below hem (A–B line). Label sections 1, 2, and 3.

Figure 1

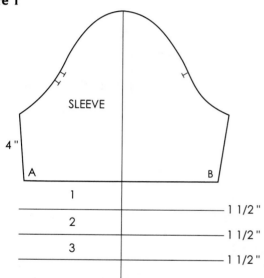

Figure 2

- Fold so that section 1 is up, section 2 down, and section 3 underneath.
- Draw underseams with ruler on both sides of fold as guides and cut from paper while folded. Unfold.

Figure 2

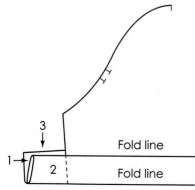

Figure 3

- The completed sleeve.

Figure 3

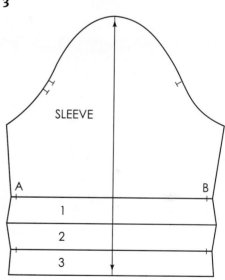

Separated Cuff

Figure 4

Follow instructions above for all-in-one cuff, with exceptions:

- Omit third section.
- Cut along A–B line, separating cuff from sleeve.
- Add seams.

Figure 4

Cap Sleeves

Cap sleeves can jut away from the arm (Design 1 or conform to arm Design 2). This type of sleeve can be shaped in a variety of ways and is usually designed for a bodice, dress, or blouse.

DESIGN 1 DESIGN 2

Jutting Cap

Pattern Plot and Manipulation

Figure 1 *Sleeve cap*

- Trim approximately 1 inch from cap height (causes hemline of sleeve to swing away from arm).

- Use illustrations as guide for sleeve draft.

- Trim 1/4 inch from each side of underseam.

- True sleeve cap to armhole (1/4 inch ease required on each side of cap). Add to or remove from cap height to control fit.

Figure 1

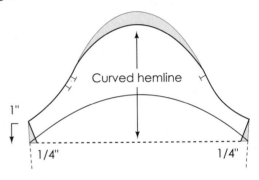

Figure 2
- Example of short curved cap (self-faced).

Figure 2

Note: When shoulder pads are used, add to shoulder of garment but not to sleeve cap, see page 318.

Dartless Sleeve Pattern

The dartless sleeve pattern differs from the basic sleeve in two ways: It does not have an elbow dart and it does not taper to the hemline. Its purpose is for use in developing sleeves with wide sweeping hemlines (flare, bishop, bell), fullness in the sleeve or cap (puff sleeve), and those not requiring an elbow dart (shirt sleeves).

Two dartless sleeve patterns are illustrated, a full pattern and a half pattern.

The basic sleeve pattern can also be used to develop sleeve designs, but the dartless sleeve patterns simplify the process.

Pattern Plot and Manipulation

Figure 1

- Trace basic sleeve, including all markings. (Broken line indicates original pattern.)

 A–C = A–B, squared down from A.

 D–E = A–C, squared down from D.

 Draw a line from C to E. Mark center and label F. Measure out from each side of F one-half of entry measurement. Mark.

- Cut from paper, discard unneeded section.

Figure 1

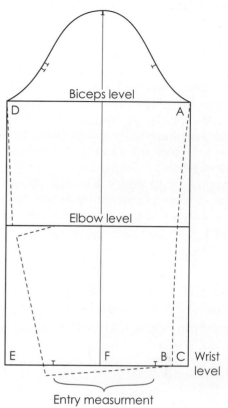

Figure 2 *Full sleeve*

- Draw lines equally on both sides of grainline to quarter the sleeve. Label X.

Figure 3 *Half sleeve*

- Make a copy of the back sleeve from grainline to underarm seam. Trace front underarm curve on the back armhole. (When using the half sleeve, the center [grainline] is on fold; illustrated where appropriate.)

Figure 2 **Figure 3**

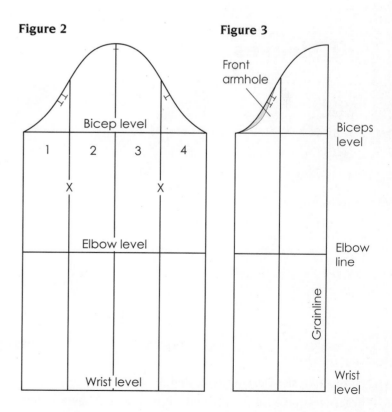

Modifying Armhole for Sleeve Cap Ease

Figures 1, 2, 3

Cap ease of the basic sleeve is necessary for fitting over the ball of the arm. Sleeve designs (other than the basic sleeve or those with gathers along the cap) require much less ease to avoid puckering. Ease allowance for design sleeves is 1/2 inch (1/4 inch on each side of cap). Before modifying the sleeve or armhole, measure both and subtract to determine cap ease. Follow the example to reduce or redistribute cap ease.

Example: Cap ease = $1^1/_2$ inch. Allow 1/2 inch for ease; 1 inch remains to be distributed, or modified. Modify in any sequence to solve the fitting problem.

- Lower front and back armhole notches 1/4 inch each.
- Add 1/16 inch at shoulders and side seams, to zero.
- Lower cap height 1/4 to 1/2 inch (flared sleeves).

Figure 1

Figure 2

Figure 3

Trim cap 1/4" to 1/2"

Puff Sleeves

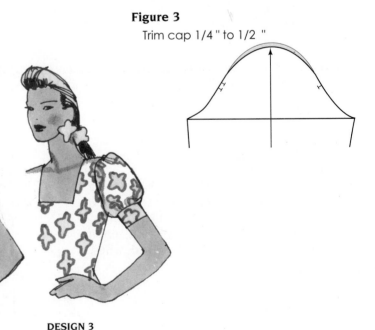

DESIGN 1 DESIGN 2 DESIGN 3

Design Analysis: Designs 1, 2, and 3

Puff sleeves have fullness added—Principle 2. They are designed with gathers at the hemline, at the capline, or at the cap and hemline. The puff sleeve can be of any length, and fullness can be more or less than illustrated. See instruction above to modify armhole or sleeve cap. The dartless half pattern is the base for developing the puff sleeve designs.

Fullness at Hem

Figure 1

- Use the dartless half pattern for the following puff sleeve designs.
- Trace sleeve 2 inches below biceps.
- Draw and cut slash lines from hem to, but not through, capline.

Figure 1

Figure 2

- Fold paper and place sleeve on paper and spread.
- Trace sleeve and front sleeve underarm curve. Mark notches.
- Extend 2 inches at center front and blend curve line to underseam (creates the puff).
- Add 1/2-inch seams.
- Mark seam notches and cut from paper.

Figure 2

Figure 3

- Unfold pattern, draw grainline. Trim front sleeve underarm curve (shaded area).

Figure 3

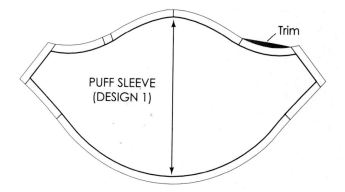

Figure 4 *Sleeve band*

- Sleeve bands or elastic are used for short sleeves. For sleeves ending above elbow, use elbow measurement plus 1/2-inch ease. For those ending below elbow, measure the arm at the level of the sleeve length. Add 3/4-inch ease. Example: Square length equal to elbow measurement ($10\frac{1}{2}$ inches) and width 2 inches (finished band width is 1 inch).

Figure 4

Fullness at Cap

Figure 1

- Use the dartless half sleeve; see page 323, Figure 1.
- Place sleeve on paper with hem touching fold. (Place hem 1/2 inch over fold line to tighten hemline if desired not illustrated.)
- Spread using measurements given.
- Trace sleeve and front sleeve underarm curve.
- Measure up 2 inches from cap. Mark and draw curved line for cap (creates the puff).
- Cut from paper.

Figure 1

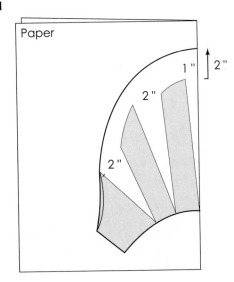

Figure 2

- Unfold pattern.
- Draw grainline, notch, and trim front sleeve curve.

Facing

- Trace hemline of sleeve $1\frac{1}{4}$ inches wide.

Figure 2

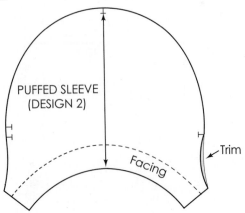

Fullness at Hem and Cap

Figure 1

- Use the dartless sleeve; see page 323, Figure 1.
- Square a guideline 3 inches up from fold.
- Place pattern on fold with hemline on guideline (indicated by broken lines). Label A and B.
- Measure up 2 inches from cap and down 2 inches from hem. Mark.
- B–C = One-half or all of A–B measurement for greater fullness. Mark on guideline.
- Shift pattern along guideline until point B touches C mark.
- Trace sleeve to X-guideline, including front sleeve curve (shaded area).
- Blend curved line 2 inches above cap and below hem.

Figure 1

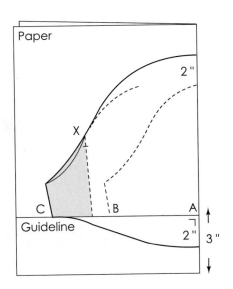

Figure 2

- Unfold pattern, draw grainline. Notch. Trim front sleeve curve.

Figure 2

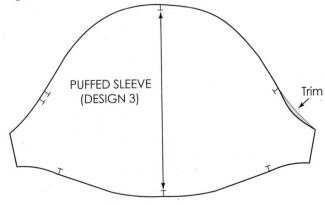

Circular Hemline Sleeves

Half-Circle Sleeve

Design Analysis

The dartless sleeve pattern is used as a basis for increasing sleeve hemline fullness to a half circle. The sleeve can be developed to any length desired; see Designs 1, 2, and 3. The short sleeve (Design 1) should be used as a guide for longer lengths. See page 324 to adjust armhole or eliminate cap ease as shown in Figure 2.

DESIGN 3

DESIGN 1 DESIGN 2

Pattern Plot and Manipulation
Figure 1

- Trace dartless sleeve back 2 inches below biceps. Remove pattern. Square a line across sleeve hem.
- Draw slash lines.
- Cut slash lines to, not through, cap.

Figure 1

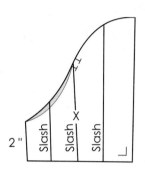

Figure 2

- Fold paper.
- Square a guideline 2 inches down from fold.
- Spread each section until underseam touches or is parallel with guideline.
- Trace sleeve and front sleeve curve. Remove pattern.
- Cut from paper.

Figure 2

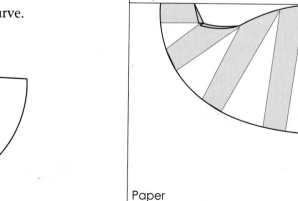

Figure 3

- Unfold pattern.
- Draw grainline. Notch. Trim front sleeve curve.

Figure 3

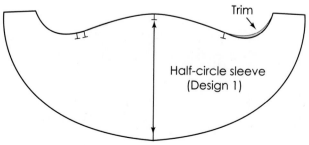

Half-circle sleeve
(Design 1)

Trim

Full-Circle Sleeve

Design Analysis

The full-circle sleeve for Designs 1 and 2 is developed using the Radius Chart for circles and cascades (found in Chapter 13). Design 1 is illustrated, showing an uneven hemline, while Design 2 is provided as a thought problem. (Question: Is the pattern the same for both designs? Analyze both designs and pattern for the answer.)

Adjust armhole; see page 324.

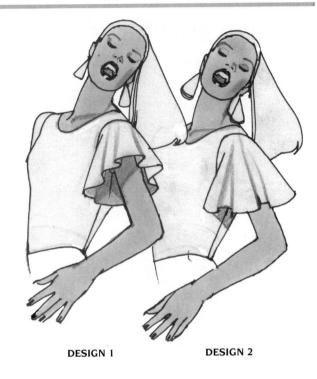

DESIGN 1 **DESIGN 2**

Pattern Plot and Manipulation

Measurements needed:
- Sleeve length (example: 7 inches).
- Measure front and back armholes (example: 16 inches).
- Locate measurement in Column 1 of the Radius Chart to find the circle's radius in Column 5, less 1/2 inch for seam allowance.

Paper needed: Sleeve length. (Example: Sleeve length (7 inches) × 2 = 14, plus 2 × radius (4 inches), plus 5 inches, or a total of 23 inch square of paper.)

Figure 1

Figure 1
- Fold paper into four equal parts. Label corner of fold A.
- Draw outer circle with measuring device using sleeve length plus radius from chart.
- Label hem of circle B at fold.

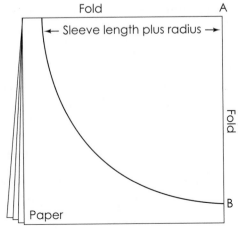

Fold — A

← Sleeve length plus radius →

Fold

Paper B

Figure 2

- Cut circle from paper and unfold. (Broken lines represent original fold lines.)

 A–C = Radius. Mark.

- Draw inner circle using C as center, or place circle in center of sleeve for length variation.

- Label D above C (notch placement).

- Cut inner circle by slashing through pattern from B to A. (B to A should be notched 1/2 inch on each side for seam allowance. Seam allowance eliminates the bias stretch.) If inner circle does not stretch to equal armhole, trim 1/16 inch or more from inner circle until it does.

Figure 3 *Position of sleeve to armhole of* **Design** 1

- Circle is placed in armhole with point D at shoulder tip seam and point A (underseam) at side seam of armhole. (Broken line indicates inner circle under the overlapping sleeve.)

Figure 2

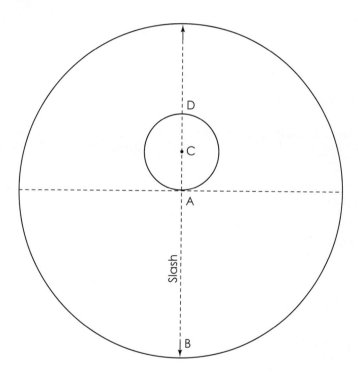

Figure 3

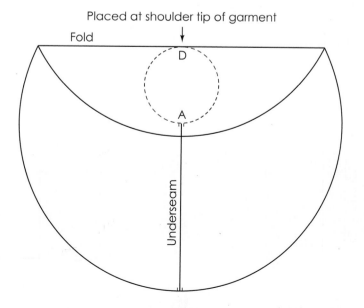

Bell Sleeves

Design Analysis

A bell sleeve has a smooth cap and a hemline flaring out in the shape of a bell. The bell sleeve may be developed to any length and flare desired. It can be based on the dartless sleeve back, the bishop sleeve, or the exaggerated bishop sleeve (with the hemline trimmed). The dartless sleeve illustrates three sleeve lengths.

 Adjust the armhole or sleeve cap; see page 324.

Pattern Plot and Manipulation

Figure 1

- Trace dartless sleeve back. Include quarter line. Label X.
- Mark length of bell sleeve as desired. (Example: 3 inches below biceps for Design 1, elbow level for Design 2, and full length for Design 3.)
- Draw slash line between X-line and grainline.
- Cut slash lines to, not through, cap.

Figure 2

- Fold paper.
- Place point A of sleeve on fold of paper and spread for desired hemline sweep or use measurements given.
- Trace pattern outline. Trace front underarm curve of sleeve.
- Draw an inward curve to taper underseam.
- Cut from paper, unfold, draw grainline, and trim front armhole curve. (Full pattern shown.)

Figure 1

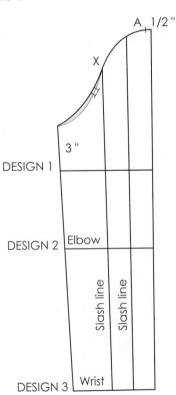

Figure 2

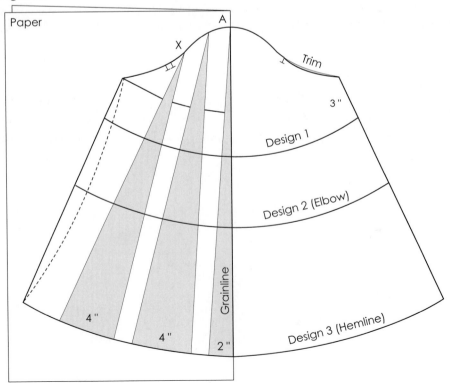

Petal Sleeves

Design Analysis

Petal sleeve is a term used to describe a shaped sleeve that resembles a petal as the sleeve sections cross over each other at the cap. The sleeves are developed in a number of ways and at varying lengths. Several petal sleeves are illustrated. The full dartless sleeve is used to develop the petal. The front sleeve underarm curve is trimmed. All three variations are developed from the same pattern.

Note: Sleeve may be self-faced or lined. See page 324 for adjusting armhole.

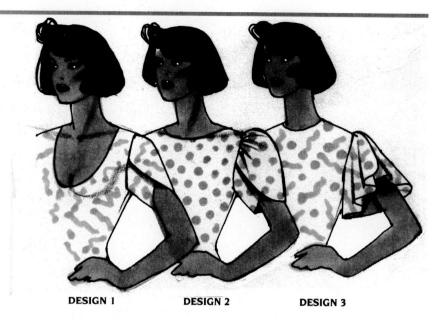

DESIGN 1 DESIGN 2 DESIGN 3

Plain Petal—Design 1

Pattern Plot and Manipulation

Figure 1

Trace dartless sleeve to $1\frac{1}{2}$ inches below biceps line. Include all markings.

- Measure in 1/2 inch at underseam. Draw line to corner of sleeve.

 A–B = 5 inches. Mark.

 A–C = $3\frac{1}{2}$ inches. Mark.

- Draw petal styleline.
- Trace front sleeve curve for front petal.
- Cut back petal from paper.

Figure 1

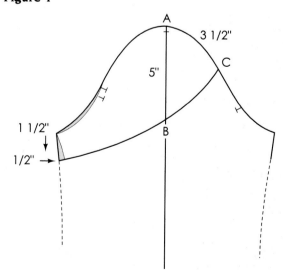

Figure 2 *Two-piece petal*

- Trace petal pattern and cut.
- Trace again for front petal.
- Cut front, trim excess from front armhole curve (shaded area). Draw grainlines.

Figure 2

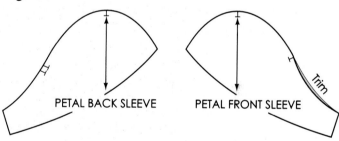

PETAL BACK SLEEVE PETAL FRONT SLEEVE

Figure 3 *All-in-one petal*

- Align underseams and retrace pattern.
- Draw grainline, cut from paper, and trim sleeve curve.

Figure 3

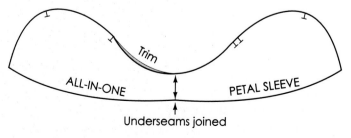

ALL-IN-ONE PETAL SLEEVE

Underseams joined

Gathered Petal

Figure 4
- Trace back petal frame for Design 2. Extend underseam length 3 inches. Blend (broken line is original petal sleeve).
- Draw slash lines.

Adjust armhole, see page 324.

Figure 4

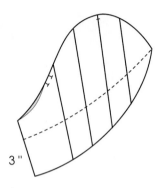

Figure 5 *Back sleeve*
- Cut slash lines to, not through, hemline. Place on paper and spread for gathers. (Example: 1 inch each section; 1/2 inch on each side of center.)
- Trace and remove pattern.
- Add 1 inch to cap height. Blend and cut from paper.

Figure 5

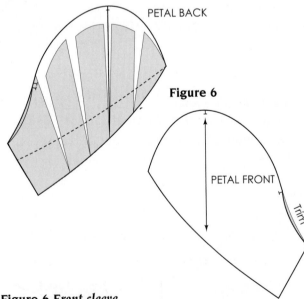

Figure 6 *Front sleeve*
- Retrace for front sleeve.
- Cut and trim excess from sleeve curve. (If all-in-one petal is desired, align underseams. See Figure 3.)

Flared Petal

Figure 7
- Trace back petal sleeve for Design 3.
- Draw slash lines equally across pattern.

Adjust armhole; see page 324.

Figure 7

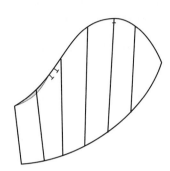

Figure 8
- Cut slash lines to, not through, cap.
- Draw squared guidelines on paper. Square out from each side of vertical line for horizontal guideline.
- Align cap with vertical line and corner of underseam with horizontal guidelines. Spread pattern sections and trace.
- Shape petal to within 2 inches of notch point.
- Cut from paper.

Figure 8

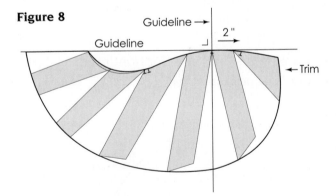

Figure 9
- Retrace for front sleeve.
- Draw grainline. Cut and trim front sleeve curve.

Figure 9

Lantern Sleeves

Design Analysis

A lantern sleeve is a two-section sleeve that flares out from the cap (upper section) and hemline to a styleline within the sleeve. The sleeve can be developed at varying lengths and fullness. The three designs show the flexibility of the lantern sleeve silhouette. Design 3 is given as a practice problem. Adjust armhole; see page 324.

DESIGN 1 **DESIGN 2** **DESIGN 3**

Long Lantern Sleeve—Design 1

Measurement needed:
• Around hand _____. (See page 318.)

Pattern Plot and Manipulation
Figure 1
• Trace dartless sleeve pattern and all markings.
• Label quarter sections X.
• Mark one-half of the around-hand measurement, less 1/2 inch from each side of grain at hemline.
• Draw lines from wrist marks to biceps.
• Draw styleline 6 inches up from hem (varies).
• Divide sleeve into eight parts and number.
• Cut and discard unneeded sections (shaded area).

Figure 1

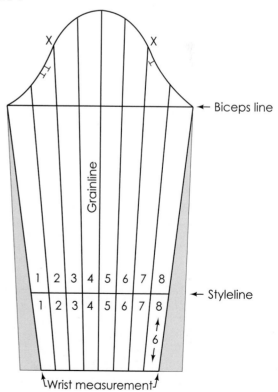

Figures 2 and 3

- Cut and separate upper from lower section.

Figure 2

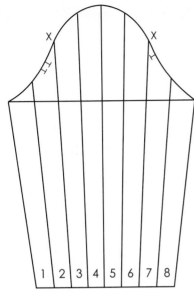

Figure 3

Figure 4 *Upper sleeve*

- Cut slash line to, not through, cap.

- Place on paper and spread desired amount, secure, and trace.

- Measure down 1 inch from the bottom panel.

- Blend curved line to underseams.

- Notch centerline of sleeve.

- Cut from paper.

Figure 4

Figure 5 *Lower sleeve*

- Develop lower section, spreading same amount as upper sleeve.

Note: Lantern styleline must measure equally to true to upper section.

Figure 5

LOWER SLEEVE

Short Lantern Sleeve—Design 2

Pattern Plot and Manipulation

Figure 1

- Trace back half of dartless pattern to 5 inches below biceps. Include front underarm curve.
- Draw line from biceps, ending 1/2 inch in from hemline. (Broken line indicates original underseam.)
- Draw lantern styleline, dividing upper and lower sections equally.
- Draw slash lines and label.
- To adjust armhole; see page 324.

Figures 2 and 3

- Cut sleeve from paper.
- Cut and separate upper from lower section.

Figure 2

Figure 1

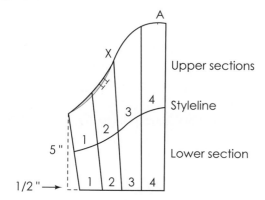

Figure 4

- Cut slash lines to, not through, cap and hem of both sections.
- Place sleeve on fold of paper (point A of upper section touches fold line).
- Spread upper and lower sections. (Example: $1\frac{1}{2}$ inches; 3/4 inch each side of center line.)
- Trace patterns and front underarm curve.
- Extend centerline of sleeve sections 1 inch at styleline, blending curved line. (Upper and lower stylelines must measure the same.)
- Notch where shown and cut from paper. Unfold and trim front underarm curve (shaded area).

Figure 4

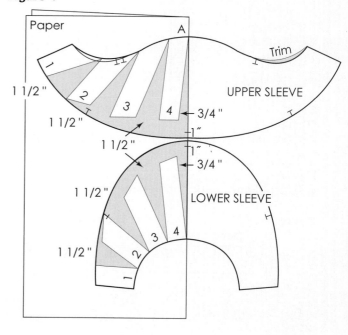

Sleeves with Extended Caps

Darted Cap

Design Analysis—Design 2

Sleeve extends out from the ball of the arm and is controlled by three darts for Design 2. Design 1 is based on the same pattern except that the cap is blended for gathers. Cap ease can be eliminated as illustrated, or see page 324 for adjusting armhole.

Pattern Plot and Manipulation

Figure 1

- Trace the basic sleeve.
- Draw slash lines 2 inches away from center grainline at cap.
- Draw 1/8-inch wedge *along* each slash line at cap (1/16 inch out from each side of notch) to zero at grainline of the biceps line. This eliminates some of the cap ease. Disregard instruction if armhole has been adjusted.
- Cut sleeve from paper. Discard unneeded sections (shaded area).

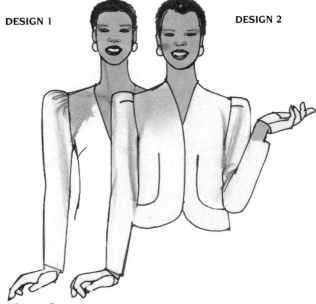

DESIGN 1 DESIGN 2

Figure 2

- Slash from cap to, not through, corners of biceps line.
- Raise biceps $1\frac{1}{4}$ inches. Spread sections equally and trace.
- Center and mark dart points $1\frac{1}{4}$ inches down each opening. Draw dart legs.

Figure 1

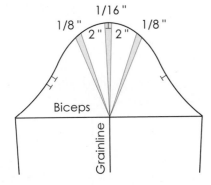

1/16 "
1/8 " 2 " 2 " 1/8 "
Biceps
Grainline

Figure 3

- Fold dart legs, cupping pattern while blending cap.

Figure 4

- Unfold and mark notches and punch circles.

Figure 3 **Figure 4**

Blend

Folded darts Completed darts

Figure 2

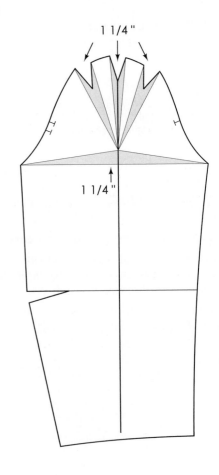

1 1/4 "

1 1/4 "

Crescent-Shaped, Extended Cap

Design Analysis—Design 3

The sleeve cap is extended, forming a crescent-shaped styleline parallel with armhole. Instruction for Design 4 follows this project. See page 324 to adjust armhole.

DESIGN 3 DESIGN 4

Pattern Plot and Manipulation

Figure 1

- Trace basic sleeve and all markings.
- Label center grainline A. Mark E, $1\frac{1}{4}$ inches down from A.
- Mark B and C, 4 inches from A.
- Square in $1\frac{1}{4}$-inch lines from B and C, and in between A–B and A–C.
- Draw curved line from D to E to F parallel with sleeve cap.
- Cut sleeve from paper.
- Cut slash lines *carefully* from A to E, E to D, and E to F.
- Cut out capline from A to B and A to C.

Figure 1

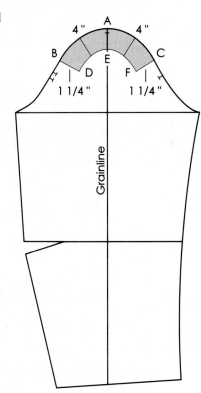

Figure 2

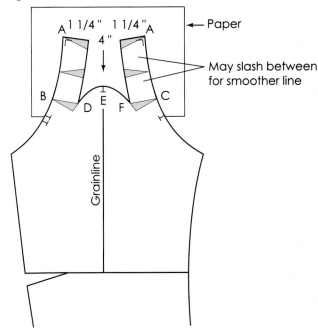

Figure 2

- Cut to, not through, remaining slash lines (from inner to outer cap). Place paper underneath and secure.
- Spread until sections D and F touch curve of sleeve.
- Measure the opened space and use as spread amount for next section.
- Secure by pinning spread sections to paper underneath.
- Square lines from A equal to panel width ($1\frac{1}{4}$ inches). From this point, draw lines to D and F parallel to cap. *Note:* D and F lines should both equal 4 inches. If they do not, adjust by increasing or decreasing spread.
- Cut from paper.
- Slash through E to elbow.

Figure 3

- Draw vertical guideline (grainline) on another paper.
- Continue the slash across elbow level to, not through, underseam and dart point.
- Place on paper. Spread E, $1\frac{1}{2}$ inches out from each side of guideline. Secure. If elbow dart does not completely close, notch $1\frac{1}{2}$ inches each side of elbow level and from each dart leg to control remaining ease. Blend.
- Measure up $1\frac{1}{2}$ inches from guideline. Mark and label G.
- Draw curve from G to D and from G to F. Curved line must measure 4 inches. If it does not, adjust spread.
- Trace sleeve.
- Complete pattern and cut from paper.

Figure 3

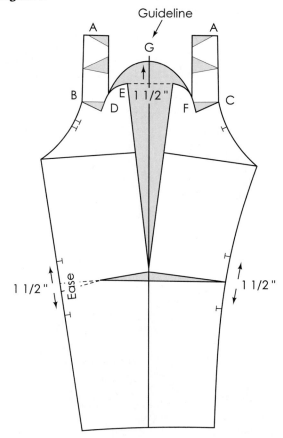

Gathered Crescent Sleeve

Design Analysis—Design 4

The sleeve extends beyond the ball of the arm with gathers forming around crescent styleline.

Figure 1

- Follow instructions given for crescent-shaped, extended cap sleeve, with the following exceptions:
- Spread point E 6 inches or more.
- Measure up 3 inches to form gathered section ending at D and F.

Figure 1

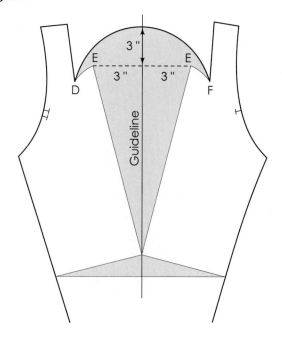

Sleeve with Vertical Pleat

A pleat is folded through the length of the sleeve and over the sleeve cap. The pleat is stitched together at the shoulder tip.

The sleeve can be developed with the dartless half sleeve foundation. The hemline can be held by elastic or a drawstring. (The underseam can be tapered to control fullness. If a cuff is desired, use the shirt sleeve (see page 477). Adjust the armhole using instructions on page 324.

Pattern Plot and Manipulation

Figure 1 *Dartless half pattern*

If the sleeve is not available, see page 323. For reference, the cap is A and the guideline (quarter section) is X.

Figure 2

- Fold paper and square a line across paper 8 inches down from the top.
- Place pattern on the fold, aligning biceps line with guideline. Secure.
- Trace sleeve cap from A to X and trace hemline.
- Measure cap from A to X. Record.
- Shift pattern 4 inches on guideline. Pattern is parallel with the fold. Secure.
- Trace to complete the pattern, starting from X.
- Extend X line using A to X measurement. Square across 4 inches and down to touch X, completing the sleeve draft. Mark center of the pleat fold.

Complete pattern for a test fit.

Figure 1

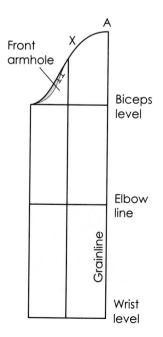

DESIGN 1 **DESIGN 2**

Figure 2

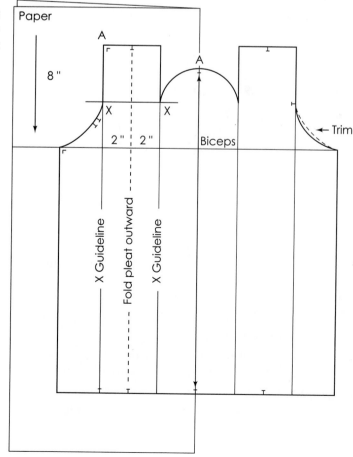

Leg-of-Mutton Sleeve

DESIGN 1 DESIGN 2

Design Analysis

Design 1 is developed by enlarging the biceps and cap area, tapering the fullness toward the elbow level. Design 2 is developed by doubling or tripling the measurements given.

Pattern Plot and Manipulation

Figure 1

- Trace basic sleeve and all markings. Label cap A and B.
- Mark 4 inches down from cap on grainline. Label C.
- Draw slash lines from C to under seams.
- Cut from paper.

Figure 1

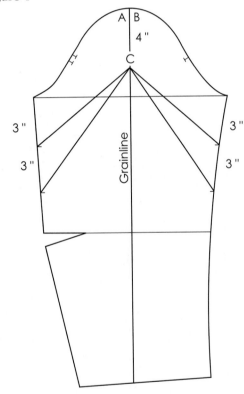

Figure 2

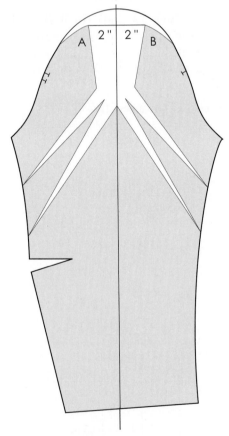

Figure 2

- Cut slash line to C and to, not through, under-seams.
- Draw vertical guideline in center of paper.
- Place pattern on paper, matching sleeve grainline with guideline.
- Spread A and B sections 2 inches or more, spacing remaining sections equally apart. Secure.
- Trace.
- Measure up $1\frac{1}{2}$ inches from cap and blend to sleeve notches.

Cowl Sleeve

Design Analysis

The cowl sleeve drapes from the center of the sleeve cap to any desired depth (example: 5 inches). It is developed from the dartless back sleeve to any sleeve length. Design 2 is a practice problem.

Pattern Plot and Manipulation

Figure 1

- Trace dartless back sleeve.
- Mark A, 1/2 inch from cap (eliminates cap ease). Omit instruction if armhole was modified.
- Mark B, 5 inches or more down from cap. Connect A and B.
- Mark C, 2 inches from A.
- Mark D, between biceps and elbow.
- Draw slash lines from C and D to B.
- Cut from paper. Discard (shaded area at cap).
- Slash from B to, not through, C at cap, D at underseam, and from elbow level to underseam.

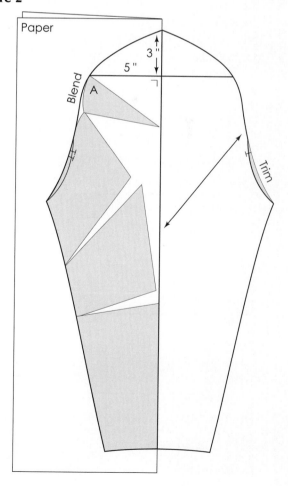

DESIGN 1

DESIGN 2

Figure 2

- Place pattern on fold, spreading sections until point A is 5 inches from fold. Spread more for a deeper cowl and secure.
- Trace pattern outline and front sleeve underarm curve to paper underneath.
- Square a line from fold to point A.

Foldback facing

- Measure up 3 inches from square line at fold and draw curve line to A.
- Cut from paper, unfold, trim front sleeve curve (shaded area). Draw bias grainline.

Figure 1 **Figure 2**

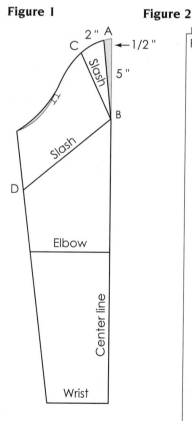

Wedding Sleeve

The traditional long, buttoned wedding sleeve is based on the basic sleeve with the elbow dart transferred to the hemline. Other variations are also possible; see Designs 2, 3, and 4.

Design Analysis

Sleeve of Design 1 has pointed hem with loops and buttons along edge of opening.

Pattern Plot and Manipulation

Figure 1

- Trace basic sleeve.
- Draw slash line from dart point to wrist 2 inches in from underseam. Label A.
- Label B at corner of front underseam.
- Draw guideline 1 inch over from grainline and 1¼ inches down from hem. Label C.
- Draw styleline from C to A and B.
- Cut from paper.

Figure 2

- Cut slash line to, not through, dart point.
- Close elbow dart. Tape.
- Trace pattern and mark grainline.
- Mark placement for loops. Space as desired.

DESIGN 1

Figure 3 Facing

- Trace sleeve section for facing (indicated by broken line in Figure 2).
- Separate facing at dart point.
- Add seams and grainline.

Note: Dart leg can be stitched 1 to 2 inches down to shorten.

Figure 1

Figure 2

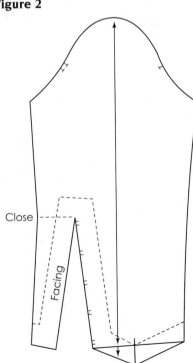

Figure 3

Sleeve Variations with Patterns

Designs 2, 3, and 4 show possible sleeve variations with the elbow dart transferred to hemline (Principle #1, Dart Manipulation). In Design 3, the dart is transferred to the cap area. (Remember, the dart can be transferred to *any* location around the pattern's outline.) Designs include added fullness (Principle #2).

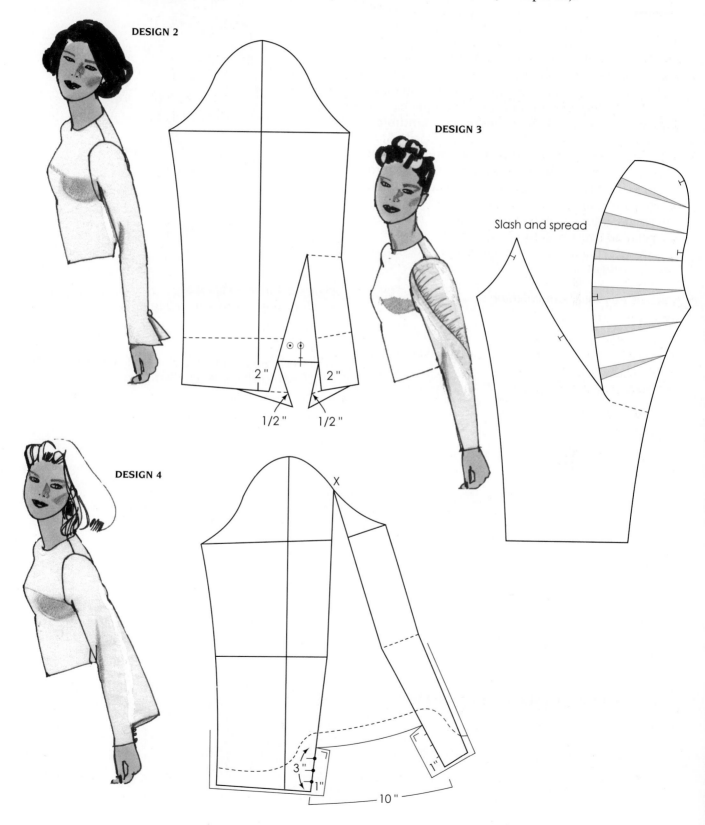

DESIGN 2

DESIGN 3

Slash and spread

DESIGN 4

Sleeve with Lowered Armhole

Design Analysis

Designs with deep-cut armholes (originally called Dolman sleeve) require sleeve and bodice modifications. The underarm seam of the sleeve must be increased in length an amount equal to the lowered bodice armholes; otherwise, the arm cannot be raised without strain on the upper garment (a diagonal fold will appear on the sleeve from the ball of the arm, draping slightly under the armhole). *Exception:* A very full garment with sufficient flare will allow the arm to move freely and will *not* require lengthening of the underarm of the sleeve to compensate for the *lowered* armhole. There are two methods for modifying the sleeve, and both are illustrated. Method 1 requires that the sleeve be slashed and spread; Method 2 does not.

See Chapter 21 for developing shirt sleeves for casual garments.

Pattern Plot and Manipulation

Method 1: Slash and lift

Figure 1 *Sleeve and bodice*
- Measure down 2 or more inches on sleeve and bodice. Mark.
- Draw curved line from marks to notches.
- Draw another curved line 2 inches below first line of sleeve.

Figure 2 *Sleeve modification*
- Cut to, not through, cap line.
- Place on paper, lifting each section 2 inches. Secure.
- Trace sleeve, drawing blending line from corner of cap to elbow level. Blend sleeve cap.
- Cut from paper.
- Adjust armhole; see page 324.

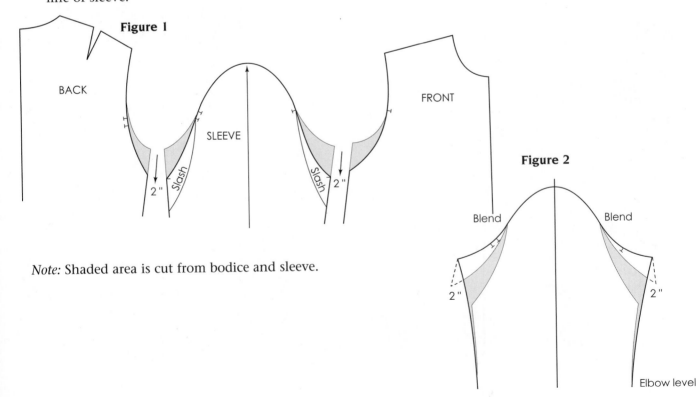

Note: Shaded area is cut from bodice and sleeve.

Method 2: *Extending biceps*

Figures 3 and 4 *Lowering armhole*

- Lower bodice armholes 2 or more inches and blend to notch locations.

- Measure original armhole and subtract from lowered armhole. Use these measurements when extending biceps line.

Figure 3

BACK

Record diff.

Figure 4

FRONT

Record diff.

Figure 5

Figure 5 *Modifying sleeve*

- Extend biceps line equal to measurements recorded from front and back armholes. Modify back sleeve, then front sleeve. (Broken line indicates original sleeve.)

- Blend line from biceps to elbow level. True sleeve to armhole and cut from paper.

Adjust armhole; see page 324.

Basic Bishop Sleeve

Design Analysis

The bishop is a billowy sleeve that hangs gracefully over the arm from a smooth cap. Length is added for blousing.

The sleeve draft is based on the shirt sleeve. See Chapter 21 for the shirt sleeve instruction. The pivotal method is illustrated.

To modify armhole or sleeve cap, see page 324.

Bishop Sleeve Draft

Figure 1
- Trace the shirt sleeve and all markings.
- Number the panels.
- Label grainline A and B.
- Mark quarter section X.

For cuff development, see page 319.

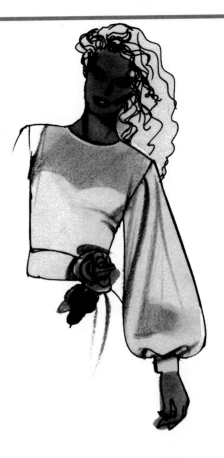

Figure 1

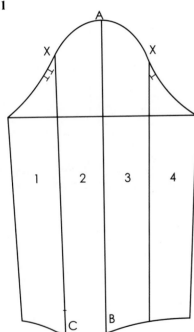

Figure 2

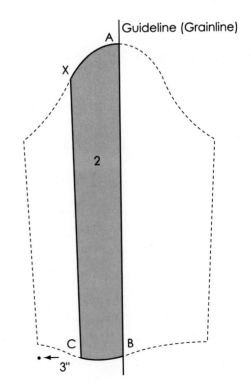

Figure 2
- Draw vertical guideline on paper.
- Place pattern on guideline with A–B of sleeve.
- Trace Panel 2 (shaded area). Label C at hem.
- Measure out 3 inches from C on paper and mark.

Figure 3

- With pushpin at X, pivot pattern until C is in line with mark on paper.
- Trace Panel 1 and crossmark at point C.

Figure 3

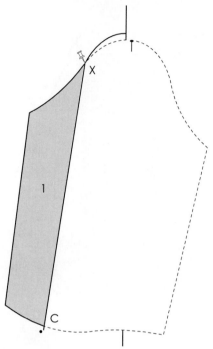

Figure 5

- With pushpin at X, pivot pattern until D is in line with mark on paper.
- Trace Panel 4 and crossmark. Remove pattern.

Figure 5

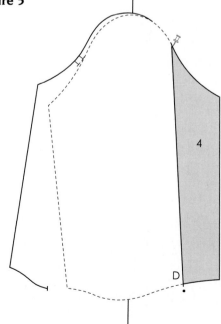

Figure 4

- Return pattern to guideline with A and B of sleeve on guideline.
- Trace Panel 3 (shaded area) and crossmark point D of front sleeve.
- Measure out $1\frac{1}{2}$ inches from D and mark on paper.

Figure 4

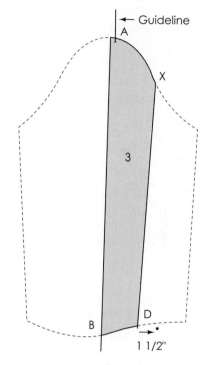

Figure 6

- Draw blending curved line across hemline of sleeve. (Marked area indicates fullness added.) For blousing, add 3/4 inch to length of sleeve at hemline.
- Draw grainline and complete for test fit.

Figure 6

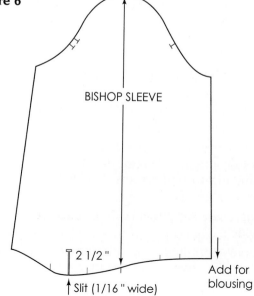

Exaggerated Bishop Sleeve

Design Analysis

The exaggerated bishop sleeve is based on the bishop pattern with greater fullness at the wrist and longer length for greater blousing. For cuff development, see page 319.

Pattern Plot and Manipulation

Figure 1

- Trace basic bishop sleeve, see page 346. Mark quarter-sections X.
- Draw slash lines. Divide each quarter-section in half (eight panels).
- Cut from paper.

Figure 1

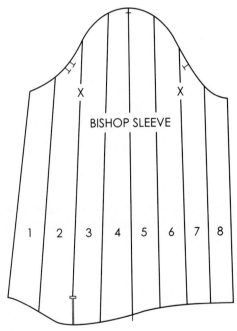

BISHOP SLEEVE

1 2 3 4 5 6 7 8

Figure 2

Figure 2

- Cut up from hem to, not through, sleeve cap.
- Spread as desired or follow illustration.
- Draw pattern outline.
- Draw curved hemline 1 inch or more below original length (for blousing), tapering to underseams (Panels 1 and 8).
- *Slit:* Draw slit 2 inches long, 1/16 inch wide.
- Draw grainline; cut and notch slit. Complete pattern for test fit.

1 2 3 4 5 6 7 8

2" 2" 2" 1" 1" 2" 2" 2" 2"

15

Kimono, Raglan, Drop Shoulder, and Exaggerated Armholes

Introduction to Sleeve–Bodice Combinations

The sleeve and top of any garment (blouse, dress, jacket, or coat) can be combined in a variety of ways, categorized as follows:

Kimono designs. The sleeve is all in one with the top garment.

Raglan designs. The sleeve combines with part of an armhole and shoulder area of the garment.

Drop shoulder designs. Part of the sleeve cap combines with the garment. The garment can be developed with or without the lower sleeve, or the lower sleeve can be attached to the garment.

Deep-cut armhole. The armhole section of a top combines with sleeve.

Each of the foundation patterns can be used to develop other design variations by exaggerating their special characteristics or by changing the style-line position.

Deep-cut armhole

Drop shoulder

Raglan

Kimono

Basic Kimono

The Western-style kimono is developed by combining the sleeve length with the bodice or top. The basic kimono is the basis for developing the dolman sleeve.* The kimono can be adapted and modified for a variety of other designs, several of which are illustrated. (The kimono underseam can end anywhere along the side, even extending to the hemline for the "batwing" dress.) With the armhole absorbed into the kimono design, compensation must be made to the front bodice armhole to avoid strain when the arm is in a forward position. This is corrected by transferring part of the dart excess to the mid-armhole before the kimono pattern is developed. The back shoulder dart is transferred to mid-armhole. (See Figures 1 and 2.)

 *Dolman was formerly a sleeve developed for a deep armhole.

Kimono Draft

Figure 1

Back pattern modification

- Allow enough paper to draw kimono sleeve.
- Trace basic back pattern, transferring shoulder dart to mid-armhole.

Figure 1

BACK

Figure 2

Front Pattern Preparation

- Trace and cut basic front pattern.
- Draw slash lines from mid-armhole and dart point to bust point.
- Slash to, not through, bust point. Set aside until the back draft is complete.

Figure 2

FRONT

Slash

Figure 3

- Mark 1/4 inch up from shoulder tip.
- Place ruler at mid-shoulder, touching the mark, and draw the length of the sleeve.
- Square a line one-half of the around-hand measurement.
- Draw a line to armhole.
- Draw the underseam to desired shape.
- Cut from paper. Trace a second copy and mark original shoulder tip as a guide.

Figure 3

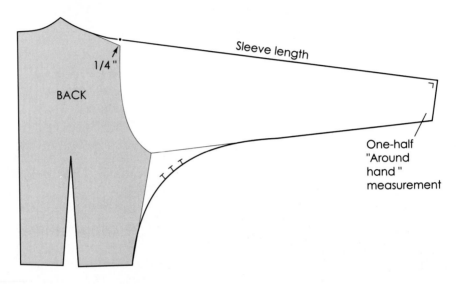

Figure 4

- Lay the front pattern on top of the traced copy, and place a pushpin at the shoulder tip to the shoulder mark of the back pattern.
- Close the waist dart until the side waist touches the side waist of the back. (Release bust point, if necessary). Secure.

- Trace front pattern in red pencil from mid-shoulder and to the side front waist. The sleeve is now a part of the front pattern. Remove pattern.
- Blend the front shoulder line to mid-shoulder of the back pattern.
- Cut around the front pattern and sleeve.
- Complete the pattern for a test fit.

Figure 4

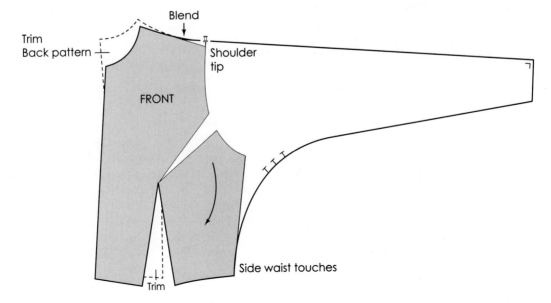

Figures 5 and 6

- Complete front and back patterns.
- Mark notches at front and back shoulder tips.
- Draw grainline and complete pattern for test fit.

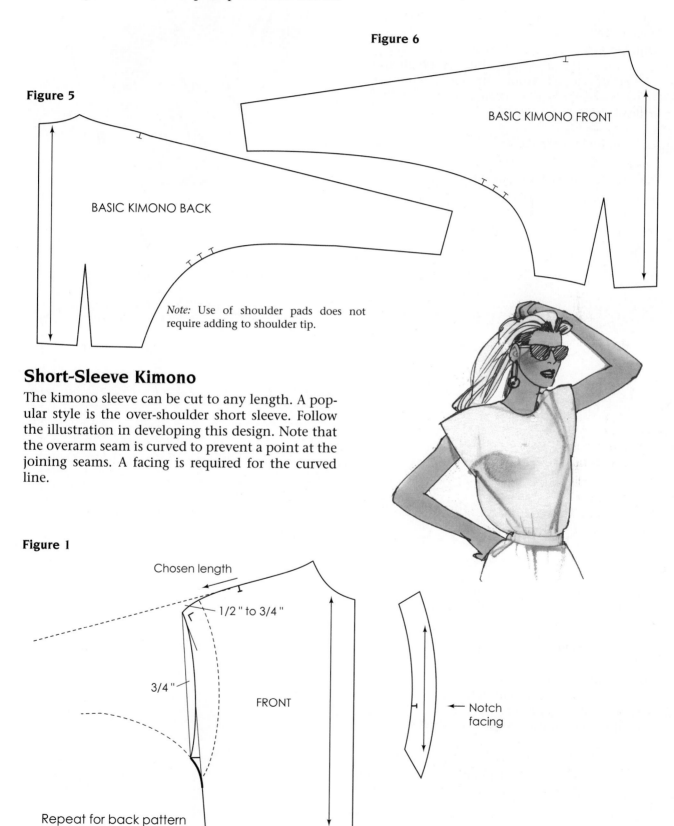

Figure 6

BASIC KIMONO FRONT

Figure 5

BASIC KIMONO BACK

Note: Use of shoulder pads does not require adding to shoulder tip.

Short-Sleeve Kimono

The kimono sleeve can be cut to any length. A popular style is the over-shoulder short sleeve. Follow the illustration in developing this design. Note that the overarm seam is curved to prevent a point at the joining seams. A facing is required for the curved line.

Figure 1

Chosen length

1/2" to 3/4"

3/4"

FRONT

Notch facing

Repeat for back pattern

Basic Dolman

Design Analysis

The dolman has lowered underseams with exaggerated folds under the arms, providing for a high arm lift. It is developed from the basic kimono. Originally a dolman was a lowered armhole with a set-in sleeve.

Pattern Plot and Manipulation

Figures 1 and 2

- Trace front and back Kimono foundation.
- Draw slash lines from shoulder tips, ending 3 to 4 inches up from side waist.

Figure 2

Figure 1

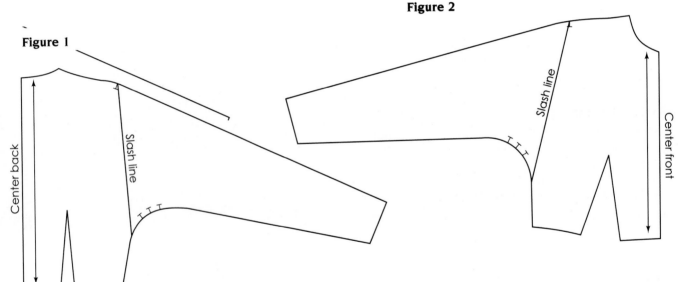

Figure 3

- Slash or pivot to spread under-arm sleeve, giving as much lift as desired. Blend underseam.
- Repeat for back and true under-seams.

 Note: Bold and uneven broken lines indicate possible dolman sleeve stylelines. For practice, explore other design variations.

Figure 3

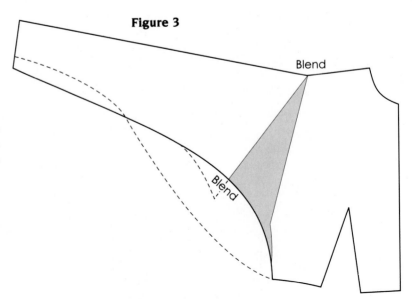

One-Piece Combinations

One-piece combination designs are developed by aligning the front and back patterns along either the sleeve (Design 1) or the shoulder (Designs 2 and 3). The instructions for the basic kimono also apply to the dolman, raglan, or kimono with gusset.

Use the following illustrations as a guide for developing the designs, noting the special instructions given below.

Grainline options
- Parallel with center front.
- Bias.
- Along original overarm seam (see Figure 1).

Kimono with Shoulder Line Seam

Figure 1
- Place overarm seams together, allowing 1 inch between shoulder tips.
- Trace.
- Blend shoulders to meet about $1^1/_2$ inches below shoulder notch.

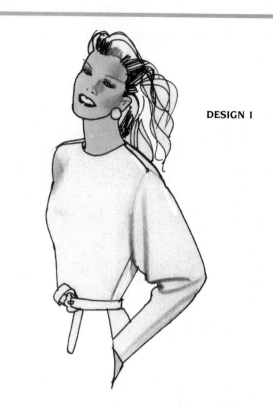

DESIGN 1

Figure 1

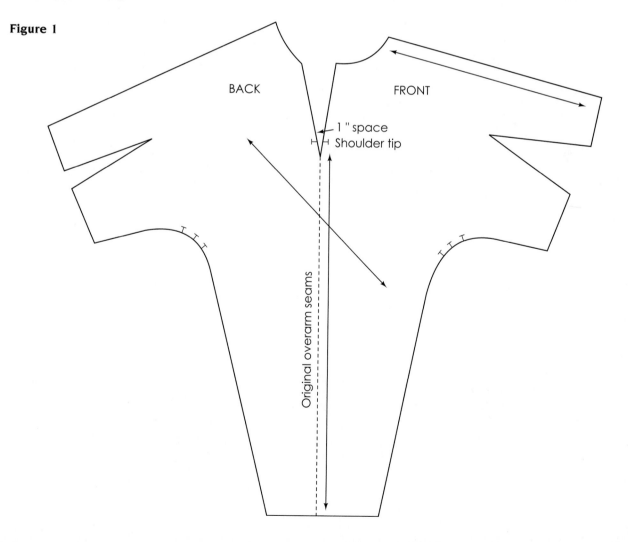

BACK FRONT

1 " space
Shoulder tip

Original overarm seams

Full-Sleeve Kimono (Without Overarm Seam)

The hemline of the sleeve is gathered. A bell silhouette is created if the sleeve is left uncuffed.

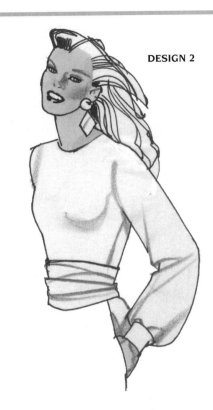

DESIGN 2

Figure 2

- Place shoulder-neck and shoulder tips together. Trace. (Broken lines indicate shoulder line and sleeve position.)
- Blend curved area across open space at wrist.
- For additional fullness, add to underseam of sleeve. The sleeve does not have an overarm or shoulder seam.

Figure 2

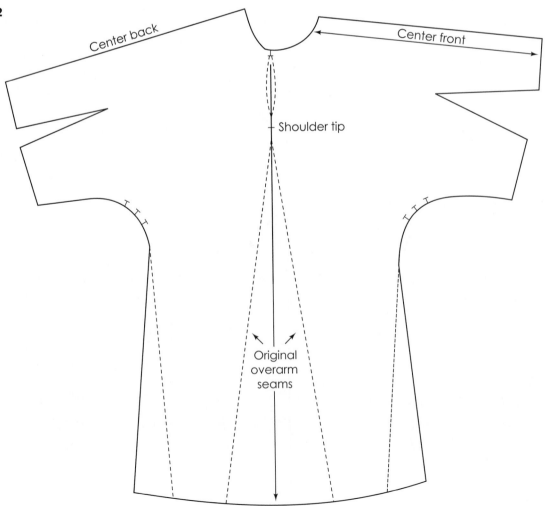

Tapered Sleeve (Without Overarm Seam)

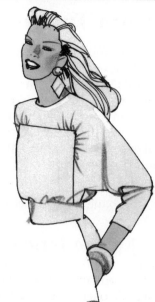

DESIGN 3

Figure 3

- Place shoulder-neck and shoulder tips together. Trace. (Broken lines indicate sleeve position.)
- Mark center point between sleeves at wrist.
- Draw line to shoulder tip. Square out back and front hand entry. Blend with underseams. Plot pattern for Design 3.

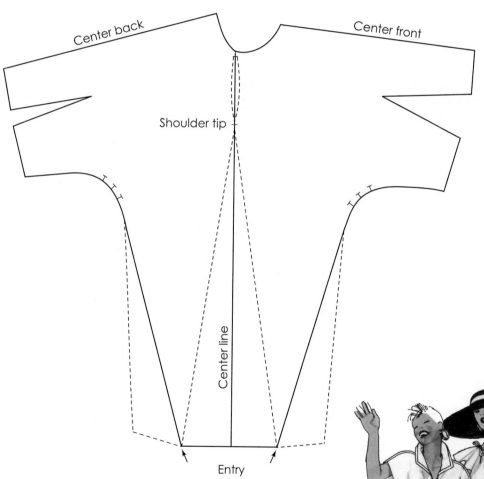

Kimono and Dolman Variations

The practice problems illustrated are design variations based on the kimono and dolman patterns.

Kimono Torso Foundation

The kimono foundation can be based on the basic front and back patterns, or on the torso foundation as used in the illustration. The torso foundation simplifies the draft for garments without waistline seam.

The front and back patterns are drafted together and separated at the completion of the draft. It is helpful to draft the front pattern with a sharpened red pencil for clarity.

Measurements needed:
- Around-hand _____. (See Chapter 14.)

Basic Kimono Torso Draft

Figure 1
- Trace the back torso pattern and transfer the shoulder dart to the armhole (armhole is not traced). Label side seam A.
- Draw a guideline through shoulder-neck parallel with the center back line. Label X.
- Place the front torso pattern on top of the back pattern so that the shoulder-neck touches X guideline with hip levels touching and the center lines parallel.
- Trace front pattern along the neckline, shoulder, center front line, and side seam, ending at dart leg.
- Dot mark between front and back side seams at the hip level and waist level, and ending at the notch of the side dart.

Figure 2
- Draw side seam, touching marks at hip, at waist, and at dart level.
- Dot mark between front and back shoulder-neck and shoulder tips.
- Measure 1/4 inch up from C. Label D.
- Place a ruler at mid-shoulder and point D. Draw line from mid-shoulder past point D equal to sleeve length. Label E. Square a line down from E equal to one-half of the around-hand measurement. Label F. Square a short guideline.
- Draw a guideline from B, passing A $2^1/_2$ inches or more (broken lines).
- Draw underseam curve of the sleeve. Blend with the side seamline. Mark three underseam release notches. Underseam shape can vary.
- Place paper under draft and cut back pattern outline from paper. Use undercopy as back pattern. Trim the upper pattern along the center front and neckline to create the front pattern.

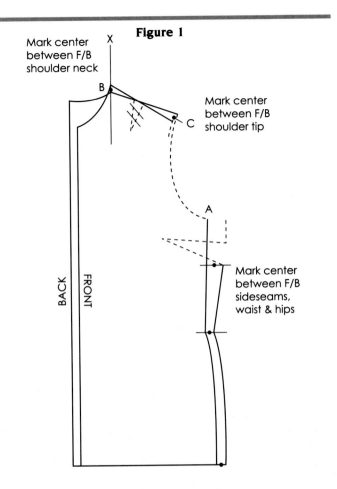

Figure 1

Mark center between F/B shoulder neck

X

B

Mark center between F/B shoulder tip

C

A

Mark center between F/B sideseams, waist & hips

BACK

FRONT

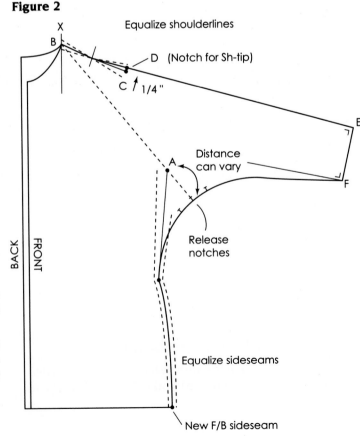

Figure 2

X

B

Equalize shoulderlines

D (Notch for Sh-tip)

C ↑ 1/4"

E

F

A

Distance can vary

Release notches

BACK

FRONT

Equalize sideseams

New F/B sideseam

Oversized Kimono

The front and back oversized kimono patterns are drafted together. Trace basic kimono and follow illustration.

Kimono Draft

Figure 1

- Follow illustration as a guide to drafting the oversized kimono pattern.

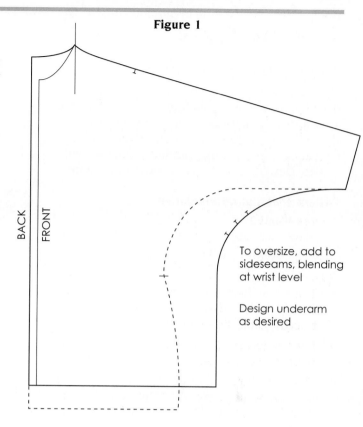

Figure 1

To oversize, add to sideseams, blending at wrist level

Design underarm as desired

Pattern Adjustment for a Shoulder Pad

Figure 1

A shoulder pad is thick and will raise the garment and shorten the length of the sleeve. To adjust the sleeve length, slash and spread the front and back patterns a distance equal to the thickness of the shoulder pad.

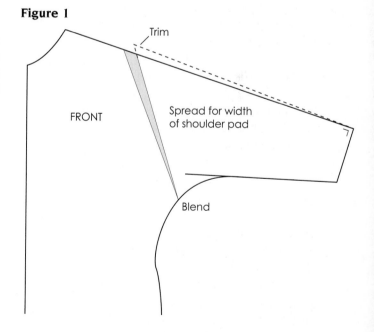

Figure 1

Trim

FRONT

Spread for width of shoulder pad

Blend

Kimono Dress

Design Analysis: Designs 1, 2, and 3

Design 2 is the basis for the draft. The basic neckline is cut away before fullness is added around the neck for gathers. The sleeve is either shortened for a loosely flowing sleeve or gathered at the hemline and banded or encased with elastic. Designs 1 and 3 are thought problems.

Pattern Plot and Manipulation

Figures 1 and 2

- Draw neckline of the front and back over-sized kimono patterns.

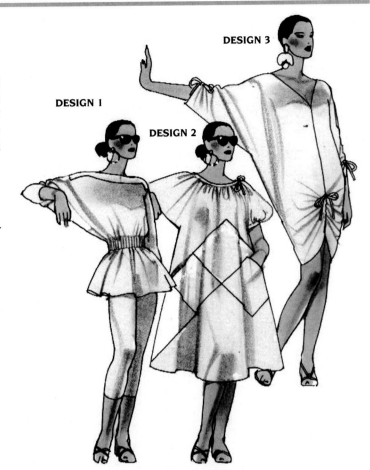

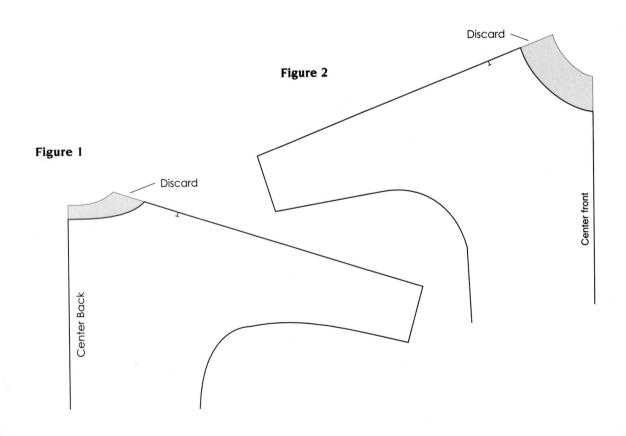

Figure 3
- Trace center line.
- Shift pattern for gather fullness (5 to 8 inches).
- Trace and blend neckline and sleeve.

Option: Add flare to side of garment for greater fullness.

Figure 4
- Square a guideline from center, touching shoulder.
- Using cap height as a guide, draw to desired sleeve length.
- If hemline has band or elastic control, add length for sleeve puff.
- Trace back pattern to complete the design.

Figure 3

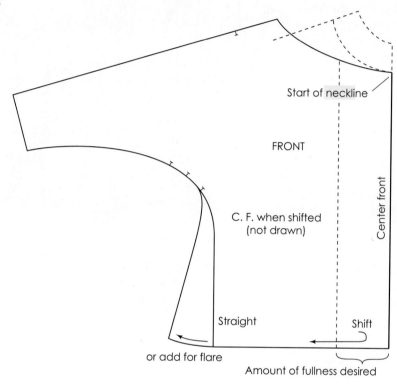

Figure 4

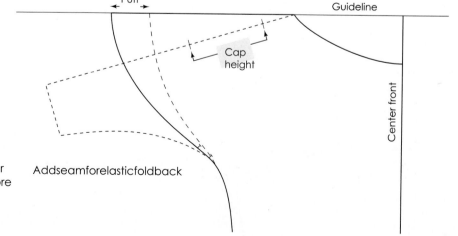

Figure 5
- Sleeve band, if required.

Figure 5

Caftan

A caftan (also spelled *kaftan*) is a long, wide-sleeved robe, usually fastened by a belt or sash, worn in Eastern Mediterranean countries. The following two caftans are stylized versions of this great robe, and are based on the torso foundation pattern.

Design Analysis—Design 1

The caftan is gathered over the shoulder with a tie at the neck, or may have a snap for closure. The sleeve hem can be tacked to hold the front and back together or let free. There is a slit at side seam. Design 2 is a practice problem. The underarm cowl is on the fold.

Pattern Plot and Manipulation

Caftan Draft

Figure 1

- The front and back caftan are drafted together and the shoulder lines are equalized. Extend to length desired.

 A–B = $3\frac{1}{4}$ inch extended out from shoulder.

 C–D= 3 inches up from C bust point and parallel with centerlines.

- Draw curve line from B to D. Label E at armhole.
- Cut along side seam and dart, continuing from E to B.
- Cut from dart point to C.
- Cut from E to D and D to, but not through, C.
- Close side dart and tape.

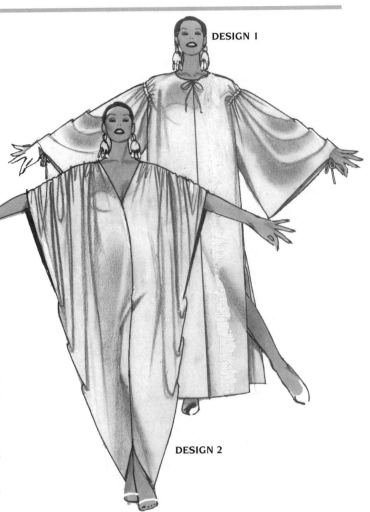

DESIGN I

DESIGN 2

Figure 1

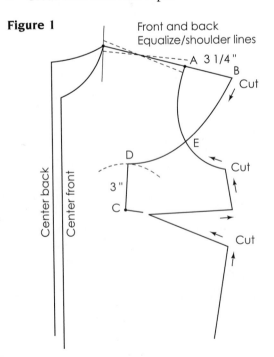

Front and back
Equalize/shoulder lines

A 3 1/4 "
B
Cut

E
Cut

D

3 "

C
Cut

Center back

Center front

Figure 2

- Label open dart legs D´ and E´.
- Place paper behind draft and tape.
- Add 4 to 8 inches, (or more) to side hip, and square up to armhole level.
- Mark midway up from waist at side seam. Label L.
 B–F = 1½ inches up from B.
 A–G= 1/4 inch.
- Draw line from mid-shoulder to G to F, extending line (broken line).
 F–H = E´ to E, plus 1/2 inch.
 H–I = D´ to D.
- Draw curve line from E to H parallel to E´ to F line.
- Draw line from I to J to equal sleeve length, less 3½ inches.
- Square a line from J to K at level with L. Label K.
- Draw line from K to L.
- Notch for slit just below knee level.

Figure 2

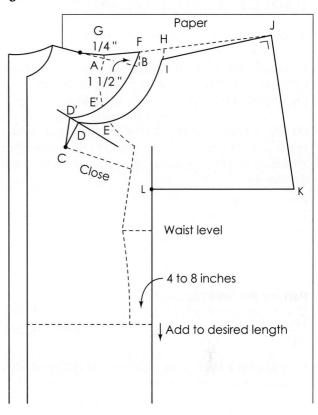

Figure 3

- Draw line from D´ and D. Mark center. Label X.
- Draw curve line from X, blending with curves.
- Add seams and place paper under draft.
- Cut pattern. The undercopy is the back pattern.
- Cut front neckline to the centerline of the back as the front extension.
- Complete patterns for test fit.

Figure 3

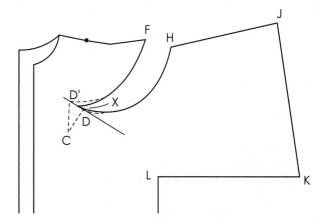

Stitching Guide

Stitch the front and back overarm seams (shoulder and sleeve lines). Stitch from X to F–H of the front and back. Place a gathering stitch on each side of the arc styleline and pull to shirr. Place on model to fix the limits of the gathers over shoulder. Stitch a twill tape to secure gathers, or gather separately and join with a piping to hold the gathers.

 Options:
- Stitch side seam from notch(slit) to L and from L to K, or do not sew the underseam from L to K.

Kimono with Gusset

A gusset provides room for arm lift and a closer fit.

Gussets are triangular or diamond-shaped wedges inserted in slits in the underarm sleeve section (as either one or two pieces). Two types are illustrated. One type provides maximum lift (180°) and the other provides minimum lift (90°). The choice depends on the use of the garment, and is controlled by the pitch (or angle) of the sleeve when attached to the bodice at the time the pattern is developed.

Kimono Draft

Figure 1 *Back sleeve*

(Allow room on paper for front and back bodice draft. Trace sleeves approximately 5 inches apart. See page 365.)

- Trace back half of the sleeve to midpoint of wrist (new placement for overarm seam). Include all markings. (Broken lines indicate part of sleeve not traced.) Remove pattern.

- Draw grainline to wrist mark. Extend grainline 1/4 inch up from cap and square a short guideline.

- Crossmark $1\frac{1}{2}$ inches below biceps at underseam. Label X.

Figure 2 *Front sleeve*

- Repeat instructions given for back sleeve.

- Draw a straight line from biceps to wrist at front underseam.

Figure 1

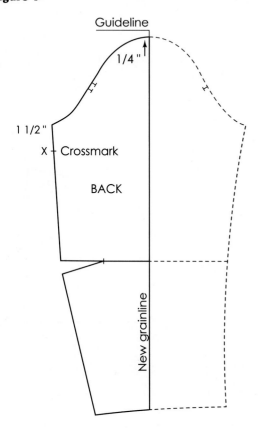

Figure 2

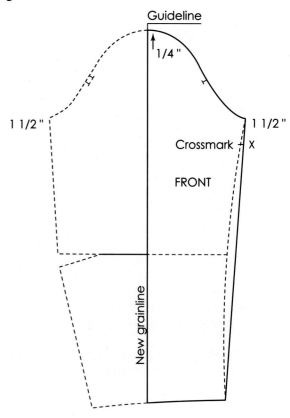

Figures 3a and 3b *Back bodice and sleeve combined*

- Place back bodice on sleeve matching X-points. Shoulder tip (A) must touch on guideline. (Curve of sleeve cap may overlap armhole.)
- Trace and remove bodice pattern.
- Measure up 1/4 inch from A. Mark.
- Measure down 3 inches from guideline and out 1/2 (or more inches for design variations). Mark.
- Draw a straight line from mark to wrist. (Line can be drawn parallel, enlarging sleeve for a more casual fit.) This line establishes the over-arm seam.
- Draw a curved line from mark, ending at mid-shoulder.
- Draw a $3\frac{1}{2}$-inch gusset line from X-point in direction of sleeve-bodice intersection. Label B.

Figures 4a and 4b *Front bodice and sleeve combined*

- Trace bodice, transferring 1/2 inch to mid-arm-hole. Cut from paper.
- Repeat instructions given for back.

Elbow dart options
(Options are noted on illustrations.)

1. Elbow dart is used for sleeves tapered from elbow to wrist.
2. Excess from elbow dart can be used as ease. Mark ease control notches $1\frac{1}{2}$ inches up and down from dart legs. Front: Mark notches $1\frac{1}{2}$ inches up and down from elbow level.
3. Eliminate dart at wrist level by squaring a line from the overarm seam (shaded area).
4. Use half of dart excess as ease, removing the other half at wrist level.

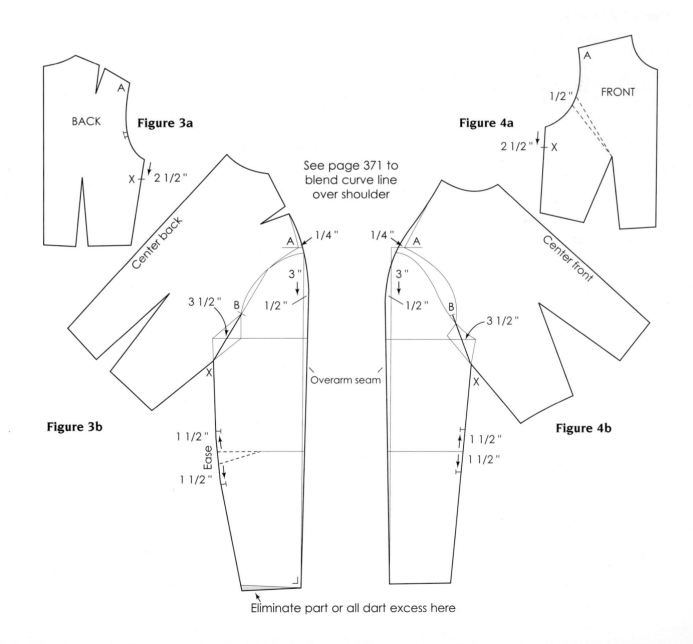

Figure 5 *Slit for gusset*
Front:

- Mark 1/4 inch out from each side of X (seam allowance).
- Draw a line from point B through mark to side seam of front bodice. Label C.
- Draw a line from point B through mark equal to B–C measurement. Label D. Connect C with D.
- Connect D with elbow level for new underseam.

Back:

- Repeat instructions for back, using B–C measurements. Blend.

Figure 6 *Gusset with maximum lift*
- Fold paper. Square a 2-inch line from fold at center of paper. Label B.
- Draw lines from B to fold of paper equal to B–C measurement. Add 1/4 inch seam allowance, cut, and unfold.

Option 1:
- One-piece gusset stitched in as is.

Figure 5

Figure 6

Figures 7 and 8
Options 2 and 3:

- Separated gusset (vertical or horizontal) trim 1/4 inch at center to zero at ends. (Broken line indicates original shape.)

Figure 7 **Figure 8**

Figure 9 *Gusset with moderate lift*
- Draw 90° angle equal to B–C measurement.
- Draw a 2-inch diagonal line out from corner. Draw a blending curve line. Add seams.

Figure 9

Figures 10 and 11

- Cut front and back patterns and gussets from paper. (Front and back patterns are shown with elbow dart eased in.) Notch shoulder tips.

Gusset slit

- Cut 1/16-inch-wide opening through X to within 1/8 inch from B line. Fold slit line and notch across end (crossbar). This prevents pattern from tearing when making marker.

- Draw grainlines and complete pattern for test fit.

Trueing patterns

- True over- and underarm seams. Equalize and blend curved lines at shoulders. See page 371, Figure 9. Adjust length difference at hem of sleeve and, if necessary, increase or decrease elbow ease.

Figure 10

KIMONO FRONT WITH GUSSET

B

X

Figure 11

KIMONO BACK WITH GUSSET

B Crossbar

Slit

X

Raglan Sleeve

The raglan sleeve pattern is developed by including part of the neckline and armhole to complete the sleeve draft. The raglan can be designed for bodice, dress, blouse, jacket, coat, or other garments. The armhole is generally lowered at varying depths to create a more casual fit. Develop a raglan sleeve using the torso foundation as a working pattern.

Pattern Plot and Manipulation
Raglan Draft
Figures 1a and 1b B*odice modification*
- Trace patterns, transferring back shoulder dart and 1/2 inch of front dart to mid-armholes.
- Lower armholes 1 inch (may be lowered more or less, according to the design.
- Draw new armhole, using illustration as a guide.
- Label armhole A, B (back) and C, D (front).

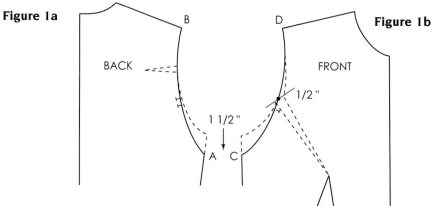

Figure 1a

BACK

B

D

FRONT

1/2 "

1 1/2 "

A C

Figure 1b

Figures 2a, 2b, 2c, and 2d B*ack yoke pattern*
A–X = One-half of back armhole, less 1 inch. Draw a line from X, ending $1^1/_4$ inches down from shoulder-neck. Mark midpoint and measure up 3/8 inch. Draw raglan styleline, as illustrated.

Front yoke pattern
C–X = A–X
Repeat process for front pattern. Separate patterns along raglan stylelines. Upper yoke section attaches to the sleeve and lower section completes the pattern (Figures 2a and 2c).

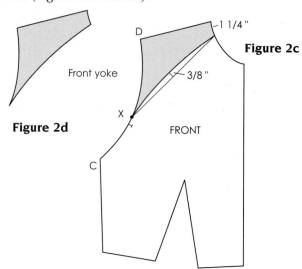

Figure 2a 1 1/4 "

B

3/8 "

X

BACK

A

Back yoke

Figure 2b

Front yoke

1 1/4 "

Figure 2c

D

3/8 "

X

FRONT

C

Figure 2d

Figure 3 *Modification of the sleeve cap*

- Trace sleeve.
- Lower sleeve same amount as bodice (1 inch) and label cap Y and biceps E and F.

Figures 4a and 4b *Modification of lower sleeve*

- Mark center of wrist for new grainline. Draw grainline ending at grainline of sleeve cap. Figure 4a.

Elbow dart

- The excess of the elbow dart can be converted to elbow ease (for a sleeve fitting more closely to the wrist), or be eliminated for wide sleeve hemlines. A combination of both can also be used.

Eliminate darts excess

- Draw line down from elbow dart continuing the angle of the underarm seam.
- Square a line from center sleeve grainline to front sleeve, and continue line across to back sleeve (Figure 4a).

Fitted hemline (Elbow ease)

Square from grainline across hemline.

- Measure down 1/2 inch from square line and draw line to front sleeve.
- Mark for ease control notches at elbow dart.
- Separate sleeve on new grainline.

Figure 3

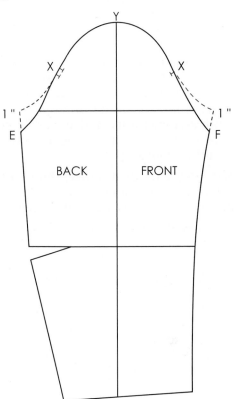

Figure 4a

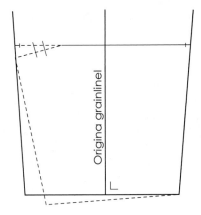

Figure 4b

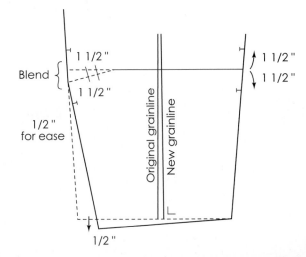

Figures 5a and 5b *Sleeve lift*

- Trace front and back sleeves. Measure up 1/4 inch from overarm seam and square a short guideline.

- Draw lines out from biceps (E and F). Measure 2 inches up from biceps for lift. Mark and draw short guideline parallel with biceps. (The amount of lift depends on the style on the garment. If a garment fits close to the figure, more lift may be necessary. If a garment has flare, little or no lift is required.)

- Replace sleeve on draft (broken lines) and place pushpin at Y. Pivot pattern upward until E touches lift line. Trace sleeve cap and remove. Label G.

- Draw a straight or an inward curved line from G to hemline of sleeve.

- Repeat the process for the front sleeve and label. Underseam of back sleeve can be tapered for a closer fit at wrist level.

Figure 5a **Figure 5b**

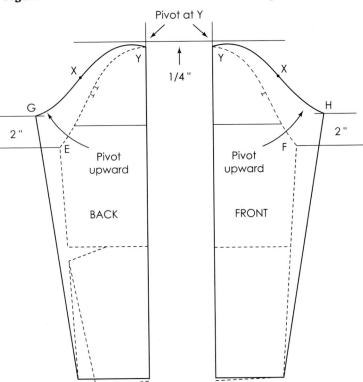

Figures 6a and 6b *Placement of raglan yoke*

- Place back yoke on back sleeve, matching X points. Hold X points at edge with pushpin and pivot yoke until shoulder tip touches square guideline. Trace yoke.

- Repeat for front sleeve.

Figures 7a and 7b *Equalizing shoulder tips*

- If B and D are not equally spaced from overarm grainline (Y), add to and subtract from each shoulder tip to equalize. Re-mark shoulder tips. Draw shoulder lines to neck.

- Measure down 3 inches from Y and out 1/2 inch. Label J. More width can be added at point J for varying effects.

- Raise shoulder tips 1/4 inch. Label Z.

Figure 6a **Figure 6b** **Figure 7a** **Figure 7b**

Equalize Shoulder Tips

Figure 8 *Completing the sleeve*

- Draw a line down from J to hemline or parallel to it.
- Use the French curve to shape the shoulder line from J, touching or blending with Z. From mid-shoulder draw inward curve line, blending with rounded curve at or near Z.
- Notch shoulder tips.
- Grainline may be on bias or parallel with the overarm seam.

Figure 8

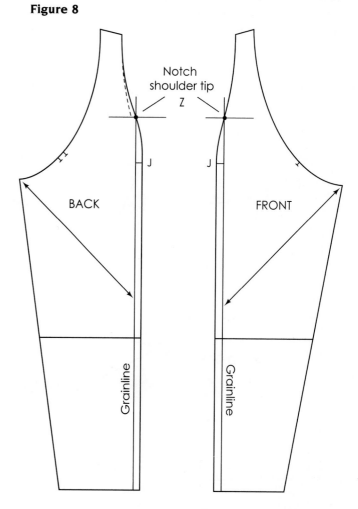

Figure 9

- Cut the back raglan sleeve and place on top of front sleeve. Blend shoulder curved lines over seams and adjust length at sleeve hem, if necessary.

Figure 9

Figure 10 *Adjustment for shoulder pad*

- Add height to shoulder tip equal to half the thickness of the shoulder pad. Added sleeve length is also required. Slash from shoulder tip to corner of underseam. Spread equal to the shoulder pad thickness (example 1") for adjustment of the raglan pattern.

Figure 10

Figure 11 *Completed raglan patterns*

- Draw grainline on bodice patterns and complete for test fit.

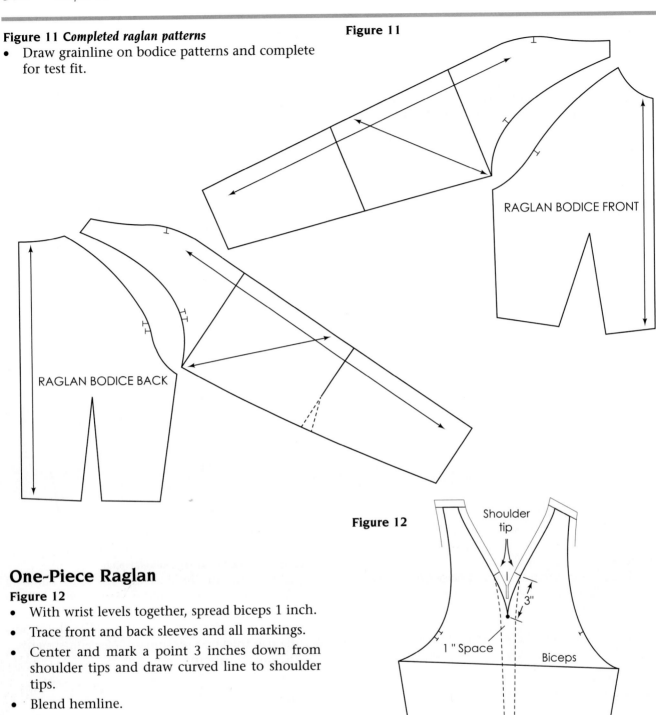

Figure 11

RAGLAN BODICE FRONT

RAGLAN BODICE BACK

Figure 12

One-Piece Raglan

Figure 12

- With wrist levels together, spread biceps 1 inch.
- Trace front and back sleeves and all markings.
- Center and mark a point 3 inches down from shoulder tips and draw curved line to shoulder tips.
- Blend hemline.

Shoulder tip

3"

1" Space

Biceps

Elbow

Blend

Deep Armhole Raglan

A design may require a deeper raglan armhole. The design is based on the basic raglan.

Pattern Plot and Manipulation

Figures 1 and 2

- Plan armhole depth (example: 2 inches) and label.
- Draw curved lines from A and B to X and blend with raglan styleline. (Broken lines indicate section of pattern to be removed.)

Figure 1 **Figure 2**

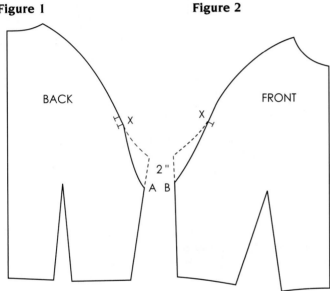

Figure 3

- Lower armholes 2 inches and blend to notches. Draw slash lines to shoulder tips.

Figure 3

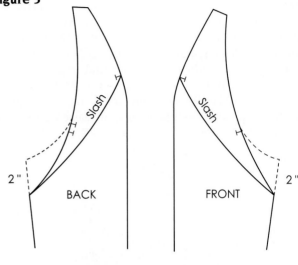

Figure 4

- Slash and lift 2 inches. Retrace sleeve. Blend to elbow.

Figure 4

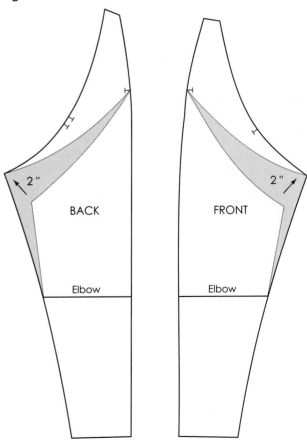

Raglan Variations

General Instructions

To simplify pattern development, use the raglan sleeve with any pattern. Basic front and back patterns are illustrated. Plot and separate patterns. Use illustrations below as a visual guide to develop the armhole princess raglan, the yoke raglan, or any other similar raglan design. (The broken lines on the pattern plot indicate the original raglan shape.) *Note:* Lower notches on front and back armhole and sleeve if styleline is placed at or near them. Determine styleline placement on basic pattern. See page 368, Figure 1a, 1b to mark A–X and B–X.

DESIGN 1

DESIGN 2

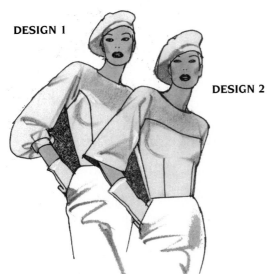

Figure 3

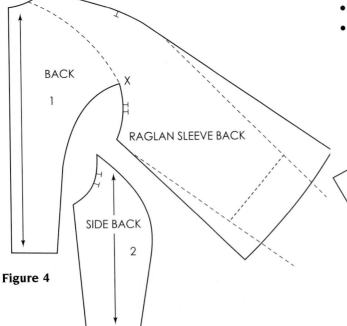

Figure 4

Armhole-Princess Raglan

Pattern Plot and Manipulation

Figures 1 and 2

- Draw princess line from X-points to dart points for Design 1.

- Separate patterns.

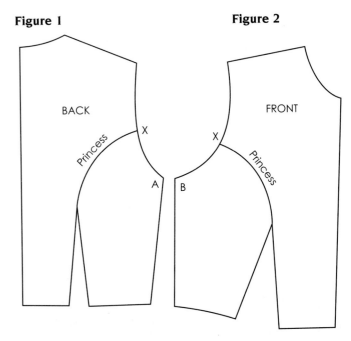

Figure 1

Figure 2

Figures 3, 4, 5, and 6

- Place raglan sleeves on pattern sections 1 (back) and 4 (front), matching neck and X-points. (Broken line indicates original raglan sleeve.) Place on paper and trace.

- Mark for length and fullness.

- To make cuff pattern, see Chapter 14.

Figure 5

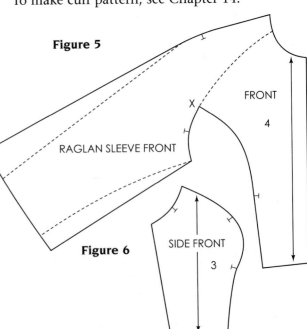

Figure 6

Yoke Raglan with Bell Sleeve

Pattern Plot and Manipulation

Figures 1 and 2 *Yokeline*

- Square line from center front and center back to armhole (X-points).

- Separate pattern.

Figures 3, 4, 5, and 6

- Place front and back raglan sleeve on sections 1 (back) and 4 (front), matching neck and X-points. Place on paper and trace.

- Mark for bell length and flare.

Figure 1 **Figure 2**

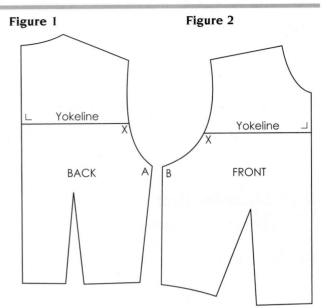

Figure 3

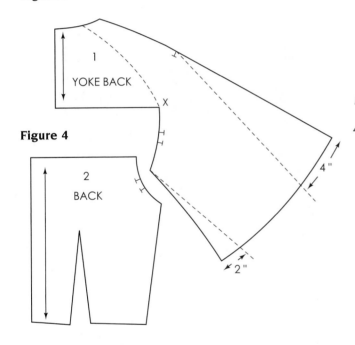

Figure 4

Figure 5

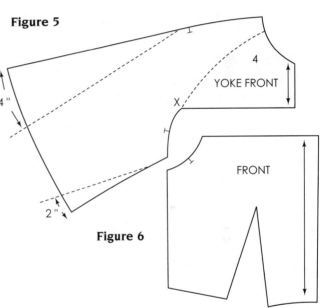

Figure 6

Other Designs Based on Raglan Foundation

The illustrated designs based on the raglan foundation are generated by changing the direction of the styleline from X-points. Develop patterns for practice or design other variations.

Drop Shoulder

The drop shoulder pattern is developed by attaching a portion of the upper sleeve cap to the bodice. The dropped shoulder extends beyond the shoulder tip and covers part of the upper arm at varying lengths. It may be developed without the lower sleeve (Design 1) or with the lower sleeve (Design 2). Instructions apply to dresses, blouses, jackets, coats, activewear, evening dresses, and so on. Design your own variations showing the creative flexibility of the drop shoulder pattern. See pages 378 and 380.

Drop Shoulder Draft

Pattern Plot and Manipulation

Figure 1

Sleeve preparation

- Mark the center between the cap and biceps.
- Square a line across the sleeve cap from this mark.
- Mark 1/2 inch down from center, and draw a curved styleline. Label X.
- Measure armhole curves A to X and B to X. Record.

Separate cap from lower sleeve (shaded area). Cut through grainline to separate the cap.

DESIGN 1

DESIGN 2

Figure 1

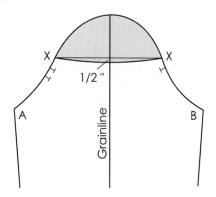

Figure 2

Figure 3

Figures 2 and 3

Trace patterns, allowing room for the cap.

- Trace back bodice, transferring shoulder dart to armhole. Trace front bodice.

 C to X = A to X

 D to X = B to X.

Figures 4 and 5 *Sleeve cap to bodice*
Place cap sections on front and back bodice with X-points touching and curve of cap 1/4 inch away from shoulder tips.

- Mark 1/4 inch up from shoulder tips and draw blending curve over cap, ending at mid-shoulder as shown. When trueing, blend curve of the shoulders.

Figure 6 *Lower sleeve section*

Figure 6

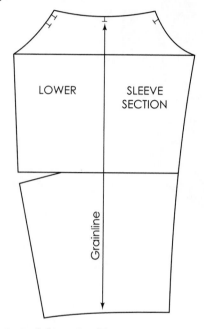

Figure 7 *Casual drop shoulder*
For Design 2, use bottom of sleeve section.

Note: For a more casual fit, add 1/2 inch to the width of the cap. Split sleeve along grainline and spread 1 inch to zero at hem, or parallel for looser sleeve. True to cap. For a more exaggerated sleeve, add more to the cap and spread lower sleeve by equal amounts. (See page 378.)

Figure 7

Figure 4 **Figure 5**

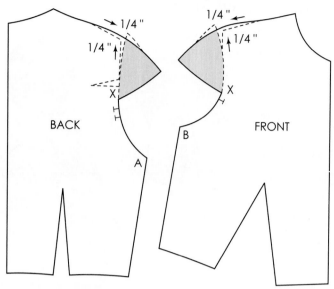

How pattern will look for designs not using lower sleeve pattern. Design 1.

Figure 8 *Notching an inverse corner*
- After seams are added, draw a line through the corners of stitch line and seamline. Follow illustration as guide to mark, cut, and notch pattern.

Figure 8

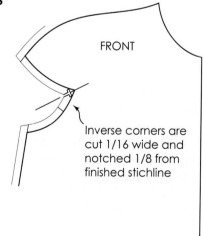

Inverse corners are cut 1/16 wide and notched 1/8 from finished stichline

Drop Shoulder with Shoulder Pad and Lowered Armhole

Only sleeve section of each design is illustrated.

DESIGN 1

DESIGN 2

Figure 1

- Follow Figures 1, 2, and 3 of page 377 for attaching sleeve cap to pattern.

 A–B = Thickness of the shoulder pad (example 1 inch). Mark.

- Place sleeve section to point X. Hold with push-pin and pivot until cap is 1/2 inch from A. Trace pattern.

 D–E = 1/2 inch. Mark.

- Draw line from X, to 1 inch past E. Label F. Square a guideline up from F. Draw a line out from mid-shoulder past B intersecting with guideline. Label G. Draw a curved line in from G, as illustrated. Lower armhole and add width to side seam as desired. Draw new armhole and measure. Measurement is needed to enlarge sleeve. Repeat for back pattern.

Figure 1

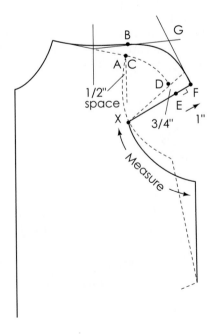

Figure 2 *Lower sleeve adjustment*

- Slash and spread at grainline of sleeve to true with upper sleeve (2 inches). Spread 1 inch at hemline. Trace.
- Extend a line out from biceps. Use underarm measurement of bodice to increase sleeve curve to equal that measurement.

Elbow ease

See raglan (page 369) for controlling elbow ease. A casual sleeve needs little or no elbow ease.

Design 1 Box-pleated sleeve

To develop the sleeve of Design 1, add for box pleat intake by separating sleeve along grainline and spreading the needed amount. (Example: 6 inches.)

Figure 2

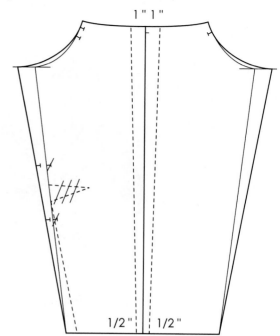

Design 2 Barrel sleeve

Figures 3a and 3b *Separate lower sleeve*

- Separate sleeve through grainline.
- Measure out 1 inch at top and 1/2 to 1 inch at hem of front and back sleeve. Label A and B.
- Draw line from A to B.
- Find midpoint of A–B, and measure out 1 inch. Label C.
- Draw a curved line touching A, C, and B.

Adjust sleeve cap

- Place the sleeve sections at joining part of cap sections. Blend curved line of sleeve with sleeve cap section.

Figure 3a

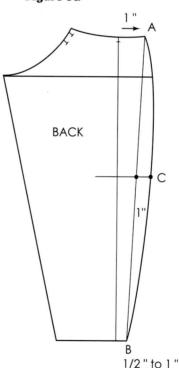

Figure 3b

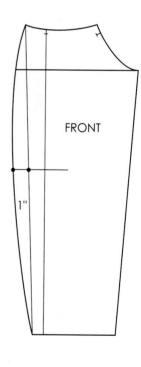

Drop Shoulder Variations

DESIGN 1 DESIGN 2 DESIGN 3

Drop Shoulder Development

The drop shoulder pattern is a base for designs that fall over the shoulder tip with or without sleeve attachment. See Designs 1 and 2. It is also the base for designs having partial sleeves that attach under the curve of the arm. See Design 3.

Figure 1 illustrates a front draft using the drop shoulder pattern of Designs 1 and 2.

(Spread sleeve section for gathers—Design 2.)

Figure 1

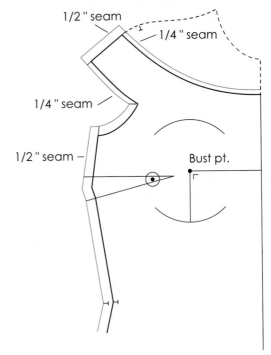

1/2 " seam

1/4 " seam

1/4 " seam

1/2 " seam

Bust pt.

Exaggerated Armholes

Armholes can be exaggerated by cutting deeply and widely into the garment. The pattern is developed by attaching a portion cut from the bodice to the sleeve, as illustrated by the squared armhole designs. Exaggerated armholes can be developed using the top of any pattern. The instructions should be used as a guide for similar designs.

DESIGN 1

Deep-Cut Square Armhole

Design Analysis—Design 1

Sleeve is set deeply into a square armhole of the bodice and tapers to wrist level.

Exaggerated Armhole Draft

Figures 1 and 2 Bodice modification

- Trace front and back bodice. Transfer back shoulder dart to mid-armhole.

- Mark A, 1/2 inch out from front and back shoulder tips.

- Mark B, 3 inches down on side seams of the front and back armholes.

- Mark C, 2 inches squared from B.

- Connect C with A using a slightly curved line. (Broken lines of front and back bodice indicate original armhole.) Mark for notches.

- Cut from paper. Trim B–C sections to complete patterns.

Figure 1

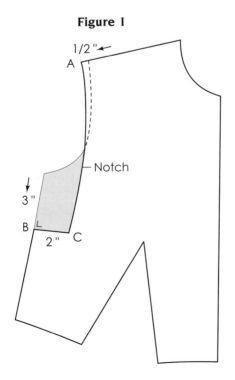

Figure 2

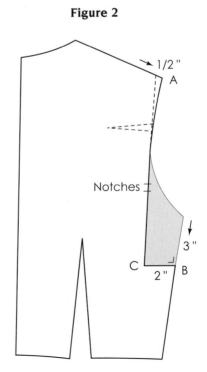

Figure 3

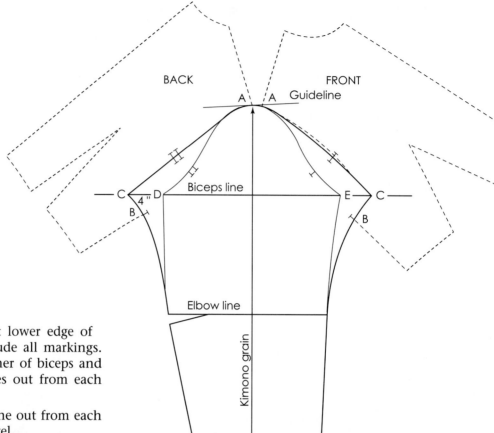

Figure 3 *Sleeve*

- Center basic sleeve at lower edge of paper. Trace and include all markings. Label D and E at corner of biceps and extend a line 4 inches out from each end for guide.
- Square a short guideline out from each side of grain at cap level.
- Place back and front patterns on draft with C on biceps guideline and A touching on cap guideline.
- Draw bodice armhole, including notches, and remove pattern. (Broken lines indicate untraced pattern.) Crossmark points B on sleeve. Remove pattern.
- Redraw front armhole curve, flattening slightly.
- Draw curved lines from B to elbow level on front and back.

Note: The space on the front cap between A-points is cap ease. If this measures more than 1/2 inch, slash grainline at cap to, not through, wrist and overlap to remove unneeded excess. Tape pattern (not illustrated).

Figure 4 *Adding lift*

- Draw curved slash line from B to midpoint of cap line.
- Divide area into 3 sections and draw slash line.
- Cut sleeve from paper.
- Starting at points B, cut slash lines to, not through, cap line.

Figure 4

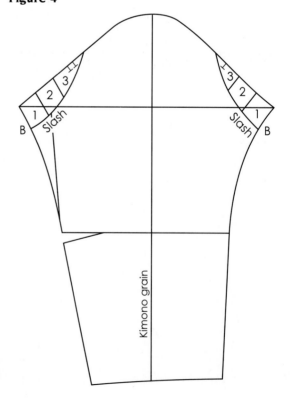

Figure 5 *Sleeve lift*

- Place sleeve on paper.
- Raise points B 2 inches or less, spreading sections evenly.
- Trace pattern (bold lines).
- Draw curved lines from points B to elbow. (Underarm seam can be drawn straight. See elbow dart options, page 369, Figures 4a and 4b.)
- Draw grainline and complete for a test fit.

Figure 5

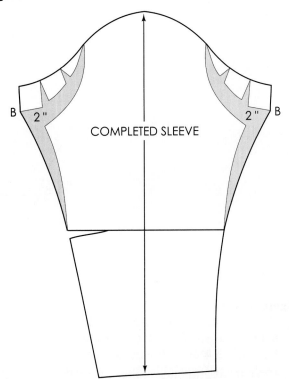

Square Armhole with Gathered Three-Quarter Sleeve

To develop the pattern for this and similar designs, follow the general instructions given for the deep-cut square armhole.

Pattern Plot and Manipulation

Figures 1 and 2

- Trace front and back patterns. Transfer shoulder dart to armhole.
- Draw styleline for armhole.
- Cut and separate bodice from A–B–C sections.

Figure 1 **Figure 2**

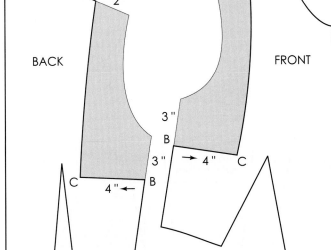

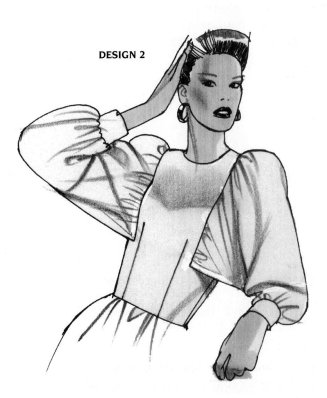

DESIGN 2

Design Analysis—Design 2

The three-quarter-length gathered sleeve is set deeply into a squared armhole. Sleeve is cuffed.

Figure 3

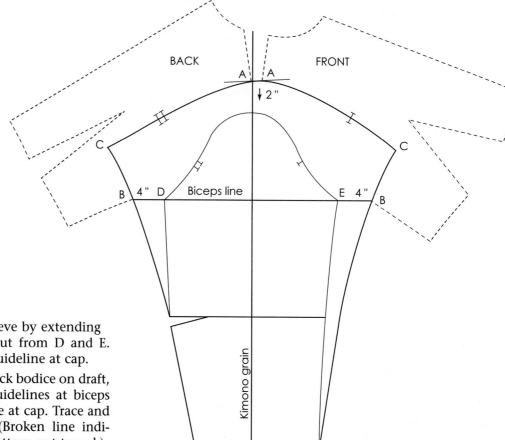

Figure 3
- Prepare traced sleeve by extending a line 4 inches out from D and E. Square a 2-inch guideline at cap.
- Place front and back bodice on draft, matching B to guidelines at biceps and A to guideline at cap. Trace and remove pattern. (Broken line indicates section of pattern not traced.)

Figure 4

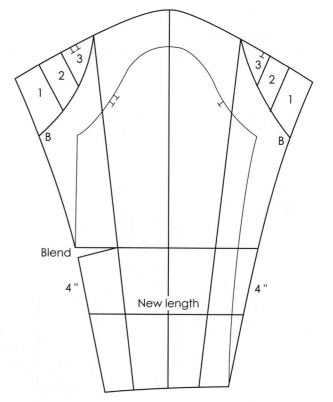

Figure 4 *Sleeve plot for gathered sleeve and lift*
- Mark sleeve length 4 inches below elbow level. Blend dart. Draw curved slashline from B and 1, 2, 3 slash lines.
- Cut sleeve from paper.
- Discard section below sleeve length.
- Cut B section to, but not through, cap line.
- Separate pattern along slash lines.

Figure 5 *Adding fullness*

- Elbow dart is closed, transferring excess to hemline of sleeve.
- Spread sleeve 3 inches or less. Trace. Spread lift from $1^1/_2$.
- Measure down 1 inch from sleeve hemline (between space 1 and 2). Mark slit $2^1/_2$ inches up from this point. Blend hemline and dart area.
- Cut from paper for test fit.
- To develop cuff, see Chapter 14.

Figure 5

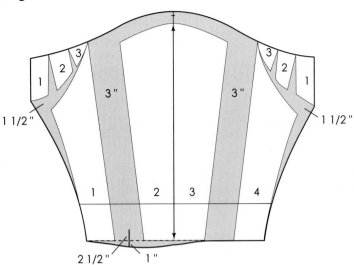

16

Buttons, Buttonholes, and Facings

Buttons and Buttonholes

Buttons and buttonholes are both functional and decorative, but their primary purpose is to hold two sides of a garment together by having a button on one side of the garment slipped through a corresponding opening or loop on the other side. (Other types of closures are Velcro, snaps, hooks and eyes, and grippers.)

Buttons range in size from small to large and come detailed or flat in a wide range of geometric shapes, such as circles, squares, rectangles, quarter-balls, half-balls, and full balls (see illustration). They are commonly designated by "line" (ligne), inches or centimeters representing the diameter of the button.

Buttons can be made of plastic, metal, or natural substances (wood, bone, mother-of-pearl), or covered in fabric or leather. They can be plain or decorative—jeweled, corded, carved, or saddle-stitched. There are buttons for every type of garment from sportswear to formal wear, making the button an important fashion statement.

Buttonholes are openings or loops wide enough to accommodate the size of the button, placed on an overlapping section of the garment or as a loop where the centerlines meet. Women's-wear garments button right over left, through vertical, horizontal, or angled slits.

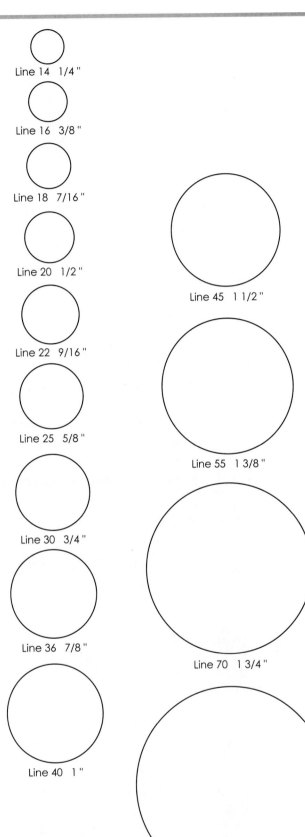

Flat

Quarter ball

Half ball

Full ball

Line 14 1/4"

Line 16 3/8"

Line 18 7/16"

Line 20 1/2"

Line 22 9/16"

Line 25 5/8"

Line 30 3/4"

Line 36 7/8"

Line 40 1"

Line 45 1 1/2"

Line 55 1 3/8"

Line 70 1 3/4"

Line 80 2"

Basic Types of Buttons

Sew-through. Sew-through buttons have two or four holes for attachment.

Two-hole button Four-hole button

Shank buttons. Shank buttons have a solid top and some type of shank (wire, fabric, loop, metal, or plastic) attached to the underside. The shank raises the button away from the fabric surface, allowing room for layers of fabric to fit smoothly under the button when closed.

Metal shank Cloth shank

Types of Buttonholes

Machine-stitched. Buttonholes can be stitched for straight or keyhole openings.

Bound buttonholes. Folded fabric covers the raw edge openings in the garment. This type of buttonhole can be made by a seamstress or sent to a trim house for stitching.

Bound

Loops. Loops are narrow strips of turned bias with or without a filler. For mass-produced garments, loops are generally made by a trim house. Loops are stitched at centerline. The joined side can be developed with or without an extension.

Slits. Slits can be cut in leather, plastic, or fabric that will not ravel (not illustrated).

SPAGHETTI LOOPS THREAD LOOPS

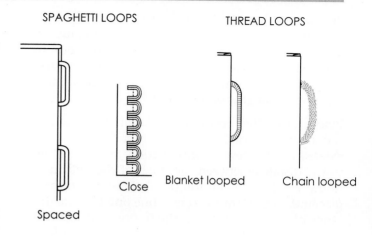

Spaced Close Blanket looped Chain looped

Closure

Overlap. Button closures require an overlap extending beyond the centerline. The overlap should be equal to the diameter of the button (or one half the diameter plus 1/4 inch, on inexpensive garments). Asymmetric garments have extensions that are parallel with the asymmetric line. The center of the button rests on the centerline with equal width of the button on the garment and the extension.

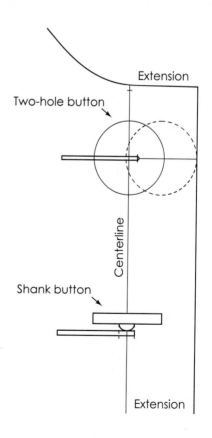

Extension

Two-hole button

Centerline

Shank button

Extension

Buttonhole length. The length of a buttonhole is determined by the diameter of a flat button plus 1/8 inch. For stylistic buttons (odd shapes), it is best to cut a slit in a sample fabric and slip the button through the opening to determine the length. Mark buttonhole length on the pattern.

Placement. The buttonhole placement generally starts 1/8 inch out from the center front (on the extension). However, consideration must be given to the distance between the holes of the button or to the width of the button shank. Mark buttonhole placement out from the center line one-half the distance between the holes of the button and one-half the width of the shank. Otherwise, the buttonhole will not be centered with the button.

Belted garment. Mark position so that buttonhole is at least $1\frac{1}{2}$ inches up and down from belt or buckle width. Waist can be secured with Velcro or hook and eye, if needed (see examples). For waistband on buttonhole side, apply the same rule.

Button and Buttonhole Placement Guide

Necklines. Mark buttonhole down from neckline at a distance equal to one-half the diameter of the button, plus 1/4 inch.

Unbelted garment. Mark buttonhole placement at waistline to secure waist.

Buttonhole spacing. Mark first and last buttonhole. Divide the remaining space among the remaining buttonholes needed. When spacing buttonholes, consider placing buttonhole as near to bust level as possible to avoid gapping. This may require closer or wider placement than desired.

Button placement. Mark for buttons on left side corresponding to buttonholes, centering space between holes of button or center of shank on centerline of garment.

Diagonal buttonholes. The rules stated above apply. Make a copy of the button and buttonhole placement for the buttonhole maker.

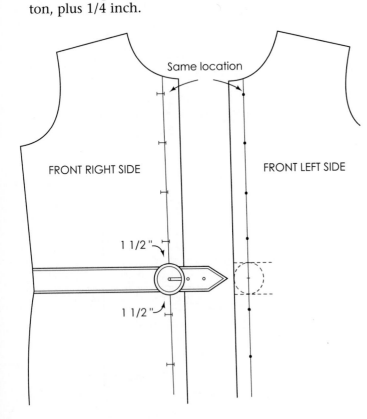

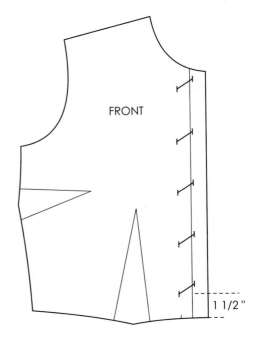

Vertical buttonholes. Used for inset bands or with tiny buttons. Button placement is marked at the top of the buttonhole at neck and at the lower end of the last buttonhole, with the remaining buttons centered.

Lapels. Mark button and buttonhole at a point where the lapel folds over from the extension (breakpoint). Place remaining buttons and buttonholes using previous information.

Waistbands and cuffs. Instructions for button and buttonholes apply.

Center

Center

Facings

A facing is a duplicate-shaped piece of fabric stitched to the outside edge of a garment and folded over to conceal the raw edges. Facings control the fit of a garment when the cut edge is bias (stretches) or crosses the hollow areas above the bust. Foldback facings are part of the main pattern piece that folds back over the area being faced.

The following instructions apply only to neckline, shoulder, and armhole facings. Foldback facings requiring buttons and buttonholes are discussed with shirts. Foldback hemlines of shirts, jackets, sleeves, pockets, collars, cuffs, yokes, inset hemlines, and other self-faced sections are covered in the appropriate chapters.

Facings are planned as part of the pattern plotting. They are traced from the pattern before or after the design pattern has been developed. Facings for deeply cutout necklines or armholes may be modified, with the cut edge of the neck and armhole of the garment eased into the facing to offset stretch or cause the garment to fit closer to the figure. Both methods are illustrated.

Separate Facings

Figures 1 and 2

- Facings are traced from the front and back design pattern. The outer edge of the facing is trimmed 1/16 inch at the shoulder to zero at shoulder tip and 1/8 inch in from side to zero at armhole. This eliminates looseness and stretch. (Broken line indicates original pattern from which the facing is traced.)

Types of Facings

Two types of facings are featured:

Separate facings: Individual facings for armhole or neck.

Combined facing: All-in-one armhole and neckline facing.

Facings vary in width and shape but generally are from $1\frac{1}{2}$ to 2 inches around the neck and armhole. Combined facings are blended, connecting facing of neck with the armhole facing. Facing width at center back is generally planned to exceed the depth of the front neckline for hanger appeal.

Figure 1

Figure 2

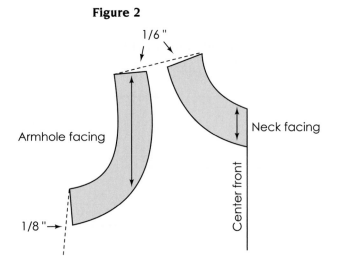

Facings for Cutout Necklines and Armholes

In the featured series, facings are modified to offset stretch of cut-out necklines and sleeveless garments. The edge of the garment is eased into the modified facing for a closer fit. (Review contouring for guidance when facing rather than bodice is modified.) Cutout neck and armholes have all-in-one facings.

V-Neck Facing

Two types of V-neck facings are illustrated, one modified for stretch and the other modified for contouring.

Figures 1 and 2

- Draw cutout necklines on front and back patterns. (Broken line area is discarded from pattern.)
- Draw front and back facings (shaded areas). Center back facing should be deeper than depth of V-neck on front (Example: 10 inches.)
- Mark shoulder line 1/16 inch down from shoulder of front and back bodice.

DESIGN 1 DESIGN 2 DESIGN 3

- Draw slash line across front facing, one-third the distance up from center front on V-line.
- Measure 3/8 inch for overlap. This measurement varies according to stretch of fabric. Mark. (Shaded area.)
- Mark ease control notches as shown.
- Cut front and back patterns from paper.
- Trace facings from pattern. Cut from paper.

Figure 3 Modify for stretch

- Cut through slash line. Overlap and tape.
- Trace and blend.

Figure 4 Contour facing

- Cut slash line to, not through, facing.
- Overlap 3/8 inches to zero. Tape.
- Retrace facing and blend as shown. (Broken lines indicate original pattern shape.)

Figure 1

FACING BACK 10"

BACK

1/16"

Figure 2

1/16"

FACING FRONT

FRONT

3/8" 1 1/2" 1 1/2"

Figure 3

Overlap

Figure 4

Blend →

Scoop-Neckline Facing

Figure 1

- Plan facing using illustrations as guide. (For back facing see V-neckline, Figure 1.)
- The facing can be used as is or can be modified for stretch or for contour fit.

Figure 1

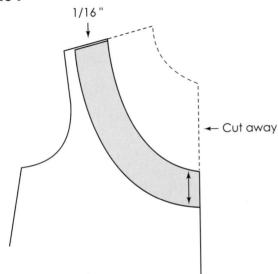

Square-Neckline Facing

Figure 1

- Repeat instructions given for scoop-neckline facing.

Figure 1

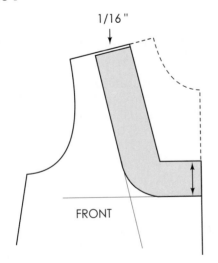

Figure 2 *Contour facing*

- Draw slash and ease control notches.

Figure 3

- Overlap, retrace, and blend.

Figure 2

Figure 3

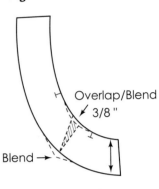

Figure 2

- Draw slash for overlap.

Figure 3 *Contour facing*

- Overlap and blend.

Figure 2

Figure 3

Cutout Armhole Facing

Figure 1

- Draw cutout armhole on front and back patterns (back not illustrated).
- Draw facing (shaded area). Facing may be used as is or may be modified for stretch or closer fit.

Figure 1

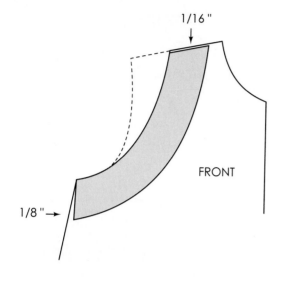

Figure 2 *Contour facing*

- Draw slash line and ease control notches.

Figure 2

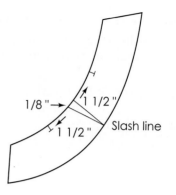

Figure 3 *Contour facing*

Figure 3

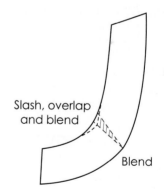

Combined Facings

Figures 1 and 2

- Combined facings are traced from front or back patterns, trimmed 1/8 inch at shoulder, neck, and sides, and blended to zero as shown.

- To complete back facing, the shoulder dart is closed (broken line); otherwise, it would be too bulky.

- Facing length at center back varies according to depth of front neck. Measurements given may be used for basic neckline.

Figure 1

Figure 2

Figures 3 and 4

- Facings for garments with stylelines should be developed before the bodice pattern is separated. However, if the pattern has been separated, place style seamlines together and trace section being faced.

- Trim 1/8 inch at shoulder, neck, and side, with line blended to zero as shown.

- Repeat for back (not illustrated). (Broken lines indicate original pattern.)

Note: Insert tape along V neckline to help prevent stretching.

Figure 3

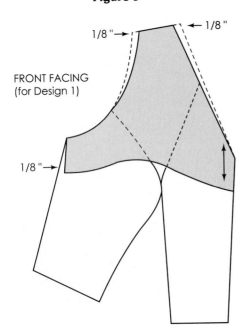

Figure 4

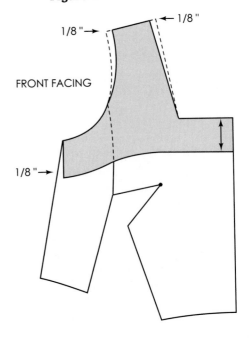

17

Plackets and Pockets

Plackets

Plackets are finished slits or faced openings designed on all types of garments—bodice, sleeve, skirt, dress, jacket, pant, and so forth. Plackets can be of any length and width, with blunt, pointed, rounded, or stylized ends. Some plackets have buttons and buttonholes, others do not. When designed for neckline openings, the placket can end at the neck edge or be extended beyond the neck and become part of the collar. The measurement can be varied to create different effects.

Pointed Placket with Facing-in-One

DESIGN 2

DESIGN 1

Design Analysis

The pointed placket of Design 1 is set into a cutout section of the bodice. (Collar not illustrated in pattern plot.) Topstitching finishes the placket. Design 2 is included for practice.

Pattern Plot and Manipulation

Figure 1
- Fold paper.
- Place center front on fold and trace.

Plan placket:

 A–B = placket length (example: 8 inches).

 B–C = 1 inch.

 C–D = 1 inch.

- Square lines 3/4 inch from B and C. Label E and F.
- Draw a line from F to neck, parallel with center front.
- Connect point F with D.

Plan facing for placket:
- Draw facing 2 inches from shoulder at neck, ending 3/4 inch from E. Connect facing with E (indicated by broken line).
- Trace placket and facing to underneath side.

Figure 1

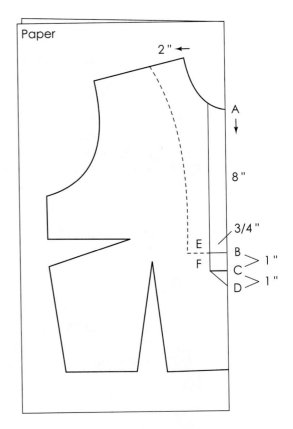

Figure 2

- Unfold and pencil in perforated line (broken line).
- Place paper underneath pattern and trace placket and facing for *right side* of garment (shaded area).
- Remove paper and pencil in perforated line.

Figure 2

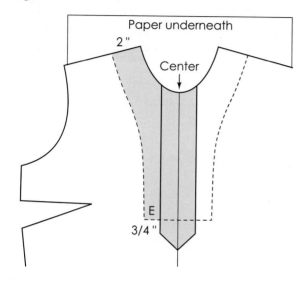

Figure 3

- Repeat for other side, tracing placket across at level with point B (shaded area). Note that point of the placket is not included.
- Remove paper and pencil in a perforated line.

Figure 3

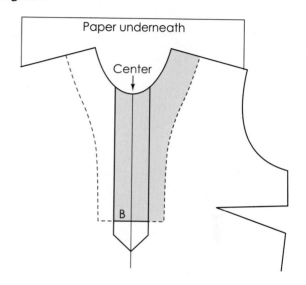

Figure 4 *Placket for right side*

- Fold paper along placket edge. Square from fold at neck, touching center line. (Broken line indicates original neck.) Trace placket only (shaded area). Omit facing section. Unfold and pencil in a perforated line. (Finished pattern shape shown.)

Figure 4

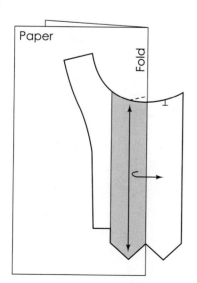

Figure 5 *Placket for left side*

- Repeat for other side.

Figure 5

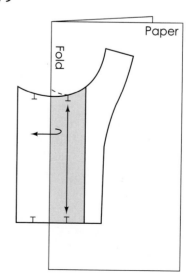

Figures 6 and 7 *Placket*

- Add seams and label *Right-side-up.* Shaded area indicates facing side of placket.

Figure 8 *Bodice section*

- Add seams, notches, and grainline.
- Cut from paper, trimming excess from placket inset area, and unfold.
- Cut basic back to complete design.

Figure 6 **Figure 7**

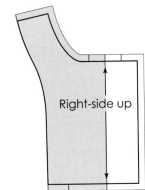

Right-side up Right-side up

Figure 8

Paper

BODICE FRONT

Wing Collar Placket

Design Analysis

Design 1 features an all-in-one placket and collar set into a cutout opening in front. The placket is connected halfway, ending at shoulder-neck location. Seam allowance is indicated because of its unique feature. Design 2 is included for practice.

DESIGN 2

DESIGN 1

Pattern Plot and Manipulation
Figure 1
- Trace front pattern on left side of paper.

 A–B = Placket length (Example: 10 inches).

 A–C = Depth of opening (Example: 6 inches). Mark.

 A–E = $1\frac{1}{2}$ inches or more.

- Draw curved line from E to F and E to C. Blend.

 B–D = $1\frac{1}{2}$ inches, squared from B. Connect a slightly curved line from D to F.

- Place paper underneath (indicated by broken line), and trace placket (B, D, F, E, C to B). Remove paper and pencil in a perforated line.

Figure 1

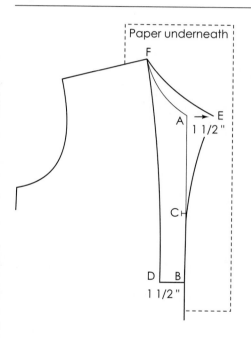

Figure 2
- Finish placket with 1/4-inch seam allowance. Notch. Cut 4 pieces, self-faced. (Placket joined from C to B.)

Figure 2

Figure 3 Bodice
- Fold paper at center front. Add seam allowance (1/4 inch where placket is attached). Cut from paper, trimming excess from placket insert area.
- Cut basic back to complete design.

Figure 3

BODICE FRONT

Slit Opening with Placket

DESIGN 1

DESIGN 2

Design Analysis

Placket band of Design 1 is attached to a slit on one side of the garment and three spaghetti loops and buttons are used for closure. Design 2 is for practice.

Figure 2
- Completed facings.

Note: Facing can be separated, as illustrated, or developed as one-piece facing.

Figure 2

FACINGS

A B

Figure 3 *Placket extension band*
- Draw a line twice the length of slit. (Example: 16 inches.)
- Draw a parallel line equal to desired width. (Example: 1½ inches.)
- Label C and D and midpoint E. Band is self-faced. To stitch, fold band at point E with points

Pattern Plot and Manipulation
Figure 1
- Trace and cut a full front.
- Draw 8-inch parallel line for slit, 2 inches out from center line.
- Draw another line 1/16 inch from slit line. (Space is needed for width of pencil lead when tracing pattern on paper, fabric, or when making a marker.) Cut slit line and crossnotch end. Label A and B.
- Mark for loops.
- Draw facing 1½ inches wide (indicated by broken lines).
- Transfer facing by placing paper under pattern (broken line area).
- Remove pattern. Pencil in facing.

Figure 1

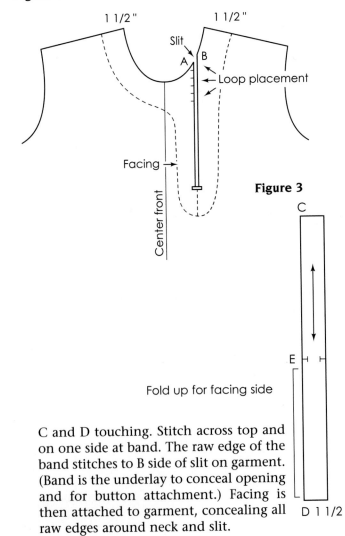

Figure 3

Fold up for facing side

C and D touching. Stitch across top and on one side at band. The raw edge of the band stitches to B side of slit on garment. (Band is the underlay to conceal opening and for button attachment.) Facing is then attached to garment, concealing all raw edges around neck and slit.

- Draw grainline.

Pockets

A pocket is a cavity or pouch that has a closed end and is usually sewn into or onto a garment. It can be a decorative or functional feature, or both. Its primary use is a depository or temporary holding place for items or hands. A pocket opening should be wide enough for hands and deep enough to keep objects from falling out. Pockets are designed for all types of garments. Pocket size, shape, and placement should complement the design of the garment.

Pocket Classification

Outside pockets. Pockets such as the patch pocket are attached to the outside of a garment. This type of pocket can be designed in a number of sizes and shapes, with or without a flap.

Inserted pockets. Pockets are inserted into a straight or stylized seam, with the cavity or pouch on the inside of the garment. Inserted pockets can also be stitched to the inside of a garment, giving the appearance of a patch pocket on the right side of the garment.

Welt pockets. Pockets are characterized by a separate strip or flap stitched to the pocket opening with the pouch falling to the inside of the garment. The pockets can have a double welt or single welt, or can be stylized with or without flaps.

Outside Pockets

Patch Pocket

The placement of a patch pocket should be planned and drawn on the working pattern. The pocket is indicated by punch and circles marked 1/4 to 1/2 inch inside the finished length and width. (See variations.) Generally, seams of 1/2 inch or more are given for foldback seams, with 1/4-inch seam allowance for faced sections to complete the pocket.

SHIRT FRONT

Patch Pocket Variations

Figure 1
- Patch with fold-under hem and without a flap.

Figure 1

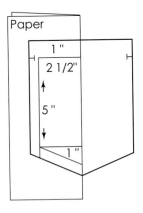

Figure 2
- Patch without a flap is folded and stitched to finish pocket.

Figure 2

Figure 3
- Patch with foldover flap in-one with pocket. (*Options:* Pocket flap may be faced by tracing flap end and adding 1/2 inch at bottom; see flap in Figure 4. Pocket can also be cut twice and self-faced.)

Figure 3

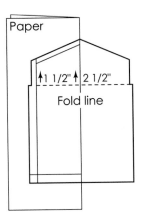

Figure 4
- Patch with separate flap and fold over hem.

Figure 4

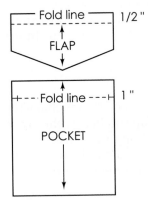

Pouch Pocket

The pouch pocket has a band stitched around the outer edge allowing room in the pocket for large items. This pocket does not provide the same amount of room as does the accordion pocket (see page 406), but does allow more space than the flat stitched-on pocket.

Measurements needed:
- Pocket width and length, plus fold-back for hem at entry.
- The width of the band around the pocket (example 3/4 inch finished), plus length.

Figure 1

Pouch Pocket **Draft**

Figure 1
- Draw pocket width and length.
- Measure around pocket for length of the banding, minus fold-back.

Figure 2
- Draw banding pattern.

Stitching guide: Fold back the facing and banding when stitching band to pocket. The other end of the banding is stitched to the garment.

Figure 2

Fold back

Pocket banding

Accordion Pocket

The accordion pocket was first developed as a utilitarian and functional add-on to garments. The pocket has also been a fashion item for pants, jackets, and coats. The pocket edge is folded to form pleats that open, allowing space for large items. The pocket flap holds the pleated folds in place and the items securely.

Measurements needed:
- Width and length of the pocket (example 5″ × 5″).
- Number of pleats (Example: 2 pleats).
- Depth of the pleat (Example: 3/4 inch). This can vary. The pleat underlay equals $1\frac{1}{2}$ inches.
- Mark pocket location on pattern.

Accordion Pocket Draft

Figure 1
- Draw pocket width and length desired. Label A at corners.

 A–B = 4 times pleat depth = 3 inches.

- Square out from A and up to pocket level from B. Add 3/4 inch at top of pocket for hem fold-back and notch.

 A–C = A–B.

- Square down from A and square across paper.

Figure 4

Figure 2

B–D = 3/4 inch (pleat depth).

C–E = B–D.

- Square in from D and up from E. Label F at intersection.

- Divide B to F and C to F into 4 equal sections, indicated by broken lines.

- Label each section by number as illustrated.

- Draw connecting lines from 1 to 2, to 3, to 4, to F.

- Repeat this process to other end of the pocket.

- Add 1/4-inch seam allowance around pocket except for fold-back hem.

Figure 2

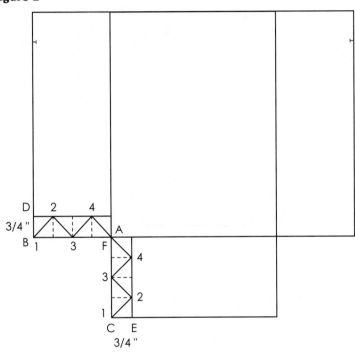

Note: Cut zig-zag shape when cutting pocket pattern from paper.

Stitching guide: For pleat stitching, fold C–E to B–D. Stitch zig-zag seams together. Edge stitch to hold fold of pleat shape. Fold under seam around the pocket when it is placed into position on the garment, and topstitch.

Figure 3

- The finished pocket.

Figure 3

Stylized Outside Pocket

Two designs are given to illustrate outside pockets. Figure 1 shows pattern development for Design 1 (pant). Figure 2 shows pattern development for Design 2 (skirt). Use instructions and illustrations as a guide. (Broken lines indicate the original pattern shape and pocket facing.)

DESIGN 1

DESIGN 2

Figure 1

- Plot pocket using measurements given.
- Plan facing on entry side of pocket (broken line).
- Trace pocket by placing a paper underneath.
- Remove paper and pencil in a pocket outline.
- Notch pant for pocket location.

Figure 1

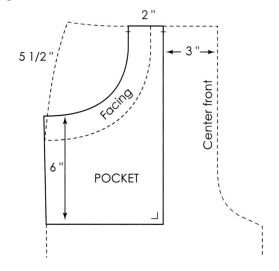

Figure 2

- Follow illustration and instructions given for Design 1, Figure 1.

Figure 2

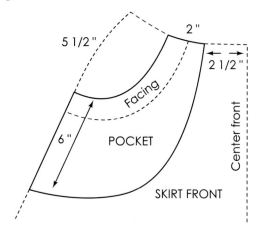

Inserted Pocket

Stylized Opening

Design Analysis

Pocket opening curves from waistline to side seam.

Pattern Plot and Manipulation

Figure 1

- Draw pocket shape, using illustrations and measurements as a guide. (Broken line indicates outer edge of pocket pouch.)

Figure 1

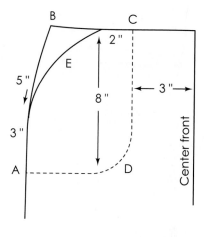

Figure 2

- Trace two copies of pocket, including pocket's curved opening.
- Label one copy *Backing*.

Figure 2

Figure 3

- Trim to curved opening on other traced pocket. Label it *Facing*.
- Trim curved line on skirt pattern after pocket is traced.

Figure 3

Variation of an Inserted Pocket

Design Analysis

Design features a pocket that extends 1/2 inch out from the side, providing additional room for entry. Waistline is gathered.

Figure 2 *Pocket facing*

- Trace pocket sections C, D, E, and F. Label the piece *Facing*.

Figure 2

POCKET FACING

Figure 3

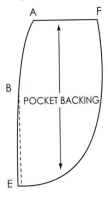

POCKET BACKING

Pocket In-One with Side Seam

Pattern Plot and Manipulation

Figure 1

- Plan pocket along side seam of the front pattern. (Repeat for back; not illustrated.)
- Place punch mark $1\frac{1}{2}$ inches down from waist at side seam and 1/8 inch out on pocket side. Repeat 6 inches below for hand entry. Circle punch marks.

Stitching guide: Stitch down from waist and up from hem to just beyond punch marks. (The unstitched space forms pocket opening.) Stitch around pocket. Pocket is placed on front side of garment.

Pattern Plot and Manipulation

Figure 1 *Plan Pocket*

- Use illustration and measurements given.
- Draw line from D to zero at hem of garment.
- Draw curved pocket pouch from F to E as shown.
- Draw line from E, blending with B (broken line).

Figure 1

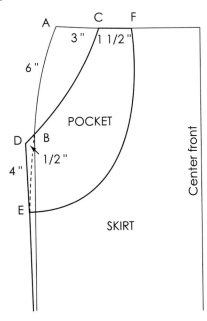

POCKET

SKIRT

Center front

Figure 3 *Pocket backing*

- Trace pocket section A, B along broken line to E, and to F. Label piece *Backing*.

Figure 1

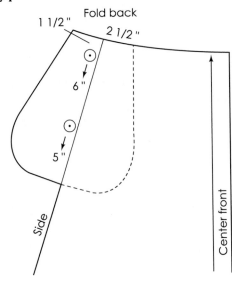

Fold back

Side

Center front

Pocket In-One with Yoke

Design Analysis

Pocket is formed in-one with part of the yokeline on bodice.

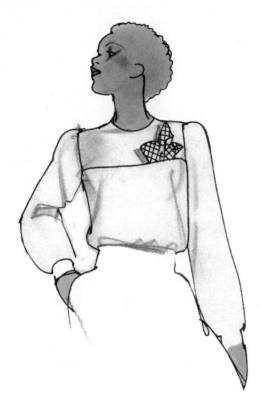

Pattern Plot and Manipulation

Figure 1 Plan Pocket

- Square yokeline from center front.
- Locate center on yokeline and move point 3/4 inch toward side seam. Mark. Pocket width: 4 inches. Length: 3 inches.
- Label sections A and B.

Figure 1

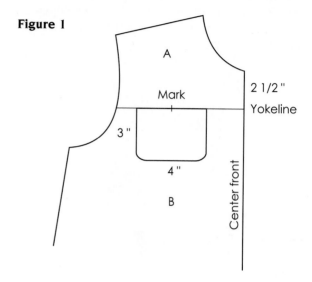

Figure 2

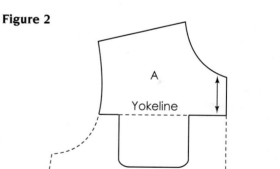

Figure 2 Section A

- Trace section A, including pocket shape. Add seams.

Figure 3 Section B

- Fold pattern on yokeline. Trace pocket.
- Unfold; pencil in pocket. Add seams.
- Cut section B, including traced pocket (bold line).

Figure 3

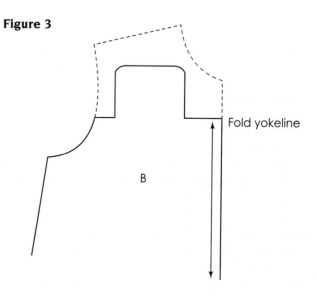

Insert Pockets—Side-Seam Pocket

Pocket with Gathered Front

Design Analysis

Side seam is straight from the hip level to the waist-line, with fullness absorbed in the waistband as gathers. Part of the side seam pocket is developed on the skirt section. (The same technique can also be used for pants.)

Figure 1 *Front pocket*

- Draw a curved line 1/2 inch out from side waist, ending 6 inches down from side seam to blend with hipline. Mark and label X (end of opening).

- Draw pocket, using illustrations and measurements as a guide. (*Note:* Pocket shape ends 1 inch below point X.) Mark notch 1 inch down from waist.

- Trace two copies of pocket section.

Figure 1

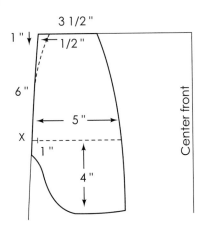

Figure 2 *Pocket facing*
- Label one copy of traced pocket *Facing*.

Figure 3 *Pocket backing*
- Separate second copy of traced pocket, using measurement given. Mark notches. Label *Backing* and sections A and B.

Figure 2 **Figure 3**

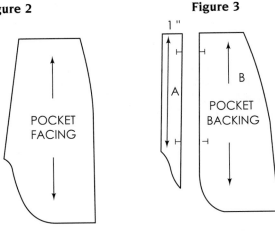

Figure 4 *Back skirt*
- Adjust side seam, using front skirt instructions. Excess from side waist is taken up equally by the darts. (Broken lines indicate original dart intake.)

- Align pocket section A to side seam and waist. Tape to pattern, or trace (eliminates seamline at pocket entry). Section B is pocket backing.

Figure 4

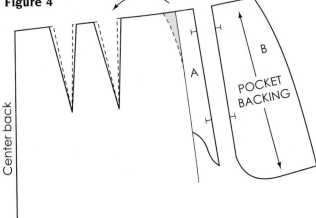

Pocket with Control Lining

Design Analysis

The inserted pocket at side seam has a facing combined with lining that extends from side to center front. The lining is used to hold pleats and pocket in place.

Stitching guide:
- Pocket facing is stitched to garment (front pocket opening between notches).
- Pocket backing is stitched flat on top of lining and together stitched to back pant side seam.
- Facing is stitched to lining to complete the pocket. The center front secures the lining.

Figure 1
Note: Use illustration and measurements as a guide.
- Trace section of upper pattern.
- Plot lining. Draw dart points to lining depth (shaded areas). Mark notches.
- Cut pattern from paper.

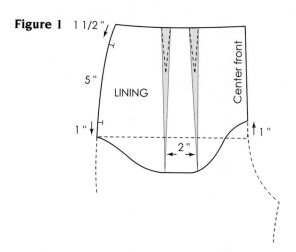

Figure 1

Figure 2
- Slash to, not through, lining pattern and overlap both dart legs (broken lines). Tape. Retrace and label.

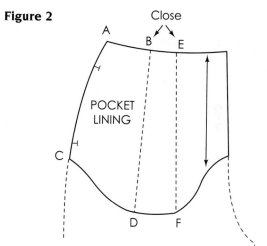

Figure 2

Figure 3 *Pocket facing*
- Trace lining sections A, E, F, and C. Include notches. Label *Pocket facing.*

Figure 4 *Pocket facing*
- Trace lining sections A, B, C, and D. Include notches. Label *Pocket backing.*

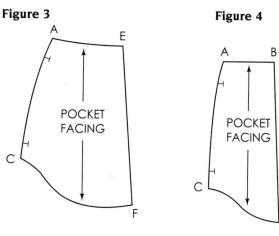

Figure 3 **Figure 4**

18

Dresses without Waistline Seams

(Based on Torso Foundation)

Torso Foundation

The torso foundation is a bodice and skirt combination without a waistline seam. The foundation ends at hip level (HBL). Length is added to or subtracted from the foundation as required by the design. The fit is controlled by sets of double-ended darts and side darts. The side darts lift the fabric until the crossgrain is parallel with the floor, balancing the garment at the hip level. The torso is important as a base for other basic foundations: Shirts, blouses, dartless knit tops, dresses and gowns (without waistline seams), jackets, coats, and activewear (bodysuits, leotards, and swimwear).

Three versions for developing the back torso are discussed. One version creates greater length at the center back; the second version creates greater fullness across the back. A compromise is offered as a third version.

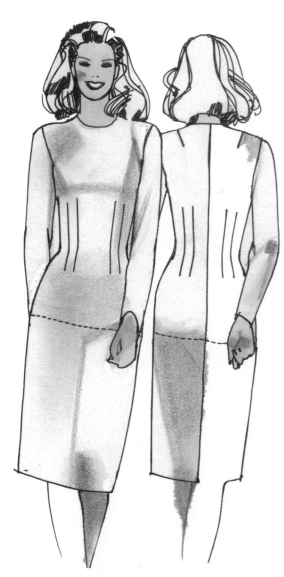

Torso Draft

Measurements Needed:

- (25) Hip Depth: CF _____
- (23) Hip Arc: F_____, B_____

Pattern Plot and Manipulation

Figure 1

Front

- Trace the basic one-dart pattern.
- Label side waist X.
- Square a line from center front to side seam at level with bust point. Cut slash lines to, not through, bust point.

Back:

- Trace and cut back pattern.
- Label side waist (X).
- Draw a slash line (for Version 2), as illustrated.

Figure 1

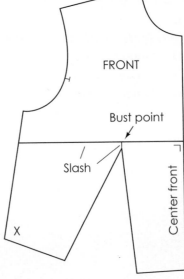
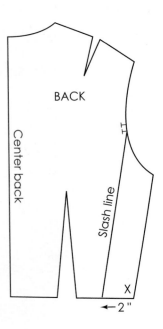

Figure 2

Front lower torso

- Square a line and mark corner A.

 A to B = Front hip arc, plus 1/2 inch ease. Mark.

 B to C = Front hip depth, squared up from C and squared from C to the center line (D).

- Dot mark 3/4 inch in from C.

Figure 3

- Place bodice on the square line. Secure.
- Close waist dart until point (X) touches the square line. It may not touch the dot mark.
- Trace pattern indicated by the bold line, omitting the broken lined area.
- Remove pattern.

Figure 2

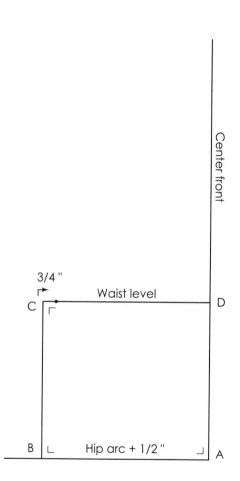

Figure 3

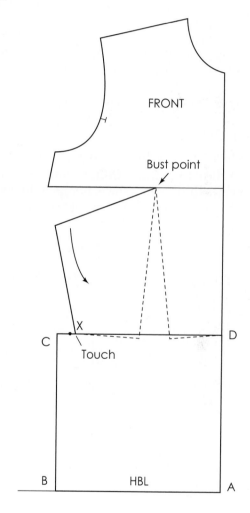

Figure 4

Back lower torso

- Square a line and mark corner A.

 A to B = Back hip arc, plus 1/2 inch ease. Mark.

 B to C = *Front hip depth,* squared up from C, and squared from C to the centerline (D).

- Dot mark 3/4 inch in from C.

 A to E = Center back hip depth. Crossmark.

Version 1—Center back length is increased.
Figure 5

The center back pattern is placed on the vertical line with the side waist (X) touching the C line. The pattern is traced and removed. The added length is between center back waist and crossmark (E).

Version 2—Width across the back is increased.
Figure 6

- Extend (C) line.
- The center back waist is placed at point (E).
- Pivot at the curve of the armhole until side waist (X) touches the (C) line. Trace, not including side seam. The width across back is increased.

Figure 4

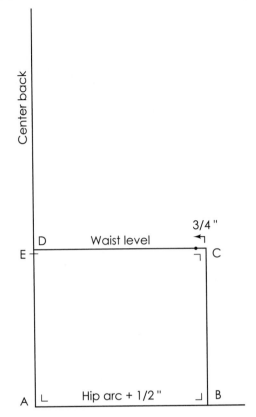

Figure 5 **Figure 6**

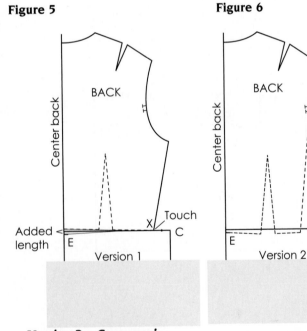

Version 3—Compromise
Figure 7

- Place center back waist at (D). (Side waist [X] will fall below this line.)
- Pivot at the curve of the armhole until side waist (X) touches the (C) line. Trace, not including side seam.

Figure 7

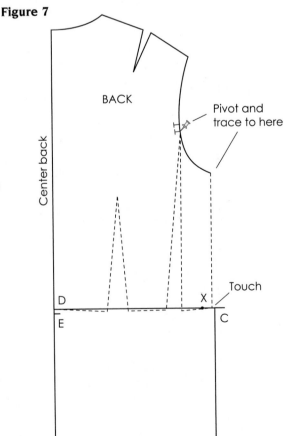

Figure 8

Side dart

- Draw side dart legs to bust point.
- Center dart point 1 inch from bust point.
- Draw dart legs to dart point.
- The side dart is folded and the side seam is drawn up from the dot mark at waistline.
- Draw hipline curve, as illustrated.

Double-ended darts

- Square a line down from bust point, ending 3 inches below waist level.
- Square a guideline 1 inch below bust level.
- Draw a parallel line $1^3/_4$ inches from this line.
- Follow illustration for dart intake. Draw dart legs.

Figure 9

- Draw hipline curve to dot mark, and continue the line to the armhole.

Double-ended darts

- Square guidelines from center back 1 inch below armhole level and $5^1/_2$ inches below waist.
- Mark $3^1/_4$ inches and $5^1/_2$ inches from center back waist.
- Square lines from each mark up to the guidelines.
- Follow illustration for dart intake. Draw dart legs.

See example for punch and circle guide for marking darts. If side seams do not true, increase or decrease side dart. The side seams or darts may be taken in for a closer fit providing that the HBL remains parallel with the floor. Adjust side seams if strain appears. Shorten dart points if tightness appears at the hip.

Figure 8

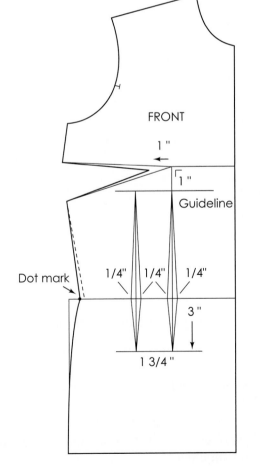

Figure 9

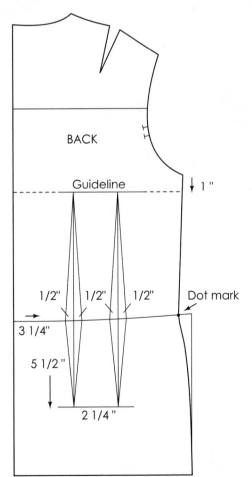

Example for
punch-circle guide

Contour Guidelines

The foundation pattern should be drawn with contour guidelines for developing designs that contour the body, and for designs with cutout necklines or armholes. See Chapter 9, Contouring, as a guide, if necessary.

Figure 10

Front

Guidelines:

(1)—applies to cutout necklines

(2)—applies to cutout armhole

(3)—sleeveless garments

(4)—applies to empire stylelines

(5)—applies to cleavage contour

(6)—applies to strapless designs (combines guide-lines 1, 2)

- Draw a line indicating side ease.
- Mark 1/8 down at mid-shoulder and connect to neck and shoulder tip.

Figure 11

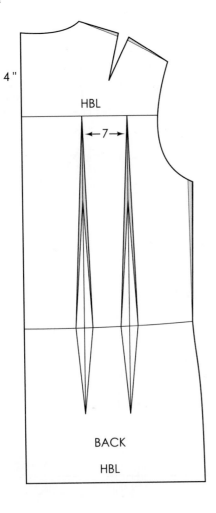

Figure 10

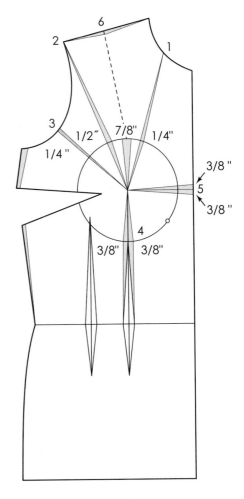

Figure 11

Back

Guidelines:

(7)—applies to strapless and low-cut necklines.

- Square the HBL line (one-fourth the distance from neck to waist).
- The centers of both darts are extended to the HBL line.
- Draw a line indicating side ease.
- Mark 1/8 down at mid-shoulder and connect to neck and shoulder tip.

Dress Categories

Dresses may be grouped into two categories—those with a waistline seam and those without. Dresses designed without the waistline seam are based on the torso pattern. Dress foundations such as the fitted sheath, semifitted shift, straight-line and A-line silhouettes, princess, panel, empire, tent, torso dress, blouson, and oversized dress are based on the torso pattern. Dresses without waistline seams are featured in this chapter.

Knit Dress Designs

Garments designed for knits should be based on the dartless knit patterns—Drafts 1 and 2 (see Chapter 26). Other patterns may be used. Patterns that are used for knit designs should be modified to compensate for stretch and shrinkage.

Shirtmaker Dresses

To develop patterns for shirtmaker dresses, see Chapter 21 for shirt with yoke, without yoke, and the oversized shirt. Add desired dress length.

The Three Basic Dress Foundations

Each of the three basic dresses is based on the torso foundation with the fit of the garment controlled by the amount of dart control at the waistline.

Sheath: Fitted with a series of double darts.

Shift: Semifitted with a series of single darts.

Box-fit: Elimination of all waist darts, and an increase of intake at the side dart.

Find designs in fashion magazines and other sources based on these foundations. Creating for the basic dress foundations includes modifying stylelines and increasing or decreasing hemline sweep (changes the silhouette). The addition of collars, sleeves, pockets, and other add-ons brings variety to these very basic foundations.

The sheath (fitted silhouette). Both darts of the front and back torso patterns are marked for stitching.

The shift (semifitted silhouette). One waist dart is marked for stitching and the other dart is left unmarked (broken lines) as ease around the waistline.

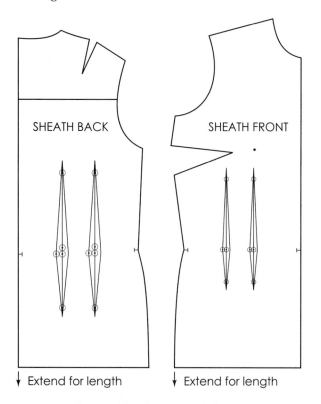

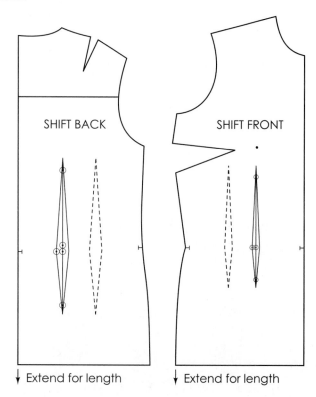

The Box-fitted silhouette. Waist darts are left unmarked (broken lines) and unstitched as ease around the waistline.

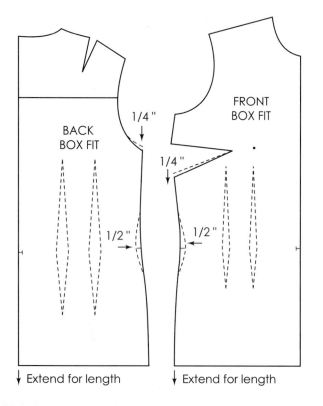

Modify Torso Foundation for the Box Fit

Front

• Increase dart intake 1/4 inch. Draw line to dart point.

Back

• Lower back armhole 1/4 inch and blend.

• Mark 1/2 inch or more out from front and back side seams.

• Draw blending lines to original side seams. (The shortened side seam length will not affect the balance line of the HBL level of the hipline. The straighter line should measure less than the original curve of the side seam to hold the garment straight at the side.)

Princess-Line Foundation

The princess-line foundation is used to develop all designs with similar styleline features.

Pattern Plot and Manipulation

Figures 1 and 2

- Trace front and back torso foundations. With pushpins, transfer waist darts to pattern underneath.

Back styleline

- With skirt curve, draw styleline from leg of shoulder dart to dart point of first waist dart and from bottom of dart point to hip level, parallel with center back.
- Move shoulder dart point to styleline.

Front styleline placement

- Draw styleline in line with back shoulder dart to bust point and from bottom of dart point to hip level, parallel with center front.
- Draw slash line from bust point to side dart point. Crossmark 3/4 inch from bust point on slash line for pivotal point.
- Mark notches $1^1/_2$ to 2 inches up and down from bust point on styleline, and at side waistline darts.

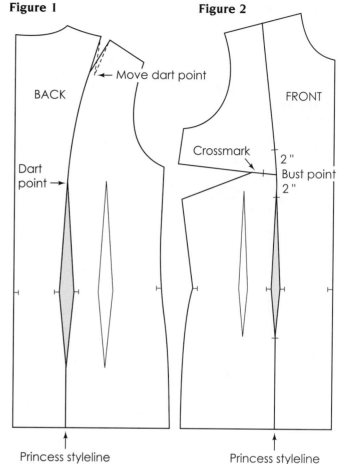

Figure 1

Figure 2

Figures 3, 4, 5, and 6

- Cut and separate styleline on each side of the dart legs.
- Cut slash line from bust point and dart point to, not through, the crossmark.
- Close side dart legs. Tape.
- Retrace princess panel.
- Shape and blend styleline. (Broken line indicates original pattern.) Circle punchholes.

Complete the princess-line dress foundation as illustrated. Several designs are given using the princess line as a foundation pattern.

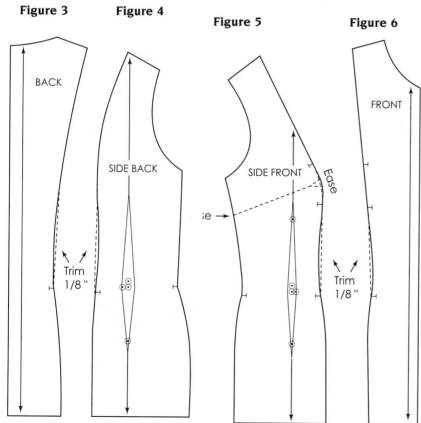

Figure 3 **Figure 4** **Figure 5** **Figure 6**

A-Line Princess

Design Analysis

Design 1 is a fitted princess-line dress with an A-line silhouette. The design pattern is based on the princess foundation pattern (page 423). If the princess design pattern is available, see Figure 3 option. Designs 2 and 3 are for practice.

DESIGN 1

DESIGN 2

DESIGN 3

Figure 1 **Figure 2**

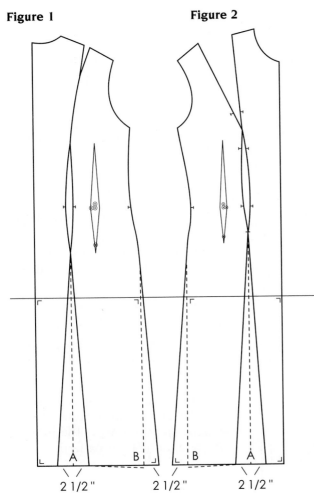

2 1/2 " 2 1/2 " 2 1/2 "

Pattern Plot and Manipulation

Figures 1 and 2

- Draw a horizontal guideline on paper.
- Place the back panels together with hipline on guideline and trace. Transfer darts and grainline with pushpin to paper underneath. Remove patterns.
- Repeat for the front.
- Square down from hip level to length desired and square across for hemline.
- Draw a line down from dart points parallel with center front and back (broken lines). Label A and B.
- Mark a point $2\frac{1}{2}$ or more inches from A and connect to dart point of the princess line. Mark a point $2\frac{1}{2}$ inches out from B and connect to the outermost part of the hipline curve.
- Square in from side at hemline and blend.

Figure 3

- Cut from paper. Trace and separate patterns along styleline.
- Draw grainline, punch, and circle darts.

Figure 3

Option for Princess Design Pattern

- For additional hemline sweep, add more flare to each panel and add to center front and back panels.

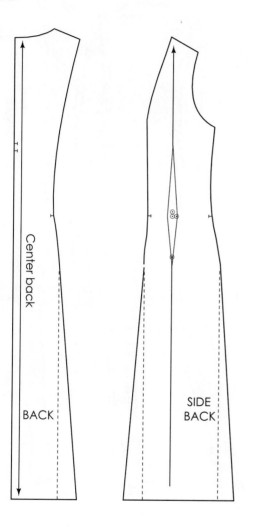

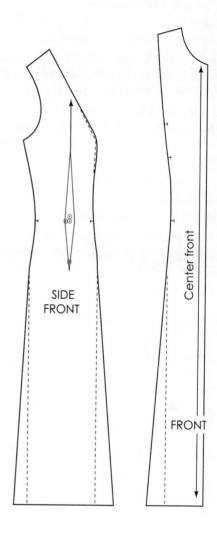

Panel Dress Foundation

The torso panel is a semifitted foundation without side seams. Designs 1 and 2 are based on this foundation. With imagination many other variations can be created from this foundation.

Pattern Plot and Manipulation

Figures 1 and 2

- Trace front and back torso foundation.

- Square a line up from hip level 1/2 inch from armhole. Draw a blended curve to styleline. (Broken line indicates original darts.)

- Reposition darts to stylelines. Use intake from one dart, plus one-half of the other. Divide equally on each side of styleline at front and back waist.

- Draw new dart legs (shaded area).

- Draw slash line 1 inch below original location of side dart ending at dart point.

- Cut and separate pattern panels along styleline, discarding unneeded section (shaded area between dart legs).

DESIGN 1

DESIGN 2

Figure 1

Figure 2

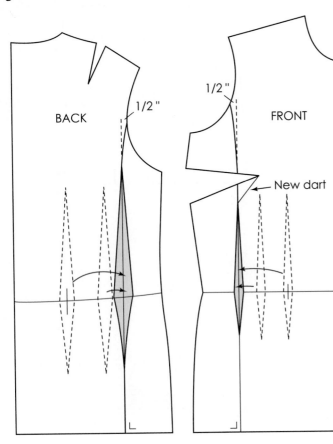

BACK

1/2 "

1/2 "

FRONT

New dart

Waistline level

Add for length

Figures 3 and 4 *Front and back panels*
- Cut slash line for new dart. Close dart. Tape.
- Add 1-inch extension at center back.
- Draw grainline and mark notch.

Figures 5 and 6 *Side panels*
- Close side dart legs of the side panel.
- Draw a horizontal guideline and square a line. Label A, B, and C.
- Place the hip of the front and back panels on the horizontal line, and the corners of the armholes touching line A. (The hips may touch, overlap, or have space between them, and the armholes may not be at the same level.) Trace and remove patterns.

Adjust panels
Armhole: Equalize the difference so that both armholes will meet.
- Mark 1/2 inch in at waistline. (Disregard instructions if side hips meet.)

Hips that overlap or have space between them
- Measure the amount. Add or subtract one-half the amount on each side of the panels.
- Mark and square up about 2 inches.
- Draw panel stylelines slightly inward above waist and slightly outward below waist. Blend where noted (original shape indicated by broken lines).

Figure 3 **Figure 4**

PANEL BACK

Close →

PANEL FRONT

Cut on fold

← 1 "

Figure 5 **Figure 6**

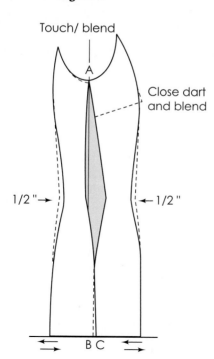

Touch/ blend

A

Close dart
and blend

1/2 "→ ← 1/2 "

B C

SIDE PANEL

Empire Foundation

The styleline of the empire dress crosses under the bust and across the back (optional). A single dart above the styleline and a pair of darts below the styleline control the contour fit.

The empire foundation is developed from the basic torso and should include all contour guidelines. Use as the base to develop Designs 1 and 2.

DESIGN 2

DESIGN 1

Pattern Plot and Manipulation

Figure 1 *Front Torso*

For those not using the Contour Guide pattern, follow plot and measurements given.

- Trace front torso. Mark bust point, darts and draw bust circle (3-inch radius). With pushpin, transfer Guideline 4 (under bust), or use measurement given.

- Draw slash line from dart point to bust point.

Empire styleline

- Square a line from center front, touching circle under bust to side seam. Label A (broken line).

- Mark B, 3/4 inches down from A.

- Draw curved line from B to under bust. Excess of second dart above styleline is for ease.

- Label C at side waist.

Lower section

- Measure out 3/16 inch from each side of dart leg at styleline and connect to waist (shaded area).

Figure 1

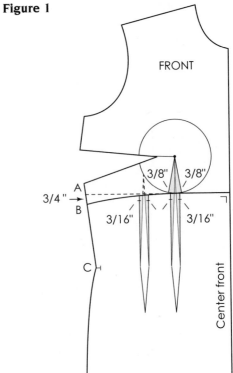

FRONT

3/8" 3/8"

A
3/4 "→
B
3/16" 3/16"

C

Center front

Lower section

Figure 2 B*ack torso*
- Trace back torso. Label side waist D.

Empire styleline

D–E = C–B (of the front).

F–G = D–E, less 1/2 inch. Square a short line.

- Draw curved styleline from E, blending with G.
- Mark center for new dart between existing darts and draw line to the HBL, parallel with center back.
- Draw dart legs equal to dart intake.

Lower section
- Mark 1/8 inch out from each dart leg (shaded area).
- Draw new dart legs, ending dart at waist.

Figures 3 and 4
- Separate patterns along stylelines.

Front
- Cut slash lines to bust point and close side dart. Retrace pattern.
- Extend dart legs 1/4 inch below bust and down 1/8 inch at center front (square a short line). Blend lines and shape dart legs. (For gathering under bust and back, draw blending lines across darts—broken lines.)

Trueing
- True upper and lower torso patterns. If front does not true (excluding 1/8-inch ease) adjust pattern by increasing or decreasing bust dart intake. Adjust the dart leg nearest to the side seam. If the back does not true, subtract from side seam of back upper torso. Blend to zero at armhole (broken line).
- Use basic sleeve to complete the pattern.

Contour guidelines
Mark all contour guidelines for future reference. Complete pattern for test fit.

Figure 2

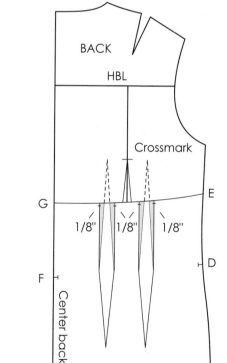

Figure 3

Figure 4

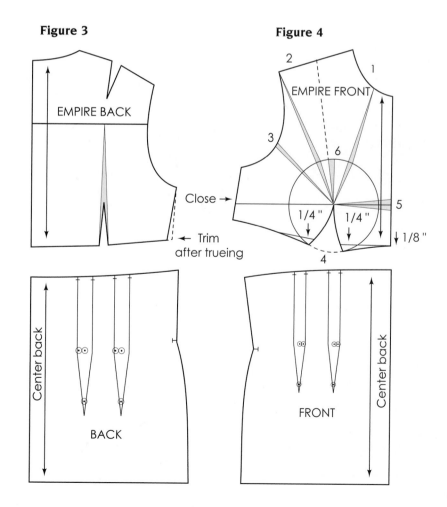

Tent Foundation

The tent silhouette has a sweeping hemline. The amount of sweep can be controlled by the side dart and by adding flare. The tent foundation may be used as is (Design 1), or used as a base for design variations (Designs 2 and 3).

Pattern Plot and Manipulation

DESIGN 2

DESIGN 3

DESIGN 1

Figures 1 and 2

Trace front and back torso, omit darts. Plot as illustrated.

Figure 1 **Figure 2**

HBL

BACK

Pivotal point

Center back

Slash line

FRONT

Slash

Bust point

Center front

Slash line 2

Slash line 1

Figure 3 B*ack*

- Cut slash lines to, not through, pivotal point. Close shoulder dart allowing slashed section to spread.
- Label A, B, and C.
- Mark 1/2 inch out from side waist. Label E.
- C–D equals one-half of A–B. Mark.
- Draw line from E to D, continuing line to desired length. Blend side seam.
- To complete, square down from hip at center back and blend hemline parallel with hip.

Figure 4 F*ront*

- Cut slash lines from hip level to bust point, cutting through bust point to, not through, dart point of side dart.
- Cut second slash line to, not through, dart leg.
- Place pattern on paper. Close side dart, spreading sections equally. (Dart legs may not meet at side.)
- Tape. Trace outline of pattern.
- Blend side seam at closed dart leg.
- Extend length from hip level equal to back side length (even broken lines). (Hem is parallel with hip level.)
- Mark 1/2 inch in at side waist. Connect with hem and blend with side as indicated by bold line.

Figure 3

Equalizing hemline sweep

- To equalize hem, cut back pattern and place on top of front, matching side seam from armhole to waist. Divide sweep overhang in half, adding one-half the difference to the back and subtracting one-half from the front. (Uneven broken line is adjusted side seam.) Blend side seams.

Figure 4

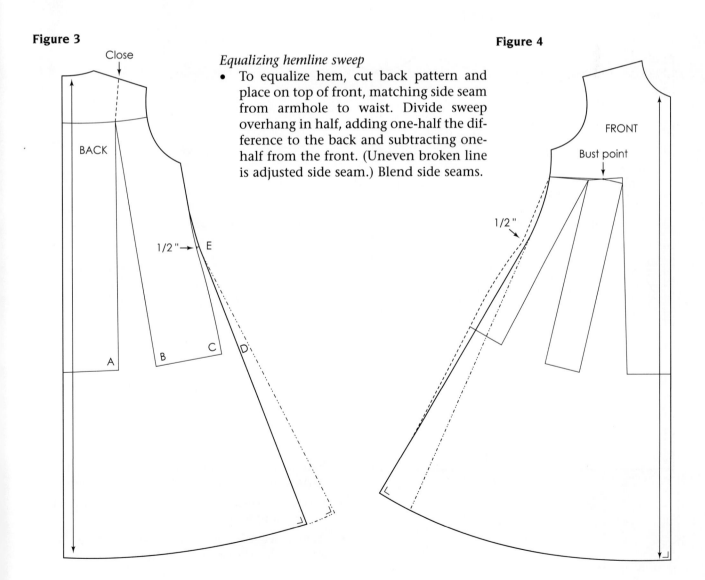

Oversized Dress

Design Analysis

Design 1 is an oversized garment developed by adding to the width of the pattern as illustrated. The side dart excess is held automatically in the armhole area, allowing enough room for a shoulder pad. (Color blocking is not included.) Design 2 is a practice problem.

Pattern Plot and Manipulation
Figures 1 and 2

- Trace front and back torso pattern and transfer shoulder dart to armhole.
- Oversizing can vary from measurements given.
- Draw front and back cutout neckline.
- Extend shoulder line 6 inches.

Figure 1 **Figure 2**

DESIGN 1 DESIGN 2

Hem

- Extend to desired length, and square out 1 inch less than front and back hip arc. Draw a line from hem to shoulder guideline.
- Mark for a notch point 5 inches up from waist level.
- Extend 1/2 inch out from shoulder, and draw a curved line to notch mark (armhole opening).
- It is not necessary to raise the shoulder tip when using shoulder pads.
- Adjust sleeve length at the time of fitting. Make a facing for the armhole at that time.

Jumper

Design Analysis

Design 1 has deeply cutout armholes and a scoop neck, with buttons down the center front. A jumper is a garment generally worn over another garment, and therefore is not fitted close to the figure. Design 2 is for practice.

DESIGN 2 DESIGN 1

Figures 3 and 4 *Facing*

- Connect front facing at dart legs. Tape.
- Trim 1/8 inch from each side of facing to zero at center front and center back. (Broken line indicates original facing.)

Figure 3 **Figure 4**

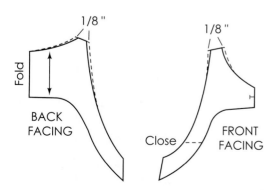

Pattern Plot and Manipulation
Figures 1 and 2

- Trace front and back torso, transferring shoulder dart to mid-armhole. With a pushpin transfer first waist dart of front and back patterns.
- Extend to length desired. Add flare. Blend hemline.
- Plot armhole and neckline. Suggestion: Fold side dart and draw styleline.
- Draw a 1-inch extension at center front, plus 2 inches for fold-back. (When pattern is cut, fold paper along extension and trace neckline shape onto fold-back.)
- Draw grainline. Mark button and buttonholes. (See Chapter 16 for closure information.) Punch and circle for dart intake.
- Plot facing (broken lines).
- Front facing ends 1 inch from center front. It is stitched to fold-back (eliminates bulk).
- Trace and cut facing.

Figure 1 **Figure 2**

Special Patternmaking Problems

The following examples illustrate plot and pattern development for designs featuring creative detailing crossing through darted areas of the pattern. Design 1 has gathers and Design 2 (page 435) has stylelines crossing the darted areas. Designs 3 and 4 (page 435) feature stylelines that require a one-piece front. The examples do not represent completed patterns, but should be used as a guide for plotting patterns with similar features. To complete the designs, and for practice, plot the back patterns with appropriate stylelines for each of the designs.

Gathers Crossing Dart Areas

Figure 1

DESIGN 1

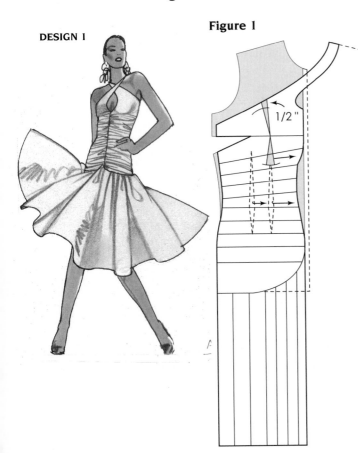

Figure 1 *Plot the torso pattern*

- Remove 1/2 inch from the center front to compensate for bias stretch. (If garment is still loose at time of fitting, remove more from the gathered area.)

- Eliminate the waist dart excess at the center front by drawing the width and length of both darts (shaded area).

- For under-bust contouring, remove an additional 3/4 inch at the center front (at level with the bust circumference).

- When pattern is cut from paper, the unneeded section is trimmed from the pattern (shaded areas).

Figures 2 and 3 *Completed pattern*

- The pattern is slashed, spread, retraced, and blended.

Figure 2

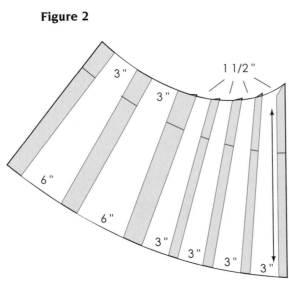

Figure 3

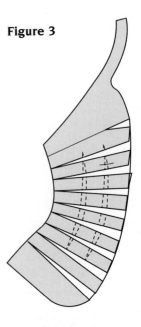

Stylelines Crossing Dart Areas

Figure 1

- Draw stylelines across the open darts as indicated by the design.
- Number each section.
- For bust contouring, increase dart intake under bust as illustrated.

DESIGN 2

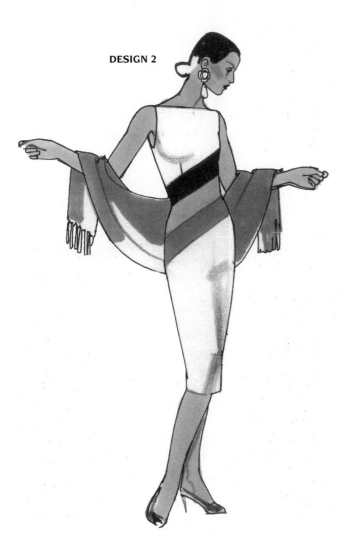

Figure 1

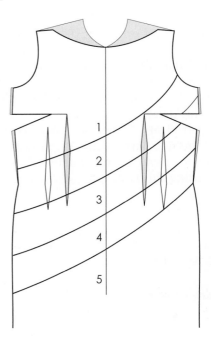

Figure 2

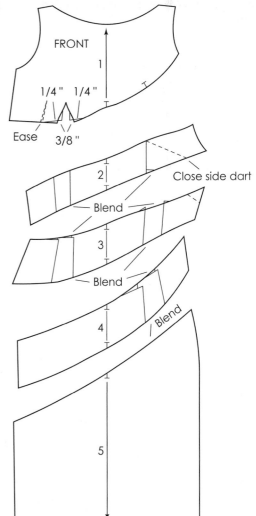

Figure 2 *Completed pattern*

- Separate patterns along the stylelines.
- Close all darts.

Note: Stylelines that cross open darts at an angle will not true when darts are closed. Adjust by blending after the panels are traced.

Stylized One-Piece Front

Designs 3 and 4 illustrate garments created as one-piece fronts without side darts. To plot working patterns for such designs, the styleline ends at bust point or the dart point of the side dart. After the styleline is cut and the side dart is closed, the pattern opens, allowing space between the stylelines to complete the details of the design (such as flare, Design 3 and pleats, Design 4). This would not be possible if the side dart remained as a dart. Develop the pattern for Design 4 for practice. Design other variations using this concept.

Figure 1
- Draw styleline to bust point.
- Draw all other stylelines. (Relocate waist darts as indicated by the design.)

Figure 2 *Completed pattern*
- After side dart is closed, complete the remaining pattern.

Note: Allow space for seam allowances (1/4 inch can jog to 1/2 inch) where needed.

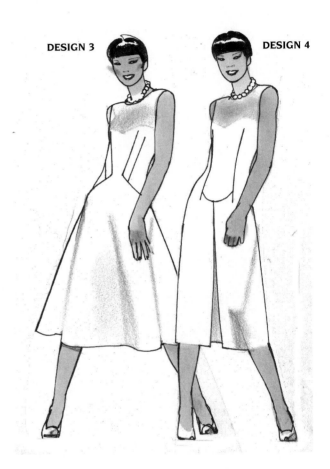
DESIGN 3 DESIGN 4

Figure 1

Figure 2

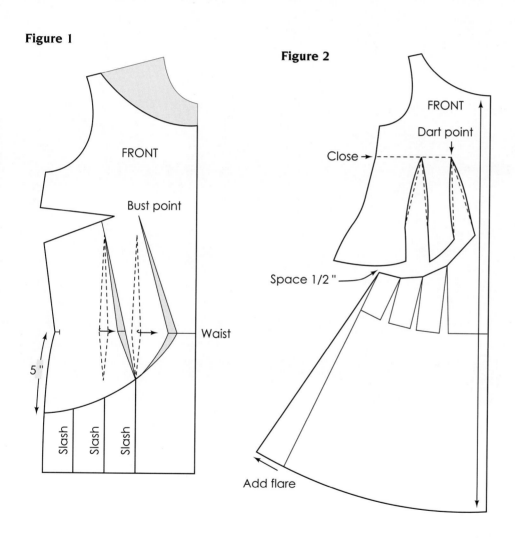

FRONT

Bust point

Waist

5"

Slash

Slash

Slash

FRONT

Dart point

Close →

Space 1/2" —

Add flare

19

Strapless Foundation and Interconstruction

Introduction

Strapless styles are designed as day dresses, evening wear, gowns, separate bustier, theatrical costumes, and dancewear. Designs of this type usually require an undersupport to keep the top part of the design in place when worn. Support is from minimal to extensive interconstruction (a second garment). The amount of support depends on the design, the weight of the fabric, the amount of plies, and the amount of beading. Examples of varied types of interconstruction are illustrated later in the chapter. Three strapless foundations are given for the purpose of building designs from them or on them.

Three Strapless Foundations

The Contour Guide pattern should be used to develop strapless tops. If the patternmaker has not developed the guide pattern, see Chapter 9. Measurements are provided for contouring each of the design projects. However, it is best that the patternmaker understand the principles so that they can be applied to all designs that contour the figure. Strapless tops are designed with a number of different stylelines. The most popular foundations are illustrated. The joining skirt is designer's choice.

Princess Bodice—Contoured above, below, and in-between the bust. However, if the bust is bridged, contouring between the bust is omitted.

Princess Torso—Contoured above, below, and in-between the bust.

Bra-Top Empire—Contoured above, below, and in-between the bust.

Princess Bodice Princess Torso Bra-Top Empire Torso

Strapless Princess Bodice Foundations 1 and 2

Foundation 1—Contoured above, below, and in-between the bust.
Back strapless, cut low.

Foundation 2—Bust is bridged and centerline is not seamed. Contoured above and below bust. Back strapless, cut low.

Foundation 1
Figure 1

Those not using the Contour Guide pattern should follow pattern plot and measurements.

- Trace front bodice. Transfer contour guidelines 4 (semifit—3/16 inch in from each dart leg), 5, and 6, and bust arc (3 inches) above and below bust.

- Draw strapless styleline, as illustrated.

- Mark notches 2 inches up and down from bust point.

- Cut princess patterns from paper.

Figure 2

- Trace back pattern; include guideline 7 to the HBL line.

- Draw back strapless line as illustrated.

- Cut strapless back from paper.

Figure 1

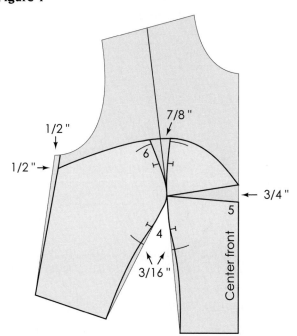

Figure 2

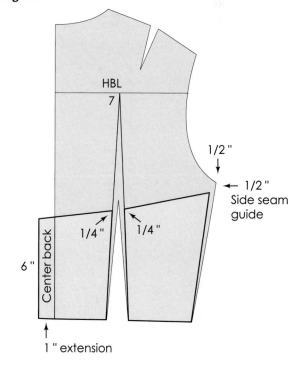

Figure 3

- Close center front dart and trace the pattern.
- Mark 1/4 inch out from the bust point (room for boning). Draw a blending curve of the bust area.
- Draw grainline straight or on the bias.

Figure 3

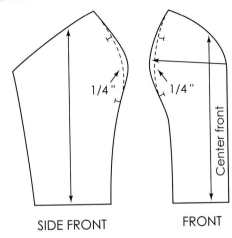

SIDE FRONT FRONT

Figure 4

- Close back dart legs and trace the pattern.
- Draw grainline straight or on the bias.
- Complete the pattern for the test fit.
- Interconstruction is discussed on page 450.

Figure 4

Foundation 2

Figure 5

Those not using the Contour Guide pattern should follow pattern plot and measurements.

- Trace front bodice and draw bust arc (3 inches) above and below bust.
- Transfer contour guidelines 4 (semifit—3/16 inch in from each dart leg) and 6.
- Draw strapless styleline (squared from center).
- Mark notches 2 inches up and down from bust point.
- Cut princess patterns from paper.

Figure 5

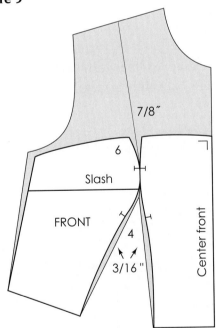

Figure 6

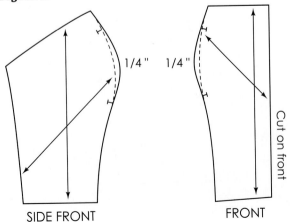

SIDE FRONT FRONT

Figure 6

- Mark 1/4 inch out from the bust point to allow room for boning. Draw a blending curve of the bust area.
- Draw grainline straight, or on the bias.

 See page 441, Figure 2 for the strapless back.

Princess with Gathered Panels

Design Analysis: Design 1

The strapless princess has a gathered front panel shirred on an angle indicating added fullness (parallel openings) and is an application of Principle #2 (Added Fullness) combined with Principle #3 (Contouring). Use the strapless princess to develop the pattern (see page 441). Back can be with or without gathers.

Pattern Plot and Manipulation

If inner support is required, see page 450.

Figure 1

- Trace 3 copies of the back and front strapless princess patterns (include grainlines). Use one pattern set for backing, one for slashing and spreading, and one for the lining.
- Draw angle slash lines exactly as they appear on the design. Label each section for reference.

Figure 1

Figure 2

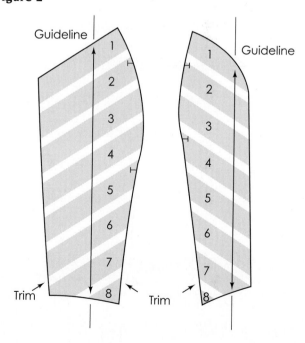

Figure 2

- Draw a vertical guideline on paper.
- Cut through each section of the pattern.
- Align grainline with the vertical guideline.
- Spread each section 1 inch (can be more or less) and secure.
- Trace outline of the pattern and mark the corners of each section.
- The guideline is the straight grain, or a bias grainline can be drawn.*

Follow the same procedure for a gathered back, if desired (not illustrated).

The gathered panels are stitched to the backing panels, and together they are stitched to the stitched lining.

Spaghetti straps: 1 × 36 inches.

*Trim 1/4 inch from pattern seamlines if bias grainline is used.

Bra-Top Torso Foundation

Figure 1

Those not using the Contour Guide pattern should follow pattern plot and measurements.

- Trace front and back torso and draw bust arc (3 inches) above and below bust.
- Transfer contour guidelines 4, 5, and 6 (front). Connect contour guidelines.
- Mark 1/2 inch above the bust, and draw bra styleline using measurements given.
- Draw torso styleline, as illustrated or as desired.
- The first waist dart is increased to absorb the second dart.

Figure 2

Back

- Draw a line between the two darts.
- Mark the excess of each dart out from the line. At the strapless line, mark 3/8 inch.
- Connect dart legs to establish the princess line. Cut and separate patterns.

For information about interconstruction, see page 450.

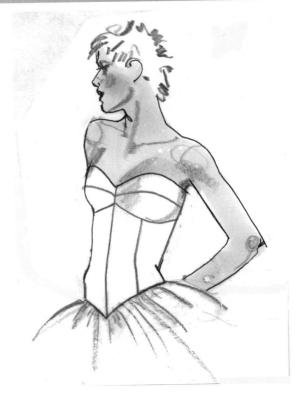

Figure 1

Figure 2

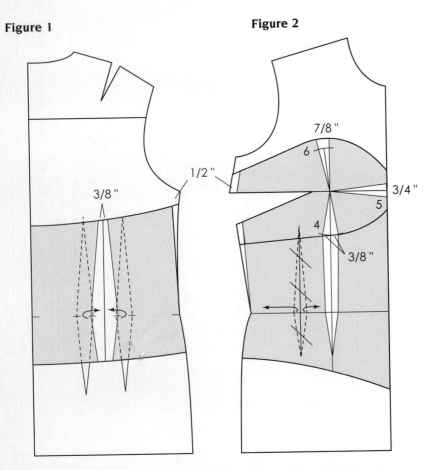

Figure 3
Bra top
- Bra-top cut from paper.

Figure 3

Separated pattern

Figure 4

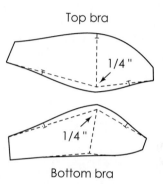

Top bra

1/4"

1/4"

Bottom bra

Figure 4
- Close dart above and below bust.
- Trace upper and lower bra patterns.
- Add 1/4 inch at bust point and draw curved lines to front and side seam. (Provides room for the bust mound and interconstruction.) Blend under bust.
- Mark notches where indicated.

Figure 5
Princess panels
- True princess line up and down from waist. Adjust the difference.
- Draw slightly outward curved lines down from waist.

Figure 5

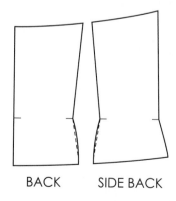

BACK SIDE BACK

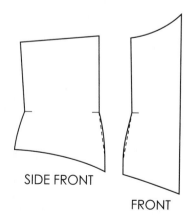

SIDE FRONT

FRONT

Princess Torso Foundation

The princess torso foundation is used to illustrate the application of various types of interconstruction. Fitting problems of the bust area are discussed, and solutions suggested.

Figure 1
Those not using the Contour Guide pattern should follow pattern plot and measurements.
Front

- Trace front torso foundation and draw arc (3 inches) above and below bust.
- Transfer contour guidelines 4, 5, and 6. Connect contour guidelines.
- Remove ease from side seam (1/2 inch).
- The first waist dart absorbs the excess of the second dart. Mark dart intake to the left dart leg.
- Cut pattern from paper and separate princess panels.

Figure 2
Back

- Draw a line between the two darts.
- Mark the excess of each dart out from the line. At the strapless line, mark 3/8 inch.
- Connect dart legs to establish the princess line.
- Cut and separate patterns.

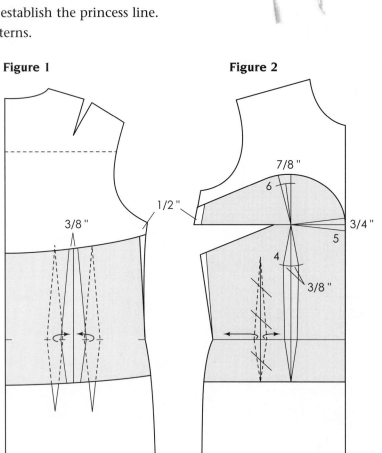

Figure 1 **Figure 2**

Figure 3

- Slash from bust point to side dart point.
- Close side dart. Mark ease control notches 2 inches up and down from bust point.
- Close center front dart and mark notches (5).
- Complete the patterns. Cut and stitch a full torso (skirt not to be included) for the test fit.

For information about interconstruction, see page 450.

Figure 3

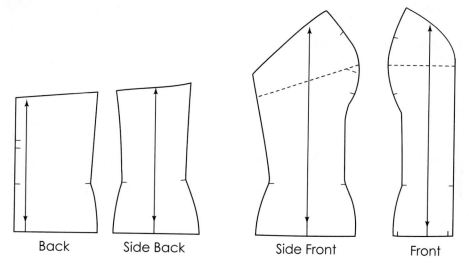

Back Side Back Side Front Front

Fitting Problems and Solutions

Garments designed to fit the contour of the bust often create special fitting problems for the pattern-maker. A good fit allows the bust cup of the garment to fit to the contour of the figure without stress and without having the center front fall away from the chest. Bust size or insufficient ease at the bust may be the cause for fitting problems.

Good Fit
Figure 1
The cups fit to the contour of the bust without stress or the bust cups falling away at centerline.

Stress Around the Bust Area or a Falling Away between the Busts
Figure 2a ,b
Open stitch line over the bust. Press in at the centerline. Measure the open space and correct the pattern.

Figure 2a

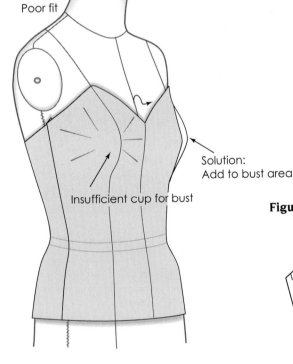

Poor fit

Insufficient cup for bust

Solution:
Add to bust area

Figure 1

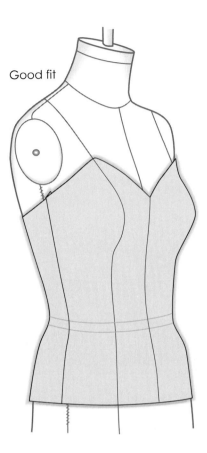

Good fit

Figure 2b

Side Front

1/4"

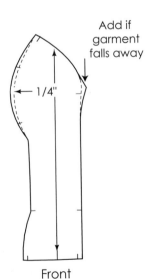

Add if garment falls away

1/4"

Front

Bust Too Large for the Bust Cup
Figure 3a, b
Open stitch line over the bust. Slash from bust to side and to center front. Measure and correct the pattern.

Figure 3b

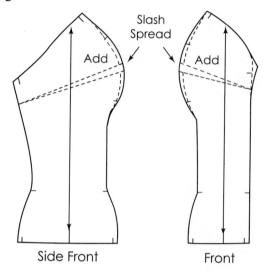

Slash Spread

Add Add

Side Front Front

Tight or Loose around the Waist or the Bust Area
Figure 4
Looseness—Pin excess along the princess line. Measure and correct the pattern.

Tightness—Release stitchline along the princess line.

Measure the opening and correct the pattern.

Figure 4b

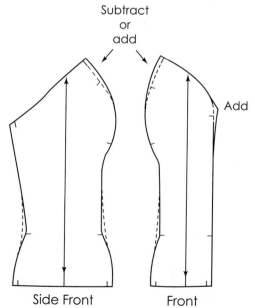

Subtract or add

Add

Side Front Front

Figure 3a

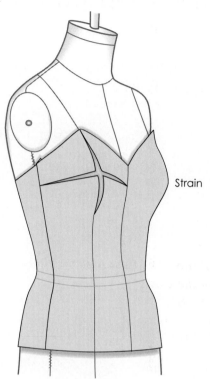

Strain

Figure 4a

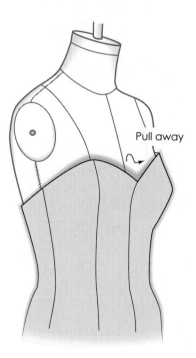

Pull away

Additional information
If interconstruction is to be added to the strapless foundation, see page 450 for instruction. A constructed strapless top should be fitted on the form with collapsed shoulders. Looseness is pinned at the side seams.

Construction Support for Strapless Garments

Patterns of the strapless foundations are the bases for the development of the constructed parts of the under support of designs.

Support is generally needed to secure the strapless top when the design involves heavy beading or the weight of several plies of fabric (drapery, gathers, and pleats) that overlay the bustier.

Types of Interconstructions

Lightweight Interconstruction

Minimal support might include the use of shoulder straps or boning stitched over selected seams (for example, bust and side seams). The strapless design could also have facings or a lining. A fused or non-fusible interlining would add additional support, which should be lined. A lightweight construction may be appropriate for certain designs, particularly if the garment is featherweight and generally unlined.

Supplies for lightweight construction:

Fabrics: Cotton net, organdy, lightweight cottons for the base.

Boning: (optional) see page 455 and twill tape.

Lining: Use depends on which side of the support garment faces the underside of the design overlay.

Heavyweight Interconstruction

An undersupport functions as a corset (a second garment), and is made of heavy fabric, boning, or underlining, often with a lining. Extensive construction is required for designs that are heavily beaded or with overlays consisting of several plies of fabric.

Supplies:

Undersupport

Fabrics: Medium-weight canvas; drill; poplin; weighty satin; sturdy (non-stretchy), preshrunk linen; or heavy satin Lycra.

Underlining—Shields the garment from boning and raw seams of the undersupport that faces it.

Fabrics: wool felt, or a blend (not less than 50-50); cotton flannel; or batiste.

Lining

Fabrics: Rayon, China silk, or the design fabric.

Bust padding (attached to the undersupport)

Fabric: Thick fiber-filled batting, 2 to 3 plies of a stiff fabric (canvas or Belgian linen).

Other items

Grosgrain ribbon or twill tape (1/4 inch) for holding ease at the top of the strapless garment. Grosgrain or elastic (3/4 to 1 inch wide) for securing the garment to the waist.

Types of Boning

Boning provides a lightweight skeletal frame that supports the garment. It ranges from firm, ridged, or webbed plastic called Rigilene to a flexible wire boning with caps. Boning comes with and without a casing (covering around the boning). Boning should end 1/4 to 1/2 inch from each end of the finished seams. Depending on the amount of support needed, boning can be stitched on seams as well as in between seams. To protect the garment, the casing folds over the ends of the cut boning. The casing is stitched on the selected seams and the boning is slipped into it.

Rigilene
(webbed plastic)

Boning and casing

Flexible coil wire

Preparing Patterns for the Undersupport

The princess torso is the prototype for the following instruction. However, the information can be applied to other foundations and design patterns. See page 446 for instructions on developing the princess foundation.

Lining and Underlining Patterns

Trace two copies of the torso patterns Add 3/4 inch to the top of each pattern to allow for fitting adjustments.

Figure 1 *First Copy*
The first copy is for the lining, if required.

Figure 1

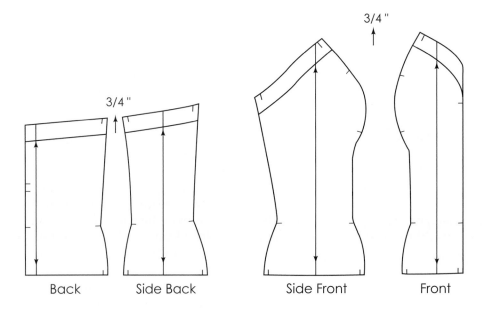

Back Side Back Side Front Front

Figure 2 *Second Copy*
* Add 1/4 inch on each side of the bust mound panel to allow for boning or padding; to serve as an underlining for the design garment; and as a base for generating the design garment.
* Cut in fabric of choice.
* Press seams open.

 Go to Figure 10, if bra padding is not desired.

Figure 2

Add 1/4" Add 1/4"

Side Front Front

Padded Bra
Figure 3

- Place the upper part of the pattern on paper.
- Trace the bust area and 2 inches wide across the back patterns (shaded sections).
- Cut from paper.

Figure 3

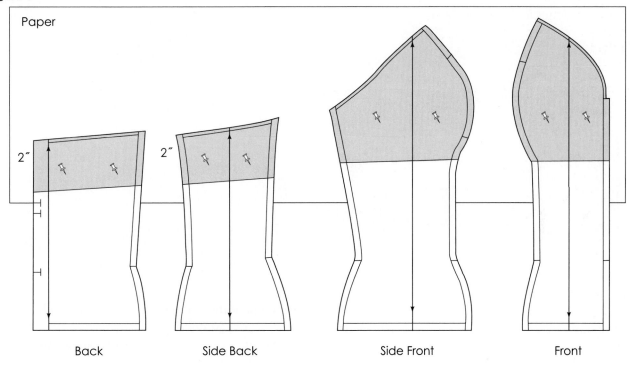

| Back | Side Back | Side Front | Front |

Bra Cups
Figure 4

Mark notches and trim seam allowance (unless the pattern was seamless).

Figure 4

| Back | Side Back | Side Front | Front |

Preparing the Padding for the Bra Cup
Figure 5
- Choose the fabric for the padding; see page 451, bust padding.
- Cut the fabric 9 inches × 20 inches.
- Topstitch 1/4-inch rows vertically through the fabric.
- Place bra patterns on the padding. Trace and cut.
- Mark notches, but do not slash.

Figure 5

Top stitched padding

Joining Bra Padding
Figure 6
- Join raw edges by hand stitching or zig-zagged by machine.

Setting the Padding

Figure 7
- Fit padding snug to the garment, 1 inch from the top. Pin to hold.
- Stitch around the outer edges to secure padding to undergarment.

Figure 6 **Figure 7**

Center front

Attaching the Cased Boning
Figure 8

- Measure length of the chosen seams.
- Cut the boning and pull from casing. Cut 1/2 inch from the boning or push casing back and trim as shown.

Figure 9

- Fold casing 1/4 inch and stitch each side of the casing through the selected seams ending 1/4 inch from top and bottom of each seam.

Figure 8

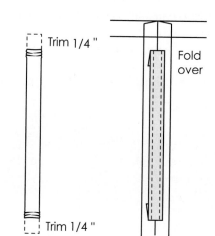

Cut to length

Trim 1/4 "

Trim 1/4 "

Fold over

Figure 9

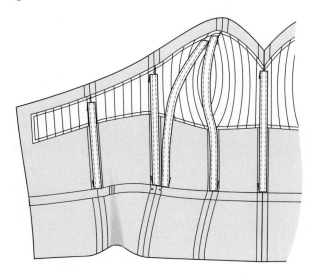

Uncased Boning—Rigilene
Figure 10

Boning is stitched in the ditch of the seam. The constructed side of the support garment faces the underlining of the design garment. The raw seams are inside and do not require a separate lining, which may, however, be desired. An optional feature is to catch-stitch the boning to the seam.

Figure 10

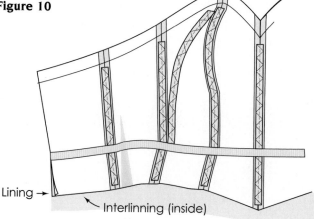

Lining →

Interlinning (inside)

Attaching the Constructed Undergarment

Figure 11

The constructed undergarment is attached to the design garment in one of two ways, with or without lining. If there is a lining, the design garment is placed between the undersupport and the lining, covering the raw seams, boning, and padded bra to clean finish the garment, as illustrated in the example. Stitching 1/8 inch above the strapless line joins all three. If the design garment is beaded or has several plies of fabric, the stitchline may be more than 1/8 inch above the strapless line.

 Lining is not required when the raw seams, boning, and padded bra face the underside of the design overlay. In this case, the finished side of the undersupport serves as the lining. This type of construction requires that an underlining back the design overlay. If lightweight construction is chosen, an underlining is not required.

Figure 11

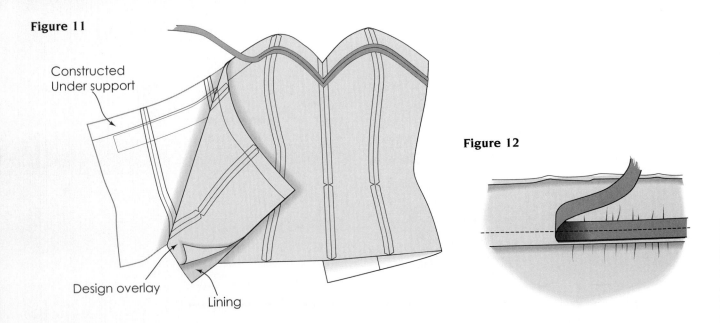

Constructed
Under support

Design overlay

Lining

Figure 12

Controlling Ease

Figure 12

- Stitch twill or grosgrain 1/16 inch above the stitchline of the strapless top, starting at the center back to the side seam.

- Hold 1/8 inch ease from the side seam to princess line and 1/8 inch to the center front.

- Repeat on the other side to help secure the strapless top on the figure.

- Trim the strapless tops to within 1/4 inch of the seam allowance.

 Edge-stitch when the garment is turned. A piece of 1/2- to 3/4-inch grosgrain can be placed along the waistline and tacked at the center and sides and into the center back. It can be caught in with the zipper, or a 1-inch opening in the fold of the lining at the center back. Pull the grosgrain through ribbon and secure with hook and eye across the inside of the zipper.

20

Patternmaking for Bias-Cut Dresses

Introduction

Before the advent of bias-cut dresses, fashion garments required the use of girdles to harness the body. Then, the late designer Madeleine Vionnet (1876–1975), called the "Euclid of fashion," draped bias-cut dresses that clung to the natural curves of the figure. As the bias fell from the hip, it created flares at the hemline. The beauty of the bias dress was in the graceful swing of its hemline as the body was in motion. Vionnet's designs revolutionized the way women wore their clothes, and the girdle was discarded. Bias-cut dresses are timeless in style and continue to influence designers today. To replicate the essence of the Vionnet look, a system that combines drafting and draping must be considered.

Nature of Bias-Cut Fabric

a. As bias stretches in length, its width decreases.

b. The straight and crossgrain run in opposite directions from the center of true bias.

c. The crossgrain is not twisted as tightly as the straight grain and falls more easily on the bias.

d. Where the crossgrain and straight grains intersect at true bias, one side hangs longer (unless the grain runs in one direction across the garment).

e. After the bias has been stretched, it does not return exactly to its original shape.

The nature of bias-cut fabric poses problems for the patternmaker. All garments cut on the bias should be test-fitted to eliminate excess created by the stretch of the bias. Chapter 12, Cowls, addresses this problem.

Patternmaking for Bias-Cut Garments

Designs that are cut totally on the bias or partially on the bias are discussed in this chapter.

Foundation patterns that are chosen as a base to develop bias-cut garments are not reliable; but they do serve the purpose of creating pattern shapes of the design. The garment is cut and joined using the long stitch by machine, by basting, or by pinning when placed on the form to hang overnight. The bias part of the garment will stretch beyond its original shape in fitting to the curves of the form. The garment is marked between the original lines of the pattern and the adjusted markings. The differences are trimmed from the patterns where they occur. New pattern shapes emerge from the corrections that are smaller and shorter than the originals to offset bias stretch. When cut again for the final test fit, the bias will stretch naturally to fit the shape of the form. Designs 1 and 2 are prototypes for bias-cut garments. The instructions include two methods for the management of bias and the adjustments to the pattern.

Two Methods for Reducing Bias Stretch

Method 1—The garment is cut from the design pattern and allowed to stretch to determine the pattern corrections. The slip dress illustrates this method, and management of the cutting process.

Method 2—The stretch of the fabric is determined first and the pattern is adjusted before the design patterns are developed. The all-in-one dress illustrates this method.

Fabric Selections for Bias-Cut Garments

Lightweight Fabrics

Crepe

Flat crepe

Crepe de chine

Silk

Rayon

Medium-Weight Fabrics

Satin-back crepe

Charmeuse

Georgette

Chiffon

Stretch knits can also be used for the designs that follow.

Slip Dress with a Slinky Skirt

Design 1 is the prototype for skirts of this type. Additional width is added to the side seams for adjustment after the bias has stretched freely overnight from a partially stitched garment. (Suggestion: Pin drapery weights along the hemline to encourage the greatest amount of stretch.)

Design Analysis—Design 1

The dress is designed to resemble a slip. The bra is gathered under the bust with a princess bra underneath for support. The empire skirt is cut on the true bias. Use the torso foundation for the design.

Pattern Plot and Manipulation

Figure 1

Those not using the Contour Guide pattern should follow pattern plot and measurement (see Chapter 9).

- Trace the front and back torso foundation.
- Transfer contour guidelines 4, 5, 6, and 7 (back).
- Draw bust arc (3 inches) above and below bust.
- Connect front and back contour guidelines.
- Draw princess bra top 1/4 inch above bust arc.
- Continue the lines across back.

Figure 1

Figure 2

Bra-top support

- Separate bra-top at bust point.
- Use the patterns for Figures 3 and 4.

Figure 3

Gathered bra-top

- Close all darts except under bust, and trace.
- Extend dart legs 1/4 inch below bust.
- Draw curved lines under the bust. Mark notches.

Figure 4

Princess undersupport

- Close side and center bust darts and trace.
- Add 1/8 inch at bust points and draw outward curved lines.

Figure 5

Back strapless

- Close darts and blend.

Figure 6

Front and back empire skirts

- Measure intake of each dart, front and back.
- Add together, plus 1 inch. Record.
- Draw guidelines between the two darts, ending 5 or more inches below waist.
- Mark one-fourth of the measurement out from each side of the front and back guidelines.
- Connect to dart points.

Figure 2

Figure 3

Close

1/4 "

1/4 "

Gathers

Figure 4

Princess bra

1/8 "

1/8 "

Close

Close

Figure 5

Blend

3/4 " ext.

Figure 6

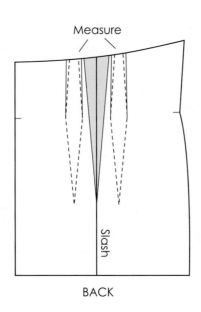

Measure

Slash

BACK

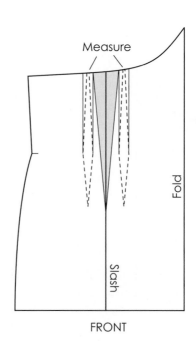

Measure

Fold

Slash

FRONT

Figure 7

Front and back slinky skirt

- Slash to dart points from waist down and hips up.
- Close darts and trace patterns, with front traced on fold. C to D = 2 × A to B measurement. Mark.
- Draw side from outermost part of hip touching D to desired length (added length is parallel with the hip HBL).

Figure 7

Paper

Fold

Measure

D C B A

To length
(parallel with
HBL)

To lengthen
parallel with
HBL line

HBL A B C D

Grainline Placement

The grainline of the bias skirts can be cut with the grains running in the same direction, as illustrated on next page. This placement allows the bias grain to fall equally at the side seams when cut in one direction. If you cut the back with the grainlines running in opposite directions, one side seam of the front and back will hang at a different length from the other. The bra-tops are cut on the straight grainline.

Cut the front skirt on fold, and cut 2 copies of the back. Cut 2 gathered bra patterns, 2 princess under-supports, and 4 strapless backs. Spaghetti: Length, plus 1 inch.

Preparing for Cutting
Figure 8
Patterns
Draw bias grainlines (45°) on front and back empire skirt patterns, and straight grain on the bra-tops.

Trace patterns on marking paper (or the equivalent) with the patterns' grainlines parallel to the selvage. After tracing the patterns, add 1-inch seams to the skirt, and 1/2 inch for bra-tops (self-lined).

Lay of tissue, fabric, marking paper
To control the fabric for cutting, place tissue on the cutting table first. Place the fabric on top of the tissue, and marking paper on top of the fabric. All three layers are pinned around the edges and through the traced patterns to keep them in place while cutting. See illustrations. Cut patterns and draw center guideline on the front skirt.

Figure 8

Figure 9

Preparing for the Test Fit
Figure 9

- Sew the front and back bras separately.

- Join bra-top to the front and back slinky skirt separately. Due to the stretch, the bias will go beyond the side seams.

- Place the garment on the form. Pin the center guideline to the center front of the form and do not allow it to move from that location when fitting the garment.

- Raise the form to prevent the skirt from touching the floor.

- Pin the sides seam (not too closely at the side waist), ending 6 inches below waistline.

- The unpinned seamline will allow the bias to stretch freely overnight. (Suggestion: Pin drapery weights along the hemline.)

Figure 10

After the garment has hung overnight:

- Adjust, pin, and mark the new side seams.

- Hemline is pin-marked parallel with the floor.

- The garment is removed from the form.

- Release the bra and true the new lines.

Clip

Figure 10

Weights

Pin mark hem line

Figure 11
Draped skirt
- Measure the distance from the original seam line to the adjusted marked line that indicates the amount of bias stretch. Pin or chalk mark new side seam and hemline.
- Repeat for the back skirt.

Figure 12
Pattern
- Use the measurements taken from the skirt and measure in from the pattern's edge to mark, true, and blend the adjusted pattern.
- Repeat for the back skirt.

Figure 12

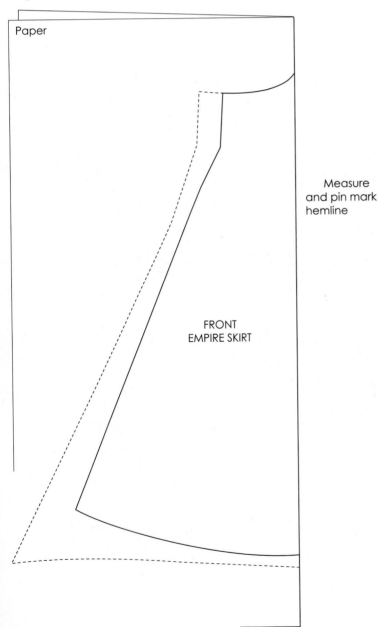

Figure 11

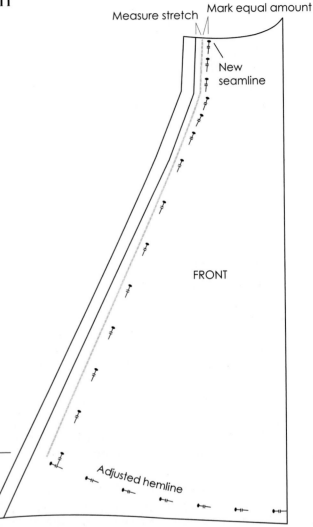

Twist Bodice with a Slinky Skirt

The bodice twist closely relates to a design by Vionnet. The dress slips over the shoulder without a closure. The cowl is also excellent for this purpose.

Design Analysis

The bodice twist is cut on the true bias. The twist turns at bust level so that the other side ends right side up.
 An open space between the slinky and the bodice gives freedom for the turning of the twist.
 The twist design is plotted on the pattern. See page 460, Figure 6, through page 464 for guidance.

Pattern Plot and Manipulation

Figures 1 and 2

Front

- Square a line from center to bust point (X) and follow illustration to plot the design.

Back

- Mark (X) 2 inches up from center back waist and follow illustration to plot the design.

Dart intake

- Front—Add 3/8 inch to the dart intake.

- Back—Add 1 inch to the dart intake.

- Draw dart legs 7 inches below waist.

- Mark and draw dart legs.

- To complete the skirt, see page 460, Figure 6, and page 461.

Figure 1

1 1/2 "

Trim 1/2 "

X

2 " 2 "

Figure 2

1 1/2 "

X

3 "

2 "

Figure 3
Twist
- Slash to bust point and close side dart.
- Trim side ease and trace the pattern.
- Extend center front line and square to shoulder at start of the V neckline.
- Cut front on fold. Draw bias grainline.
- Cut in fabric for test fit.

Figure 3

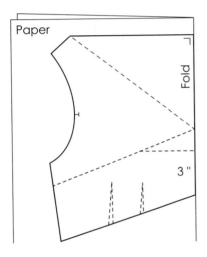

Figure 5
- Place the twist to the right shoulder and pin at shoulder and at side seam.
- Fold pleats in the fabric (in line with the center front) and twist the fabric under and over so that the right side of the fabric is to the left side of the form. Pin to the shoulder and side seam of the form.

Test fit:
- If the twist is too loose, reduce the needed amount at the center front of the pattern.

Figure 6
After the skirt has hung overnight and the pattern has been adjusted, pin or stitch to the twist for a final fitting.

Figure 4
Back empire top
- Remove dart intake at the center back and end at mark of the shoulder.
- Cut from paper and trim side ease.
- Draw a straight grainline.

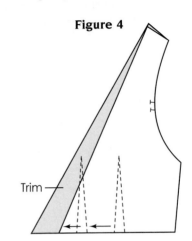

Figure 4

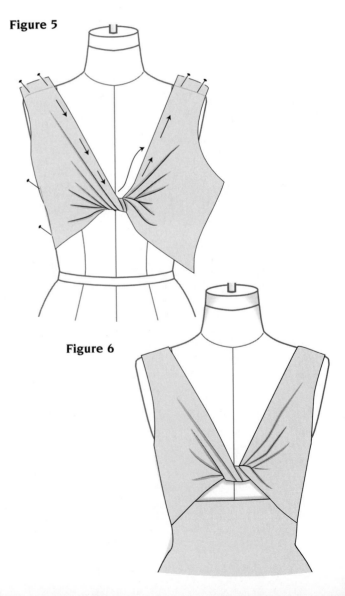

Figure 5

Figure 6

Figure 7

The completed patterns. Suggestion: The raw edges of the twist can be merrow edged or can be stitched as a baby-roll hem.

Figure 7

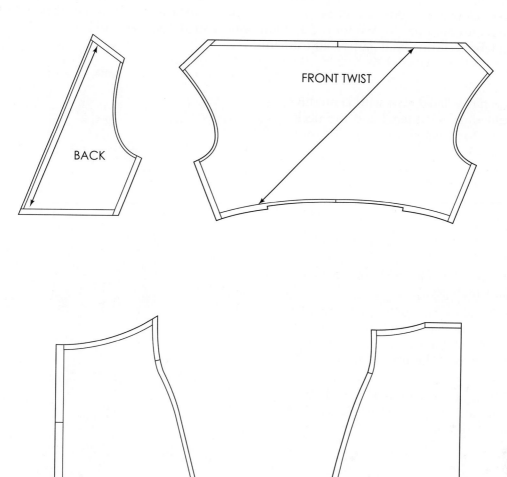

All-in-One Bias Dresses

The second method for handling garments cut on the bias is illustrated with the all-in-one dress. (However, any design cut on the bias can be adapted to this method). The difference between this method and Method 1 is that in this method, the stretch of the bias is determined first and then the pattern is modified before the design pattern is developed. This does not mean that the garment will be a perfect fit. The garment must hang overnight and all seams must be checked for the amount of fit desired. See pages 462, 463, and 464 for guidance in handling fabric, cutting, and pattern adjustments.

Design Analysis

The bias cut dress has a flared skirt with centerline seams. The shoulderline is gathered and the neckline has a V-Cut. To develop the Leg-o-Mutton sleeve, see Chapter 14.

Determining the Bias Stretch

Figure 1
Measurement needed: Back hip arc (23). Example: 9".

- Fold the fabric on true bias and pin-mark hip arc measurement (A to B).
- Lay the fabric on the ruler with pin-mark (A) secured at the 1-inch point.
- Smooth the bias across the ruler. Record the distance that the fabric has stretched beyond the hip measurement. This amount is to be removed from the centerlines of the pattern to offset the bias stretch.

The amount of bias stretch will vary according to the nature of the fabric. (For an example, chiffon may stretch more on the bias than satin-back crepe.)

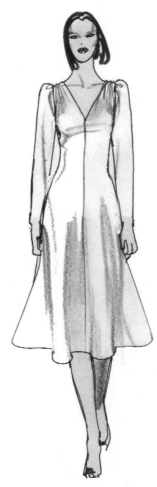

Figure 1

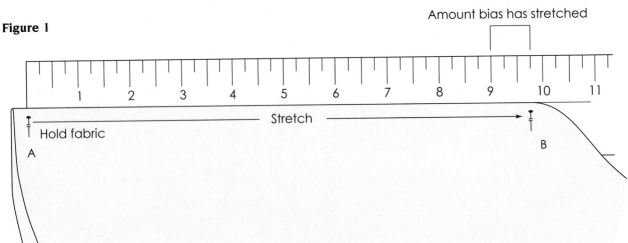

Pattern Plot and Manipulation
Figure 2

- Trace the torso patterns, transferring the side dart 1 inch from shoulder tip.

- Draw V neckline 1 inch up from bust level and ending 1 inch from dart leg.

- Draw back neckline. To eliminate remaining dart excess, trim shoulderline.

- Draw parallel lines to center front and back equal to the amount of the bias stretch (indicated by the broken lines).

- Draw curved centerlines front and back, at the adjusted centerlines, as illustrated.

Adding flare

- Extend skirt to desired length.

- Add flare starting about 7 inches below waistline of the center back, front, and side seams, following the angle of the line down from waist.

- Add 1-inch seams to the patterns.

 See pages 462, 463, and 464 for guidance in preparing the fabric and for cutting, and for draping to complete the process.

Figure 2

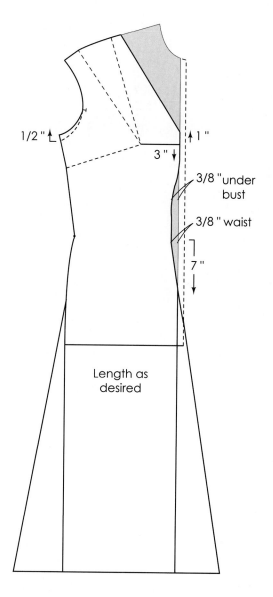
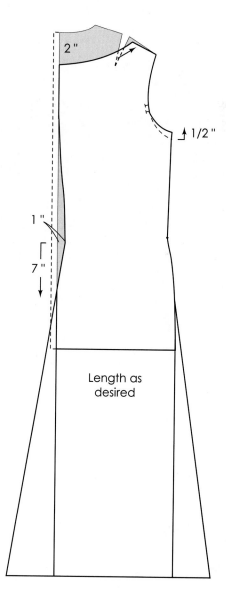

Design Variations

The designs illustrated here are for further practice
or for design inspiration.

21
Shirts

Shirt and Blouse Foundations

Shirts and blouses, even though different by design, are both worn with skirts and pants. Shirts have a tailored, mannish look; blouses have a feminine touch. But there are similarities. The armholes of shirts and blouses are placed at varying depths below the plate of the form. The armhole is made larger by transferring some or all of the side dart excess to it. The larger armhole requires changes to the basic sleeve to accommodate the new armhole.

Shirt and blouse foundations can be based on the bodice waist and side dart and basic back, or the torso foundation (see Chapter 18). Stylelines, yokes, tucks, added fullness, collars, pockets, cutout necklines and combinations, and a variety of sleeve designs (especially for blouses) add variations to these foundations.

Shirts and blouses become dresses by extending the length of the foundation patterns.

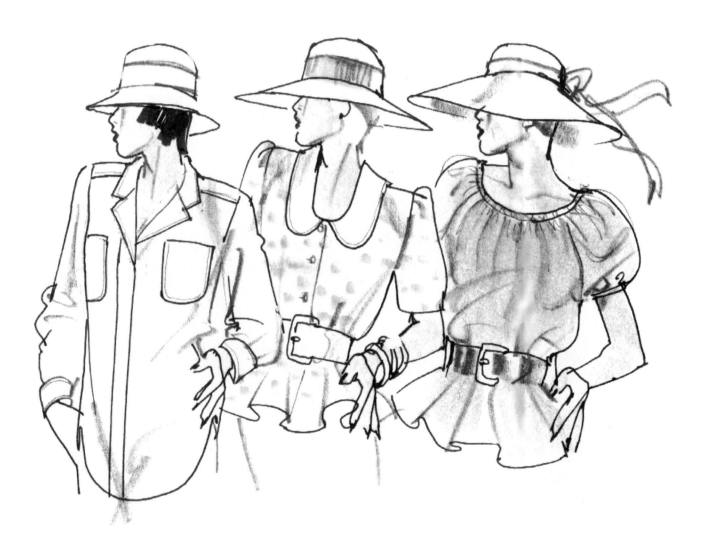

Three Shirt and Blouse Foundations

Each of the foundations has distinctive features. They differ in the following ways: the amount of fullness given to the shirt or blouse foundations, the depth and amount of enlargement of the armholes, and the modifications of the basic sleeve—wider biceps, shorter cap height, and increased length given to the underarm (for lift).

Basic Shirt or Blouse Foundation

Characteristics: The armhole is slightly lower and slightly wider than in the bodice and foundations.

Casual Dartless Shirt or Blouse Foundation

Characteristics: The armhole depth and fullness are much greater than in the basic shirt.

Oversized Dartless Shirt or Blouse

Characteristics: The armhole depth and fullness are greatly exaggerated.

Yoke Shirt and Sleeve
(Based on the Shirt or Blouse Foundation)

The front and back shirt drafts of Figures 1 and 2 are also the foundations for blouse designs. The side dart is available for design variations: gathers at the shoulder or neck, or as flare at the hemline. Trace a copy of the foundation patterns before they are modified for the yoke shirt.

The draft can be based on the bodice with side and waist dart and basic back, as illustrated, or the torso foundation (Chapter 18). The basic shirtsleeve, cuff, sleeve hemline, and closure variations follow the yoke shirt draft. Add length to adapt for a dress.

Design Analysis

The yoke shirt has more ease and the armhole depth is lowered for an easy fit.

The yoke extends 1 inch to the front. The shoulder and side darts are transferred with the side dart shared between the armhole and gathers at the yoke line. See Chapter 10 for the basic collar or collar and stand.

Shirt or Blouse Draft

Figure 1

- Trace the back pattern.
- Draw the shoulder line straight (shoulder dart placed in the armhole).
- Mark 3/4 inch down and out from the armhole (X).
- Mark 1/4 inch out at HBL.
- Draw armhole, as illustrated.
- Extend center back 7 inches, and square across and up to point (X).
- Cut from paper. Trace a copy for the blouse foundation.

Figure 1

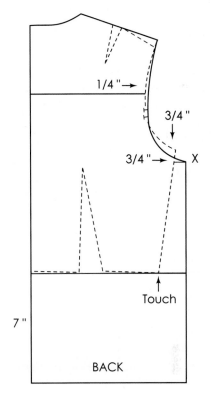

Figure 2

- Trace front bodice and transfer excess from side dart to increase armhole 1/2 inch.
- Mark 3/4 inch down and out from the armhole (X).
- Extend center front 7 inches, and square across and up to (X). Fold the dart and redraw the line for the side seam.
- Extend shoulder length 1/2 inch.
- Draw armhole passing near the center of the excess and blend to X.
- Cut from paper. Trace a copy for the blouse foundation.

Figure 2

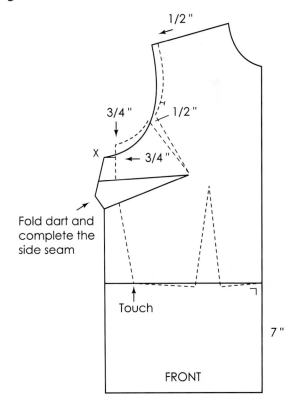

Figure 3
Yoke
- Trace back shirt foundation, and place the front shoulder to back shoulder.
- Trace 1 inch of the front shirt.
- Mark notches as illustrated.

Figure 3

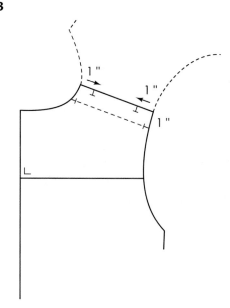

Figure 4
Yoke and back patterns
- Cut yoke from pattern.
- Draw side seam and curve of the hem.

Figure 4

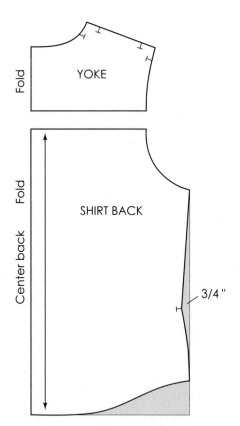

Figure 5
Front
- Trace front shirt foundation, and transfer side dart to mid-shoulder.
- Trim 1 inch at shoulder. Notch.
- Draw side seam and curve of the hem.
- Add 3/4 inch for the extension.

Figure 5

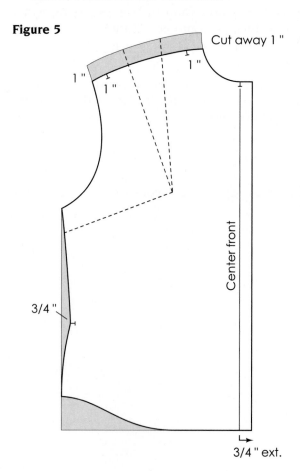

Basic Shirt Sleeve

The shirt sleeve can be drafted using the basic sleeve or the dartless sleeve; see Chapter 14. The sleeve cap is modified to fit an enlarged and lowered armhole. The shirt sleeve can be drafted with a lift, which increases the length of the underseam, or without a lift. Selections of hemlines and closures are presented on pages 478 through 481.

Figure 1

Basic shirt sleeve

- Trace the basic sleeve.
- Extend biceps 3/4 inch at each end.
- Mark 1/2 inch down from cap height, and with the french curve redraw cap crossing above the notches. To complete the cap, draw a curved line up from biceps to merge and blend with the cap line. (Suggestion: Use the shirt armhole to help shape the curve of the armhole.) Cap ease should measure 1/2 inch more than the armhole. Add to or subtract from the biceps line to adjust fit.

Figure 1

Figure 2

Square a line from center grain touching corner of the right side of the sleeve. Continue to back sleeve (eliminates the elbow dart).

A to B = One-half of biceps, less 1 inch. Mark and draw a line to new biceps.

A to C = Repeat A to B instructions.

C to D = 2 inches. Draw line parallel with B–C. Label E.

Hemline shape

E to F = Center to grainline. Mark.

F to G = 3/4 inch.

G to H = 2½ inches. Crossmark (slit for entry). Draw hemline curve from E to G to D, as illustrated.

Figure 2

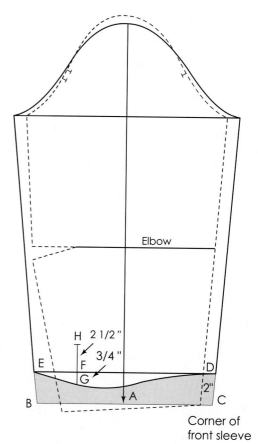

Corner of front sleeve

Sleeve Hemline Options

Subtract the around-hand measurement from the hemline of the sleeve. Choose the style preferred. Leftover excess is trimmed equally from the underseam.

Option 1: Two Pleats

Figure 1

- Mark two $1\frac{1}{4}$-inch darts 3/4 inch away from right side of slit. Dart space = 3/4 inch.

- Remove excess from side seams (broken line), allowing 1/4 inch for ease. Blend a curved line to elbow.

Figure 1

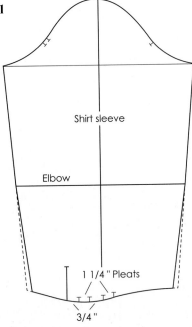

Option 2: One Pleat

Figure 2

- Shift slit 1/2 inch.

- Mark $1\frac{1}{4}$-inch pleat 3/4 inch from slit. Allow 1/4-inch ease on left side of slit.

- Remove excess from side seam, blending to elbow.

Figure 2

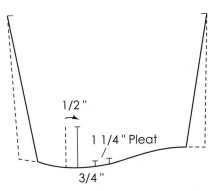

Option 3: Gathers

Figure 3

- For a gathered sleeve, notch hemline $1\frac{1}{2}$ inches in from underseams.

Figure 3

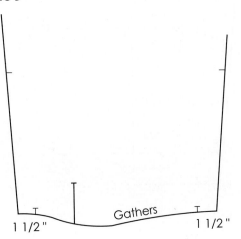

Option 4: Plain

Figure 4

- Allow 1/2 inch for ease. Remove excess from underseam at wrist, blending a slightly curved line to elbow.

Figure 4

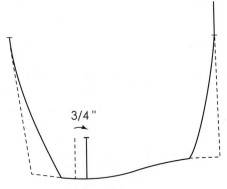

Closure Options

Banded Slit Opening

Figures 1a, b

Cut band $1^1/_2$ to 2 inches wide and two times the length of the slit.

- Use the illustration as a guide for stitching the band to the slit of the sleeve.

Figure 1a

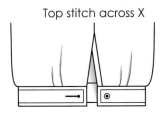

Top stitch across X

Figure 1b

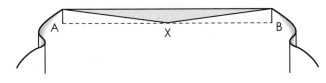

Stitch-Back Slit

Figure 2

- Fold the slit back (raw seam, overlock, or fold-over) and topstitch to hold in place.

Figure 2

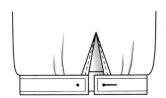

Elastic Control

Figure 3

- Add 2 inches to sleeve length (or amount equal to cuff width).
- Elastic should be 2 inches less than around-hand measurement. Width of elastic varies.

Figure 3

Underseam Opening

Figure 4

- With sleeve opening at the underseam of the sleeve, the seam is folded and topstitched.

Figure 4

Spaced Opening

Figure 5

- Space cuff so that the material between will fold when the cuff is buttoned.

Figure 5

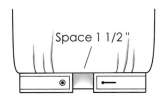

Space 1 1/2 "

Shirt sleeve Cuff

Figure 6a, b

- Square a line 2 inches up from the fold equal to around-hand measurement, plus 1 inch for extension (Figure 6a).
- Complete as illustrated in Figure 6b.

Figure 6a

1 "

2 "

8 "

Figure 6b

3/4 "

One-Piece Sleeve Placket

Figure 1 *Placket pattern*
- Draft the placket, using illustration as a guide.

Figure 1

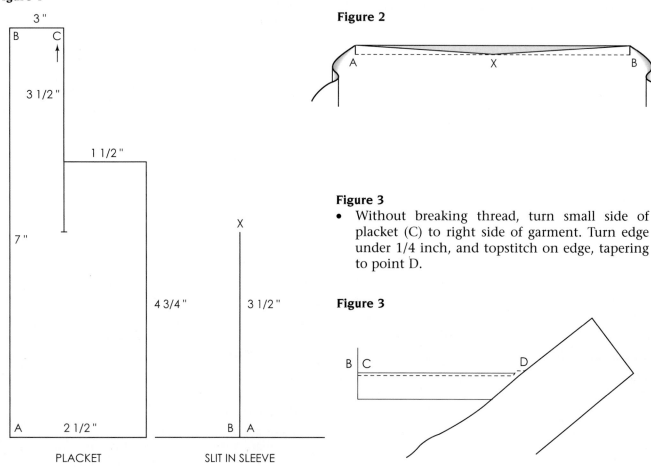

PLACKET

SLIT IN SLEEVE

Figure 2 *Right side—stitching guide*
- Place placket right side up. Place slit of sleeve on top of placket, right side up, matching points A.
- With edges even, stitch a 1/4-inch seam, allowing point X to drop to seam allowance.

Figure 2

Figure 3
- Without breaking thread, turn small side of placket (C) to right side of garment. Turn edge under 1/4 inch, and topstitch on edge, tapering to point D.

Figure 3

Figure 4

Figure 4
- Turn large side of placket under 1/4 inch. Sink needle at point X on upper placket (on top of point D). Stitch straight across, turning opposite edge under 1/4 inch. At edge, stitch down 1/4 inch, stitch across back and turn to stitch upward. Fold material under to make an even point. Edge stitch point and complete the placket.
- To make placket for left sleeve, use the same method, but start at point B on sleeve and placket, making the placket open in the opposite direction.

Shirt Facing and Band Variations

Five variations for facings are given with two versions (Types 1 and 2) illustrated in Figure 1. Choose the one appropriate for the design. Types 4 and 5 include instruction for band with facing. Facing widths can vary from those given.

Type 1: *Shaped Fold-Back Facing*
Figure 1

- Mark facing $2^{1}/_{2}$ inches wide at shoulder and 3 inches from extension line. Follow neckline curve and continue parallel with center front (broken line).
- Fold pattern on extension line. With tracing wheel, trace facing outline.
- Notch center front top and bottom.
- Unfold and pencil in neckline and shoulderline (bold line).

Type 2: *Straight Fold-Back Facing*

- Fold pattern on extension line. With tracing wheel, trace neckline. Notch center front, top, and bottom. Unfold and pencil in.
- Width of facing is parallel to extension line so that fold-back ends at corner of shoulder neck (uneven broken lines). (This type of facing is often placed on the selvage.)

Type 3: *Attached Facing*
Figure 2

- Trace shoulder, neckline, extension, and hem of shirt pattern. Use measurements given to complete facing.

Figure 1

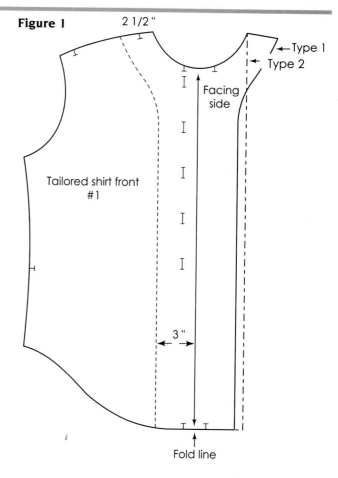

2 1/2"

Type 1
Type 2

Facing side

Tailored shirt front #1

3"

Fold line

Figure 2

2"

2 1/2"

Type 4: *Self-Faced Band*
Figure 3 *Trace band*
- Band is same width on each side of center front notch. (Example: extension is 3/4 inch wide, band is $1\frac{1}{2}$ inches.)
- Develop band by tracing $1\frac{1}{2}$ inches of neck and hem of shirt pattern. (Broken line is untraced pattern.)
- Mark notches at center front, top, and bottom.
- Remove pattern.
- Draw line to connect top and bottom to complete band.

Figure 4 *Completed band*
- Draw grainline and mark vertical buttonholes.
- Add 1/4-inch seams with 1/2 inch on side to be folded under.

Figure 5 *Stitching guide*
- To stitch band to shirt, place right side of band to the underside of the garment. Stitch band extension, ending at the center front notch at neck. Turn band to right side of shirt. Fold back 1/2 inch seam allowance and topstitch 1/4 inch in from fold line and at extension side of garment.
- Upper collar is stitched to neckline. Undercollar is folded over raw seam and stitched in the ditch (not illustrated).

Type 5: *Set-In Band with Attached Facing*
Figure 6 *Facing*
- Trace pattern section for facing using instructions given in Figure 2, or reduce facing width (broken lines) to equal width of set-in band (bold lines).

Figure 6

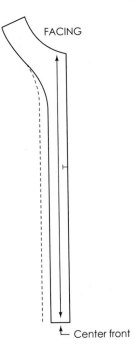

Figure 3 Figure 4 Figure 5

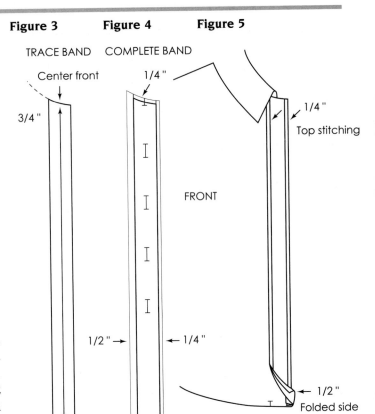

Figure 7 *Band and garment*
- Measure in from center front equal to width of extension.
- Draw line parallel with extension line.
- Separate pattern along this line.
- Trace patterns and add seams.

Figure 7

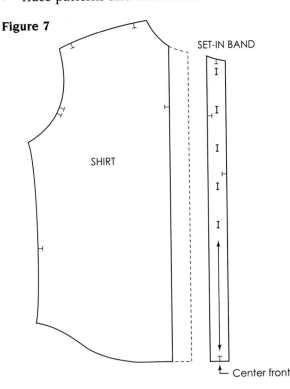

Hidden Button or Buttonhole Closure

Figure 1

Use marking paper to develop the following pattern.

- Trace front shirt.
- Add 3/4 inch for extension. Draw line A.

 A to B $= 1\frac{1}{2}$ inch. Mark.

 B to C $= 1\frac{1}{4}$ inch. Mark.

 C to D $= 1\frac{1}{4}$ inch. Mark.

- Draw lines parallel to extension line from each mark.
- Add 1/2-inch seam allowance to line D.
- Pleat-fold on each line, and trace the neckline.
- Cut the pattern from paper.

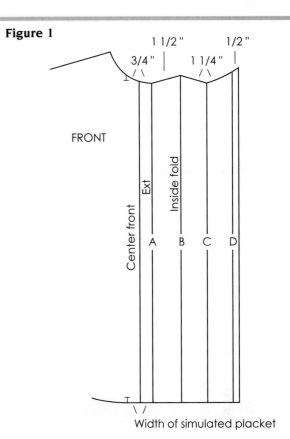

Figure 1

FRONT

1 1/2 " 1/2 "

3/4 " 1 1/4 "

Center front · Ext · Inside fold

A B C D

Width of simulated placket

Figure 2

How to stitch

- Fold on line C with the seam allowance, overlaying line B. At this time the buttonholes may be placed on the extension.

Figure 3

- Fold on line A, placing fold C with A on the back side of the garment. Stitch down on the B line to hem.

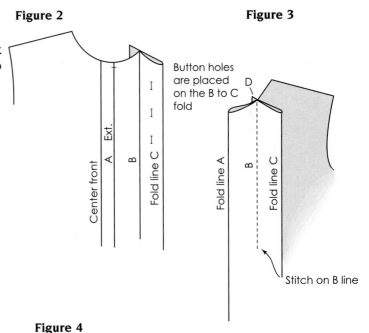

Figure 2

Center front · A · Ext. · B · Fold line C

Figure 3

Button holes are placed on the B to C fold

Fold line A · B · Fold line C

D

Stitch on B line

Figure 4

- After stitching, fold the C section over.

Figure 5

Front view

- The C fold is 1/4 inch in from the extension line.
- Collar with stand is best for this type of closure.

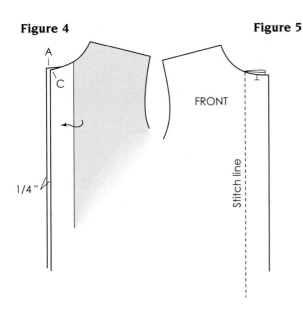

Figure 4

A

C

1/4 "

Figure 5

FRONT

Stitch line

Casual Shirt and Sleeve Foundation

The casual shirt foundation fits loosely. The armhole is made larger by the excess transferred to it from the shoulder and side darts. The armhole is lower and wider than the basic shirt. The casual shirt foundation can be developed from the front waist and side dart bodice and basic back, as illustrated, or the basic shirt foundation, page 474 (modify the measurements), or the torso foundation, Chapter 18. This casual shirt foundation is also the base for blouses, and with length added it is a base for casual dresses. The basic shirt sleeve from page 477 is modified for the casual shirt. Hemline and closures, see pages 311–313. The basic collar and the collar and stand is in Chapter 10.

Casual Shirt Draft

Figure 1
The shirt draft is based on the front waist or side dart bodice and basic back.
Back Shirt
- Trace the basic back bodice.
- Mark $1\frac{1}{2}$ inches down from armhole and out 1 inch front side waist (X).
- Square a line from center back that touches side waist.
- Draw the shoulder line straight across dart to shoulder tip. (The shoulder dart excess is now in the armhole.)

Figure 1

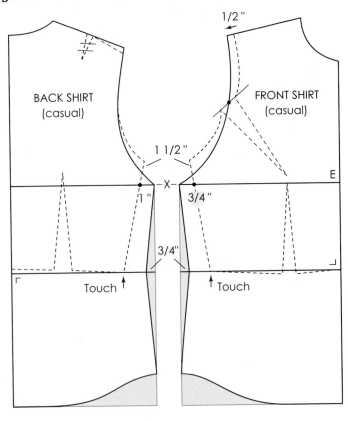

Front Shirt
- Trace front bodice, transferring the side dart to the armhole. Mark center of the space.
- Extend shoulder to equal back shoulder.
- Mark $1\frac{1}{2}$ inches down and out 3/4 inch at side (X).

Back and front
- Extend center lengths 7 to 9 inches.
- Square across from this line, and square up to touch line X.
- Mark 3/4 inch in at waist level.
- Draw side seam and the curve at hemline. Draw armhole as illustrated.

Figure 2a, b
Adjusting necklines and armholes

- Trim 1/16 to 1/8 inch from around the neckline.
- Measure front and back armholes. If they differ, equalize the difference at the shoulderline.
- Record the front armhole measurement _____.
- Mark armhole notches and transfer the notches to the casual sleeve. Shoulder pads, if desired, do not require a change in the shoulder line.

Figure 2a

1/16 "

BACK SHIRT
(casual)

3 1/2 "

Figure 2b

1/16 "

FRONT SHIRT
(casual)

Figure 3

Casual Sleeve Draft

The biceps is raised equal to the depth of the armhole. (Example: $1\frac{1}{2}$ inches.) This increases the length of the underseam (called the lift).

Figure 3

- Trace the shirt sleeve. Label A and B.
- Fold on the centerline.
- Mark $1\frac{1}{2}$ inches up from biceps line (D), and square a line across the paper. Draw a line from A, touching the new biceps line that equals the front armhole measurement. Label E.
- Draw a line to the hem of the sleeve.

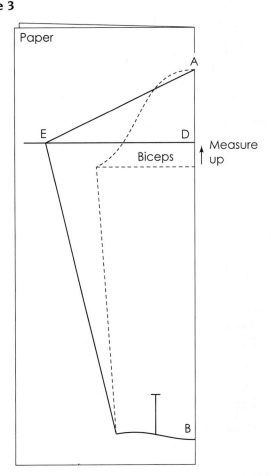

Figure 4

- Divide A–E line into fourths.
- Square up 1/4 inch and square down 1/8 inch.
- Draw a smooth cap. Mark sleeve notches.
- Sleeve cap should measure 1/2 inch more than the front and back armholes. If not, add or subtract at E.

Oversizing: *Extended Shoulderline and Lower Armhole*

Figure 5 U*se as an example.* **(Back is illustrated.)**
- Spread shoulders to desired amount (A to B.
- Lower armhole depth and draw new armhole.
- Measure the armholes and divide in half.

Figure 4

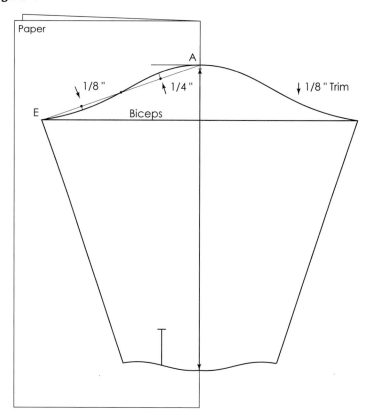

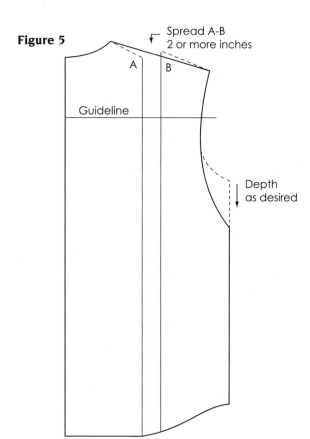

Figure 6

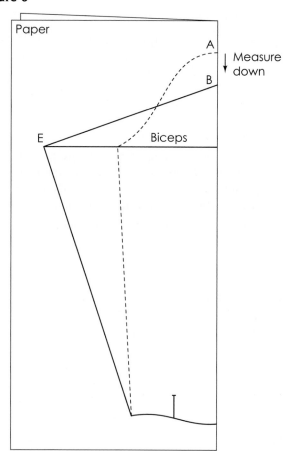

Figure 6 *Sleeve modification for extended shoulder*
- Trace shirt sleeve with grainline on fold of paper. (Sleeve length may be increased to overhang wrist.) The sleeve cap is shortened to equal A–B measurement of shoulderline extension.
- Draw line from B to E using front armhole measurement.
- Draw a line from E to sleeve hemline. To shape sleeve cap, see Figure 4 instructions.

Large Shirt Foundation

Design Analysis

The large oversized shirt, influenced by fashion and menswear, can be worn with or without shoulder pads depending on fashion trends. The sleeve is attached far beyond the natural shoulder and is not stitched into an armhole. The shirt hangs loosely around the body. Featured are large patch pockets, traditional banding, and yoke. To develop collar with band, see Chapter 10. As a shirtdress, extend pattern to length desired. The measurements given are for all sizes. The draft is based on the Torso Foundation pattern; see Chapter 18.

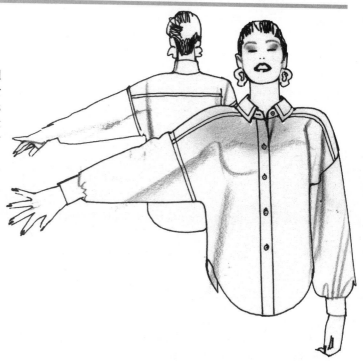

Pattern Plot and Manipulation

Figure 1 *Equalizing the neckline*

* The front and back will be developed together and then separated.

* Trace back torso indicated by bold line, omitting armhole and shoulder (even broken-lined area).

* Draw a vertical guideline at corner of shoulder-neck, parallel with center back.

* Place front torso on top of back draft, matching hip level and corner of shoulder-neck, touching guideline. (Center front must be parallel with center back.)

* Trace center front and neckline to corner of shoulder, omitting part of front pattern indicated by uneven broken lines.

* Remove pattern.

* Mark center between front and back neck on guideline. Label A and draw a blending line to front and back neck to form new neckline (bold line).

Note: For a wide and looser neck, trim 1/8 inch around front and back neckline.

Figure 1

Figure 2

Figure 2
(Broken line indicates original traced pattern section.)

- Extend a line up from center back and square a line across paper touching shoulder-neck. (Shaded area to be discarded.)
- A–B = 10 to 12 inches (depends on desired placement of the sleeve). Mark. (Point B can be lowered to create a sloping shoulderline with less fullness under the arm. If this is desired, continue with draft instruction from new position of B.
- B–C = 16 inches. Mark. (A–C should equal length from shoulder at neck to wrist. Adjust length if necessary.)
- C–D = 6 inches, squared from C.
- Draw a guideline down from B (past waist level of draft parallel with center line).
- Crossmark E, 12 inches down from B on line. Connect E with D.
- Mark notches on B–E line to indicate front sleeve.
- Mark F, between side waist and the B line.
- From E, draw curved line to point F. Continue line 3 or more inches below waist, ending 1 inch out from hip. Draw curved hemline.
- Draw square pocket and flap on pattern, using measurements given.
- Cut pattern from paper, using center back and back neckline.
- Cut and separate sleeve section along B–E line.
- Trace for back pattern. Trim to front neckline and center front of original pattern for front pattern.

Figure 3 Back
- Square a line across pattern 4 inches down from center back neck for yokeline.
- To create yoke effect on front shirt, place front shoulder A–B to back shoulderline. Trace 1 inch of shoulder and neckline. Remove pattern and connect lines.
- Mark second notch 1/2 inch below first notch to indicate back.

Figure 3

Figure 4 *Yoke section*
- Cut yoke section from back pattern. (Lower back not illustrated.)
- Notch at each end of original shoulderline and center of yokeline.
- Draw grainline.

Figure 4

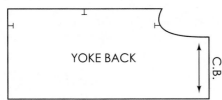

Figure 5 *Front*
- Trace front (or use pattern and mend for extension).
- Draw a parallel line 3/4 inch out from center front for extension. Square a line in at neck and continue to hemline.
- Draw a parallel line 1 inch down from shoulder. Cut this section from pattern. Discard broken-line section.
- Mark notch at center of shoulderline.
- Punch and circle for pocket and flap placement, 1/2 inch in from each corner.
- For self-faced band, see Figure 4 (page 482).

Figure 6 *Pocket*
- Slip paper underneath pattern and trace a separate pattern for pocket and flap.
- Add 1-inch fold-back to pocket. (Flap is self-faced.)

Figure 7 *Sleeve*
- Place B–C line of the front and back sleeves together (broken line). Tape. Retrace and discard.

Pleats at hemline
- Mark pleat intake as indicated.
- Notch is placed $2^1/_2$ inches up from wrist at underarm seam for entry opening.
- Mark center and back notches to match back shirt.

Figure 8 *Cuff*
- Cut cuff 4 inches × 10 inches, on fold.
- Mark for buttons and buttonholes. (See Chapter 16.)

Figure 8

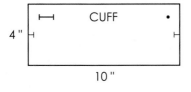

Figure 5

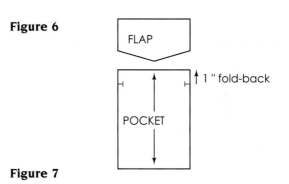

Figure 6

Figure 7

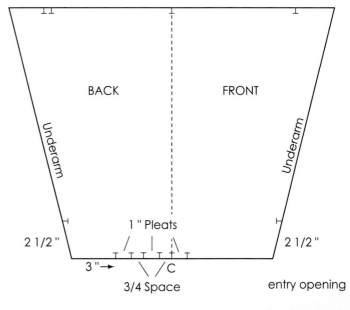

Peasant Blouse

The peasant blouse is a traditional fashion item in Western countries, but its ethnic roots can be traced to almost every country of the world. The design can be developed from the kimono, page 368, with the raglan style drawn. The front pattern can be developed and used for the back pattern. The full peasant blouse patterns are illustrated.

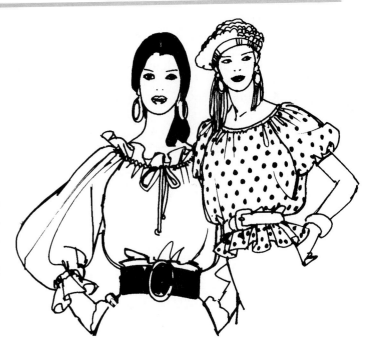

Design Analysis

The gathered scooped neckline can be banded or can have a casing with a pull-through tie or controlled by elastic. The blouse can be pulled down over the shoulders.

 The peasant blouse is based on the basic shirt or blouse foundation, Chapter 15.

Pattern Plot and Manipulation

Figures 1 and 2

- Trace the front and back shirt/blouse foundations. See page 474.
- Draw raglan style lines to the notches of the armhole.
- Draw the scooped neckline.
- Mark preferred blouse length.
- Draw slash lines from dart point to the neck and to the side waist (front).
- Draw a slash line from side waist to neckline (back).

Figure 1

Figure 2

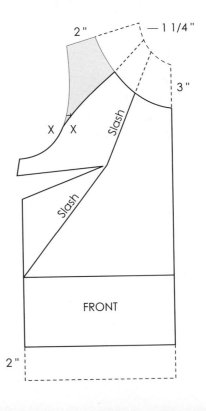

Figures 3 and 4

- Cut necklines and separate the raglan lines.
- Cut length as preferred.

Follow measurements given, or spread more:

- Slash to dart point from neck and side waist. Close the dart and spread from waist (front). Slash to side waist and spread 1 inch less than the front neck (back).

Figure 4

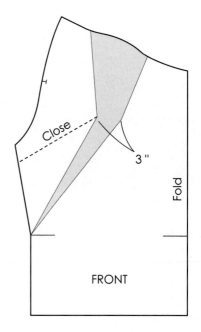

FRONT

Figure 3

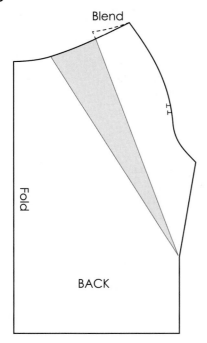

BACK

Figure 5

Figure 5

Sleeve

- Trace to about 3 inches below biceps.
- Cut and separate on the grainline.
- Place the shoulder lines of the raglan together and trace.
- Match notches X of the front sleeve to the armhole, and mark sleeve cap 1/4 inch from shoulder. Trace.
- Repeat for the back sleeve.

Figure 6

PEASANT SLEEVE

Figure 6

- Draw and cut each slash line and spread neck to equal half of B to C.
- Draw hemline.
- Cut from paper.

22

Jackets and Coats

Jacket and Coat Foundations

Jackets and coats are outer garments constructed to be worn over other garments. Patterns developed for these garments are larger than the figure's dimensions. They may be designed in a variety of ways featuring collars, lapels, and revers, or be collarless (cardigan style). Collars may follow the basic neckline, a V-shaped or scooped neckline, or a neckline of any other shape. Use previous instructions for bodice/sleeve combinations (kimono, raglan, and drop shoulder). To develop oversized and lowered armhole see Chapter 15.

The chapter features jacket and coat foundation patterns that are based on the torso foundation, with various jacket lapels. Included are instructions to develop linings, facings, shoulder pads, and interconstructions for either the jacket or coat.

Terms and Definitions

Following are terms and definitions used in this chapter (see illustrations):

Lapel. The part of a coat or jacket that folds back on the chest, forming a continuation of the collar (shawl) or the collar plus revere.

Revers (revere). The collarless part of the lapel which turns back to show the reverse side (or facing). When combined with a collar it becomes a lapel.

Breakpoint. The point at the front extension where the lapel ends and folds back (where roll line begins).

Roll line. The fold line where the lapel turns outward. (On a collar, it is the edge of the stand where the collar turns downward.)

Collar stand. The height at the center back of the collar where collar rolls over.

Center front depth. The point where the lapels overlap at the center front. (This point may be placed at any depth desired.)

Notched collar. A lapel design featuring a collar attached to revere, forming a wedge between the collar and the revere. The notch is also called a *gorge*.

Shawl collar. A one-piece lapel (collar and revere in one).

The Jacket or Coat Draft

The jacket foundation (opposite page) is developed from the torso foundation and may be used as a base for developing the coat foundation, using the same instructions. The coat foundation may also be developed directly from the torso using the instructions and doubling the measurements given. Other design variations and silhouette changes are developed from a traced copy of either of these two foundations after having been test fit and corrected.

Special notation: Ease has been added to the front armhole, neckline, and side seams to compensate for interconstruction and thickness of the fabric layers. Very bulky and/or heavy weaves may require an additional 1/4 inch to be added to each measurement given.

Figure 1 *Back draft*

- Trace back torso pattern.
- Measure in 1/8 inch around neck.
- Measure up 1/8 inch from shoulder at neck and 1/4 inch up from shoulder tip. Draw a connecting line across shoulder.
- True shoulder dart legs, adding to the shorter leg and blend with shoulder.
- Measure out 1/4 inch from shoulder tip and at mid-armhole. Measure down 1/2 inch at armhole and out 1/2 inch at side seam.
- Draw line parallel with side seam and blend armhole.

Figure 2 *Front draft*

- Trace front torso, transferring 3/8 inch from the side dart to armhole and 1/4 inch to mid-neck (indicated by broken lines).
- Shift bust point 1/4 inch toward side seam.
- Measure in 1/8 inch around neckline.
- Measure up 1/8 inch from shoulder at neck, and 1/4 inch up from shoulder tip. Draw a connecting line across shoulder.
- Measure out 1/4 inch from shoulder tip and down 1/2 inch from armhole and out 1/2 inch at side seam. Blend armhole and draw line parallel with side seam, as shown.
- Cut patterns from paper. Discard areas around neckline and armholes. True patterns and test fit.

Figure 1

Figure 2

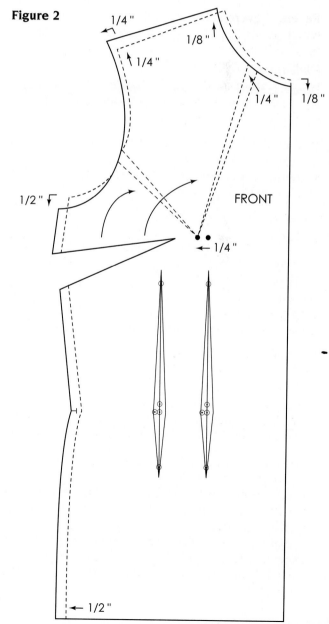

Sleeve Draft for Jacket and Coat

The basic sleeve is used to develop the jacket and coat sleeves. (For coat sleeve, double the measurements given.) The sleeve may be developed by any one of three methods. Each is illustrated. The third method of enlarging the basic sleeve involves the grading method.

Sleeve cap ease:

Cap ease can vary from 1 inch to $1^1/_4$ inches (size 6 and below), $1^1/_2$ to $1^3/_4$ inches (size 10 to 12), $1^3/_4$ to 2 inches (size 14 and above). The type of fabric helps to determine the amount of cap ease required for a good fit. See page 54 to modify cap ease, if necessary.

 Two jacket foundations are illustrated:
a) Basic jacket with a modified armhole.
b) Mannish jacket with an enlarged armhole.

 Develop sleeves for each jacket.
 Note: Double measurements for coat sleeve.

Folded-paper Method

Figure 1 *Sleeve preparation*:
- Divide sleeve in half on each side of grainline at biceps level. Mark.
- Square guidelines up and down from each mark. Label X and Y.
- Draw a guideline across cap touching guideline X. Label Z at grainline.
- Fold center 1/8 inch (folds to 1/16 inch); 1/4 inch (folds to 1/8 inch)—mannish jacket.
- Place sleeve on paper and extend guidelines X, Y, and Z. Remove sleeve. Connect lines across paper.

Figure 2
- Fold paper 1/8 inch (folds to 1/16 inch) along X, Y; 1/4 inch (folds to 1/8 inch)—mannish jacket.
- Fold paper 1/4 inch (folds to 1/8 inch) on Z guideline.
- Note: X, Y and The *center line* of the sleeve is where *added* fullness is placed. The amount of fullness can vary from 1/8 to 1/4 inch for each section of the basic jacket sleeve, or 1/4 to 1/2 inch for the mannish jacket sleeve.

Figure 1

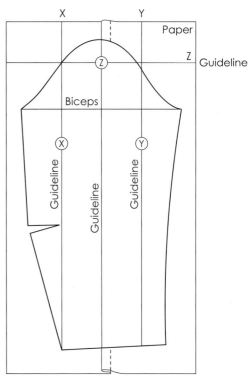

Figure 2

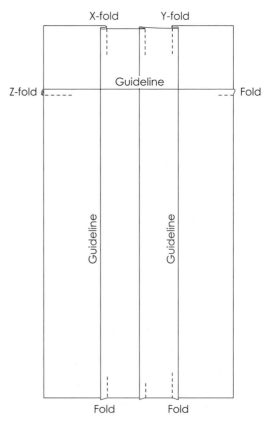

Figure 3

- Replace sleeve on paper, matching X, Y, and Z guidelines with folds on paper. Trace sleeve. Remove.
- Unfold paper and blend across open spaces. Add 1/2 inch at biceps to zero at wrist.
- Lower biceps 1/2 inch and blend to capline. Mark notches by walking armhole of jacket up from biceps of front and back sleeve.
- Cut pattern from paper.
- Stitch sleeve to garment. See page 56 to modify cap ease, if necessary.
- Adjust center cap notch to equalize cap ease. Add to wrist level for wider hemline, if desired.

Figure 3

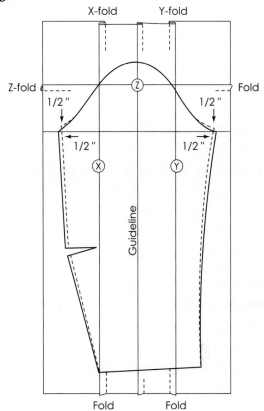

Cut-and-Separate Method

Figure 4 *Sleeve preparation*

- Divide sleeve in half on each side of grainline at biceps level. Mark and label X and Y.
- Square guidelines up and down from each mark.
- Draw a guideline across cap touching X guideline. (See Figure 1, label Z.)

Paper preparation

- Draw a vertical line through the center of the paper (represents sleeve grainline).
- Square a line out from each side of line, 8 inches down from top of paper (represents biceps line).
- Cut and separate sleeve at center line and along X, Y, and Z guidelines.
- Place pattern sections on paper, matching biceps line with guideline. Spread each section as shown. Secure pattern parts and trace.
- Lower biceps 1/2 inch, and add 1/2 inch at biceps to zero at wrist. Blend to capline.
- Double measurements for coat sleeve. Remove pattern, blend across open spaces. Mark notches by walking armhole up from biceps.
- Cut pattern from paper.
- See page 54 to modify cap ease, if necessary.
- Adjust cap notch to equalize cap ease.

Figure 4

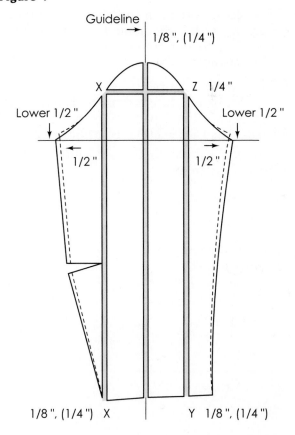

Grading the Jacket Sleeve

Grading Terminology

The terms are in relation to the position of the grader to the guidelines placed on the paper.

Out. Away from the grader (\uparrow)

In. Toward the grader (\downarrow)

Up. To the right of the grader (\rightarrow)

Down. To the left of the grader (\leftarrow)

The top pattern is to the right of the grader.

Measurements apply to the jacket sleeve and mannish sleeve. (Special measurements are given in parentheses for the mannish sleeve). The following method can be simplified with the use of the Hinged Ruler.

Cap ease should total $1^1/_2$ to 2 inches.

See page 54 for cap ease adjustment. The measurements are doubled for a coat sleeve.

Figure 1

- Draw a 25-inch guideline.
- Square a line 7 inches down from top.
- Place the biceps and grainline of the sleeve on the guidelines.
- Draw the hemline, extending 1/4 inch out from each corner.

Figure 1

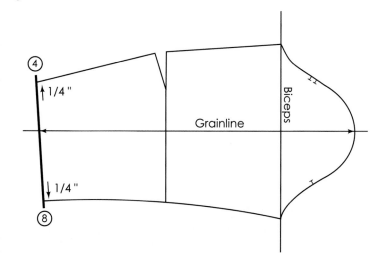

Figure 2

Move the sleeve pattern in the direction indicated by the arrows. Follow the numerical order and the amounts given. Sections of the cap are drawn with each set of moves.

Back sleeve grade

- The grainline and biceps must be parallel with the guidelines as the pattern moves from grade to grade. The back grade ends at number 3.
- Return the pattern to the guideline, aligning biceps and grainline.

Figure 2

Figure 3

Front sleeve grade

• The grainline and biceps must be parallel with the guidelines as the pattern moves from grade to grade.

• Start grade with number 5 and end with number 7.

Figure 3

Figure 4

Back underseam

• Place the back underseam at points 4 and 3 and draw the underseam.

Front underseam

• Place the back underseam at points 8 and 7 and draw the underseam.

Cap line

• Use the grading sleeve to help shape and blend the cap line.

• This completes the sleeve grade.

• Measure the cap and subtract from the front and back armholes. To increase or decrease cap ease, see page 54.

Figure 4

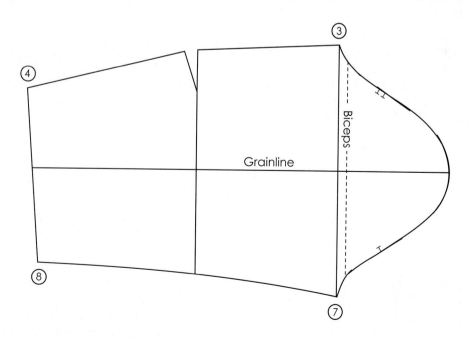

Tailored Two-Piece Sleeve

The two-piece tailored sleeve is based on the basic jacket sleeve and is drafted with an upper- and undersleeve together. The sections of the sleeve are separated when the sleeve draft is completed.

Figures 1 and 2

- Trace jacket or coat sleeve, and cut from paper.
- Fold the back sleeve on biceps, with corner touching center grainline.
- Trace the armhole curve and label X.
- Unfold, and repeat the process for front sleeve.

Figure 1 **Figure 2**

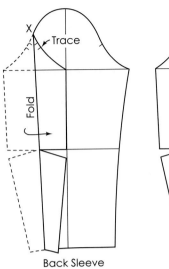

Back Sleeve Front Sleeve

Figure 3 *The uppersleeve draft* (Use blue pencil.)

- Divide the elbow and wrist in half out from center grain. Mark X.
- Draw a line through pattern connecting X points.
- Square a line $1\frac{1}{4}$ inches out from X guideline to sleeve cap. Label Y. Continue line to Z. Repeat on front sleeve.
- Mark 1 inch from X at elbow (back sleeve), 3/4 inch from X at elbow (front sleeve).
- Mark 3/4 inches out from X at wrist. Draw a connecting lines through marks ending at Y.
- Mark $1\frac{1}{2}$ inches up and down from dart legs (ease control notches back sleeve).
- Redraw slightly curved lines, rounding the back sleeve, and an inward curved line for front sleeve. This completes the uppersleeve (shaded area). Trim the outer sleeve.

Figure 3

UPPER SLEEVE DRAFT

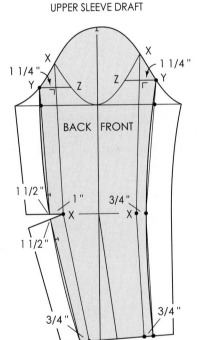

Figure 4

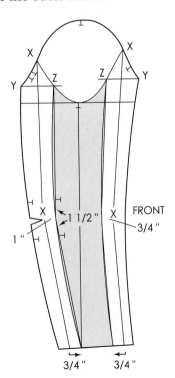

3/4" 3/4"

Figure 4 *The undersleeve draft* (Use red pencil.)

- Mark 1 inch from X guideline at elbow of back sleeve, and 3/4 inch at elbow of front sleeve.
- Mark in 3/4 inch at wrist. Draw connecting lines through marks ending at Z.
- Measure $1\frac{1}{2}$ inches up and down from elbow mark notches to control elbow ease of back sleeve.
- Redraw slightly curved lines, rounding the undersleeve of back, and an inward curved line of front sleeve.
- Place paper under sleeve and trace undersleeve (shaded area).

Figure 5

- The completed sleeve is shown. *Note:* To true sleeve, start from top of sleeve to first ease control notch point, slip pattern to hem, and true from bottom up to ease control notch point. Adjust undersleeve notches, if necessary. Blend hemline.

- Adjust sleeve notches if necessary by walking sleeve around armhole of jacket or coat, starting from notch of undersleeve.

Figure 5

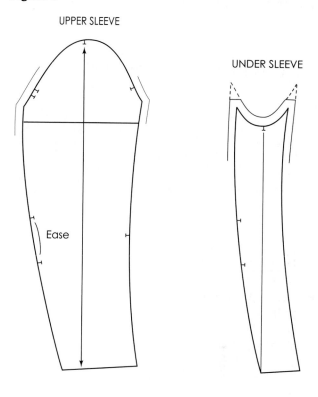

Figure 6

- If it is necessary to increase elbow ease or to give more angle to the sleeve, trace the upper- and undersleeve. Slash along elbow level to, not through, other side, and spread. (Example: 1/4 to 3/8 inch.)

- Retrace patterns.

Figure 6

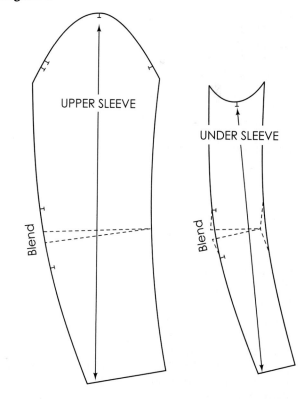

Lapel Designs

Lapel designs are developed by modifying the jacket or coat foundations by lowering or raising the notch, changing the depth at center front, or modifying the width and stand of the collar. Any number of variations can be developed using the same general instructions.

Basic Notched Lapel

Design Analysis

The basic notched lapel is developed with the notch (wedge or *gorge*) level with the base of the neck.

Note: The shape of the lapel and the measurements can be varied to change the look of the design. If a wider collar is desired, follow basic collar instructions. The basic collar is required for slash and spread formulas to develop design collars. (See page 505, Figures 9, 10, and 11.)

(Use the same instruction for coat foundation.)

Measurement Needed

* CB neck to shoulder of back pattern, plus 1/8 inch (compensate for thickness of collar interconstruction). Record _____.

Pattern Plot and Manipulation

Figure 1

- Trace front and back jacket patterns (back not illustrated).
- Label shoulder-neck A.
- Label center front depth B. (Example: 1 inch above bust level—point where lapels overlap.)
- *Extension:* Draw a parallel line 1 inch from center front, ending at level with B. (Width of extension should equal diameter of button.)
- A–C = 1 inch (collar stand). Draw line from C through B, ending at extension (roll line). Label D (breakpoint of lapel).

Figure 1

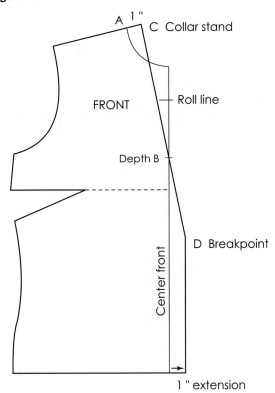

Figure 2

- Fold paper along roll line and trace neckline and A–C line. Unfold paper.

Figure 2

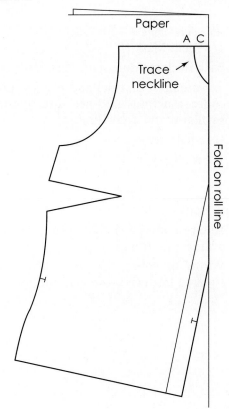

Figure 3

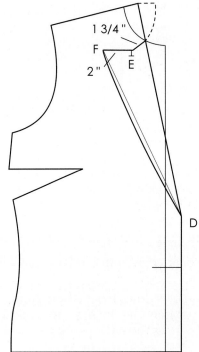

Figure 3 *Lapel development*

- Following the curve of the traced neckline (broken line), extend curve $1^3/_4$ inches into the front of the jacket. Label E and mark for notch.

 E–F = 2 inches.

 (*Guide:* Place square rule at center front to draw line.)

- Draw straight line from F to D. Redraw line, curving slightly outward.

Figure 4

- Refold paper along roll line, tracing complete outline of lapel (shaded area).

- Crossmark points E and D (notch placements). Unfold and pencil in lapel.

Figure 5a *Collar development*

A–G = 1/4 inch. Mark.

G–I = Back neck measurement plus 1/8 inch.

- Locate measurement on ruler and place at point G with ruler touching mid-neckline (controls angle for collar draft). Draw line.

G–J = One-half of G–I. Mark.

I–K = 1/2 inch.

Figure 5b

- Draw line from J to K.

K–L = Square a line $2^3/_4$ inches from K–J. Square a short line from L.

G–H = Width of collar. (Example: $2^3/_4$ inches squared from G–J—broken line.

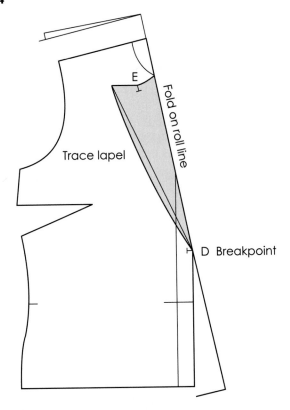

Figure 4

Trace lapel

Fold on roll line

D Breakpoint

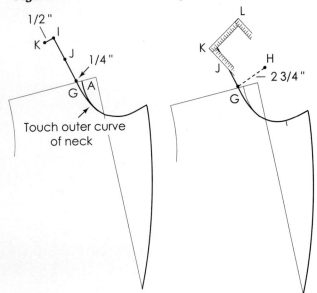

Figure 5a

1/2"

K I

J 1/4"

G A

Touch outer curve of neck

Figure 5b

L

K

J H

2 3/4"

G

Figure 5c

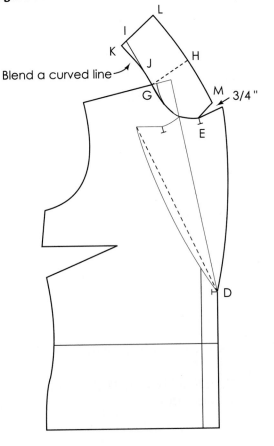

L

I

K J H

Blend a curved line

G M 3/4"

E

D

Figure 5c

- Blend a curved line from K, J to G.

- Draw collar edge from L to H parallel with back neckline.

E–M = Draw line $1^3/_4$ inches ending approximately 3/4 inch from lapel. This completes the basic jacket collar.

Figure 6

- Place paper underneath draft and trace collar. Broken line is part of jacket draft and is not traced. Crossmark G (notch for shoulder-neck placement).

Figure 7 *Completed collar*

- Remove paper and pencil in collar. Roll line starts 1 inch up from center back of collar and blends to roll line of lapel. (Broken lines indicate roll line of collar when attached to jacket.)

Figure 6 **Figure 7**

Figure 8

- Cut jacket section from paper following original neckline curve (E to A, not E to G). (Broken line indicates where collar was drafted.)

Figure 8

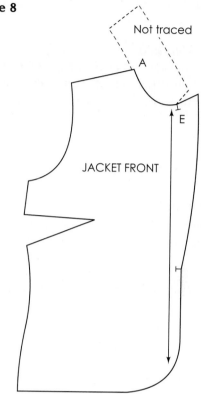

Collar Modifications

Follow instructions if a lower stand and wider collar are desired. Broken lines show possible design variations.

Note: Spread may be increased by very bulky fabrics. Test fit collar before stitching complete garment. To develop undercollar, see page 528.

Figure 9

- To modify collar, divide the back collar into four equal parts.
- Cut slash lines from collar edge to, not through, neckline edge, and spread.

Figure 10 *1/2-inch stand*

- Spread each section 3/8 inch. Collar width—3 1/2 inches. (Collar design should blend with back collar level with shoulder-neck notch.)

Figure 11 *Flat roll*

- Spread each section 1/2 inch. Collar may be of any width (narrow or wide) and design.

For lining and interconstruction, see pages 522–528.

Figure 9

BASIC COLLAR

Figure 10

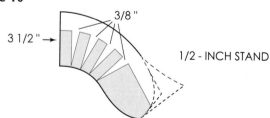

1/2 - INCH STAND

Figure 11

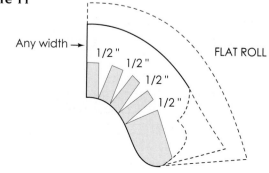

FLAT ROLL

Low-Notch Lapel

Design Analysis

The neckline is adjusted for a lowered collar. When planning a neckline, consider depth placement. Necklines placed too close to the depth mark cause the lapel to be short and unflattering.

Measurement Needed

- CB neck to shoulder of back pattern, plus 1/8 inch (compensate for thickness of collar interconstruction). Record _____.

Pattern Plot and Manipulation

Figure 1

- Trace front and back jacket patterns. (Back not illustrated.)
- Label shoulder-neck A and center front depth B. (Example: At bust level—point where lapels overlap.)
- *Extension:* Draw a parallel line 1 inch from center front, ending at level with B. (Extension should equal diameter of button.)
- A–C = 1 inch (collar stand). Draw line from C through B, ending at extension (roll line). Label D (breakpoint of lapel).

Figure 2 *New neckline shape*

- Fold paper along roll line. Draw curved line for new neck from point A to fold line. Bold line (between neck and bust level) is chosen for draft. (Broken lines indicate other variations.)
- Trace new neckline and A–C line. Unfold paper.

Figure 1

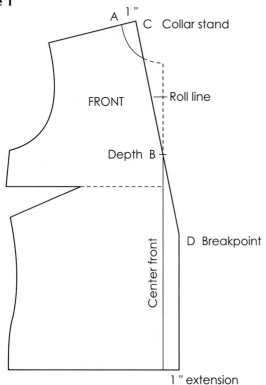

Figure 2

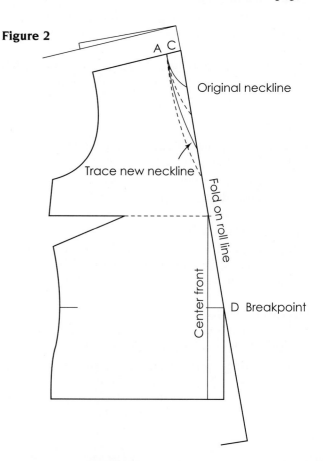

Figure 3 *Lapel development*

- Following curve of traced neckline (broken line), extend curve 1 inch (or more) into frame of jacket. Label E and mark for notch.
- E–F = $2\frac{1}{2}$ inches (more or less). Connect F with D.
- Redraw line, curving slightly outward as shown.

Figure 4

- Refold paper along roll line, tracing complete outline of lapel.
- Crossmark E and D (notch placement). Unfold and pencil in lapel.

Figure 3

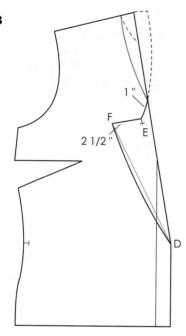

Figure 4

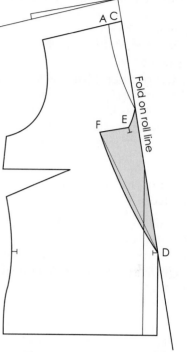

Figure 5 *Collar development*

A–G = 1/4 inch.

G–H = Width of collar (Example: $2\frac{3}{4}$ inches).

G–I = Back neck measurement plus 1/8 inch. Locate measurement on ruler and place at point G with ruler touching mid-neckline. Draw line.

G–J = One-half of G–I. Mark.

I–K = 1/2 inch. Draw line from J to K.

K–L = $2\frac{3}{4}$ inches, squared from K–J line. Square a short line from L. Blend back neckline. Draw collar edge from L to H, parallel with back neckline.

E–M = 2 inches, ending approximately 3/4 inch from lapel. Complete the collar shape.

Figures 6 and 7

- Transfer collar from draft. To modify collar, refer to instructions given for the basic notch (Figures 9 through 11, page 505). For lining and interconstruction see pages 522–528.

Figure 5

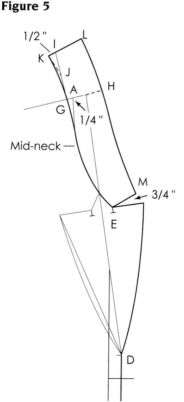

Figure 6 **Figure 7**

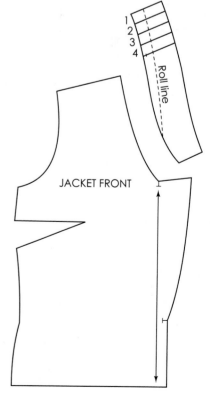

Portrait Lapel

Design Analysis

A portrait lapel frames the face around an open neckline much like a picture in a frame. The draft is based on the basic notch with the difference being in the placement of collar at shoulder and the development of a new neckline.

Pattern Plot and Manipulation

Figures 1 and 2

- Trace the front and back jacket patterns.
- Label A, 2 inches from front and back shoulder/neck.
- Draw back neck, ending 3/4 inch down from center back. Measure neckline plus 1/8 inch and record for collar development.
- Label center front depth B. (Example: Bust level—point where lapels overlap.)
- *Extension:*
 Draw a parallel line 1 inch from center front, ending at level with B. (Extension should equal diameter of button.)
- A–C = 1 inch (collar stand). Draw line from C through B, ending at extension (roll line). Label D (breakpoint of lapel).

Neckline
- C–X = 3 inches (varies).
- Connect A to X. Draw a curved neckline approximately 1/8 inch out from midpoint, as shown.

Figure 3
- Fold paper along roll line and trace new neckline and A–C line.

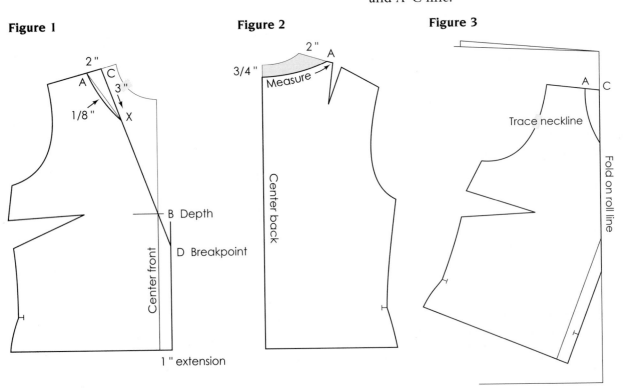

Figure 1

2 "
C
A
3 "
1/8 "
X
B Depth
D Breakpoint
Center front
1 " extension

Figure 2

2 " A
3/4 "
Measure
Center back

Figure 3

A C
Trace neckline
Fold on roll line

Figure 4
- Unfold paper.
- Following the curve of the traced neckline (broken line), extend curve 3 inches into frame of jacket. Label E and mark for notch.
- E–F = 2 inches (more or less). Connect F with D. Redraw line, curving slightly outward as shown.

Figure 4

Figure 5
- Refold paper along roll line, tracing complete outline of lapel.
- Crossmark E and D (notch placement). Unfold and pencil in lapel.

Figure 5

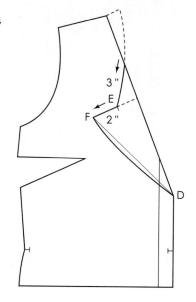

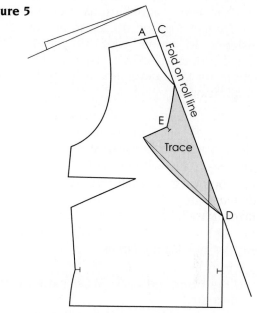

Figure 6 *Collar development*

A–G = 1/4 inch.

G–H = Width of collar (Example: $2^3/_4$ inches).

G–I = Find back neck measurement on ruler and place at point G with ruler touching mid-neckline. Draw line.

G–J = One-half of G–I. Mark.

I–K = 1/2 inch. Draw line from J to K.

K–L = $2^3/_4$ inches, squared from K–J line. Square a short line from L. Blend back neckline at J. Draw collar edge from L to H, parallel with back neckline.

E–M = 2 inches ending approximately 3/4 inch from lapel. Complete the collar shape.

For lining and interconstruction see pages 522–528.

Figures 7 and 8 *Finished pattern pieces*
- Transfer collar from draft. To modify collar, refer to basic notch instructions. See page 528 for undercollar instruction.

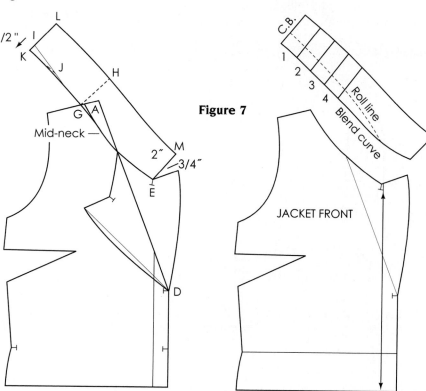

Figure 6

Figure 7

Figure 8

Double-Breasted Jacket with Lapel

Design Analysis

A double-breasted jacket has a wide extension to accommodate two rows of buttons. A double-breasted lapel overlaps high on the chest; because excess is transferred to center front, the lapel relaxes, allowing an open neckline. Follow the general instructions for lapel development with the following modifications:

- The front extension should equal at least three times the diameter of the button (or more, if desired), and the breakpoint should be established before the roll line is drawn.

 Note: The same instructions apply to double-breasted coats. (The sleeve and design details are not included.)

Pattern Plot and Manipulation

Figure 1

- Trace the front and back jacket patterns. (Back not illustrated.)
- From side dart, transfer 1/4 to 3/8 inch to center front.
- Follow instructions for basic notched lapel.
- Establish center front extension: Draw a parallel line equal to three times the diameter of the button (Example: $2\frac{1}{4}$ inches).
- Establish the desired breakpoint on the extension line. (Example: at waist level.) Connect with C (roll line). Label D (breakpoint).

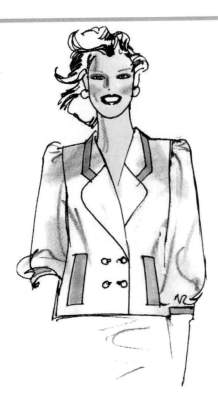

Figure 2

- Complete the draft.
 Note: Buttons are spaced at an equal distance from the center front. Refer to Buttons and Buttonholes, Chapter 16, for more information, if necessary. (For convenience, facing is indicated by broken lines following the shape of the jacket.)

Figure 2

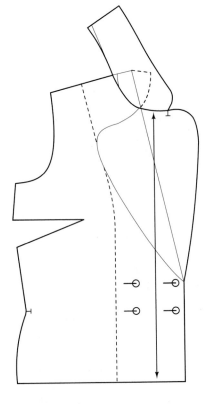

Figure 1

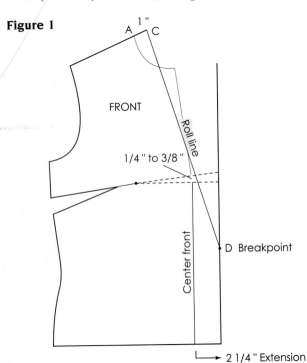

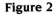

The Mannish Jacket Foundation

There are differences between the cut of a basic jacket and that of the mannish jacket: the excess from the side dart is transferred to the front armhole enlarging its measurement; the collar is designed to square into the neckline of the jacket; and special inter- and innerconstruction is developed for the "chest piece" to stabilize the fit of the jacket between shoulder and armhole area. Two style cuts are illustrated—the wrap-around styleline and the panel jacket, oversizing and armhole depth can be lowered for design variations. The two-piece sleeve completes the pattern. The following instruction also applies to coats.

The Mannish Jacket Draft

Figure 1

Front:

* Draw a guideline perpendicular to paper's edge. Place front jacket pattern on paper with hipline on guideline.

* Trace the pattern, transferring the dart's excess to mid-armhole. Mark a point in center of armhole opening. Redraw armhole touching mark and blending armhole to shoulder tip.

* Measure down 1/4 inch at shoulder tip. Redraw shoulder line.

* Draw a parallel line 3/4 inch from the center front for extension.

* Mark A 1/8 inch from shoulder/neck.

* Mark B 3/4 inch down from center waist (break point of the lapel).

* Draw a dart between the waist darts. Mark 3/8 inch out from each side. Draw new dart legs to length of the original dart.

* Mark a notch 1/4 inch from side seam at front armhole.

Back:

* Place back jacket pattern on paper with hipline on guideline with the armhole/side seam touching. If the armholes do not align, blend a curve between them. The side hips of the front and back patterns may touch, be spaced, or may overlap each other.

* Trace back pattern transferring 1/8 inch to neckline and blend.

* Mark a point 1/4 inch up at shoulder tip. Redraw shoulder line, and blend with armhole. The remaining excess of the shoulder dart is eased into the shoulderline.

* Draw a line 1/2 to 5/8 inch in from center back waist blending with an inward, and outward curved line to center back.

* This completes the jacket foundation for the wrap-around (page 512) and panel styles (page 515).

Note: Sleeve notches are placed when the 2-piece sleeve is walked around the armhole.

Figure 1

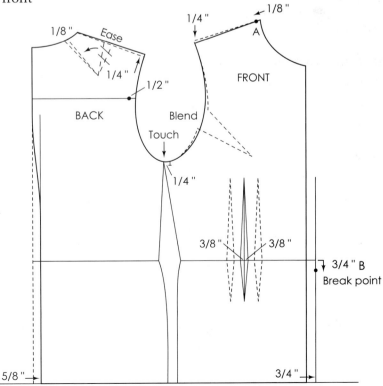

Jacket Stylelines

The Wrap-around Styleline

(See Figure 1, page 511 for jacket foundation pattern.)

Figure 2

- Square a panel guideline up from back hipline that ends 1/2 inch in from back armhole. Label X (waistline) and Y at hem.

Back Panel

- Measure out 3/4 inch from X, and draw an inward curved line touching guideline at level with armhole depth. Continue the curved line to the armhole. Label Z.
- Continue the styleline with an outward curved line from waist to hip ending at point Y.

Wrap Panel

- Measure out 3/8 inch from X and draw an inward curved line up from waist, blending with the styleline at guideline.

- Continue the styleline with an outward curved line down from waist to hem ending 5/8 inch out from Y. Label Y^1.
- The stylelines from waist to hip should measure the same. If the two seams are not of equal length, move Y^1 out from styleline to gain more length. The shaded area indicates the wrap-around part of the jacket. Jacket can be of any length.
- Continue with instructions for collar and lapel development.

Note: The panel styleline can be drafted on the wrap-around. For reference, see page 515. Walk the mannish two-piece sleeve around the armhole. Shift cap notch to equalize cap ease.

Figure 2

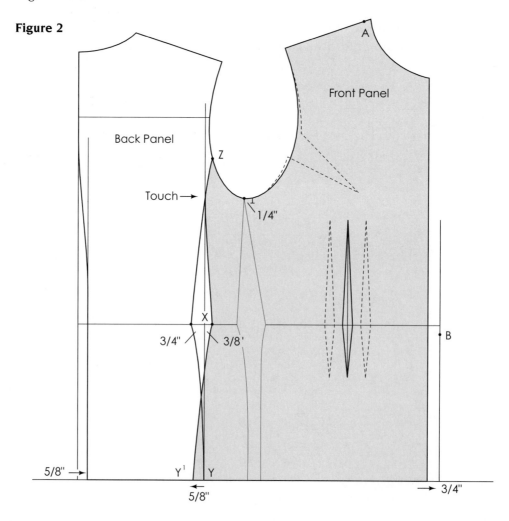

Collar and Lapel for Wrap-around and Panel Styles

Figure 3

A–C = 1 inch.

- Draw line from C to B (establishes roll line of the lapel).
- Measure 5/8 inch down from neck on roll line. Label D.
- Measure 5/8 inch down from center front neck. Label E.
- Draw a line from E passing 1/2 inch beyond D. Label G.
- Extend line out from E $2\frac{1}{8}$ inches. Label F.
- Draw a line from A to G.
- Draw a line from F–B. Redraw with a curved line.

Figure 3

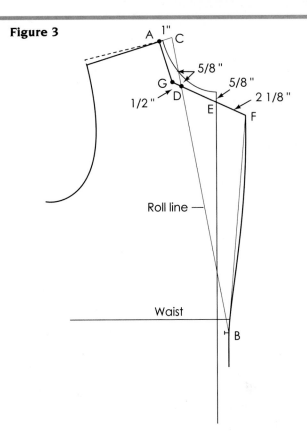

Completion of the Collar for Wrap-around and Panel Styles

Figure 4

A–H = Back neck pattern measurement plus 1/8 inch (line continues from angle of the A–G).

H–I = 3/4 inch. Draw a slightly curved line to A–I equal to A–H measurement.

- Square a $2\frac{3}{8}$ inch line up from A–I. Label J.
- Square a short line down from J.

E–K = 3/4 inch.

K–L = $1\frac{1}{4}$ inch, spaced 3/4 inch from F.

- The collar width and spacing can be varied. Draw collar and blend.

Collar

Figure 5

- Place paper under the draft and transfer the collar. Follow instructions for undercollar on page 528.

Figure 5

Figure 4

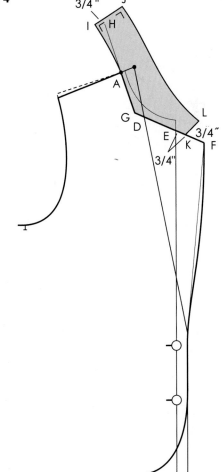

UPPER COLLAR

Option: *Transfer excess in armhole to the neckline as a dart.*

Figures 6a and 6b

Form a dart in the neckline of the jacket to reduce the enlarged armhole measurement. Draw a dart from armhole to bust point. Draw slash line from bust point to neckline. Slash to bust point. Close armhole dart. Establish dart point (Figure 6b). Shift notch 1/4 to 3/8 inch to equalize sleeve cap ease.

Figure 6a

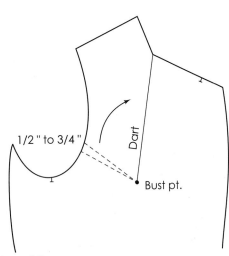

Figure 6b

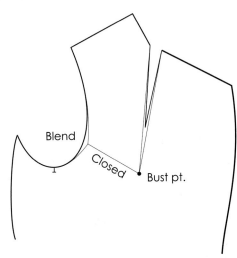

Figures 7 and 8

The patterns are illustrated with seam allowance and indicate where to trim points (up 1/2 inch from stitchline). See page 500 for guide in drafting the two-piece sleeve. For lining and interconstruction see pages 522-528.

Figure 7

Figure 8

The Panel Styleline

See page 511, Figure 1 for pattern foundation for the panel jacket and to prepare for panel styleline, see page 512.

Figure 2

Figure 2

- Square a line up from front hip level, ending 1/2 inch from curve of the armhole. Draw a curved line from guideline to armhole. Label Z.
- Label guideline at waist X. Using measurements given draw inward curved lines up from waist blending to armhole.
- Draw outward curved lines from waist to hip level, extending 1/2 inch on the front panel. The shaded area is the panel design.
- See page 513 for lapel and collar instructions.
- See pages 522–528 for lining and interconstructions.
- See page 500 for two-piece jacket sleeve instruction.

Figures 3, 4, and 5

- Walk the mannish two-piece sleeve around the armhole. If more ease is needed, add to each side of the upper- and underseams equally; blend to elbow of the underseam lines.

Figure 3

Facing 13/4"

BACKJACKET

Addhereif
ifmore
hiproom
isneeded

Figure 4

Trim

Trim

SIDEPANEL

Figure 5

FRONTJACKET

Design Variations

Other jacket or coat designs may feature collars or be collarless. The following designs are included for inspiration and as practice problems. Instructions provided in previous chapters for collars, built-up necklines, cutout necklines, sleeves, and so on, should be used as a guide for developing these patterns.

- Designs 1 and 2 feature cutout necklines with collars.
- Design 3 shows a built-up neckline and extended sleeves.
- Design 4 illustrates the classic collarless cardigan.
- Design 5 illustrates the asymmetric overlap.

DESIGN 1 **DESIGN 2**

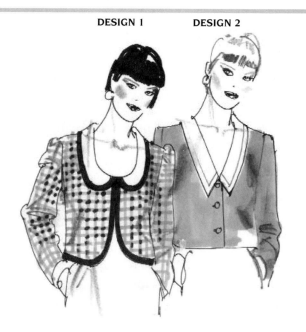

DESIGN 3 **DESIGN 4** **DESIGN 5**

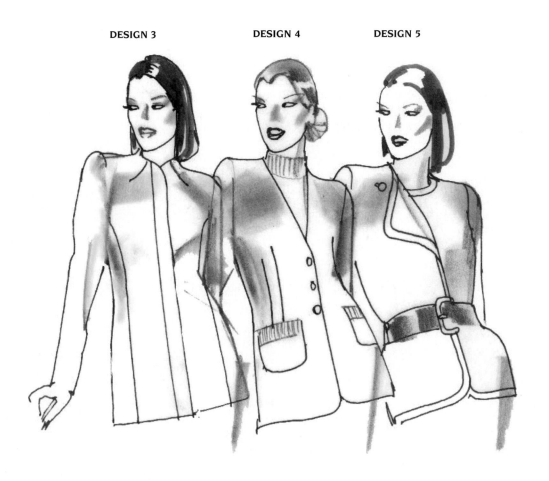

Shawl Foundation

The basic shawl collar or lapel is developed in one with the front jacket. The collar extends beyond the shoulderline and attaches to the back neckline of the jacket. A hidden dart stitched under the lapel removes excess when the front neckline is not part of the collar. Shawl designs are developed by varying the shape between points H and D on the draft. Variations are illustrated in the series that follows. Apply instructions to the coat foundation for shawl designs. *Note:* The instructions also apply to shawl collars featured on blouses and dresses.

Shawl Draft

Figures 1 and 2 *Neckline modification*

- Trace front jacket foundation including all markings.
- Trace basic back jacket transferring shoulder dart to neck.

Realign shoulders

- *Front:* Trim 1/4 inch from front shoulder-neck (label A).
- *Back:* Add 1/4 inch up from shoulder-neck and connect with shoulder tip (improves roll of the collar).

Figure 2

Figure 3

- Label shoulder-neck A and center front depth B. (Example: 1 inch above bust level—point where lapels overlap.)
- *Extension:*

 Draw a parallel line 1 inch from center front, ending at level with B. (Extension should equal diameter of button.)

 A–C = Back neck pattern measurement plus 1/8 inch. Locate measurement on ruler and place at point A with ruler touching point B. Draw line, ending at extension. Label D (breakpoint).

 A–E = One-half of A–C. Mark.

 C–F = 1/2 inch. Draw line from F to E.

 F–G = Square a line $2^3/_4$ inches (from F–E line). Square a short line from G. Extend line from shoulder $2^3/_4$ inches past A. Label H (broken lines). Draw a blending curve for back neckline. Draw collar edge from G to H parallel with back neckline.

Hidden dart

- Measure down 6 inches from A on guideline. Crossmark 3 inches down and measure out 1/8 inch on each side of crossmark. Draw curved lines. Punch and circle dart in center when intake is 1/4 inch wide. Dart may be shortened when needed. This completes the shawl foundation. Shawl lapels are developed from point H as illustrated in the following series. *Note:* Hidden dart is not stitched if developed for blouses or dresses.

Figure 3

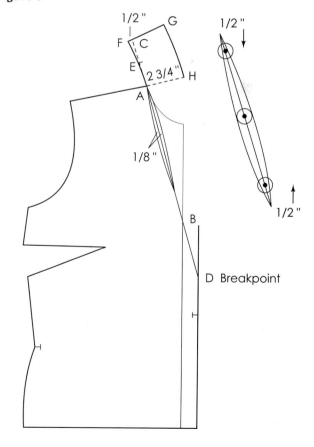

Shawl Collar Variations

DESIGN 1 DESIGN 2 DESIGN 3

Figure 1 **Figure 2**

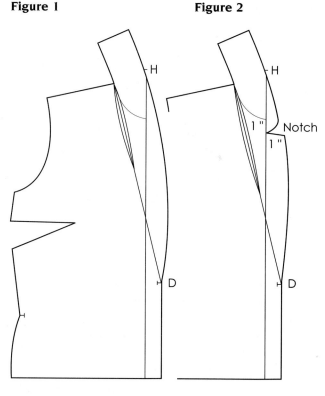

Figure 3 **Figure 4**

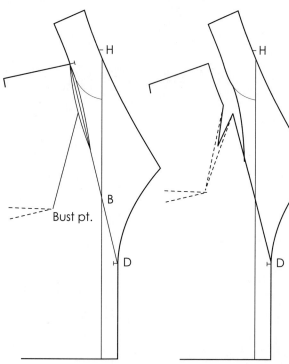

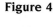

Design 1: *Basic Shawl Lapel*
Figure 1
• Draw curve outward from H to D.

Design 2: *Shawl with Notch*
Figure 2
• Draw curve from H to D and notch where desired.

Design 3: *Winged Shawl*
Figure 3
• Draw line outward from H, curving inward to D (width as desired).

Figure 4
Option: The side dart can be transferred to intersect with the hidden dart.

• Draw line from bust point to midpoint of the hidden dart, and from bust point to dart point of side dart.
• Cut along hidden dart legs and cut slash line to bust point mark.
• Slash from side dart point to bust point.
• Close side dart.
• Trade and draw dart legs.
• Notch shoulder at neckline edge of the collar.

Wide Shawl Collars

Design Analysis

The technique for developing wide shawl collars requires modifying the back collar of the shawl draft. The collar may be developed with a 1/2-inch stand with widths up to $3\frac{1}{2}$ inches along the back collar (below H, it may be of any width), or as a flat-roll collar of any width desired. A variety of lapel shapes can be designed from them, as suggested in the collar draft (indicated by bold and broken lines). For practice, develop lapels for Designs 1, 2, and 3.

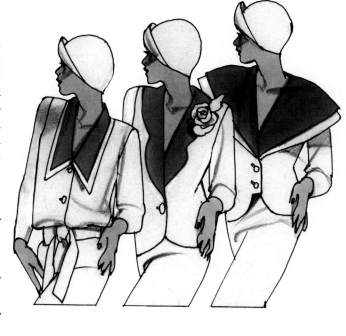

Figure 1 *Pattern preparation*
- Trace back collar of shawl. (Broken lines represent untraced section.)
- Divide into four equal parts.
- Cut from paper and slash from collar edge to, not through, neckline edge.
- Trace shawl pattern, place slashed collar on draft, and spread as illustrated to vary collars.

Figure 1

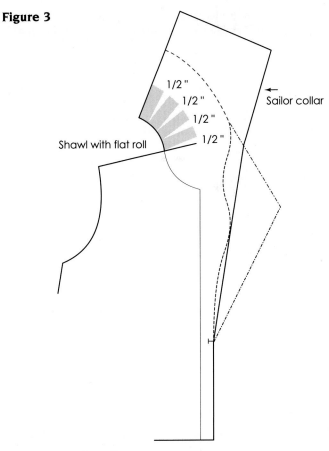

Figure 2

Shawl with 1/2˝ stand

3/8 "

Various shawl designs

Figure 3

1/2 "
1/2 "
1/2 "
1/2 "

Shawl with flat roll

Sailor collar

Figure 2 *1/2-inch stand*
- Spread each section 3/8 inch.
- Draw width of collar 3 1/2 inches.

Figure 3 *Flat roll*
- Spread each section 1/2 inch.
- Draw width of collar 4 inches or more.

Shawl Collar with Separated Undercollar and Facing

Instructions apply to any shawl lapel design. The basic shawl with notch (gorge) is illustrated.

Pattern Plot and Manipulation

Figure 1

- Trace basic shawl pattern. Include hidden dart.

- Draw notch (gorge) anywhere along shawl line and curve the lapel.

- Draw a curved line from shoulder-neck to notch (gorge) location at lapel for the undercollar.

- Draw facing, starting 2 inches from shoulder-neck and ending $2\frac{1}{2}$ to 3 inches from center front at hemline.

Figure 2 *Facing*

- Trace facing section from pattern.

- Extend center back collar 1/8 inch and blend to zero at collar point.

- Add 1/8 inch at midpoint of lapel. Blend to notch and breakpoint. (Broken line indicates original pattern.)

- *Hidden dart:* The hidden dart may be removed between the facing and the lining by shifting the dart to stitchline and trimming from pattern. It may be stitched at its original location, or it may be left unstitched (not ideal).

Figure 1

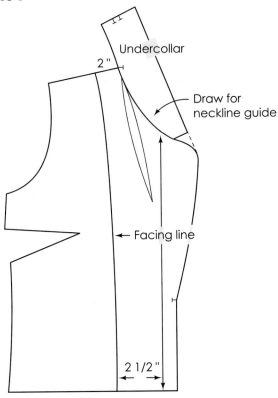

Figures 3 and 4

- Cut and separate collar from jacket (becomes undercollar). Place punch and circles.

Figure 2

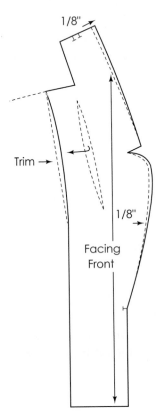

Figure 3

Figure 4

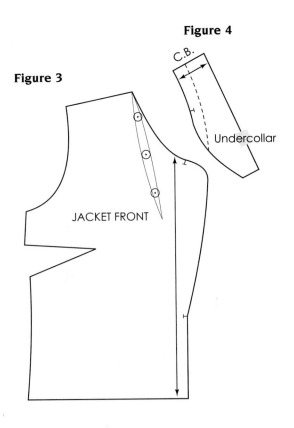

Interconstruction for Jacket and Coats

Interconstructions of woven or nonwoven fusible materials are placed in jackets and coats to give shape and form, and for insulation. As many as four layers of interconstructions can be found in a garment, depending upon the style and type of garment, the fabric, and the cost of the garment. Softly tailored garments require less interconstruction; very tailored garments require maximum layers. Following is a description of the four basic types.

Update: Pellon is now called Vilene, Freudenberg nonwovens.

Lining →

← Interfacing

Interlining

Underlining

Terms and Definitions

Interfacing. Interfacing is the layer placed between the outer fabric and the facing. Its function is to shape and stabilize detail areas, such as collars, cuffs, flaps, lapels, waistbands. It prevents stretching and supports the garment at strategic stress points—necklines, sharply angled points, gussets, diamond-shaped inserts. *The pattern for interfacings is developed from the garment pattern and facing patterns.* Seam allowance is placed on patterns for woven fabric; a seamless pattern is used for fusible nonwovens.

Underlining. (Also called backing or mounting.) Underlining reinforces the outer fabric and provides body to the cloth. *Patterns for underlinings are cut from the same pattern piece as the outer garment and on identical grain.* When sewn together with the outer fabric, the underlining acts as one layer of fabric.

Interlining. Interlining is the layer between the lining and underlining. Its purpose is to add insulation between the lining and underlining for warmth. It is omitted in pleats and sleeves (too bulky). *The pattern for interlining is the same as the lining pattern.* The interlining is stitched to the lining sections individually, then to the garment as a single layer.

Lining. The lining is a finishing layer that covers the inside construction. It is developed from the jacket pattern and will be illustrated.

Guide for Interconstruction Placements

Use the following guides (examples by Facemate and Vilene, Freudenberg Nonwovens Corp.) for the placement of fusible woven and nonwoven interconstruction parts on each of the jacket (or coat) sections. (Remove all or part of seam allowances of patterns cut for fusing.)

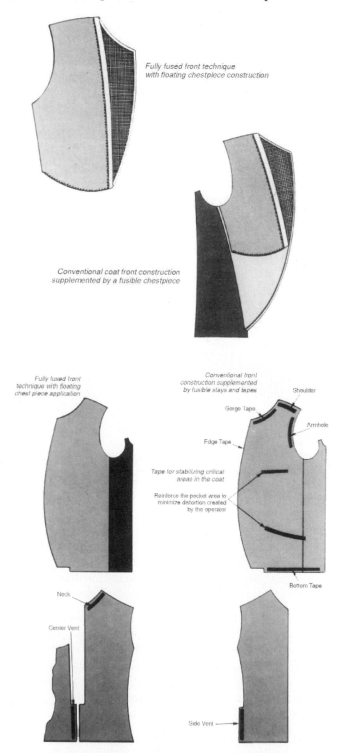

Fully fused front technique with floating chestpiece construction

Conventional coat front construction supplemented by a fusible chestpiece

Fully fused front technique with floating chest piece application

Conventional front construction supplemented by fusible stays and tapes

Shoulder

Gorge Tape

Armhole

Edge Tape

Tape for stabilizing critical areas in the coat

Reinforce the pocket area to minimize distortion created by the operator

Bottom Tape

Neck

Center Vent

Side Vent

FULL FUSED FRONT

FUSED FULL FACING

FUSED LAPEL AREA

FUSED TOP COLLAR & STAND
FUSED BOTTOM COLLAR

SHORT FUSED CHEST-PIECE

SEW-IN SLEEVEHEAD

FUSED CUFF WIGGINS

FUSED HEM

FUSED POCKET FLAP

FUSED WAISTBAND

Style Jacket with Facing, Lining, and Interconstruction

The basic notched lapel pattern with armhole princess styleline is used as an example of how to develop a jacket with a lining, facing, shoulder pads, and interlinings. The information is to be used as a guideline for all styles of lined jackets and coats.

Pattern Plot and Manipulation

Figures 1a and 1b

A basic notched collar and lapel is illustrated. Modify jacket as follows:

- Mark for length 5 inches below front waistline and draw line parallel with front and back hip level.
- Draw a styleline from the front at mid-armhole to bust point. Continue line to hem parallel with the center front. Draw slash line from bust point to side dart. (Second dart is omitted.)
- Crossmark 2 inches up and down from bust point on styleline (ease control).
- Draw curve of hem from center front to princess styleline.
- Draw styleline for back, touching dart point of dart nearest center back. (Second dart is omitted.) Crossmark dart point.

Dart development

- At waistline, measure out 3/8 inch from each side of styleline in front and 5/8 inch in back. (Shaded areas to be discarded.)
- Connect marks to notch on front and crossmark in back to form dart above waist.
- Connect dart legs $3^1/_2$ inches below waist in front and $4^1/_2$ inches in back, forming double-ended darts. (Shape dart for better fit.) Mark notches at waistline and sides at waist level.
- Mark notch 1/2 inch up from front styleline of jacket for lining placement later. Label X.
- Add $1^1/_2$-inch hem allowance, starting at side panel in front and across back.
- Draw pocket flap placement. Mark punch and circle 1/2 inch in from corners to guide positioning flap on jacket when sewing. If pocket is placed over an open dart, move punch or circle mark equal to dart intake.

Facing

- Draw location for facing on pattern for later reference. *Note:* Facing can be cut to follow the styleline of a jacket or it can bypass the styleline as the illustration will show. The facing continues upward from the bust as indicated by broken lines.

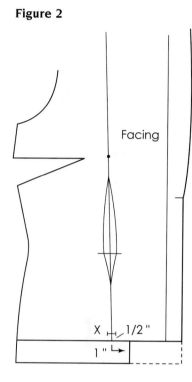

Figure 2

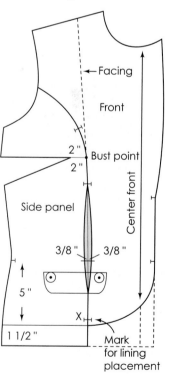

Figure 1a

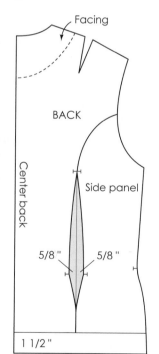

Figure 1b

Figure 2
- Hem allowance for jackets with squared corners (not having a princess line): Extend hem 1 inch beyond the facing.

Shoulder and Sleeve Cap Adjustment for Shoulder Pads (If Required)

Figures 3 and 4

- Garments with shoulder pads require an adjustment to the shoulderline and the sleeve cap as follows: Raise the shoulder tips and height of sleeve cap equal to the thickness of the shoulder pad, less 3/8 inch. Blend cap and shoulderline (shaded area). Do not raise shoulder tip or sleeve cap of the lining patterns.

- Cut pattern from paper. *Do not separate along styleline yet.*

Figure 3

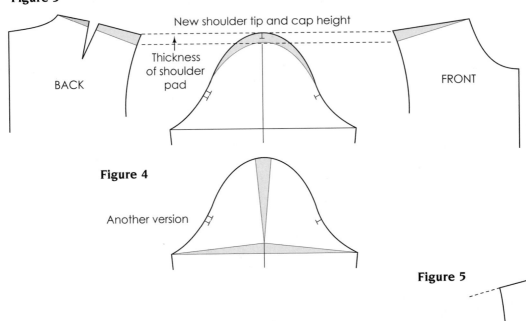

Figure 4

Another version

Facing

Figure 5

- Trace front facing from pattern and all notch markings. Use a pushpin or tracing wheel to transfer the facing lines within the pattern (indicated by bold lines).

- Add 1/8 inch to lapel at midpoint (1/4 inch for bulky fabrics); blend. (Broken line indicates original shape.)

- Extend facing 3/16 inch and blend to curve line of facing. (Stitching of facing to lining tends to feed in, causing a shortening of the facing edge (prevents curling).

- *Use facing to establish interconstruction pattern.*

Figure 6

- Place fold of paper at center back and trace facing.

Figure 7

- Remove paper. Pencil in facing and draw grain.

Figure 5

Figure 6

Figure 7

Lining

The lining is usually lighter in weight than the outer garment fabric and should be cut larger than the garment to avoid stress and to compensate for shrinkage. The lining may be developed to follow the styleline of the jacket or coat, but is more often modified to avoid putting seamlines in the same place as on the outer garment. This will help avoid excessive bulk. (The facing can be modified for the same reason.) Hemlines are developed in a number of ways, depending on how the lining is to be attached. The lining that is illustrated is machine stitched to the hemline of the jacket.

Lining Pattern Manipulation
Figures 1 and 2
- Trace front and back patterns to establish the lining.
- Mark all notches including point X.
- Omit stylelines and sections used for facings (bold line indicates lining pattern, and broken lines unneeded sections.)
- Remove pattern.
- Extend front and back shoulders 1/2 inch.
- Add 1/4 inch to side seam at armhole, blending to original side seams at hip (or 1/4 inch parallel to side seam).
- Extend side seam 1/2 inch above armhole. (This will raise the lining over the edge of the seamline of the outer garment to prevent puckering and stress under the arm of the garment.)
- Blend front and back armholes.

Hemline of lining. The lining should end above the bottom of the jacket. The amount varies.
- Hemline in this example is 1/2 inch less than hem allowance of jacket. (Example: 1 inch.) From point X, measure down 1 inch for hem of lining. Draw hemline parallel with jacket hem. (Figure 1)
- The fold line of the hem is placed at notch (point X) of the facing when stitching.
- Repeat hem allowance for back.

Action pleat at center back. Add $1\frac{1}{2}$ to 2 inches at center back. Pleat may be parallel with center back or tapered to waist level (uneven broken lines). (Figure 2)

Shoulder dart. To remove dart, measure in from facing line equal to width of dart.
- Draw blending line. (Shaded area to be trimmed from pattern.)

Waist darts. Back dart can be developed as a dart or tuck dart.
- Front waist dart is removed through seamline of lining.

Figure 1

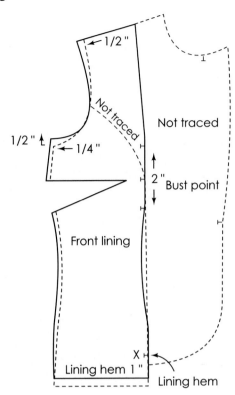

Figure 2

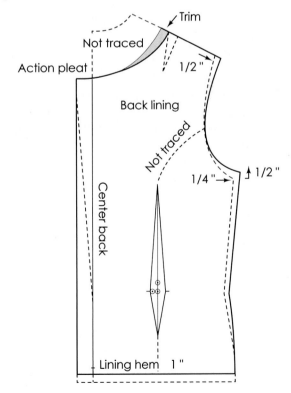

Side Dart of Front Lining
Figures 3, 4, and 5

- The side dart of the lining may be closed to dart point, transferring excess to the stitchline of the lining, and held as ease (Figure 3); transferred to mid-shoulder and removed through the stitch line (Figure 4); folded or transferred one inch from mid-shoulder, and folded; or stitched as a tuck dart and used as an action pleat (Figure 5).

Figure 3

Figure 4

Figure 5

Jacket Sleeve Modifications
Figure 6

(Instructions apply to any style of sleeve used with jacket or coat designs.)

- Trace jacket sleeve. Add $1^1/_2$ inches for hem allowance.
- Fold hem and trace both sides of sleeve at hem. Unfold and remove 1/8 to 1/4 inch from sides of hem to avoid bulk when lining is attached. Label fold line X.

Figure 6

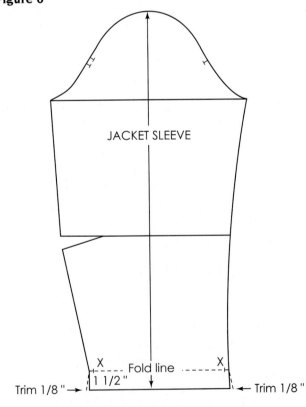

Sleeve Lining
Figure 7

- Trace sleeve. Remove.
- Subtract 1/2 inch from sleeve cap height. Blend. (Shaded area to be trimmed from pattern.)
- Raise front and back armholes 1/2 inch. Blend.
- Add 1/4 inch to underseam to zero at hemline (or 1/4 inch parallel with underseams).
- Hemline of lining is 1/2 inch less than hem allowance of sleeve. (Example: 1 inch.)
- Notch 1/2 inch up from points X to establish fold line for lining hem. (Broken line indicates original sleeve.) *Note:* Elbow dart may be stitched as a dart, folded as a pleat, or eased in. If eased in, mark notches $1\frac{1}{2}$ inches up and down from dart legs and mark other side 1 inch up and down from elbow level. Blend dart (not illustrated).
- True hem of lining with hem of sleeve, trimming equally on each side.

Outer Garment

Figures 1, 2, 3, 4
After the lining and facings have been traced from the pattern, the outer pattern is separated along the stylelines. Pattern is cut apart through waist darts and mid-armhole in front and back, with the center back on the fold. Add grainline to each pattern.

Figure 7

Trim 1/2"

SLEEVE LINING

1/2" ←1/4" 1/4"→ 1/2"

X Lining hemline 1" X 1/2"

1/2"

Side Front Panel

- Slash from bust point to, not through, dart point of side dart. Close dart. Retrace, blending bust line.
- Use patterns to develop interlining and other interconstruction parts (if desired).

Figure 5
- Trace pocket flap. Cut 4 self, or cut 2 self and 2 lining.

Figure 5

POCKET FLAP

Note: Label patterns with felt-tip pens using the following colors:

- Black—Outer garment patterns
- Red—Lining patterns
- Green—Interconstruction patterns.

(Colors help to group patterns for marker makers.)

Figure 1

Figure 4

Paper

BACK

Figure 2 Figure 3

FRONT

Center back

SIDE BACK

SIDE FRONT

Center front

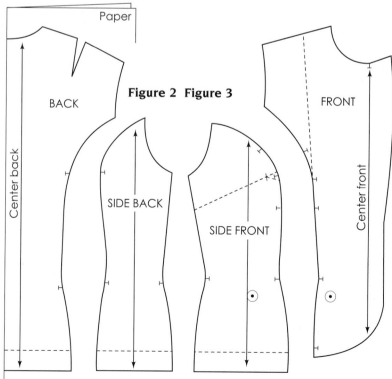

Collar

Figure 1 Upper collar

- Trace collar on fold; include all markings.
- Measure up 1/8 inch or more (depends on thickness of fabric) at center back of collar. Draw blending curve to tip of front collar and cut from paper.

Figure 1

Figure 2

- Unfold and label *Upper collar.* Mark center back notch and shoulder notches.
- Draw straight grainline.
- Trace this pattern or undercollar for interconstruction parts.

Figure 2

Figure 3 Undercollar

- Trace collar on fold; include all markings.
- Mark notch for top of collar at center back and notch 1/8 inch away from center back collar at neckline edge. (Two notches indicate undercollar.) Cut from paper.

Figure 3

Figure 4

- Unfold and label *Undercollar.*
- Draw straight or bias grainline.

Figure 4

Figure 5 *Two-piece bias undercollar*

- Cut undercollar in two pieces. Draw grainline, straight or bias (collar will roll more smoothly). To develop interconstruction patterns for fusibles, remove some or all of seam allowances. Label *Interconstruction patterns* with green felt-tip pen.

Figure 5

23

Capes and Hoods

Capes

A cape is a sleeveless garment that hangs over the shoulders (sometimes with slip-throughs for arms). It can be worn separately over coats, jackets, dresses, or sportswear, or can be attached to a dress or cloak. Two basic capes are developed from the torso foundation—A-line and circular capes. They can be used to generate many variations of current fashion trends.

A-Line Cape Foundation

Design Analysis

Cape has A-line silhouette with slits for arm entry. Three buttons secure front. Design 1 illustrates how this foundation can be used.

Figure 1

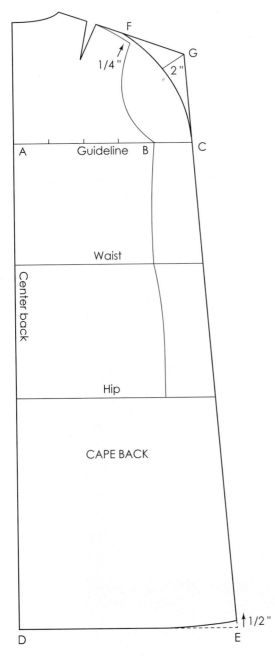

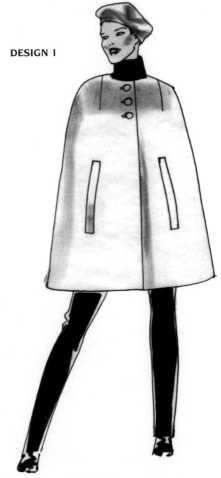

DESIGN 1

Pattern Plot and Manipulations

Figure 1 Back

- Trace back torso.
- Square a guideline from the center back touching armhole. Label A and B. Divide A–B line into fourths.

 B–C = One-fourth of A–B. Extend line.

- Extend center back to length desired. Label D. D–E = A–C plus 3 inches, squared from D.
- Draw a line from E. Extend line through C.
- Blend hem 1/2 inch up at side seam.
- Mark 1/4 inch above shoulder tip. Label F.
- Extend line from mid-shoulder through F, intersecting E–C line. Label G.
- Draw a 2-inch diagonal line from G, and draw shoulder curve from C to F to mid-shoulder.
- Cut pattern from paper.

Figure 2

- Trace front torso, transferring side dart to mid-shoulder in line with back dart placement (broken line).
- Square a line from center front touching armhole. Label H.

 H–I = B–C of back cape.

- Add length to center front below hip equal to back. Label J.

 J–K = D–E of back cape, squared from J. Connect K with I. (curve not shaped as yet)

- Blend hemline 1/2 inch up from side seam.
- Draw 1-inch extension parallel with center front.

Figure 3

- Place back on top of front cape, matching guidelines with C and I touching. (Back indicated by broken line.)
- Trace curve of back cape, ending at the *back* shoulder dart leg (will cross front dart leg). Mark. Remove pattern. (If back shoulder is higher or lower than front, balance the difference at shoulder tip and blend curve line.)

 Note: Shoulder pads do not require shoulder adjustment. (Excess has already been transferred to armhole area.)

- Center dart point $1^1/_2$ inches up from bust point and draw adjusted dart legs to dart point. (See Figure 2.)
- Complete pattern for test fit. (Shoulder overarm curve to be adjusted on model.)

Armhole slit

- Mark 1 inch in from side waist. Label L. Square 5 inches up and down from L. (Placement and length can vary.) Slit should be cut 1/16 inch wide and notched across top and bottom.
- Cut welt strip 10 inches × 3 inches (not illustrated). *Note:* Slit is faced with lining.

Figure 2

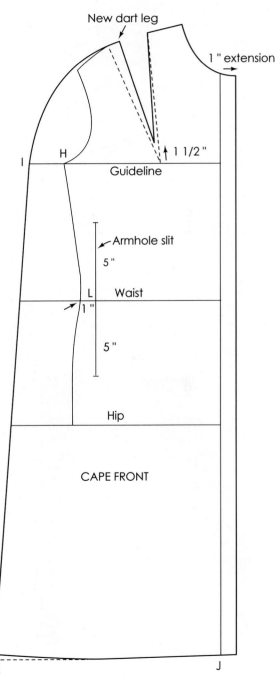

Figure 3

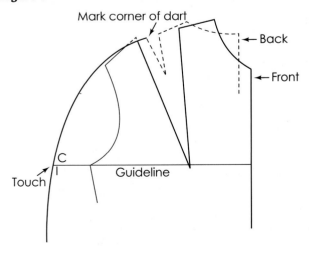

Flared Cape Foundation

Design Analysis

This flared cape has a tied neck and turned up Peter Pan flat roll. (Collar and tie not included.) Develop the flared cape foundation from the front and back torso.

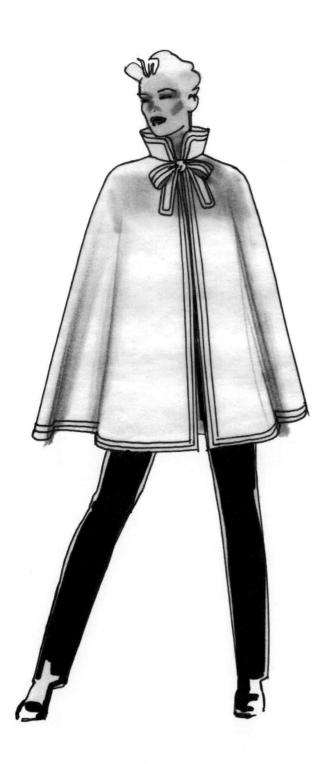

The Flared Cape Draft

Figure 1

Trace front and back patterns, transferring shoulder and side darts to hip level, and cut from paper.

* Square a line on paper. Place back and front on square line with shoulder tips 1 inch apart and trace. Label side hips A and B.

* Mark center between shoulder tips and points A and B. Draw separating line. Label D.

* Mark C, $1\frac{1}{2}$ inches down on line from shoulder tips.

* Draw curved shoulder from C to front or back mid-shoulders, passing 1/4 inch above shoulder tips.

* Mark notch for shoulder tips.

* Shape hemline between front and back patterns.

* Extend hemline to desired length. New hemline is parallel with hip level.

* Draw 1-inch extension at center front for button and buttonholes, if desired.

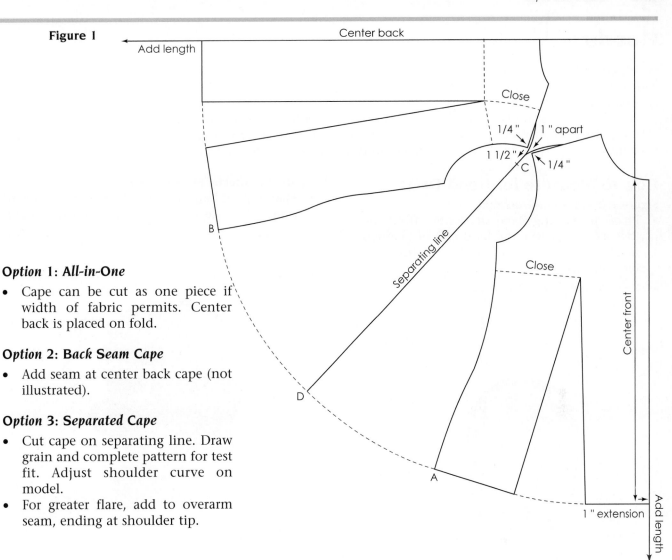

Figure 1

Option 1: All-in-One

- Cape can be cut as one piece if width of fabric permits. Center back is placed on fold.

Option 2: Back Seam Cape

- Add seam at center back cape (not illustrated).

Option 3: Separated Cape

- Cut cape on separating line. Draw grain and complete pattern for test fit. Adjust shoulder curve on model.
- For greater flare, add to overarm seam, ending at shoulder tip.

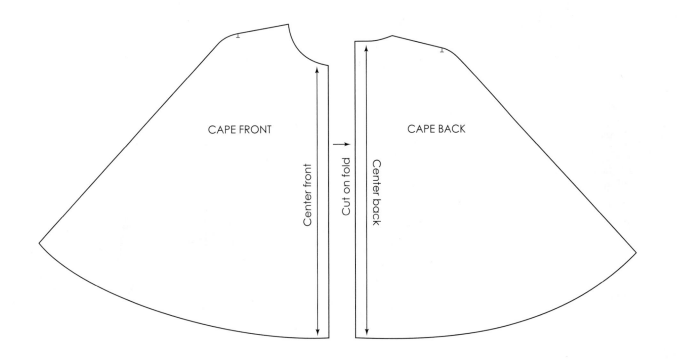

Hoods

Hoods cover the head and neck and sometimes part of the face. They can be worn separately or as part of a garment, for protection from the weather or as a design feature. Hoods, like all garments, come in endless styles and varied shapes.

Two hood foundations are illustrated—the contour hood and the loose-fitting hood. From the two foundations, other variations can be developed. Hoods illustrated are attached to the garments. The front and back neckline of the pattern to which the hood is attached is used in the draft.

How to Measure for Hood Draft

Figure 1 *Overhead Measurement*

- Place measuring tape at center front neck (between clavicles) and hold end of tape while measuring up and over the head, starting at center front neck.
- Record one-third of this measurement and add 3/4 inch: _____.

Figure 1

Figure 2 *Horizontal Measurement*

- Place tape at hairline at eye level and measure to other side. Record one-half of measurement: _____.

Figure 2

Contoured Hood Foundation

Design Analysis

The contoured hood fits the shape of the head, with control darts at the crown and neck area. The hood is attached to the neckline of the garment, starting at the center front.

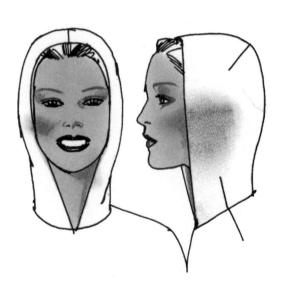

Pattern Plot and Manipulation

Figure 1

A–B = Overhead measurement. (Example: 10 inches.)

B–C = A–B, less 1 inch. Square from B.

C–D = $1^1/_2$ inches. Square from C.

A–E = One-half of A–B. Mark.

E–F = 3/4 inch, squared from E.

F–G = Horizontal measurement squared from E. (Example: 8 inches.)

B–H = 1 inch. Mark.

B–I = One-half of B–C. Mark.

Figure 1

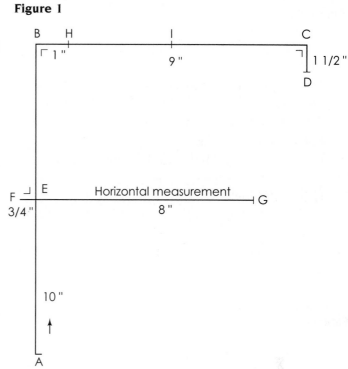

Figure 2

- Place back pattern on draft with center back on A–B line and neck at A.
- Trace back neck to corner of shoulder. Label J.
- Shift pattern 3/4 inch, with center back parallel to A–B line.
- Trace shoulderline from corner of neck to dart leg. Label K. (Broken lines indicate untraced pattern.)
- Remove pattern.

Figure 2

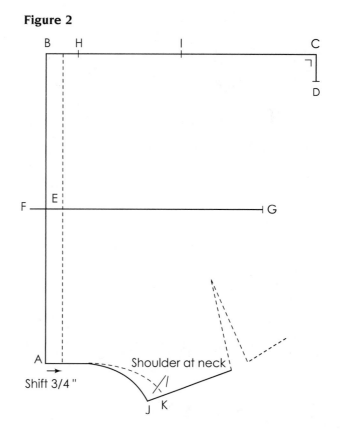

Figure 3

- Extend shoulder (for guideline).
- Place shoulder of front pattern on guideline with corner of neck touching point K.
- Trace front neck. Label center front neck X. (Broken lines represent untraced pattern.)
- Remove pattern.

 K–L = 3 inches. Mark.

 L–M = 3/8 inch. Mark and draw line from H to M.

 H–N = 3/4 inch. Mark.

- Square out $1\frac{1}{8}$ inches from both sides of N. Label O and P.
- N–Q= One-third of H–M. Mark and connect Q with O and P.

Figure 4 *Shaping Hood*

- Draw outward curved line of hood, connecting points A, F, O, and P, I, D.
- Draw inward curve from D, G, L, to X. Blend at point G, for continuous inward curve if necessary.

Neck dart
- Mark center between points J and K. Draw a 3-inch line parallel with A–B line. Label R.
- Connect J and K with R for dart.

Crown dart
- Mark midpoint of O–Q and Q–P and measure out 1/8 inch. Mark and draw curved lines connecting points Q with O and P.
- Draw grainline parallel with A–B line. Complete pattern for test fit.

 Note: Fold neck dart with excess in direction of A–B line.

Figure 3

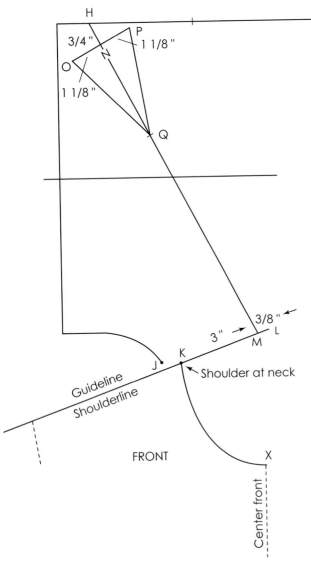

Figure 4

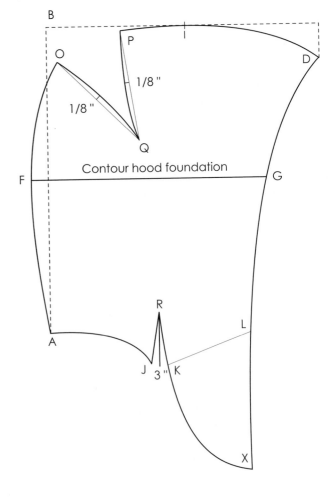

Contour hood foundation

Dartless Hood

Figure 5a, b, c

- Draw a line through the dart.
- Trim 3/8 inch from the front and back necklines, as illustrated.

Figure 5a, b, c

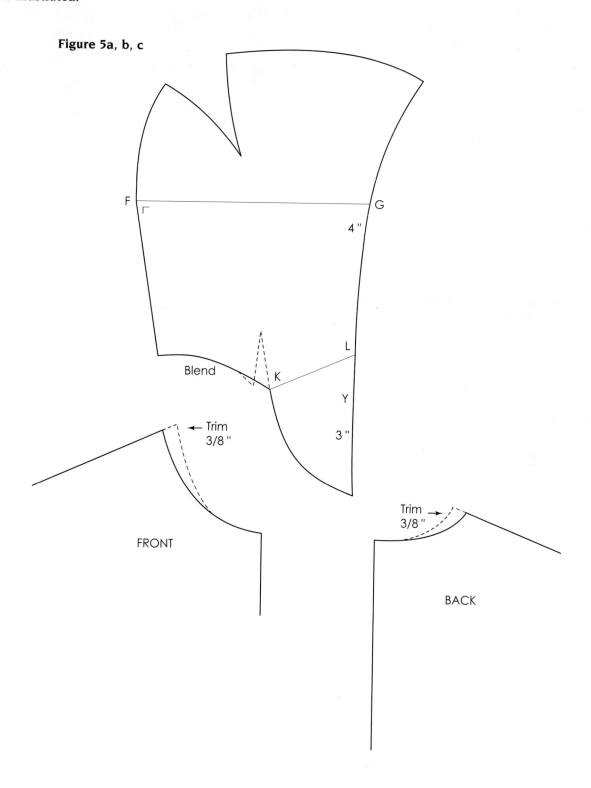

Contoured Hood Design

Design Analysis

The contoured hood encircles the face, buttoning from the chin down the center front of the neck and garment to which it is attached. The hood gathers along the neckline and the styleline ends at the side of the face. Design 2 is included for practice.

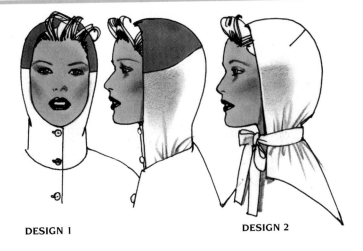

DESIGN 1 DESIGN 2

Figure 1

- Trace contour hood foundation, including F–G line and K–L line. (See hood draft, pages 535 and 536).
- Draw styleline from dart point of crown dart, ending 4 inches below G-line.
- Square down from point F (for fullness), and blend neckline across dart (dart excess is part of gathers). For dartless hood, see page 537, Figures 5a, b, and c.

Extension at neck
- X–Y = 3 inches. Mark.
- Locate $1\frac{1}{2}$ inches on square rule and place at point Y, with other leg at point X. Draw square line touching X with Y. Label point Z. Blend from Z to L.
- Draw 1-inch extension parallel with X–Z line.
- Connect ends.
- Mark button placement (Chapter 16).

Figure 1

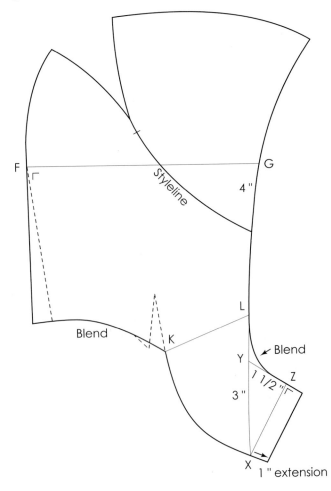

Loose Hood Foundation

Loose hoods are most often used with coats and capes. The hood may be pointed or squared in back, with the front hood folded over.

Design Analysis

The foundation is drafted with a fold-back and fits to the height of the crown of the head, with either a point or a square across the back (eliminating the point). Instructions are given for both Design 1 and Design 2 (exaggerated fullness).

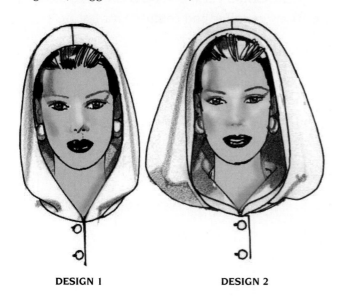

DESIGN 1 DESIGN 2

Pattern Plot and Manipulation

(For greater looseness, add 2 inches or more to A–B measurement. See Design 2.)

Figure 1

A–B = Overhead measurement. (Example: 10 inches.)

B–C = $2^1/_2$ inches.

C–D = A–B, squared from C.

- Square down from D, as shown.
- Place center back on A–C line with corner of neck touching A.
- Draw neck to corner of shoulder. Label E.
- Shift pattern 3/4 inch, keeping center back parallel with A–C line.
- Draw shoulder, starting at corner of neck (F), to dart leg.
- Remove pattern and extend shoulderline (guideline). (Broken line indicates untraced pattern.)

Figure 1

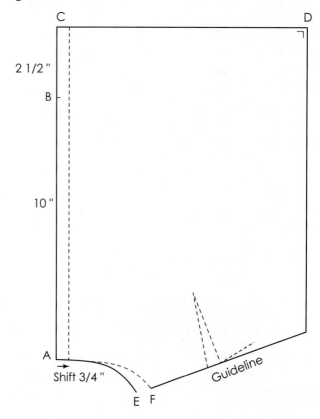

Figure 2

- Place front shoulder on shoulder guideline of draft with corner of neck touching point F.
- Dot mark center front neck (indicated by broken line).
- With pushpin at point F of front pattern, swing from pattern 2 inches away from dot mark.
- Trace neckline. Remove pattern and label center front H.
- Draw curve of hood from point H, blending with square line at shoulder guide as shown.

Figure 3

- Mark center of dart between E–F. Draw 3-inch line parallel with A–C line. Label I.
- Draw connecting line from E and F to I (dart). (For dartless hood, see page 537.)
- To remove point from hood, square out $2\frac{1}{2}$ inches from B. Label J.
- Square up from J to C–D line.
- Cut section from pattern.

 Note: Center back of hood is cut on fold.

- Draw grainline and complete for test fit.

Figure 2

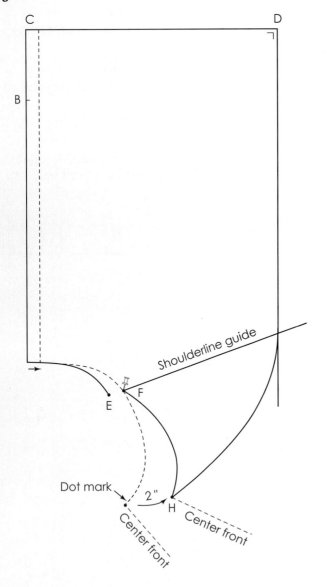

Figure 3

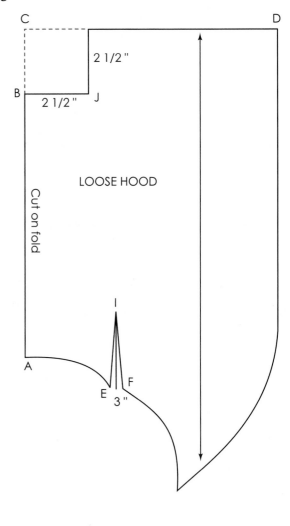

24

Knock-Off-Copying Ready-Made Designs

Knock-off is a fashion industry word for copying ready-made garments. This is a common practice and generally happens when hot items hit the retail market. Other manufacturers want a piece of the action before the season ends or before sales cool down. Such items must be produced quickly. This is accomplished by applying a variety of short-cut methods to the patternmaking process.

Knock-Off Methods

- The garment is laid over paper and traced by pencil, pen, or a tracing wheel.
- Paper or muslin is placed over the garment and the design is rubbed off with tailor's chalk.
- Transparent plastic (dry cleaner's plastic bag cut apart, or a firmer quality purchased from the hardware store) is placed over the garment and the design is copied with a marking pen.
- The garment is placed on the form and draped with muslin to its exact shape and design.
- Garments can be generated through measurements and following the grainlines of the design.
- The garment is taken apart, pressed, and the fabric patterns traced.
- A computer can be used to copy designs.

Knowledge of the various methods for knocking-off garments is essential to the patternmaker. The following projects are guides for generating copies of designs with and without darts.

T-Tops

Marking paper underneath is illustrated.

Figure 1

- Place pins at the center of the garment.
- Fold paper and square line out from fold.
- Place center of the garment on fold and hemline on the squared line. Secure with pushpins.
- Pencil the outline of the garment; trace the armhole and stitchline of the front and back necklines with a tracing wheel.
- True the lines and add seams to the copy.
- Cut pattern from the paper along the back neckline. Trace a copy for the back pattern.
- Trim front neckline of the original pattern.

Figure 2

Figure 1 Measure ribbing length and width. Length adjusted after stretching.

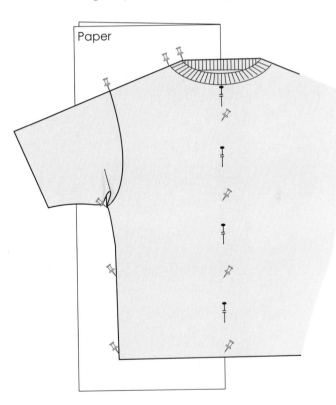

Figure 2
- Place center of sleeve on fold of paper. Smooth flat so curve of cap is visible. Pin.
- Pencil outline and trace sleeve cap with a tracing wheel. Remove and true.

Shirt Types

Marking paper placed on top of garment.
(If muslin or plastic is used, follow procedure.)

Figure 1

- Lay the front of the shirt parallel with the cutting table. Pin to secure.
- Smooth the shirt flat and smooth along the neckline and armhole.

Prepare marking paper
- Draw a guideline on paper.
- Place the guideline on the edge of the front extension. Slash and trim along the neckline and secure the marking paper with pins.
- With tailor's chalk, rub along the stitch lines of the shirt and across the pocket and banding.
- Remove and true the lines of the shirt and pocket.
- The pocket and placket are drafted by measurements.
- Mark button placements.

Figure 1

Paper

Figures 2a, b
Collar and stand
- Pin mark center back of collar and stand.
- Place collar on paper and smooth flat. Pin to secure, then trace. Remove collar and true.
- Repeat the process for the collar stand.

Figure 2a

Paper

Figure 2b

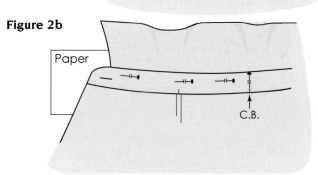

Paper

C.B.

Figure 3

Measure pleat intake and cuff.
- Slip the ruler into each pleat of the sleeve, and double each measurement. Double the intake of each pleat. Record for reference later.
- At this time, measure the width and length of the cuff for the draft of the pattern.

Figure 3

Measure depth of each pleat

Cuff: measure width + length

Figure 4

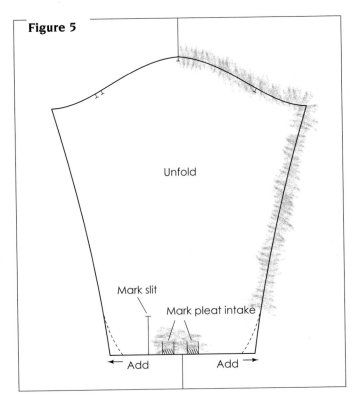

Back side of sleeve

Do not trace curve

Paper

Figure 4

Sleeve
- The back side of the sleeve is copied.
- Smooth pleats and cap line of the sleeve so that it lies flat and the curve of the cap is smooth to its true shape. Pin.
- Place folded paper along fold of the sleeve. Pin to secure.
- Chalk-rub over the sleeve and pleats to the cuff line.

Figure 5
- Remove paper and with tracing wheel, trace the outline through to the other side of the fold.
- Unfold, then pencil in the shape of the sleeve.
- Straighten the underseam line. Mark.
- Use the measurements of each pleat intake, marking the first pleat at the location nearest to the slit. Mark space and the second pleat intake. Mark cap notches about 3 inches up from the underseam. Notch pleat intake.

Back shirt and yoke
- Copy the back shirt following the same procedures to complete the knock-off garment. Walk the sleeve and mark notch locations. The sleeve cap should measure 1/2 inch greater than the front and back armhole.

Figure 5

Unfold

Mark slit

Mark pleat intake

Add Add

Pant Types

Pant with two pleats

Marking paper, muslin, or plastic may be used and placed on top of the pant.

Preparing Pant for Copy

Figure 1a, b

- Measure length and width of the belt for the draft.
- Pinmark pocket pouch.

Pleat intake

- Slip ruler under the pleats at waist to measure pleat depth. Double each measurement and record for use later.
- Measure dart intake and length of the back pant (not illustrated).

Figure 1a

Measure X's 2

Figure 1b

Measure X's 2

Figure 2

- Place pins along the curve of the crotch.
- Fold at the outside and inside seams and pin.
- Pin fold of the pleat to zero at hem.

Figure 2

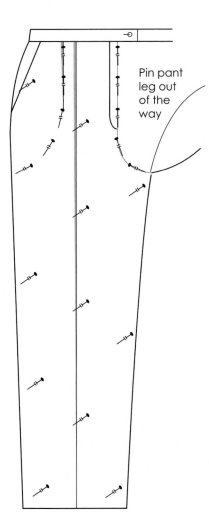

Pin pant leg out of the way

The pant is ready for copying.

- Chalk-rub if muslin or marking paper is on top. Trace with marking pen if plastic is used.
- After a copy is made, true all lines, including pleat locations and pocket pouch.
- Draw a line from the first pleat to the center of the pant hemline.

Figure 3

The example illustrates a pant copied by chalk-rubbing.

- After rubbing the pant, remove the paper and true all lines of the copy, including the pocket and pleat locations.

- Mark X out from side waist that equals the intake of both pleats.

Figure 3

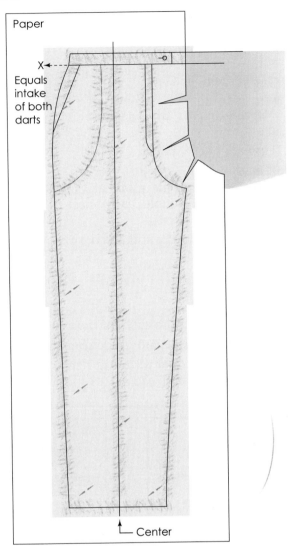

Paper

X ←

Equals intake of both darts

Center

Figure 4

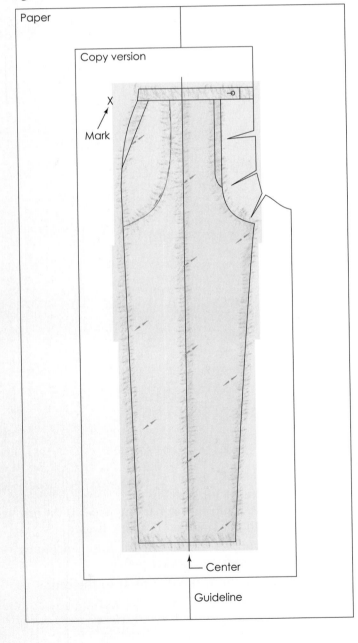

Paper

Copy version

X

Mark

Center

Guideline

Figure 4

Transferring Copy to Paper

- Draw a line through paper.

- Place the pant copy on paper matching guidelines and pin to secure.

- Trace the shaded area from the first pleat along the crotch curve, along the inseam to the hemline, stopping at the guidemark.

- Crossmark X point.

Figure 5

- Place a pushpin at the corner of the pant leg.
- Pivot the pant until the side waist is placed at the X mark on the paper underneath.
- Secure and trace the outside seam and the waistline to the second pleat. Trace pocket and pouch (shaded area). Remove copy.

Figure 6

- True and blend all lines.
- Mark location and intake for each pleat.
- Place paper underneath and trace the pocket backing and a copy for the pocket lining.

Figure 6

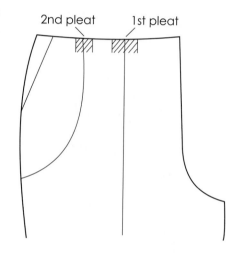

2nd pleat 1st pleat

Figure 7a, b

- Copies of the pocket backing and pocket lining.

Figure 7a

Pocket backing

Figure 7b

Pocket lining

Figure 8

Back pant

- Follow procedure given for the front pant.
- Measure dart intake, add this amount to center back crotch, and draw line to curve of the crotch.
- Draw dart leg at the location marked on the copy.

Figure 5

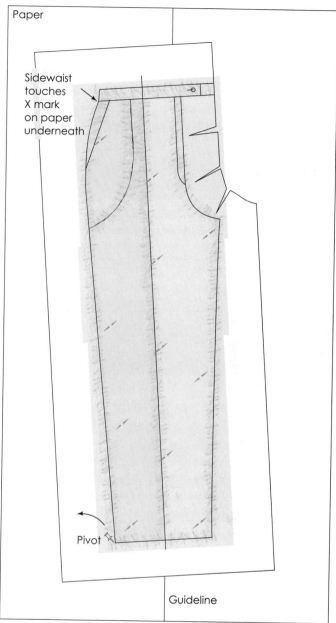

Paper

Sidewaist touches X mark on paper underneath

Pivot

Guideline

Figure 8

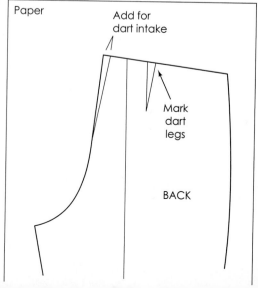

Paper

Add for dart intake

Mark dart legs

BACK

Jacket Copy

The jacket can be copied on a table (as illustrated in the example of the shirt, page 543) or it can be copied while placed on the form. The sleeve is copied on the table. Copying can be done with muslin or transparent plastic draped over the jacket. To copy with muslin, it is suggested that the seams of the jacket be pinmarked for clarity when rubbing. It is not necessary to pinmark if transparent plastic is used. After the component parts of the jacket are copied, the muslin (or plastic) is trued and the patterns are made. Compare measurements of the copy with those of the garment. The paper patterns are the base for developing facings, interconstruction, and lining.

Preparing the jacket

Figure 1

- Pinmark one side of the front and back jacket.
- Lift the collar and pinmark the neckline, shoulder line, around the armhole, and styleline panels.

Dart intake
- Feel the fold of the dart at the styleline and pin. Measure and double the width. Record for reference later.

Figure 2

Muslin preparation
- Cut muslin to length and width, plus 3 inches.
- Draw a guideline 1 inch from edge.
- Square a line from the guideline 1 inch up from the bottom.

Drape the front panel.
- Pin the sleeve away from the armhole.
- Place the guidelines on the extension and hem. Pin to secure. Pin at the dart point.
- Smooth muslin around the jacket from the bottom up and from the top down, with the excess pinned at the location of the dart. Pin to secure.
- Chalk-rub the front panel along the pinmarks and lapel.
- Remove the muslin and true all lines.

Figure 1

Figure 2

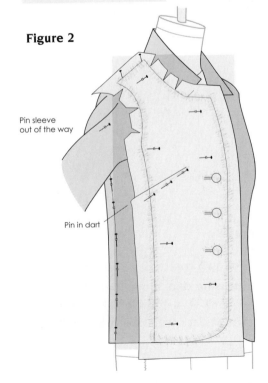

Pin sleeve out of the way

Pin in dart

Figure 3

Side panel—muslin preparation

- Draw straight grainline through center of the muslin.
- Place grainline in the center of the side panel. Pin to secure.
- Slash muslin to seamline under the armhole.
- Chalk-rub. Remove and true lines. Repeat the process for the back panel.

Figure 4

Collar—Use paper under the collar

- Pinmark center of the back collar.
- Draw line on paper.
- Place center back of the collar on line of the paper. Pin to secure.
- Draw the outline of the collar and with a tracing wheel, trace neckline, shoulder location, and center back.
- Remove collar and true the lines.

Figure 5a, b

Preparing the sleeve

- Pinmark the hem of the sleeve in line with the side seam of the form.
- Pinmark where shoulder and sleeve cap meet.
- Pin across the sleeve in line with the curve of the armhole underneath.
- Cross-pin through the sleeve at the center of biceps level.

Figure 3

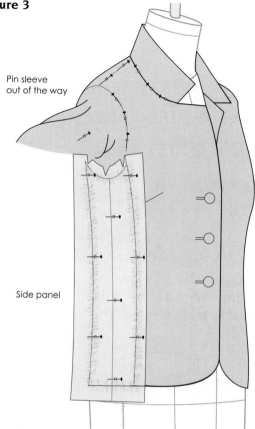

Pin sleeve out of the way

Side panel

Figure 4

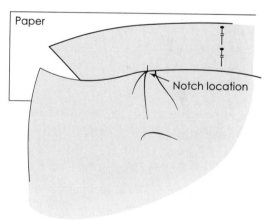

Paper

Notch location

- Pin sleeve at level with the waistline (elbow level).
- Measure the sleeve length (A to B). Record.
- Measure from cap at shoulder to pinmark at biceps level (A–C). Record.
- Measure across biceps and double the measurement.
- Remove jacket from the form.

Figure 5a

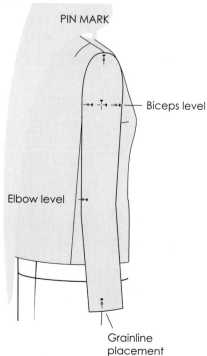

PIN MARK

Biceps level

Elbow level

Grainline placement

Figure 5b

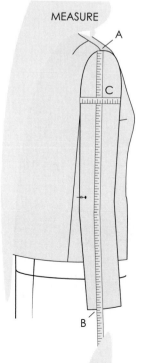

MEASURE

A

C

B

Figure 6

Under sleeve

- Place jacket on the table and turn to the under sleeve. Lay sleeve flat.
- Cross-pin to set the alignment of the sleeve from the other side.
- Pin along the fold line as indicated.
- Pinmark $1\frac{1}{2}$ inches up and down from the pin at elbow level for ease notches.

Figure 7

- Draw a straight grainline through center of the muslin.
- Place the guideline on the sleeve in line with the center pins. Pin to secure.
- Slash muslin for a close fit at the armhole.
- Chalk-rub along fold lines and draw undercurve.
- Remove muslin and true all lines.

Figure 6

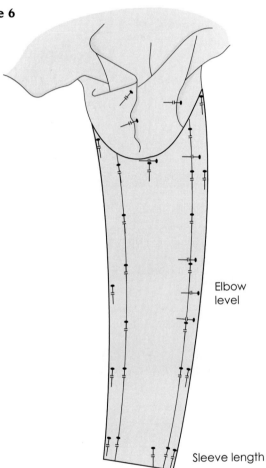

Elbow level

Sleeve length

Figure 7

Paper

Figure 8a, b

- Fold muslin at the upper-sleeve part of the copy and trace the corner section (bold line).
- Unfold and repeat on the other side.

Figure 8a

Figure 8b

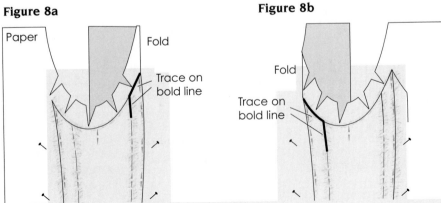

Paper

Fold

Trace on bold line

Fold

Fold

Trace on bold line

Figure 9

Measure from the seamline of the under sleeve to the fold at elbow level and hem. Use measurements to mark a point out from the fold at each side. Connect with the curve ruler, as illustrated.

Figure 10

Use the sleeve measurements to draw lines.
A to B = Sleeve length (straight grainline).
A to C = Biceps level.

Figure 11

- Place muslin guideline on the A–B line with hem touching B line at the grainline.
- Secure and trace the outline of the upper sleeve and under sleeve (lined area).
- Mark notches for ease control at elbow.
- Notches for the sleeve should be marked at the time all patterns are trued.
- Remove muslin copy.
- Draw curve of the sleeve cap, touching point A, as illustrated.

Figure 9

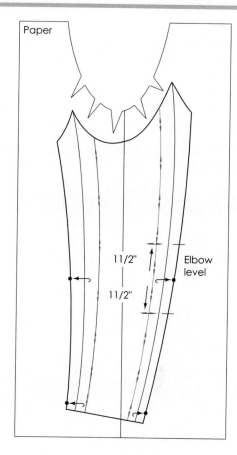

Figure 10

Figure 11

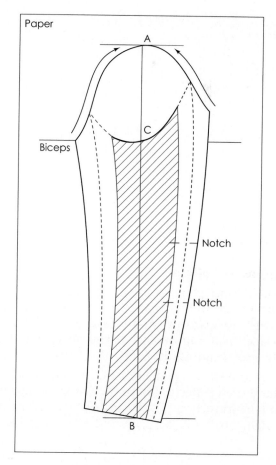

Figure 12
- Trace the under sleeve from the over sleeve pattern.
- Mark ease control notches at elbow.

Figure 13
Over sleeve
- Walk under sleeve from hemline to the ease notch of the over sleeve. If the difference between the placements of the notches is less than 1/4 inch, add to the length (for additional ease) as illustrated and adjust notch location.
- Add seam and cut from paper.

Figure 12

UNDER SLEEVE

Figure 13

OVER SLEEVE

Ease notches

Complete the Pattern
- Make paper patterns for all the rub-off garment parts. True and compare the lengths and widths with the garment. Add seams and grainlines. Mark sleeve cap notches as the sleeve is walked around the armhole.
- Cut and stitch for the test fit. After the patterns have been perfected, make the facing, lining, and interconstruction. They are developed from the original patterns, see pages 522–528 as a guide.

25

Pants

Bifurcated—What's That?

Thank heavens Mrs. Bloomer knew! She was immortalized for creating the bloomer, the first divided (bifurcated) pant for ladies.

We have come a long way since Mrs. Bloomer's bloomers in embracing not only pants but jumpsuits, swimsuits, and bodysuits as well—as though our very lives depended upon them. No matter what shape, what length, what color, or even how outlandish the bifurcates, they have found their way into our hearts, our wardrobes, and our lives.

New concepts in the way pants should fit the female figure have become the focal point for designers and patternmakers. The grand old standby, the trouser, has not always resulted in the look desired, nor has it responded well to the uniqueness of the female form. Designers and patternmakers have been forced to rethink the philosophy of fit and the utility of pants and their derivatives.

The basic principles underlying pant development are not being challenged here. These principles are being utilized in a special way, always keeping in mind the distinct characteristics of the female figure.

The trouser, slack, and jean foundations, as well as other designs, apply to menswear. Modifications to the draft are noted.

The Leg Relative to the Pant

The leg performs a variety of functions, such as walking, running, bending, squatting, and sitting. Whenever the leg moves or the knee bends, the muscles and skin of the lower torso increase and decrease in length. The illustrations show where and when the body increases and decreases in length due to movement. If a garment is to fit comfortably and hang well on the figure, the pant must not hinder the actions of the leg.

To insure the pant fits well, measurements must be taken with care and accuracy (Chapter 2). Each pant foundation should be cut in a firm fabric (not a knit) and test-fit. The foundation pattern should be corrected before being used for other designs; otherwise, fitting errors will be passed on to all designs based on it.

Pant Terminology

The following terms relate to the pant draft, the human figure, and the pant garment. The illustration links terms and locations.

Bifurcated. Divided into two parts (right and left sides).

Crotch. Base of torso where legs join the body.

Crotch depth. The distance from waist to base of crotch of the figure.

Rise. A tailor's term referring to the crotch depth.

Crotch length. A measurable distance from the center front waist, around crotch base, to the center back waist.

Crotch extension. An extension of crotch line at center front and back that provides coverage for the inside part of the leg.

Crotch point. End of crotch extension.

Crotch level. Dividing line separating torso from legline of the pant. (The total width across the pant from the front crotch point to back crotch point.)

Outseam. Side seam joining front and back pant.

Inseam. Seam between the legs joining front and back pant.

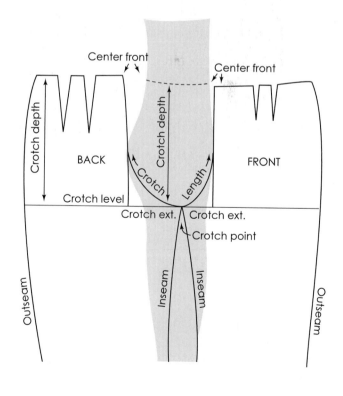

Analysis of Pant Foundations

The principle. Pant foundations are determined by the length of the crotch extensions. Longer extension causes looser fit around crotch level. Shorter crotch extension causes closer fit.

The foundation of a pant covers the area from the waist to the crotch, while the style is determined by the shape of the legline. The foundation is separated from the pant style at crotch level (illustrated as broken lines on the following four pant foundations). Crotch extensions provide the portion of the pant that covers the inside part of the leg. The length of the extension is determined by: a) foundation desired, b) percentage of the hip measurement, and c) upper thigh measurement.

Analyze and compare the four pant foundations illustrated below. Each pant foundation fits the abdomen and buttocks in a special way. Aside from the legline styles, how do they differ?

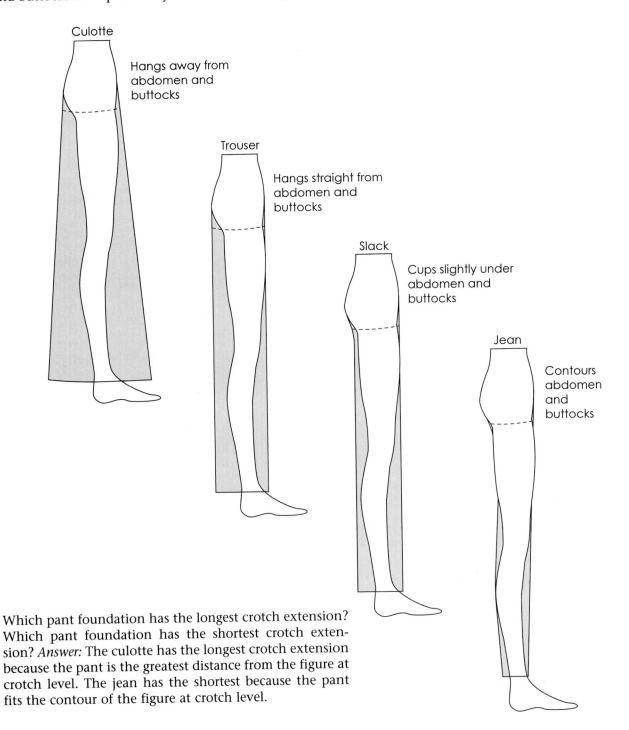

Culotte — Hangs away from abdomen and buttocks

Trouser — Hangs straight from abdomen and buttocks

Slack — Cups slightly under abdomen and buttocks

Jean — Contours abdomen and buttocks

Which pant foundation has the longest crotch extension? Which pant foundation has the shortest crotch extension? *Answer:* The culotte has the longest crotch extension because the pant is the greatest distance from the figure at crotch level. The jean has the shortest because the pant fits the contour of the figure at crotch level.

Summary of the Pant Foundations

A pant has two identities: its *foundation* (that part above crotch level) and its *legline* (the style below the crotch level). There are four major pant foundations, characterized by the hang of the pant from abdomen and buttocks: The culotte hangs away, the trouser hangs straight, the slack cups, and the jean contours the abdomen and buttocks areas.

The foundation of a pant is controlled by the length of the front and back crotch extensions. The extensions are based on a percentage of the hip measurement, with consideration for the upper thigh measurement.

Formula for Crotch Extension

Culotte: Back—One-half of back hip, plus 3/4 inch.

Front—One-half of front hip, minus 3/4 inch.

Trouser: Back—One-half of back hip.

Front—One-fourth of front hip.

Slack: Back—One-half of back hip, minus 3/4 inch.

Front—One-fourth of front hip.

Jean: Back—One-fourth of back hip for contour fit, one-third of back hip, minus 1/2 inch for close fit.

Front—2 inches. (Subtract 1/8 inch for sizes under 10 and add 1/8 inch for each size over 14.)

The *crotch level* measurement (the distance from front crotch point to back crotch point) should measure greater than the upper thigh measurement at least to the amounts that follows:

Trouser: $3^1/_2$ inches more.

Slack: $2^1/_4$ inches more.

Jean: 1 to $1^1/_2$ inches for contour fit and about 2 inches for a relaxed fit.

The *crotch length* of the pant should measure at least the same as that of the form or figure. When it does not, the needed length should be added to the pattern as follows:

Jean: Pitch the back pant.

Slack: Pitch the back pant and extend back crotch point equally.

Trouser: Extend front and back crotch points equally.

To test the fit of a foundation pant, cut the pant in firm fabric. To test the fit of a styled pant, cut in the fabric of choice. If the pant shows strain, pulling, or looseness due to insufficient or excessive fabric, adjust the fit and correct the pattern.

Measuring for the Pant Draft

To draft a pant for personal fit, follow these instructions. If the waist, hip abdominal, and hip depth measurements have already been taken and recorded on the Measurement Chart, use them. Otherwise, take the circumference measurement of the waist and hip. Divide each measurement by 4 and modify as follows:

Example: Waist 26″ ÷ 4 = 6$\frac{1}{2}$″

Add 1/4″ = 6$\frac{3}{4}$″ front waist

Subtract 1/4″ = 6$\frac{1}{4}$″ back waist

Hip 38″ ÷ 4 = 9$\frac{1}{2}$″

Subtract 1/4″ = 9$\frac{1}{4}$″ front hip

Add 1/4″ = 9$\frac{3}{4}$″ back hip

- To determine dart intake, subtract waist from hip circumference measurement. If the difference is more or less than 10 to 12 inches, see page 43 for personal dart intake.
- For hip depth instructions, see Chapter 2.
- Record all measurements on the Measurement Chart.

Vertical Measurements (Record on Measurement Chart)

Figure 1

With metal-tipped end of the tape placed below waist tape at side, measure the following locations:

To ankle level (27).

To floor (27).

To mid-knee (27).

Circumference Measurements

Waist arc (19) Center front to side seam.

 Center back to side seam.

Hip arc (23) Pin-mark 9″ below waist at center front. Measure at this level.

 Center front to side seam.

 Center back to side seam.

Upper thigh (29). Near crotch base.

Mid-thigh (29). Between crotch and knee.

Knee (30). Mid-knee level.

Calf (31). Widest part below knee.

Ankle (32)

Figure 2

Crotch length (28). Center front under crotch to center back.

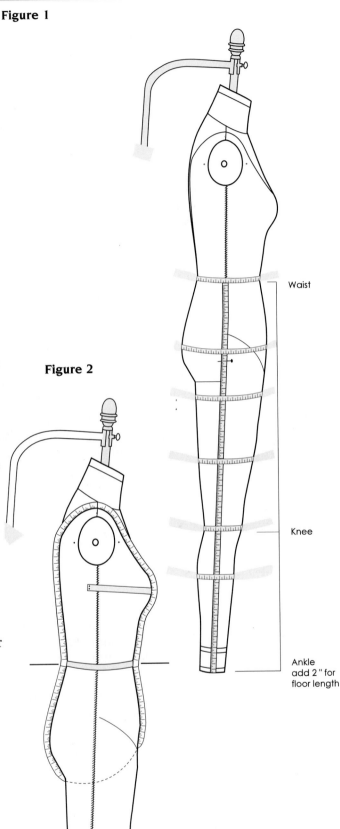

Figure 1

Waist

Knee

Ankle
add 2″ for
floor length

Figure 2

Vertical trunk (28) – Front, back sh/neck passing undercrotch

Figures 3 and 4
Crotch depth (24)

Form: With square ruler in place, measure from waist level to crotch level (not to the end of the ruler).

Personal: Place belt, elastic, or a tie around the waist. Measure below belt to base of the chair.

Figure 3

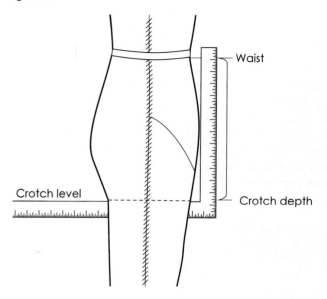

Figure 4

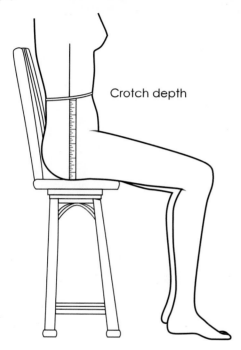

Figure 5
Foot entry

Measure around heel and instep of the foot.

Figure 5

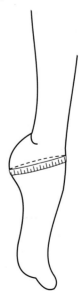

Culotte—Foundation 1

When it first became fashionable for women to ride bicycles, it was unfashionable (even improper) for them to wear pants. A garment was needed that was both functional and ladylike. This led to the development of the culotte (then known as the divided skirt), a pantlike skirt providing the wearer with maximum mobility, while still being acceptable for the mores of that period. So successful and practical was the culotte that it was accepted as a style for both casual and dressy garments. It continues to be an important fashion item.

The culotte foundation is developed from a basic A-line skirt; however, any skirt design can be adapted into a pantlike skirt by following the instructions given. The foundation is used as a base for the traditional box-pleated culotte and for designs with varying lengths and wide-sweeping hemlines. Culotte designs are given on pages 574–577.

Measurements needed

- (24) Crotch depth _____ plus 3/4 inch (varies to $1\frac{1}{4}$ inches).

Culotte Draft

One-half of the front and back pant are drafted. (Refer to Chapter 2 for taking measurements.)

- *Patterns needed:* Front and back A-line skirt and belt; see page 241.

Figure 1 *Front*

Place patterns at least 8 inches from paper's edge to allow for crotch extensions. Trace front and back skirt. Include all markings.

A–B = Crotch depth plus 3/4 (or more) inch.

A–X = One-half of A–B less 1/2 inch. Mark.

B–C = One-half of front hip, less 3/4 inch, squared from B.

D–E = B–C, squared from D. Connect C with E.

B–b = 1½-inch diagonal line.

　　　Draw crotch with curve, touching C and b and ending at or near X-point. Modify curve if unable to touch B.

Figure 1

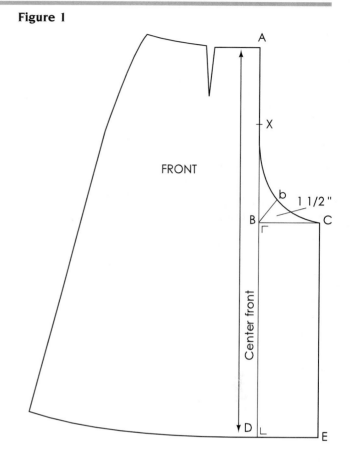

Figure 2 *Back*

F–G = D–B (of front pattern).

G–H = One-half of back hip plus 3/4 inch, squared from G.

F–J = G–H, squared from F. Connect J with H.

G–X = B–X (of front pattern). Mark.

G–g = 1¾-inch diagonal line. Draw crotch with curve beginning near H–g, and ending at or near X-point.

• Cut for a test fit.

Figure 2

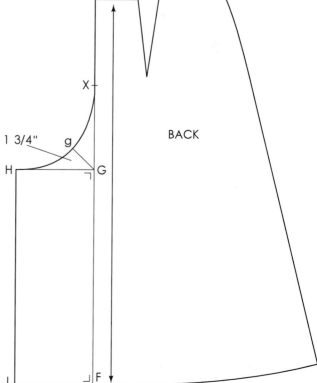

Trouser—Foundation 2 (for Women or Men)

The trouser is a pant that hangs straight downward from the outermost part of the abdomen and buttocks. It fits closer to the body than does a culotte because the front crotch extension is shorter. This pant may be worn in its present form or modified for other pant designs, such as the pleated trouser, the baggy, the clown, and the gaucho (see Pant Designs). It is also used as a base for pant derivatives such as the short, the jamaica, the bermuda, and the pedal pusher, to name a few.

The trouser draft can be adapted for men by changing the dart intake. Measurements needed for the draft are noted by asterisks on the measurement chart. To take measurements see page 558.

Measurements needed
- (27) Pant length to ankle _____.
- (24) Crotch depth _____.
- (23) Front hip _____. Back hip _____.
- (19) Front waist _____. Back waist _____.

Trouser Draft

Figure 1

A–B	= Pant length.
A–D	= Crotch depth plus 3/4-inch ease (varies).
D–C	= Hip depth: one-third of D–A.
B–E	= Knee depth: one-half of B–D plus 1 inch (toward crotch level).

Square out from both sides of A, B, C, D, and E.

Figure 1

KEY LOCATIONS

A Waist

C Hip

D Crotch Depth

E Knee

B Ankle

Figure 2

Back

C–F = Back hip plus 1/4 inch (ease).

D–G = Same as C–F.

A–H = Same as C–F.

Connect G with H.

G–X = One-half of G–H.

G–I = One-half of G–D.

Front

C–J = Front hip plus 1/4 inch (ease).

D–K = Same as C–J.

A–L = Same as C–J.

Connect K with L.

K–X = One-half of K–L, less 1/4 inch.

K–M = One-fourth of K–D.

Figure 2

Figure 3 Dart placement*

Back dart intake

H–N = 3/4 inch.

N–O = Back waist, plus $2^1/_4$ inches (1 inch for men's pant) for dart intake, plus 1/4 inch ease.

N–P = 3 inches (dart placement).

Subtract 1/8 inch for each size under 10. Add 1/8 inch for each size over 12.

Mark 1 inch for each dart intake. Space $1^1/_4$ inches.

For men's pant, mark *one* dart and intake 3/4 inch.

Square down $4^1/_2$ inches from center of each dart.

Front dart intake

L–Q = Front waist, plus $1^1/_4$ inches (3/4 for men's pant).

L–R = 3 inches (dart placement).

Mark 1/2 inch for each dart intake. Space $1^1/_4$ inches.

(For men's pant, mark one dart.)

Square down 3 inches from center of each dart.

Personal fit—use chart measurements for dart intake. Add 1/4 inch for ease. (Decrease dart intake if O touches A line.)

Figure 3

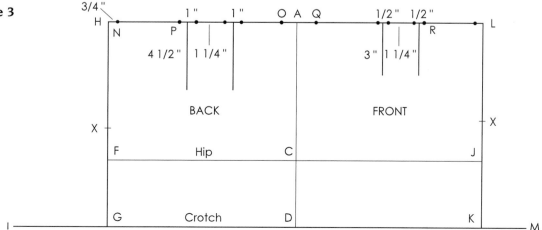

Figure 4

Back

N–S = 1/4 inch squared up from N.

Draw line from S to X, and ending at crotch level.

G–T = 2 inch diagonal line, (less 1/8 to 1/4 inch for sizes under 10).

Draw crotch curve from I to X, touching or blending at T.

Front

K–U = $1\frac{1}{2}$ inch diagonal line.

Draw crotch curve from M to X, touching or blending at U.

Figure 4

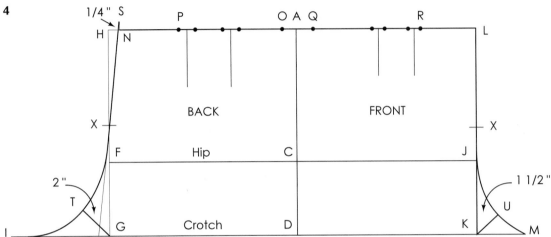

Figure 5 *Back and front waistlines*
- Draw inward curved line from S to O.
- Draw inward curved line from 1/4 inch below L to Q.

- Draw dart legs to waistline, and true by adding to shorter legs.
- Draw hip curves just above C to O, and to Q.

Figure 5

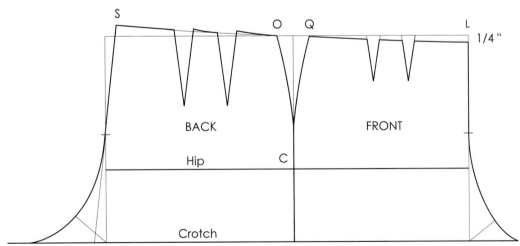

Figure 6

Back

D–V = One-half of D–I, plus 1/4 inch. Square up and down from V (grainline).

Front

D–W = One-half of D–M, plus 1/4 inch. Square up and down from W (grainline).

- Mark hemline widths (1/2 inch less for sizes under 10).
- *Outseams:* Draw straight lines from ankle marks to C (blend with hip line).
- *Inseams:* Mark 1/2 inch in from M and L and draw straight lines to ankle marks. Draw inward curved lines from I and M blending close to knee level.
- For trueing and seam allowance instructions, see pages 572–573.
- To develop a waistband, see page 240.

Figure 7

- Equalize side hipline.
- Measure distance between O and Q. Divide in half, and mark out from A equally. Draw adjusted side seam. Broken lines are original side.

Figure 7

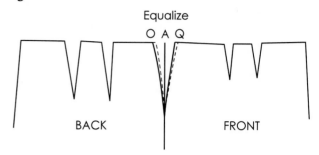

Figure 6

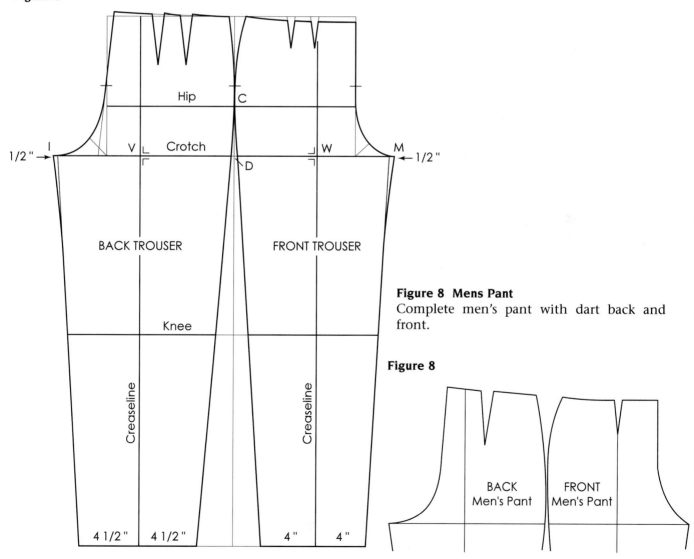

Figure 8 Mens Pant

Complete men's pant with dart back and front.

Figure 8

Slack—Foundation 3 (for Women and Men)

The slack foundation fits closer to the figure than does the trouser because of shorter crotch extensions. The shortened extension causes a slight cupping under the buttocks, creating the slack's unique fit. Pant designs based on the slack have a classic appeal for most women, especially those who are uncomfortable in the loose trouser and the contour-fitted jean. The slack foundation is very versatile as it may be worn as drafted, or adapted to countless other pant designs (see Pant Designs). It is a popular base for pant derivatives, such as the short, the jamaica, and the pedal pusher, to name a few. Men's and boys' trousers can be modified for a slack pattern.

Slack Draft

Figures 1 and 2

- Trace front and back trouser, omitting darts closest to side seam. For mens pants, use original darts and do not remove excess from side seams. Modify pattern using illustration and measurements as a guide.

- Shaded area indicates parts of the pattern that are cut away.
- Broken lines indicate original pattern shape.
- Bold lines indicate slack foundation.
- For trueing and seam allowance instructions, see pages 572–573. See page 240 for belt.

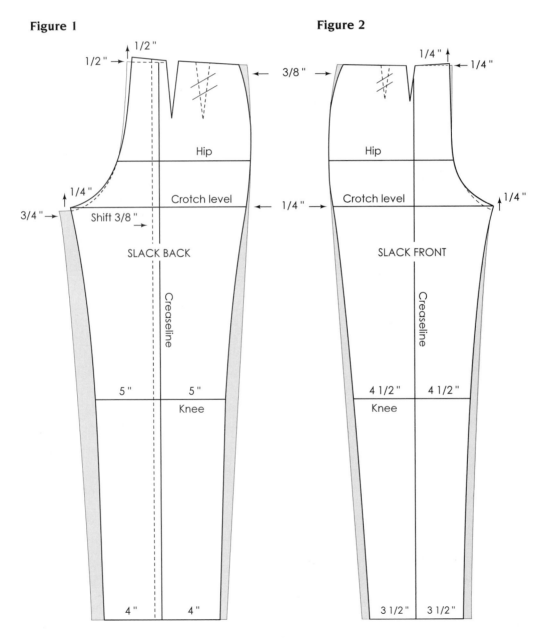

Figure 1

Figure 2

Jean—Foundation 4 (for Women and Men)

The jean foundation is drafted with a very short front and back crotch extension, resulting in a pant that contours the figure. The shortened extension causes a loss in crotch length; therefore, the center back waist is extended (pitched) far beyond the waistline of the draft.

The jean foundation is as versatile as other pant foundations. It may be used as drafted or modified for a variety of designs, such as the loose-fitting jean, bell-bottom, flare, Wrangler, and boot pant. (See Pant Designs.) It is also a common base for the short, jamaica, and other pant derivatives.

The jean draft can be adapted for boys and menswear pants. Measurements needed are noted by asterisks. See Chapter 2 for taking measurements.

Measurements needed

- (27) Pant length to ankle _____.
- (24) Crotch depth _____.
- (23) Front hip _____. Back hip _____.
- (19) Front waist _____. Back waist _____.

Jean Draft

Figure 1

A–B = Pant length.

A–D = Crotch depth. (Subtract 1/4 to 1/2 inch for higher crotch.)

D–C = Hip depth: one-third of D–A.

B–E = Knee depth: one-half of B–D plus 1 inch. Square out from both sides of A, B, C, D, and E.

Figure 1

KEY LOCATIONS

A Waist

C Hip

D Crotch Depth

E Knee

B Ankle

Figure 2

Back

C–F = Back hip, plus 1/8 inch (ease).

D–G = Same as C–F.

A–H = Same as C–F.

Connect G with H.

G–X = One-half of G–H, less 1/2 inch.

G–I = One-fourth for contour fit, or add 1 inch for a relaxed fit. (Add 1/4 inch for sizes over 14; subtract 1/8 inch for sizes under 10.)

Front

C–J = Front hip, plus 1/8 inch (ease).

D–K = Same as C–J.

A–L = Same as C–J.

Connect K with L.

K–X = One-half of K–L plus 1/2 inch.

K–M = 2 inches. (Add 1/4 inch for sizes over 14; subtract 1/8 inch for sizes under 10.)

Figure 2

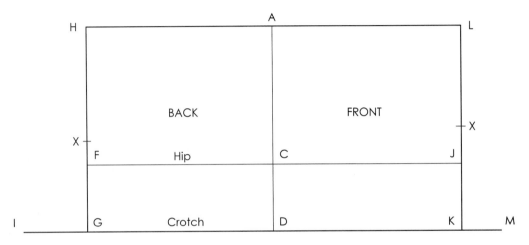

Waist and dart intake

If points O and R meet or overlap point A, don't be alarmed. Adjustment will be made later. See Figure 7.

Figure 3

Back

H–N = $1^3/_4$ inches.

N–O = Back waist, plus 1 inch (dart and ease included).

N–P = One-half of N–O.

Square down $3^1/_2$ inches from P.

Measure out 3/8 inch from each side of P, and mark.

Front

L–Q = 1/2 inch.

Q–R = Front waist, plus 3/4 inch. (dart and ease included)

Q–S = $3^1/_4$ inches.

Square down $2^1/_2$ inches from S.

Measure out 1/4 inch from each side of S, and mark.

Figure 3

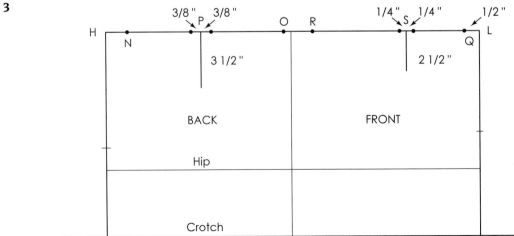

Figure 4

Back

N–T = 1 inch squared up from N.

Draw line from T to crotch level, touching X.

G–g = $1^3/_4$ inch diagonal line.

Draw curve with ruler touching X and g, at or near I. Blend at g, if necessary.

Front

Q–U = 1/4 inch squared up from Q.

Draw a line from U to crotch level, touching X.

K–k = $1^1/_4$ inch diagonal line.

Draw curve with ruler touching X, k, and M. Blend at k, if necessary.

Crotch level should measure from 1 to $1^1/_2$ inches more than upper thigh for a contour fit, and 2 to $2^1/_2$ inches for relaxed fit jeans. Add to or subtract from G–I extension line, if necessary.

Figure 4

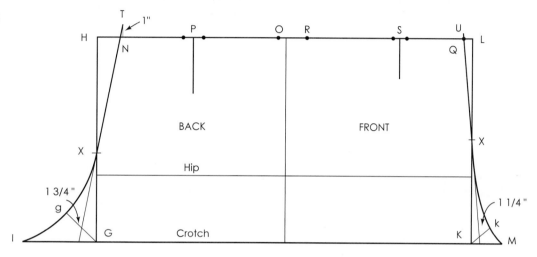

Figure 5

Back and front

- Draw slightly curved line from T to O and U to R.
- Draw dart legs from dart points to curve of waist-line.
- True dart legs by adding to shorter leg. Blend with side waist.
- Draw hip curves just above C to O and C to R. (If O and R overlap, go to Figure 7.)

Figure 5

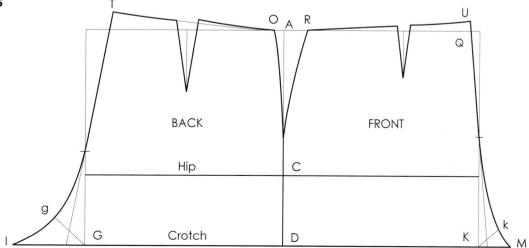

Figure 6
Back
D–V = 3/8 inch. Mark.
V–W = One-half of V–I.
 Square up and down from W.

Front
D–Y = 3/8 inch. Mark.
Y–Z = One-half of Y–M.
 Square up and down from Z.

Legline for test fit

- Measure out from both sides of grainline at hem and knee level using measurements given. Mark. (For hips 44 and over, add 3/4 inch to each side of back knee.)
- *Outseams:* Draw straight line from ankle marks and knee marks to crotch level. Use flattest inward part of the skirt curve to draw legline from just above knee to just past V and Y and blend outward curves to C. Draw inward curve to I and to M.
- Blend hip, if necessary.
- To develop the waistband, see page 240.

Figure 6

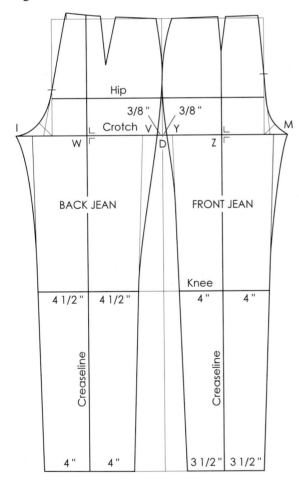

Figure 7

O *and* R *Overlap* Point A

Use red pencil to shape front hip and blue pencil to shape back hip as follows:

- Draw hipline curves from C to R and C to O equal to A–C measurement. Continue curve to crotch level.
- Mark centers at crotch level and square through pattern.
- Place paper under draft and trace back pant before separating and cutting front pant.

Figure 7

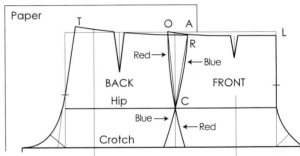

Dartless Jean Pant

Use the following illustration as a guide for eliminating waist darts. (Broken lines are original pattern.)

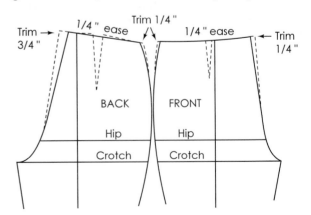

Note:
- For trueing and seam allowance instructions, see pages 571–572.

Variations of the Jean Fit

Close Fit Under Buttocks and Upper Thigh

Figure 1

The jean pant can be adjusted to fit closer by shortening the back crotch extension 3/4 to 1 inch. For a personal fit, the front and back crotch level should measure from 1 to $1^1/_2$ inches more than the upper thigh measurement. Recenter grainline and legline as illustrated.

Reestablish Crotch Length

Figure 2

Measure front and back crotch length. Spread center back to increase the measurement to amount needed. Adjust and blend center back seam.

Figure 2

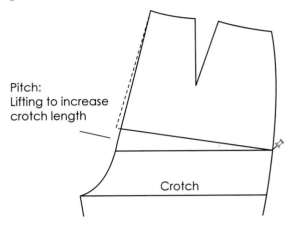

Figure 1

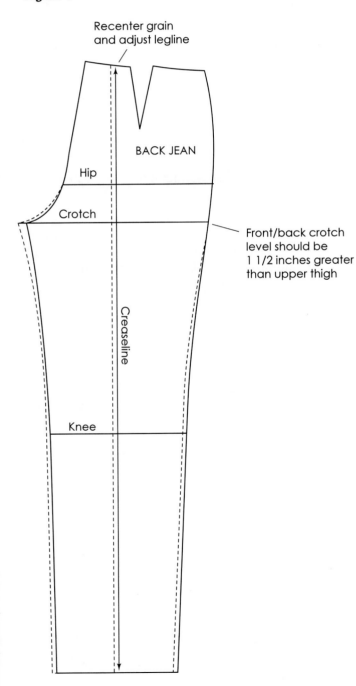

Completing the Pant Pattern

All patterns should be trued before cutting a garment for test fitting. Use the following information for all pant foundations and pant design patterns.

How to True the Pant Pattern

In order to keep the pant balanced, always true the pant by beginning at hemline and working upward. Blend seams where needed when trueing the leglines.

Figure 1

- Cut pant front from paper.
- Place on top of pant back, matching inseams at hem.
- Walk the pattern along inseams (using pushpin to control pattern), ending at crotch point of front pant. Mark and remove pattern. The back inseam may be longer than front.

Figure 2

- Draw new crotch curve from mark, and blend. (Shaded area is discarded from the back pant.)

 Note: More can be removed from the back inseam at crotch to eliminate bias stretch.

Figure 4

- *Option 1:* Notch the hip level and ease excess in between waist and hip notch.
- *Option 2:* Trim excess above mark at side waist, and blend waistline to dart leg.

 Note: The waistband for the pant should fit tighter than a skirt waistband. The waist is eased into the waistband.

Figure 1

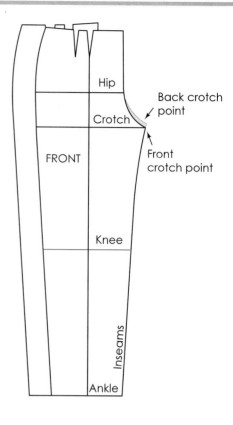

Figure 3

- Place front on top of back pattern, matching outseams at hemline. Walk pattern along outseam (using pushpin to help control pattern), ending at side waist. Mark and remove pattern.

Figure 2

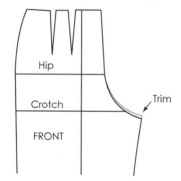

Figure 3

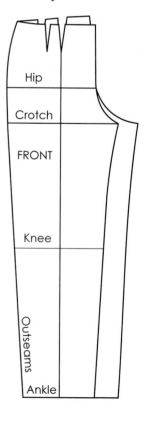

Figure 4

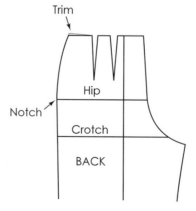

Seam Allowance

The pant foundations should remain seamless when used as a working pattern; however, experienced patternmakers generally work with seams. If seams are to be added to pant design patterns, extend lines out from each corner of the pattern as a guide for notching. Use the following seam allowances for test fitting and for pant design patterns. To test fit the basic foundation, add seams directly on the muslin.

Figure 1

- Waistline = 1/2 inch.
- Inseams = 1/2 inch.
- Outseams (side seams) = 1/2, 3/4 to 1 inch.
- Hemline (fold back) = 1 inch. Fold hem and cut to inseams and outseams.
- Around crotch = 1/2 inch.
- Zipper seam = 1/2, 3/4 to 1 inch. (Length of seam = 1 inch longer than zipper.)
- Zipper notch = 1/2 inch longer than zipper length.

 Note: For test fit, mark grainline, hip, crotch, and knee guidelines on muslin.

Figure 1

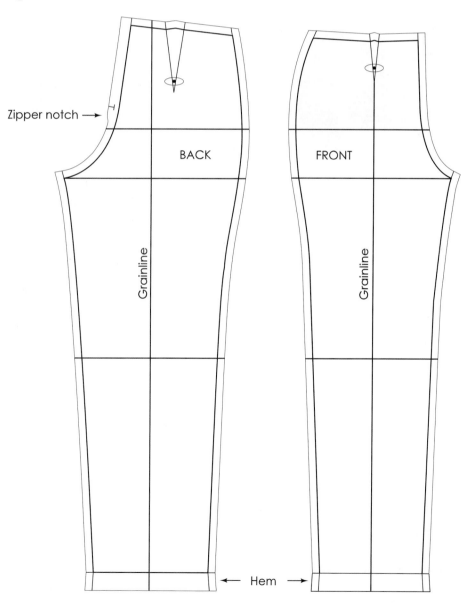

Zipper notch →

BACK

FRONT

Grainline

Grainline

← Hem →

Pant Designs

Box-Pleated Culotte

Design Analysis

The pant has a center front box pleat, stitched approximately 5 inches below the waist. The culotte back foundation completes the design. Additional flare is added to the center front extension to improve the hang of the pleat.

Figure 2
- Shift pattern 5 inches along guideline for pleat (pleat intake varies).
- Trace remaining pattern, starting at the center front. Label C.
- Draw parallel lines from points A and C to hem. Connect C with B at waist and blend hem.

Pattern Plot and Manipulation
Figure 1
- Place center front culotte foundation on paper. Secure, and square a guideline across pattern.
- Trace center front, crotch extension, hem, and $2\frac{1}{2}$ inches of waistline. (Broken lines indicate part of pattern not traced.) Label A and B.

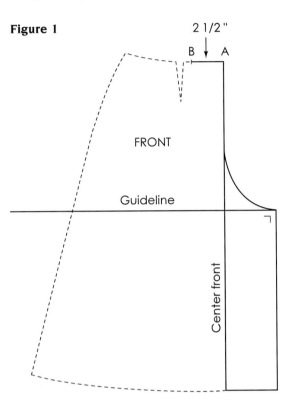

Figure 1

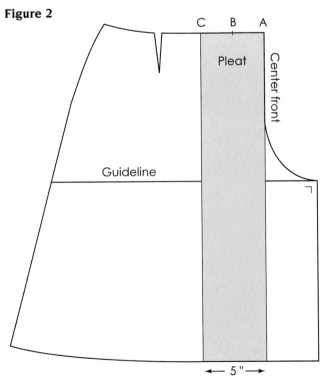

Figure 2

Figure 3

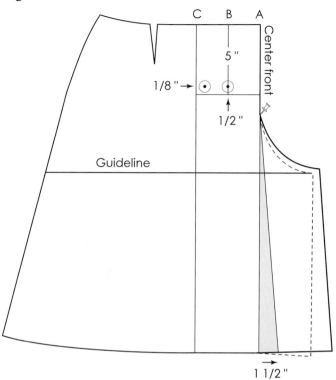

Figure 3

- *Pleat guidemarks:* Draw a 5-inch line down from B parallel with center front. Punch and circle 1/2 inch up on line, and 1/8 inch in from C line.

- For additional flare at center front and center back, place culotte foundation on top of traceoff. With a pushpin at crotch curve, swing pattern $1\frac{1}{2}$ inches away from center front at hem. Trace crotch extension. Blend hemline. (Broken line indicates original extension, lined section is added fullness for flare.)

- Trace culotte back foundation to complete the design. (If back pleat is desired, follow instructions given for front.)

- Draw grainline and complete pattern for test fit.

Gaucho Pant

The American designers' version of the gaucho, originally inspired by the South American gauchos from the Pampas region, has become a classic. Variations can be developed from the basic gaucho pant silhouette.

Design Analysis

The gaucho design ends just below knee level, but length may vary. The pant has additional flare at the center front and back of the crotch extension. Deep-cut pockets are part of the front design detail. The gaucho can also be developed from the slack foundation.

Pattern Plot and Manipulation

Figures 1 and 2

- Trace front and back patterns and all markings.
- Lengthen pant to 2 inches below knee level.

- Shift waist dart 1/2 inch toward side.
- Plot pocket section. Draw pocket style using measurements given. (See pockets, Chapter 17).

Figure 1

Figure 2

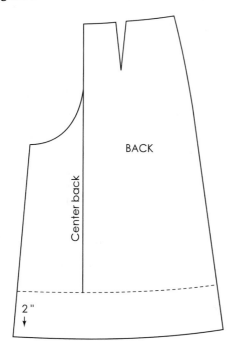

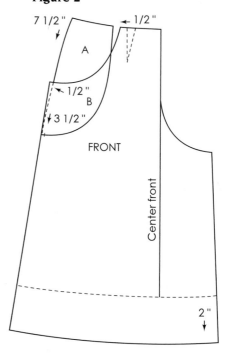

Figure 3

- Slip two sheets of paper underneath pocket section.
- Trace back side of pocket, section A, using original hipline shape (broken lines).
- Trace underside of pocket, section B.
- Remove paper and pencil in perforated line.

Figures 4 and 5

- Cut back side of pocket (section A) from paper.
- Cut underside of pocket (section B) from paper. Discard unneeded section above pocket curve (broken lines).

Figure 3

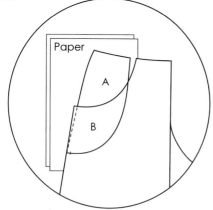

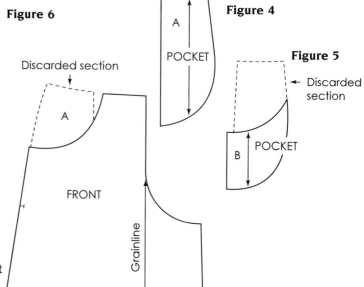

Figure 6

Figure 4

Figure 5

Figure 6 Gaucho front

- Discard section A (broken line).
- Draw grainline and complete pattern for test fit.

Culotte with Wide-Sweeping Hemline

To develop culottes with wide-sweeping hemlines for evening wear, use the suggested skirt silhouettes as a base. (See Chapter 13 for pattern development, if needed.) Add length and crotch extensions using instructions given for the culotte foundation, page 561.

- the slinky skirt (page 254);
- gathered waist with flare skirt (page 250); or
- dirndl skirt (page 253).

Pattern for culottes with full-sweeping hemlines may not fit the width of the fabric. In this instance, the overhang is separated from the pattern and placed elsewhere on the fabric. Use illustration (Figures 1 and 2) as a guide for modifying culotte for this problem.

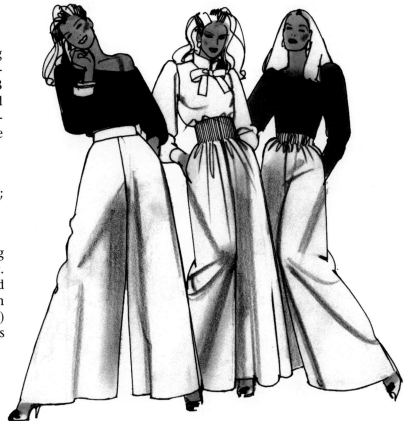

Figure 1

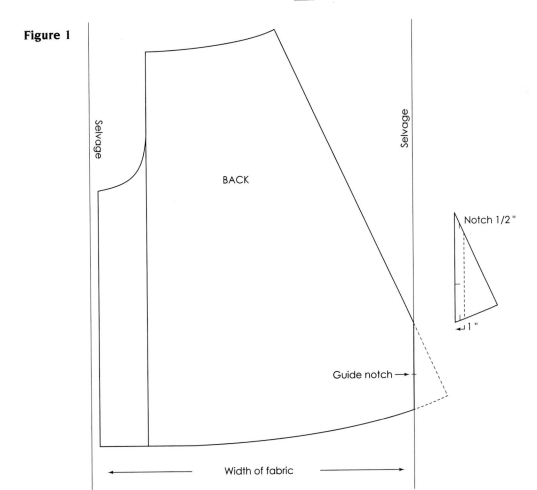

BACK

Notch 1/2 "

1 "

Guide notch →

Selvage

Selvage

Width of fabric

Pleated Trouser (for Women or Men)

Design Analysis

The pant design resembles a traditional trouser with a full front pleat (added fullness) and a smaller companion pleat (dart equivalent), seam pockets, and a basic waistline belt. The back trouser completes the garment detailing. The design is based on the trouser foundation for women's and men's trousers pages 562–565.

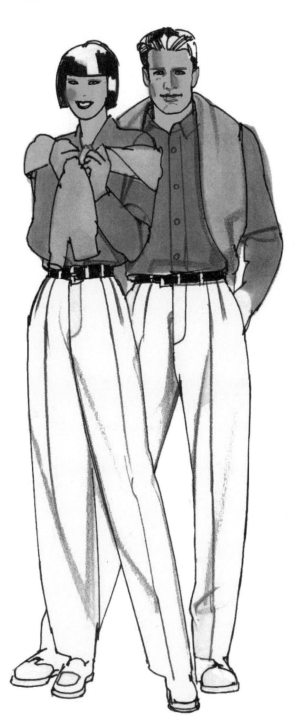

Pattern Plot and Manipulation

Figure 1

- Trace trouser front from grainline at hem to first dart leg (bold line). Omit section indicated by broken lines.

Figure 1

FRONT

Figure 2a, b

- With pushpin on grainline at hem, swing traced pattern out 2 inches (or more for deeper pleat). Trace remaining pattern to dart leg. Remove pattern.
- Notch for pleat control (lined area). Transfer dart excess to other dart by placing notch 1/2 inch out from dart leg. This is the second pleat.
- Blend hemline.

Trace trouser back pattern to complete design (not illustrated).

Men's pant—Shift dart 3/4 inch, add 1/2 inch to intake. (Total 1 inch intake). Add 1/2 inch to side seam.

Pocket:

For instructions for a pocket with control lining, see Chapter 17.

Figure 2b

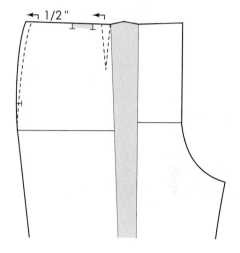

Figure 2a

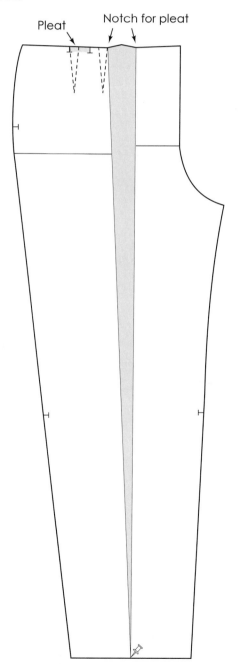

Baggy Pant (for Women or Men)

Pattern Plot and Manipulation

Figure 1a, b

- Draw a horizontal guideline across the paper.
- Place front and back patterns (women or men) on the paper, matching crotch levels with guideline. Space patterns at crotch 1 to 3 inches (or more) for added fullness. Trace.

Modify as follows:

- Add $1^1/_2$ inches to length of pant for overhang.
- Extend center front up $2^1/_2$ inches and square across pattern. Draw line to center back. (When folded, it becomes a casing for cord to pull through. Figure 1b.)
- Mark notch for foldover $1^1/_4$ inches down from top.
- Mark buttonhole 3/4 inch in from center front.
- Square down from crotch points to hem or taper legline.
- Draw pocket.
- Mark punch and circles 1/4 inch down and in from corners of pocket.

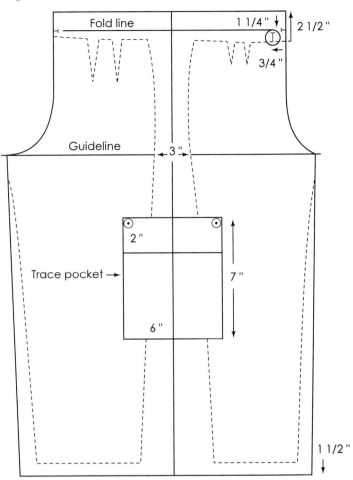

Figure 1b

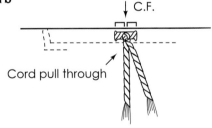

Cord pull through

Figure 2 *Hemband*

- Length = at least ankle and heel measurement. Width = 3 inches (finished width = $1^1/_2$ inches). If button and buttonhole are desired, add 1-inch extension; otherwise, the band is seamed together.

Figure 2

Pull-On Pant with Self-Casing

Design Analysis

A pull-on pant has elastic inserted in self-casing, causing slight gathering at the waistline that replaces darts. Pant should be cut in a firm knit and modified to offset stretch. The pull-on pant can be developed using any pant foundation. The slack pant is illustrated.

Pattern Plot and Manipulation

Measurement needed
* (2) Waistline circumference _____.

Figures 1 and 2
* Trace front and back of slack foundation.
* Extend waist up $2\frac{1}{4}$ inches (for 1-inch wide elastic).
* *Elastic:* Width = 1 inch. Length = waist measurement less $1\frac{1}{2}$ inches. Use 1/2 inch for overlap.

Figures 3 and 4
* When cut in a firm knit, trim pattern (shaded areas) by following illustrations. (For more information concerning knits, see Chapter 21).
* Draw grainline and complete pattern for test fit.

Figure 5 Casing
* Casing should be 1/4 inch wider than elastic to facilitate insertion. Use safety pin or bodkin to insert elastic.

Figure 5

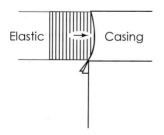

High-Waisted Pant (for Women or Men)

Pattern Plot and Manipulation

Figures 1 and 2

- Trace front and back pant and all markings.
- Flip patterns upward touching center front, center back, and sides at waistline. (Waistline is shown as broken lines.)
- Trace $2^1/_2$ inches up from waist of flipped pattern; include darts. (Broken lines are untraced part of pattern.)
- Remove pattern and draw line across top, parallel with waist.
- *Darts:* Extend line from dart points through center of darts ending at high waist. Measure out 1/4 inch on each side of back dart, and 1/8 inch on each side of dart front at high waistline. Draw new dart legs to waist.

Figure 1 **Figure 2**

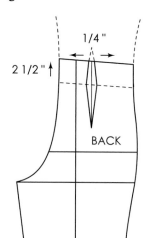
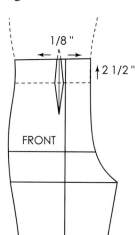

Figure 3

- Punch and circle darts. Notch dart legs at high waist.

Figure 4 *Facing*

- Trace 3 inches of front and back waist section.

Figure 4

Figures 5 and 6

- Close dart legs, trace with front facing blended, and cut on fold.
- Draw grainline and complete pattern for test fit.

Design Analysis

Waistline extends above the natural waist. Pant has cuffed hem, zipper back, and separate suspenders. The high-waisted effect can be developed using any pant foundation. The jean pant is illustrated. This pant is adaptable for menswear.

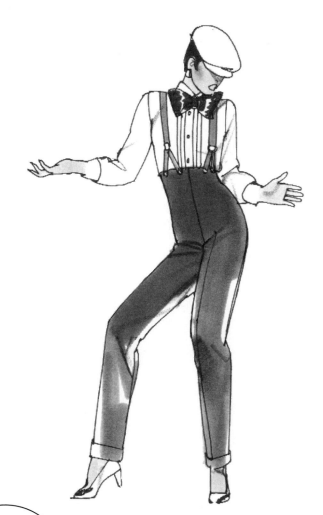

Figure 3

Figure 7
Cuff
Width—$3^1/_2$ inches, to finish $1^3/_4$ inches folded, (1/2 inch fold-under, and 1/2 inch for seam).

Length—Front and back hemline measurement, add seams.

Figure 5 **Figure 6**

Figure 7

Hip-Hugger

Design Analysis

The pant waistline falls 3 inches below the normal waist. A $1^1/_2$ inch-wide band simulates a belt. Fly front zipper opening. The hip-hugger effect can be developed with any pant foundation. The jean pant is illustrated.

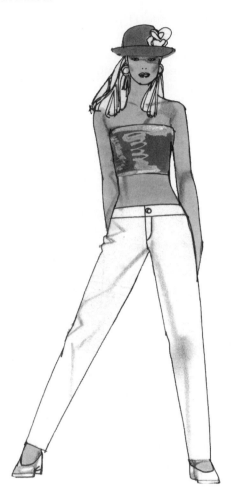

Figures 5a, b Fly front

- Length—$6^1/_2$ inches (for a 5-inch zipper), width—$1^1/_2$ inches.
- A folded extension for other side is the same length but doubled in width. (Figure 5b).
- Draw grainline and complete pattern for test fit.

Figure 5a **Figure 5b**

Pattern Plot and Manipulation

Figures 1 and 2

- Trace jean front and back and all markings.
- Draw a parallel line 3 inches below front and back waist (varies). (Broken line indicates unneeded sections.)
- Draw a parallel line 11/2 inches wide for belt (varies). Belt is indicated by angle lines.

Figure 1 **Figure 2**

Figures 3 and 4 Band

- Cut band section from pant. Place front and back bands together at the side and trace two copies. Extend front band 1 inch on the right side for button, with the other copy ending at center front for buttonhole. Blend.
- Notch side seams, center front, and center back.

Figure 3 and Figure 4

Jean with Back Yoke (for Women or Men)

Design Analysis

Design 1 features a waist having a contoured band with belt loops, a V-shaped yoke, and patch pockets in back. Legline is tapered. Design 2 has all the same features except that the hemline is widened to fit over a boot. The yoke effect can be developed using any pant foundation. The jean foundation is illustrated. The yoke back jean is adaptable to men's pants.

Measurements needed
- (31) Ankle plus 3 inches _____.
- (29) Knee measurement plus 2 inches _____.

Pattern Plot and Manipulation

Figures 1 and 2

- Trace jean front and back (women or men) and all markings. Mark for fly front (see page 583).
- Draw a parallel line $1\frac{1}{2}$ inches (or more) below waist for the belt section (lined area).
- Use measurements given or reduce legline to equal ankle and knee measurements. (Divide measurements into fourths and measure out equally from both sides of grainline at hem and knee level.)
- Follow illustration to plot yoke and pocket.
- Cut and separate patterns. Save sections indicated by lined area for contour belt.

Figure 1 **Figure 2**

1 1/2"

3"

5"

7"

BACK FRONT

4" 4" 3 1/2" 3 1/2"

3 1/2" 3 1/2" 3" 3"

Figures 3 and 4

- Trim remaining dart excess from both sides of the front waist, and at the center back waist. (Broken lines indicate original pattern.)

Figure 3 **Figure 4**

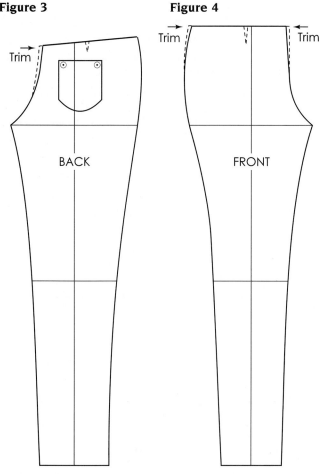

Figure 5 *Back yoke*

- Close dart and trace.

Figure 5

Figure 6 *Pocket*

- Slip paper underneath pocket section and trace. Punch and circle pocket placement 1/4 inch from corners as shown in Figure 3.

Figure 6

Figures 7 and 8

- *Contour belt:* Close dart legs. Tape. Place front and back sides together and tape. Trace four copies (two copies each for right and left side). The center back belt will be seamed. Draw 1-inch extension on right side belt for button attachment (Figure 7). Belt for left side will end at the center front (Figure 8). Notch between the center front and center back for belt loop placement. Notch side seam.

- *Belt loop:* Cut four strips 1 inch × $1^3/_4$ inches, plus seams (not illustrated).

 Note: If preferred, a straight belt can be drafted.

Figure 7

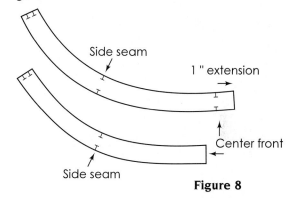

Figure 8

Figure 9 *Design 2—Boot legline*

- Measure out 1 inch or more at each side of hemline. Draw curved legline blending with knee.
- Draw grainlines and complete pattern for test fit.

Figure 9

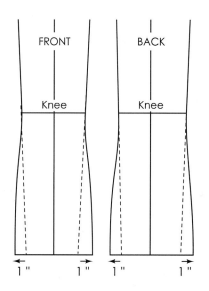

Contour Pant with Creaseline Flare

Design Analysis

The contour pant design is achieved by removing excess from under buttocks via a seam replacing the back creaseline. Pant hemline flares out at side and back seamlines, dropping low at center back and rising at center front. The design is based on the slack foundation.

Pattern Plot and Manipulation

Figure 1

- Trace pant back from side seam to creaseline (broken line indicates untraced section). Shift dart to creaseline to remove through the styleline.

- Measure in 1/2 inch from creaseline at crotch level. Label A.

- *Buttocks contour:* From point A, draw an inward curve blending with an outward curve to dart point. Continue curve from A to knee level.

- *Hemline flare:* Extend hemline $1^{1}/_{2}$ inches (more or less). Measure down $1^{1}/_{2}$ inches from creaseline. Mark. Measure down 1/2 inch at side seam. Mark. Draw straight lines from marks to knee levels. Draw curved hemline.

Figure 2

- Trace pant back from inseam to grainline (broken line indicates untraced section). Repeat the process for shaping pant.

Figure 3

- Trace pant front. Extend hemline $1^{1}/_{2}$ inches at side and inseam. Measure down 1/2 inch at each end. Draw straight lines from each mark to knee level. Blend inward curve at hemline as shown.

- Cut pant patterns from paper, discarding unneeded sections. Draw grainlines and complete pattern for test fit.

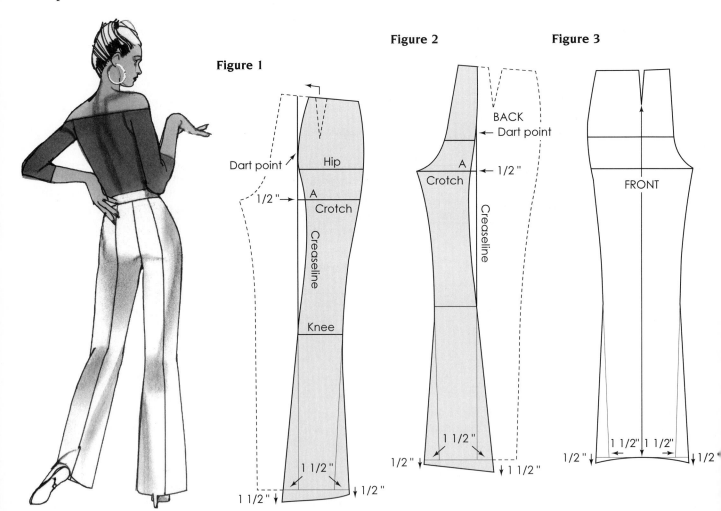

Pant with Flared Leg (for Women or Men)

Design Analysis

The hemlines of the designs have a flared or bell-shaped effect, starting at varying locations along the legline. Flared leglines can be developed on trouser, slack, or jean foundations.

Pattern Plot and Manipulation

The width or flare of a pant is usually determined by the fashion silhouette or personal preference. A method for adding width to the hemline is illustrated.

Figures 1 and 2

- Add length to pant (approximately 1 inch).
- Measure the *back* crotch level and divide in half. Measure out equally from each side of creaseline at hem using this measurement. Mark.
- Draw line from marks at hem to a location below, at, or above knee level.
- Square in from legline, blending to grainline at hem of pant.
- Repeat instructions for front, subtracting 1/2 inch from measurement.
- Draw grainline and complete pattern for test fit.

Flare above knee Flare at knee Flare below knee

Figure 1 **Figure 2**

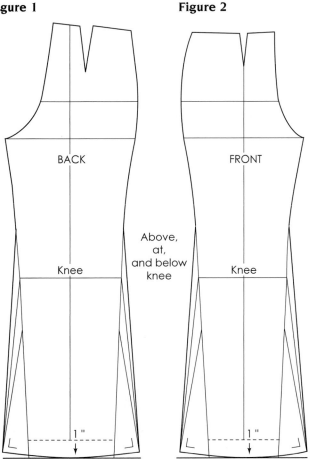

Pant with Curved Hemline

Design Analysis

Hemline curves upward in front and downward toward center back. The legline can be developed on the trouser, slack, or jean foundations (women or men).

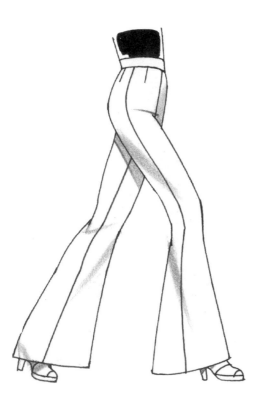

Pattern Modification

Figures 1 and 2

The following are approximate measurements:

- Extend grainline at hem $1^{1}/_{4}$ inches on pant front and back. Square lines across paper from the creaseline (broken line).

- *Front:* Measure up 1/2 inch from creaseline.

- *Back:* Measure down 3/4 inch from creaseline.

- Shape hemline with a curved rule. Hemline requires a facing $1^{1}/_{2}$ inches wide (not illustrated).

Figure 1 **Figure 2**

BACK FRONT

↓ 1 1/4 " ↓ 1 1/4 "

3/4 " 1/2 "

Pleated Cowl-Draped Pant

Design Analysis

Three deep-pleated cowls form along the front and back of each leg. The elongated legline is pushed up and held by the ankle. The pleated cowl effect can be developed using the trouser or slack foundation. The trouser foundation is illustrated.

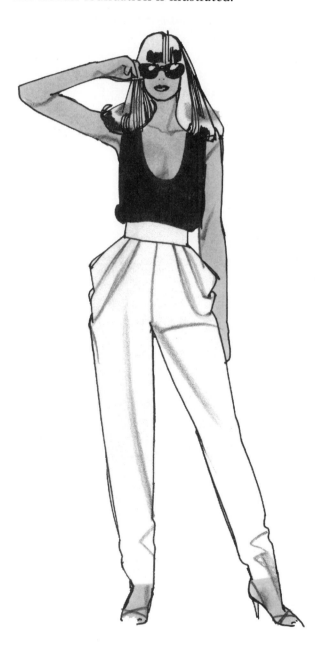

Measurement needed

- (31) Ankle plus 3 inches _____.

Pattern Plot and Manipulation

Figures 1 and 2

- Trace pant front and back. Crossmark crotch level and midpoint between crotch and knee. Draw knee and grainline.
- Extend length 5 inches.
- Equalize front and back dart intake. Add front and back dart excess together and divide into fourths. Adjust each dart to equal this amount and redraw dart leg ending $4\frac{1}{2}$ inches below waist. (Broken lines indicate original darts.)
- Draw slash lines from each dart point to crotch level mark and midpoint mark. (Cowls can be placed higher.)
- Taper hemlines to equal ankle measurement. Mark.
- Square up from hem marks.
- Draw new legline. (Shaded area is original legline.)
- Cut pants from paper.

Figure 1 **Figure 2**

4 1/2 "

BACK FRONT

Mid-point

Knee Knee

5 "

Figure 3 *Pant front*

- Cut slash lines to, not through, side.
- Place on paper and spread darts $1^1/_2$ to 2 inches (depth of cowl pleat). Secure with pushpins (see Figure 4).
- Extend grainline 3 inches up from waist (label A) and square out.

Figure 3

Figure 4

- Separate pattern at side seam and spread until side waist touches square line. If side waist does not reach the square line, redraw square line. Label B. Space sections equally and tape. Label D and E.
- Length B to C equals A to B. Square down from C, touching D, and draw outward curve from D, touching E, ending at knee level. Blend.
- Repeat for back.

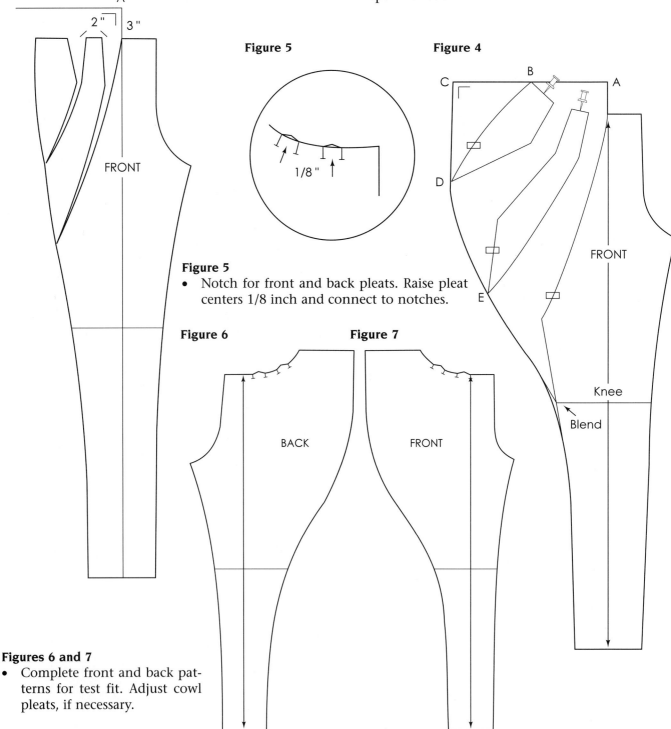

Figure 5

Figure 4

Figure 5

- Notch for front and back pleats. Raise pleat centers 1/8 inch and connect to notches.

Figure 6 **Figure 7**

Figures 6 and 7

- Complete front and back patterns for test fit. Adjust cowl pleats, if necessary.

Clown Pant

Design Analysis

A stylized pant with added fullness gathered evenly into the waistband, giving a puffy effect, tapering to a narrow hemline at ankle level. Scarf is pulled through a stylized waistband. The clown pant can be developed from the trouser or slack foundation (trouser is illustrated).

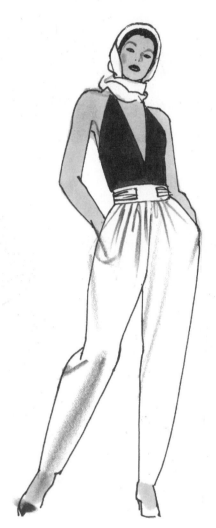

Measurement needed
- (31) Ankle plus 3 inches _____.

Pattern Plot and Manipulation
Figure 1

- Trace trouser front, back, and grainline from knee to hem level.
- Taper hemline by subtracting ankle measurement equally from hemline measurement.
- For a tighter hemline, an opening for a zipper or button is required for foot entry (unless cut in stretch knit).
- Cut patterns from paper.
- Cut slash lines from darts to knee, and from knee to inseams and outseams (hinge effect).
- Place slashed pattern on paper, spreading upward at knee. Spread approximately 5 inches (more or less).
- Square up from side seam at hip level for additional fullness.
- Retrace outline of pant. Blend across waistline.
- Draw continued grainline through pant and complete pattern for test fit.

Figure 1

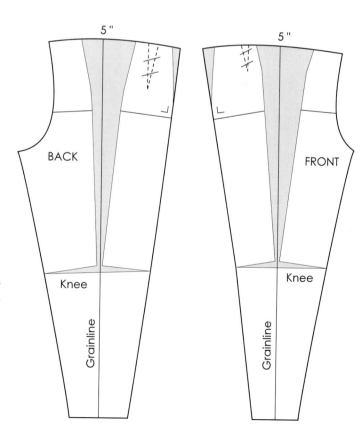

Figure 2 Belt
- Mark buttonholes of basic belt 3 inches out from center, spaced 2 inches apart for pull-through scarf. A regular belt may replace stylized version.

Figure 2

Geometric-Draped Pant

Design Analysis

Two designs are featured, with cowl folds appearing on the inside legline of Design 1 and on the outside legline of Design 2. Design 1 is illustrated. Design 2 is a thought problem.

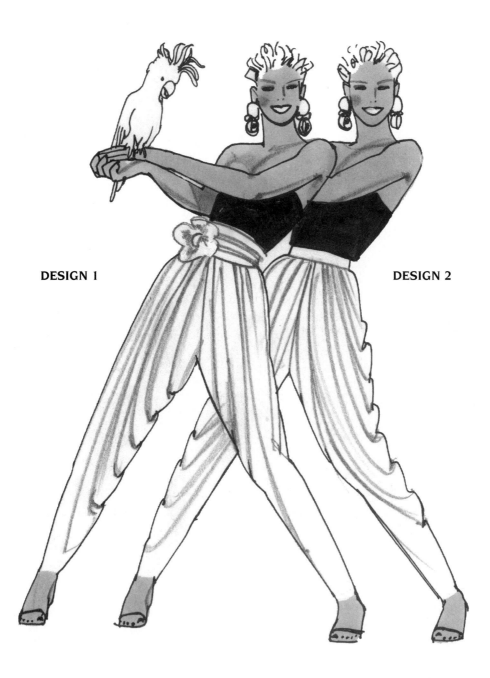

DESIGN 1 DESIGN 2

Measurements needed

- (31) Ankle plus 3 inches _____.
- (26) Pant length _____.

Paper needed
45-inch square. Fold paper to form a triangle.

Pattern Plot and Manipulation

Figure 1

Label corners of triangle A, B, and C.

A–D = 18 inches.

 Square down from D to fold line (represents center front and back to crotch depth).

E–F = One-half of ankle measurement. Locate this measurement on square rule and position it where it squares out from B–C line and touches fold line.

F–G = Pant length plus 1 inch (side seam). Square from G across paper (waistline).

 Cut from paper, discarding unneeded section (shaded areas).

Figure 1

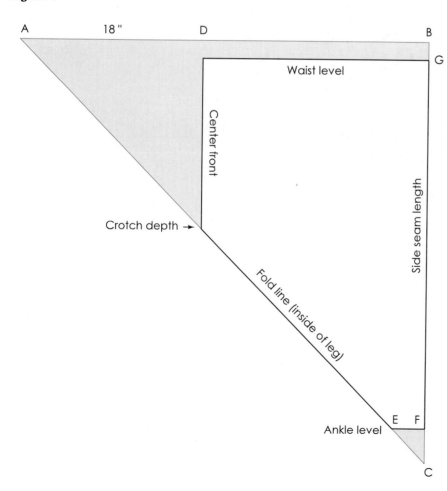

Figure 2

- Unfold and draw a curved line at entry, blending hemline.

Figure 2

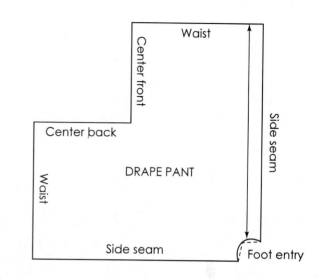

Figure 3

Figure 3 *Facing*

- Cut facing $1\frac{1}{4}$ inches wide. Draw grainline.
- The facing pattern is for one side of the pant front and pant back. Cut two to complete the garment for test fit. (Draft includes seams.)

Pant Derivatives

Pant derivative describes the length of a pant whenever its original hemline is raised or lowered. Pant length variations apply to all pant foundation patterns; however, the slack and jean are most commonly used for this purpose. For convenience, it is recommended that pant length markings be placed on all foundation patterns. When developing the pedal pusher, toreador, and capri lengths, provide an opening in the side seam at the ankle for ease of foot entry. Illustrated are common pant lengths, with their style names.

Shorty-shorts. One and one-half inches below crotch at inseam, ending 1 to $1^{1}/_{2}$ inches above crotch level at side seam (broken line).

Shorts. Two inches below crotch level.

Jamaicas. Midway between crotch and knee.

Bermudas. Between jamaica and knee.

Pedal pushers. Two inches down from knee.

Toreador. Between knee and ankle.

Capri. One inch above ankle.

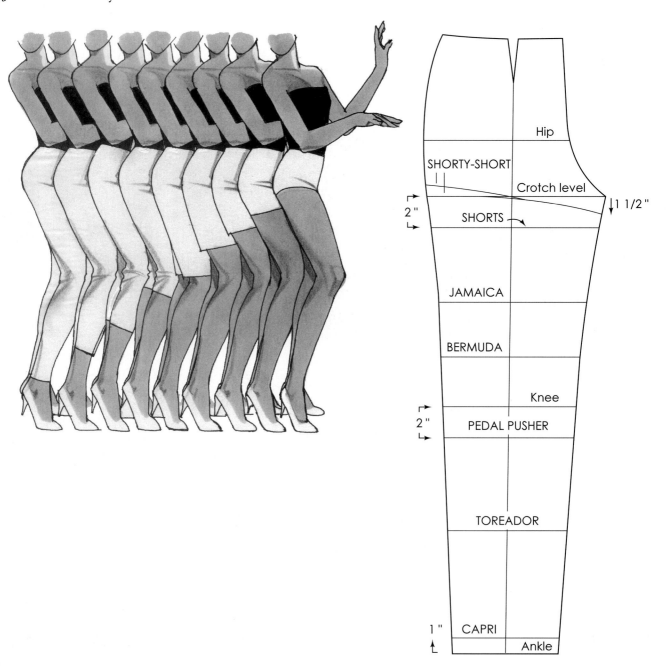

Shorty-Shorts

Figures 1 and 2

- Trace front and back to shorty-short styleline. Crossmark. Use pushpin to transfer the curve of legline within the pattern frame.
- Remove pattern and pencil in curved line.
- Draw slash line 3 inches from inseam.
- Cut from paper.

Figure 1

Figure 2

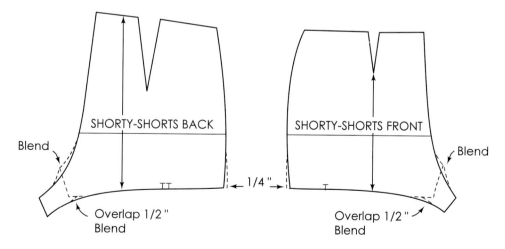

Figures 3 and 4

- Pivotal method can be used, or cut slash from leg to, not through, crotch curve.
- Overlap 1/2 inch. Tape.
- Place on paper and trace. (Broken lines indicate original pattern.)
- Blend new legline and crotch curve. Reduce side seams 1/4 inch. Mark notches.

Figure 3

Figure 4

Figures 5 and 6

- Develop facings as shown.

Figure 5

Figure 6

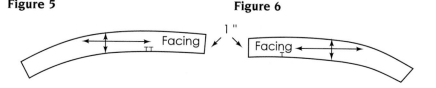

Shorts

Figure 1 **Figure 2**

Figures 1 and 2

- Trace front and back pant to shorts length. Include all markings.

- *Inseam:* Measure in 1/4 inch.

- *Outseam:* Measure in 1/2 inch and blend with hipline.

- *Foldback:* Add 1 to $1\frac{1}{2}$ inches to length of pant. Fold along hemline and trace sides. Unfold and pencil in shape.

- Complete pattern for a test fit. (Adjust legline on figure, if required.)

Jamaicas

Figure 1

Instructions apply to front and back. Front is illustrated.

- Trace front and back to jamaica length. Include all markings.

- *Inseam:* Measure in 1/4 inch.

- *Outseam:* Measure in 3/8 inch. Redraw legline to crotch level.

- *Foldback:* Add $1\frac{1}{2}$ inches to length of pant. Fold along hemline and trace sides. Unfold and pencil in shape.

- Complete pattern for a test fit. (Adjust legline on figure, if required.)

Figure 1

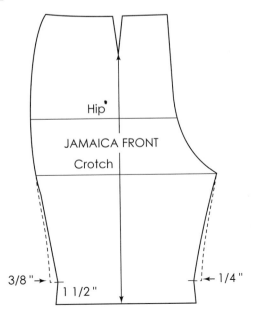

Bermudas

Figure 1

Instructions apply to front and back. Front is illustrated.

- Trace front and back to Bermuda length. Include all markings.
- *Inseam:* Measure in 1/2 inch.
- *Outseam:* Measure in 1/2 inch. Redraw legline to crotch level.
- *Foldback:* Add 1 to $1\frac{1}{2}$ inches to length of pant. Fold along hemline and trace sides. Unfold and pencil in shape.
- Complete pattern for test fit. (Adjust legline on figure, if required.)

Figure 1

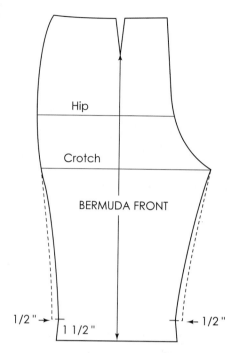

Hip

Crotch

BERMUDA FRONT

1/2 " → 1 1/2 " ← 1/2 "

Pedal Pushers

Figure 1

- Trace front and back to pedal pusher length. Include all markings.
- *Inseam:* Measure in 1/2 inch.
- *Outseam:* Measure in 1/2 inch. Redraw legline to crotch level. Hemline instructions follow.

Figure 1

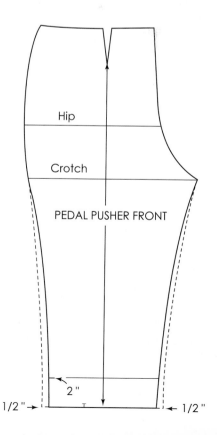

Hip

Crotch

PEDAL PUSHER FRONT

2 "

1/2 " → ← 1/2 "

- *Hemline:* Place notch at least 2 inches up from outseam for bent knee action. Add 1 to $1\frac{1}{2}$-inch hem. For foldback facing, see instructions given for Bermuda pant, or make separate facing, as follows:

Figure 2

- Facing: Place front and back inseams together and trace legline $2\frac{1}{2}$ inches up from hem. Remove pattern. To finish facing, draw line parallel with hem.
- Complete Pattern for test fit. (Adjust legline on figure, if required.)

Figure 2

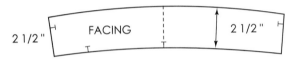

Toreador

Figure 1

Instructions apply to front and back. Front is illustrated.

- Trace front and back to toreador length. Include all markings.
- *Inseam:* Measure in 1 inch.
- *Outseam:* Measure in 1 inch. Redraw legline to crotch level.
- For foldback or separate facing, see instruction given for the bermuda or pedal pusher.

Capri

Figure 1

Instructions apply to front and back. Front is illustrated.

- Trace front and back to capri length.
- *Inseam:* Measure in 1 inch.
- *Outseam:* Measure in 1 inch. Redraw legline to crotch level.
- For foldback or separate facing, see instruction given for the bermuda or pedal pusher.
- Complete pattern for test fit. (Adjust legline on figure, if required.)

Figure 1

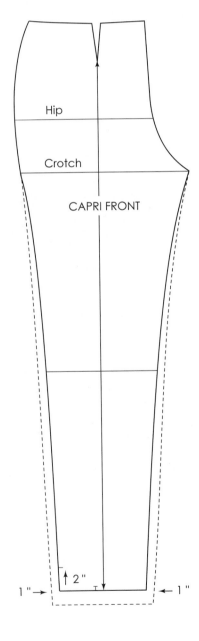

Figure 1

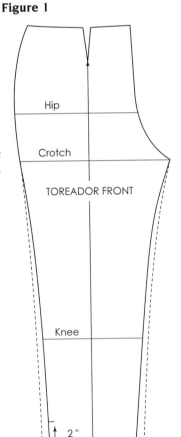

Design Variations

The following practice designs are included to stimulate the imagination of the designer and patternmaker. Each design utilizes concepts and instructions from previously developed skirt and pant designs. For example, Design 1 is based on a flared skirt and Design 8 on the baggy pant. Each pant design may be developed to any length desired. If the finished design looks like the sketch, the pattern was correctly developed.

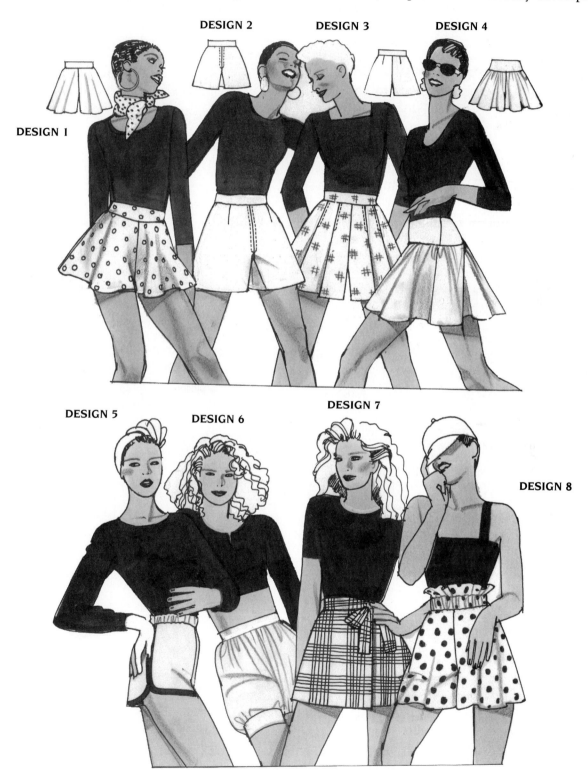

DESIGN 1 DESIGN 2 DESIGN 3 DESIGN 4 DESIGN 5 DESIGN 6 DESIGN 7 DESIGN 8

Jumpsuit Foundations

The jumpsuit can be based on any of the four pant foundation patterns (or any pant design). It can be developed as a one-piece or two-piece jumpsuit foundation (seamed at waistline) or as a combination of both. Once developed, the foundation should not be altered but used as a base for other designs. Jumpsuit designs with sleeves are developed from the basic or dartless pattern. Suggested styles are illustrated at the end of the jumpsuit series.

Trouser/Slack Jumpsuit Foundations

Note: The following instructions apply to both the trouser and slack jumpsuit foundations. Trouser pant is illustrated.

Figures 1 and 2

- Trace front and back torso and all markings. Crossmark midway between waist and hip at center front and back.
- Place pant front and back on traced torso, matching hip level and center lines of the torso.
- *Important:* Creaseline of pant *must* be parallel with the center front and center back of torso. If not, place pushpin on pant at crossmark and pivot pant pattern, until creaseline grain is parallel.
- Trace pant pattern from hem to hipline. Transfer creaseline of pant to paper with pushpin. (Broken line indicates untraced pant pattern above hip level.)
- Remove pattern. Draw grainline through pant and torso.
- Lower front and back crotch 1/2 inch. Blend crotch and hipline of pant with torso.
- For convenience, draw bust circumference and contour lines on bodice (see Chapter 9).
- Hipline of torso extending beyond hipline of pant is trimmed. Blend.
- Complete pattern for test fit. (Draw hip, crotch, and knee lines on muslin.)

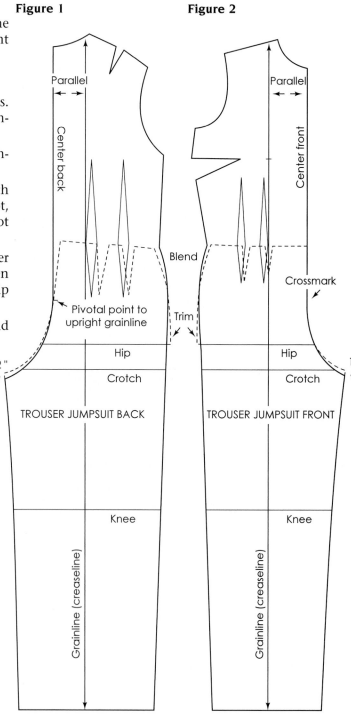

Figure 1 **Figure 2**

Jean Jumpsuit Foundation

The jean foundation has a high pitch at center back. The pitch (seating room) is eliminated by overlapping the pant to align with the torso (causing a loss in the overall crotch length). For this reason, the jean jumpsuit should be cut in a knit (double knit) or spandex to provide ease of movement. When cut in a rigid fabric, the back should be developed in two pieces as a separate jean pant back and bodice back (not illustrated). Jean shown on page 602.

Figures 1 and 2

- Trace torso front and back, omitting one dart (broken line). Locate midpoint between waist and hip at centerlines and crossmark 1 inch below.

Figure 1 **Figure 2**

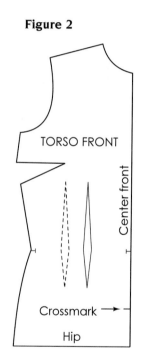

Figures 3 and 4

- Place jean pant front and back on paper, matching hip level and touching centerlines at crossmarks.

- *Important:* Creaseline of pant *must* be parallel with center front and center back of torso. If it is not, place pushpin on pant at crossmark and pivot pattern until creaseline grain is parallel with center front and back.

- Trace pant pattern from hem to hipline. Transfer creaseline of pant to paper underneath with a pushpin. (Broken line indicates untraced pant pattern above hip level.)

- Remove pant pattern. Draw grainline through pant and torso.

- Remove 1/4 inch from the side and blend with the hipline of the pant as shown.

- For convenience, draw bust circumference and contour lines on bodice (see Chapter 9).

- Complete pattern for test fit. (Draw hip, crotch, and knee lines on fabric.)

Figure 3 **Figure 4**

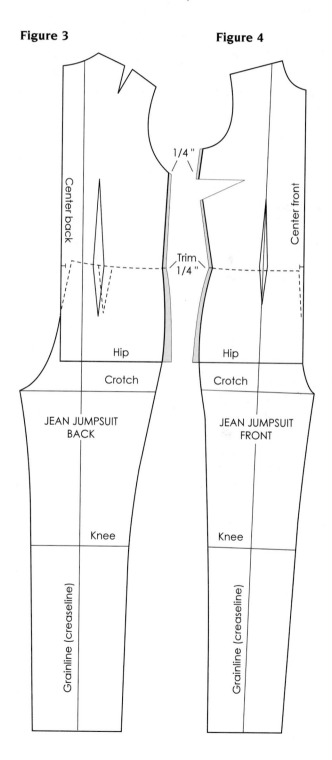

Jean Jumpuit

Culotte Jumpsuit Foundation

Figures 1 and 2

- Trace torso front and back, allowing ample paper for culotte foundation. Include all markings. Label A and B, as shown.
- Place culotte on torso, matching hip and center lines. Draw centerline and crotch extensions of the culotte. Crossmark at centerline at hem.
- For flare at centerlines, place pushpin at the center front and center back (between crotch and waist), and swing pattern out 2 inches at hem. Redraw crotch extension. Remove pattern and blend hemline.
- Add for additional flare at side seam if desired.
- For convenience, draw bust circumference and contour lines on bodice (see Chapter 9).
- Complete pattern for test fit. (Draw hip, crotch, and knee lines on muslin.)

Culotte Jumpuit

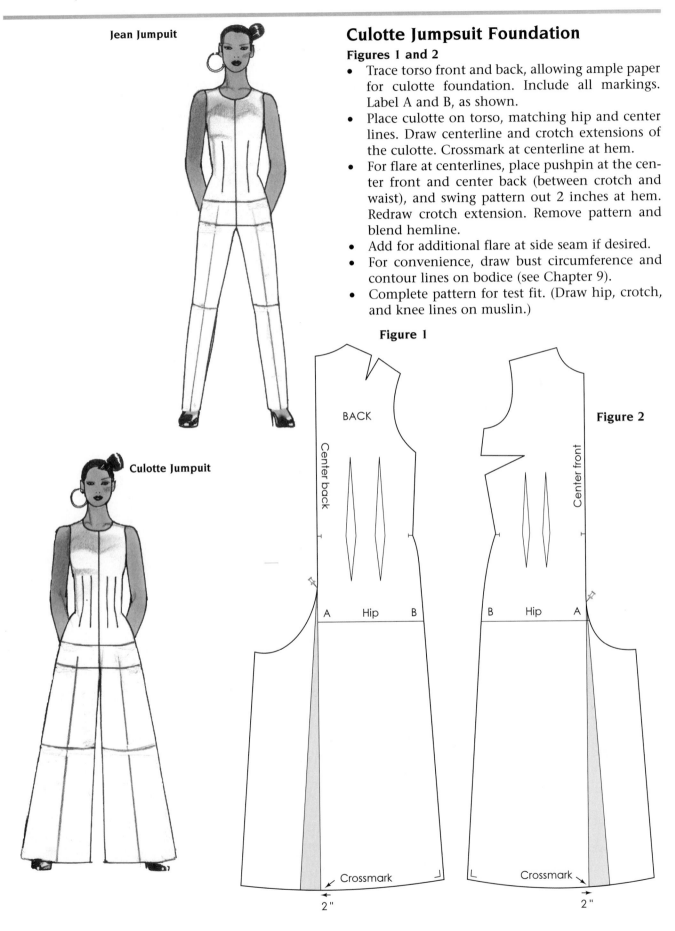

Figure 1

Figure 2

BACK

Center back

A Hip B

B Hip A

Center front

Crossmark

2"

Crossmark

2"

Mini Coverall

Design Analysis

The legline of the mini coverall is cut short and rolled. The back has a curved yoke with gathers at the seamline. It is finished with deep pockets.

Pattern Plot and Manipulation

Figures 1 and 2

• Use the illustration as a guide for plotting the pattern. The broken lines indicate the trouser foundation not needed for the design. The pant may be made looser by adding more to the side of the pattern. Strap width is from $1\frac{1}{4}$ to $1\frac{1}{2}$ inches.

Figure 1

Figure 2

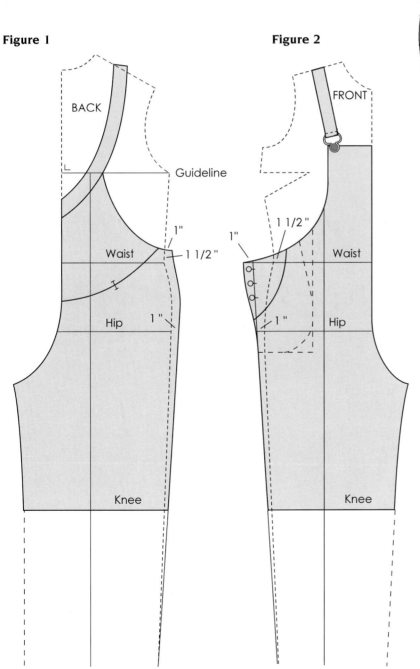

Figures 3 and 4

- The separated back patterns are shown. More fullness can be added to the back by pivoting the pattern out a greater distance from center back.

Figures 5 and 6

- Pocket facing and backing are traced from the front pattern.

Figure 5

POCKET FACING

Figure 6

POCKET BACKING

Figure 3

TOP BACK

Figure 4

2"

BACK

Knee

Figure 7

- Strap is joined at the shoulder and self-faced (4 copies).

Figure 7

STRAP

Fold

Shoulder

Oversized Jumpsuit

Design Analysis

The collarless, beltless design is oversized with a large styled patch pocket ending into the side seam. Either a banded or an accordion pocket can be substituted (see Chapter 17). The armhole is lowered and the excess from the side dart is placed into the armhole. The casual sleeve is appropriate for the design (see page 484). The trouser jumpsuit is illustrated.

Pattern Plot and Manipulation

Figures 1 and 2

- Trace front and back patterns.
- Raise back shoulder tip 1/2 inch. Shift pattern 2 inches. Redraw armhole. Lower armhole 2 inches. Mark.
- Measure in 3/4 inch (or more) from each side of the leglines, and draw a line up to the new armhole.

 C–D = A–B measurement.

 G–H = E–F measurement.

- Draw front and back armholes.

(Use 3/4 to 1 inch shoulder pads.)

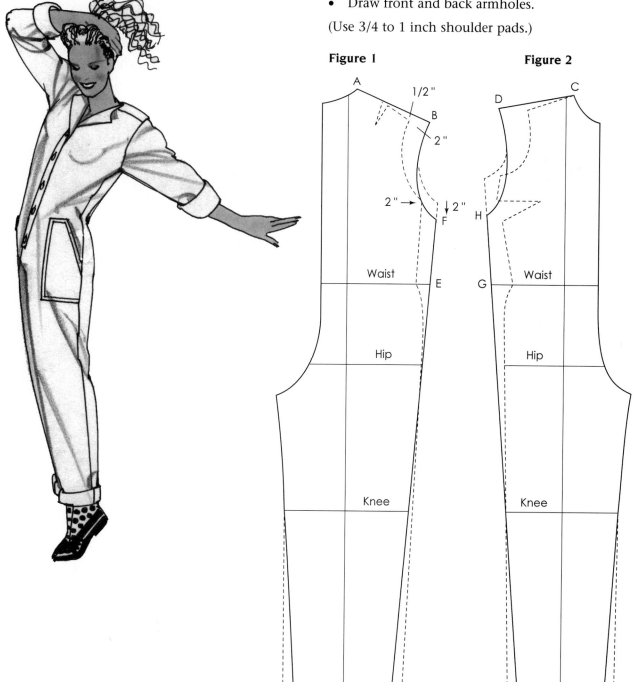

Figure 1 **Figure 2**

Great Coverall

Design Analysis

The coverall has a trouser bottom and shirtmaker top, with large patch pockets, yoked back, and shirtmaker sleeve. Waistline gathers are controlled by an inserted elastic (stitched partially above and below the waistline) drawn through a pleat-like opening slit, where it is attached to a tab that buttons in front. Center front has zipper to waistline. Design is based on the shirtmaker (Chapter 20) and the trouser foundation (page 562); however, any pant and any top can be combined to achieve the jumpsuit effect.

Measurement needed

- (2) Waist measurement _____.

Pattern Plot and Manipulation

Figures 1 and 2

- Trace front and back trouser. Mark notch placements for first dart leg, but omit tracing darts. (Broken lines indicate original pattern.)

Modifying trouser pant

- Square up from hiplines at the side seams of the front and back trouser. (For wider leglines, add to side seams.)
- Add 1/2 inch to the center back. Draw line to blend with crotch.
- Blend line across the waistline.
- *Front pant:* Draw a 1-inch line down from notch placement of first dart leg parallel with the center front.

Figure 1 **Figure 2**

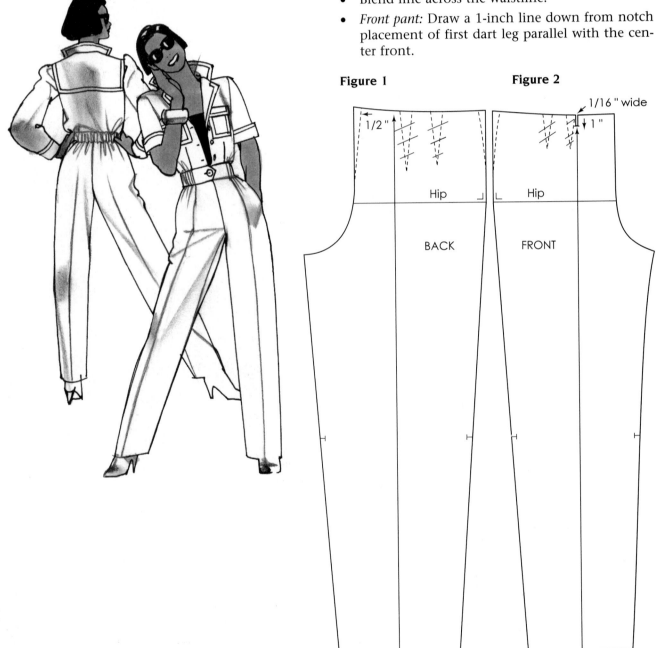

Figures 3 and 4 Modifying shirt

- Trace front and back shirt. Trace collar with stand and shirt sleeve. (Set aside for use with the completed pattern; not illustrated.)

- *Front shirt:* Square a line 1/2 inch below waist, starting from facing and ending 4 inches past center front. Draw a blending curve line from this point, ending 1 inch below waist at side.

- Square a 1-inch line up from new waistline equal to slit placement on pant. (Measure in from the center front for slit placement.) Slit opening is cut 1/16 inch wide. Notch across end of slit by folding pattern.

- Adjust width of waistline to equal width of front pant. Blend line to armhole at side. (Broken lines indicate original pattern.)

- *Back shirt:* Square a line 1 inch below waist of the center back, ending at the side.

- Adjust new waistline to equal width of the back pant. Blend line to armhole.

Figure 3

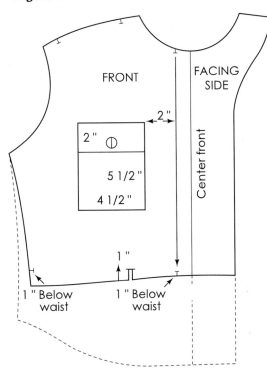

Figure 4

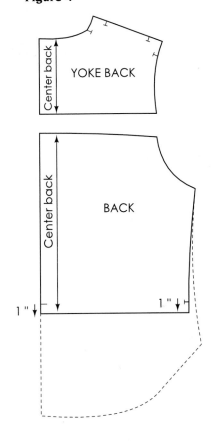

Figure 5 Pocket

- Place paper under draft of shirt and trace pocket. Add flap to traced copy, or draft pocket using measurements given.

Figure 6 Belt tab

- Width = $1\frac{3}{4}$ inches. Length = From slit to fold-back of facing, plus 1-inch extension. Draw point as shown. *Special information:* Elastic length = 7 to 8 inches less than waist measurement. Elastic can be attached in one of two ways (see Figures 7 and 8).

Figure 5

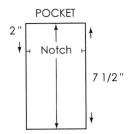

Figure 6

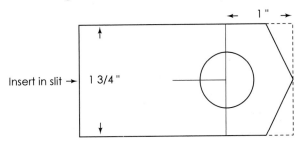

Figure 7
- Elastic may be slipped through casing which is stitched above and below the waist.

Figure 7

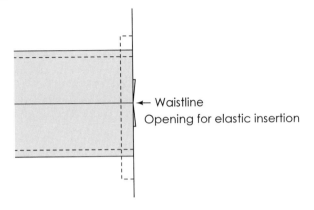

← Waistline
Opening for elastic insertion

Figure 8
- Elastic can be centered between waistline, stretched, and zigzagged to the edge of the garment.
- Tab is inserted in slit and stitched after elastic is attached.

Figure 8

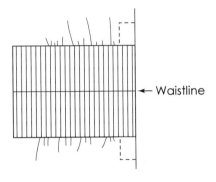

← Waistline

Jumpsuit Design Variations

The following designs are given as practice problems. Develop patterns for each design, or design other variations. The finished garment should look like the design. If it does not, locate the problem and try again.

26

Knits—Stretch and Shrinkage Factors

Introduction

Knits are some of the most popular fabrics in the market today, primarily for the following reasons:

- *Structure:* Knit fabrics are made of natural and synthetic fibers.

- *Versatility:* Knits are suitable for dressy, daytime, and active wear.

- *Stretchability:* Knits have the capacity to stretch in length or width or both (in addition to the bias stretch common to all fabrics).

Many manufacturers and designers devote part or all of their lines to knit designs. The patternmaker should be knowledgeable about the special characteristics of knits and their stretch and recovery factors so that a good fit can be achieved with a minimum number of corrections. This is accomplished by modifying the pattern before cutting in knit.

Stretch and Recovery Factor

The ability of a knit fabric to stretch and return to its original shape (length and width) is referred to as the fabric's *memory*. (See the Stretch and Recovery Gauge, page 611.)

The *stretch factor* is the amount of stretch per inch that occurs when the knit is stretched to its maximum length and width. The stretch factors of knits range from 18 to 100% or more.

The *recovery factor* is the degree to which a knit will return to its original shape after being stretched. Knits with good recovery are those that return to their original length and width when released. If the fabric does not return to its original dimension, or close to it, the garment will eventually sag on the body and lose some of its original shape.

There is a variance in the degree of stretch among knits and the degree of stretch between the length and width of each specific knit. Knits that stretch in both directions are two-way stretch knits.

If some of the stretch is not removed from garments made with a blended Lycra, the garment will sag on the figure. To remove stretch, the pattern is reduced in its length and width as designated by the stretch of the fabric. To determine the stretch of knits, use the stretch gauge as illustrated on page 611. Buy the type of knit appropriate to the garment's use.

Stretch and Recovery Gauge

Ruler at edge of page is used to determine the stretch and recovery factor of knits. *Suggestion:* Make a copy of the ruler, glue on cardboard, and take it with you for testing when buying knits. To use stretch gauge ruler, follow instructions:

Determining the Stretch and Recovery Factor of Knits

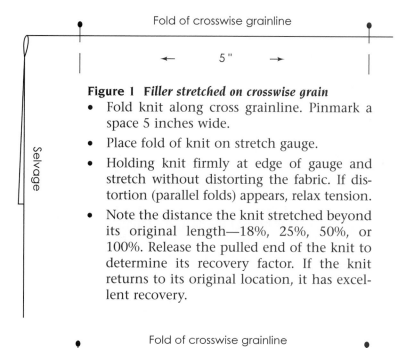

Fold of crosswise grainline

← 5 " →

Selvage

Figure 1 *Filler stretched on crosswise grain*

- Fold knit along cross grainline. Pinmark a space 5 inches wide.
- Place fold of knit on stretch gauge.
- Holding knit firmly at edge of gauge and stretch without distorting the fabric. If distortion (parallel folds) appears, relax tension.
- Note the distance the knit stretched beyond its original length—18%, 25%, 50%, or 100%. Release the pulled end of the knit to determine its recovery factor. If the knit returns to its original location, it has excellent recovery.

Fold of crosswise grainline

← 5 " →

Selvage

Selvage

Figure 2 *Warp stretch on lengthwise grain*

- Repeat the process with the knit folded on the length grainline. If the stretch and recovery are not compatible with the type and use of the garment, do not use the knit. Test knits until the correct selection is made. Fabric for a bodysuit, leotard, or maillot should have a 50 to 100% stretch factor in one or both directions. If a knit does not have good recovery, do not consider using it for a bodysuit, leotard, or maillot. It will sag rather than contouring the body as a second skin.

Some knits stretch beyond 100 percent

Classification of Knit Fabrics

Knits come in many fibers: cotton, antron, and nylon to name a few. When combined with Lycra spandex or Lastex latex, the fabric will vary in weight, texture, direction, and degree of stretch and shrinkage.

Lycra (spandex) is a manufactured fiber in which the fiber-forming substance is a long-chain synthetic polymer comprised of at least 85% of a segmented polyurethane. The Du Pont Company introduced the first spandex fiber called Lycra in 1958. Du Pont (the leader) has issued standards for Lycra spandex for activewear garments:

- Must have a minimum of 12.5% elongation.
- Must withstand power of at least 0.6 pounds per square inch to insure good recovery under wet and dry conditions.
- Must have zero pullback after 3,000 flex cycles.
- Must have a lycra content of at least 0.6 ounces per square yard to insure working stretch.

Lycra spandex may be combined with antron, nylon, and cotton for swimwear, bodysuits, and leotards. Spandex has the ability to spring back to its original shape when stretched (referred to as its memory). After repeated stretching it shows only a small increase in length.

Lycra allows the body to move with complete freedom when in a flexed position:

Across the back: Flex movement from 13 to 16%.
Elbow flex:
Length—35 to 40%.
Circumference—15 to 22%.
Seat flex: Across—4 to 6%.
Knee flex:
Length—35 to 45%.
Circumference—12 to 14%.

There are single-knit and double-knit fabrics; however, knits can generally be classified in the following ways:

Stable (firm) knits. A stretch factor of 18% on the crosswise grain. (Example: 5 inches will stretch to $5^7/_8$ inches.) This type of knit has a limited degree of stretch and will retain its original shape well. Fit is similar to that of a garment cut in a woven fabric. Example: Double knit in any fiber.

Moderate-stretch knits. A stretch factor of 25% on the crosswise grain. (Example: 5 inches stretches to $6^1/_4$ inches.) Combines characteristics of both stable and stretchy knits. Generally used for sportswear when stretch is used for comfort and a close fit, but should not be used for garments contouring the figure. Example: Nylon tricot.

Stretchy knits. A stretch factor of 50% on the crosswise grain with 18 to 50% on the straight grain. (Example: 5 inches will stretch to $7^1/_2$ inches.) Because it is stretchy and lightweight, stretchy knit drapes well and is used for garments that contour the figure. This type of knit is suitable for bodysuits, leotards, maillots, and clinging dresses and tops (provided the knit has an excellent recovery factor). Example: cotton/spandex, nylon/spandex, cotton/latex, nylon/latex. Any fabric containing spandex or latex.*

Super-stretch knit. A stretch factor of 100% in the lengthwise and crosswise grain. (Example: 5 inches stretches to 10 or more inches.) Its excellent stretch and recovery make it suitable for bodysuits, leotards, and skiwear, as well as tops. The elastic fiber of this type of knit can stretch many times its length and yet return to its original measurements. Examples: Any fiber blended with spandex or latex.*

Rib knits. A stretch factor of 100% (1×1 ribs will stretch less than 2×2 or 3×2). Used for tops and banding. (Example: The "knit two, purl two" traditional wristband stitch.) Rib knits are dependent on the *knit pattern* used, as well as on fibers.

Direction of Stretch

Knits can also be classified by the direction of stretch in the following ways:

Warp stretch. Stretch yarns run lengthwise.

Filling stretch. Stretch yarns run crosswise.

Two-way stretch. Stretch yarns run in both the length and crosswise directions.

To utilize the built-in stretch of knits, the maximum stretch should *encircle* the figure when knits are used for dresses, jackets, pants, and tops. The maximum stretch should go *up and down* the figure for bodysuits, leotards, jumpsuits, and skiwear to allow for maximum mobility.

*See Chapter 27—Activewear and Chapter 28—Swimwear.

Adapting Patterns to Knits

There are two reasons for adapting a pattern to knit fabrics: The shrinkage factor requires the size of the pattern to be enlarged, and the stretch factor requires the size of the pattern to be reduced. The choice is determined by the type of knit and use of the garment.

White (C) = Enlarged pattern
Shaded (B) = Original pattern
White (A) = Cloth pattern

The Shrinkage Factor

For loosely fitted garments, shrinkage is considered to be the most important factor. Therefore, the pattern is enlarged to compensate for shrinkage. To do this, the shrinkage factor must be known.

Enlarging the Pattern

Figures 1 and 2

- Cut garment parts. (The torso and sleeve are used as the example.)

- Wash and dry the fabric. Place pattern on top of the fabric, aligning the centerline and waist of the torso, and the grainline and biceps line of the sleeve. [White area indicates the garment part (A), the shaded area the original pattern (B), and the outside white area the new enlarged pattern (C).]

- Enlarging the pattern: Draw guidelines out from the corners of the fabric pattern and working patterns. Measure the distances from the cloth pattern and the working pattern at each guideline. Use these measurements to mark the distances out from the working pattern at each location. Draw new pattern by connecting lines from one mark to the next, blending curved lines. True the patterns when cut.

Note: Placement of garment parts on pattern may look different from the illustrations, but the process for developing the enlarged pattern remains the same.

Figure 1

Figure 2

The Stretch Factor

Knits with varying stretch and recovery factors (firm knits and stretch knits), require different methods for reducing the pattern. Three methods are discussed.

Reducing the Pattern

To determine how much a pattern's length and width should be reduced, follow the examples and measurements given for knits with a stretch factor from 18 to 25%. *For knits stretching beyond 25% but less than 50%, add 1/8 inch to all measurements given below.* The measurements are general and may require additional adjustments at the time of the fitting. Knits shrink when washed. This should be considered before fitting a garment close to the figure. The basic front bodice, skirt, sleeve, and pant are illustrated and should be used as guides for all simi-lar pattern modifications. (Broken lines indicate original patterns.)

Figures 1, 2, and 3 Bodice, skirt, and pants

- *Neckline:* Raise 1/4 inch. Blend. Back neck is not adjusted unless neckline is deeply cut.
- *Side seams:* Remove 1/4 inch (parallel with original line of pattern). Repeat for back. Remove 1/4 inch from inseam of pant.
- *Armhole:* Raise 1/2 inch. Blend. Repeat for back.
- *Dart points:* Raise 1/4 inch where shown.
- *Hemline and waistline:* Remove 1/4 inch (parallel with original hem or waist of pattern).
- *Crotch:* Raise 1/4 to 1/2 inch (amount depends on style of pant). Example: 1/2 inch for trouser, 1/4 inch for slack or jean. Repeat for back.

Figure 1

Figure 2

Figure 3

Figure 4

Figure 4 Sleeve

- *Biceps:* Raise 1/2 inch. Blend.
- *Underarm seam:* Remove 1/4 inch (parallel with original line of pattern).
- *Hem:* Remove 1/4 inch (parallel with original hemline of pattern).
- *Elbow dart:* Reposition 1/4 inch up.

27

Knit Foundation

Knit Top Foundations

Three dartless knit drafts are illustrated: Draft 1—tops cut in two-way stretch and tubular knits; Draft 2—tops cut in firm knits (double knits, for example); and Draft 3—oversized knit tops. All are based on the torso foundation pattern. For information about knits, see Chapter 26.

Several designs are illustrated. Use previous information to develop patterns for the designs shown below (or design others) using one of the knit foundation patterns. *Note:* Knit garments stitched on an overlock machine require 3/8-inch seam allowances; otherwise use 1/2 inch. There are a number of textbooks devoted to handling knits. Read them for instruction on stitching and ribbing attachment. To use a foundation as a base for dresses, extend the length of the pattern.

Dartless Stretchy Knit—Draft 1

Front and back pattern pieces are drafted together, with the only differences being in the shape of the front armhole and shape of the front and back necklines. The patterns are separated after the draft has been completed.

Pattern Development
Figure 1
- Trace back torso as indicated by bold lines. Omit sections indicated by broken lines.
- Move pattern upward on centerline 1/2 inch and draw approximately 3 inches of armhole.
- Label shoulder at neck A, shoulder tip B. For closer fit, measure in 1/2 to 1 inch at waist from side seam and draw new side seam.

Figure 2
- Place front torso on top of back draft, matching *hip* and *centerlines*.
- Trace corner of center front neck, shoulder at neck, shoulder tip, and bust point. Omit sections indicated by broken lines.
- Remove pattern. Draw bust circumference for reference when developing stylelines and necklines. Label shoulder-neck C and shoulder tip D. (Line-up of patterns may appear different from illustration.)

Figure 1

A

Mark corners

B

BACK

↑1/2"

←1/2" to 1"

Figure 2

A

C

D

B

Figure 3
- Draw guideline through A and C and mark midpoint. Label E.
- Locate midpoint between D and B. Label F.
- Draw a straight line from E to, or through, F equal to front shoulder length. From E, draw a blending curve to center back neck and center front neck (establishing new neckline).
- With french curve, draw armhole, blending curve with lower armhole.
 Personal fit: Narrow shoulders and large bust pose a problem when blending the armhole. Extend shoulder 1/4 to 1/2 inch and blend armhole.
- Cut pattern from paper.

Figure 3

Figure 6

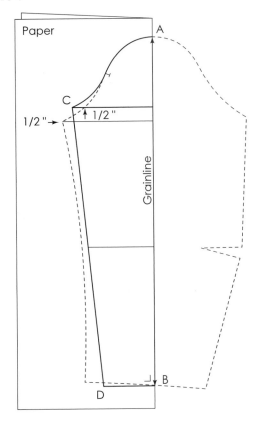

Separating Front and Back Patterns

Figure 4
- Place paper under draft; pin and cut for back pattern. Label *Knit back*.
- Measure armhole and record.

Figure 5
- Trim front neck from original pattern. Label *Knit front*.
- Trim 1/8 inch from curve of armhole and blend.
- Using one-fourth of the waist and hip measurements, draw a reference side seam. Use the line for fitted garments cut in Lycra-blended fabrics.

Figure 4 **Figure 5**

↑ Line for fitted garment ↑ Line for fitted garment

(*Note:* When using rib knit, draw straight side seams of front and back patterns to avoid runs in the knit.)

Figure 6 *Knit sleeve*
- Fold paper. Place basic sleeve front on paper with center grain on foldline and trace.
- Mark biceps, elbow, and notch. Remove. Label grainline A–B. (Broken line indicates original sleeve.)
- Measure in 1/2 inch on biceps line. Mark. Square up 1/2 inch from mark and label C. Square new biceps line from fold to point C. Erase original line.
- Blend new armhole curve with cap.
- Square a line from B equal to one-half of wrist (plus 1/4 inch) measurement. Label D.
- Draw a slightly inward curved line from D to C.

Figures 7 and 8 S*leeve adjustment*

- Sleeve cap should measure 1/4 inch more than armhole (1/2 inch total). Measure sleeve cap and compare with armhole measurement.
- If cap measurement is less than armhole, extend biceps and blend with cap.
- If cap measurement is more than needed, measure in from biceps and blend new cap.
- Draw line to elbow or wrist level.
- Mark center cap notch.

Figure 7

Figure 8

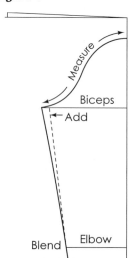

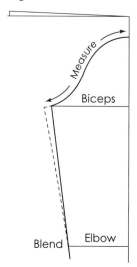

Dartless Firm Knit—Draft 2

Figures 1 and 2

- Trace torso foundation pattern, transferring shoulder and side dart to armhole. The armholes have been enlarged. The front is greater than the back. Measure to find the difference. Record.

 Example: The front armhole is 3/4 inch greater.

- Add 1/4 inch to back shoulder.
- Subtract 1/4 inch from front shoulder.

 Add 1/2 inch to back side seam and subtract 1/2 inch from front seam. Draw lines to waist, as illustrated.

Sleeve

The sleeve cap of the basic sleeve should measure 1/2 inch more than front and back armholes. If it does not, follow instruction given in Figures 7 and 8. To adjust the patterns for the stretch factor, see page 614.

Figure 9

- Cut sleeve from paper. Unfold.
- Complete sleeve. Label *Knit sleeve*. The sleeve is shaped equally on both sides.
- Add seams to all patterns (1/2 inch, or 3/8 inch for overlock stitch).

Figure 9

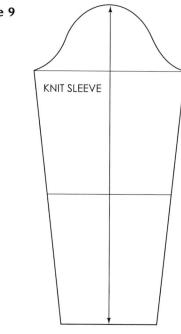

Figure 1

Figure 2

Oversized Knit Top—Draft 3

The oversized knit top has a special sleeve drafted to accommodate the modified armhole. Front and back patterns are drafted together and separated when the draft has been completed. For information on the theory of the modified armhole and sleeve, see page 484.

Oversized Cotton Knit Draft
(Based on the dartless knit top, page 616)

Figure 1

- Square a line on paper.
- Place the dartless pattern on the square.
- Trace the neckline and end at mid-shoulder.
- To oversize the pattern, shift from 1 to 3 inches with the hip level on the squared line.
- Trace the remaining pattern and remove.
- Draw shoulderline from shoulder tip to neck.
- Lower the armhole 3 or more inches.
- Draw armhole and measure for the sleeve draft.
- Record in space provided on page 620.
- Place back dartless knit pattern on top of the tracing, matching the centerline and hipline. Trace back neckline.
- Square a line up from hip to armhole.

Figure 1

Figure 2

Figure 2

- Place paper underneath pattern and trace for the back copy.
- Trim back neck from front pattern.

Ribbing

- Trim the neckline equal to ribbing width (allow 3/8 inch seam). Measure the neckline. Cut ribbing to this length.
- The ribbing is stretched to the neckline. The unused length is subtracted from the neck measurement.

Sleeve **Draft**

Measurements needed
- Sleeve length _____.
- Armhole measurement of pattern _____.
- Around hand measurement _____.
 See Chapter 2.

Figure 4
- Draw a line in middle of paper, equal to sleeve length less 3 inches. Label A–B, and fold paper on line.

 A–C = 3 inches (biceps level).
 Square out from C.
 B–D = One-half of B–C (elbow level).
 Square out from D.
 A–E = Armhole measurement.

- Draw a line equal to armhole measurement, touching biceps line. Divide into fourths. Using illustration as a guide and using measurements given, draw sleeve cap.

 B–G = One-half of around-hand measurement.

- Draw a line from F to 1/2 inch in from E and draw curved line from E, blending to line.

- Complete the pattern, cut, and stitch to knit top. The sleeve can be modified for other designs.

Figure 4

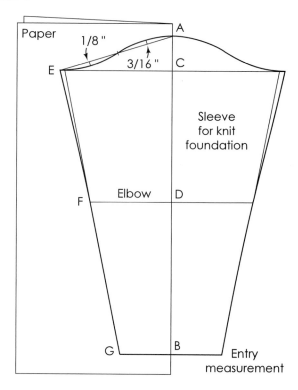

Crop Top with a Muscle Sleeve

Design Analysis

The knit top fits close to the figure, indicating that a ribbed knit or Lycra should be the fabric of choice. The top fits under the bust and has a scooped neckline. The sleeve fits to the muscular arm, making this an ideal garment for exercising. The top can be based on the stretchy knit foundation.

Figure 1
Trace the dartless foundation and draw the outline of the top front and back, as illustrated.

Figure 1

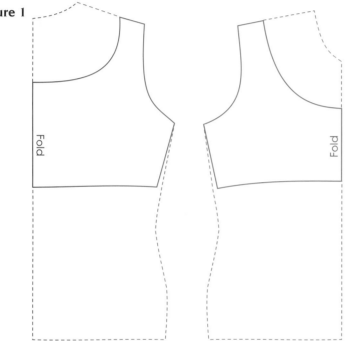

Figure 2
Sleeve

- Trace knit sleeve.
- Draw a line 2 inches up from biceps.
- Pivot sleeve to the new biceps line 3 inches down from cap. Trace.
- Repeat for the other side of the sleeve.
- Blend capline of the sleeve.
- Complete the sleeve, following the illustration.

 Cap should measure 1/2 inch greater than armhole. Add to or subtract from the new biceps measurement.

Figure 2

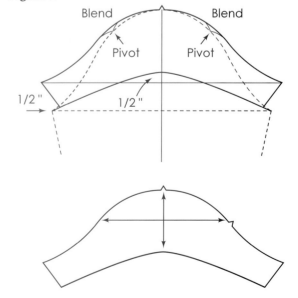

Knit Top

Design Analysis

A popular shirt design is based on the oversized cotton knit foundation. The top has a placket (see pages 398–402 for guide) and rib collar.

 The ribbed collar can be cut from knit yardage, or ordered with a finished edge and to the size needed.

Figure 1a, b, c

- Trace oversized dartless foundation on fold.

Placket inset

- Draw 3/4 inch from center to length desired.
- Add seam allowance and cut out this section.
- Draw placket on fold $1\frac{1}{2}$ inches wide and equal to the length of the opening. Trace a second copy. Add seam allowance.

Sleeve

- Trace sleeve and shorten, allowing for hemline.

Figure 1a, b, c

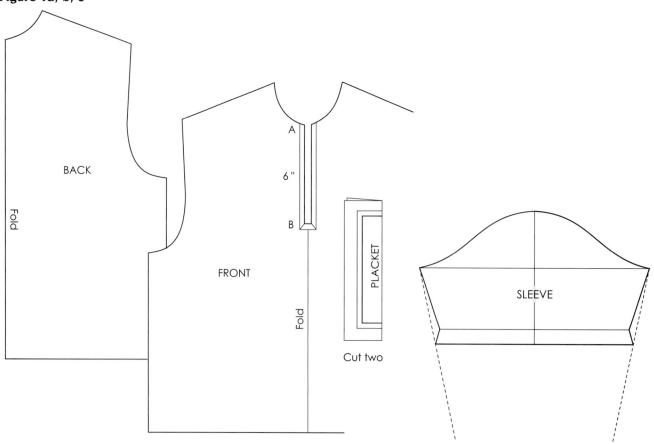

28

Actionwear for Dance and Exercise

Bodysuits and Leotards

Actionwear is a classification of garments designed to allow complete freedom of movement for physical activities and sports. The bodysuit and leotard are ideal for such purposes. To be functional, the bodysuit and leotard should be cut in two-way or four-way stretch knits having from 30 to 100% stretch and recovery in both directions. Suitable knit fabrics are those combined with spandex (synthetic) or latex (rubber). Popular choices are nylon spandex, cotton spandex, nylon latex, and cotton latex. Study Chapter 26 before purchasing knits for these garments.

Bodysuit Foundation

The bodysuit foundation can be drafted with the use of the torso pattern, the dartless knit pattern, on the basic back pattern as illustrated. The bodysuit draft includes 3/8 inch seams and foldback for the leg hem. The knit sleeve draft is used for both the bodysuit and leotard. The length of the pattern is placed on the knit in direction of the greatest stretch. The front and back are drafted together and separated at completion of the draft.

Measurements needed

- (19) Front waists arc _____.
- (23) Front hip arc _____.
- (24) Crotch depth _____.
- (27) Waist to ankle _____.
- (30) Knee _____.
- (32) Ankle _____.

The Bodysuit Draft

Figure 1
Transfer shoulder dart to armhole.

Figure 2
The shaded pattern helps to indicate line placement.
Trace back pattern, starting 1/4 inch from neck (A) and ending at the side seam of the armhole (B).

Figure 1

BACK

Figure 2

A 1/4"

BACK

B

Figure 3

- Shift pattern until neck touches (A).
- Trace neckline and centerline to waist.
- Mark 1¹/₂ inch up from waist (C).
- Square a line from C (waist level).

Figure 4

*C–D	=	Waist arc (19), less 1/2 inch.
		Draw a line from D, 1 inch past B. Draw and blend new armhole.
		Measure armhole and record _____.
		Shape side seam.
		Draw front neckline 1¹/₂ inches below back neckline.
C–E	=	Draw line for crotch depth, less 1¹/₄ inches.
*E–F	=	Hip arc (23), less 1/2 inch square from E.
E–G	=	One-third of E–F. Square line out from E. Draw 1³/₈ inch angle line. Label H. Draw crotch curve. (Curve may cross inside the angle line.)
G–I	=	One-half of G–F. Square a line up and down from I. Label waist J.
J–K	=	Waist to ankle (27), less 3 inches.
I–L	=	One-half of I–K, minus 1/2 inch.
		Square out one-fourth of knee plus 1/4 inch, and ankle plus 1/4 inch from each side of guideline. Mark. Draw lines from ankle marks, just past knee marks. Draw inward curved lines, blending with G, and just past F at hip.

*If milliskin knit (4-way stretch) is used, subtract 1¹/₂ inches from waist and hip arc.

Notching Guide

There are two types of notches used for knit fabrics:
1. Notch to a depth of 1/8 inch.
2. Cut pyramid shapes out from the seam line edge—1/4 inch wide, and 1/8 inch high (Δ).

Figure 3

Figure 4

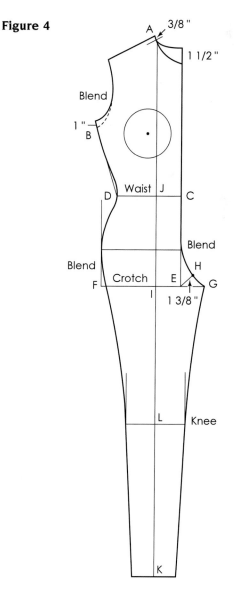

Figures 5 and 6 *Separate patterns*

- Place paper under the draft and secure.

- Cut pattern from paper and separate. Label the undercopy *Back Bodysuit,* and draw direction line.

Center back options

The center back may be shaped for a closer fit when required. See page 637, Figure 4 (indicated by broken lines).

- Trim to front neckline of the draft, and draw direction line on the pattern. Label *Front Bodysuit.*

- The bust point and circumference line is marked on the pattern at the time of fitting (Figure 5). For sleeve draft, see page 628.

Figure 5

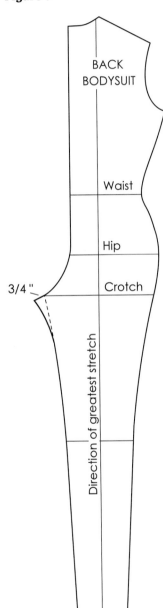

Figure 6

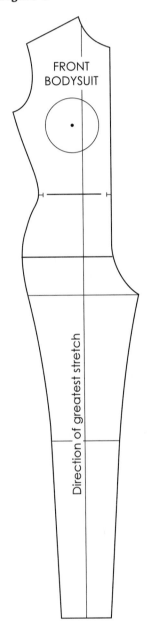

Method for Correcting Pattern to Improve Fit

The bodysuit should be cut in knit, stitched, and test fitted on the figure. Mark bust point and below bust to rib. Check for looseness or tightness in the length between crotch and shoulders, and below crotch to ankle (open Y guideline). Open X guideline to correct fit around the figure. Use pins to take up looseness. If tight, add to the pattern in increments of 3/8 inch. Do not take in too much fabric. Doing so can stress and weaken the fibers and affect the performance of the garment.

Adjustment Guidelines

Figure 1

- Draw lines through the length (X), and width (Y) of the pattern. The X and Y lines are spread or overlapped to correct a fitting problem. The arrows indicate that any part of the pattern can be changed in either direction.

- Mark the location of bust, and bust radius from the garment to the pattern.

Stitching guide

- Overlock seams together, leaving a 7-inch opening at the back seam for entry.
- Stitch sleeve to the garment.
- Elastic is not required for this garment, unless a design has a cutout through the body of the garment. Instruction for elastic attachments are on pages 677, 681.

Pattern Adjustments for Knits with Less Stretch

To cut designs in a knit with less stretch, adjust the pattern by expanding the width and length, using X and Y. Generally, expanding the pattern's length and width using one-half the measurements given for the pattern's reduction prepares the garment for a test fit.

Figure 1

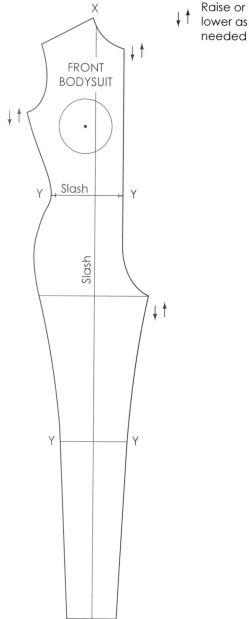

FRONT BODYSUIT

Raise or lower as needed

Slash

Slash

Lycra Sleeve Draft

The sleeve adapts to all garments made from the bodysuit and leotard patterns. The sleeve must be test fitted to the garment and corrected, if necessary. A new sleeve is required if the bodysuit or leotard pattern is modified for knits with less stretch. The maximum stretch goes through the length of the sleeve. Seam allowance (3/8 inch) is included.

Measurements needed Use personal recorded measurement, or take measurements, see pages 50–51.

- (33) Sleeve length (includes 1/2 inch foldback hem) _____.
- (36) Wrist, plus 3/4 inch _____.
- (34) Elbow, plus 1/2 inch _____.
- Armhole measurement _____.

Figure 1
Draw a line on paper and fold on line. Draft one-half of the sleeve. Match grainline to fold of paper.

A–B	=	Sleeve length.
A–C	=	One-half of cap height, plus $1^3/_4$ inches.
B–D	=	One-half of B–C. Square lines out from C, D, and B.
A–E	=	Armhole measurement. Divide into thirds and draw sleeve cap as illustrated.
B–G	=	One-half of wrist measurement. Square from B.

- Draw a line from G to E. Draw an inward curved line for underseam. Use the elbow measurement for a close fit.
- Cut sleeve from paper. Unfold.
- Label direction of greater stretch on center line.

Figure 1

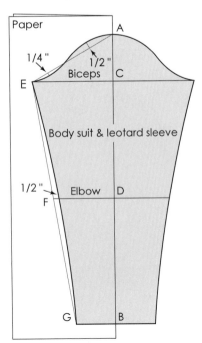

No-Side-Seam Bodysuit

The front and back bodysuit are traced side by side with side seam and hip overlapped to remove side seam allowance (3/8 inch from each side).

The No-Side-Seam Draft
Figure 1
Trace front with patterns overlapping seam allowance at side armhole and hip. Draw guidelines through waist and knee levels. Draw a guideline between waist and ankle space. Label line *Direction of greater stretch.*

C–D	=	A–B.
E–F	=	A–G.
		Draw a new center front and center back line, blending with original lines.
K–L	=	One-half of knee measurement. Mark.
K–M	=	K–L.
H–I	=	One-half of ankle measurement. Mark.
H–J	=	H–I.

- Draw leg lines. Cut pattern from paper, true legline, and test fit.

Figure 1

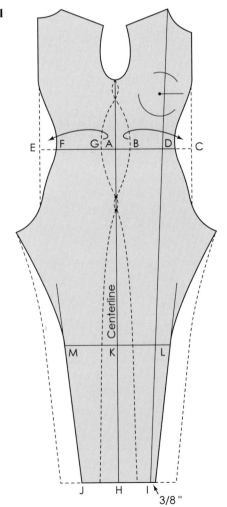

One-Piece Bodysuit

The one-piece bodysuit is shaped at the center back of the pattern through the waist level, and blended to the original lines. The one-piece bodysuit is used for designs with color blocking or other design style-lines that cross over the side of the figure.

The One-Piece Draft

Figure 1

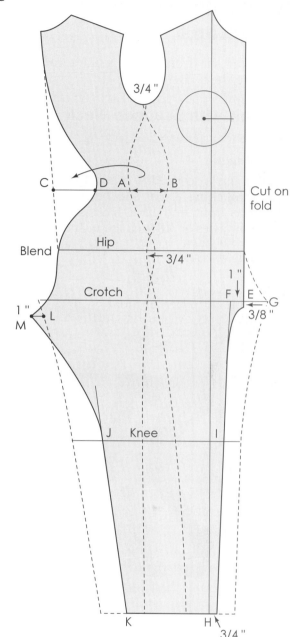

Figure 1

- Trace the front on fold of paper. Place back bodysuit pattern side by side (overlapping side seams).

- Square guidelines out from waist, hip, crotch, and knee. Broken lines indicate the original pattern.

 C–D = A–B (space between the patterns at waist). Mark.

- Draw a line down from center front 3/8 inch past crotch level. Label G. Mark.

 E–F = 1 inch. Mark.

- Draw a line 3/4 inch from H to F (inseam).

- Draw a curved line from G blending with inseam.

- Label knee I.

 H–K = Ankle measurement, plus 3/8 inch.

 I–J = Knee measurement, plus 3/8 inch.

- Draw a line from K just past J.

 J–L = I–G, less 3/4 inch.

 L–M = 1 inch.

- Draw an inward curved line up from J to M.

- Draw an inward curved line from M passing above point L, continuing line to hip.

- Draw an outward curve touching point D, continuing to the center back. Lines must blend well.

- Cut pattern from paper and test fit.

Possible Adjustment for Fit Problems

- If fabric bulges at center back at buttocks, pin and correct the pattern.

Bodysuit Design Variations

Designs for the leotard and maillot can also be adapted to the bodysuit.

Bodysuit with Scooped Neck and Cutouts

Design Analysis

Design 1 has a scooped neckline with cutout side sections touching above and below bust arc and waist. The front and back have same stylelines. Seam allowances of 3/8 inch are included.

Pattern Plot and Manipulation

Figure 1

- Trace front pattern. Mark bust point. Draw bust circumference.
- Draw stylelines (1 inch above bust circumference) using measurements given.
- Cut pattern from paper.
- Draw grainline in direction of greatest stretch.

Figure 2

- Retrace for back pattern.
- For elastic instruction, see Chapter 28.
- To develop stirrup, see page 634.

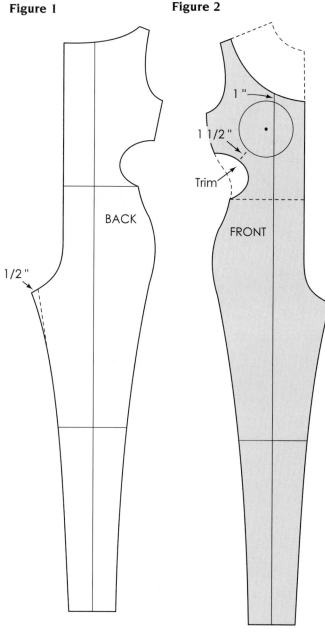

Figure 1 **Figure 2**

Bodysuit with High-Necked Halter Top

Design Analysis

The halter top has a high neck extending above the natural neckline in front and back. A torso styleline gives a two-piece effect. Front and back have the same stylelines. The neckband has loops and buttons on one side for entry. Seam allowances are included.

Pattern Plot and Manipulation

Figure 1

- Trace front pattern. Mark bust point and circumference around bust.

- Square a line up from side waist, ending at one-half the length of side seam. Square out and mark a point between the side seam and square line. From this point, draw a curved line to waist and a straight line ending 1/2 inch from shoulder-neck.

- To provide for bust room, measure out 1 inch at a point $1^1/_2$ inches up from bust level.

- Draw curved lines ending at shoulder.

- Draw torso styleline to length desired. (Example: between waist and crotch level.)

- Cut pattern from paper and separate at torso level.

Figure 1

Figure 2 *Legline*

- Add 1/2 inch to crotch point of back pant when traced.

- Add 3/8 inch seam at torso line of front and back pant.

Figure 2

Add 1/2 " to back pant

3/8 "

BACK PANT

Figure 3 *Front torso*

- Trace front torso with the center line 3/8 inch extended beyond the fold line.

- Add 3/8 inch seam allowance where illustrated.

Figure 3

Figure 4 *Back torso*

- Trace front pattern for back pattern.

- Draw a straight line from neck to side to eliminate curved line.

- Add 3/8-inch seam allowance where illustrated.

- Complete pattern for a test fit. For instruction on attaching elastic to cutout styleline, see Chapter 28.

Figure 4

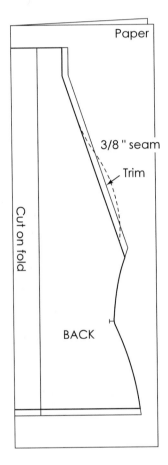

Separated Bodysuit

The bodysuit can be separated at varying points along its length. The legline can be shortened, or at full length, the legline can include stirrups. The bodysuit, when separated, an also be used for swimwear designed with little-boy leglines cut in spandex.

Design Analysis

The bodysuit modified with separated midriff area and short legline is but one of many designs that can be created from this foundation. The center back bodice and pant are held in with a loop for gathers. To create the design without gathers, eliminate the loop control and trim the extension of the back pant.

The Bodysuit Draft

Figures 1 and 2

- Trace front, and back patterns.
- Plot the stylelines, using illustrations as a guide.

Figure 1

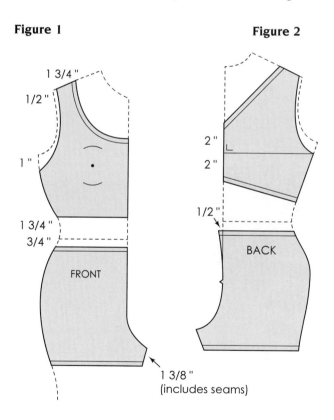

Figure 2

Figures 3 and 4

The examples illustrate the use of loops for controlling gathers at the back bodysuit.

- Cut the loop $1^3/_4$ inches \times $2^3/_4$ inches. Sew together and wrap around the centerlines of the garment, or place the loop on the back before stitching center back bodice. The loop of the pant should be stitched across the seam of the top side of the pant, located at a depth of 3 to 4 inches, and wrapped around the top of the pant to the back side. Topstitch loop to secure.

Figure 3

Figure 4

TOP

Band loops around gathers

PANT

Tights

Figure 1

- For leggies, trace bodysuit from $1\frac{1}{2}$ inches above waist to ankle.

- *Elastic:* Width, 3/4 to 1 inch. Length, 1 inch less than waist (overlap 1/2 inch to secure ends). Fold waist to form casing.

- Draw grainline in direction of greater stretch.

- Patterns for front and back are identical. Hip, crotch, and knee guides are optional.

- Note that 3/8-inch seams are included.

Figure 1

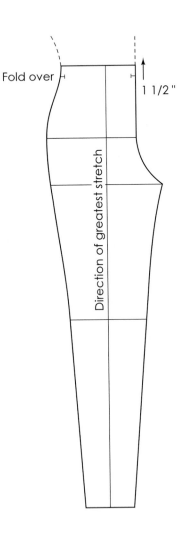

Stirrups

Figure 2

- For bodysuit designs with stirrups (rings extending around and under feet), cut out leg at ankle as shown.

- Hemlines at each side of front and back pant are stitched together. (This section lies at the bottom of the foot's instep.)

- Note that 3/8-inch seams are included.

Figure 2

Leotard Foundation

The leotard can be drafted with the use of the basic back pattern, the torso, or the dartless knit pattern. The basic back pattern with shoulder dart transferred to armhole is illustrated for the draft. The leotard draft includes a 3/8-inch seam allowance. The front and back are drafted together and separated at the completion of the draft. The knit sleeve completes the pattern (see page 628).

Measurements needed
- (19) Front waist arc _____.
- (23) Front hip arc _____.
- (28) Crotch length _____.

Leotard Draft
Figure 1
Transfer shoulder dart to armhole.

Figure 2
The shaded pattern helps to indicate line placement. Trace back pattern, starting 1/4 inch from neck (A) and ending at the side seam of the armhole (B).

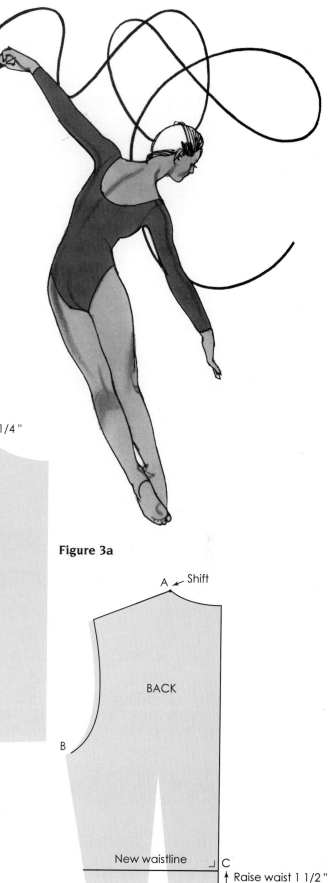

Figure 1

BACK

Figure 2

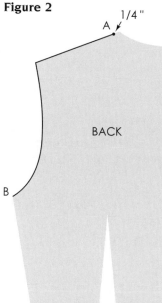

A ↙ 1/4 "

BACK

B

Figure 3a

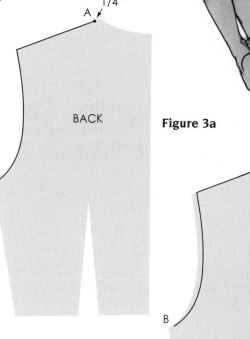

A ↙ Shift

BACK

B

New waistline ⌐C

↕ Raise waist 1 1/2 "

Figure 3a, b
- Shift pattern until neck touches (A).
- Trace neckline and the centerline to waist.
- Mark 1¹/₂ inch up from waist (C).
- Square a line from C (waist level).

*C–D = Waist arc (19), less 1/2 inch.

 Draw a line from D, 1 inch past B, and draw armhole.

 Measure armhole and record _____.

 Draw an inward curved line for side seam blending with straight line.

 Mark 3/8 inch down from A, and draw front neckline $1\frac{1}{2}$ inches below back neckline.

C–E = One-half of crotch length, less $1\frac{1}{4}$ inch (28).

E–F = One-half of E–C, plus 1 inch (hip level).

*F–G = Hip arc, less 1/2 inch (23) squared from F.

E–H = 2 inches, squared from E. (1/8 inch less for each size under 10; 1/8 inch more to each size over 12).

H–I = 3/8 inch, mark and square to hip level.

Back leg opening
- Draw a line from I, passing 3/8 inch in from G.
- Center and square out 1 inch (K).
- Shape legline from K, passing through marks at the 3/8 points. (See figure 3b.)

Front leg opening
- Divide F–G into fourths.
- Draw a 2-inch line at an angle.
- Mark 2 inches up from I.
- Draw the leg curve, touching marked points. (The curve may or may not touch the angle line).
- For leg opening with a higher cut, see page 637. Complete pattern for a test fit.

 *If milliskin knit (4-way stretch) is used, subtract $1\frac{1}{2}$ inches from waist, and hip arc.

Notching guide
There are two types of notches used to mark knit garments:

1. Notch to a depth of 1/8 inch.
2. Cut pyramid shapes out from the seam line edge—1/4 inch wide and 1/8 inch high (△).

Separate patterns
Place paper behind draft for back copy. Secure, and cut outline of pattern. Remove, and trim points at side seam and crotch of legline. See back leg curved lines.

Elastic stitching guide
Elastic is required around the leg opening. See page 677 for instruction and stitching guide.

Figure 3b

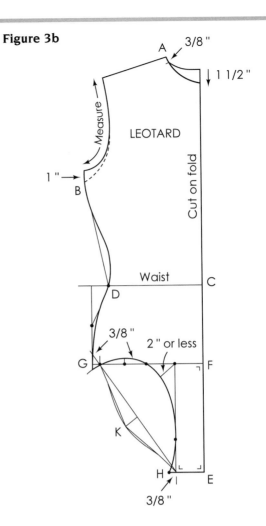

Figure 3b

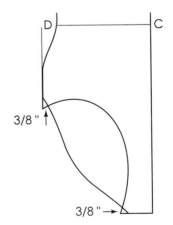

Figure 4 B*ack leotard*

- Trim side seam, removing curve.
- Trace a second copy and draw a new center back with inward and outward curved lines. Use for any leotard design requiring a more fitted back.

Figure 4

Figure 5 *Front leotard*

- Trim draft for front neckline and front leg opening.
- Mark bust point at time of fitting. Label patterns and draw line for direction of greatest stretch.

Figure 5

Figures 6 and 7 **H*igh-cut leg opening***
Back
Mark midpoint of side hip. Draw a line from I, passing 3/8 inch in from G. Mark a point that is centered (K), and square out 1/4 inch from K. Shape the back leg opening.

Figure 6

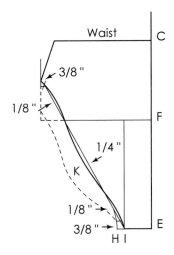

Front
Mark midpoint of hip and draw inward curved line to H. True; join crotch seams, allowing for 3/8 inch stitch seam.

Figure 7

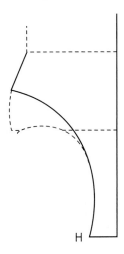

Method for Correcting Pattern to Improve Fit

The leotard should be cut, stitched, and test fitted to the figure. Check for looseness or tightness around the figure, in the length between crotch and shoulders. Use pins to take up looseness. If tight, add to the pattern in increments of 3/8 inch. Do not take in too much fabric. Doing so can stress and weaken the fibers and affect the performance of the garment.

• Mark bust point and under the bust to the rib bone (bust radius) when on the figure.

Adjustment Guidelines
Figure 1
Pattern
• Draw lines through the length (X) and width (Y) of the pattern. The X and Y lines are spread or overlapped to correct a fitting problem. The arrows indicate that any part of the pattern can be changed in either direction.

Fitting
• Transfer the location of bust and bust radius from the garment to the pattern.

• Elastic is required around the leg opening and for designs with cutouts through the body of the design. For instruction on elastic attachments, see page 677.

Pattern Adjustments for Knits with Less Stretch

To cut designs in a knit with less stretch, adjust the pattern by expanding the width and length, using X and Y. Generally, expanding the pattern's length and width using one-half the measurements given for the pattern's reduction prepares the garment for a test fit.

Figure 1

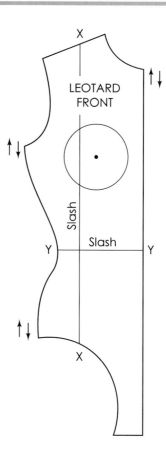

All-in-One Leotard

The all-in-one leotard is developed for stylelines crossing the figure at varying locations without the need to be concerned about seams, except for the seam at center back.

The All-in-One Leotard Draft

Figure 1

- Trace front and back on fold, overlapping side seams at the armhole and hip.
- Square guidelines at bust and waist.

 C–D = A–B space (between front and back waist).
- Shape center back seam, as illustrated.
- Cut pattern from paper.

Figure 2

- The completed pattern shape. Mark with pyramid shape (Δ) to indicate side of pattern.
- Complete pattern for test fit.
- For elastic and stitching guide, see page 677.

Figure 2

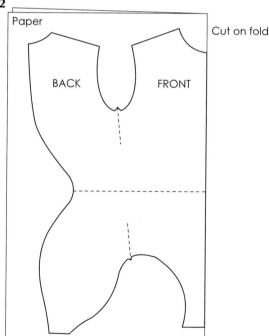

Figure 1

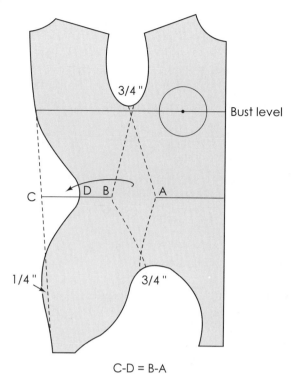

C-D = B-A

DESIGN 1

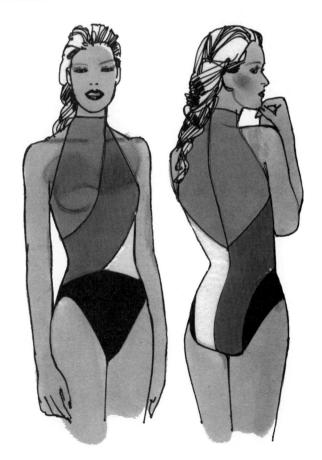

Color-Block Design for Leotard

Design Analysis—Design 1

The all-in-one leotard foundation is the base for the color-block design. Three colors are selected (any three that combine well) and are drawn on the pattern. Use the sketch and plot to help in the placement of the stylelines. This design is only one example of the many other arrangements using two or more colors.

The Color Block Draft
Figure 1
- Trace pattern on fold.
- Draw high neckline (one-fourth of neck circumference), as illustrated.
- Draw halter styleline (includes seam allowance).
- Cut pattern from paper and unfold.

Figure 2 *Placement of color blocks*
- Plot color blocks.
- Mark notch or pyramid symbols to help control the garment parts when stitching.
- Cut and separate the pattern along the stylelines.

Figure 2

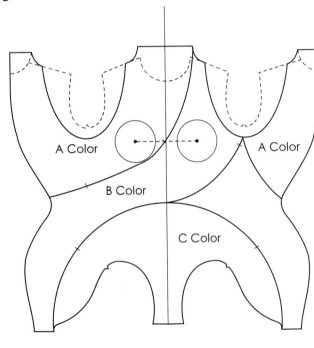

Figure 1

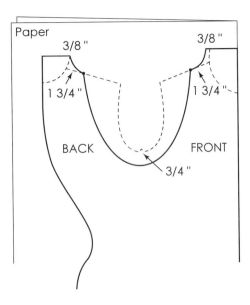

Figure 3 *Separated patterns*
- Add 3/8-inch seams to all joining sides of the color-block patterns. The pyramid symbol is illustrated.
- Complete the pattern for a test fit.
- For elastic and stitching guide, see page 677.

Figure 3

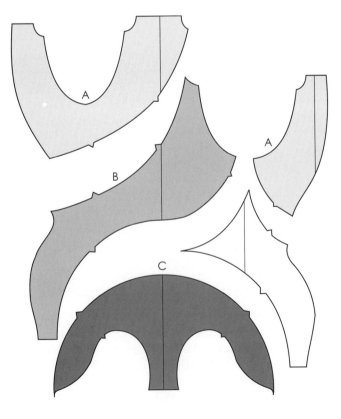

Leotard Design Variations

Empire-Cut Leotard

Design Analysis

The design has a stylized empire cut (V-neckline in front and bateau in back) with shirring at the center front held in place by a separate foldover band.

Pattern Plot and Manipulation

Figures 1 and 2

- Trace front and back; include all markings.
- Plot empire styleline, ending 3/4 inch from bust level. Label A.
- Notch 1/4 inch from A (space for gather control loop).
- Draw front and back necklines. Label front neckline B–C and measure.
- Mark a point 3 inches up from A. Label D.
- Draw a line from B through D equal to B–C line, and connect to notch.
- Shape side seam of front pattern (broken line indicates original pattern).
- Cut and separate patterns.

Figures 3, 4, and 5

- Retrace on fold. Add 3/8-inch seam allowance at neckline and empire stylelines.
- When cutting, place length of pattern in the direction of greatest stretch.

Figure 1 **Figure 2**

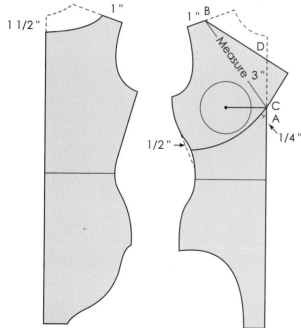

Figure 3

Figure 4

Figure 5

Figure 6

- Tab: 2 inches × 2 inches
- Wrap tab over fabric at center front. Stitch into seam to hold fullness.

Crotch lining and elastic instructions
See page 677.

Leotard with Raglan Sleeve

The leotard with raglan sleeve can be worn over tights or as a top to be worn with pants and skirts. It can be worn for dance or exercise. Other designs can be developed from this versatile pattern. The measurements given are approximate.

Design Analysis

Design 2 is a basic raglan (with bordered stretch eyelet fabric.) Design 1 is a thought problem.

Raglan Sleeve Draft

Figures 1 and 2

- Trace front and back leotard and sleeve patterns.

 A–X = One-third of armhole.

 B–X = A–X

- Draw curved line to within 1 inch of shoulder-neck.
- Use basic or high-cut legline.
- Draw neckline.
- Cut patterns from paper.

DESIGN 1 DESIGN 2

Figure 1

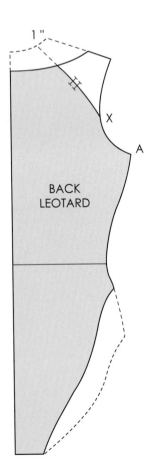

BACK LEOTARD

Figure 2

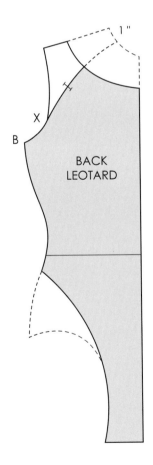

BACK LEOTARD

Figures 3 and 4 *Separate pattern*
- Trim patterns to the cutout neckline.
- The bottom part of the pattern is complete.
- Add 3/8 inch to raglan styleline.

Figure 3　　　　　　**Figure 4**

Figure 5 *Raglan sleeve*
- Place knit sleeve on fold of paper, and trace.
- Mark X, using A–X measurement of the back pattern.
- Place raglan yoke on sleeve, overlapping cap by 3/4 inch (eliminates seam allowance).
- Trace pattern.
- Add 3/8-inch seam allowance to styleline, as illustrated.

Figure 5

Figure 6
- Cut pattern from paper.
- Complete the patterns, and cut for test fit.
- For stitching and elastic guide, see page 677.

Figure 6

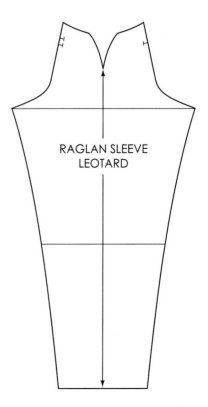

Basic Tank Leotard

The basic leotard can be worn alone or over a body-suit or tights. It can also be worn as a top with pants and skirts. The back strap placement is toward the back neckline. The following information explains the need for the strap adjustment.

Back Strap Adjustment

The strap placement of the back pattern for leotard, bodysuit, and maillot designs having a low cutout neckline should provide strap adjustment. Cutting out parts of the back causes the knit fabric to relax, and gap along the cut line of the back styleline. To eliminate gapping, slash the pattern along the waistline (after the styleline has been plotted on the pattern) to, but not through, the side seam. Overlap the pattern until the strap swings to the shoulder-neck or toward center back neckline. Mend the pattern and reestablish the styleline of the back, if necessary. The example is part of the tank top design.

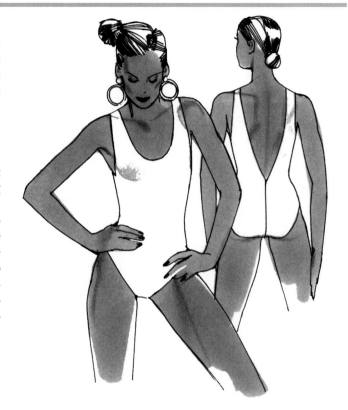

Tank Top Draft
Figures 1 and 2

- Trace the front and back leotard patterns.
- Plot the tank top stylelines, using the illustration as a guide. Use basic or high-cut legline.
- The shoulder strap of the back pattern can be plotted so that the slash and overlap are not required. (If unsure, slash and overlap.)
- Add 3/8-inch seams along the cutout styleline, or plot with seams included.
- Cut pattern from paper.
- Complete pattern for test fit.
- For stitching and elastic guide, see page 677.

Figure 1 **Figure 2**

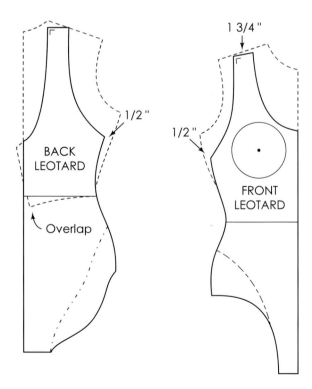

Off-the-Shoulder Leotard

Design 1 is a garment to be worn with pants or skirts for dancing or exercising.

Design Analysis

The off-the-shoulder design has bust fullness added. The method used for adding fullness can be adapted to other designs. Part of the sleeve cap is removed at level with the front leotard. In Design 1, a banding outlines the cut line of the design. Design 2 is illustrated.

DESIGN 1 **DESIGN 2**

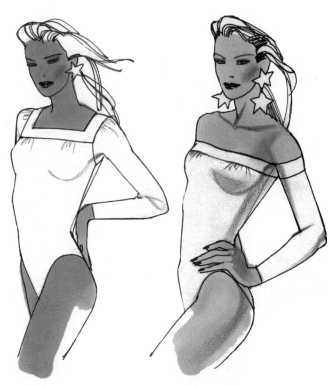

The Off-the-Shoulder Draft

Figures 1 and 2

- Trace front and back patterns.
- Mark styleline 1 inch above bust arc.
- Draw a slashline through bust point to waist.
- Draw band to finish 1 to $1^1/_4$ inches. Mark for notches.
- Cut and separate patterns.

Figure 3

- Slash pattern, and spread 3 to 4 inches.
- Draw blending curved line 3/4 inch above the bust.

Figure 1 **Figure 2**

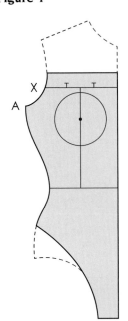

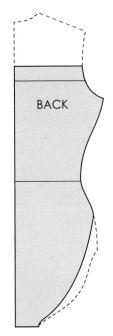

Figure 3

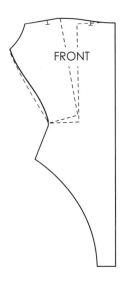

Figure 4

- Trace band on fold and add 3/8 inch seam allowance. Use for front and back patterns. Cut 4 pieces.

Figure 4

Figure 5 *Sleeve*

- Trace sleeve pattern on fold.
- Mark A–X equal to A–X on front pattern.
- Draw band equal to width of the front band pattern.
- Cut pattern from paper and separate.
- Add 3/8 inch to sleeve at cut line.

Figure 5

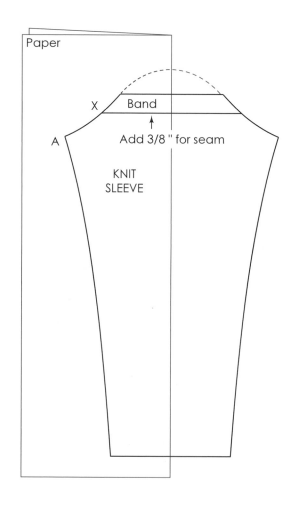

Figure 6 *Sleeve band*

- Trace band on fold, adding 3/8-inch seam allowance where indicated.
- Complete pattern for test fit.
- For stitching and elastic guide, see page 677.

Figure 6

Sleeve band
Cut 4

29

Swimwear

Swimwear Types

In the nineteenth century, swimwear covered the female figure from neck to lengths that fluctuated between the knee and ankle. These suits were not always conducive to swimming. Today's swimwear fashions cover much less and allow complete freedom of movement. They are designed in a variety of fabrics, prints, and textures, ranging from cotton to stretchy knits.

The four swimsuit foundations illustrated in this chapter have distinct characteristics and differ from one another in a number of ways: the cut of the legline, the type of bust support, the type of fabric in which the suit is cut, and the silhouette desired.

Maillot foundation. The cut of the legline encircles the leg starting at crotch level, and ends at varying distances above crotch level at the side. This one-piece suit is usually cut in stretchy knits and clings closely to the figure's contour. The maximum stretch goes around the figure rather than up and down. Very little stretch is required in the length of the garment. The maillot has little or no bust support.

Bikini foundation. The cut of the legline of the two-piece bikini encircles the leg starting at crotch level, and ends at varying distances above crotch level at the side. It can be cut in any fabric. The bra top can be developed with underwire or have little or no bust support.

Little-boy legline foundation. A one-piece or two-piece (separated at or just below the waistline) foundation has legline ending at the shorts or shorty-short length. Since the foundation is developed with waist and side dart control, the bust shape is defined and bust cups can be added for support, if desired. The foundation can be cut in rigid fabrics or firm knits (little stretch). This foundation is also an excellent base for tennis garments and sunsuits.

Full-figured foundation. The one-piece foundation has legline ending at crotch level. Since the foundation is developed with waist and side dart control, the bust is defined through the use of darts. Bust cups are inserted. This foundation is often used as the base for full-bodied or mature figures. It can be cut in all fabrics. The legline is often disguised by a short skirt stretched across the legline just below crotch level.

Important: When cutting knits, the maximum stretch goes around the figure, rather than up and down the body. Knits combined with spandex or latex are best.

Maillot **Bikini** **Little-Boy** **Full-Figured**

Maillot Foundation

The maillot swimsuit is developed for knit fabrics having from 30 to 100% (or more) stretch with excellent recovery. Information about knit fabrics can be studied in Chapter 26. Maillot designs that are cut in firm knits with less stretch than required, adjustments can be made to the pattern by increasing length and width. The maillot pattern can be adjusted for bra cups with added fullness above, below, or in between the bust area, for design variations. All swimwear garments designed for production should be test fit on the figure, and tested for water retention and drying time. When buying knits, ask if the fabric has been chlorine tested. The greatest stretch goes around the figure. Seams are included in the maillot draft.

Measurements Needed
- (19) Front waist arc _____.
- (23) Front hip arc _____.
- (28) Crotch length _____.

Maillot Draft

The basic back pattern is illustrated. However, the draft can also be based on the dartless knit foundation pattern on Chapter 21, or the leotard foundation on page 635.

Figure 1
Transfer shoulder dart to armhole.

Figure 2
The shaded pattern helps to indicate line placement. Trace back pattern, starting 1/4 inch from neck (A) and ending at the side seam of the armhole (B).

Figure 3
- Shift pattern until neck touches (A).
- Trace neckline and the centerline to waist.
- Mark 1/2 inch up from waist (C).
- Square a line from C (waist level).

Figure 1 **Figure 2** **Figure 3**

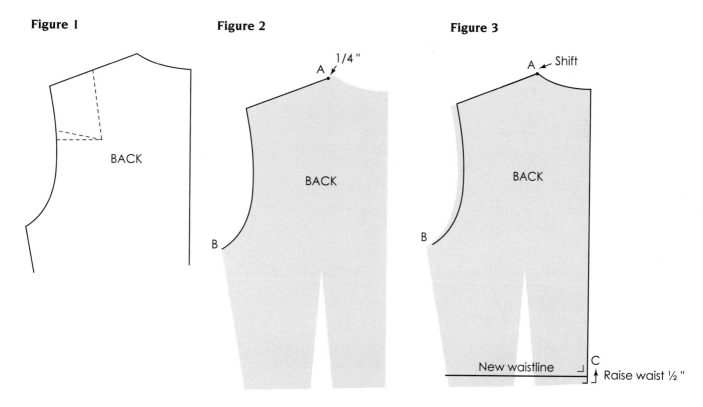

Figure 4 *Front*

C–D = Waist arc (19), less 1 inch, squared from C.
- Draw a line from D to armhole B. Shape side seam, as illustrated.
- Measure down $1\frac{1}{2}$ inches from neck, and draw front neckline (3/8 inch is marked as seam allowance).

 C–E = One-half of crotch length (28), less 3/4 inch.

 C–F = One-half of C to E, less 1 inch.

 F–G = Hip arc (23), less 1/2 inch, squared from F. Square up from G to waist.

 E–H = 2 inches, squared from E (1/8 inch less for each size under 10; add 1/8 inch for each size over 12).

 H–I = 3/8 inch.
- Square a line up from I to the F–G line. Label J.

Back legline
- Mark 3/8 inch in from G.
- Square 3/8 inch up from H.
- Draw a connecting line through the 3/8 inch marks. Mark center of the line and square out 1 inch.
- Shape back leg opening, as illustrated.

Front legline
- Divide and mark F–G line into fourths.
- Mark 2 inches up from I guideline.
- Draw $1\frac{3}{8}$-inch angle guideline from J.
- Draw front leg opening, as illustrated.

High-cut leg opening
- For a higher leg cut, see page 637 as a guide.

Figure 5 Back
- Place paper under the draft and secure.
- Cut pattern from paper. The under copy is the back pattern (Figure 4). Label and draw the stretch direction line through waist.
- Trim bust curve from the pattern.
- Trace a second copy of the back pattern, and draw a center back curved for closer fit when required.

Front
- Cut front neckline of the top pattern, and trim to front leg opening. Label pattern.
- Mark bust point and under bust at time of fitting.
- Draw crotch pattern on fold (shaded area). Mark direction line through waist.
- Draw high leg opening for reference.
- Cut for a test fit. See page 638 for fitting guide and guidelines for modifying patterns for knits with less stretch.

Figure 4

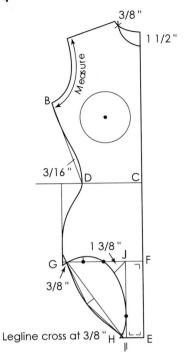

3/8 "
1 1/2 "
Measure
B
3/16 " D C
1 3/8 " J F
G
3/8 "
Legline cross at 3/8 " H E

Figure 5

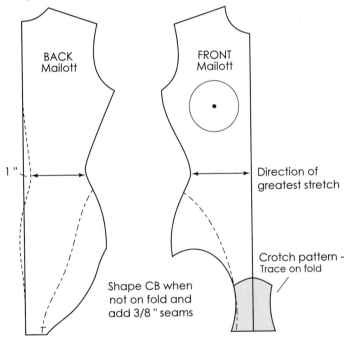

BACK Mailott

FRONT Mailott

1 "

Direction of greatest stretch

Shape CB when not on fold and add 3/8 " seams

Crotch pattern - Trace on fold

Stitching guide
- Overlock seams, leaving a 7-inch opening at center back for entry. For stitching guide, see page 677.

Notching guide

There are two types of notches used.
1. Notch to a depth of 1/8 inch.
2. Cut a pyramid shape out from seam edge 1/4 inch wide and 1/8 inch high (Δ).

Basic Tank-Top Maillot

Two versions are given of the basic tank maillot swimsuit—a tank top without a bra cup, and a tank with a modified pattern allowing room for a bra cup.

Maillot Draft without a Bra Cup

Figures 1 and 2

- Trace the basic front and back maillot patterns.
- Plot the design, using the illustration as a guide. Trim front and back side seam 1/2 to 1 inch from armhole to waist for closer fit. (The back strap location is discussed on page 644.)
- Cut pattern from paper.
- Note that 3/8-inch seams are included in the draft.
- Complete pattern for test fit.
- See page 638 for guide to fit and pattern adjustment.

Maillot Draft with Bra Cup

Figure 3

- Plot the tank top swimsuit.
- Draw slash lines from armhole and side seam to bust point.

Figure 3

Figure 4

- Cut slash line from side to bust point, and from bust point to, but not through, armhole, and spread pattern. (For smaller cup, subtract 1/4 inch; for larger bust, add 1/4 inch to each cup size greater than B cup.)

Figure 4

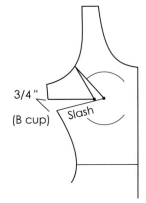

Figure 1 **Figure 2**

Figure 5

- Center dart point 1 inch from bust point.
- Fold dart and redraw side seam by taking from dart leg, adding to the other.
- See page 679 for instruction on bust cup insertion and attachment to the swimsuit. Test fit.

Figure 5

Maillot with Bra Lining

The maillot swimsuit is designed with a bra lining. Follow this example for other swimsuit designs requiring inside coverage over the bust area.

Design Analysis

The styleline is across the bust with gathers at the side of the front garment. Legline can be a basic cut or a high cut. See page 637.

The Maillot Design Draft

Figure 1 Front

- Measure 2 inches above armhole at side (includes seams). Label A. Add more for greater fullness, if desired.
- Square a line from center front to A.
- Square a line from center front 1 inch below bust. Label B (guide for bra lining).
- Crossmark 1 inch below point A, and 1 inch up from point B (notches for gather control).

Figure 2 Back

- Plot styleline for back design.
- Crossmark 1/2 inch down from armhole. Label F.
- Measure up from waistline D to E equal to C–B measurement of front. Crossmark.
- Mark for notches 1 inch down from F, and up 1 inch from E.

Figure 1 **Figure 2**

Figure 3 *Strap*
- Measure the length of the strap, less shoulder seam allowances. Add front and back strap lengths together.
- Draw length of strap and width of 1 inch.

Figure 3

STRAP

1 " (to finish 3/8 ")
Wrap in elastic
1 to 1 ratio.

Figure 4 *Bra lining*
- Fold paper and trace bra section of the pattern. Square from A to B.
- Draw a line from A to G that is equal to E–F (back) measurement, and out 1 inch from side of lining pattern.
- Mark gather-control notches 1 inch down from A and 1 inch up from G.
- Draw underbust shape, using illustration as a guide.
- Mark gather-control notches under bust, using center front and original side seam as a guide.

Elastic
Elastic is placed along the bottom of the bra lining and is stretched between the notches to finish $2\frac{1}{2}$ inches (2 inches for size 6 and under). The elastic is stitched into the side seam to secure, with the upper bra lining taken in with the top garment. The lining is cut from lightweight tricot or its equivalent.

- Use 5-inch stay at the sides of the swimsuit.
- For crotch lining, elastic, strap, and bra instruction, see pages 677–681.
- Cut patterns from paper.
- Complete patterns for test fit. For guide to pattern adjustment, see page 638.

Figure 4

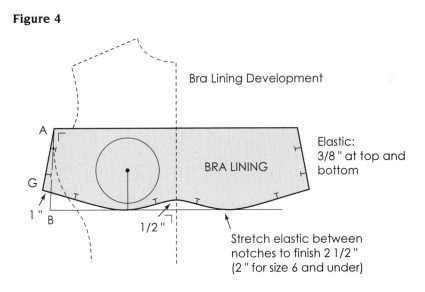

Bra Lining Development

A

BRA LINING

Elastic:
3/8 " at top and bottom

G

1 " B

1/2 "

Stretch elastic between notches to finish 2 1/2 "
(2 " for size 6 and under)

Maillot with Color Blocking

Design Analysis

The maillot color-block swimsuit is open through the abdomen area and crosses over at the sides.

The Maillot Design Draft

Figures 1 and 2

- Trace front and back patterns. Plot the pattern using the illustration as a guide. (The broken lines represent the original pattern and parts not needed for the design, except where broken lines pass through shaded area).

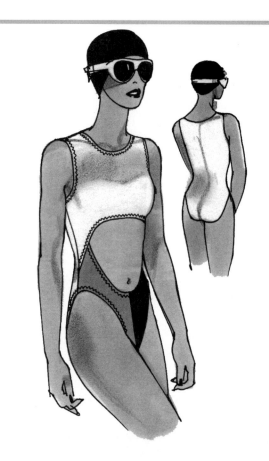

Figure 1 **Figure 2**

Figures 3 and 4 *Separated patterns*

- Add 3/8-inch seam allowance to the inside patterns and center line, as illustrated. The armhole and neckline seams are included in the draft.

- Draw direction lines on the pattern parts, and label patterns.

- For instructions on crotch lining and elastic, see pages 677–678.

Figure 3 **Figure 4**

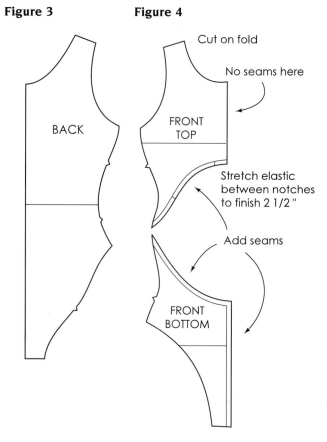

Princess Maillot

The princess-line or any styleline crossing the bust point can be extended, making room for the bust and for bra cups to be added to the design when needed. Use this example for other swimsuit designs requiring a bra cup.

Design Analysis

Design 1 and Design 2 are styled with princess-lines. Design 1 is illustrated. The maillot pattern is modified for the inclusion of a bra cup. The back is cut low with the strap continued from the back pattern. The strap can be buttoned at shoulder or extended for a tie. The circle skirt is stitched into the torso line of the swimsuit. The flare skirt is lettuce-edged.

The Princess Maillot Draft

Figures 1 and 2

- Trace front and back patterns.

- Plot the pattern, using the illustration as a guide. The princess styleline is centered between the strap and shoulder, passing through bust point and 1 inch in from center at waist. Square down from waist and mark 1/2 inch out. Draw line to waist. Cut and separate patterns.

DESIGN 1 DESIGN 2

Figures 3, 4, and 5 *Separated patterns*

Front

- Add 1 inch out from bust point at front and side front panels. (For large bust, slash from bust point to side and front pattern. Spread and blend bust mound.) See Chapter 19.

- Mark 1/8 inch out from above and below bust circle.

- Draw a blending curved line over the bust.

- Draw crotch lining pattern.

- Add seam allowance of 3/8 inch.

- Draw direction lines on patterns, and label.

Figure 1 **Figure 2**

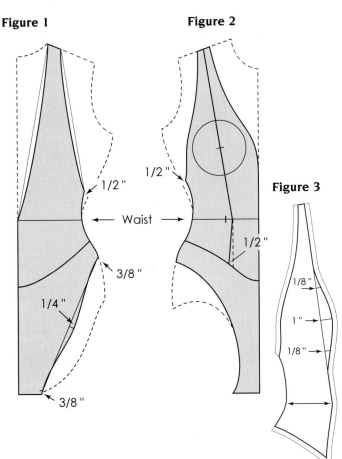

Figure 3 **Figure 4** **Figure 5**

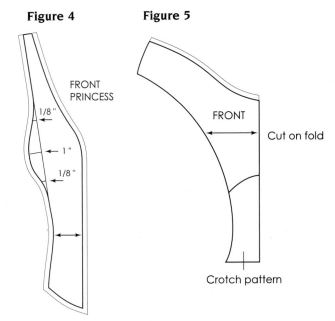

3/8 " Seam allowance

Figures 6 and 7

Back

- Add seams, label, and draw direction lines on patterns.

Figure 6

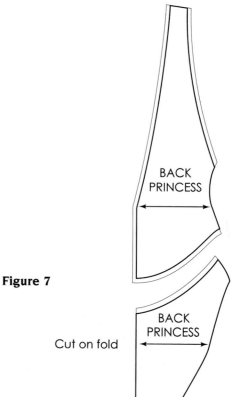

BACK PRINCESS

Figure 7

Cut on fold

BACK PRINCESS

Figures 8 and 9 *Skirt frames*

- Trace skirt frames from front pant (Figure 8), and back pant (Figure 9) for spreading.
- Draw slash lines.

Figure 8

C.F.

Figure 9

C.B.

Figures 10 and 11

- Spread skirt to the amount of fullness desired. (Example: 2 to 1, 3 to 1, and so on.)

Test Fit

- Place pattern on knit in direction of greatest stretch.
- Overlock garment together.
- For elastic and crotch lining instructions, see pages 678–679.
- Place on form or figure.
- If loose around the figure, pin in along side seam or center back.

 If too long in the length, pin along the waistline. Care must be taken not to remove too much stretch (garment may pull downward).

- Check fit of the legline.
- Correct pattern if necessary.

Figure 10

SS

Fold

C.F.

Figure 11

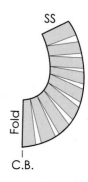

SS

Fold

C.B.

Maillot with Inset Bra

Design Analysis

Design 2—Maillot has a set-in bra and self-loop at center front, holding excess, and creating a gathered effect.

DESIGN 1 **DESIGN 2**

Figures 3, 4, and 5

- Trace patterns on fold (back not illustrated). Add fullness to the inset pattern as illustrated. Add 3/8-inch seams at stylelines, and at cut line of bra and strap.
- Cut patterns from paper.

Pattern Plot and Manipulation

Figures 1 and 2

- Trace front and back maillot foundation, including all markings.
- Plot the design on the patterns. Side seams are of equal lengths.
- Square a line above and below the bust circumference.
- Cut and separate pattern sections.

Figure 1

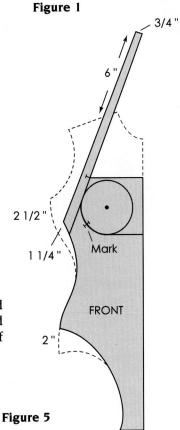

Figure 2

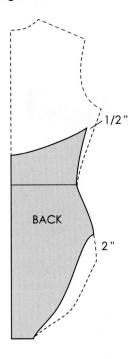

Figure 6

- Draw loop tab $3 \times 1\frac{1}{2}$ inches (finished width 3/4 inch).
- For crotch lining and elastic instructions, see pages 678–679.

Figure 3

Figure 4

Figure 5

Fullness 1 1/2" to 1"
(May be more, or less)

STRAP

Figure 6

1 1/2"

3"

LOOP

Asymmetric Maillot

Design Analysis

Maillot has an asymmetric styleline from the shoulder, across bust, to a point below armhole. Added fullness (Principle #2) is shirred into one side of front.

Pattern Plot and Manipulation

Figures 1 and 2

- Trace a full front and full back pattern.
- Plot stylelines and slash lines.
- Draw slash lines in the direction gathered from side seam.
- Cut patterns from paper.

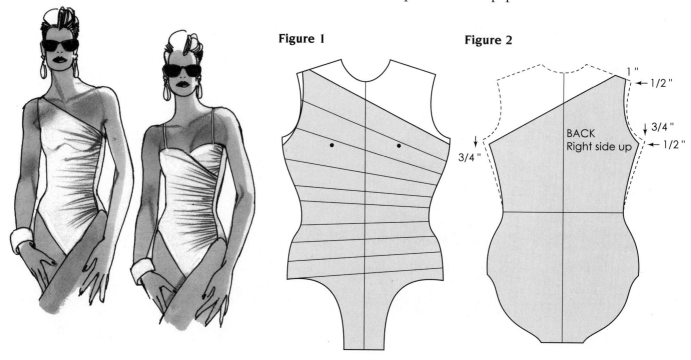

Figure 1

Figure 2

Figure 3

Figure 3

- Measure side seam length and record _____. Slash and place on paper. Spread until side seam equals 2 to 3 times original measurement. Spread equally, if possible. (Example: Original side length, 18 inches. Spread 36 or 54 inches.)
- Secure to paper and trace pattern's outline. Blend a curved line at side seam.
- Add 3/8-inch seam allowance to neckline.
- Remove 1 inch from side where spreading occurred, blending to zero at legline.
- For crotch lining and elastic instructions, see pages 678–679.

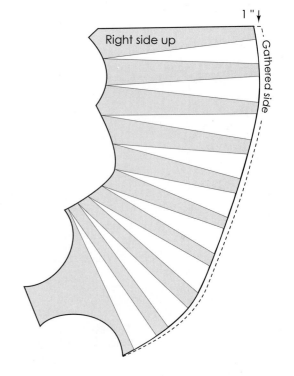

Bikini Foundation

The bikini is a brief two-piece swimsuit distinguished by its low-cut waistline, high-cut legline, and bra-like top. Bikini styles range from modest to extreme, depending on fashion trends and personal preference, and can be cut in cottons or knits. The bikini bottom can be based on the maillot (or leotard) or developed from the basic skirt front. The bikini top is developed from the Contour Guide Pattern; see Chapter 9.

Bikini Based on Maillot or Leotard Foundation

Figures 1 and 2

- Trace front and back maillot (leotard) patterns from waist to legline (broken lines show untraced sections).

- Square a line from center front and center back, midway between waist and legline at side as shown.

- Cut bikini bottom from paper. Label *Knits only.*

- Trace another copy, adding 1/2 inch to side seam, plus 3/8 inch for seam allowances. Label *Wovens only* (not illustrated).

Bikini Based on Front Skirt Foundation

Measurement needed
- (28) Crotch length _____.

Figures 1 and 2
- Trace the front basic skirt from waist to hip level. Square a line 4 inches down from front.

- Label center front waist C and follow instructions for the leotard, starting from C–E (see page 636).

Adjustments after completing the draft
- Trim 1/4 inch from front and back side seams and cut from paper.

- Label *Wovens only.*

- Trace another copy. Trim 1/2 inch from side seams. Label *Knits only.* (Seams are included.)

Figure 1 **Figure 2**

BIKINI BACK BIKINI FRONT

Front and back patterns separated

BIKINI BACK ←— 1/4 " —→ BIKINI FRONT ↓ 4 " C

Bikini Bottom Variations

Bikini without Center Seams

Pattern Plot and Manipulation

Figures 1 and 2

- Trace pattern with center front and back on fold.
- Add 3/8 inch if cut in wovens.
- Cut from paper and duplicate for lining.

Figure 1

Figure 2

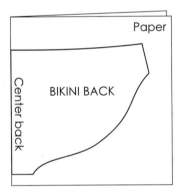

Figures 3 and 4

- Unfold pattern and add grainline (straight or bias) as shown.
- For crotch lining and elastic instructions, see pages 678–679.

Figure 3

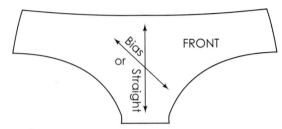

Figure 4

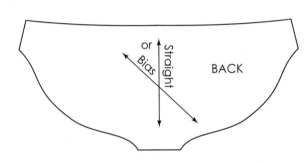

All-in-One Bikini

Figure 1

- Place front and back patterns on paper with crotch seams together. Trace.
- Draw grainlines (straight or bias). Add 3/8-inch seams if cut in wovens.
- Cut from paper and duplicate for lining.
- For crotch lining and elastic instructions, see pages 678–679.

Figure 1

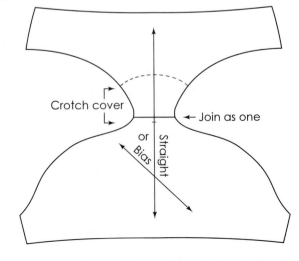

High-Cut Leg Bikini

The bikini pant can be designed with high-cut leg openings and with different shapes along the waist-line.

Design Analysis

Design 1 has a sloped waist and high-cut leg opening. Design 2 has a gathered center line created from the bikini design. Design 3 has a full flare skirt with lettuced edge and sloped back bikini. Back views: Finishes at level with front designs.

DESIGN 1 DESIGN 2 DESIGN 3

Design 1—Stylecut

Figures 1 and 2

- Trace basic bikini or maillot foundation.
- Plot design, using illustration as a guide.

Figures 3 and 4 *Separated patterns*

- Mark vertical grainline if cut in cotton. Add seams to this pattern.
- Draw horizontal direction line if cut in spandex. Add seams when stylelines are cut.

Figure 1 **Figure 2**

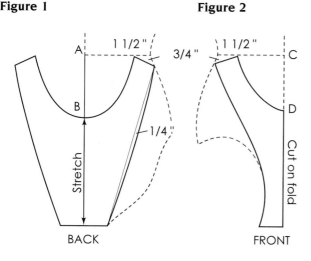

Figure 3

Figure 4

Design 2—Gathered Center Line
Figure 5
- Trace style bikini front, and spread for fullness.
- Use back pant to complete the design.

Figure 5

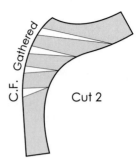

Design 3—Flared Skirt
Figure 6
- Trace style bikini front, and spread for fullness (2:1 or more for fullness).

Figure 6

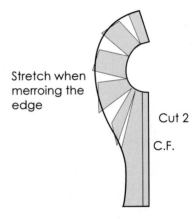

Figure 7a, b

Back flounce
- Draw a rectangle equal to back pant curved line and $1^1/_2$ inches wide.
- Draw four slash lines (five equal parts).
- Place on fold and spread for flare.

Figure 7a

Figure 7b

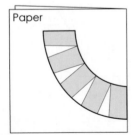

Bikini Top Variations

The brief bikini top covers the bust much like a bra and is the perfect complement for the bikini bottom. The four tops illustrated should be used as a guide for developing other similar bra designs. Bikini tops are based on the Contour Guide Patterns, Chapter 9. The bust circumference is a reference for styleline placement while the reduction guidelines on the Contour Guide Pattern enable the patternmaker to accurately contour around the bust (shaded areas in illustrations). If not using the Contour Guide Pattern, follow illustrations and measurements given as a guide for pattern development. Bikini straps can be stitched directly to the top or pulled through a casing, such as spaghetti straps. Straps can extend around the neck or over the shoulders and can be tied or buttoned. Three back strap variations are given.

Princess-Line Bikini Top

Design Analysis

The bikini has a styleline crossing over bust point from top to bottom (princess line).

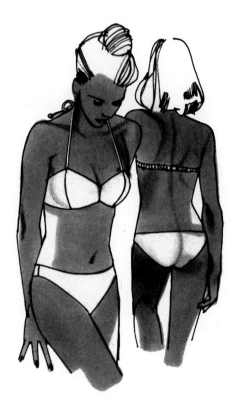

Figure 2
- Cut and separate bikini bra from pattern.

Figure 3
- Close dart. Enlarge bra pattern to provide room for the bust mound.
- Draw grainline.
- Choose strap type desired.
- For bra cup instructions, see page 679–680. (Place "stay" at side seam. See page 665, Figure 4.)

Pattern Plot and Manipulation

Figure 1 Bikini bra
- Trace front Contour Guide Pattern. Use pushpin to transfer Guidelines 6 (over-the-bust contour), 4 (under-the-bust contour), and 5 (between-the-bust contour). Connect guidelines to bust point.
- Remove ease from side seam.
- Draw bust circumference (example: 3 inches) and bra stylelines, using measurements given.

Figure 1

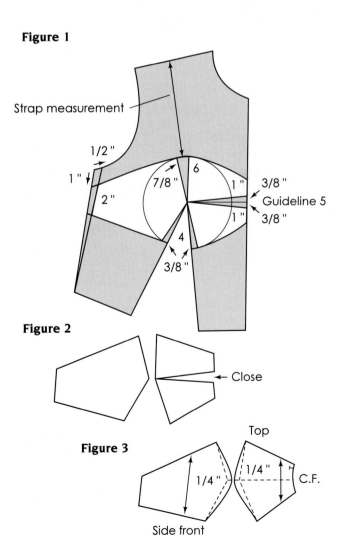

Figure 4 *Back strap*

- Draw strap, using illustration as a guide. (The 3/4 inch removed from center back eliminates dart excess.)

Figure 4

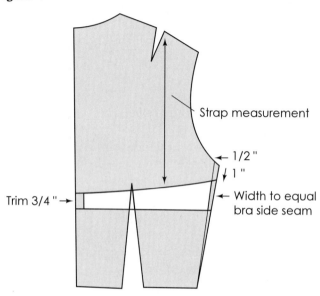

Strap measurement

← 1/2 "

↓ 1 "

Trim 3/4 " →

← Width to equal bra side seam

Figure 5 *Strap frame (base for strap variations).*

- Cut strap from pattern, retrace, and add seams.

Figure 5

Join

Figure 6 *Neck strap*

- *Length:* Measure from front bra to mid-shoulder to back strap, and add 3 inches.
- *Width:* As desired. (Example: Length, 20 inches; width, 2 inches. Finishes to 3/4 inch).
- Mark buttonhole 3 inches from pattern. Space buttonholes as shown.

Figure 6

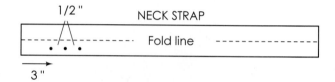

1/2 "

NECK STRAP

Fold line

3 "

Strap Variations

Tie Strap
Figure 7

- Trace strap frame on fold (full strap shown).
- Extend 10 inches and shape tie end.
- Draw grainline and add 1/4-inch seams. Cut from paper.

Figure 7

1 "

10 "

Strap frame

Elastic and Hook Strap
Figure 9

Note: The closure requires a bra design with 1/2-inch-wide side seams.

- Draw a strip $1\frac{1}{2}$ inches × 12 inches (cut two).
- Cut two elastic strips 1/2 inch × 6 inches. (Stretch elastic when inserted between folds and stitch.)
- Fold strap to make loop and stitch. Other strap is folded over the hook and stitched. (Hook is inserted into the loop to secure the garment.)

Button Control with Elastic
Figure 8

- Trace strap frame on fold (full strap shown).
- Extend $2\frac{1}{2}$ inches. Mark 1 inch in from A (indicates center back). Mark 5 inches in from A. Label B.
- Mark buttonhole and button placement.
- Cut two elastic strips 3/4 inch × 4 inches. (Elastic is attached at A and stretched to point B between the folds.)

Figure 8

1 "

2 1/2 "

Strap frame

A

5 "

B

Figure 9

Bra Top with Horizontal Styleline

Design Analysis

The styleline of the bikini top crosses bust points from center front to side seam. (Use personal measurements or those given.)

Figure 3

- Join pattern sections. Enlarge bra to provide room for the bust mound.
- Retrace, draw grainlines, and add seams. Cut from paper. Trace bra patterns for lining.
- Bra strap: see princess bikini top, Figure 6, page 664.
- Back strap: see page 664, Figures 4 through 9.

Figure 3

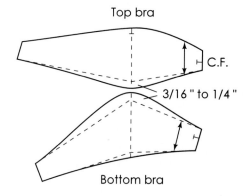

Pattern Plot and Manipulation

Figure 1

- Trace front Contour Guide Pattern and include the bust point and bust circumference. (Example: 3-inch radius.)
- Use pushpins to transfer Guidelines 6 (over-bust contour), 4 (under-bust contour), and 5 (contour between the bust).
- Draw line 1/2 inch in from side seam, ending at waist, to remove ease. Connect guidelines to bust point.
- Square a line from center front to side, touching bust point.
- Draw bra stylelines, using measurements given.

Figure 1

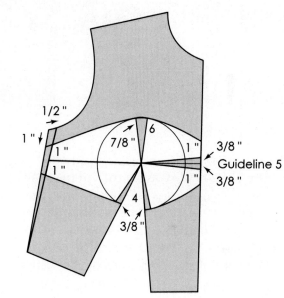

Figure 2

- Cut bikini bra from pattern.

Figure 2

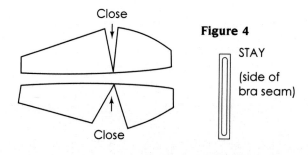

Figure 4

Figure 4

- *Stay:* Support at side seam of bra.

Bra Tops for Bikini Bottoms

The bra top is also a fashion item that goes with pants and skirts. The bra can be cut in spandex or in cotton. However, when cut in cotton, add 3/8 inch to pattern pieces (cotton does not stretch). Three different bra tops are illustrated.

Design Analysis: Design 1

Bust cups are connected with 3/4 inch elastic (finishes 1 inch wide) and covered with fabric, the length of which is 2 inches. The underwire controls the fit and is wrapped into the seam allowance (1/2 inch). The bra should have a tricot lining developed from the same pattern. See page 664, Figure 9 for closures used with woven fabrics.

DESIGN 1 DESIGN 2 DESIGN 3

Figures 1 and 2

- Trace horizontal style bra pattern (page 665).
- Draw bra, using the illustration as a guide for plotting the pattern. The width and length of each pattern should equal one-half of the bust radius.
- The width of the top bra at side is $3^1/_2$ inches.
- The bust radius separates the center of the pattern.

Figure 3 Back band

- Use maillot pattern to develop width and length of back bra band. Include length of side bra.
- Add seams and cut from paper.

Figure 3

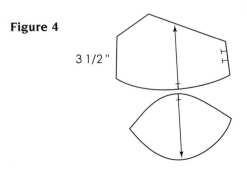

loop: 1 1/2 "
(finished: 3/8 ")

1 3/4 " 3 1/2 "

Loop

- Draw loop tube $2 \times 2^3/_4$ inches.
- Elastic cut 1 inch long, 3/4" wide. The loop is slipped around elastic and stitched to connect bra cups.

Figure 1

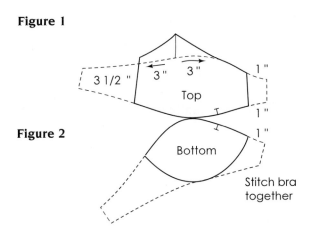

3 1/2 " 3 " 3 " 1 "
Top
1 "

Figure 2

Bottom 1 "

Stitch bra together

Figure 4

- Measure strap length for tie around neck.
- Mark notches for elastic insertion.

Figure 4

3 1/2 "

Figure 5a, b *Finished bra top*

- The underwire is stitched into the seam of the bra. The shape of the underwire is shown in Figure 5b.
- For sewing instruction for connecting strap to bra, see page 681.

Figure 5a

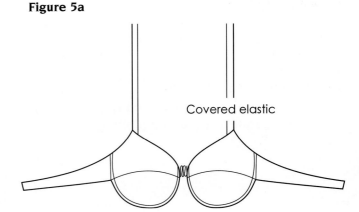

Covered elastic

Figure 5b

U-Shape bra wire

Design Analysis: Design 2

Bra is controlled at center front with a loop and gather at the side seam. A band across the back holds garment to figure. Cut back band on fold when cut in spandex. When cut in cotton or other woven fabrics, see page 664 for types of closures desired.

Figure 1

- Trace upper maillot patterns.
- Plot bra and back band, using the illustration as a guide.
- Cut bandeau on fold.
- Add seams.

Figure 2

- Use back maillot pattern to develop back strap.

Figure 3 *Loop*

- Draw loop tube as illustrated.
- See page 664 for closures if bra is cut in a woven fabric.

Figure 3

Tube to hold gathers

4 1/2 " X 3 "

Figure 1

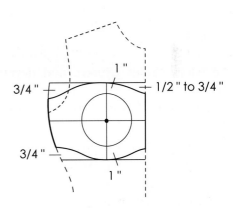

3/4 " 1 " 1/2 " to 3/4 "

3/4 " 1 "

1/4 " elastic for top and bottom of bra and strap

Figure 2

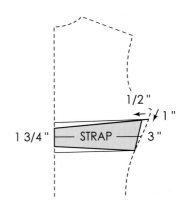

1/2 " 1 "

1 3/4 " STRAP 3 "

Design Analysis: Design 3

Center front is gathered and is controlled to a wire bra by a band.

Figure 1

* Trace upper part of maillot pattern.
* Place underwire on pattern and trace its shape. Use illustration as a guide for plotting the design.

Figure 1

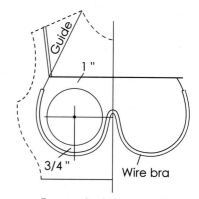

Trace wire bra on pattern

Binding is used around
the wire (cleans seams)

Figure 2 *Back strap*

* Trace bra on fold. Add 3/8-inch seam allowance.
* Trace back maillot pattern, and develop back band pattern. (See Figure 2, page 667).
* See page 664 for closure if bra is cut in a woven fabric.
* Draw tube tie $3^{1}/_{2} \times 4$ inches.
* Complete pattern for a test fit.

Figure 2

String-a-Long Bikini Top

Design Analysis

Bikini top is shaped like a triangle. Straps attached to the bra tie at the back neck with spaghetti strap pulled through folded-hemline casing and tied in the back. Top is gathered under the bust and is self-faced or lined.

Pattern Plot and Manipulation

Figure 1

- Trace the front Contour Guide Pattern.
- Square out 1/4 inch below bust. Label A and B 1 inch in from side seam.
- Draw guideline from bust point to neck corner.
- Mark 5 inches up from bust point on guide and square out 1/4 inch on each side.
- Draw lines to A and B.
- Draw inward curve 1/8 inch from bust circumference.

Figure 1

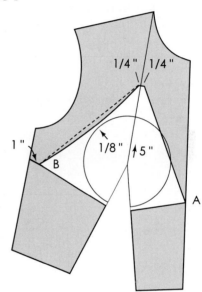

Figure 2

Figure 2

- Blend across open dart.
- Draw grainline. Add 1/2 inch for foldback. All other seams 3/8 inch. Cut from paper.
- Trace pattern for lining.

Bra to neck strap: Cut two pieces 1 inch × 18 inches. (Ties attached to bra top.)

Pull-through strap: 1 inch × 40 inches. (Tie is pulled through casing at hem of bra and tied in back.)

Casing Guide: After lining is stitched.

Bandeau Bikini Top

Design Analysis

The bandeau-effect bikini top is supported by a spaghetti strap pulled through a foldback (casing) at the sides. The strap goes around the neck and ties in back.

Pattern Plot and Manipulation

Figure 1

- Trace front Contour Guide Pattern.

- Square a line from center front, touching the top, and 1/2 inch below bottom and 1/2 inch out from side of circumference line.

- Measure in 1/2 inch from each end at corners. Mark.

- Draw curved lines touching each mark as shown.

- Cut bandeau from pattern.

Figure 1

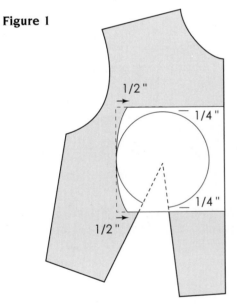

Figure 2

- Retrace on fold and add seam allowance. Cut pattern paper.

- Trace pattern for lining.

- Draw grainlines (straight or bias). Add 1/2 inch for foldback (casing). All other seams 3/8 inch.

- Cut bias strap: 1 inch × 60 inches.

Figure 2

Little-Boy Legline Foundation

The little-boy foundation is developed from the slack jumpsuit. If unavailable, see jumpsuit instructions (Chapter 25) and develop jumpsuit to knee level.

Little-Boy Draft

Figures 1 and 2

- Trace front and back slack jumpsuit to $1\frac{1}{2}$ inches below crotch point on inseam of front and back. Draw a blending line to side seam at crotch level, or draw legline parallel with crotch level for a modest cut (broken lines).

- From crotch point, measure up $2\frac{1}{2}$ inches along crotch curve. Mark and draw a slash line to legline as shown.

Figure 1 **Figure 2**

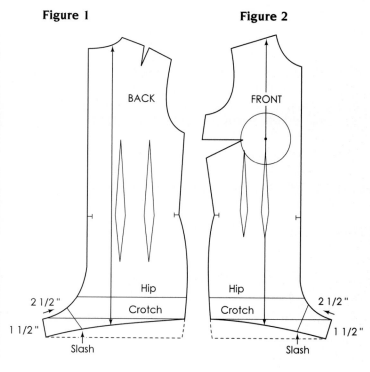

Figures 3 and 4

- Cut slash line to, not through, crotch curve.
- Overlap 1/2 inch and tape. (Tightens legline.)

Figure 3 **Figure 4**

Figures 5 and 6

- Raise crotch point 1/4 inch.
- Measure in 3/8 inch at side seams.
- Blend leg and crotch areas.

Figure 5

Figure 6

Figures 7 and 8

- Figures show completed foundation. If cut in a stable knit, remove 1/2 inch from sides and 1 inch from waist.

Figure 7 **Figure 8**

Little-Boy Legline Variations

The designs that follow show the versatility of this foundation. The foundation can also be used to develop tennis and sunsuits. Design 1 features a little-boy slit legline while Design 2 features a princess-line overdress to which is attached an underframe to control fit. The legline is gathered and used as bloomers. Design 1 is illustrated. Design 2 is a practice problem.

Slit Legline

Design Analysis

The little-boy legline (Design 1) is cut in cotton and lined. It features an empire cut with stylized neckline and lowered back. The bra section (bust cups are optional) has folded darts that point away from bust point. The legline is slit. Darts in front and back control fit. Straps follow the lowered armhole and have button adjustments.

Pattern Plot and Manipulation

Figures 1 and 2

- Trace front and back Contour Guide Patterns. (See Chapter 9.)
- Mark bust point and draw bust circumference. (Example: 3-inch radius.)
- Use pushpin to transfer Guidelines 6 (over-bust contour), 4 (under-bust contour), and 5 (contour between the bust). Connect guidelines to bust point.
- Use personal measurements or those given.
- Plot styleline as illustrated (one dart front and back).
- Continue dart intake (of lower section), ending at waist dart (shaded area of front pattern).
- Transfer one half of the remaining front and back darts' excess to center front and back at the sides.
- Measure in an additional 1/2 inch at center back, blending to zero at crotch for a tighter fit.
- Cut and separate pattern. Cut slash lines to bust point.

Figure 1

Figure 2

Figure 3 B*ra top*

- Close side dart and Guidelines 6 and 5. Retrace.
- Measure out 1 inch from each side of bust point (new dart points). Label A and B. Mark center of open dart. Label C.

Figure 3

BRA TOP

Close Guideline 6

Close dart — 1"|1" — Close Guideline 5

B A

C

Figures 4a, b

- Crease-fold dart legs to point C, and direct dart points to marks A and B. Use tracing wheel to transfer styleline to folded darts underneath. Unfold and pencil in perforated lines. (See Figure 4b for dart shape.)
- Draw grainline.
- For bra cup information, see pages 679–680.

Figures 5 and 6

- Trace patterns for lining. For facing, draw line 1 inch above legline as indicated by broken lines. Trace facing shape to paper.
- Add seams. Punch and circle darts, as shown.

Figure 4a

B A

C

Fold dart to center

Figure 4b

BRA TOP

B A

Shape of dart legs

Figure 5

STRAP

BACK

Facing

Figure 6

BOTTOM FRONT

Facing

Full-Figure Swim Foundation

The full-figure foundation is used for swimwear garments cut in woven fabrics or knits such as latex and spandex. When cut in knit, the pattern is modified. Darts are needed to control the fit of the garment through the waist and bust areas, and bra cups give extra support for the bust. A traced copy should be used to develop design patterns from this foundation. The pattern is seamless.

Full-Figure Swim Draft

Measurement needed
- (27) Crotch length _____.

Patterns needed
Torso front and back patterns, with legline instructions from the leotard draft.

Pattern Plot and Manipulation

Figure 1
- Trace torso front and back patterns.
- Mark bust point and bust circumference. Use pushpin to transfer Guidelines 6 (over-bust contour), 4 (under-bust contour), and 5 (contour between the bust). Connect guidelines to bust point.
- Measure out 1/4 inch at front hip. Draw new hipline for front and back torso, ending at waist (broken line indicates original hipline).
- Label center front waist A.
- Use the instructions given for the maillot draft, page 650, Figures 4 (starting with C–E crotch length) and 5. Use 1/2 inch for reduction of the crotch length and hip area.
- After the legline is complete, cut pattern from paper.

Figure 2 Back foundation
- Place front on top of torso back, matching hip levels and center front and back.
- Trace back legline. Remove pattern and cut from paper.

Figure 3 Front foundation
- Trim to front legline.

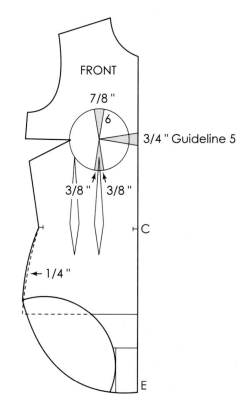

Figure 1

FRONT

7/8 "

6

3/4 " Guideline 5

3/8 " 3/8 "

C

← 1/4 "

E

Figure 2 **Figure 3**

BACK FRONT

Trace legline

Figures 4 and 5 *Leglines for skirted swimwear*
- Square out from center front and center back at hip (A) and crotch (B) equal to hip measurement. Label C. Square up from C to side hip.
- Draw legline as shown (broken line indicates original legline).

Figure 4 **Figure 5**

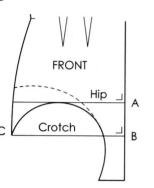 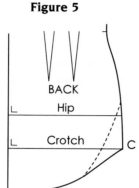

Reduction of the Full-Figure Foundation

Use reduction instructions when cutting in firm knits.

Figures 6 and 7

- Trace front and back patterns.
- Measure in 1/2 inch at side at armhole.
- Measure in $1\frac{1}{2}$ inches at waist.
- Measure in $1\frac{1}{4}$ inches at side leg.
- Draw a blending line for new side seam. (Shaded area to be discarded.)

Figure 6 **Figure 7**

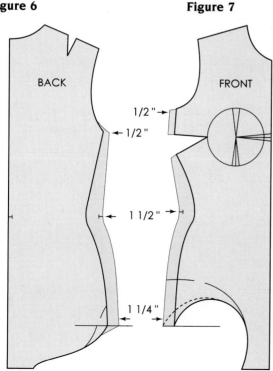

Swimsuit with Skirt Front

Design 1 is cut in spandex and is based on the full-figure swim foundation. The traced pattern should be reduced for stretch before the pattern is developed, using instructions given for Figures 6 and 7. Remember: The width of the pattern should lie on the fabric in the direction of the greatest stretch. Design 2 is given as a practice problem.

Design Analysis

The empire cut, with styleline of bra crossing bust points, has spaghetti straps that tie in back. The bra top is supported by bra cups, and the lower skirted section covers the legline. The underneath section is lined in tricot or power knit while the crotch section (visible on the right side of garment) is self-lined.

DESIGN 1 **DESIGN 2**

Pattern Plot and Manipulation
Figures 1 and 2

- Trace modified front and back full-figure foundation and include all markings. Use instructions for modified legline for skirted designs (Figures 4, 5, 6, and 7, page 675).
- Use personal measurements for contouring, or those given.
- Draw stylelines, using illustration and measurements as a guide.

 Note: Trim bottom section at side equal to dart intake so that patterns will true when joined together along empire styleline (Figure 2).
- Cut and separate patterns.

Figures 3, 4, 5, and 6

Bra top
- Join sections and blend as shown. (Broken lines indicate original pattern.) Retrace (Figure 3).
- Trace patterns with front cut on fold. Figures 4 and 5).

Skirt pattern
- Trace front lower section on fold and square from center front at crotch level to side. (When adding seams, add 1 inch to hem for attachment of 1-inch-wide elastic cut to skirt pattern width.) (Figure 6).
- Add seams, and cut from paper.

Straps (not illustrated)
Cut bias strip 1 inch × 36 inches. Cut in half to make two straps.

Figure 1 **Figure 2**

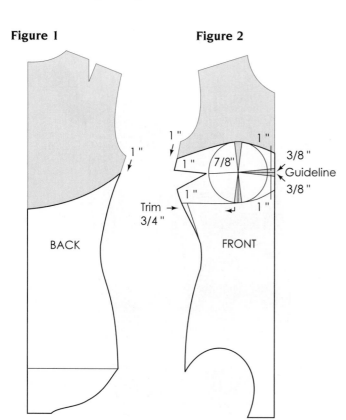

Note: For elastic and bra cup instructions see pages 677–680.

Figure 3

Figure 5

Figure 4

Figure 6

Supplies and Special Information

The following general information and illustrations should be used to complete patterns for actionwear garments. Also included is special information relating to the garment construction for use wherever appropriate. Supplies needed include:

- *Needles:* Use ball point, sizes 9 to 11, and 10 to 12 stitches per inch.
- *Thread:* Corespun (nylon or polyester) or cotton.
- *Bra cups, with or without power-knit frame:* Purchase at fabric stores, notions counter, or supply houses catering to manufacturers of mass-produced garments.
- *Power knit or nylon tricot:* For bra cup frames and crotch or swimsuit lining.
- *Elastic:* 1/4 inch (3/8 inch is easier for beginners to handle). For bra frame, use 1/4-inch lace elastic and where appropriate 1/2-inch felt-back elastic, if available. Use 1-inch elastic for skirted-front swimsuits.

Use of Elastic

Elastic is attached to all raw edges of the garment, whether cut in rigid or knit fabrics, except where seams are joined together or faced. Elastic helps the garment cling to the figure, especially where stylelines cross the hollows of the body—above, below, or between the bust mounds; under the buttocks; and where cutouts cross through a part of the waistline. It is also used around lowered waistlines of the bikini pant.

Elastic Guidelines

An elastic ratio of 1:1, as given in the examples, means that when the elastic is attached it is not stretched. Elastic is attached to the garment with a zigzag, overlock, or straight stitch. The elastic is placed on the wrong side of the garment (see shaded areas, Figures 1 and 3), stitched, folded over, and restitched. It should be stretched evenly while being stitched.

Elastic Measurements
Figures 1, 2, and 3
- *Front neckline:* Cut elastic 1 inch less than neckline.
- *Back neckline:* Cut elastic, using 1:1 ratio.
- *Cutout armholes:* Cut elastic 1/2 inch less than armhole. Use 1:1 ratio for regular armhole.
- *Legline:* Cut elastic $1^1/_2$ inches less than front and back legline (1/2 inch used for overlap). Stretch elastic across back and continue $1^1/_2$ inches past crotch seam of front leg. Use 1:1 ratio on the remaining front legline.

Figure 1

View of front side

View of underside

1:1

1/2 " less

1 " less

Stretch

Stretch

1:1 ratio

2 " less

No stretch

Stretch

Figure 2

1:1

BACK

Figure 3

View of underside

Fold over

Zig zag

Figure 4

- *Cutout waist:* Cut elastic 1 inch less than length of style cut, stretching 1/2 inch under bust and 1/2 inch along remaining styleline.

- *Straps:* Cut elastic using a 1:1 ratio.

Figure 4

Figure 5

- *Bikini:* Cut elastic $1^1/_2$ inches less than total waist.

Figure 5

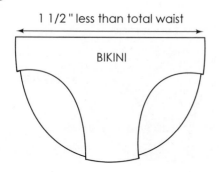

Finishing Crotch and Shoulder

Crotch Lining Pattern
Figure 1

- Trace front pattern from crotch to approximately 6 inches up (1 inch past crotch level).

- Remove pattern. Draw curved line to leg as shown.

Figure 2

- Cut from paper, place on fold, and retrace. (Full pattern shown.)

- Cut in self-fabric or nylon tricot.

- Place on the underside of the garment and stitch in with legline elastic.

Figure 1

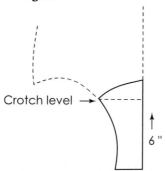

Figure 2

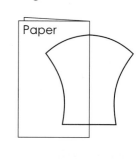

Shoulder Tape
Figure 3

- Cut tape equal to shoulder length of pattern. Use along shoulderline of bodysuits and leotards to prevent stretching.

Figure 3

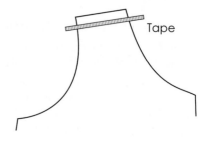

Bra Cups for Swimwear

Two types of bra frames are illustrated, with instructions for attaching each to the garment. Bra Frame 1 should be used for garments *without* stylelines crossing under the bust mound (example: the empire styleline). The bra cup is attached to a frame that hangs free of the garment, except at the top and sides. Bra Frame 2 is used for garments *with* stylelines crossing under the bust; however, a free-hanging frame can also be used. The complete frame is attached to the garment.

Bra Frame 1

Figure 1

Measurement needed

- (10) Bust span _____.

- Cut power knit, nylon tricot, or self-fabric equal to the length and width of the pattern from the strap to just under bust level, plus 2 inches.
- Draw a chalk line through center, and a horizontal line 4 inches up from the bottom.
- Locate bust points on the horizontal line (out from center) and mark.
- Place bra cups on fabric, aligning bust points of bra cup with bust marks. Pin cups to fabric, and trace.

Figure 1

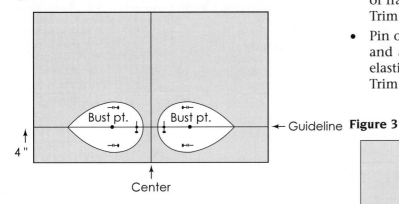

Figure 2

- Turn fabric over and trim excess from around bra cups to within 1/2 inch. Place on form or figure and adjust cup position if necessary. Stitch around edge of bra cups.

Figure 2

Figure 3 *Bra cup attachment guidelines*

- Attach 1/4-inch lace elastic on the stitchline around bra cups on the underside of the garment.
- Cut 1/2-inch-wide elastic (felt-back), 1/2 inch less than width of pattern. Attach along bottom of frame just under bust level, stretching evenly. Trim excess to bottom of elastic.
- Pin or stitch bra frame to wrong side of garment and attach with elastic to garment. Stitch with elastic to garment with a zigzag or straight stitch. Trim excess.

Figure 3

Bra Frame 2
Figure 1
- Trace pattern of bodice front (section for bra insert).
- Cut in fabric and stitch. (Bra with empire style-line shown as the example.)

Figure 1

Figure 2
- Place stitched empire frame on form or figure. Put bra cups over fabric and the bust mound. Pin in place on fabric.
- Pencil in cup outline.
- Remove bust cups from garment. Remove top from form.

Figure 2

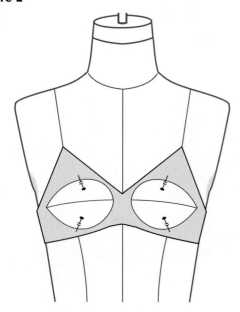

Figure 3
- Remove dart stitches from frame and trace pattern on fold, transferring penciled outline of bra cup. Allow 1/4 inch for attaching bra cups. Cut from paper.
- Cut in power knit, nylon tricot, or self fabric.
- Stitch frame together at bottom. Follow instructions for bra cut attachment for Bra Cup 1. Felt-back elastic can be attached along styleline for comfort.

Figure 3

Bra Lining
Figure 4
- Trace top part of the design bra.
- Square a line from center front, crossing 1/2 inch below bust arc.
- Mark side seam width according to design.
- Measure out 1 inch and draw under bust curve.
- Follow instructions given on the illustration.
- The lining is stitched into the top with elastic (if elastic is used).
- Notches are marked 1 inch in from front and side for fullness under bust.

Figure 4

Attaching Straps to Swimsuit

(Applies to both swimsuits and bra tops.)

Figure 1
- Mark 1 inch from strap points on front and back swimsuit.
- Start zigzag stitch from the marks with elastic applied to the wrong side. Include bra lining with this process.

Figure 1

Figures 2a, b

Strap
- Fold strap with right sides together. Stitch using 3/8 inch seams.
- Turn right side out (not illustrated).
- Peel back the bra lining and slip strap through. Pin strap so that it allows for 3/8 inch seam allowance from both sides.
- Stitch across to hold strap. Figure 2a.
- Trim point to within 1/8 to 3/16 inch from cross stitch. Figure 2b.
- Pull strap through and turn garment to right side. A stitch across the strap area enforces and strengthens the pull on the strap (not illustrated).

Figure 2a

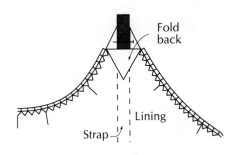

Figure 2b

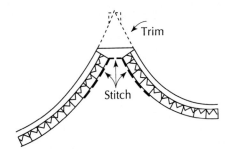

30

Introduction to Childrenswear

Creating childrenswear offers some new challenges to the designer and patternmaker. Comfort, which reflects good fit, proportion, and function, is nowhere more important than in the creation of childrenswear. While adults are sometimes willing to sacrifice comfort for aesthetics, children never are. The business of children is to learn. In order to successfully accomplish the many activities on which learning hinges, children require unencumbering and, at the same time, stimulating clothes.

One of the most stimulating aspects of children's clothes is the primary palette that remains the favorite of children every season. Fabric, too, must be functional, and parents frequently demand material that requires only limited maintenance. Fibers and fabric types for childrenswear are not much different from those found in clothes for comparable uses among adults and teens, although prints, plaids, and stripes are proportioned for the smaller body.

The discussion of the sizes and shapes of children in this text includes infants, crawlers, toddlers, and juniors. However, only sizes 3 to 6X and 7 to 14 (boys and girls) are represented in the patternmaking illustrations.

Sizes for children's clothing are grouped according to body circumference and proportion. Overlap between toddlers' and children's sizes occurs as proportions and heights vary within the age range, almost to the same degree that those with the 7 to 14 sizes overlap on the upper end with junior sizing. Size groupings reflect changes in the proportions of children as they pass from infant (3, 9, 12, 18, or 24 months), through toddlers' (2T, 3T, 4T) to children's (3, 4, 5, 6, boys' and girls', with 6X for girls only), and into boys' and girls' sizes (7, 8, 10, 12, and 14). (Size 16 is used for larger boys' pants.)

Body shapes from infants' through children's size ranges are indistinguishable between boys and girls. Although many differences can be observed in styling and color between boys' and girls' clothing from infant through sizes 6 and 6X, differences necessitated by form only become a reality at size 7, when physical shapes begin to diverge.

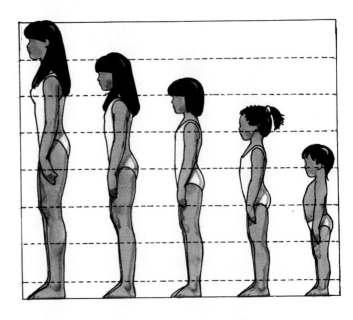

Size Categories for Childrenswear

Infants or Babies

Sizes: 3 months, 6 months, 12 months, 18 months. Sizes may also be labeled as Small (S), Medium (M), Large (L), and Extra Large (XL).

Sample size: 12 months or Medium.

Physical observations: Newborn to children beginning to crawl.

Toddlers

Sizes: 2T, 3T, and 4T (1T may also be considered in this size range).

Sample size: 3T.

Physical observations: Child is walking by this time. Head seems to sit on shoulder; neck is not developed. Shoulders are rounded and have almost no width. Outward thrust of tummy is a prominent feature. Boys' and girls' sizes are indistinguishable, and except for color difference and dresses, fashion is unisex.

Children

Size: Sizing for children within this group is mixed. They are either sized 3 to 6X (X meaning larger than size 6) for both boys and girls, or they are sized 4 to 6X for girls, and 4 to 7 for boys, with size three labeled for toddlers.

Sample size: 5

Physical observations: There is rapid growth through this period. Proportions differ greatly as the torso remains about the same length, but the legs grow longer. The protrusion of the stomach is reduced. Boys and girls have similar shapes at this age, and the waistline, as yet, is not defined. Boys and girls begin to diverge at age 7.

Boys and Girls (Preteen)

Sizes: 7 to 10. Another method for sizing this group is: girls 7 to 14 classified as elementary to junior high school; boys 8 to 20 classified as elementary to junior high school (with chest measurements used for sizing).

Sample size: 10.

Physical observations: Figures diverge when boys and girls reach age 7. Major changes are taking place. Baby fat is replaced with muscle tissue. Slimming and lengthening of the torso and limbs occur, but the figure does not, as yet, have defined curves.

Young Juniors (Referred to as Bubble Gum Juniors)

Sizes: 10 to 14.

Physical observations: There is a jump in growth and figure is more defined. The torso is longer, a natural waistline appears, and bust and hips start to take shape in girls. Boys have slim hips, blending into the waistline. For both boys and girls, this is an interim period when the figure matures at varying stages. Garments within this upper size range do not always fit the figure well. A better fit may be found in the junior department, with boys' pants fitting better in a size 16. Slim and Regular sizes are separate labels for girls; and Slim, Regular, and Huskys are labels for boys' pants. This labeling indicates special fits for other figure types.

Juniors

Sizes: 1, 3, 5, 7, 9, 11, and 13.

Sample size: 9.

Physical observations: The young woman's figure is developed to almost adult maturity with a defined waistline, high, rounded breast, and shapely hips. The teenager is now ready to wear garments in the junior size range. In young men, the figure is developed almost to maturity. Muscle is more defined and hips are slim, blending with the waistline.

Sizing Methods

Measurement charts for children's sizes 3 to 6X and 7 to 14 are found in Chapter 31. A Measurement Recording Chart is placed at the back of the text for use in recording the measurements taken from the Measurement Chart or those taken from personal model measurements. The chart may be removed and reproduced for future use.

The anatomical changes that take place in children between ages 6 and 7 tend to interrupt the regular sequence of graded sizes. The measurement differences will be noticed in some of the graded areas of the chart.

The measurement chart offered in this text is one of many such attempts to establish a good set of working measurements for the industry.

It is difficult for manufacturers, patternmakers, and designers to decide which set of measurements best represents their consumers. They may use age or *height* and *weight* as the standard upon which to determine the sample size, and from which to base the pattern grade.

Alternate Sizing

Another method used for sizing garments uses letters rather than numbers, as follows:

XXS = size 2/3
XS = size 4/5
S = size 6/7
M = size 8
L = size 10
XL = size 12
XXL = size 14

Large and oversized garments, pants, shorts, and tops are commonly labeled small, medium, large, and extra large.

Sources of Inspiration

Designers of childrenswear gain inspiration from many diverse sources, including those provided by fashion-minded children.

Younger children are influenced by what they see on TV, in movies, and in books. They want to wear clothing displaying their favorite characters from TV (Sesame Street characters, the Simpsons, the Flintstones, Mickey Mouse, Bugs Bunny, Barney, and others), Walt Disney movies, Superman, or Jurassic Park themes, to name a few. A manufacturer must be licensed to use characters based on various television shows. A premium is paid to the creator of cartoon characters that are used on garments. Older children, while still interested in TV and movie characters, become more interested in fashions that are "hip."

Boys and girls aged 7 to 14 are influenced by fashions of the junior market. They want their garments to reflect those worn by an older sister or brother or by classmates. They have heroes—key players from football, baseball, basketball, hockey, and other sports. They idolize movie stars and music personalities from country, rap, or rock categories, and want to dress like them. This infatuation creates fads in fashion such as the M.C. Hammer bag pant, underwear worn as outerwear, and the grunge look (over oversized). Designers who want to be up to date with the latest fads should study children at school, on the playground, on TV, and in the movies.

Other sources of inspiration are:

- Trims (lace, rickrack, cording, ruffle trims, braiding, appliqués, bows, and so on).

- Closures of unusual design (buttons, zippers, ties, frogs, clasps, ornate metal closures, Velcro, lacings, and others).

- Combinations of fabrics, colors, and textures.

Clever usage of all that is available to the designer allows for endless creative ideas.

The smart designer also shops the market for inspiration, as well as knowing what the competition is doing. When possible, the designer should go to Europe and other fashion centers for inspiration and fashion direction. Literature, historical references, and folk costumes often provide themes for designer collections. Children's fashion magazines are a valuable source of fashion direction. A list of magazines, clipping services, and historical books follows.

Children's Fashion References

Fashion Magazines and Services

Publications

- *Bimbi Di Elegantissima* (twice a year). In Italian; Includes all ages up to teens.

- *Earnshaw's Infants, Girls and Boyswear Review* (monthly).

- *Kids Fashions* (monthly). Merchandising of childrenswear.

- *Moda Bimbi* (three times a year). In Italian.

- *Children's Business.* Published monthly by Fairchild; covers children's apparel, footwear, toys, and licensing.

- *Seventeen, Elle* (both domestic and French editions), *Lei,* and occasional childrenswear issues of *Town and Country.*

- *Teens and Boys* (monthly). Forecasts style trends.

- *Vogue Bambini* (four times a year). In Italian, highstyle children's magazine.

- *Child.* A resource for upscale childrenswear from both domestic and foreign designers.

- *Yound Fashions* (monthly). Fashion magazine for youthwear.

- *Children's Clothing,* Selma Rosen. Fairchild Publications, 1983.

Services

- *Drawing and Designing Children's and Teenage Fashions,* Patrick John Ireland. John Wiley and Sons, 1979.
- First View Girls
- First View Boys
- First View Baby
- D3—Junior Retail Report
 The Patricia Brandt Company
 Phone: (323) 650-1222
 Fax: (323) 650-2355
- The Middlemarck Clipping Service. Features sketches of childrenswear around the country.

Historical References

- *Complete Book of Fashion Illustration*
 How to Draw Children
 Tate and Edwards, Prentice Hall (3rd ed.)
- *Inside Fashion Design*
 Chapter 8 covers this topic.
 Sharon Tate, Prentice Hall (4th ed.)
- *History of Children's Costume,* Elizabeth Ewing. Charles Scribner's Sons, New York.
- *Boys Fashions, 1885 to 1905,* Donna H. Felger. Hobby House Press, 1984, Cumberland, Md.
- *Children's Clothes 1939–1970, The advent of Fashion,* Alice Guppy. Pool: Blandford Press for the Pasold Research Fund, 1978.
- *The Way We Wore: Fashion Illustrations of Children's Wear, 1870 to 1970,* Charles Scribner's Sons, 1978.

31

Drafting the Basic Pattern Set

Measurement Taking, Standard Measurement Charts

Measuring the Form— Children, 3 to 6X, Girls, 7 to 14, and Boys, 7 to 14

All measurements must be taken carefully to avoid errors and fitting problems. With the exception of circumference measurements, only one-half of the front and back form are measured, using the same half throughout for consistency. Arc measurements are taken only at the bust or chest, waist, and hip areas of the form.

To measure the form, place the metal-tipped end of the measuring tape at a landmark on the form, extending the tape to another landmark. As measurements are taken, record them on the Measurement Recording Chart (located at the back of the book). The chart may be removed from the text for reproduction. Measurements are numbered to correlate with the chart for quick reference.

Form Preparation

Figure 1

Place pins through the form to mark the following locations:

• Roll line at shoulder tip.

• Roll line of front and back at mid-armhole (at level with plate screw).

• Armhole depth. Place pinhead below plate at side seam of form, using the measurement indi-.cated by the size of the form.

Armhole Depth Chart

Children		Boys and Girls	
Size	Space below plate	Size	Space below plate
3	1/8 inch	7	1/2 inch
4	1/4 inch	8	5/8 inch
5	3/8 inch	10	3/4 inch
6	1/2 inch	12	7/8 inch
6X	5/8 inch	14	1 inch

Torso Circumference Measurements

Measurements do not include ease.

Figure 2

Bust or Chest (1). Measure over chest or bust and across back.

Waist (2). Measure around the waist.

Hip (3). Measure around the widest part of the hip, holding the measuring tape parallel to the floor. Pin-mark location at side seam.

Figure 2

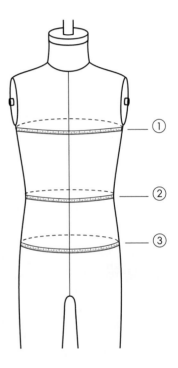

Figure 1

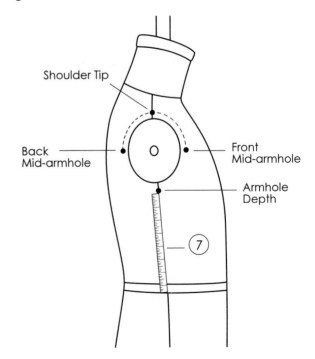

Vertical Measurements

Front and Back

Figures 3 and 4

Center length (4). Measure at center neckline to below waist (front and back).

Full length (5). Measure from shoulder-neck to below waist tape. Measuring tape is held parallel to the center line (front and back).

Shoulder slope (6). Measure from shoulder tip (pin mark) to center line at waist below tape (front and back).

Side length (7). Measure from pin mark to below waist of the side seam, see Figure 1.

Horizontal Measurements

Front

Figure 5

Shoulder length (8). Measure from shoulder-neck to shoulder tip at pin mark.

The following measurements are taken across the form, divided in half, and recorded.

Across shoulder (9). Measure from pin mark at shoulder tip to shoulder tip.

Across chest (10). Measure from pin mark at mid-armhole to mid-armhole.

Bust/chest arc (11). Measure from pin mark at side seam to side seam.

Waist arc (14). Measure from side seam to side seam.

Hip arc (15). Measure from side seam to side seam at pin mark with measuring tape held parallel to the floor.

Back

Figure 6

Across shoulder (9). Measure from pin mark at shoulder tip to shoulder tip.

Across back (12). Measure from pin mark at mid-armhole to mid-armhole.

Back arc (13). Measure from pin mark at side seam to side seam.

Waist arc (14). Measure from side seam to side seam.

Hip arc (15). Measure from side seam to side seam at pin mark with measuring tape held parallel to the floor.

Figure 3

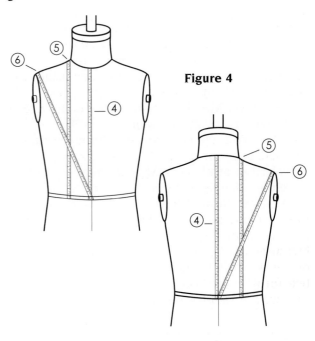

Figure 4

Figure 5

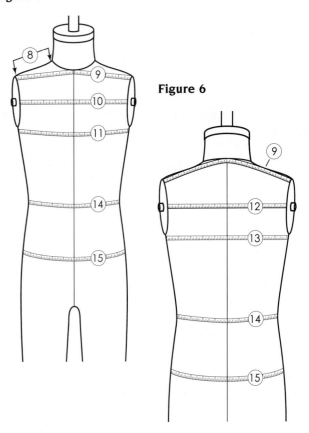

Figure 6

Leg Measurements

Figure 7

(If the form is legless, record measurement numbers 16 through 27 from the Standard Measurement Chart for the size of the form being measured.)

The following measurements are taken from below the waistline tape.

Waist to hip level (16). Measure from waist tape to pin mark at side seam.

Waist to knee (17). Measure from waist at side to mid-knee.

Waist to ankle (18). Measure from waist at side to below ankle tape.

Waist to floor (19). Use waist to ankle (18) measurement and add $2^{1}/_{4}$ inches.

Figure 8

Upper thigh (20). Measure around the widest part of the upper leg.

Knee (21). Measure around the fullest part of the knee.

Calf (22). Measure around the fullest part of the calf.

Ankle (23). Measure around the fullest part of the ankle.

Foot entry (24). Add $2^{1}/_{4}$ inches to ankle measurement.

Figure 9

Trunk length (25). Measure from front shoulder neck downward, passing under crotch to back shoulder-neck.

Figure 10

Crotch length (26). Measure from center front waist, passing under crotch to center back waist.

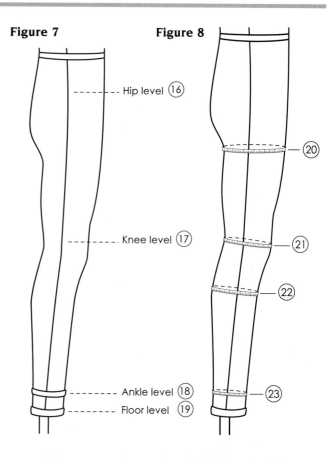

Figure 7 **Figure 8**

Hip level ⑯

⑳

⑰ Knee level

㉑

㉒

⑱ Ankle level
⑲ Floor level

㉓

Figure 11

Crotch depth (27). Place square ruler between legs of the form with edges of the ruler arms touching abdomen and crotch. Measure from below waist to top edge of ruler arm at crotch level.

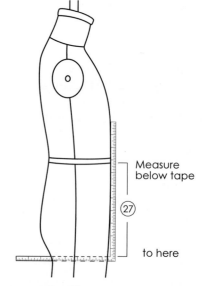

Figure 11

Measure below tape

㉗

to here

Arm Measurements

Measurements used for the sleeve draft are given on page 699. Standard arm measurements are numbers (28), (29), (30), and (31). See pages 693 and 694.

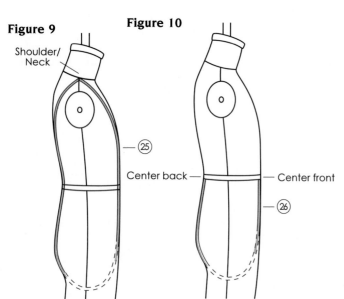

Figure 9

Shoulder/
Neck

㉕

Figure 10

Center back —

— Center front

㉖

STANDARD MEASUREMENT CHART FOR BOYS AND GIRLS*

Sizes	3	4	5	6	6X
HEIGHT	$36–38^1/_2$	$39–41^1/_2$	$42–44^1/_2$	$45–46^1/_2$	$47–48^1/_2$
WEIGHT	29–32	33–36	37–40	41–46	47–53
HEAD CIRCUMFERENCE	$19^3/_4$	20	$20^1/_4$	$20^1/_2$	$20^3/_4$

Circumference Measurement
(Does not include ease)

	3	4	5	6	6X
1. Bust/Chest	$22^3/_4$	$23^3/_4$	$24^3/_4$	$25^3/_4$	$26^3/_4$
2. Waist:	22	23	24	25	26
3. Hip:	$22^3/_4$	$23^3/_4$	$24^3/_4$	$25^3/_4$	$26^3/_4$
4. Center Length:					
Front	$8^1/_4$	$9^3/_8$	$9^1/_2$	$9^5/_8$	$9^3/_4$
Back	10	$10^1/_8$	$10^1/_4$	$10^3/_8$	$10^1/_2$
5. Full length:					
Front	$10^3/_4$	$11^1/_{16}$	$11^3/_8$	$11^{11}/_{16}$	12
Back	$10^1/_2$	$10^{11}/_{16}$	$10^7/_8$	$11^1/_{16}$	$11^1/_4$
6. Shoulder Slope					
Front	$10^5/_8$	11	$11^3/_8$	$11^3/_4$	$12^1/_8$
Back	$10^1/_4$	$10^5/_8$	11	$11^3/_8$	$11^5/_8$
7. Side length	$4^1/_4$	$4^3/_8$	$4^1/_2$	$4^5/_8$	$5^3/_4$
8. Shoulder length	$3^1/_4$	$3^3/_8$	$3^1/_2$	$3^5/_8$	$3^3/_4$
9. Across shoulder					
Front	$5^1/_8$	$5^5/_{16}$	$5^1/_2$	$5^{11}/_{16}$	$5^7/_8$
Back	$5^3/_8$	$5^9/_{16}$	$5^3/_4$	$5^{15}/_{16}$	$6^1/_8$
10. Across chest	$4^1/_2$	$4^3/_4$	5	$5^1/_4$	$5^1/_2$
11. Bust/chest arc	$5^7/_8$	$6^1/_8$	$6^3/_8$	$6^5/_8$	$6^7/_8$
12. Across back	$4^1/_2$	$4^3/_4$	5	$5^1/_4$	$5^1/_2$
13. Back arc	$5^1/_2$	$5^3/_4$	6	$6^1/_4$	$6^1/_2$
14. Waist arc					
Front	$5^1/_2$	$5^3/_4$	6	$6^1/_4$	$6^1/_2$
Back	$4^7/_8$	$5^1/_8$	$5^3/_8$	$5^5/_8$	$5^7/_8$
15. Hip arc					
Front	$5^5/_8$	$6^1/_8$	$6^3/_8$	$6^5/_8$	$6^7/_8$
Back	$5^1/_2$	$5^3/_4$	6	$6^1/_4$	$6^1/_2$
16. Waist to hip	$4^5/_8$	5	$5^3/_8$	$5^3/_4$	$6^1/_2$
17. Waist to knee	$12^1/_2$	14	$15^1/_2$	16	$16^1/_2$
18. Waist to ankle	18	$20^1/_4$	$22^1/_2$	$24^3/_4$	26
19. Waist to floor	$20^1/_2$	$22^1/_2$	$24^3/_4$	27	$28^1/_4$
20. Upper thigh	$12^1/_4$	$12^3/_4$	$13^1/_4$	$13^3/_4$	$14^1/_4$
21. Knee	$9^1/_4$	$9^5/_8$	10	$10^3/_8$	$10^3/_4$
22. Calf	$8^3/_4$	$9^1/_8$	$9^1/_2$	$9^7/_8$	$10^1/_4$
23. Ankle	$6^1/_2$	$6^3/_4$	7	$7^1/_4$	$7^1/_2$
24. Foot entry	$8^3/_4$	9	$9^1/_4$	$9^1/_2$	$9^3/_4$
25. Trunk length	$35^3/_4$	$38^1/_8$	$40^3/_4$	$42^1/_8$	$43^1/_2$
26. Crotch length	$17^1/_8$	$18^1/_4$	$19^3/_8$	$20^1/_2$	$21^5/_8$
27. Crotch depth	$5^1/_2$	6	$6^1/_2$	7	$7^1/_2$

Sleeve Measurements, see page 699.

*Some manufacturers use size 6 measurements to include size 6X with the only difference noted in the length. Others combine 6X with size 7, and still others eliminate size 7 from the size range.

STANDARD MEASUREMENT CHART FOR GIRLS

Sizes	7	8	10	12	14
HEIGHT	48–50	$50^1/_2$–$52^1/_2$	53–55	$55^1/_2$–$57^1/_2$	58–60
WEIGHT	47–53	54–63	64–74	75–84	85–94
HEAD CIRCUMFERENCE	21	$21^1/_4$	$21^1/_2$	$21^3/_4$	22

Circumference Measurement
(Does not include ease)

	7	8	10	12	14
1. Bust/Chest	30	31	32	33	34
2. Waist:	24	25	26	27	28
3. Hip:	30	31	32	33	34
4. Center Length:					
Front	11	$11^1/_8$	$11^1/_4$	$11^3/_8$	$11^1/_2$
Back	$12^1/_8$	$12^1/_4$	$12^3/_8$	$12^1/_2$	$12^5/_8$
5. Full length:					
Front	13	$13^1/_4$	$13^1/_2$	$13^3/_4$	14
Back	$12^3/_4$	13	$13^1/_4$	$13^1/_2$	$13^3/_4$
6. Shoulder Slope					
Front	$12^7/_8$	$13^1/_8$	$13^3/_8$	$13^5/_8$	$13^7/_8$
Back	$12^3/_8$	$12^5/_8$	$12^7/_8$	$13^1/_8$	$13^3/_8$
7. Side length	$5^1/_8$	$5^1/_4$	$5^3/_8$	$5^1/_2$	$5^5/_8$
8. Shoulder length	4	$4^1/_8$	$4^1/_4$	$4^1/_2$	$4^5/_8$
9. Across shoulder					
Front	6	$6^3/_{16}$	$6^3/_8$	$6^9/_{16}$	$6^3/_4$
Back	$6^1/_8$	$6^5/_{16}$	$6^1/_2$	$6^{11}/_{16}$	$6^7/_8$
10. Across chest	$6^5/_{16}$	$5^7/_{16}$	$5^5/_8$	$5^3/_{16}$	6
11. Bust/chest arc	$7^3/_4$	8	$8^1/_4$	$8^1/_2$	$8^3/_4$
12. Across back	$5^5/_8$	$5^{13}/_{16}$	6	$6^3/_{16}$	$6^3/_8$
13. Back arc	$7^1/_4$	$7^1/_2$	$7^3/_4$	8	$8^1/_4$
14. Waist arc					
Front	$6^1/_4$	$6^1/_2$	$6^3/_4$	7	$7^1/_4$
Back	$5^3/_4$	6	$6^1/_4$	$6^1/_2$	$6^3/_4$
15. Hip arc					
Front	$7^1/_2$	$7^3/_4$	8	$8^1/_4$	$8^1/_2$
Back	$7^1/_2$	$7^3/_4$	8	$8^1/_4$	$8^1/_2$
16. Waist to hip	$6^1/_2$	$6^1/_2$	7	7	7
17. Waist to knee	$17^1/_2$	$18^3/_4$	20	$21^1/_4$	$22^1/_4$
18. Waist to ankle	$32^3/_4$	$34^3/_8$	$34^7/_8$	$36^5/_8$	$38^3/_8$
19. Waist to floor	$34^1/_4$	$35^7/_8$	$37^1/_2$	$39^1/_4$	41
20. Upper thigh	17	$17^5/_8$	$18^1/_2$	$19^5/_8$	$19^3/_4$
21. Knee	12	$12^1/_2$	13	$13^1/_2$	$14^1/_8$
22. Calf	$11^1/_8$	$11^1/_2$	12	$12^1/_2$	$13^1/_4$
23. Ankle	8	$8^1/_8$	$8^1/_4$	$8^3/_8$	$8^1/_2$
24. Foot entry	$10^1/_4$	$10^3/_8$	$10^1/_2$	$10^5/_8$	$10^3/_4$
25. Trunk length	50	51	52	$53^1/_2$	55
26. Crotch length	$21^3/_4$	$22^7/_8$	24	$25^1/_8$	$26^1/_4$
27. Crotch depth	$6^3/_4$	$7^7/_8$	9	$10^1/_4$	$11^1/_2$

Sleeve Draft measurements, see page 699.

*Some manufacturers use size 6 measurements to include size 6X with the only difference noted int he length. Others combine 6X with size 7, and still others eliminate size 7 from the size range. A 1 inch grade used for all sizes.

The Basic Pattern Set

The pattern set is seamless for pattern development and for projects in this text. (It may be seamed for experienced patternmakers.) It is important that the basic pattern be cut in fabric and test fit on the model or form. If not, errors in the patterns will be passed on to each design based on them.

To complete the patterns, see page 63.

The Basic Pattern for Boyswear

Follow draft instruction for the basic pattern (bodice front, back, and sleeve). Convert to the dartless foundation (page 734) and sleeve (page 699).

Front Bodice Draft

Figure 1

Square a line, and mark the following locations:

A–B = Full length, plus 1/16 inch (5).
A–C = Across shoulder (9).
Square a short line down from C.
B–D = Center front length, less 3/8 inch (4).
Square a line in from D.
B–E = Bust or chest arc. Add 1 inch for sizes 3 to 6X, or 1/2" sizes 7 to 14, (11).
Square a line up from E.
B–F = Slope measurement plus 1/8 inch (6).
F–G = Shoulder length (8).
Square a line down from F–G line.
B–H = 2$\frac{1}{2}$ inches.
H–I = 3/4 inch (1$\frac{1}{2}$ inches for sizes 7 to 14).
H–J = One-half of H–I. Mark.
Square a line up from J equal to side length (7), less 3/4 inch. Label K.
Draw dart legs from K to H and K to I.
E–L = 3/4 inch. Mark.
Draw a slightly curved line from L to I.
L–M = Side length (7). Mark.
Square a short line out from M.
F–N = 2 inches.
N–O = 3/8 inch.

Measurements needed

- (5) Full length F_____ B_____.
- (9) Across shoulder F_____ B_____.
- (4) Center length F_____ ' B_____.
- (11) Bust or chest arc _____.
- (6) Shoulder slope F_____ B_____.
- (8) Shoulder length _____.
- (7) Side length _____.
- (13) Back arc _____.

Reference measurements
- (14) Waist arc F_____ B_____.

Figure 1

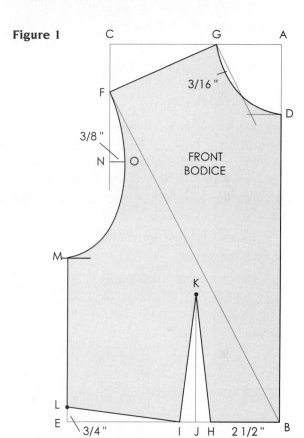

Figure 2 *Neckline*
With french curve touching D, G, and 1/8 inch in at mid-neck, draw neckline curve.

Figure 2

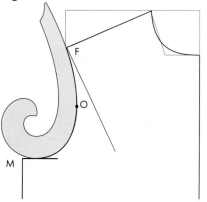

Figure 3

Figure 3 *Armhole*
With french curve touching points F, O, and M, draw armhole curve. The curve line may blend with the square line before touching point M.

Back Bodice Draft

Figure 4

Square a line and mark the following:

A–B = Full length, plus 1/16 inch (5).

A–C = Across shoulder. (9)

Square a line down from C.

B–D = Center back length (4).

Square a line in from D.

B–E = Back arc. Add 1 inch for sized 3 to 6X, and 1/2 inch for sizes 7 to 14 (13).

Square a line up from E.

B–F = Slope measurement, plus 1/8 inch (6).

F–G = Shoulder length plus 1/4 inch (ease).

B–H = 2$\frac{1}{2}$ inches.

H–I = 5/8 inch. (1 inch for sizes 8 to 14)

H–J = One-half of H–I. Mark.

Square a line up from J equal to side length (7), less 3/4 inch. Mark and label K. Draw dart legs from K to I, and K to H.

E–L = 3/4 inch. Mark.

L–M = 1/8 inch.

Draw a slightly curved line from M to I.

M–N = Side length (7).

Square a short line from N.

F–O = 2 inches.

O–P = 1/2 inch.

Figure 4

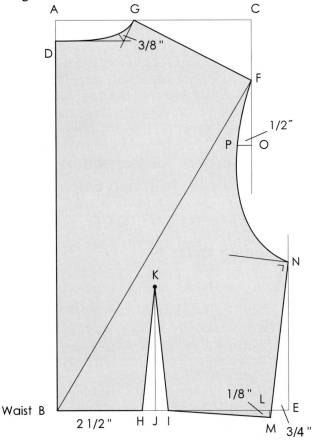

Figure 6

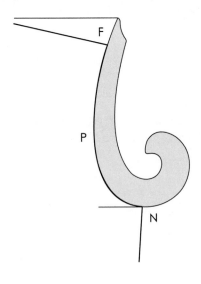

Figure 6 *Armhole*

With french curve touching F, P, and N, draw armhole curve.

Figure 5

Figure 5 *Neckline*

With french curve touching D and G, draw neckline curve.

Darts and Dart Equivalents

The basic front and back bodice patterns contain darts. Darts, which provide excess, are best used in forms other than stitched darts for children sized 3 to 6X. The dart excess can be controlled with elastic or ties to help define the nebulous area designated as the waistline, if a waistline must be defined (see Designs 1 and 2).

Yoke stylelines and those that rest relatively near the armholes (such as the empire) provide the greatest freedom, best proportion, and a high degree of flexibility in fit without the need for darts (see Designs 3 and 4). Darts are primarily used in designs to help define the developing bustline for girls sized 7 to 14 (see Design 5).

DESIGN 1 **DESIGN 2**

DESIGN 5

DESIGN 4

DESIGN 3

Basic Skirt Draft

The basic skirt is part of the basic pattern set, and is stitched to the bodice for test fit. It can be used as a separate skirt with waistband and should also be test fit.

Measurements needed
- Skirt length _____.
- (15) Hip arc F_____, B_____.
- (16) Waist to hip _____.
- (14) Waist arc F_____, B_____.

Figure 1

A–B = Skirt length.

A–C = Waist to hip (16).

C–D = Front and back hip arc (15), plus $1^1/_2$ inch ease (1 inch for sizes 7 to 14).

A–E = C–D.

Square line from A.

B–F = C–D.

Square line from B.

Connect a line from E to F.

A–G = Front waist arc (14), plus 3/8 inch (ease), and 5/8 inch for dart intake.

E–H = Back waist arc (14), plus 3/8 inch (ease), and 1 inch for dart intake.

Side seam placement
- Mark a point centered between points H and G. Label I, and square down to B–F line. Label J, and label hip K.

Dart placement
- Mark $2^1/_2$ inches in from front and back for dart placement.
- Measure out 5/8 inch for front dart and 1 inch for back dart.
- Mark centers of each dart and square down $2^1/_2$ inches for front dart and 3 to 4 inches for back dart.
- Draw dart legs for front and back skirt.

Hipline
- Draw hipline up from K to 1/16 inch past H and G.
- Draw waistline from H and G to dart legs.
- Recheck waistline of skirt with bodice. Adjust at side seams to true.
- Cut patterns from paper and separate.

The pattern is seamless for pattern development. Add seams to muslin for test fit. For belt construction options, see page 766.

Figure 1

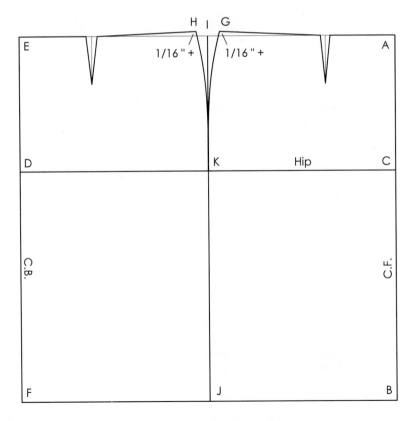

Basic Sleeve

The average cap ease is from 1 to $1\frac{1}{4}$ inches. When there is more or less than that amount, the sleeve cap is adjusted. The basic sleeve is drafted with an elbow dart. Entry measurement may vary from that of the draft, and can be modified when the draft is complete.

Sleeve Draft

Figure 1

A–B = Sleeve length.

A–C = Cap height (establishes biceps level).

B–D = One-half of B–C.

D–E = 1/2 inch (establishes elbow level).

Square out from both sides of C, E, and B.

C–F = One-half of biceps measurement.

C–G = C–F.

Draw lines from A to F and A to G. Divide into thirds. Label H and I (back), and J and K (front).

F–L = One-half of F–I.

G–M = One-half of G–K.

Square out 1/2 inch from H.

Square in 1/8 inch from L.

With french curve, draw sleeve cap (Figure 2).

Square out 1/2 inch from J.

Square in 1/4 inch from M (Figure 2b).

Figure 2a, b

Draw capline, using illustration as a guide.

Sleeve Draft Measurements

The standard sleeve draft measurements apply to the sizes given.

Sizes	3	4	5	6	6X
Sleeve length	13	$13\frac{3}{4}$	15	$16\frac{1}{4}$	$17\frac{1}{4}$
Cap height	$4\frac{1}{8}$	$4\frac{1}{4}$	$4\frac{3}{8}$	$4\frac{1}{2}$	$4\frac{5}{8}$
Biceps (with ease)	$9\frac{1}{2}$	$9\frac{3}{4}$	10	$10\frac{1}{4}$	$10\frac{1}{2}$

Sizes	7	8	10	12	14
Sleeve length	$17\frac{1}{4}$	$18\frac{3}{8}$	$19\frac{1}{2}$	$20\frac{5}{8}$	$21\frac{3}{4}$
Cap height	$4\frac{3}{4}$	$4\frac{7}{8}$	5	$5\frac{1}{8}$	$5\frac{1}{4}$
Biceps (with ease)	$11\frac{1}{8}$	$11\frac{3}{8}$	$11\frac{5}{8}$	$11\frac{7}{8}$	$12\frac{1}{8}$

Figure 1

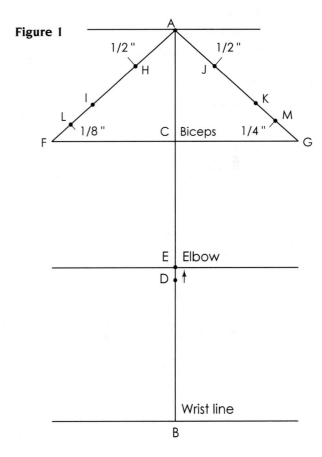

Figure 2a

Figure 2b

Figure 3

Lower sleeve draft

B–N = 1$\frac{1}{2}$ inches less than C–F.

B–O = B–N.

 Draw lines from F to N and G to O.

 Label elbow P–Q.

P–R = One-half of P–E.

P–S = 3/4 inch.

 Draw dart leg from R to S equal to P–R.

N–T = 1/2 inch.

 Draw a line from S through T equal to P–N. Label U.

 Draw a line from U to V equal to N–O.

 Draw a line from V to Q.

Sleeve notches

Mark two notches for the back sleeve, 1/2 inch below I and spaced 1/2 inch apart. Mark one notch for front sleeve, 1/2 inch below K.

Figure 3

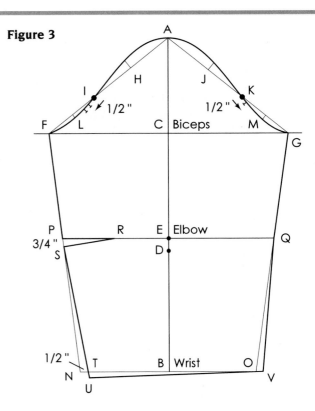

Determine Sleeve Cap Ease

Figures 4 and 5

Measure front and back cap. Measure front and back bodice armhole. Subtract the armhole measurement from cap measurement. The difference is the amount of ease of the sleeve cap. The average cap ease is 1 to 1$\frac{1}{4}$ inches. If the amount is less than 1 inch, add to biceps (see Figure 4). If the amount is more than 1$\frac{1}{4}$ inches, decrease biceps (see Figure 5). Redraw capline and underseam, as illustrated. Cut sleeve from paper. Walk sleeve up from the curve of the front and back armholes, and mark notch locations on bodice. It may be necessary to move the center cap notch to equalize the fullness.

Other modification suggestions

If the operator is unable to stitch cap ease without puckers, add to the front and back shoulder tips and side seams to zero at neck and waist.

Figure 4

Figure 5

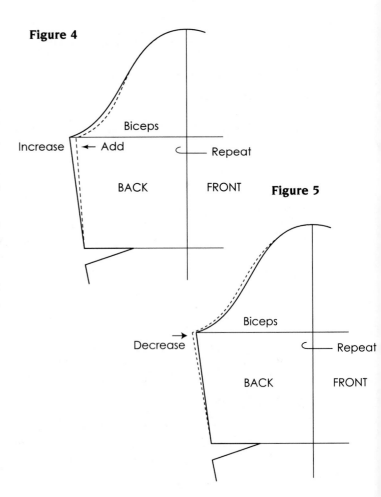

32

Collars, Sleeves, and Skirts

Collars

The theory, terminology, and other design variations for collar development are found in Chapter 10.

Shirt Collar

Two types of basic collars are illustrated—one having a curved neckline edge and the other with a straight neckline edge. The straight neckline edge is more casual and less fitted around the neck area.

Measurements needed:
- Center back neck to shoulder _____.
- Center front neck to shoulder _____.

Figure 1
Shirt Collar Draft

A–B = Front and back neck measurement of the basic pattern (or of any pattern to which the collar will be attached).

A–C = Center back to shoulder-neck. Mark for notch.

A–D = $2^1/_2$ inches. Square a line from D. Square a line up from B.

B–E = 1/2 inch.

Draw a curved line from C to E. Point of collar is 3/4 inch out from square. Draw line to E. (Broken lines indicate roll of collar.) Label *Upper collar,* and cut from paper.

Figure 2—*Undercollar*
- Retrace collar on fold.
- Measure down 1/8 inch from D, and draw line to zero.
- Notch as shown.

Figure 3
Straight Shirt Collar Draft

Follow instruction for shirt collar, except the neckline edge of the collar is straight. Collar width can be $2^1/_2$ to $3^1/_2$ inches.

Figure 1

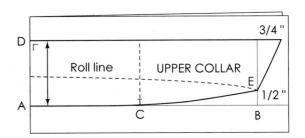

Figure 2

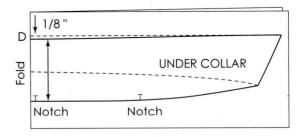

Figure 3

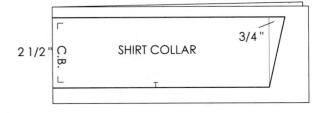

Peter Pan Collar

The flat Peter Pan collar is used when designing wide collars that lie flat to the chest, buttoned or unbuttoned. For Peter Pan designs having a full or partial collar roll, see pages 184 through 187.

Peter Pan Draft

Figure 1

- Trace upper part of front bodice.
- Place back pattern on top of front pattern with necklines touching and shoulders overlapped 1/4 inch. Trace neckline.
- Lower center front neck 1/4 inch, and blend.
- Draw collar shape as wide as desired, parallel with neckline.

Figure 2 **U**pper collar

- Trace collar on fold, add seams, and cut from paper.

Figure 1

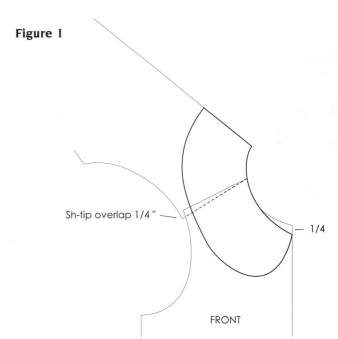

Sh-tip overlap 1/4 "

1/4

FRONT

Figure 2

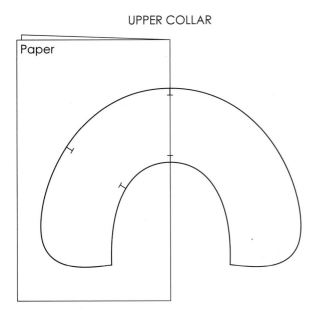

UPPER COLLAR

Paper

Figure 3

UNDERCOLLAR

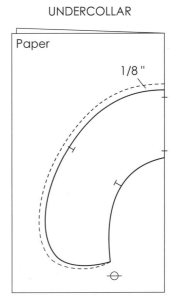

Paper

1/8 "

Figure 3 **U**ndercollar

- Trace collar and trim 1/8 inch (or more) for the undercollar.
- Place notch on each side of center back.

Sailor Collar

The sailor collar is based on the Peter Pan principle. For other design variations see pages 188 through 190.

Sailor Draft
Figure 1

- Trace upper part of front bodice.
- Place back pattern on top of front pattern with necklines touching and shoulders overlapped 1/4 inch. Trace back neckline and center back line.
- Draw sailor collar with a V neckline.

Figure 1

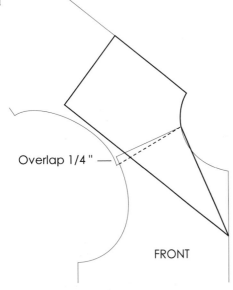

Overlap 1/4 "

FRONT

Figure 3 *Upper collar*

- Cut sailor collar from paper and retrace on fold.
- Trace for undercollar on fold.
- Trim undercollar, as illustrated.
- Cut from paper. Mark for notches.

Figure 3

Figure 2 *Front bodice*

- Trace bodice and trim neckline to V shape.

Figure 2

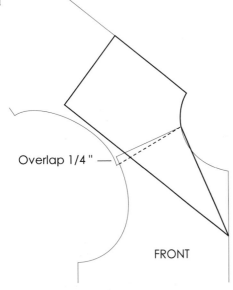

FRONT

Discard

Ext.

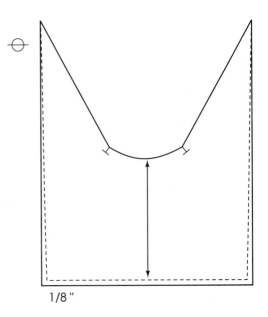

1/8 "

Collar with Stand

The collar with stand is generally used for shirts and tailored dresses. For design variations, see pages 194.

Collar and Stand Draft

Figure 1 Stand

- Trace mandarin collar, or follow draft for the mandarin draft; see page 702, Figure 1 (A–B and A–C).
- Add 3/4 inch to center front for button and buttonhole.
- Cut from fold of paper.

Figure 1

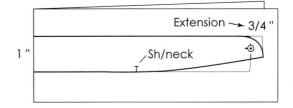

Figure 2 Collar

- Trace collar stand (broken lines).
- Draw collar shape 1/2 inch below collar stand. The collar point is from 1 or more inches below collar stand. Draw line to center front of stand.
- Draw two slash lines on collar.
- Cut collar from paper.

Figure 2

Figure 3

- Cut slash lines on collar.
- Place on fold of paper and spread collar's edge.
- Trace collar and cut from paper.

Figure 3

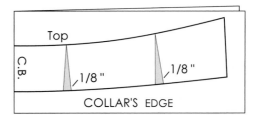

Dartless Sleeve Foundation

The dartless sleeve is developed from the basic sleeve. The dartless sleeve can be used as a base for sleeves not requiring an elbow dart. Two types of dartless sleeve are illustrated: the full sleeve and the half sleeve. Use the full dartless sleeve for sleeve designs that vary on each side of the grainline, and the half sleeve for designs that are the same except for the curve of the front capline.

Dartless Sleeve Draft

Figure 1
- Trace the basic sleeve (broken lines).
- Square a line from grainline to front hemline, and continue line across pattern (broken lines indicate the original hemline).
- Square lines down from biceps. (The elbow dart is eliminated.)

Figure 1

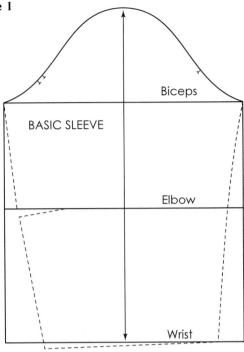

Figure 2
- Measure and mark one-half of entry measurement out from each side of grainline, and draw lines to biceps for reference.
- Divide sleeve into four equal parts and draw lines through pattern.
- Divide cap into four equal parts.
- Cut sleeve from paper.

Figure 3 *Half sleeve*
- Trace back sleeve to grainline, include parts' lines (1 and 2).
- Mark for entry.
- Place front sleeve on top of back sleeve and trace curve of sleeve (gray area separates front from back sleeve).

Suggestion: Mark sleeve lengths for quick reference.

Figure 2

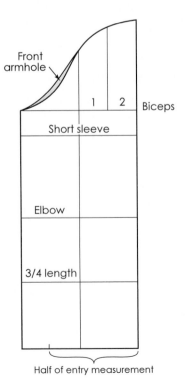

Figure 3

Puff Sleeves

The puff sleeve can be developed with gathers at the hemline (Design 1), at the cap (Design 2), or at the cap and hemline (Design 3).

DESIGN 1 DESIGN 2 DESIGN 3

Puff Draft

Figure 1

- The dartless sleeve foundation is used as a base for the sleeve drafts.
- Plot each of the puff sleeves, using the dartless sleeve pattern with slash lines. Cut slash lines.

Figure 1

Figure 2

- Draw slit line on center (or off-center) for cuff opening.

Figure 2

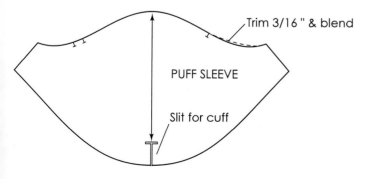

Trim 3/16 " & blend

PUFF SLEEVE

Slit for cuff

Hemline Gathers—Design 1

Figure 3

- Place slashed pattern on fold of paper, and spread for fullness. Add length for "puff."

Figure 3

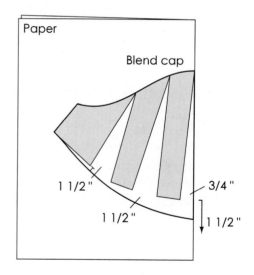

Paper

Blend cap

1 1/2 " 3/4 "

1 1/2 " 1 1/2 "

Figure 4 *Sleeve band*

- Use measurement of elbow or biceps (whichever is greater); add 1/2-inch ease, plus extension for button and buttonhole.

Figure 4

Ext. 3/4 "

Sleeve Cap Gathers—Design 2

Figure 1

- Trace dartless sleeve (see page 707, Figure 1).
- Cut slash lines, place on fold of paper, spread for fullness, and trace.
- Add to height at cap for "puff."

Figure 1

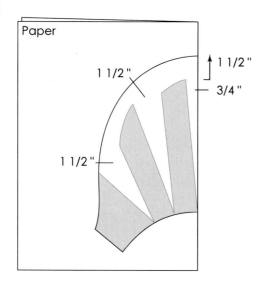

Figure 2

- The completed sleeve.
- Trace for a facing pattern.

Figure 2

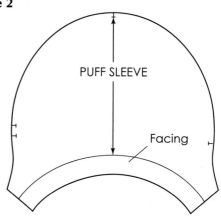

Cap and Hemline Gathers—Design 3

Figure 1

- Trace dartless sleeve pattern and mark quarter slash line. Place on fold of paper.
- Trace cap and hem, and shift pattern along squared guideline for added fullness, as desired.
- Add to height and length for "puff."

Figure 1

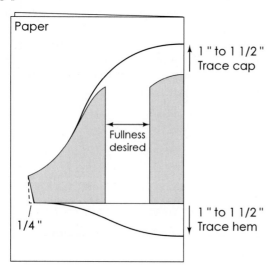

Figure 2

- The completed pattern. Notch for gather control.
- For sleeve band, see page 707, Figure 4. Do not extend for button and buttonhole.

Figure 2

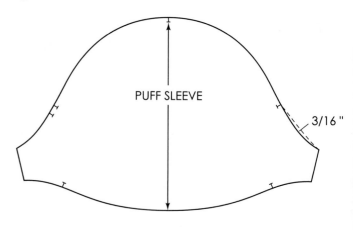

Sleeve Design Variations

The first four sleeve designs are illustrated, with Design 5 presented as a thought problem.

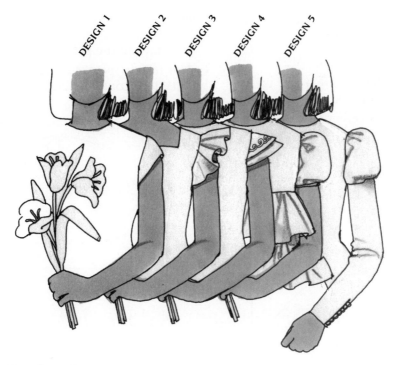

DESIGN 1 DESIGN 2 DESIGN 3 DESIGN 4 DESIGN 5

Cap Sleeve—Design 1

The sleeve cap fits closer around the upper arm area than does the basic sleeve.

Figure 1

- Trace upper part of the dartless sleeve.
- Mark slash line and underarm length.
- Draw the curved hemline, as shown.

Figure 1

1/2" to 1"

Center

1/2"

Mark back sleeve

Figure 2

- Cut pattern from paper, slash, and place on fold of paper.
- Overlap and trace sleeve, blending lapped area.
- Cut and test fit.

Figure 2

Paper

Overlap 1/4"

Trim

Blend

Ruffled Sleeve—Design 2

The ruffled sleeve is stitched to the armhole, notch to notch. To determine fullness, measure front and back bodice armhole from notch to notch, and add two times the measurement. The sleeve can be stitched lower under the armhole, if desired.

Figure 1

- Fold paper and mark center. Square a line up as illustrated or to the width desired.
- On fold, measure out from center to amount of fullness desired.
- Draw a curved line to marks on each side of center.
- Complete pattern for test fit.

Figure 1

Fullness: 2 or 3 to 1

Saucer Sleeve—Design 3

The sleeve juts directly out from the armhole and can be varied for different effects.

Figure 1

- Trace sleeve cap and follow illustration as a guide for plotting the pattern.
- Cut from paper. The sleeve should be self-faced, with interconstruction to hold its shape.

Figure 1

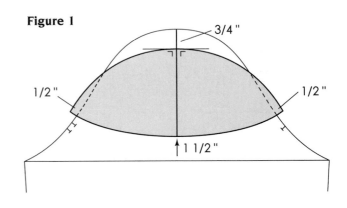

Baby Puff Sleeve—Design 4

The baby puff is specially drafted for controlled fullness that will not overwhelm the garment to which it is attached. The sleeve is for sizes 3 to 5.

Figure 1

- Trace sleeve cap on fold of paper (broken lines).
- Draw a square line across biceps.
- Shift sleeve along biceps line equal to its width (for fullness).

- Place pushpin at notch and pivot pattern downward, 1 inch below square line.
- Trace sleeve curve to 1 inch down the underseam. (Broken line is the position of the sleeve when pivoted.)
- Remove sleeve and draw curved capline and hemline of sleeve, as illustrated.
- Complete pattern for test fit.

Figure 1

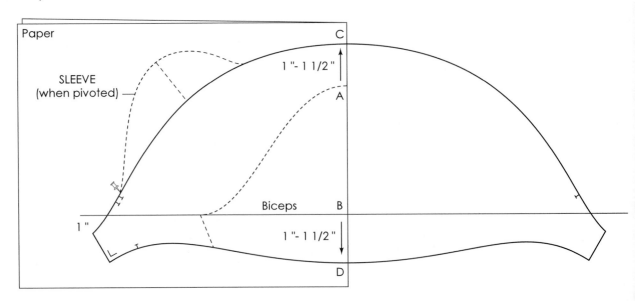

Drawstring Sleeve

The sleeve with a pull-up tie is based on the basic or the dartless sleeve pattern.

Figure 1

- Trace half sleeve 1 inch below biceps. Label X.
- Plot sleeve design lines. Label cap A. C is marked at biceps level. B is one-half of A–C. Cap ease, less 1/4 inch, is removed from the sleeve. The slight curve between points B and C allows the arm to show through. Mark and cut slash lines, as illustrated. Trim sleeve from X to C.

Figure 1

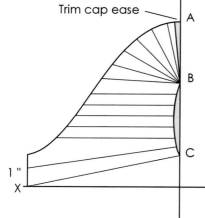

Figure 2

- Draw a square line and spread the slashed lines to fit the square line. The letters A, B, and C indicate their locations on the pattern.

Figure 2

Figure 3

- Add seam allowances.
- Retrace the sleeve and trim the curve of the front sleeve. Note the locations of the letters and their relationship to the plotted pattern (Figure 1).
- Complete pattern and test fit. Stitch A–B together.

Figure 3

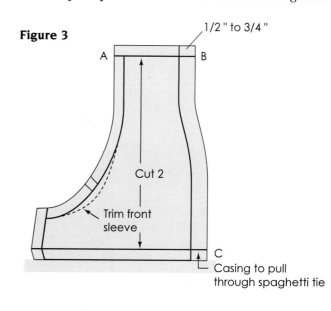

Petal Sleeve

The petal sleeve is based on the basic or dartless sleeve pattern. This sleeve design is appropriate for sizes 3 to 6X and 7 to 14.

Design Analysis

The petal sleeve can be lapped toward the front or back, as illustrated by Design 3. The underarm width and petal width can be changed for design variations. For guidance in developing Designs 2 and 3, see pages 331 and 332.

Petal Draft

Figure 1

- Trace sleeve to length desired.
- Plot styleline of the petal sleeve.

Figure 1

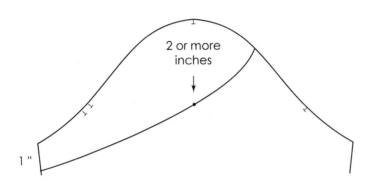

Figures 2 and 3

- Trace petal sleeve twice.
- Trim front sleeve.
- Cut from paper.
- Complete pattern for test fit.

Figure 2

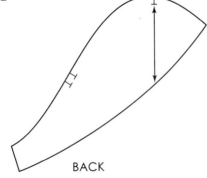

BACK

Figure 3

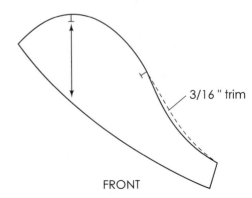

3/16 " trim

FRONT

Bell Sleeve

The bell sleeve is based on the dartless foundation pattern and can be cut to any length. Designs 1, 2, and 3 are examples of the variations that can be developed from this pattern.

DESIGN 1 **DESIGN 2** **DESIGN 3**

Bell Sleeve Draft

Figure 1

- Trace dartless pattern, divide into thirds, and slash.
- Place pattern on fold of paper, spread, and trace.
- Cut to length desired.

Figure 1

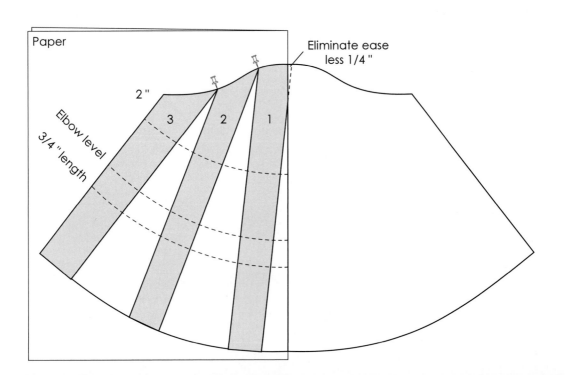

Leg-o-Mutton Sleeve

The leg-o-mutton sleeve can be as full as desired. Design 1 has basic fullness and Design 2 has greater fullness. Because of the size of the model, it is suggested that the armhole be modified by shortening the length of the shoulder at the shoulder tip and redrawing the armhole, blending to the curve or to the front and back armhole notches. Mark, and cut inside the basic armhole of the pattern. The sleeve is based on the basic foundation pattern.

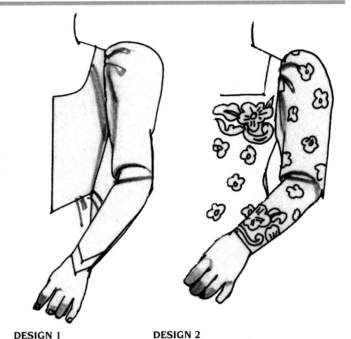

DESIGN 1 DESIGN 2

Leg-o-Mutton Draft

Figure 1

* Trace basic sleeve, and plot.

 A–C = One-half of A–B.

 E is one-half the distance of D and elbow.

 D–F = One-half of D–E.

 Draw slash lines.

Figure 2

Cut pattern from paper, and slash.

* Place on fold of paper, and spread for fullness. The greater the spread, the higher the puff. The broken lines illustrate greater height.

* Complete pattern for test fit.

Figure 1

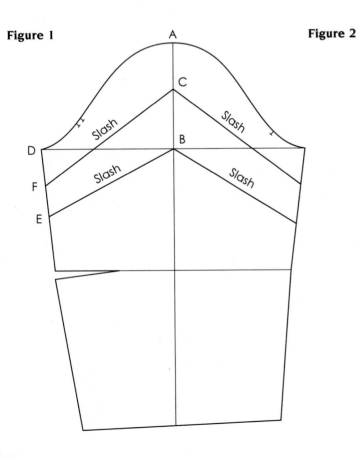

Figure 2

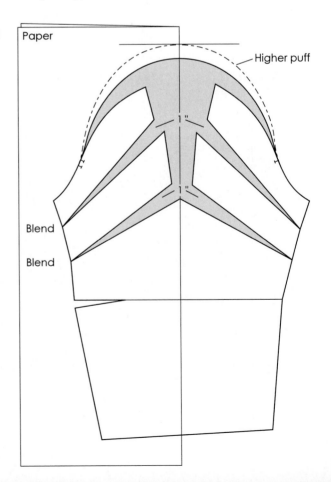

Skirts

For skirt terminology, belt construction, and other skirt designs, see Chapter 13. Skirts for sizes 3 to 6X may be belted without elastic. However, waist bands generally have elastic inserted either across the back section of the belt or completely around the waist band. See page 766 for guidance.

Other skirt designs:

Gored Skirt—Pages 256–272

Pleated Skirt—Pages 288–293

Circular Skirt—Pages 303–310

Tiered Skirt—Pages 282–287

Dirndl Skirt—Page 253–254

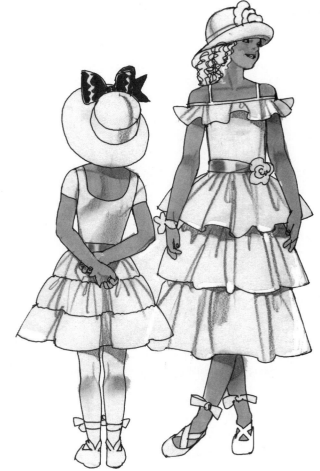

Flared Skirt

Design Analysis: Designs 1 and 2

Design 1 is a flared gored skirt. Design 2 is a basic flared skirt (like Design 1 but without a center seam). Design 3 is a gathered skirt with a stylized waistband. Designs are appropriate for sizes 7 to 14.

Flared Skirt Draft

Figures 1 and 2

- Figures 1 and 2 illustrate the waist darts closed, transferring excess to hemline sweep, with at least $1\frac{1}{4}$ inches added to side seam for A-line silhouette.

- Complete patterns for test fit, either as a gored skirt with center front and center back seams, or as a basic flare. Cut on fold.

- For belt options, see pages 766–767.

DESIGN 1 **DESIGN 2** **DESIGN 3**

Figure 1

FRONT

Figure 2

BACK

Gathered Skirt with Stylized Waistband

Design Analysis: Design 3

Waistbands that are designed below the waistline of the figure must take the design shape from the skirt before the pattern is manipulated. The fullness of the skirt is equal at waist and hem.

Skirt Draft

Figure 1

- Plot the styleline on the basic pattern, and cut from paper.

Figure 1

Figure 2

- On fold of paper, trace waistband and trace copy of the skirt curve section to the band.

Figure 2

Figure 3

Figure 3

- Slash and spread to desired amount of fullness. Follow the centers of the spread sections when drawing waistline of the skirt.

- Repeat the process for back skirt, without the curved line of the front pattern.

- Complete pattern for a test fit.

Yoked Circular Skirt

The skirt is designed for sizes 3 to 6X and 7 to 14. Elastic can be inserted into the waistband, leaving the back dart excess to be gathered into the band. See thought problems. For more about yoke skirts, see page 278.

Design Analysis

The yoked skirt is designed and separated from the skirt draft before the lower skirt section is manipulated.

For belt options, see page 766.

Yoked Skirt Draft

Figure 1

- Trace the basic skirt front.

- Plot the pattern, using illustration, design, size, and height of the model as a guide. Skirt can be any length desired.

Figure 1

Repeat for back skirt

← Length

Figure 2

- Cut yoke from pattern and trace on fold of paper, closing waist dart. (Do not close dart if elastic is used in the waistband.)

Figure 2

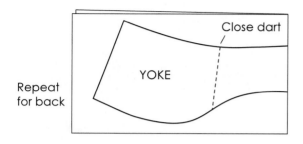

Figure 3

- Cut slash lines, place skirt on fold of paper, and spread for hemline sweep. Add to side seam, as illustrated.
- Repeat for back skirt.
- Complete patterns for test fit.

Figure 3

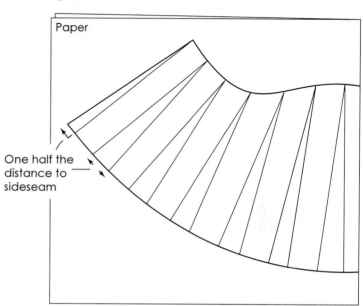

33

Dresses and Jumpers

The Shift Foundation—3 to 6X and 7 to 14

The shift draft is based on the basic bodice patterns. The shift foundation is the base for such designs as the princess, empire, and torso-length dresses, to which gathered or pleated skirts are attached.

Shift Draft

Figures 1 and 2

- Trace front and back patterns and all markings, including darts.
- Extend center front line to desired length and square across and up to armhole.
- Square across the back pattern to the armhole and square down equal to side length of the front.
- Square across the hem and up to center back.
- Mark a point 1/2 to 3/4 inch in from midpoint of side seam. Label X.
- Add $1\frac{1}{2}$ to 2 inches out at the side seams for A-line silhouette. Mark a point 1/4 inch up, and draw a curved hemline.

- Draw side seam from hem to Point X, and connect to armhole, as illustrated.
- Cut front shift from paper.

Darts

Extend lines through center of darts to length indicated. Draw dart legs to waistline. Shorten the length of the dart legs by 1/2 inch for sizes 3 to 6X.

- Cut patterns from paper.
- Complete the patterns for the test fit.
- The basic sleeve completes the pattern set.

Figure 1 **Figure 2**

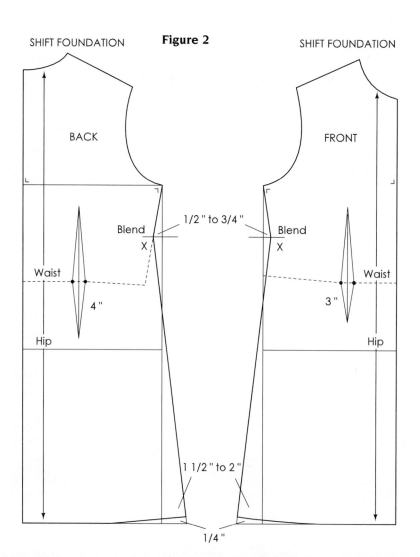

Princess Styleline

The princess styleline is an appropriate foundation for sizes 3 to 6X and 7 to 14.

Design Analysis

The princess styleline (to mid-shoulder or to mid-armhole) is a popular base for a variety of designs. Flare can be added to each panel (from waist) or to any point along the goreline (see pages 256ff for additional ideas). Godets are also a source of flare (see pages 296–297). Flare is part of the shift pattern. Add additional flare to the side seams, if necessary, to balance the design. Designs 1 and 2 are but a few of the ideas that can be developed from the Princess pattern.

The Princess Draft

Figures 1 and 2

- Trace the front and back shift patterns.
- Plot the style for mid-shoulder of mid-armhole (uneven broken lines). The styleline touches dart point.
- Draw true lines from dart points to hem, parallel to front and back center lines.

DESIGN 2

DESIGN 1

Figure 1

BACK

Figure 2

FRONT

Figures 3, 4, 5 and 6

- Cut patterns apart along princess line. The waist dart is cut out.

- Trace patterns and add flare (width as desired). The flare is equal to each side of the front and back panels. Add to side seam to balance the design, if necessary.

- Blend line through waist area for a loose fit. If a closer fit is desired, follow the dart legs.

Figure 3

Front
Side
Panel

Blend

Add
flare

Add
flare

Figure 4

Front
Panel

Blend

Add
flare

Figure 5

BACK
Panel

Blend

Add
flare

Figure 6

Blend

Back
Side
Panel

Add
flare

Add
flare

Empire with Flare

The shift foundation is used as the base for designs with stylelines passing under the bust line, and for those not having a waistline seam. The bodice darts are generally not stitched for empire designs for sizes 3 to 6X. (See Designs 1 and 2.)

Design Analysis

Design 3: The empire styleline is plotted through an open dart. For sizes 7 to 14, greater amounts of fullness may be taken into the dart for a closer fit (contouring). Slash lines are marked on the lower pattern where flare and a pleat give the skirt its fullness.

DESIGN 2

DESIGN 1

The Empire Draft

Figure 1

- Trace front and back shift pattern.
- Plot pattern, using illustration, design, size, and height of the model as a guide.

Empire styleline

- Square a line from center front that is half the length of the waist dart.
- Draw curved styleline below square line at center, and above square line at side. Label A–B.
- Take in 1/4 to 1/2 inch at side.

Contouring

Measure out 1/4 inch from each dart leg at empire styleline, and redraw dart legs to dart point.

- Mirror bust dart (broken line).

Figure 2

- Trace back shift pattern.
- Plot the pattern as illustrated.
- C–D = A–B.
- Cut patterns from paper, and separate.

Figure 2

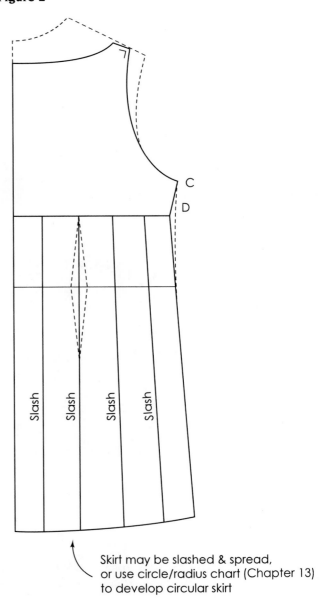

Skirt may be slashed & spread, or use circle/radius chart (Chapter 13) to develop circular skirt

Figure 1

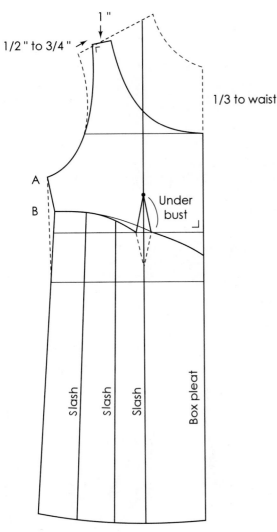

Figures 3a, b
- Trace front and back bodice.
- Add 1 inch extension on back pattern.

Figure 3a

Figure 3b

Figure 4
- Fold pleat on paper.
- Place skirt pattern on fold and spread for fullness desired, allowing space for center front pleat. Side flare C–D equals one-half of A–B.
- Trace pattern, blending waistline.
- Add seams and cut skirt from paper, folding pleat for seamline shape.
- Sweep of back skirt equals front skirt without pleat (not illustrated).
- Complete the pattern and test fit.
- For sleeve design, see page 714.

Figure 4

Tent Foundation

The tent foundation is appropriate for sizes 3 to 6X and 7 to 14.

Several versions of the tent are illustrated. Tent A is the basic tent based on the shift; tent B is based on the basic front and back patterns. To increase hemline sweep, add to the center line. Several designs are given to show the flexibility of the tent foundation.

Tent Draft

Figure 1 *Tent A:* **Based on shift pattern**

- Trace front and back shift.
- Plot the slash lines from hem to curve of armhole.
- Cut slash lines and spread from 3 to 5 inches.
- Retrace, and add flare to the side seam that is one-third of the allowance of spread area. Draw side seam, blending line just above the waistline.
- The waistline darts are not stitched.
- Repeat for back (not illustrated).

Figure 2 *Tent B:* **Based on basic pattern**

- Plot slash lines as illustrated.
- Add fullness to hemline at the center front and back tent. Draw line to the center necklines.

Figure 3

- Slash and spread for fullness desired.
- Add length parallel to waist.
- Repeat for back (not illustrated).

Figure 2

Figure 1 Tent A

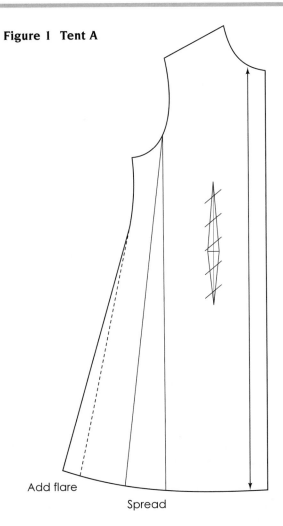

Add flare

Spread

Figure 3 Tent B

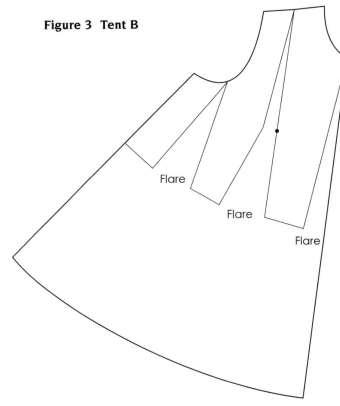

Flare

Flare

Flare

Tent Variations

The Bib Jumper

Design Analysis

The tent fullness is gathered and controlled with binding at the top of the dress, with the fullness under the bust area controlled with a drawstring pulled through a casing. A spaghetti strap holds the garment to the shoulder of the model. Based on Tent B.

The back design is the same as the front. If the placement under the bust is varied, a back pattern is required. Designs 2 and 3 are thought problems.

Bib Jumper Draft

Figure 1

* Trace tent pattern B.

* Plot the styleline, using illustration, design, size, and height of the model as a guide. Bust point helps to place line under bust. Add fullness desired.

Binding

* Measure top styleline front, and multiply by two.

* Add strap measurement, front and back.

Stitching suggestion:

* Gather top to establish measurement and stitch a tape to hold gathers before applying the bias binding.

* Stitch bias tape (casing) around line under bust front and back for elastic pull-through.

* Complete the pattern and test fit.

DESIGN 1

DESIGN 3

DESIGN 2

Figure 1

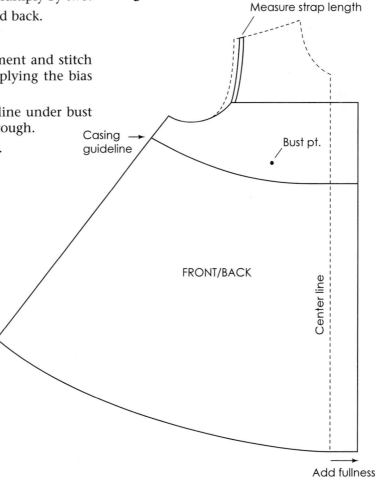

Measure strap length

Casing guideline

Bust pt.

FRONT/BACK

Center line

Add fullness

Tank-Top Jumper

Appropriate for sizes 3 to 6X and 7 to 14. Neckline styles that are the same front and back use only the front pattern to cut the garment. Different front and back designs require a back pattern. The jumper is based on the basic (A) or exaggerated tent pattern (B).

Design Analysis

A design cut low in the neck and armhole areas requires a top underneath. The strap is drafted toward the shoulder-neck to help secure strap to shoulder. The sweep of the hemline can be reduced to control fullness.

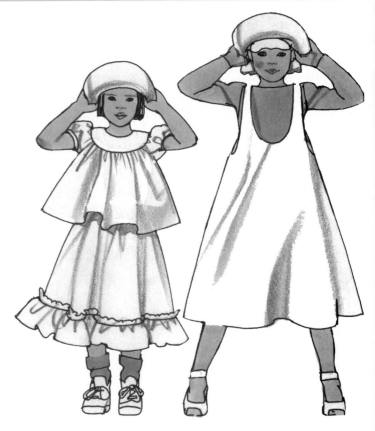

Tank-Top Jumper Draft

Figure 1

- Trace front tent pattern.
- Plot neckline and armhole.
- A facing pattern can be traced from the neck and armhole areas, or can be overlocked and top-stitched.

Figure 1

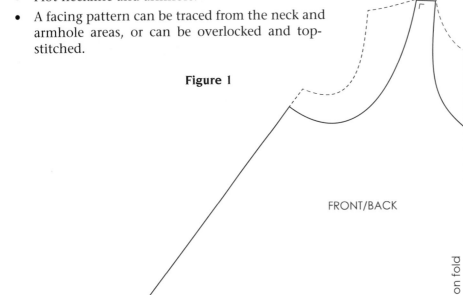

FRONT/BACK

Cut on fold

Torso Jumper

The dartless pattern is used as a base for dresses not having a waistline. Appropriate for sizes 3 to 6X and 7 to 14.

Design Analysis

Designs with very low-cut armholes and necklines are based on the front pattern. If the necklines vary, trace the front pattern to design the back neckline.

Torso Jumper Draft

Figure 1

- Trace the dartless front pattern.
- Plot the pattern, using the illustration, design, size, and height of the model as a guide.
- Add width to the skirt for gathers, as desired.
- Cut patterns from paper and separate the pattern parts (A for upper torso and B for skirt).

Back

- Retrace torso pattern for back jumper, shifting shoulder strap toward back (broken lines).
- Complete pattern for test fit.

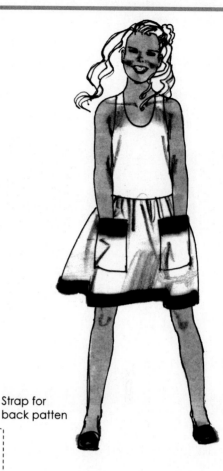

Figure 1

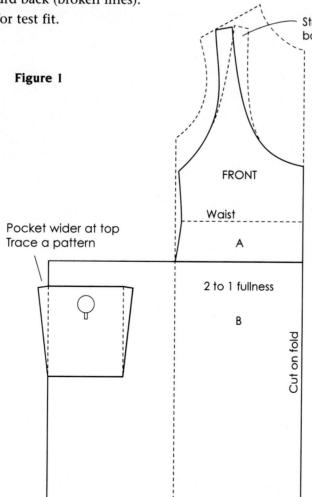

Strap for back patten

FRONT

Waist

A

Pocket wider at top
Trace a pattern

2 to 1 fullness

B

Cut on fold

34

Tops

Dartless Top Foundation

Appropriate for sizes 3T to 6X and 7 to 14, boys' and girls' sizes. The dartless draft is based on the basic front and back patterns.

The armholes are modified so that the waist and hip align at the same level to balance the pattern. The shoulder ease of the back bodice remains but can be trimmed when not needed. The front and back waist darts are marked for reference when needed. The dartless sleeve or basic sleeve completes the pattern.

The dartless pattern is an important base for the development of the jacket, coat, skirt, knit tops, bodysuit, and leotard foundations.

The Dartless Shirt Draft

Figure 1—Front
- Square a line across paper. Place center front waist of the bodice 1/4 inch below square.
- Trace bodice front, and dot-mark dart legs and bust point.
- Draw a line in center of dart leg, ending 2 to 3 inches below waist.
- Extend a line down from center front to equal hip depth and square a 20-inch line across paper. Square a line up from hip.

Figure 2—Back
- Place back pattern on square with side waist, touching square line. Label X and armhole Y.
- Trace pattern, and dot-mark waist dart. Mark dart center, and draw line 4 to 5 inches below waist.

Equalize armhole
- Square a line from center back, touching Y and passing through front pattern. Label Z.
- Mark 1/2 inch out from Y. Mark 1/2 inch in from Z. Square down from Y and Z to hipline.
- Draw curve of armhole from Z, and blend armholes.
- Mark a place on back shoulder indicating 1/4 inch ease (a reference for trimming when not needed).

Figure 1 **Figure 2**

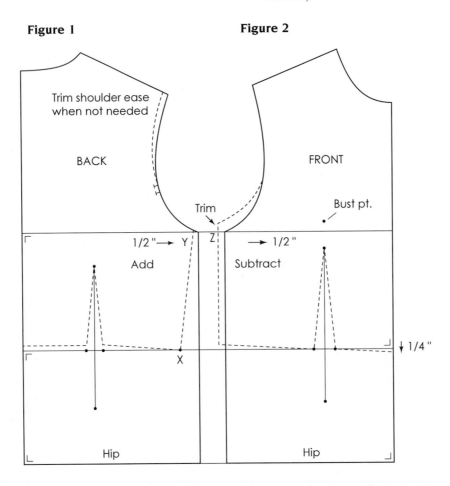

Figure 3a, b

Add ease

- For a looser fit, add 1/4 to 1/2 inch to side seams.
- Cut and test fit.

Figure 3b

Figure 3a

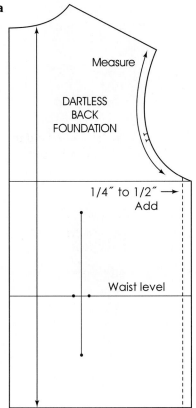

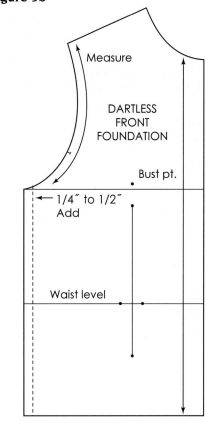

Figure 4a, b

Sleeve modification

The enlarged armhole may require a modified basic sleeve. To determine cap ease, measure the following:

- Front and back armhole. Record _____.
- Front and back sleeve cap. Record _____.

 Subtract to find the difference. If the cap ease is more or less than 1/2 inch, add to or subtract from the underseams of the sleeve equally.

- See page 706 to draft a dartless sleeve pattern.

Figure 4a

Figure 4b

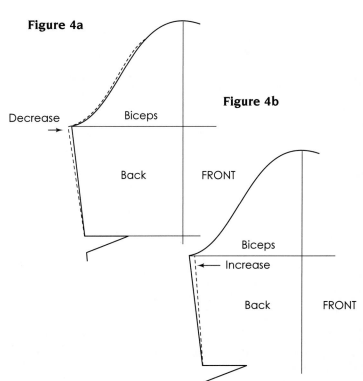

Basic Shirt and Sleeve Foundation

The basic shirt is based on the dartless pattern. The shirt is for boys' or girls' sizes 3 to 6X and 7 to 14. The shirt is drafted with a back yoke. The basic sleeve is modified for the shirt pattern. A basic collar or collar with stand are appropriate collars for the shirt. However, any collar can be designed.

The Shirt Draft

Figure 1

Fold paper and draw a line 3/4 inch in from fold for the extension.

- Place front dartless pattern on pencil line and trace.
- With tracing wheel, trace the neckline.
- Unfold paper and mark notches.
- Extend shoulder to equal back shoulder.
- Lower armhole 1/2 inch (or more).
- Draw a curved shirttail, (broken line) if desired, and cut from paper.

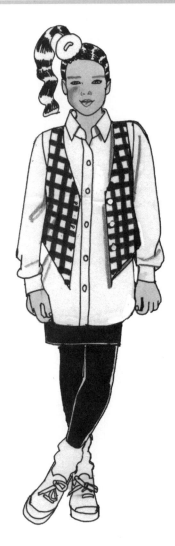

Figure 1

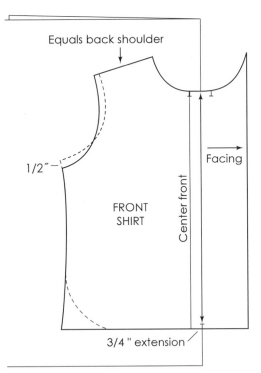

Equals back shoulder

1/2″

Facing

FRONT SHIRT

Center front

3/4 " extension

Figure 2

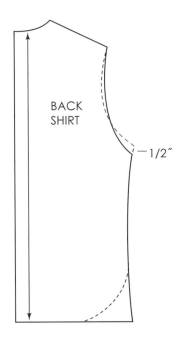

BACK SHIRT

−1/2″

Figure 2 Back

- Trace back pattern.
- Lower armhole equal to front armhole and blend.

Figure 3 *Relocating shoulder line*
- Place front shirt, touching necklines.
- Trace 3/4 inch of front pattern. Mark notches.

Figure 3

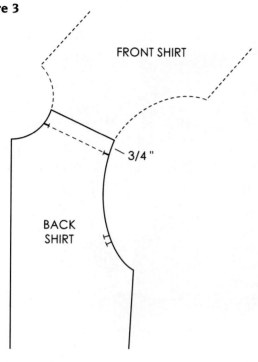

Figure 4
- Cut 3/4 inch from front pattern.

Figure 4

Figure 5 *Yoke*
- Square a line across back pattern, locating back yoke (use one-fourth of back length to waist).
- Add 1 to 1$\frac{1}{2}$ inches for back pleat.

Figures 6 and 7
- Separate patterns. Place yoke on fold and trace.
- Complete patterns including shirt sleeve for test fit.

Figure 5

Figure 6

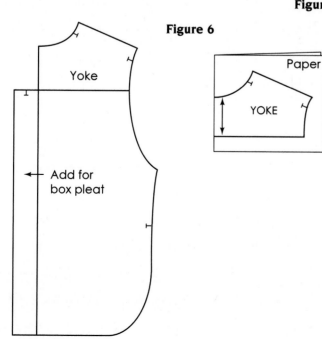

Figure 7

Shirt Sleeve

The shirt sleeve is more casual than the basic sleeve. A lift (which extends the underarm seam for greater movement) and the addition of a cuff makes this sleeve different. The hemline of the sleeve can be varied from the example.

Shirt Sleeve Draft

Figure 1

Figure 1

- Trace the basic sleeve.
- Measure up 1 inch from hemline (A) for cuff allowance. Label B.
- Square a line from center grainline touching B. Label grain (C). Continue line across pattern so that line C–D equals C–B.
- Draw a parallel line 1/2 inch up from biceps.
- Place pushpin $1^1/_2$ inches from sleeve cap E and swing pattern upward until biceps touches parallel line. Trace capline, and blend.
- Repeat for front sleeve.
- Draw lines from lift to hemline of front and back sleeve.

Sleeve hemline

- Entry slit is placed one-half the distance of C–D, plus 1 inch (toward underseam).
- Measure down 1/2 inch and continue line upward 2 inches.
- Draw hemline curve as illustrated.
- Cut slit 1/16-inch wide, and add crossbar notch.

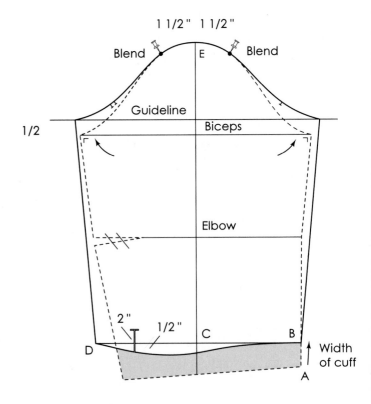

Figure 2
Completed pattern.

Figure 2

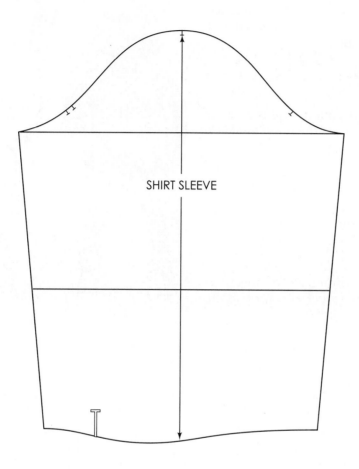

SHIRT SLEEVE

Figure 3 *Cuff*
- Use entry measurement, plus 1 inch extensions.
 (Cut width 2 inches, plus seam allowance.)
 Finished width 1 inch.

Figure 3

Oversized Shirt and Sleeve

The oversized shirt is based on the basic shirt or drafted from the dartless pattern. The difference from the basic shirt is the width of the garment and the way the sleeve is developed.

Oversized Shirt Draft

Figures 1 and 2
- Trace a copy of the shirt pattern (see page 736) and cut through the center of the front and back at shoulders.
- Draw a line on paper.
- Place hem of pattern on line and spread 1 to $1\frac{1}{2}$ inches (or more).
- Trace patterns. Lower armholes 1/2 inch.
- Blend shoulder yoke.
- Draw pocket placement.
- Measure front and back armhole. Add together. Divide in half. Record for casual shirt sleeve draft _____. (A–E of the sleeve draft).

Figure 1

Figure 2

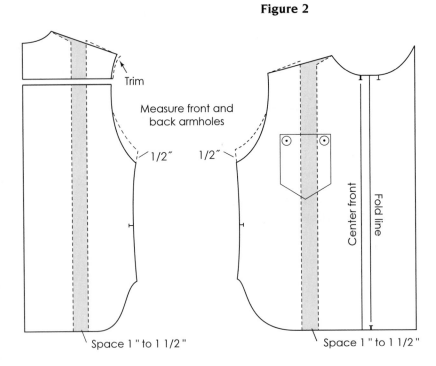

Measure front and back armholes

1/2″ 1/2″

Space 1″ to 1 1/2″

Trim

Center front Fold line

Space 1″ to 1 1/2″

Figure 3

Figure 4

Paper

Yoke

Fold

Figure 3
- Trace yoke and cut on fold.

Figure 4
- Trace pocket; add foldback and seams.
- Complete pattern for test fit when the sleeve is drafted.

Oversized Shirt Sleeve Draft

The oversized shirt sleeve has a short cap height. The cap height is determined by the length of the shoulderline of the shirt. For example, if the added width of the shoulderline is 1 inch, subtract 1 inch from the original cap height, or use one-half of cap height. The sleeve length can either hang over wrist and knuckles or end at wristbone (or any length in between).

Figure 1

A–B = Sleeve length, less cuff width.

 Draw line and fold paper.

A–C = One-half of original cap height.

B–D = Elbow level, plus 3/4 inch.

 Square out from B, C, and D.

A–E = One-half of the armhole measurement.

 (Add front and back armholes together, divide in half; A–E is that measurement.)

 Draw line from A to E.

- Divide A–E into fourths.
- Measure out 1/4 inch, and in 1/8 inch, as illustrated.
- Draw curve of cap with french curve.

 Square down from E to wrist level.

 Label F.

 Square in at hemline level.

 The hemline may be treated in several different ways, with or without gathers and pleats.

- For gathers, subtract 1 or more inches from F.
- Draw slit (opening), approximately $1\frac{1}{2}$ inches from underseam.
- At this mark, extend 1/2 inch below and draw a 2-inch long slit up.
- Cut sleeve from paper.
- Unfold and draw blended line for hem.

Figure 1

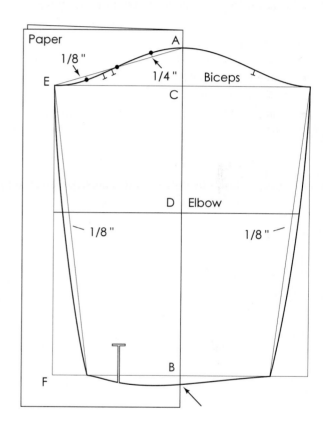

Figure 2 *Cuff*

- Use entry measurement, plus 1 inch extension. (Cut width 2 inches, plus seam allowance.) Finished width 1 inch.

Figure 2

Knit Foundation and Sleeve

The knit draft is based on the dartless foundation pattern. It is a casual garment and is developed oversized. If oversizing is not desired, use the dartless pattern as the base for designs. A special sleeve is drafted for this type of garment. Knit fabrics shrink. (See Chapter 26 for information regarding pattern adjustment to offset shrinkage.)

The front and back patterns are drafted together and separated at the completion of the draft.

Knit Draft

Figure 1

- Trace dartless front pattern.
- Place back pattern on top of front pattern, matching hip levels and shoulder-neck points. (If shoulder and neck do not meet, equalize the difference, and mark.)
- Trace back neckline and centerline.
- Add 1/2 inch or more at the side seam, square up and in to level with shoulder tip, and mark center. Label X.
- Draw new shoulderline from neck to X.
- *Optional:* Lower armhole 1/2 inch or more.
 Draw new armhole, and measure. Record _____. (A–E measurement of the sleeve draft.)

Figure 1

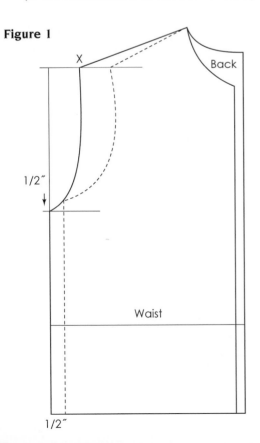

Figure 2 **Figure 3**

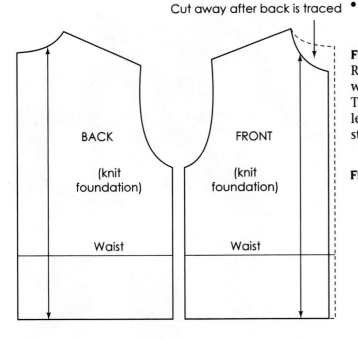

Cut away after back is traced

BACK

(knit
foundation)

Waist

FRONT

(knit
foundation)

Waist

Figures 2 and 3
- Cut pattern from paper and trace for the back pattern.
- Cut away to front neckline and centerline for the front pattern.

Figures 4a, b *Ribbing*
Ribbing placed around the neckline, hemline, and wrist is a common feature of the knit foundation. Trim away an amount equal to the width of the rib, less seam allowance (3/8 inch). Ribbing should be stretched as it is stitched to the garment.

Figure 4a

FRONT

Figure 4b

BACK

Knit Sleeve Draft

Measurements needed
- See measurements chart, page 699.
- Sleeve (overarm) length _____.
- Armhole measurement (A–E) _____.
- Hand entry measurement _____.

Figure 1

A–B = Sleeve length. Draw a line in middle of paper, and fold.

A–C = 3 inches (biceps level).
Square out from C.

B–D = One-half of B–C (elbow level).
Square out from D.

A–E = One-half of the armhole measurement.
Draw line touching biceps line.
Divide the line into fourths.
Using measurements given, draw sleeve cap.

B–G = One-half of hand entry measurement.

D–F = B–G plus, 1/2 inch or more.
Draw line from G to F, and a curved line from F to E.
Add 3/8 inch seam allowance.
Complete pattern for test fit.

Figure 1

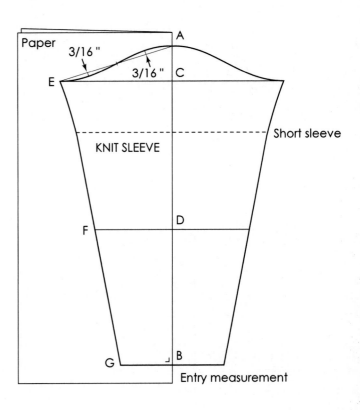

Paper

3/16"

3/16"

A

E

C

KNIT SLEEVE

Short sleeve

F

D

G

B

Entry measurement

Modified Knit Top

This design illustrates how the dartless knit pattern can be adjusted to minimize the looseness (gapping) of the front armhole.

Design Analysis

The knit top design can be used as a base for other designs.

Modify the Side Seam

Figure 1

- Trace dartless knit pattern.
- Plot the styleline, using the illustration as a guide.
- The armhole is modified by raising armhole 3/8 inch and trimming 3/8 inch from the front hem at side seam. The armhole and hemline are blended for a smooth transition line.
- Remove 1/8 inch or more along side seam for a closer fit, if desired.
- Cut from paper, and complete the pattern for a test fit.

Figure 1

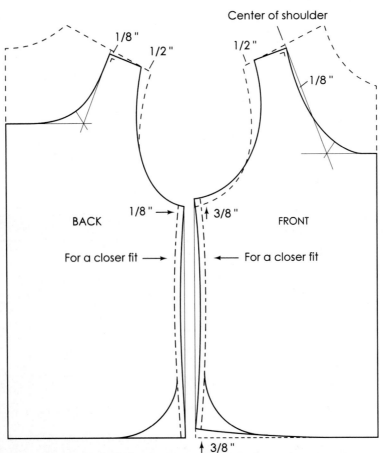

Tank Top

The tank top is based on the dartless pattern.

Design Analysis

Tank tops can be designed in a number of variations. The example is cut very low in the armhole and neckline area, with length ending at the hipline or longer.

The Tank Draft

Figures 1 and 2

- Trace front and back dartless patterns.
- Plot stylelines, using illustration, design, size, and height of model as a guide.

 The back shoulder strap is placed at the center of the back shoulder or moved to shoulder-neck area. This is done to help hold strap to the shoulder when front and back necklines are cut low.

- Complete pattern, and test fit.

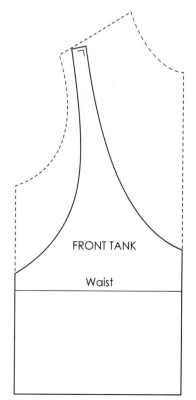

Figure 1

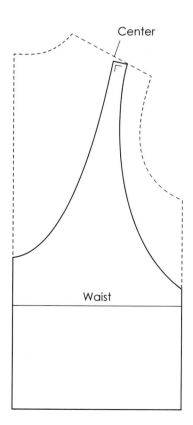

Center

Waist

Figure 2

FRONT TANK

Waist

Kimono Foundation

The kimono is appropriate for sizes 3 to 6X and 7 to 14. The kimono draft is based on the dartless pattern and can be modified by extending the pattern length. It may be tapered, flared, fitted, or made oversized (uneven broken lines). The sleeve can be of any length, tapered or gathered, with a drop shoulder, or cut through with stylelines. The variations are limited only by the creativity of the designer. Sleeve lengths are imposed on the draft for illustration.

The front and back kimono are drafted together and separated at the completion of the draft.

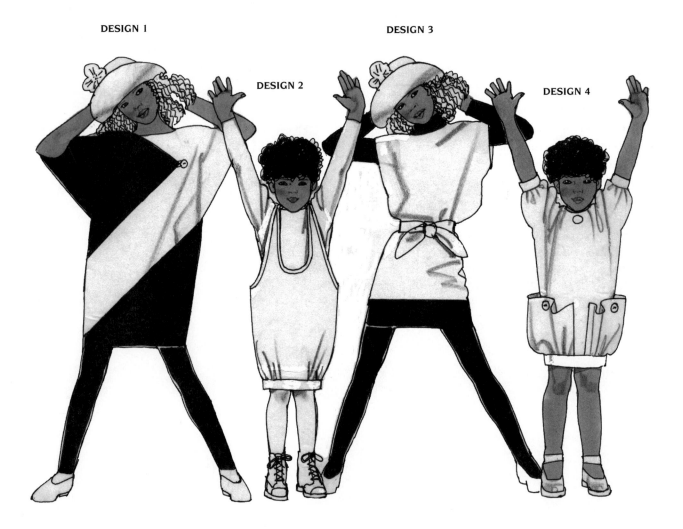

DESIGN 1 DESIGN 2 DESIGN 3 DESIGN 4

Kimono Draft

Figure 1

- Trace front pattern.
- Draw a guideline up from shoulder-neck, parallel with the centerline of the pattern.
- Place back pattern on top of front, matching hemline and shoulder-neck, touching guideline. The centerlines of front and back are parallel. Trace back pattern. If the shoulder and neck do not touch, divide the difference and redraw front and back neckline, blending to the centerlines of the draft.
- Draw sleeve length, following the shoulder slope.
- Square down from hem of sleeve equal to one-half of entry measurement.
- Draw a line from wrist to the side seam, shaping underseam to the armhole depth desired.
- Cut pattern from paper and trace for back pattern.
- Trim drafted pattern at the neckline and the centerline for the front pattern.

Figure 1

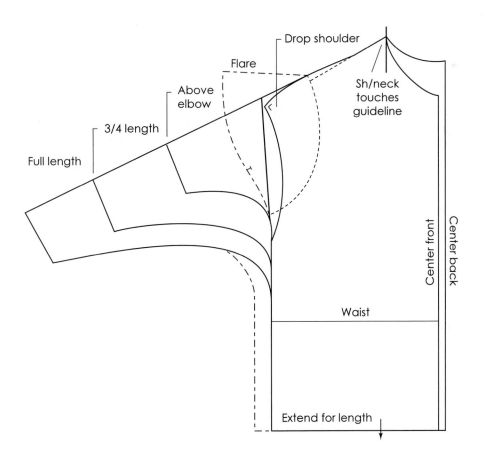

Raglan Foundation

The styleline of the raglan sleeve combines part of the bodice with the sleeve. The raglan can be drafted onto the basic pattern, shift, knit, dartless pattern, and the coat foundation, and is generally used for casual garments with deeper armholes. The basic dartless pattern is used.

Raglan Draft

Figure 1a, b

- Trace front and back dartless basic patterns.
- Mark 1/2 inch above the front and back notches. Label X.
- Mark armholes 3/4 inch (or more) down. Label Y.
- Draw new armholes from Y to X.

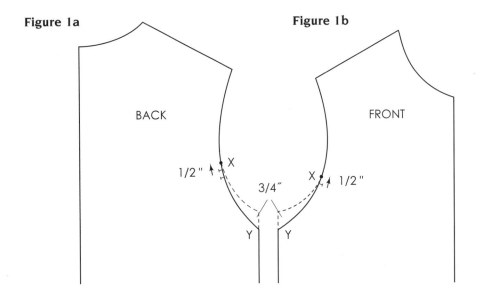

- Mark biceps 3/4 inch down. Label Z.
- Draw new curved line to blend with X.
- Separate the sleeve at the center grainline.

Figures 2a, b
- Trace the dartless basic sleeve.
- Mark 1/2 inch above the front and back notches. Label X.

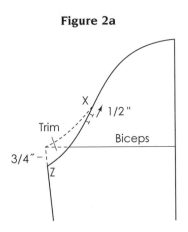

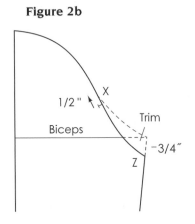

Figure 3a, b

Raglan yoke styleline, front and back

- Draw a straight line from X, ending 3/4 to 1 inch down from the neckline.
- Mark midpoint 1/4 inch above the midpoint and draw a curved raglan line (shaded sections).

Figure 3a

Figure 3b

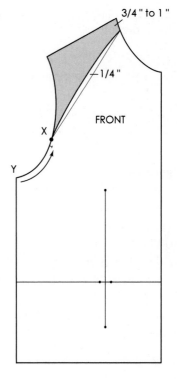

Figure 4

The lower part of the pattern is complete when seams are added. Dart locations are marked for reference.

Figure 4

Raglan Sleeve

Figures 5 and 6

- Trace front raglan yoke pattern (allow room for sleeve).
- Place sleeve on raglan yoke, matching X points and cap to shoulder tip of yoke. (Sleeve cap may overlap armhole.) Trace corner curve of sleeve to X.
- Repeat for back raglan.

Figure 5

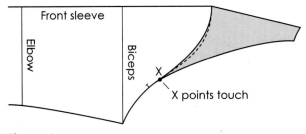

Figure 6

Figures 7 and 8

- With pushpin at sleeve cap, swing pattern 3/4 to 1 inch away from traced sleeve curve (lift).
- Secure sleeve, and trace from elbow to hem and center grainline.
- Add 1/2 to 1 inch out from biceps. For a loose sleeve, draw line parallel with grainline; taper the line for a closer fit.
- Draw a curved line from biceps 1/4 inch up from shoulder tip, blending with mid-shoulderline.
- Draw curved line up from elbow to complete underseam.
- Repeat for back raglan.

Figure 7

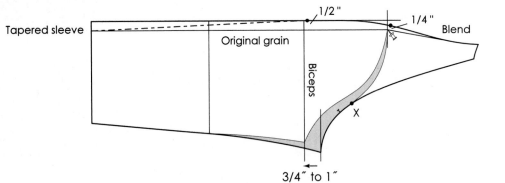

Figure 8

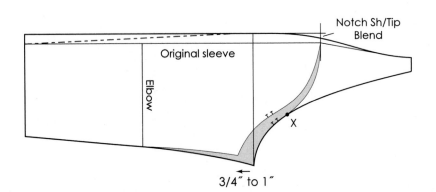

Jacket Foundation

The jacket foundation is appropriate for sizes 3 to 6X and 7 to 14, boys' and girls' sizes. The basic jacket draft is based on the dartless pattern (see page 734). The jacket and sleeve are enlarged to be worn over other garments. The basic jacket can be modified with a raglan sleeve (see page 748), kimono sleeve (see page 746), and other variations (see Chapter 15). Waist darts are included to help with shaping the garment for design variations such as the princess line.

Sleeve Modification
Figure 1
- The dartless sleeve can be graded to enlarge the sleeve, or the traced sleeve can be cut apart, spread, and retraced. Blend sleeve cap.
- Cut the pattern from paper.
- Complete the pattern for test fit. Walk sleeve to armhole. If less than 1 inch or more than $1\frac{1}{4}$ inch, adjust biceps (see page 735).

Jacket Draft
Figures 2 and 3
- Trace front and back dartless patterns.
- Use illustration as a guide for plotting the jacket draft. Armhole may be lowered more or less than 1/2 inch. (Adjust biceps of sleeves by equal amount.)

Figure 1

Figure 2

Figure 3

Jacket with Notched Collar

The jacket design is appropriate for sizes 3 to 6X and 7 to 14, boys' and girls'. The basic notched jacket is based on the jacket foundation pattern. To develop the low notch and portrait jacket collars, see Chapter 22. Jacket sleeve completes the pattern.

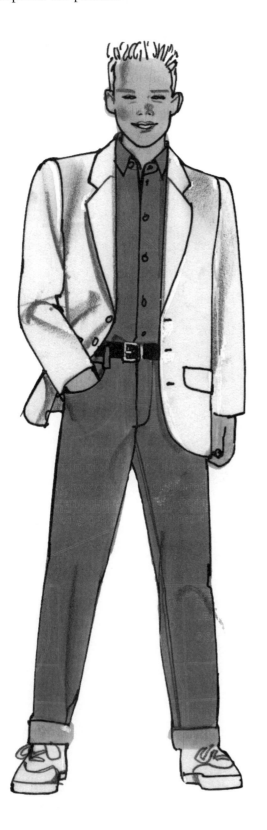

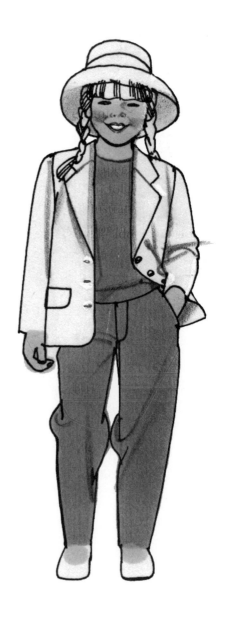

Notch Collar Jacket Draft

Figure 1 Front

- Trace jacket pattern.
- Add 3/4 inch for extension, and draw line level with armhole.

Lapel

- Draw a line out from center front neck $1\frac{1}{2}$ to 3 inches for width of lapel. (Take into consideration the size and height of the model).
- Mark a notch 1/2 to 1 inch past center front.
- Draw an outward curved lapel line to break point. Notch.
- Draw curved line at hem.
- Draw facing.
- Add 1-inch hem allowance, extending 3/4 inch in from facing.

Collar

- Measure in 1/4 inch from shoulder-neck. Label X.
- Draw a line from curve of mid-neck to X, and continue the line to equal back neck measurement of the jacket. Label Y.
- Measure 1/2 inch down from Y. Label Z.
- Draw a curved line from X to Z.
- Square up from the X–Z line equal to $2\frac{1}{2}$ to $2\frac{3}{4}$ inches. From this point, square a short line. Complete the collar to within 1/4 inch of lapel.

Figure 2 Back

- Trace back pattern. Use illustration to plot the pattern and facing.

Figures 3 and 4

- Place paper under back pattern and transfer facing.
- Trace front facing.

Figure 5

Figure 3 Figure 4

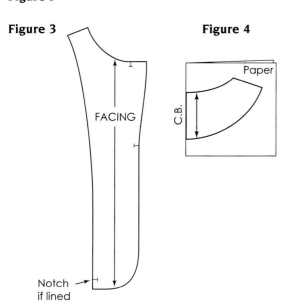

FACING

C.B.

Paper

Notch → if lined

Figure 2 **Figure 1**

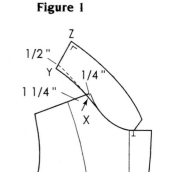

BACK FRONT

1 1/4 "

2 "

1/2 "

1/4 "

1 1/4 "

Z

Y

X

Break point

3/4 "

3/4 "

1 "

- Transfer collar to paper, and cut on fold (upper collar).

Figure 5

UPPER COLLAR

Figure 6

- Trace upper collar and trim collar's edge.
- Mark notch 1/4 inch in from center back (undercollar).

Figure 6

1/8 " or more

UNDER COLLAR

Cardigan Jacket

The cardigan design is appropriate for sizes 3 to 6X and 7 to 14, boys' and girls'. The collarless cardigan jacket is based on the basic jacket foundation. The basic jacket sleeve is used with this design.

Cardigan Draft

Figures 1 and 2

- Trace front and back jacket pattern.
- Plot styleline and facing, using illustration as a guide. Mark buttonhole placements.
- Add to shoulder tip for shoulder pads.
- To add lining and interconstruction to the garment, see Chapter 22.

Figure 1

Figure 2

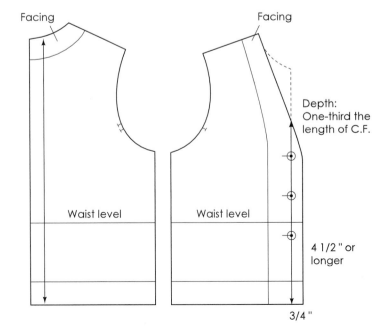

Facing

Facing

Depth: One-third the length of C.F.

Waist level

Waist level

4 1/2 " or longer

3/4 "

Vest

The design is appropriate for sizes 3 to 6X and 7 to 14, boys' and girls'. The vest can be based on the basic bodice, dartless pattern, shift, or jacket pattern. The shift pattern is used for the illustration.

The vest draft is modified by changing the width of the shoulder inside or outside the regular shoulderline. The armhole depth can be varied, as can the shape of the vest and its length.

* The vest can be lined or faced, or edges can be overlocked and stitched.

Figures 1 and 2

* Follow the illustrations as a guide to plot the design.
* Cut pattern from paper.
* Complete the pattern for a test fit.

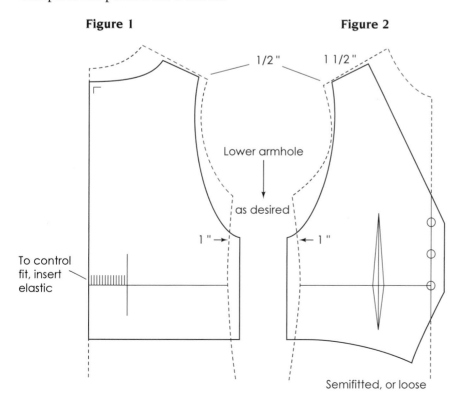

Coat and Sleeve Foundation

The design is appropriate for sizes 3 to 6X and 7 to 14, boys' and girls'. The coat pattern is based on the dartless pattern (see page 734). The coat draft is made larger than the jacket (as it too is worn over other garments), and the fabric used for coats is of a heavier weight. The basic coat can be modified for a raglan sleeve (see page 748), kimono (see page 746), or other variations (see Chapter 15).

Sleeve Draft

Figure 1

The basic sleeve is modified to increase its width. Grade the pattern or use the illustration as a guide for cutting the sleeve apart and spreading the pieces. Retrace sleeve and blend cap.

Cut the patterns from paper. Walk sleeve around the armhole. If less than 1 inch ease or more than $1^1/_4$ inches, see page 735 to adjust. Complete the pattern for a test fit.

Coat Draft

Figures 2 and 3

- Trace front and back dartless patterns.
- Follow the illustration as a guide to plot the pattern. Broken lines indicate original pattern.

Figure 1

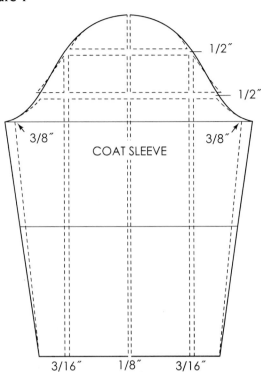

Figure 2 **Figure 3**

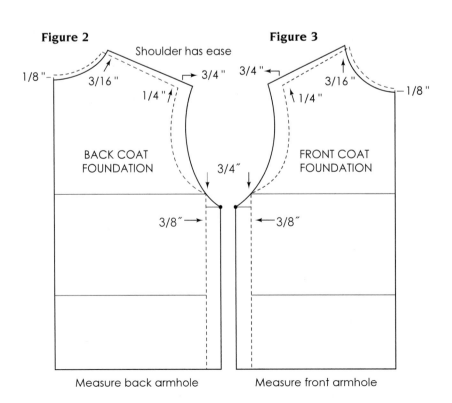

Navy Pea Coat

The design is appropriate for sizes 3 to 6X and 7 to 14, boys' and girls'. The pea coat is based on the coat foundation. (See page 756 for coat draft.)

Design Analysis

The pea coat is the traditional coat design for the Navy. The double-breasted coat is buttoned left-over-right for boys and either right-over-left or left-over-right for girls.

The Pea Coat Draft

Figure 1 Lapel

- Trace front and back coat pattern, extending to length desired. Label A at shoulder-neck.
- Choose extension from chart, and draw line parallel with center front.
- Square a line from center front at level with armhole. Mark break point. Label C.
- Extend shoulder 3/4 inch past A. Label B.
- Draw roll line from B to C.
- Label X at roll line and neck.
- Continue neckline curve 1 inch past X. Label D.
- Place square ruler on rollline and point D. Draw line to extension. Label E.

Figure 2 Collar

A–F = 1/4 inch.

F–G = Back neck measurement (plus 1/8 inch). Place edge of ruler at outer curve of neckline and touching F. Draw the line. Continue to curve of the neckline. Mark midpoint between F–G.

Pivot ruler down 1/2 inch from this mark, and square line from H to I, using H–I measurement taken from guide chart. Draw collar and shape lapel.

Figure 1

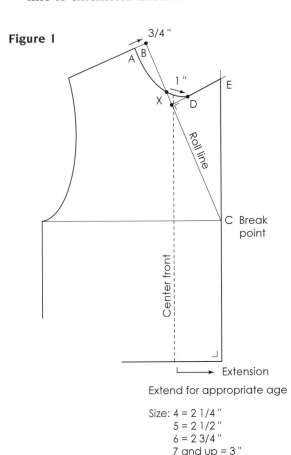

3/4 "

1 "

E

Roll line

C Break point

Center front

Extension

Extend for appropriate age

Size: 4 = 2 1/4 "
 5 = 2 1/2 "
 6 = 2 3/4 "
 7 and up = 3 "

Figure 2

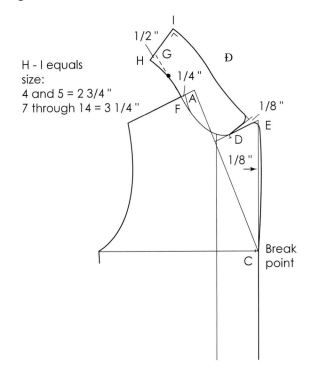

H - I equals size:
4 and 5 = 2 3/4 "
7 through 14 = 3 1/4 "

1/2 "

1/4 "

1/8 "

1/8 "

Break point

Figures 3 and 4 B*ack facing*
- Mark for back facing (unequal broken lines). Place folded paper under draft, and trace for facing. Retrace on fold.

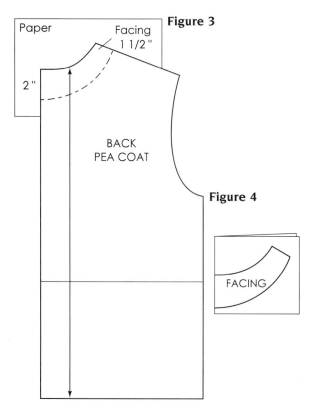

Figure 3

Figure 4

Figure 6 C*ollar*
- Add seams and cut from paper.

Figure 6

Figure 7
- Retrace upper collar, and modify for the undercollar. Add 1/2 inch for seam at center back.

Figure 7

Figure 5 *Pocket and button placements*
- Plot the pocket placement, welt, and pocket lining.

Transfer collar
- Place folded paper under front draft to transfer collar (D to F, H, I to D). Label upper collar. Mark notch at point F.

Figure 5

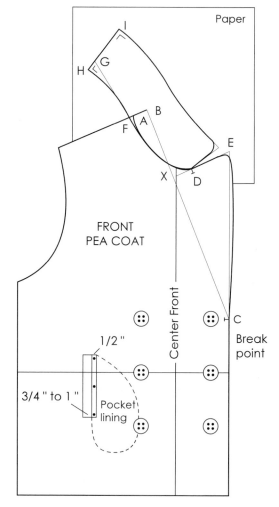

Figure 8 *Partial collar roll*
- Mark 3 slash lines, cut, and spread 1/8 inch. Retrace.

Figure 8

Figure 9 *Facing and seam allowance guide*

- Draw facing (uneven broken lines).

 Hem allowance for the coat starts 1 inch in from the facing.

Figure 9

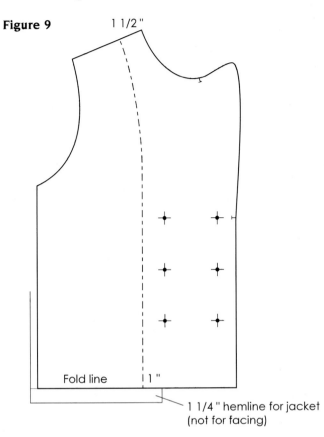

Figure 10 *Facing pattern*

- Trace facing and modify the pattern as illustrated. The facing is notched 1/2 inch up from hem level, indicating placement for the fold of the lining.

Figure 10

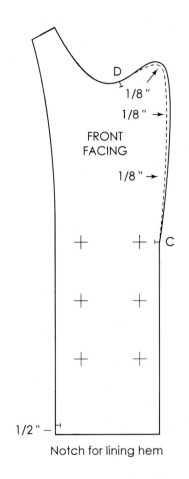

Notch for lining hem

Figures 11 and 12 *Pocket welt and pocket lining*

- Place paper under the front, and trace pocket and pocket lining.

Figure 11

Pocket lining

Cut four

Figure 12

Pocket band

Cut two

Figures 13 and 14 *Front and back lining*

- Follow illustration as a guide in drawing lining patterns.

Figure 13 **Figure 14**

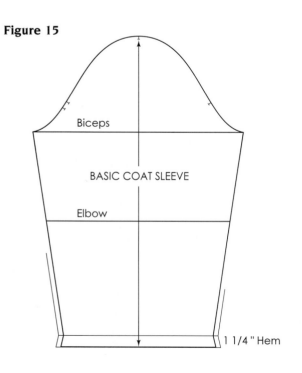

Figure 15 *Sleeve*

- Trace coat sleeve. A guide for seam allowance is illustrated.

Figure 16 *Sleeve lining*

- Trace sleeve and follow illustration for the lining pattern.

- Complete all patterns and test fit. See Chapter 22 for interconstruction.

Figure 15

Figure 16

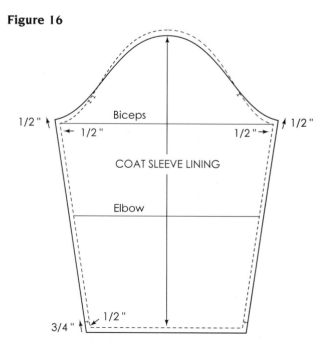

35

Pant and Jumpsuits

Introduction to Pants

The theory, terminology, and other design variations for pants are found in Chapter 25.

Three pant foundations are illustrated in this chapter. Consider size, height, and age of the model before plotting the designs. The back pant can be finished with a waistband, elastic, or a combination of both. The trouser foundation fits loosely at crotch level. The slack foundation fits closer and the jean foundation fits very close. Develop the three pant foundations and choose the appropriate pant for each of the designs.

The pant foundations are drafted for sizes 3 to 6X and 7 to 14 (16), for boys and girls.

Trouser Foundation

The trouser is a loosely fitted pant that hangs straight from the buttocks. The pleated trouser and baggy style pants are based on this foundation. For waistline options, see page 766 and 767.

Measurements needed
- (18) Waist to ankle (pant length) _____.
- (27) Crotch depth _____.
- (15) Hip arc, plus 1/2 inch F _____ B _____.
- (14) Waist arc, plus 1/2 inch F _____ B _____.
- (20) Upper thigh _____.
- (24) Foot entry _____.

Trouser Draft

Figure 1

A–B = Pant length (18).

A–C = Crotch depth, plus 3/4 inch (27).

A–D = One-half of A–C.

B–E = One-half of B–C, plus 1 inch. Mark. Square out from each side of A, D, C, E, and B.

C–F = Back hip arc (15).
Square up from F to waist. Label G.

F–H = One-half of C–F. Mark.

C–I = Front hip arc (15).
Square up from I to waist. Label J.

I–K = One-fourth of C–I. Mark.

Figure 1

Figure 2

G–F = 1/2 inch, squared up 1/4 inch.

Draw a line from F to crotch level, touching hip level.

Draw crotch curve from H to hip level.

Draw crotch curve from K to hip level.

A–L = 1/8 inch.

A–M = 3/8 inch.

Draw hipline from waist to just above D.

Draw waistline from F to L.

H–N = One-half of H–C. Mark.

K–O = One-half of K–C. Mark square grainlines through patterns.

Dart intake

(Ignore dart intake if waistline belting is elastic.) Subtract back waist arc (14), from F–L length.

- Mark dart 1 inch from grainline. (Length: 3 to 4")
- Subtract from waist arc (14) from M–J line.
- Mark dart intake on each side of grainline. (Length: $2\frac{1}{2}$ to 3 inches.)
- Inseam guidelines are drawn 1/2 inch in from points H and K. Leglines are curved from H and K to knee levels.

Figure 2

Figure 3

The finished patterns. Test fit only after waist is secured with belt, elastic, or zipper.

Figure 3

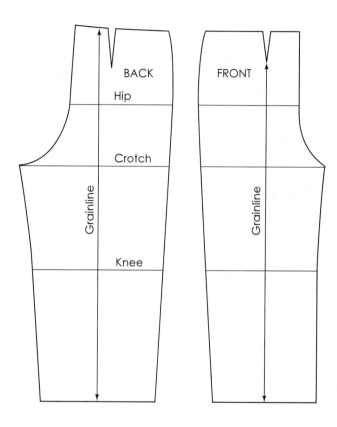

Figures 4 and 5

The fly front can be in one with the pant, or developed as a separate pattern.

Figure 4 **Figure 5** Fly extension
↓ 3/4 " to 1 inch

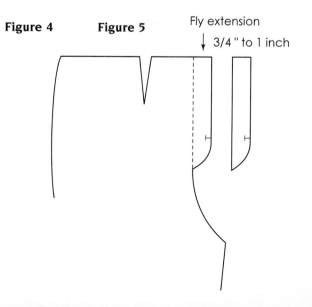

Slack Foundation

The slack draft is based on the trouser foundation. It is an appropriate draft for sizes 5 to 6X and 7 to 14, for girls and boys. The slack pant fits closer than does the trouser. The slack pant is adaptable for many designs and derivatives.

Slack Draft

Figure 1

• Trace front and back trouser pant. The crotch level is raised 3/8 inch and the pant leg is tapered.

Figure 1

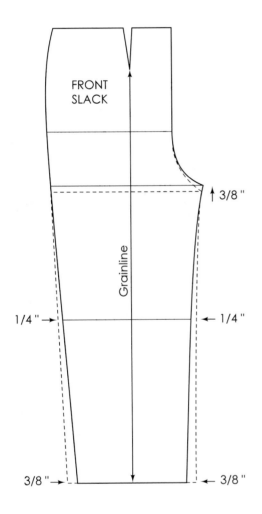

Figure 2

The back pant is adjusted to fit closer to the figure by shortening crotch point and raising crotch 3/8 inch. The grainline must be centered to balance pant.

B–C = A–B.

E–F = D–E.

• Redraw legline.
• Complete the pattern for test fit.

See page 766–767 for waistline options.

Figure 2

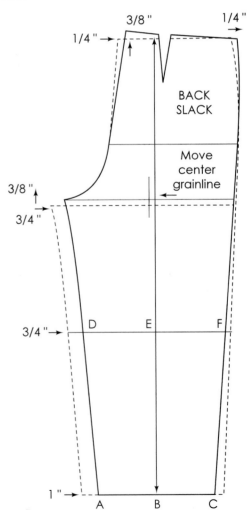

Jean Foundation

The jean foundation fits to the contour of the figure. Stylelines associated with the jean pant apply also to the slack and trouser foundations (yokes and fly fronts). Appropriate for boys and girls, 3 to 6X and 7 to 14.

For waistline options, see pages 766–767.

Measurements needed

- (18) Waist to ankle (pant length) _____.
- (27) Crotch depth _____.
- (15) Hip arc, plus 3/8 inch F _____ B _____.
- (14) Waist arc, plus 1/4 inch F _____ B _____.
- (20) Upper thigh _____.
- (21) Knee measurement _____.
- (24) Foot entry _____.

Jean Draft

Figure 1

A–B = Pant length (18).

A–C = Crotch depth (27). Mark.

A–D = One-half of A–C. Mark.

B–E = One-half of B–C, plus 1 inch. Mark.

C–F = Back hip arc (15).
Square up to waist level. Label G.

F–H = One-fourth hip arc, plus 1/2 inch.

C–I = Front hip arc (15).
Square up from I to waist. Label J.

I–K = $1\frac{1}{2}$ inches.

Figure 1

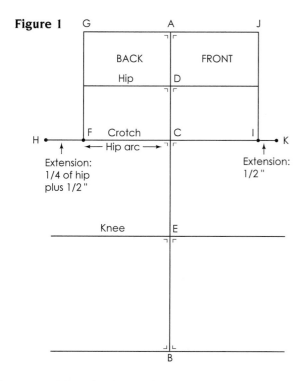

Figure 2

G–L = 1 inch in and squared up 3/4 inch.
Draw a straight line from L to crotch level, touching hipline.
Draw crotch curve from H, ending at hipline.

L–M = Waist arc, plus 1/4 inch (14). *Use red pencil to complete back draft if M overlaps A.*
Draw a line from L to M for waist.
Draw hipline curve from M to D.

J–N = 1/4 inch in, and squared up 1/4 inch.
Draw a straight line from N to crotch level, touching hipline.
Draw crotch curve from K to hipline.

N–O = Waist arc, plus 1/4 inch (14). *Use blue pencil to complete front draft if O overlaps A.*

Grainline

- Mark 1/4 inch in from each side of C. Relabel C.
- Mark centers between C–H (back) and C–K (front). Square up and down through front and back patterns for grainline.

Legline

- See instruction on the illustration.
- Draw straight lines up from hem to knee to crotch.
- Draw inward curves to points H and K.
- Draw an outward curve from D, and an inward curve up from knee, blending with hipline curve.
- If M and O overlap, place paper under the pant draft and trace either the front or back pant before cutting pants apart.

Figure 2

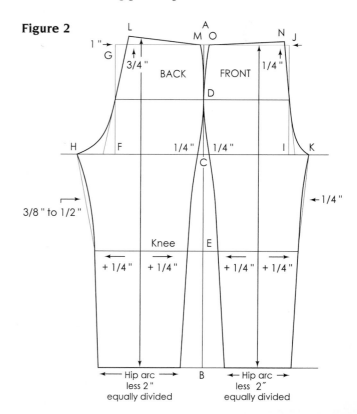

Waistline Options

The pant or skirt can be secured to the waist in one of four ways. Models sized 3 to 6X generally have part or all of the waistline encased with elastic. Sizes 7 to 14 models may desire a regular waistband attached to the garment.

Waistband Draft

- Draw line equal to waist measurement, plus 1-inch extension.
- Fold paper. Square down 1 inch for width of band.
- Add seam allowance; notch for extensions. Cut from paper.

(Button and buttonhole can be reversed)

Waist Held with a Waistband

Figure 1a, b

Waistbands are used when garment has dart control at waistline or when a garment like the jean is developed without darts.

Elastic Control

Figure 2a, b, c

The front and back waistline is raised $2^3/_4$ inches as a casing for the insertion of 1-inch elastic. The elastic should measure the same as the waistline. The elastic is overlapped 1 inch. This shortens the elastic enough to hold garment securely to the waist.

For more fullness, add to the side seam of front and back pant, or add only to the back pant.

Figure 1a

Waistband
(without elastic)

Figure 1b

FRONT PANT

BACK PANT

Figure 2a

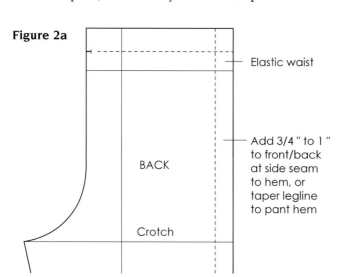

Elastic waist

BACK

Add 3/4 " to 1 " to front/back at side seam to hem, or taper legline to pant hem

Crotch

Figure 2b

Elastic waist

Figure 2c

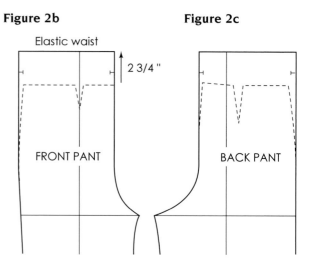

2 3/4 "

FRONT PANT

BACK PANT

Partial Waistband and Elastic

Figure 3a, b, c

The elastic is placed in the back with a partial waistband in the front. The elastic can also end at the side front of the garment (as seen in jumpsuits). The back waistline is raised $2^3/_4$ inches as a casing for 1-inch elastic. The waistband pattern measures one-half of front waist less ease allowance (waist dart is stitched). The elastic and waistband are joined at the side seams. Add to the side seam for a more casual fit. (See page 766, Figure 2a).

Figure 3a

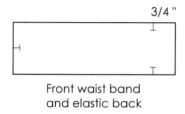

3/4 "

Front waist band
and elastic back

Figure 3b

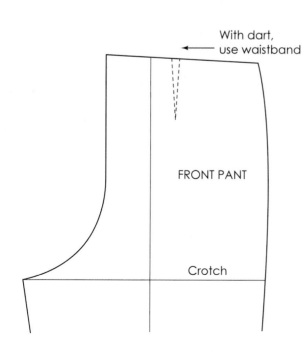

With dart,
use waistband

FRONT PANT

Crotch

Figure 3c

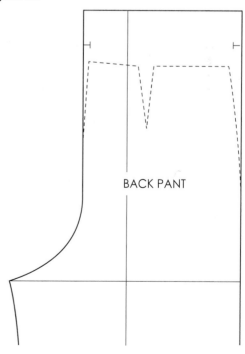

BACK PANT

Pant Variations

Pleated Trouser

The pleated trouser can also be drafted from the slack pant for a closer fit. The pant design is for sizes 5 to 6X and 7 to 14 for boys and girls. More than one pleat can be created by spreading more than one place on the draft. The pant can also be cuffed.

Design Analysis

The pant is plotted for slash placement (one pleat is illustrated, but by placing more slash lines, more pleats can be added to the pant draft). The fly front can be placed on either side of the front pant. The back pant is basic.

Figure 1 **Figure 2**

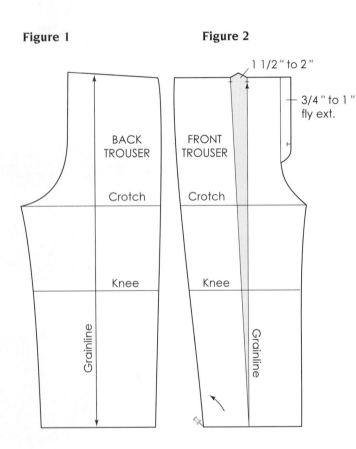

Pleated Trouser Draft

Figures 1 and 2

- Trace front and back trouser pant.

- Slash at grainline of pant and spread $1\frac{1}{2}$ to 2 inches for pleat intake.

- For fly front, (a) add 3/4 to 1 inch to pant front: (the length of the fly should be at least 1 inch longer than zipper); and (b) a separate fly is drafted 3/4 to 1 inch wide and 1 inch longer than zipper. See page 751, Figures 4 and 5. The fly is stitched to the left (for boys) or right side (for girls).

Waistline Options

Decide type of waistline best suited to the design. See pages 766 and 767.

Hammer Baggy Pant

The trouser pant is the base for pants that are very full through the legline. The draft is suitable for sizes 3 to 6X and 7 to 14, for boys or girls.

Design Analysis

A fun pant, to be made as full as desired and cut to any length. Fullness is added through the sides of the pattern. Pant is gathered at the waist and hemline of the pant, and secured with elastic. Design 2 is a thought problem.

Hammer Draft

Figure 1

- Trace front and back trouser, spacing the patterns to amount of fullness desired.
- Extend waistline $2^3/_4$ inches for 1-inch elastic.
- Cut 1-inch elastic equal to waist measurement. One inch is used for lapping and stitching together.
- Cut 1/2-inch elastic equal to foot entry measurement plus 1 inch. One inch is used for lapping and stitching together.
- Lower the crotch (it may be lower for a more exaggerated look).
- Extend pant length for blousing.
- Taper legline to control fullness.
- Complete pattern for test fit.

DESIGN 1 DESIGN 2

Figure 1

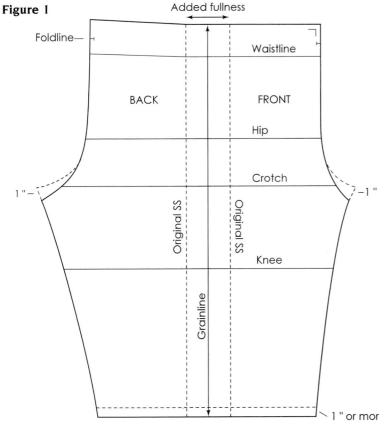

Short Bib Pant

This pant can be drafted for sizes 5 to 6X and 7 to 14, for girls or boys. The trouser or slack pant may be used.

Design Analysis—Design 1

The bib pant has a pleat-pocket combination with a short legline (derivative) and strap with ringer. The pattern plot marks locations for pleat and pocket placement in proportion to size, age, and height of the model. Pattern draft for Design 2 is on page 772.

DESIGN 1

DESIGN 2

Elastic or belted, see pages 766 and 767.

Bib Pant Draft

Decide type of waistline best suited to the design.

Figure 1a, b

- Trace front and back pant, marking pant length, and allowing length for roll-up. (Back pant is basic and is not illustrated).
- Plot pattern, using illustration and design as a guide.
- Notch for bib placement.
- Draw bib under bust or at chest level. (Figure 1b)

Figure 1b

Paper
1 1/2"
Fold to hold ringer
1"
BIB

Figure 1a

1/2" to 3/4"

Hip

Blend

Crotch

FRONT

Knee

2" hem

Figure 2a, b

- Place paper under pattern and trace pocket backing and pocket facing. Label patterns.

Figure 2a

Pocket facing

Figure 2b

Pocket backing

Figure 3

- The balance of the design can be affected if strap width is not in proportion to size of the bib. (A button is placed inside back waistband to secure the strap. Several buttonholes on the back part of the strap allow for height adjustment.)

Figure 3

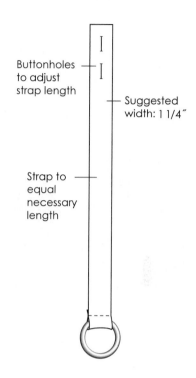

Buttonholes to adjust strap length

Suggested width: 1 1/4˝

Strap to equal necessary length

Figure 4

- Cut pant from paper, separating design parts.
- Slash and spread $1\frac{1}{2}$ to 2 inches for pleat.

 (*Note:* 1/16-inch-wide slit releases the inverse corner for turning when stitching pocket.)

- Retrace pant.
- Complete pattern for test fit.

Figure 4

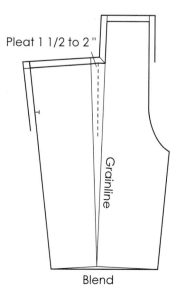

Pleat 1 1/2 to 2"

Grainline

Blend

Yoke-Pleated Pant

Pant can be drafted for sizes 3 to 6X and 7 to 14, for girls or boys. The trouser or slack foundation patterns may be used. See Design 2, page 770.

Design Analysis—Design 2

Front pant has three sections and a basic back pant. The pattern is plotted, indicating where the pattern is spread for pleats. Styleline parts and pocket are drawn in proportion to the size, age, and height of the model.

Waistline Options

To decide the type of waistline best suited to the needs of the design, see pages 766 and 767.

Figure 1

- Trace front and back pattern (back is not illustrated).
- Plot pattern, using illustration and design as a guide.
- For legline, use foot entry measurement for hemline of tapered pant.

Figure 1

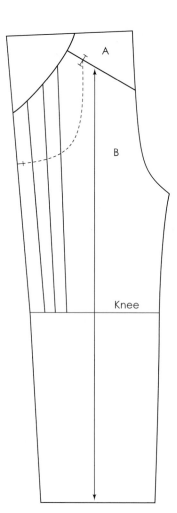

Figure 2a, b

- Place paper under pocket area of pant and trace pocket backing and pocket facing.

Figure 2a

Figure 2b

Figure 3

- Cut pattern from paper and slash for pleats to knee level. Spread each section $1\frac{1}{4}$ to $1\frac{1}{2}$ inches. Retrace. To finish pleats, the centers of each pleat are marked. Follow the direction of the arrows to draw the shape of the inside folds.
- Mark punch or circles for stitching guide to end stitching (tuck pleats).
- Complete the patterns for test fit.

Figure 3

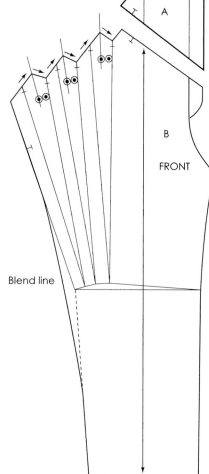

Western Jean

The standard jean pant is based on the jean foundation. The design is for 3 to 6X and 7 to 14, for boys and girls. The fly front for girls may be on either side.

Design Analysis

The traditional western jean pant can be developed with a tapered legline or designed as a boot pant.

Elastic or belted

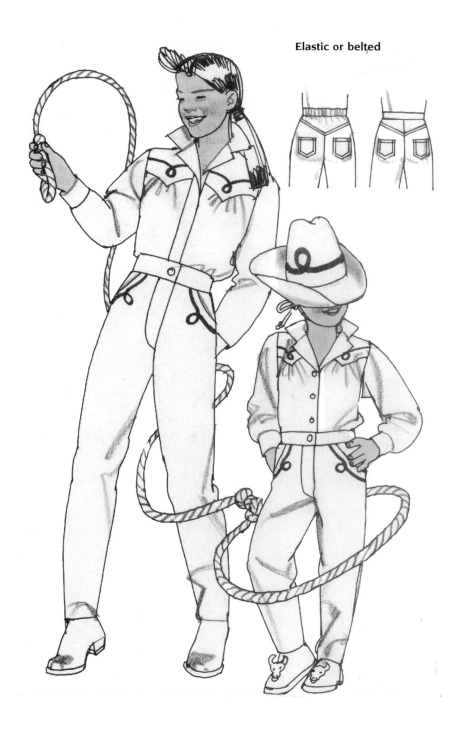

Determine type of waistline best suited to the design. See pages 766 and 767.

Figures 1 and 2

- Trace front and back jean patterns.
- Plot the patterns, as illustrated.

Figure 1

Figure 2

Figure 3a, b, c *Front*

- Place paper under pocket section of draft and trace pocket backing and facing.
- Trim pocket styleline from pattern.

Figure 3a

Figure 3b

Figure 3c

Figure 4a, b, c

- Place paper under yoke part of draft and trace back yoke.
- Trace pocket from pattern.
- Back pant.

Figure 4b

Figure 4a

Figure 4c

Figure 5a, b

- Waistband is illustrated. If back elastic is required, add 1 inch to center back. Cut on fold, or cut two pieces.
- Back pant.

Figure 5a

Figure 5b

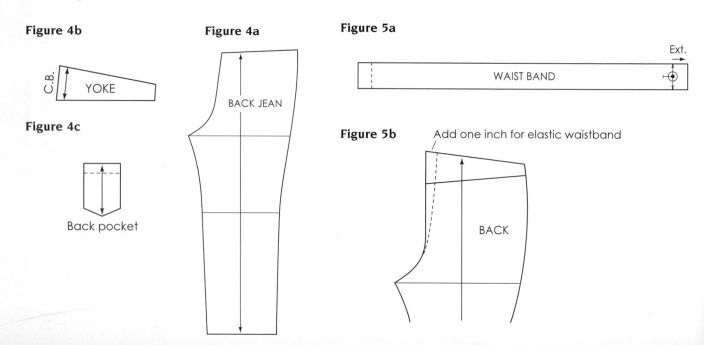

Bell-Bottom Pants

The bell-bottom pant is based on the jean foundation pattern for sizes 3 to 6X and 7 to 14, for boys and girls.

Design Analysis

Flared leglines distinguish this pant style. The flared leg can be as wide as desired and can start from any point along the legline. The stylized opening has buttons and buttonholes for control.

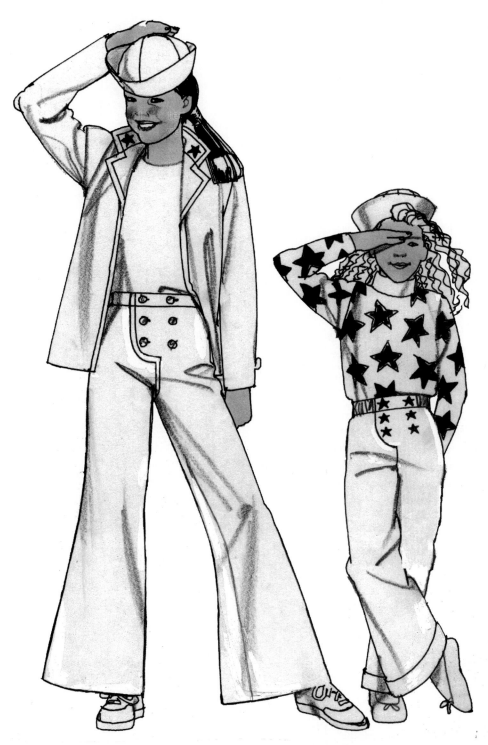

Determine type of waistline best suited to the design. See pages 766 and 767.

Flared Legline

Figures 1 and 2
- Use illustration as a guide to develop the flared pant.

Figure 1　　　　　**Figure 2**

Uneven Flared Legline

Figures 3 and 4
- Use illustration as a guide to develop the uneven flared hemline.

Figure 3　　　　**Figure 4**

Facing pattern
- For the facing, trace pant.

Figures 5 and 6
- Use illustration, design, size, and height of model as guides in plotting the pattern.

 Suggestion: Trace two copies of the flared leg pant, extending the centerlines for the overlap on one copy. Save the original pant for other designs.

Figure 7
- If a waistband is used, add extension for the overlap.

Figure 7

Figure 5　　　　**Figure 6**

Guideline Marking for Pant Derivatives

Pant derivatives have shorter leglines than that of the pant foundation. For convenience in developing other designs, mark the varied leglines on the patterns for reference. Tapered leglines may require a faced opening for foot entry. Lacings, zippers, or buttons and buttonholes are suggested for leg openings.

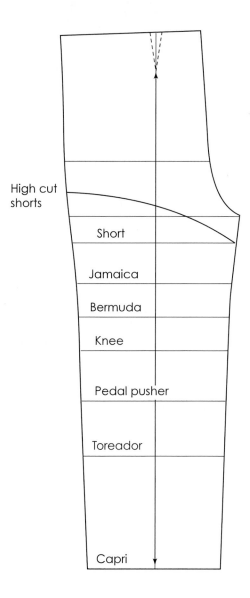

High cut shorts

Short

Jamaica

Bermuda

Knee

Pedal pusher

Toreador

Capri

Definitions

Shorty-shorts: Placed 3/4 to 1 inch below crotch level at inseam, and ending 3/4 to 1 inch above crotch level at side seam.

Short. Placed $1\frac{1}{4}$ to $1\frac{1}{2}$ inches below crotch level.

Jamaica. Placed halfway between crotch and knee.

Bermuda. Placed between knee and Jamaica.

Pedal Pusher. Placed 2 inches down from knee.

Toreador. Placed between knee and ankle.

Capri. Placed 3/4 inch above ankle.

Flared Shorts

The flared shorts draft can be based on the trouser or slack pant. The design is for sizes 5 to 6X and 7 to 14.

Design Analysis—Design 2

Two examples are illustrated for the flared short: a basic flare and added flare for greater hemline sweep. Flare is added to the inside curve of the leg-line to balance the fullness.

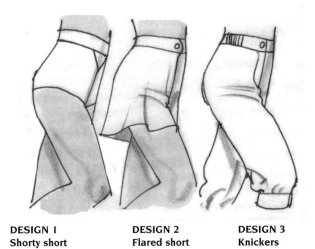

DESIGN 1
Shorty short

DESIGN 2
Flared short

DESIGN 3
Knickers

Waistline Options

To decide type of waistline best suited to the design, see pages 766 and 767.

Basic Flared Shorts

Figures 1 and 2

- Trace front and back pant and draw pant length.
- Mark slash lines from dart points to hem of pant. Slash; close darts.
- Spread for flare at curve of dart legs.

Figure 1

Figure 2

BACK

Blend FRONT

1/2" to 3/4"

3/8" to 1/2"

Shorts with added flare

Figures 3 and 4

- Slash pattern to waistline and through dart point. Spread for added flare to the desired amount.
- Add flare to the side seams of the patterns equal to one-half the space of A–B.

Figure 3

BACK

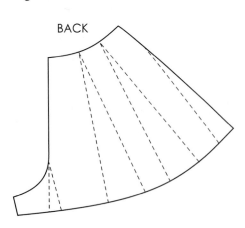

Figure 4

FRONT

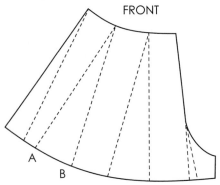

A

B

Shorty-Shorts

The high-cut shorty-short is for sizes 7 to 14 and is based on either the slack or jean pant.

Design Analysis—Design 1

The legline is plotted above crotch level at side seam, and is tightened at the inside curve of the inseams to fit closely around the upper leg.

Waistline options

To decide type of waistline best suited to the design, see pages 766 and 767.

Figures 1 and 2

- Trace the front and back patterns.
- Mark slash lines and draw curve of pant legs.
- Cut slash lines and overlap 1/4 inch.
- Retrace patterns, blending legline and crotch curves.
- Taper inseams 1/4 inch.
- For legline facing, trace legline curve (draw facing 1 to $1^1/_4$ inches wide).

Figure 1

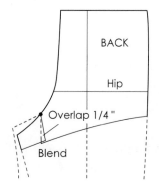

Figure 2

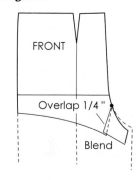

Knickers—Design 3

The knicker pant is a pant derivative and can be drafted from the trouser or slack pant for sizes 3 to 6X and 7 to 14, for boys or girls.

Design Analysis

The knicker pant is generally plotted just below the knee. The fullness is gathered into a band and is buttoned for fit control.

Waistline options

To decide type of waistband best suited to the design, see pages 766 and 767.

Figures 1 and 2

- Trace front and back pant.
- Plot pant, using illustration and design as a guide.

Figure 3

- Use knee bent measurement plus extension (3/4 to 1 inch) to develop the knicker band. The width of the band can vary for different design effects. The average finish is 1 inch.
- Complete pattern for test fit.

Figure 1

Figure 2

Figure 3

KNICKER BAND

Equal to knee, plus 1 "

Jumpsuit Foundation

The front and back basic bodice is combined with the pant foundation to develop the jumpsuit pattern. The trouser, slack, or jean can be used for the draft. However, if the jean is used as a base for a jumpsuit, the jumpsuit must be cut in a stretch fabric for comfort. The jumpsuit can be developed all-in-one with the bodice; it can be developed with the front in-one with the bodice and the back with a waistline seam connecting bodice with back pant; or a top (bodice or any other top) can be stitched to the waistline of the front and back pant.

Elastic or a drawstring can be used to hold garment to the waist. At times it is fashionable not to girdle the waistline. The draft allows for blousing along the back and side waist of the front jumpsuit. More blousing can be added for special design effects, and the jumpsuit can be drafted oversized. The pant length can also be varied. Several design ideas are given to show the versatility of the jumpsuit foundation.

The basic sleeve, shirt sleeve, or any other sleeve that fits the armhole can be used with the jumpsuit foundation. The armhole can be lowered for a more casual fit.

Jumpsuit Draft

Figure 1

- Trace front bodice.
- Place front pant on draft, matching center front bodice. (If using slack or jean foundation, the front will overlap at centerline of bodice by 1/4 inch.)
- Trace pant.

 Important: The grainline of the pant when extended through bodice must be parallel with bodice centerline.

- Draw a connecting line from armhole to hipline of the side pant.

Figure 2

- Trace back bodice.
- Place pant on draft so that the space of the back at side is equal to the front side waist.
- Trace pant so the grainline, when extended, is parallel to the centerline of the back.
- Draw sideline and centerline of back. Complete the pattern for a test fit.

Figure 1

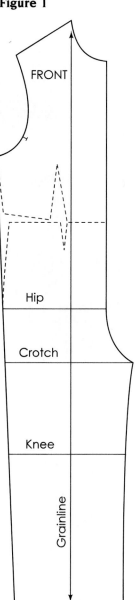

Figure 2

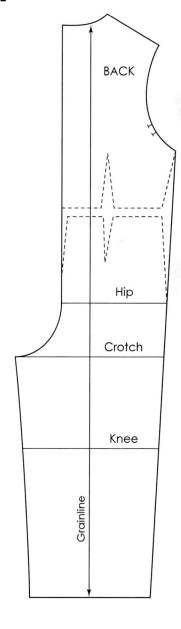

Jumpsuit with Blousing

Figures 3 and 4

For more blousing, add space between the waistline of the front and back patterns.

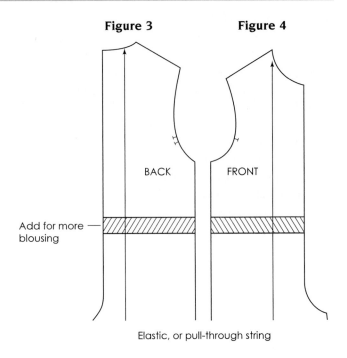

Figure 3 **Figure 4**

Add for more blousing

Elastic, or pull-through string

Oversized Jumpsuit

Figures 5 and 6

To oversize the jumpsuit pattern, add space between the shoulderlines of the front and back patterns.

The armhole should be lowered to balance with the size increase of the garment. To develop a sleeve for a lowered armhole, see page 741.

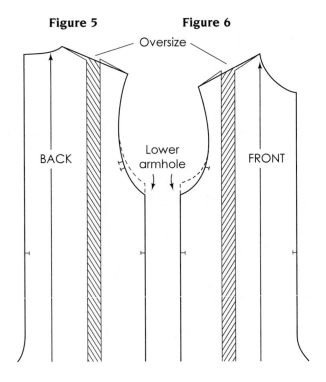

Figure 5 **Figure 6**

Oversize

Lower armhole

Tank-Top Jumpsuit

The tank jumpsuit is based on the trouser jumpsuit foundation and can be drafted for sizes 3 to 6X and 7 to 14.

Tank Draft

Figures 1 and 2

- Trace front and back trouser jumpsuit (see page 781 for trouser jumpsuit draft).
- Use illustration and design as a guide for plotting the pattern. Design 1 is illustrated.
- Cut and separate the patterns.
- Complete the pattern for test fit.

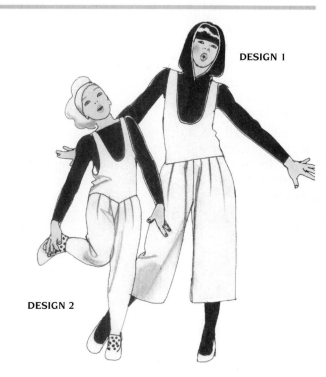

DESIGN 1

DESIGN 2

Figure 1

Figure 2

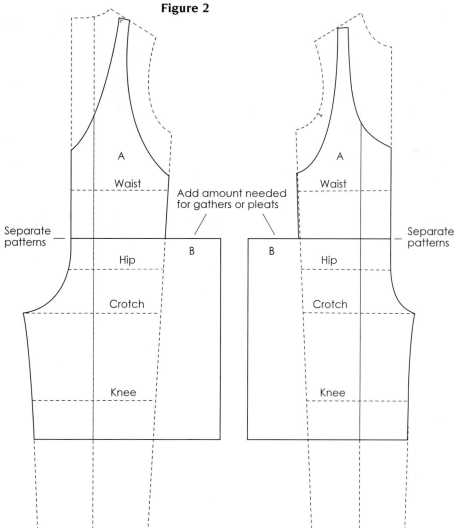

A

Waist

Separate patterns

Hip

Crotch

Knee

Add amount needed for gathers or pleats

B

B

A

Waist

Separate patterns

Hip

Crotch

Knee

Bib Overall

The bib overall is based on the trouser or slack jumpsuit (see page 781). The design is suitable for sizes 3 to 6X and 7 to 14, for boys or girls.

Design Analysis

The bib overall has a utility pocket on front of the bib, side pockets, and a patch pocket on seat of the pant. The designs show a short and a long legline. Length of the strap is controlled by button on the front bib.

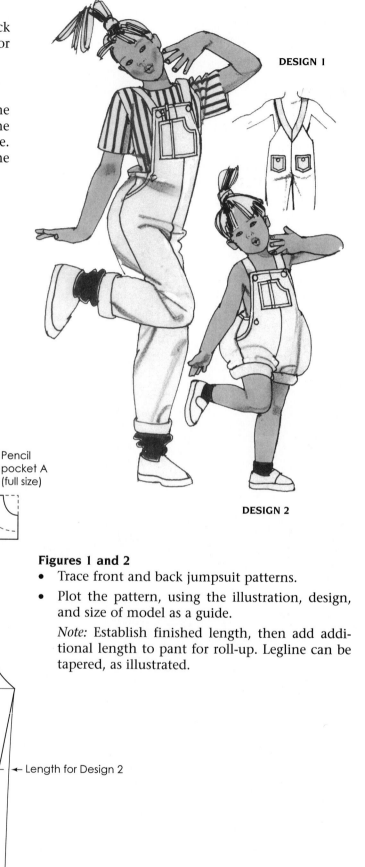

DESIGN 1

DESIGN 2

Figure 1 **Figure 2**

Pencil pocket A (full size)

Pocket C

Pocket B entry

Hip

Crotch

Knee

← Length for Design 2

← Length for Design 1

Figures 1 and 2

- Trace front and back jumpsuit patterns.

- Plot the pattern, using the illustration, design, and size of model as a guide.

Note: Establish finished length, then add additional length to pant for roll-up. Legline can be tapered, as illustrated.

Figure 3

- Front and back strap are connected at shoulder for a one-piece pattern.

Figure 3

C.B.

Figure 4

- Pattern for utility pocket is traced from the pattern.

Figure 4

Pocket A

Top stitching

Figure 5a, b

- Pocket backing and facing are traced from the pattern.

Figure 5a **Figure 5b**

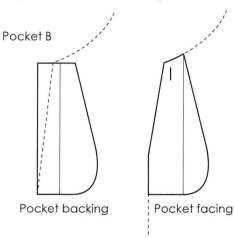

Pocket B

Pocket backing Pocket facing

Figure 6

- Patch pocket is traced from the back pant. Add foldover facing.
- Complete the pattern for test fit.

Figure 6

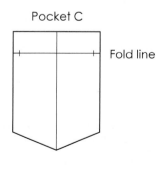

Pocket C

Fold line

36

Bodysuits, Leotards, Maillots, and Swimwear

Bodysuit

The bodysuit is an actionwear garment cut in a two-way stretch Lycra fabric for comfort and maximum body movement. (For more information about knits, see Chapter 26.) A seam allowance of 3/8 inch (overlock) is included in the draft.

The draft is based on the dartless pattern. Two bodysuit drafts are illustrated: the sleeveless (tank-top) bodysuit and the bodysuit with sleeves.

The maximum stretch of the knit fabric runs through the length of the garment. The front and back bodysuit are drafted together and separated at the completion of the draft.

Measurements needed

- (14) Waist arc front _____.
- (7) Side length _____.
- (15) Hip arc back _____.
- (27) Crotch depth _____.
- (18) Waist to ankle (pant length) _____.
- (21) Knee _____.
- (17) Waist to knee _____.
- (23) Ankle _____.

Tank-Top Bodysuit Draft

Special instruction

If milliskin knit is used, subtract 1 inch from measurements where asterisk [*] is marked.

Legline

Subtract 1/2 inch from knee and ankle measurements.

Figure 1

- Trace front pattern. Label neck A. Raise waist 1/2 inch. Label B.

 A–C = One-third of A–B.

 *B–D = Waist arc front less 1/2 inch (14), squared from B.

 D–E = One-half of side length squared up from D (7). Draw armhole and neckline, as illustrated.

 B–F = Crotch depth, (27) less 1/2 inch. Mark.

 B–G = One-half of B–F. Mark.

 B–H = One-half of B–D. Mark.
 Square up and down through pattern. (This line is the direction of greatest stretch when placed on the knit.)

 H–K = To pant length less 1 inch (18). Mark.

 *G–I = Hip arc, less 1/2 inch (back) (15). Squared from G.

 F–J = One-fourth of G–I, plus 1/2 inch. Squared from F.

 K–M = Knee level, plus 1/2 inch. Mark.

- *Legline:* Add 3/4 inch to knee (21) and ankle (23) measurement, and divide into fourths. Square out from each side at knee and ankle using these measurements. Draw legline from ankle to knee and from knee blending to hipline. Draw crotch curve from J, blending with inseam.

Figure 2 *Back bodysuit*

- Cut pattern from paper.
- Trace pattern, for back pattern.
- The back strap slants toward the neckline.
- Draw back neckline.
- Complete the pattern for test fit. See page 627 for guide to correct the pattern for fitting problems. *Note:* Modify neckline and armhole to vary the design.

Figure 1 **Figure 2**

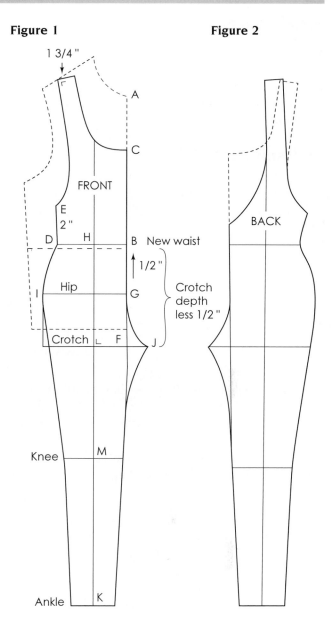

Stitching guide

- Overlock seams together, except for 5-inch opening at center back for entry.
- For elastic attachment instruction, see page 677.
- Use this pattern for all designs cut in knit having the same stretch factor.

Notching guide

There are two types of notching used for knits:

1. Notch to a depth of 1/8 inch.

2. Cut pyramid shapes out from the seam edge— 1/8-inch wide and 1/8-inch high (Δ).

Bodysuit with Sleeves

The armhole of the dartless pattern is modified for a sleeve.

Complete the draft by following the tank-top bodysuit instructions, starting with B–F. For measurements needed, see page 789.

Bodysuit Draft

If milliskin knit is used, subtract 1 inch from measurement where [*] is marked.

Figures 1 and 2

- Trace front pattern. Label neck A. Raise waist 1/2 inch, and label B.

 A–C = One-third of A–B. Mark.

 *B–D = Waist arc less 1/2 inch (14) front.

 Squared from B.

 D–E = Side length is squared up from D, 1/2 inch past armhole level, and squared out 1/2 inch.

 Draw side seam with a slight inward curve.

 Draw armhole curve parallel to the original armhole.

 Draw neckline as illustrated, or modify the shape as desired.

Armhole

- Measure armhole and record for use in developing the sleeve (A–E) _____.

Continue with draft on page 789, Figure 1, starting with B–F instructions.

Figure 1 **Figure 2**

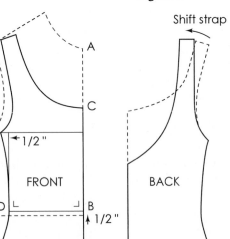

Lycra Knit Sleeve

The sleeve draft is for use with Lycra stretch knit only.

Figure 1

A–B = Sleeve length, (28) less 1/2 inch. Fold paper.

A–C = Cap height, less 1 inch. Square a line out from C (biceps level).

B–D = One-half of B–C (elbow level).

A–E = Front armhole, plus 1/8 inch.

 Line touches biceps level.

 Divide the line into thirds.

 Draw capline curve, using measurements given.

B–G = One-half of wrist entry measurement (30) plus 3/4 inch.

 Draw underseam.

 Cut pattern from paper and test fit with bodysuit or leotard.

 Greatest stretch goes around the arm.

For information about elastic, see page 677.

Figure 1

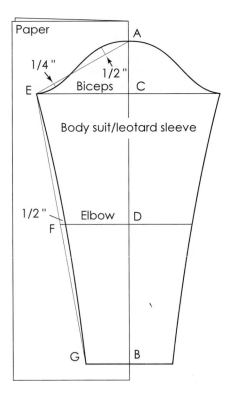

Tights with Top

To develop tights, the bodysuit pant is traced to above waistline (allow material for elastic casing). The bodysuit pattern can be separated through the midrift area for designs with top and bottom patterns. The legline length can be varied to create other effects.

Figure 1 **Figure 2**

3/4 " allowance
for 1/2 " elastic

Front and
back tights

3/4 "

3/4 "

1/2 "
(no elastic)

Top and Bottom Patterns

Figure 1

- Trace bodysuit front pattern.

- Plot styleline, using illustration, design, size, and height of model as a guide.

Elastic control

Elastic should measure the same as the pattern at the waistlines, less 3/4 inch. The measurement includes 1 inch for overlap to stitch the elastic together. See page 677 for stitching and elastic instructions.

Tights

Figure 2

- Trace bodysuit pattern and follow illustration, design, and size as a guide to plotting the pattern. For instructions to develop tights with stirrups, see page 634.

Tank-Top Leotard

The leotard is cut in a two-way Lycra stretch fabric for comfort and maximum movement. (For information about knits, see Chapter 26.) Seam allowances of 3/8 inch are included in the draft.

The leotard is based on the dartless pattern. The leotard drafts illustrated are sleeveless and with sleeves.

The maximum stretch of the knit fabric runs through the length of the garment. The front and back leotard are drafted together and separated at the completion on the draft.

Measurements needed

- (14) Waist arc front _____.
- (15) Hip arc back _____.
- (27) Crotch depth _____.
- (26) Crotch length _____.

Leotard Draft

If milliskin is used, subtract 1 inch from measurement where [*] is marked.

Figure 1

- Trace front dartless pattern. Raise waist 1/2 inch and label A–B.

A–C	=	One third of A–B.
*B–D	=	Waist arc (14), less 1/2 inch, squared from B.
D–E	=	2 inches, squared from D. Draw shoulder strap and neckline, as illustrated.
B–F	=	One-half of crotch length (26), less 3/4 inch.
B–G	=	One-half of B–F, less 1 inch.
*G–H	=	Hip arc (15), less 1/2 inch, squared from G.
F–I	=	$1\frac{1}{8}$ inch, squared from F. Square up from I. Label J. Crossmark 2 inches up from I. Label K.

Draw a $1\frac{3}{4}$-inch line from J as a guide. Draw front legline from H to K. Cut from paper.

Figure 2 *Back leotard*

- Trace front leotard pattern.
- Draw a line from A to B, 3/8 inch in from each end of the legline.
- Draw back legline, as illustrated.
- Shift shoulder strap, as illustrated (secures strap to shoulder).

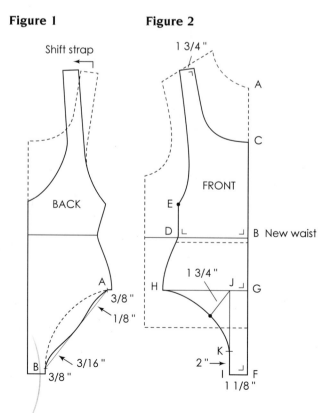

Figure 1 Figure 2

Leotard with Sleeve

If milliskin is used, subtract 1 inch from measurement where [*] is marked.

Figures 1 and 2

- Trace front pattern. Raise waist 1/2 inch and label A–B.

 A–C = One-third of A–B. Mark.

 *B–D = Waist arc (14) front, less 1/2 inch, squared from B.

 D–E = Side length is squared up from D, 1/2 inch past armhole level, and squared out 1/2 inch.

 Draw side seam with a slight inward curve.

 Draw armhole curve parallel to the original armhole.

 Draw neckline as illustrated, or modify the shape as desired.

Armhole

- Measure armhole and record for use in developing the sleeve _____. See page 790 for sleeve draft.

Continue with draft on page 792, Figure 1 starting with B–F instructions.

Figure 1 **Figure 2**

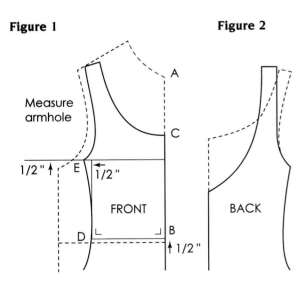

Measure armhole

1/2 " E 1/2 "

FRONT BACK

C

A

D B ↑ 1/2 "

Figures 3 and 4
The completed pattern.

Figure 3 **Figure 4**

Back Leotard

Waist

Front Leotard

Waist

Direction or greatest stretch

Maillot Foundation

The maillot swimsuit is based on the leotard pattern with basic armhole (see page 793). Seam allowances of 3/8 inch are included in the draft. The maximum stretch goes around the figure. The maillot foundation pattern is the base for the development of the bikini and bra tops.

Maillot Draft

Figures 1 and 2

- Trace front and back leotard. Modify the pattern as illustrated. Two leglines are shown for design variations.
- Extend centerline if a higher neckline is desired. (See page 677 for stitching and elastic guidance.)
- The waistline is marked using the symbol Δ rather than the notch.
- Cut and test fit.
- For guidance to pattern adjustments, see page 638.

Figure 1

Figure 2

BACK

FRONT

← Direction of greatest stretch →

1/2 "

1/2 "

Bikini Swimsuit

The bikini swimsuit is based on the maillot pattern. See page 794 to develop the maillot draft.

Bikini Draft

Figures 1 and 2

- Trace front and back maillot patterns.
- Plot bikini and bra top, using illustration and design as a guide.
- Mark direction lines.
- Cut patterns from paper.

Figure 1 **Figure 2**

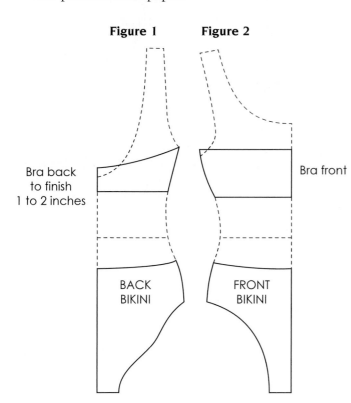

Bra back to finish 1 to 2 inches

BACK BIKINI

Bra front

FRONT BIKINI

Figure 3

- Trace bra on fold and add 3/8 inch for elastic attachment. Cut from paper.

Figure 3

A

Bra front

B

Paper

Figure 4

- Loop equals the width of the bra (D–C = A–B). The loop wraps around the bra and is tacked to the underpart.

Figure 4

C

D

Loop

Figure 5

- Cut back strap from paper. Side seams of the front and back bra can be banked together to eliminate the side seam.

Figure 5

Back bra

Figures 6 and 7

- Cut bikini pant from patterns.
- Cut front and back bikini on fold.

Figure 9

- Trace for crotch lining. Cut on fold. (See page 677, Chapter 29 for elastic and stitching guide.)
- Complete pattern for test fit.

Figure 6 **Figure 7**

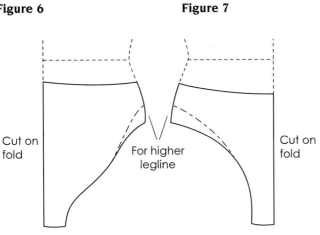

Cut on fold

For higher legline

Cut on fold

Figure 9

Crotch lining

Cut on fold

Figure 8

The bikini pant can be cut all in one.

Figure 8

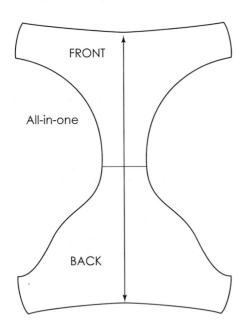

FRONT

All-in-one

BACK

Metric Conversion Table

(INCHES TO CENTIMETERS)

(1 inch, U.S. standard = 2.540005 (centimeters)

The centimeter equivalent to the inch measurement is to the nearest tenth in this text. It is an accepted general practice to measure to the nearest half-centimeter for major measurements when using the metric system of measurement exclusively.

FRACTIONS

INCHES	0	1/16	1/8	1/4	3/8	1/2	5/8	3/4	7/8	INCHES
0	0.0	0.2	0.3	0.6	1.0	1.3	1.6	1.9	2.2	0
1	2.5	2.7	2.9	3.2	3.5	3.8	4.1	4.4	4.8	1
2	5.1	5.2	5.4	5.7	6.0	6.4	6.7	7.0	7.3	2
3	7.6	7.8	7.9	8.3	8.6	8.9	9.2	9.5	9.8	3
4	10.2	10.3	10.5	10.8	11.1	11.4	11.7	12.1	12.4	4
5	12.7	12.9	13.0	13.3	13.7	14.0	14.3	14.6	14.9	5
6	15.2	15.4	15.6	15.9	16.2	16.5	16.8	17.1	17.5	6
7	17.8	17.9	18.1	18.4	18.7	19.1	19.4	19.7	20.0	7
8	20.3	20.5	20.6	21.0	21.3	21.6	21.9	22.2	22.5	8
9	22.9	23.0	23.2	23.5	23.8	24.1	24.4	24.8	25.1	9
10	25.4	25.6	25.7	26.0	26.4	26.7	27.0	27.3	27.6	10
11	27.9	28.1	28.3	28.6	28.9	29.2	29.5	29.8	30.2	11
12	30.5	30.6	30.8	31.1	31.4	31.8	32.1	32.4	32.7	12
13	33.0	33.2	33.3	33.7	34.0	34.3	34.6	34.9	35.2	13
14	35.6	35.7	35.9	36.2	36.5	36.8	37.1	37.5	37.8	14
15	38.1	38.3	38.4	38.7	39.1	39.4	39.7	40.0	40.3	15
16	40.6	40.8	41.0	41.3	41.6	41.9	42.2	42.5	42.9	16
17	43.2	43.3	43.5	43.8	44.1	44.4	44.8	45.1	45.4	17
18	45.7	45.9	46.0	46.4	46.7	47.0	47.3	47.6	47.9	18
19	48.3	48.4	48.6	48.9	49.2	49.5	49.8	50.2	50.5	19
20	50.8	51.0	51.1	51.4	51.7	52.1	52.4	52.7	53.0	20
21	53.3	53.5	53.7	54.0	54.3	54.6	54.9	55.2	55.6	21
22	55.9	56.0	56.2	56.5	56.8	57.2	57.5	57.8	58.1	22
23	58.4	58.6	58.7	59.1	59.4	59.7	60.0	60.3	60.6	23
24	61.0	61.1	61.3	61.6	61.9	62.2	62.5	62.9	63.2	24

FRACTIONS

INCHES	0	1/16	1/8	1/4	3/8	1/2	5/8	3/4	7/8	INCHES
25	63.5	63.7	63.8	64.1	64.5	64.8	65.1	65.4	65.7	25
26	66.0	66.2	66.4	66.7	67.0	67.3	67.6	67.9	68.3	26
27	68.6	68.7	69.0	69.2	69.5	69.9	70.2	70.5	70.8	27
28	71.1	71.3	71.4	71.8	72.1	72.4	72.7	73.0	73.3	28
29	73.7	73.8	74.0	74.3	74.6	74.9	75.2	75.6	75.9	29
30	76.2	76.4	76.5	76.8	77.2	77.5	77.8	78.1	78.4	30
31	78.7	78.9	79.1	79.4	79.7	80.0	80.3	80.6	81.0	31
32	81.3	81.4	81.6	81.9	82.2	82.6	82.9	83.2	83.5	32
33	83.8	84.0	84.1	84.5	84.8	85.1	85.4	85.7	86.0	33
34	86.4	86.5	86.7	87.0	87.3	87.6	87.9	88.3	88.6	34
35	88.9	89.1	89.2	89.5	89.9	90.2	90.5	90.8	91.1	35
36	91.4	91.6	91.8	92.1	92.4	92.7	93.0	93.3	93.7	36
37	94.0	94.1	94.3	94.6	94.9	95.3	95.6	95.9	96.2	37
38	96.5	96.7	96.8	97.2	97.5	97.8	98.1	98.4	98.7	38
39	99.1	99.2	99.4	99.7	100.0	100.3	100.6	101.0	101.3	39
40	101.6	101.8	101.9	102.2	102.6	102.9	103.2	103.5	103.8	40
41	104.1	104.3	104.5	104.8	105.1	105.4	105.7	106.0	106.4	41
42	106.7	106.8	107.0	107.3	107.6	108.0	108.3	108.6	108.9	42
43	109.2	109.4	109.5	109.9	110.2	110.5	110.8	111.1	111.4	43
44	111.8	111.9	112.1	112.4	112.7	113.0	113.3	113.7	114.0	44
45	114.3	114.5	114.6	114.9	115.2	115.6	115.9	116.2	116.5	45
46	116.8	117.0	117.2	117.5	117.8	118.1	118.4	118.7	119.1	46
47	119.4	119.5	119.7	120.0	120.3	120.7	121.0	121.3	121.6	47
48	121.9	122.1	122.2	122.6	122.9	123.2	123.5	123.8	124.1	48
49	124.5	124.6	124.8	125.1	125.4	125.7	126.1	126.4	126.7	49
50	127.0	127.2	127.3	127.6	128.0	128.3	128.6	128.9	129.2	50
51	129.5	129.7	129.9	130.2	130.5	130.8	131.1	131.5	131.8	51
52	132.1	132.2	132.4	132.7	133.0	133.4	133.7	134.0	134.3	52
53	134.6	134.8	134.9	135.3	135.6	135.9	136.2	136.5	136.9	53
54	137.2	137.3	137.5	137.8	138.1	138.4	138.8	139.1	139.4	54
55	139.7	139.9	140.0	140.3	140.7	141.0	141.3	141.6	141.9	55
60	152.4	152.6	152.7	153.0	153.4	153.7	154.0	154.3	154.6	60

Form Measurement Chart

Circumference Measurements

1. Bust: _____
2. Waist: _____
3. Abdomen: _____
4. Hip: _____

Upper Torso (Bodice)

5. Center length: F_____ B_____
6. Full length: F_____ B_____
7. Shoulder slope: F_____ B_____
8. Strap: F_____ B_____
9. Bust depth: _____ Bust Radius _____
10. Bust span: _____
11. Side length: _____
12. Back neck: _____
13. Shoulder length: _____
14. Across shoulder: F_____ B_____
15. Across chest: _____
16. Across back: _____
17. Bust arc: _____
18. Back arc: _____
*19. Waist arc: F_____ B_____

Dart Measurements

*20. Dart placement: F_____ B_____
*21. (not needed)

Lower Torso (Skirt/Pant)

*22. Abdomen arc: F_____ B_____
*23. Hip arc: F_____ B_____
24. Crotch depth: _____
*25. Hip depth: CF _____ CB _____ Diff: _____
*26. Side hip depth: _____
27. Waist to: Ankle _____ Floor _____ Knee _____
28. Crotch length: _____
29. Upper thigh: _____ Mid-thigh: _____
30. Knee: _____
31. Calf: _____
32. Ankle: _____

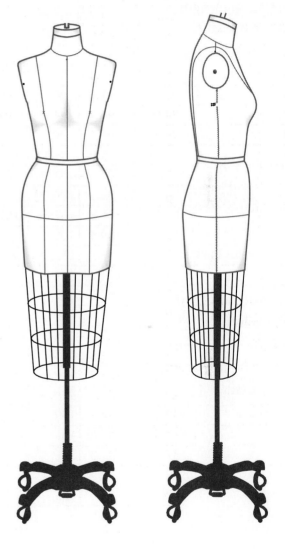

Arm Measurements (Sleeve)

Standard sleeve measurements are given on page 51.

*Measurements apply to skirt and pant development.

Personal Measurement Chart

Circumference Measurements

1. Bust: _____, plus 2″ ease _____
2. Waist _____, plus 1″ ease _____
3. Abdomen _____
4. Hip _____, plus 2″ ease _____

Upper Torso (Bodice)

5. Center length: F _____, B _____
6. Full length: F _____, B _____
7. Shoulder slope: F _____, B _____
8. Strap: F _____, B _____
9. Bust depth: _____, Radius _____
10. Bust span: _____
11. Side length: _____
12. Back neck: _____
13. Shoulder length: _____
14. Across shoulder: F _____, B _____
15. Across chest: _____
16. Across back: _____
17. Bust arc: _____
18. Back arc: _____
19. Waist arc: F _____, B _____
20. Dart placement F _____, B _____
 Personal Dart Intake:
 Front: = _____
 Back = _____

Lower Torso (Skirt/Pant)

22. Abdomen arc: F _____, B _____
23. Hip arc: F _____, B _____
24. Crotch depth: _____
25. Hip depth: CF _____ CB _____
26. Side hip depth: _____
27. Waist to ankle: _____
 Waist to knee: _____
 Waist to floor: _____
28. Crotch length: _____
 Vertical trunk: _____
29. Upper thigh: _____
 Mid-thigh: _____
30. Knee: _____
31. Calf: _____
32. Ankle: _____

Personal Arm Measurements

See sleeve draft in Chapter 3.

33. Overarm length: _____
34. Elbow length _____
35. Biceps: _____
36. Wrist: _____
37. Around Hand _____
38. Cap height _____

Note: Number 21 has been omitted from the Standard Measurement Chart.

Children's Measurement Recording Chart—3 To 6x And 7 To 14

Size: _____ Height: _____ Weight: _____ Head circumference: _____

Circumference Measurements (ease not included)

1. Bust or chest: _____

2. Waist: _____

3. Hip: _____

4. Center length: F_____ B_____

5. Full length: F_____ B_____

6. Shoulder slope: F_____ B_____

7. Side length: _____

8. Shoulder length: _____

9. Across shoulder: F_____ B_____

10. Across chest: _____

11. Bust or chest arc: _____

12. Across back: _____

13. Back arc: _____

14. Waist arc: F_____ B_____

15. Hip arc: F_____ B_____

16. Waist to hip: _____

17. Waist to knee: _____

18. Waist to ankle: _____

19. Waist to floor: _____

20. Upper thigh: _____

21. Knee: _____

22. Calf: _____

23. Ankle: _____

24. Foot entry: _____

25. Trunk length: _____

26. Crotch length: _____

27. Crotch depth: _____

28. Overarm sleeve length: _____

29. Biceps: _____

30. Wrist: _____

 Hand entry: _____

31. Cap height: _____

(Sleeve draft, see page 699.)

COST SHEET

Date _____ Division _____ Season _____ Style # _____

Fabric Resource 1 _____ Pattern _____ Selling $ _____

Width _____" Price _____ Content _____ Colors _____ Markup % _____

Ship weeks _____ Salesperson _____ # _____ Delivery _____

Fabric Resource 2 _____ Pattern _____ Sizes _____

Width _____" Price _____ Content _____ Pattern _____ O/P $ _____ M/U % _____

Ship weeks _____ Salesperson _____ # _____

I. MATERIAL	Estimate	Actual	Price	Est. Total	Actual Total
Freight					

SKETCH

Total Material Cost _____

II. TRIMMINGS	Estimate	Actual	Price	Est. Total	Actual Total
Buttons					
Pads					
Embroidery					
Belts					
Zippers					
Elastic					
Send out					
%					

SWATCH

Total Trim Cost _____

III. LABOR	Estimate	Actual	Price	Est. Total	Actual Total
Cutting					
Marking					
Grading					
Sewing					
Bag/label					
Trucking					
%					

Total Cost _____

M/U % _____

Remarks _____

Pattern Record Card

STYLE # _____

SIZE RANGE _____

YARDAGE _____

DATE _____

PATTERN PIECES SELF

			TRIM
			ZIPPER
			BUTTONS
			BELT
			SCARF
			OUTSIDE WORK

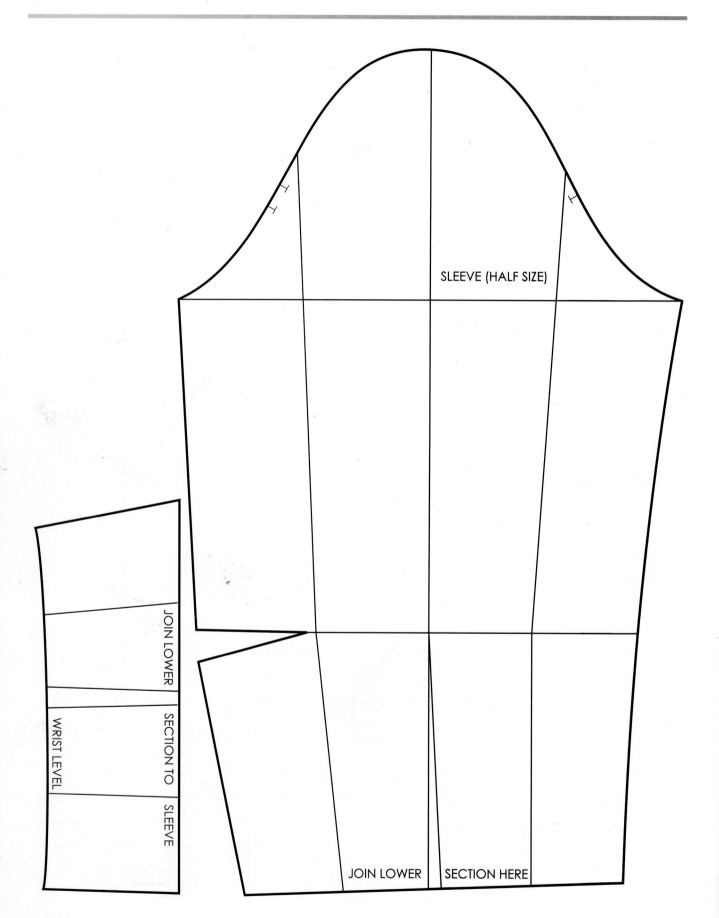

SLEEVE (HALF SIZE)

JOIN LOWER SECTION TO SLEEVE

WRIST LEVEL

JOIN LOWER SECTION HERE

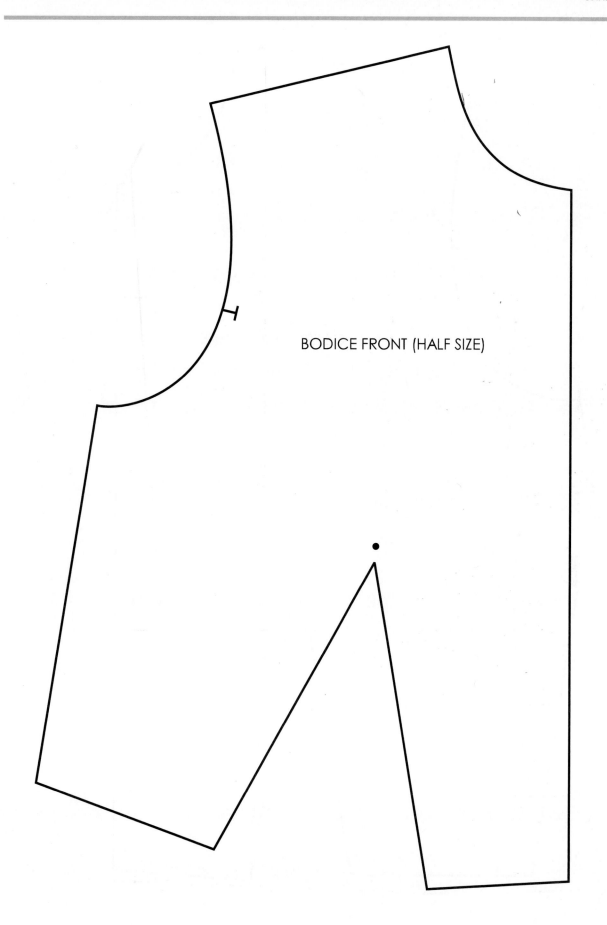

BODICE FRONT (HALF SIZE)

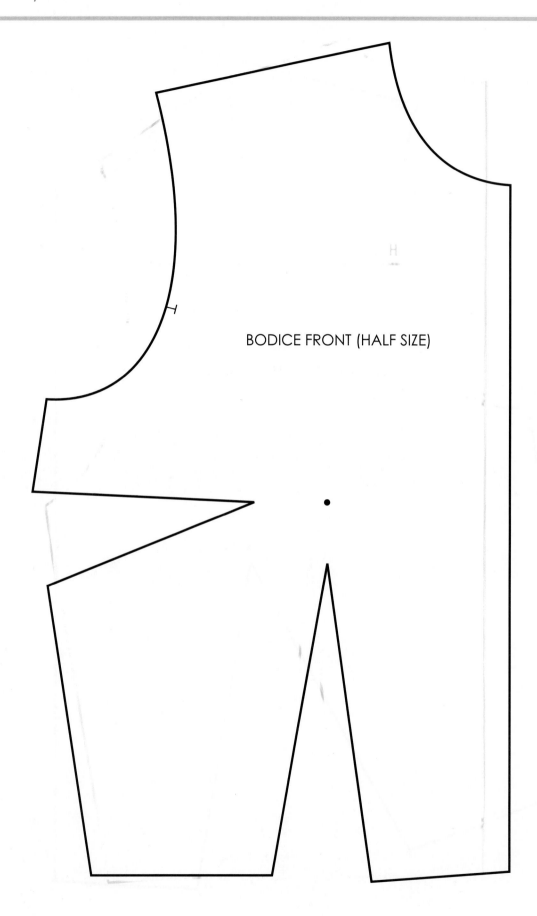

BODICE FRONT (HALF SIZE)

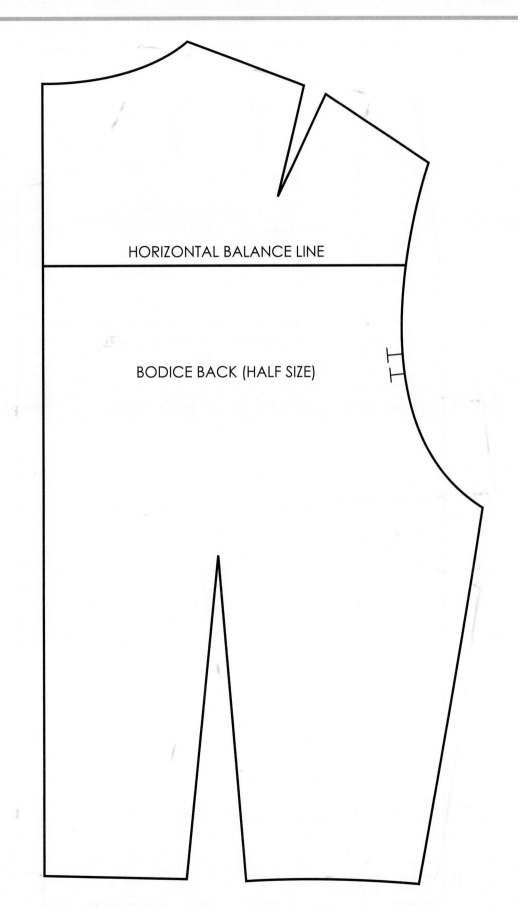

HORIZONTAL BALANCE LINE

BODICE BACK (HALF SIZE)

SKIRT FRONT (HALF SIZE)

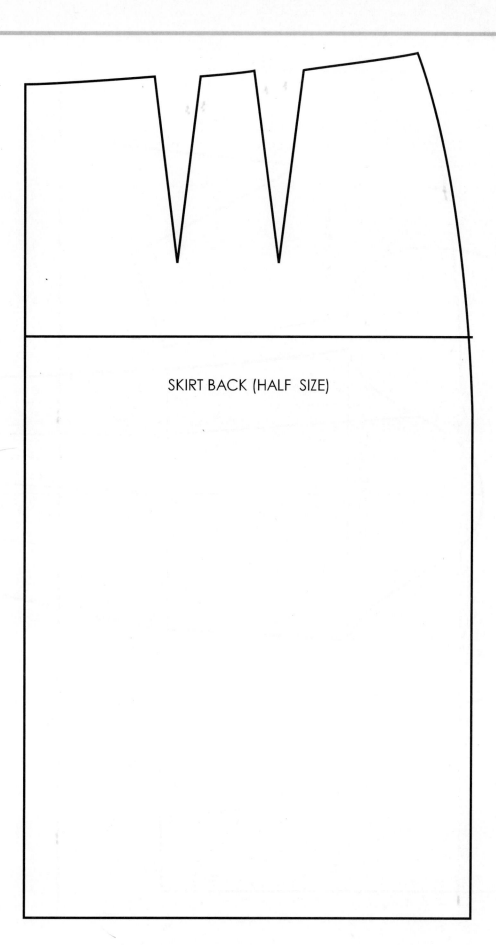

SKIRT BACK (HALF SIZE)

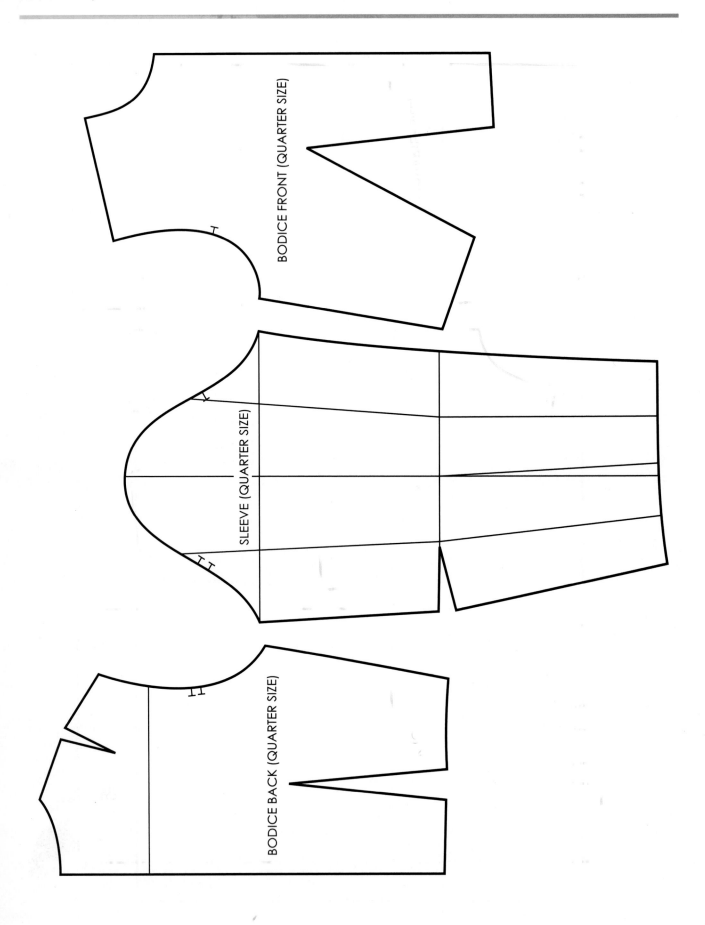

BODICE FRONT (QUARTER SIZE)

SLEEVE (QUARTER SIZE)

BODICE BACK (QUARTER SIZE)

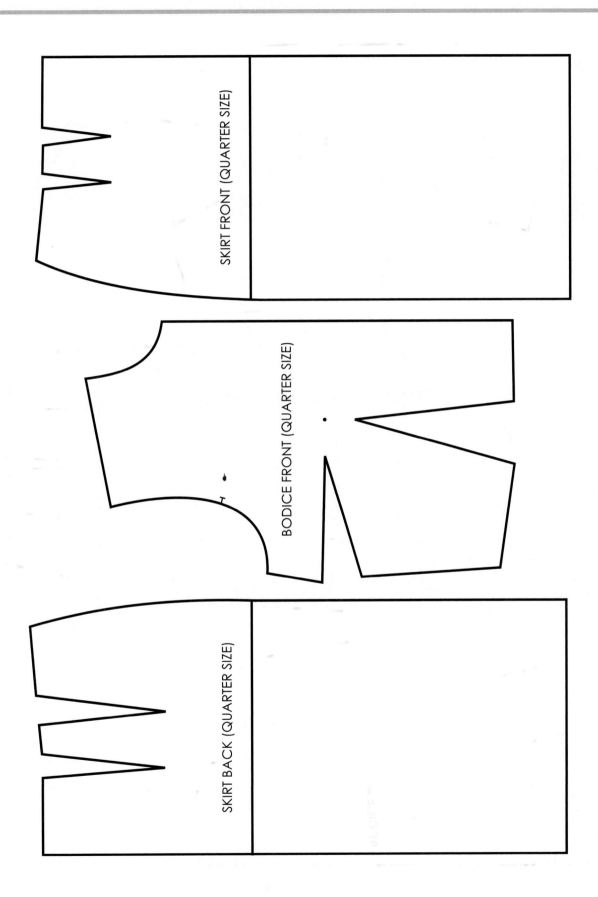

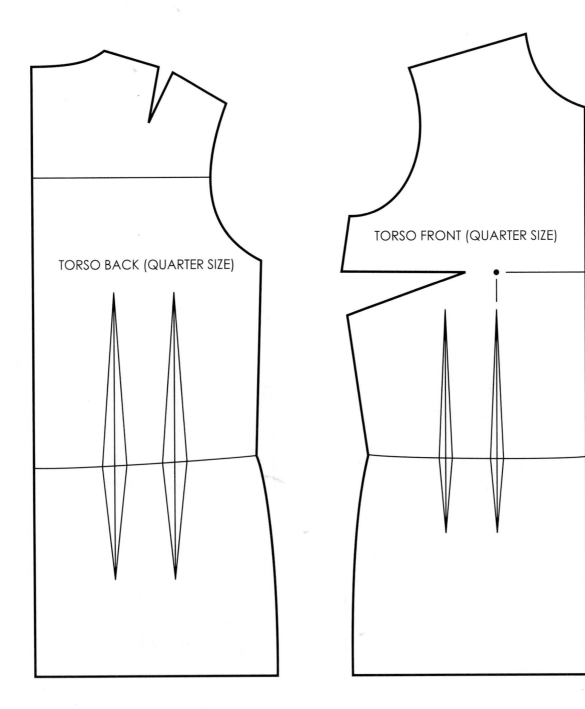

TORSO BACK (QUARTER SIZE)

TORSO FRONT (QUARTER SIZE)

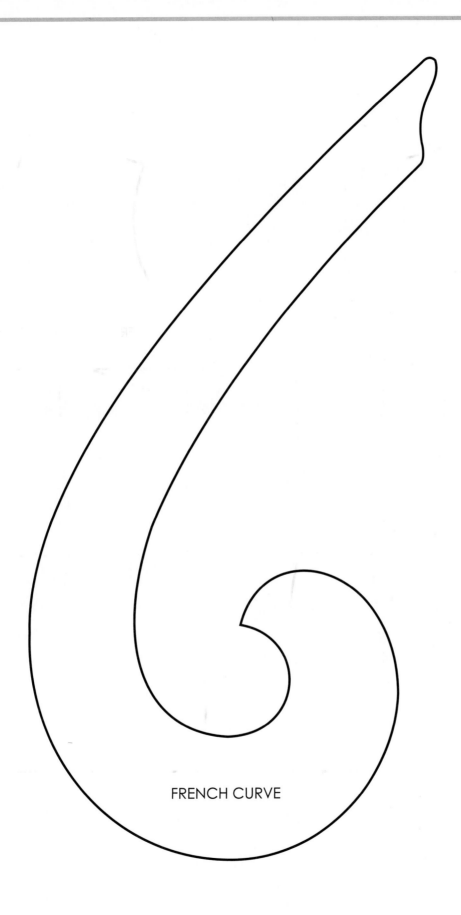

FRENCH CURVE

Index